THE REGAL IMAGE
OF RICHARD II
AND THE WILTON DIPTYCH

THE REGAL IMAGE
OF RICHARD II
AND THE
WILTON DIPTYCH

edited by

DILLIAN GORDON · LISA MONNAS
and CAROLINE ELAM

with an Introduction by

CAROLINE M. BARRON

HARVEY MILLER PUBLISHERS

HARVEY MILLER PUBLISHERS
Knightsbridge House, 197 Knightsbridge, London SW7 1RB
An Imprint of G+B Arts International

British Library Cataloguing in Publication Data
A catalogue record for this book
is available from the British Library

ISBN 1872501729

Composition by Jan Keller, London
Origination and printing by Clifford Press Ltd, Coventry
Manufactured in Great Britain

Contents

Editors' Preface

THE WILTON DIPTYCH is arguably the most exquisite panel painting to survive from the late 14th century. Of outstanding quality and beauty, it has been the subject of innumerable scholarly studies, yet some aspects of its complex iconography and the circumstances of its commissioning remain tantalisingly elusive. New research into the Diptych was stimulated when it was cleaned and conserved in the National Gallery and then made the focus of the exhibition *Making and Meaning: the Wilton Diptych* in September – December 1993. In November of that year a two-day interdisciplinary symposium 'Court Art in the Reign of Richard II and the Wilton Diptych' organized in association with the Burlington Magazine and the Medieval Dress and Textile Society, was held at the National Gallery, kindly sponsored by Esso UK plc and the Matthiesen Gallery.

The papers given at the symposium have been substantially revised and most of them are presented here. Caroline Barron has written an introduction, and there are two additional papers by Christopher Wilson and Hana Hlávacková. Because this volume had its genesis in a symposium, there are inevitably some omissions, for example the wider context of European panel painting, and some aspects of Ricardian culture, such as literature. Although the intention is that the text should be as consistent as possible, there are, not surprisingly, contrasting views and interpretations amongst the authors.

We would like to thank Claude Blair, Jenny Stratford and Caroline Barron for their help in the preparation of this volume. Thanks are also due to Martin Wyld, the Chief Restorer at the National Gallery, who kindly made the Diptych available to scholars during the course of its conservation. We are also grateful to the Matthiesen Gallery who have generously contributed towards the cost of its production. It is a book which we believe not only elucidates the Wilton Diptych, but also furthers our understanding of Richard II as monarch and patron.

Dillian Gordon
Lisa Monnas
Caroline Elam

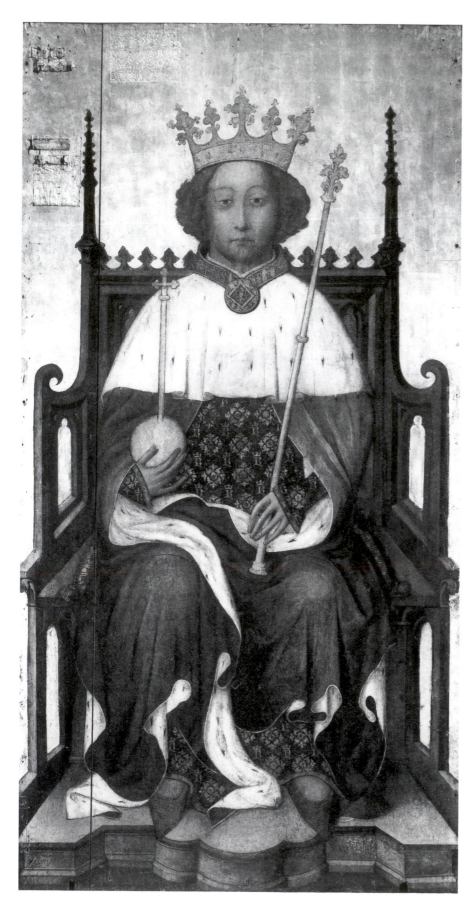

1. Richard II Enthroned, *c.* 1395(?). London, Westminster Abbey

CAROLINE M. BARRON

Introduction

NEITHER RICHARD II nor the Wilton Diptych has suffered from lack of attention: the reign of Richard II and the causes and manner of his deposition were the subject of chroniclers' speculations as soon as he was dead, and have provided material for numerous biographical studies since. The Wilton Diptych, which was in the collection of Charles I in the early seventeenth century, became the focus of scholarly attention in the nineteenth and, since its purchase by the National Gallery in London in 1929, has been increasingly the object of frequent articles and speculation. There is a great deal of material surviving (chronicles, letters, government records) for the reign of Richard II from which it is possible to try to fashion an understanding of what happened and why it happened; likewise, the Diptych clearly contains many visual clues to its meaning, challenging us to read its message while ultimately withholding the answers. So the King and his painting remain, in spite of all that we can know and all that has been written, mysterious enigmas. Scholars continue to respond to the interpretative challenges posed both by the King and by the painting; and the papers in this volume are the most recent, but they will not be the last, attempts to understand, decipher, decode and analyse the man and his making.[1]

Most of the papers printed here were given at a conference held at the National Gallery in the course of a special exhibition entitled *Making and Meaning: The Wilton Diptych* in November 1993. Some of the papers focus directly on Richard himself as the clue to understanding a painting which most people believe he commissioned: others study the painting as a way of understanding Richard himself. Yet others approach the King and the painting more circumspectly, by looking at other areas of related interest in late fourteenth-century society: architecture, clothing, contemporary painting, the crusades, goldsmiths' work, sculpture, and manuscript illumination.

In 1968 Gervase Mathew published an important book, *The Court of Richard II*. The polish and urbanity with which it was written may have led to its being taken less seriously than it deserved; but Mathew's book encompassed the whole range of courtly culture and this book takes up a part of Mathew's vision. These essays discuss the artistic world of the Wilton Diptych, but not the literary, dramatic or poetic worlds.[2] As it is, the collection is large enough, and the Wilton Diptych sits on this bed of scholarship rather as the hart sits on the bed of rosemary on the outer face of the Diptych: beautifully painted, serene and secret.

The exhibition and the flurry of scholarly interest that it provoked have, indeed, produced new information that is to be found here in these papers. Some discoveries are really new, others are rediscoveries of known material, newly

understood. Dillian Gordon's discovery under magnification of the painted scene on the tiny knob or orb surmounting the banner is, probably, the most singular and exciting discovery about the Wilton Diptych made in recent years. The significance of the painted orb has already, here in these essays, become a matter of debate and discussion. The Exchequer inventories and, in particular, the great inventories of the contents of Richard's treasury in his last years, have been much more closely scrutinized.[3] Although none of them lists the Wilton Diptych among Richard's treasures (and this was not to be expected since these are inventories of goldsmiths' work), the inventories have been used by Marian Campbell to illuminate Richard's taste in jewels, in badges and in gifts. The saints and symbols of the Wilton Diptych appear in many guises in these rich inventories;[4] the Wilton Diptych may be a unique survival but, in its time, it employed imagery which was visually ever-present at the Ricardian court.

Likewise, Lisa Monnas and Kay Staniland have used the royal Wardrobe Accounts kept at the Public Record Office (again not an unknown source but one used by them in new ways) to draw attention to the rich clothing of the royal court; the elaborate dress for ceremonial occasions and the significance and importance of the patterns chosen for the rich silks and brocades. The clothing of the King and the two royal saints is not simply an artist's invention but represents the reality of dress at the Ricardian court. Monnas has drawn our attention to the fact that Richard imported an Italian silk weaver, 'Baldewyno' of Lucca, to weave silk to designs provided by the court painter, Gilbert Prince. Shelagh Mitchell has used the surviving Wardrobe Books where royal offerings at mass and at shrines are recorded, to analyse Richard's devotion to particular saints and particular cults. Two other documents have received renewed attention from historians in this collection: Richard's tomb epitaph and his will are both reconsidered carefully here. Indeed it is surprising that historians have paid so little attention either to the Latin inscription which Richard commissioned for his tomb (1395–97) or to his will, drawn up before his final departure for Ireland, on 16 April 1399. Phillip Lindley transcribes, translates and interprets Richard's epitaph written in Latin hexameters, which he suggests provides an interesting insight into Richard's priorities and his sense of his own achievements. Nigel Saul notes Richard's claim, in this inscription, to have laid low the heretics and, as he points out, this aspect of Richard's policy in the 1390s has not hitherto been much emphasized. Likewise, Richard's will has been used by both Lindley and Campbell to provide an insight into Richard's view of his kingship: it is an arresting document and those who wish to understand Richard's state of mind in the last year of his reign could well ponder the strangely impersonal and obsessive testament.

Several of these essays invite a reconsideration of the religious preoccupations of Richard II: his cults of saints and his emphasis on the eradication of heresy. Richard was born on the Feast of the Epiphany (6 January), which the Church also celebrated as the day on which Christ was baptized by John the Baptist, and he ascended the throne on the eve of the Vigil of the Baptist's Day

(24 June). The Diptych is but one of the many witnesses to that devotion.[5] Richard's promotion of the saintly English monarchs, Edmund, and most particularly Edward, is not hard to explain: in honouring them Richard also promoted the cult of his own lineage. This same preoccupation with his ancestors may be seen again in the statues of English kings which Richard commissioned for Westminster Hall, which are here discussed by Lindley and Christopher Wilson.

Both Mitchell and Olga Pujmanová draw attention to the importance of the Magi to Richard: perhaps he saw himself as one of the Three Kings, in some senses actually present at the Adoration of the Christ Child in the stable at Bethlehem. If Margery Kempe could have visions in which she was present at the Crucifixion, why should not Richard also be present at Christ's Nativity? As Lucy F. Sandler points out, Richard is kneeling in rapt and focused and intimate adoration before the Virgin and Child. Mitchell produces interesting evidence of Richard's 'special association' with the Virgin, and Gordon has suggested that the significance of the painted orb surmounting the banner may lie in its representation of England as the dowry of the Virgin. Yet the known evidence—the Diptych apart—for Richard's devotion to the Virgin is not particularly strong or distinctive. It is true that the tester above Richard's tomb is painted with a scene showing the Coronation of the Virgin, but the Virgin is not invoked in his epitaph and is mentioned only in the usual conventional way in his will. Richard is not recorded as requesting statues of her to be made nor does he specifically make offerings at her particular shrines such as Walsingham. To Richard, perhaps, the Virgin was especially important as the Mother of Christ, the Redeemer of the World.

There is more evidence of Richard's devotion to angels: in the Wilton Diptych the beautiful, dreamy and somewhat inattentive angels all wear Richard's badge of the White Hart. Several of the papers here draw our attention to Richard's interest in angels; eight angels were to guard his tomb, but then they had also guarded the tomb of Philippa of Hainault, and that of his grandfather Edward III, which was commissioned and paid for by Richard II in the late 1380s. They featured prominently in the reconciliation pageants which the Londoners provided for Richard in April 1392 and it is shield-bearing angels 'hovering', as Wilson says, 'at the ends of the hammer-beams', who appear to carry the weight of the new roof of Westminster Hall on their backs. Likewise, there are two shield-bearing angels at the entrance to the late fourteenth-century Chapel of Our Lady of the Pew in Westminster Abbey and it is angels bearing the armorial shields of Richard and Anne who support the tester above their tomb. The idea of a supportive angelic host appears also in the roof bosses of Dartington Hall built by Richard's loyal half-brother John Holland, Duke of Exeter, in the late 1390s. As Sandler points out, other patrons and artists, Giangaleazzo Visconti or the Maréchal de Boucicaut, also, but later, invoked angels as supporters and well-wishers. That Richard felt more inclined to place his trust in a heavenly, rather than earthly, host may be understandable, but it proved unwise.

11

Several of these papers raise the implicit question, what was the Wilton Diptych for? Sandler raises it explicitly. She notes that the Diptych is closer to manuscript miniatures than it is to public altarpieces. Its composition suggests personal use, as a focus for Richard's own meditation. It is possible that Richard experienced a vision which this painting records and, in the privacy of his chapel or room, he would open the Diptych and reflect upon that vision and, perhaps, experience it again with renewed intensity. If the painting records a past vision, then the youthful appearance of the King need no longer surprise us. Richard was certainly conscious of his youth on his accession to the throne: in his will (1399) he noted 'how, since our tender age [we have] submitted our neck…to the burden of government'. This private vision of saintly encouragement, and angelic support, when Richard was entrusted by Christ with His banner (which was also the banner of St George as well as the banner of the Resurrection) may well have been a source of encouragement and hope for the King in times of trouble.

Clearly a few of Richard's courtiers were party to his vision or at least shared or understood his concerns and priorities. Perhaps those named as executors in his will may be seen as the inner circle of his last years: his half-brother John Holland, Duke of Exeter; his nephew Thomas Holland, Duke of Surrey; his cousin Edward, Duke of Aumerle; and his *éminence grise* William Scrope, Earl of Wiltshire; Richard Mitford, Bishop of Salisbury; Edmund Stafford, Bishop of Exeter; Robert Tideman, Bishop of Worcester; Thomas Merks, Bishop of Carlisle; and Guy Mone, Bishop of St David's; the clerks Richard Clifford, Keeper of the Privy Seal, Richard Maudeleyn, William Fereby, and John Ikelyngton; and the laymen John Lufwyk and William Serle. At least ten of these men remained loyal to Richard's cause, six died for him and one, the Duke of Aumerle, betrayed him. Another possible member of this inner group may have been John London, Prior of St Osyth's, who joined the conspiracy to restore Richard II (whom some believed to be still alive) in 1403. John Harvey has suggested that the Diptych may have been the icon, the shrine, of an inner, secret society or brotherhood dedicated to the restoration of the English royal prerogative. But the membership of this possible royalist brotherhood overlaps, as Maurice Keen points out, that of the well-known Order of the Passion, dedicated to the reconquest of the Holy Land from the infidel. Members of the 'royalist' brotherhood gave each other gifts, the tangible expression of their shared loyalties: Sir John Golafre, a knight of Richard's chamber who died in 1396, left to the King his brooch of the White Hart and his enamelled cup with a cover decorated with a crowned and chained hart, and a cup decorated with harts was left to another chamber knight, Baldwin Beresford. Work on the great inventories of Richard's treasury has suggested that the King received many 'significant' badges and jewels from his intimate courtiers in the 1390s.[6] England was criss-crossed with societies, mysteries, fraternities, guilds, brotherhoods, as well as noble retinues. All were in some sense secret and all bore identifying badges or insignia. That Richard's inner retinue, the men who were constantly about him at court, may have been

associated in some formal or informal brotherhood, is more than likely; at the heart of the brotherhood was the King; and at the heart of his religious experience, there was the Diptych. Nigel Morgan rightly reminds us that the Wilton Diptych was 'first and foremost a personal devotional painting for the use of Richard'. But, by extension, the painting might also have been the focus of a 'brotherhood' formed of those who were personally devoted to the King himself.

But these societies were both secret and public; secret in their oaths and purposes, public in their declared membership. Heraldry was a means of identification which encapsulated intensely complicated layers of meaning within quarterings and impalings and through the choice of supporters. Several of these papers discuss the significance of Richard's decision to impale the royal arms with those of Edward the Confessor. The banner carried by the angel is clearly also of significance: is it the banner of St George, or of the Resurrection, or of both? Badges are important symbols of association and identification, the White Hart, the broom cods, the eagles and yet other badges associated with Richard but not displayed in the Wilton Diptych, the sunburst and the ostrich plume. Perhaps historians struggle too hard to isolate and identify these badges and their meaning; they doubtless carried many meanings and many associations. Badges were not exclusive; they were not passports, only one for each person but, rather, they might be collected, designed, given and treasured, and worn on different occasions by different people. Allegiances in medieval society might be strongly observed but they operated at many levels.

Many of the flowers depicted in the Wilton Diptych were also, as Celia Fisher points out, of iconographic meaning. They too were badges or signs to be read by those who understood. Apart from the flowers scattered at the feet of the Virgin and angels in the right-hand panel of the Diptych, there are also rather more sombre plants which form the environment of the hart on the exterior. Rosemary was one of the badges of Anne of Bohemia and it was also the plant associated with remembrance. Ferns, which are also painted rather awkwardly—but prominently—in the corners of the White Hart panel, were associated with John the Baptist's sojourn in the wilderness. They were also another of Anne of Bohemia's personal devices.[7] Fisher also draws our attention to the row of yellow water irises, the French fleur-de-lis, in the background, beyond the resting hart. Here then, on the outside of the Diptych, can be seen the hart symbolizing Richard himself resting on the broken sprigs of rosemary and flanked by the ferns, both plants associated with his dead wife. In the background are lined up the irises, the symbols of the new marriage alliance which Richard had made with the House of Valois.

The use of lettered badges may have been novel in the second half of the fourteenth century, reflecting, perhaps, a universal rise in literacy. Monnas notes that Richard II wore outfits embellished with whole phrases, individual words or letters. Richard had spoons distinguished by a crowned 'R', girdles decorated with the letters 'A' and 'R'; and on the King's tomb the same letters appear powdered on his robes. The most famous of Richard's lettering is the crowned

13

'R' to be found in gold on the blue velvet of the robe worn by the King in the Westminster Abbey portrait.[8] Jonathan Alexander has drawn attention to this as evidence of 'individual subjectivity' opposed, within the painting, to the formal symbolic character of the full-frontal portrait. He notes the use of comparable crowned initials by Charles V of France (d. 1380) in the Louvre's *Parement de Narbonne*, and by Casimir the Great (d. 1370) on the doors of the Cathedral in Cracow. Hanna Hlaváčková has also discussed the significance of the 'W' (Wenceslas IV, d. 1419) and 'E' (?Johanna ?Sophia) to be found in the Wenceslas Bible. She suggests that these may be the initials of the monarch, and, more problematically, of his wife, and that they may also stand for 'World und Erde' ('World and Earth'); thus the letters may signify more than one meaning. There are, however, also religious parallels for the lettering on the statuesque figure of the Westminster Abbey portrait. In Italian painting of the late fourteenth and early fifteenth centuries, the Virgin and saints are sometimes shown with their gowns powdered with gilded initials.[9] This use of letters to 'tell a story' can be seen in the development, in the late fourteenth century, of the new Feast of the Name of Jesus: chasubles, altars and walls might be decorated with the letters 'IHS'; the letters, as it were, tell all.[10]

The Wilton Diptych appears to have been painted for an Englishman: whether it was also painted in England and by an English painter have remained controversial issues. Among the papers here there is a tacit assumption that the work is English, although it has been argued that the English had neither the financial resources nor the skill to produce a painting of the quality of the Wilton Diptych. Clearly this argument will continue; the quality of the work in the tomb effigies of Richard and Anne is extremely high, yet they were certainly made in an English workshop, and certainly expensive, so there is no obvious reason why the Wilton Diptych could not also have been made in England. Pamela Tudor-Craig suggests that, in part at least, it may be the work of Gilbert Prince (d. 1396) and/or his apprentice Thomas Litlington who was sometimes known as Thomas Prince. Whether the painters were English or not, it is certainly true that, as Ashok Roy says of the techniques of the Diptych, and Jonathan Alexander of the Westminster Abbey portrait, both of these paintings belong to the International Court Style which extended throughout Europe. When we consider the rich gifts exchanged—for example—by Richard II and Charles VI of France in 1396, or the presence of foreign craftsmen at work in London and at the English court, it is not surprising that Richard's court style was eclectic. As well as the Italian 'cloth of gold' weaver, 'Baldewyno' of Lucca, whom Richard II brought to work in his court, Italian goldsmiths worked in the Tower; some London goldsmiths who supplied Richard, such as Raymond Standelf and Hans Doubler, probably came from the Low Countries. Pieces of foreign workmanship were imported into London and sold to the royal wardrobe. The extent of Bohemian influence has been much debated, but the thrust of these essays is to reassert its significance. Clearly Anne brought with her some of the family silver bearing the arms of the Emperor, but she may also have brought paintings and

manuscripts which influenced the development of English illumination. Hla-váčková proposes to redate the great Wenceslas Bible to before Anne's departure for England in 1382, and Paul Binski redates the *Liber Regalis* to *c.* 1390 and so, by their combined efforts, it is possible to argue that Anne could have brought the 'new' Bohemian style of illumination found in the Bible with her to England and that this could in turn have influenced the *Liber Regalis* and other English manuscripts. Likewise, it might have been Anne's idea to suggest to Richard that he should, in 1392, demand that the Londoners erect statues of the King and Queen on London Bridge in the same way that a statue of Wenceslas IV had been put up in the 1380s on the façade of the Bridge Tower in the Old Town of Prague.[11]

Although the Londoners had to pay for the statues on London Bridge, many of the works reflecting Richard's international courtly culture were paid for by the King himself. This raises the old question, addressed directly in the title of Staniland's paper, whether Richard II was extravagant. Extravagance is, of course, a subjective term: money spent on projects of which we approve is necessary expenditure; money spent on unfavoured projects is extravagance. Richard has been deemed extravagant because he spent money on clothing, statues, remodelling Westminster Hall, expensive gold plate and jewellery, and other accoutrements of a cultured and beautiful court. It would seem that by dint of peace with France and some excellent French wedding gifts, not to mention over £30,000 extracted from the Londoners and other 'loans' from his subjects, Richard was extremely wealthy by 1399. In his will he intended that his executors should spend about £60,000: on providing a magnificent funeral procession (£4,000), gifts for Catholic kings in Europe, the purchase of prayers from lepers and chaplains at Westminster and Bermondsey (7,000 marks), four substantial bequests to his four chief executors (17,000 marks), and £20,000 to pay off the debts of his household, chamber and wardrobe. It is worth remembering that £60,000, which Richard appears to have held in cash in January 1399, was about double what was raised by the collection of the customary Parliamentary tax on the movable goods of his subjects (*c.* £34,000). Richard had made himself wealthy: a necessary but not the only attribute of strong kingship. Edward III had spent vast sums of money on campaigns in France, but also on jousts, tournaments, clothing and buildings. Staniland finds Richard's expenditure on clothing, even at the high level of the 1390s, acceptable. Campbell, on the other hand, notes Froissart's amazed response on receiving a gift from the King of a goblet weighing 2 marks of silver and filled with 100 nobles. Not surprisingly, Froissart felt bound to pray for Richard's soul. Clearly Richard liked to give (and to receive?) luxurious (and perhaps interesting and amusing) gifts. In spite of Froissart's comment (relating to 1395), Campbell herself notes a certain carefulness in the purchase and recycling of royal plate. Likewise, Wilson has noted that economy may have been a factor in the remodelling of Westminster Hall and the retention of as much of the old stonework as possible in the 'freestone-starved South-East of England'. Hospitality, generosity, and

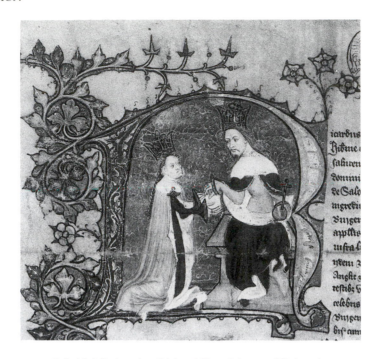

2. Initial R showing Richard II and Anne of Bohemia.
Charter of Richard II to Shrewsbury, 1389. Shrewsbury Museums, MS 1.24

visible magnificence may have been as essential to monarchy as a successful
foreign war, but they have seemed to later historians to be in some way unjus-
tifiable and profligate. Campbell cites T. F. Tout's criticism of Richard's 'inordi-
nate love of luxury, especially in dress and handsome gifts, freely indulged'. But
when Henry VI appeared in an old blue gown in 1471, he did not look the part
and the chroniclers were displeased. Had Richard II been less profligate, this
volume of essays would probably not exist. As Edward III is commemorated
by his victories at Crécy and Poitiers, and Henry V by Agincourt, so Henry III
is remembered for Westminster Abbey, Henry VI for Eton and King's College,
Cambridge, and Richard II for Westminster Hall and the Wilton Diptych. The
fact that Richard II and Henry VI were deposed and Henry III faced a baronial
revolt on a massive scale suggests that extravagance in peace, rather than war,
may be popular with art historians, but tended to be less well regarded by
contemporaries: there were likely to be more disgruntled soldiers like Thomas,
Duke of Gloucester, than contented poets like Froissart.

There seems little doubt that Richard II was more interested in his ancestors
than in his successors. Pamela Tudor-Craig draws attention to the parallels
between the chaste life of Edward the Confessor and Richard's childless mar-
riage. Wilson notes that Richard commissioned a thirteen-king series for his

16

remodelled Westminster Hall 'complete and without implication of future extension'. Moreover, a thirteen-figure series would have instantly evoked Christ and the Apostles in the minds of contemporaries. Wilson further suggests that it was also significant to Richard that he was the twelfth successor to England's most important and most recent royal saint. Richard looked back to a glorious past when kings were kings and, as Saul points out, subjects knew the value and importance of obedience.[12] Richard was uninterested in his successor, although his will acknowledged that there might be such a person. But he refused to name an heir and Tudor-Craig suggests that the placing of the orb, the symbol of his realm of England, on the bier between his own effigy and that of his dead Queen, implies that the kingdom was left for God to give to the next King of England. The right hands of the King and Queen are joined, sceptres in their left hands, their work of ruling complete. Likewise we know, from the French accounts of Richard's deposition, in an image taken up by Shakespeare, that Richard was said to have chosen to surrender his kingdom not to Henry IV but to God: let Henry take it.

A study of the Wilton Diptych, of the King who commissioned it, and of the courtly world which harboured and appreciated it, has led these several scholars in many different directions. As Morgan has pointed out, 'In writing about the Wilton Diptych it seems as if one is hardly making any single new interpretation but is reassembling, with different emphasis and reasoning, what has already been said'. That is true, but these papers certainly show that there are new things to be discovered, new manuscripts and documentary material to be brought into the debates, new interpretations or emphases to be offered and new conclusions to be drawn. The Wilton Diptych is full of meanings; the mood of the painting is serious, even sad. Richard is represented as a king, yet kneels as a man before Christ, who in His turn is represented as a child yet rules the world. Whereas God can reconcile this duality, Richard cannot. The events of 1399 broke the fragile bonds which had united Richard the man and Richard the monarch.

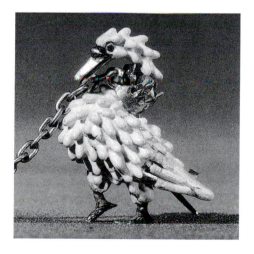

The Dunstable Swan Jewel, *c.* 1400. London, British Museum

17

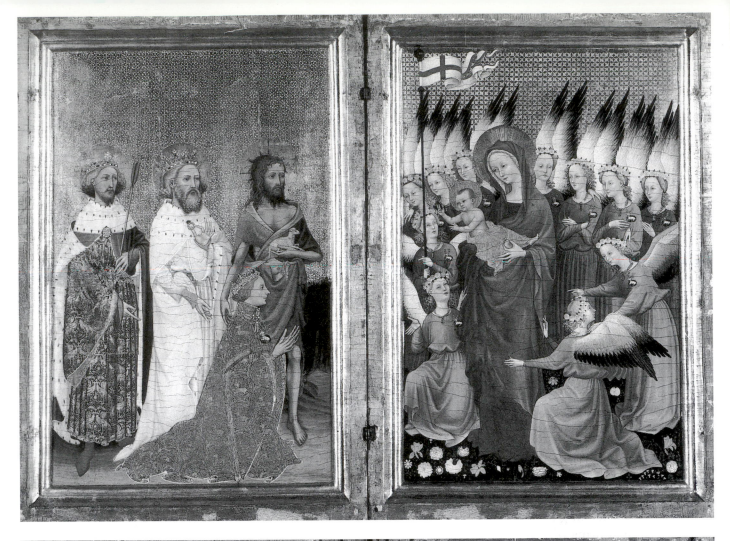
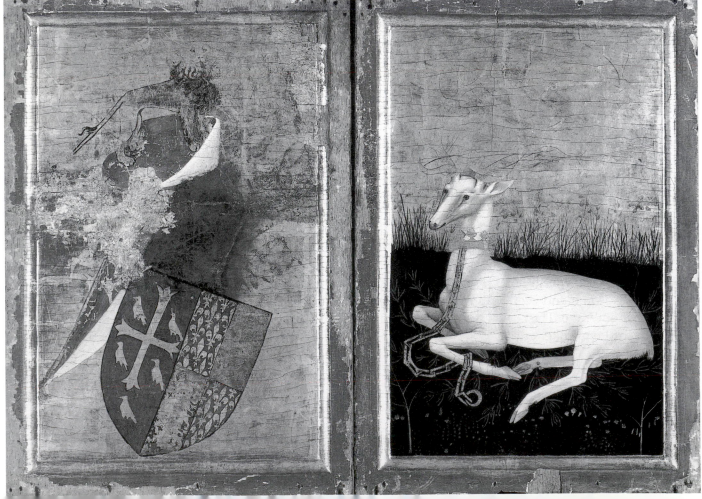

DILLIAN GORDON

The Wilton Diptych: An Introduction

T HE ONLY CERTAINTY in the Wilton Diptych is that it shows King Richard II, King of England 1377–99, being presented to the Virgin and Child by Saints Edmund, Edward and John the Baptist; the rest is conjecture. It is one of the most beautiful and perhaps amongst the most studied paintings in the history of European art. Yet it remains also one of the most enigmatic.[1]

Superficially the subject-matter is straightforward. In the left wing (*ill. 3*) is Richard II kneeling in a wasteland; round his neck he wears a broom cod collar (formed with linked pods of the broom plant) and his personal emblem of the White Hart. He is being presented by two former kings of England—Saints Edmund and Edward—and his patron saint, John the Baptist. In the right wing (*ill. 4*) are the Virgin and Child standing in a flowery meadow; the Child's halo is inscribed with the Symbols of the Passion—the Crown of Thorns and the Three Nails. The Virgin and Child are surrounded by eleven angels, each wearing a simpler broom cod collar and Richard's badge of the White Hart. One angel carries a white banner with a red cross.

The back of the Diptych is painted with heraldic emblems. In one wing (*ill. 6*) is a white hart seated in a flowery meadow, and in the other wing (*ill. 5*) is a lion *statant guardant* on a red cap of maintenance above a silver helm, and the royal arms of England and France ancient (lions and lilies) impaled with the mythical arms of Edward the Confessor (a cross *patonce* or fleury, with martlets).

This much is identifiable. But the intended meaning of the Diptych and its original function are still unclear. Pertinent to the discussion of its purpose and the relationship between the two panels is the significance of the King's gesture, the choice of saints depicted, the contrast between the wasteland and the flowery meadow, the number of angels shown and why they should be wearing livery collars and badges, the reason for the Crown of Thorns and the Nails inscribed in the Child's halo, and the meaning of the banner. One of the main problems of the Wilton Diptych is that the iconography is so complex and potentially operates on so many different levels that it is possible within reason to argue selectively in order to suit the symbolism to the theory.

There is no contemporary documentation for the Diptych. It is first recorded in 1639 when it was engraved by Wenceslaus Hollar while in the collection of King Charles I who is supposed to have obtained it from a certain Lady Jennings in exchange for a portrait of himself by the Dutch painter Jan Lievens.[2] The Diptych was given by James II to Lord Castlemain when he went as ambassador to Rome and bought from his heirs after his death in 1705 by Thomas, Earl of Pembroke. The Diptych remained at Wilton House, the Wiltshire seat of the Earls of Pembroke, until it entered the collection of the National Gallery in 1929.[3]

3-4 (*left above*). Interior of the Wilton Diptych. London, National Gallery
5–6 (*left below*). Exterior of the Wilton Diptych. London, National Gallery

While it was at Wilton House, from which it takes its name, it was the subject of a monograph written by Scharf in 1882,[4] but it did not fully come to public attention until it entered the National Gallery. Since then it has been intensively studied, and yet there is still no consensus of opinion as to its meaning or function, nor any certainty regarding the origins of its painter,[5] although some progress has been made towards establishing its date and patron.

The so-called 'International Gothic' style of the Diptych makes it extremely difficult to place and it has been called Italian, French, English and Bohemian. In the nineteenth century Waagen was sure it was Italian: in 1854 he wrote that 'it is without doubt by a very able Italian painter who probably lived at the court of Richard II', and in 1857 he called it Sienese.[6] The French, such as Lemoisne in 1931,[7] and Sterling in 1942,[8] have firmly called it French and the ever-cautious Martin Davies cataloguing it in 1957 described it as 'doubtfully retained in the French School, which some scholars think correct'.[9] But for the most part, the English have tended to call it English in very emotive terms. Beard in 1931 wrote an article entitled 'The Wilton Diptych—English!' and Cripps Day two years later gave his article the same title.[10]

The most substantial contribution towards an understanding of the Diptych has been made by two scholars, Maud Clarke in 1931,[11] and John Harvey in 1961.[12] It is significant that nearly every writer on the Diptych in this volume refers to them. Both scholars made considerable progress in establishing the date of the Diptych, arguing convincingly that there was no evidence that Richard II used the arms of Edward the Confessor impaled with the royal arms as shown on the exterior of the Diptych before 1395 (although he had earlier used them separately), and Harvey showed that at this time there was what amounted to a campaign to implement the impaled arms. Evidence for a date after 1395 is also to be found in the presence of the broom cod collars worn by Richard and the angels and encircling the harts on Richard's robe. Clarke produced overwhelming evidence that the broom cod was at least initially the livery of King Charles VI of France and argued that there was no evidence to suggest that Richard used the broom cod as a livery before marriage negotiations began with France in 1395. Recently, Ulrike Ilg, in publishing a rediscovered inventory from the reign of Richard II, argues that Richard began using the *plant à genêt* only after his marriage to his second wife, Isabelle of France, and because he was entitled to do so as her spouse.[13] This was undoubtedly the initial motive. It remains in doubt whether this was the sole reason. Harvey showed that it was used by subsequent English monarchs. This cannot be explained by the fact that Isabelle was Richard's wife but rather suggests that they had some special dynastic significance, probably the implicit reference to the Plantagenets.[14]

The heraldic evidence therefore would seem to suggest a *terminus post quem* of 1395. Moreover, most scholars now accept that the extremely personal nature of the heraldry points to the fact that it was commissioned by Richard himself and was therefore commissioned before his deposition in 1399.

If this is correct, then one is immediately faced with the anomaly of the King's

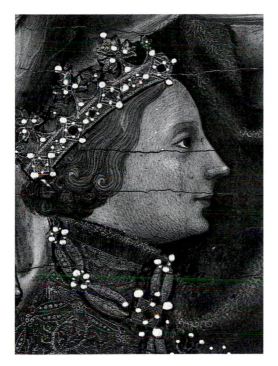
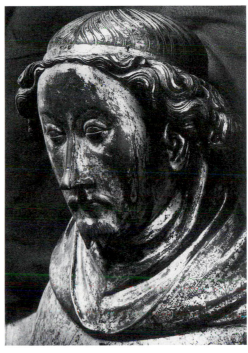
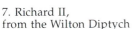

7. Richard II,
from the Wilton Diptych

8. Richard II, from the tomb of Richard II and
Anne of Bohemia. London, Westminster Abbey

appearance: Richard was born in 1367 and so he would have been between 29
and 32 years old when he commissioned the painting. Yet he is shown in the
Diptych as a fresh-faced youth, particularly when contrasted with the portrait
of a middle-aged man as recorded in his tomb effigy (*ill. 8*). The problem of
Richard's youthful appearance disappears if the Diptych is considered to have
been commissioned by someone other than Richard, and in the past several
writers found the style difficult to accommodate in the late fourteenth century,
and consequently rejected that it was commissioned by Richard II himself. Shaw
in 1934,[15] Galbraith in 1942,[16] and Panofksy in 1953,[17] all thought it had been
commissioned in the reign of Henry V in atonement for the deposition and
presumed murder of Richard by Henry IV, and Wormald in 1954 interpreted it
as a posthumous commission showing Richard's reception into Heaven.[18] At the
more eccentric end of the scale is Margaret Galway's suggestion that it was
commissioned by Richard's half-sister as a memorial to their mother, Joan of
Kent—that the Virgin Mary is a portrait of Joan and the Christ Child is Edward
of Angoulême, Richard's elder brother who died in infancy, handing over his
inheritance to him.[19] However, in recent years, while scholarly opinion has, for
the heraldic reasons discussed above, moved to accepting Richard himself as
the patron, no entirely satisfactory explanation has yet been given for Richard's
youthful appearance and the problem is complicated by the fact that in exam-
ining the Diptych for the purposes of the *Making and Meaning* exhibition held

in London at the National Gallery in 1993 it was discovered that the profile of the King had been painted in at a late stage in the execution of the Diptych.[20]

Richard's youthful appearance in the Diptych has led to the suggestion that it may commemorate Richard's defeat of Wat Tyler in the Peasants' Revolt in 1381 when the fourteen-year-old boy, having dedicated himself to the Virgin and prayed at the Shrine of Edward the Confessor, personally confronted the rebels.[21] Similarly, the King's youthful appearance has been said to commemorate Richard's Coronation at the age of ten; in that case the eleven angels would signify that Richard was in his eleventh year when he was crowned.[22] The heraldic associations have also led to the suggestion that it was a marriage gift from Richard to his second wife, Isabelle, whom he married in 1396.[23] And it has been suggested that the references to his birthday on 6 January, the Feast of the Epiphany, implicit in the composition showing Richard kneeling before the Virgin and Child with two kings standing behind him, which alludes to the Adoration of the Magi, mean that it was a birthday present.[24] An interpretation based on feast-days was extended by Ferris[25] and Wood[26] who have both argued that each saint represented a significant feast-day leading up to Richard being crowned King of England: the death of Edward III on the Sunday preceding the Feast of John the Baptist; Richard's first Parliament on the Feast of Edward the Confessor; and the Feast of Edmund, king and martyr, when Richard was invested as Prince of Wales. Ferris sees the rocks in the left wing as literally symbolizing Richard's steps toward the throne. Wood points out that the eleven angels could symbolize the eleven Apostles, taking further the theory of Harvey who suggested that the Diptych was made for a secret Order or brotherhood, 'an esoteric counterpart of the Order of the Garter with the Diptych as its altarpiece' and symbolizes 'Richard's re-dedication to the cause of the English royal prerogative as the instrument of God on earth; and his foundation of a brotherhood leagued with him to achieve this end', with the eleven angels representing the companions of the brotherhood in conscious echoes of the Apostles.[27]

The theme of Christ's Passion, implicit in the Crown of Thorns and the Three Nails in the Child's halo has led to the case for the Diptych as a crusader icon which was first put forward by Scharf in 1882[28] being taken up by Clarke in 1931[29] and Palmer in 1972.[30] The case for the crusading connotation, as discussed by Maurice Keen in this volume, rests partly on an interpretation of the banner as linked with the Order of the Passion. However, any interpretation of the banner has to take into account the symbolic intent of the painting recently found to be painted in the orb at the top.

When the Diptych was analysed for the purposes of the 1993 exhibition, while it was being treated by the Chief Restorer at the National Gallery, Martin Wyld, the shaft and orb of the banner in the right-hand panel were examined under a powerful microscope and it was discovered that painted within the orb, which is a mere one centimetre in diameter, is a green island with a white castle with two turrets and black windows. Below is a silver sea with a masted boat in full

9. Infra-red reflectogram of the orb (1 cm wide) at the top of the banner in the Wilton Diptych

sail, and above is a blue sky. On the horizon of the island are trees, only clearly visible in the infra-red reflectogram (*ill. 9*). This orb is painted over a cross stippled in the gold background—only visible in raking light, and even then with difficulty. It is possible to argue with reference to a lost work that this orb represents England as the dowry of the Virgin and that the meaning of the Diptych involves the presentation of England to the Virgin by Richard.[31]

The crucial work in this argument is a lost altarpiece which in the seventeenth century was in the English College in Rome. It is variously described in three sources, and may possibly also be identified in a fourth. The fullest written description of the altarpiece is to be found in an anti-Catholic tract, probably dating from *c.* 1606 (London, British Library MS Harley 360). There, the altar-piece is described as having been approximately 3 feet high and 5 feet wide, and consisting of five painted and gilded panels.[32] At the centre was the Virgin (presumably holding the Child). The text runs as follows: 'upon her left hand kneeleth a young king [here wrongly identified as St Edmund] in a fine robe of scarlet…who is lifting his eyes and handes towardes our Blessed Lady and

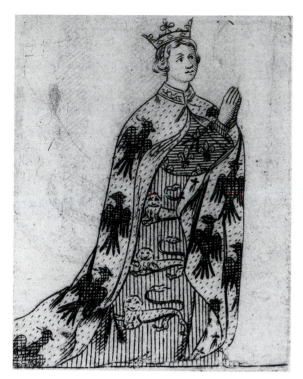

10. Anne of Bohemia, engraving.
From S. Petrasancta: *Tesserae Gentilitiae*, 1638

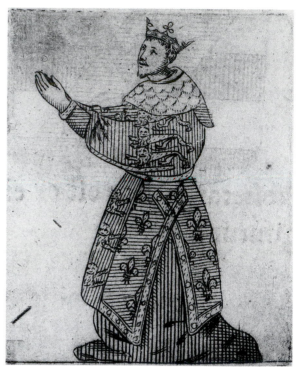

11. Richard II, engraving.
From S. Petrasancta: *Tesserae Gentilitiae*, 1638

holding between his hands the globe or pattern of England; presenteth the same·
to our Lady…His sceptre and his crown lying before him on a cushion…St
George in armour standing behind him in the same pane [i.e. panel], somewhat
leaning forward and laying his right hand in such a manner upon the king's
back that he seemeth to present the king and his presents to our Blessed Lady'.
The altarpiece had a Latin inscription: *Dos tua Virgo pia haec est, quare rege Maria*
('This is your dowry, Holy Virgin, wherefore rule over it Mary').

In 1638 Silvester Petrasancta gave the same inscription and accompanied his
description with an engraving of the kneeling figures of Richard II and Anne of
Bohemia from this altarpiece (*ills. 10, 11*). This shows Anne of Bohemia dressed
in a robe decorated with the royal arms of England—lions and lilies—with a
cloak with the Imperial eagles of Bohemia.[33] The distinctive plait hanging down
her back, also seen in the Shrewsbury Charter of 1389 (*ill. 2*), is here wrapped
around her head. The altarpiece also included her coat of arms—the royal arms
of England impaled with the Bohemian eagle. Her presence gives the altarpiece
a *terminus post quem* of 1382, the date of the royal marriage, and a *terminus ante
quem* of June 1394, the date of her death. Opposite kneels Richard II with a plain
robe and a cloak with lions and lilies. The royal arms of lions and lilies are
shown, but not impaled with the arms of Edward the Confessor, so the date of
the altarpiece is further confirmed as likely to be before 1395.

24

There are some anomalies in the written and engraved descriptions. The first discrepancy is that in the engraving Richard does not hold anything between his hands. It would be tempting to argue that the globe was, like that in the Wilton Diptych, made largely of silver which had tarnished and flaked and had therefore become difficult to interpret, were it not for the fact that Petrasancta describes what is being offered to the Virgin as the island of Britain. He shows Richard wearing a crown and kneeling on a cushion, whereas MS Harley 360 says that the sceptre and crown were lying before him on a cushion (one can rule out the possibility of two altarpieces tentatively suggested by Davies).[34] It can be argued that while the symbols of monarchy were being offered to the Virgin, Richard had to be clearly identifiable as King of England and therefore evidently still had to be shown wearing a crown.

There are also discrepancies in the identification of the saints in the altarpiece. Petrasancta wrote that the kingdom and island of Britain were being offered to the Virgin by John the Baptist, rather than St George. It would be difficult to mistake St George, said to have been dressed in armour, for St John, presumably dressed in camel-skin. An inventory of the English College drawn up in 1502 describes an altarpiece with both St John and St George which may be the one under discussion here: 'a old tabyll with the ymage of Our Lady: Saynt John: Saynt George: Saynt Katryn and Saynt Thomas'.[35] There is a problem in that the inventory omits any mention of the royal couple. This is hard to comprehend as they must have been on the same scale as the saints, rather than diminutive donor figures, since in MS Harley 360 St George is described as being in the same panel as the monarch and laying his right hand on the King's back, much in the same way that St John lays his hand on Richard's back in the Wilton Diptych. It is just possible that in 1502 the King and Queen were omitted either because they were not recognized, or because they were considered as secular and therefore irrelevant, and that the 1502 inventory is otherwise accurate. That it may be accurate and referring to the altarpiece under discussion is suggested by the fact that the other two saints are said to be St Catherine and St Thomas, and amongst the saints included in the altarpiece one would expect to find a female saint supporting Queen Anne, although St Anne would have been a more likely choice than St Catherine. The most likely explanation is that both St John and St George were shown, the latter presenting Richard, regardless of whether the inventory of 1502 refers to the altarpiece under discussion or not.

The relevance of the Rome Altarpiece to the Wilton Diptych lies first and foremost in the fact that Richard was presenting a globe to the Virgin and that this is interpreted as representing England, with the inscription describing England as the dowry of the Virgin. It can be argued that the globe in the Wilton Diptych is also a symbol of England and that Richard has offered it to the Virgin. She holds her Son, so the banner has been taken by an angel. The Christ Child is about to bless the King (on this point, see Morgan, p. 180) and will then return the banner to Richard, who waits with hands open to receive it, in token of the fact that he rules Britain with Divine blessing. The banner is therefore that of St

25

George, patron saint of England, who presented Richard in the Rome Altarpiece and is here represented in the banner. Presumably, the original cross stippled in the gold background was considered either inadequate because it was almost invisible or as overemphasizing the religious aspect of the banner which is also undoubtedly present, and the globe was painted over it to stress that it is the island of Britain which is being offered. In this context it might be argued that the angels in the Wilton Diptych are deliberately intended as a visual expression of the play on words coined by Pope Gregory the Great and that they are not only angels, but also *angles* (i.e. English), supporting Richard as their monarch.

The banner seems also to represent the banner of the Resurrection. Specific evidence that a white banner with a red cross could have this double meaning occurs in 1419 in a case cited by Ronald Lightbown[36] where a Lord of Périgord chose to have 'a white targe with a red cross, the better to have in remembrance Our Lord's Passion. And also in honour and recollection of Monseigneur Saint George, to that it may please him ever to succour me well'. Symbols of the fact that Richard will be redeemed by Christ's Passion are the Crown of Thorns and the Nails in the Child's halo. Richard's hope is that when he dies he will pass from this bare earth into the flowery green Heaven. It is worth noting at this point that the left wing of the Diptych was originally intended to show utter wasteland and the presence of bole under the forest to the right of St John the Baptist indicates that this area was originally intended to be gilded[37]—one can only assume that the gap between left and right panel was thought to be too abrupt and the intervening space filled with the forest we now see. The Diptych therefore unites the themes of sacred kingship and heavenly redemption in a complex web of allusions criss-crossing from one panel to another.

These two altarpieces, the lost one in Rome and the Wilton Diptych, are, to my knowledge, the only instances of England being described as the dowry of the Virgin during the reign of Richard II. References to it are more common in the fifteenth century, the first being in February 1400 when the Archbishop of Canterbury, Thomas Arundel, sent a writ to Robert Braybrook, Bishop of London, offering 40 days' indulgence for those who say the Lord's Prayer and five Hail Marys in honour of the Virgin at the morning bell-ringing, where England is described as the dowry of the Virgin.[38] There is no evidence to suggest that the concept of England as the Virgin's dowry existed before the reign of Richard II and one must assume—until proved otherwise—that the dedication originated with him.

The symbol of England in the orb is also a strong argument in favour of the fact that Richard himself commissioned the Diptych for his own use. Surely this tiny symbol, which is visible to the naked eye but really only legible if one knows it is there, would have been meaningless to anyone else. The papers in this volume take up the problems summarized here, in an attempt to move ever closer to the heart of this intriguing work.

I

NIGEL E. SAUL
Richard II's Ideas of Kingship

WHATEVER ITS INNER MEANING—and that still remains controversial—the subject-matter of the Wilton Diptych bears witness to the fusion of secular and religious ideas that is so vital to an understanding of Richard II's kingship. In the left-hand panel of the Diptych Richard is shown, possibly in the act of receiving a banner held by an angel in the right-hand panel opposite, which is variously interpreted as the banner of the Resurrection or the banner of St George, England's national flag; while in the panel to the right the Virgin and Child are attended by a throng of eleven angels whom Richard appropriates as his personal retainers by attiring them with his livery of the White Hart.

It is doubtful if Richard saw anything incongruous in this combination of religious and secular imagery. Throughout his reign he viewed kingship in essentially religious terms. He saw himself as 'God's substitute', 'a deputy...anointed in his sight'.[1] He was deeply conscious of the theocratic roots of his kingship. Like his predecessors, he looked to the saints for protection. Almost certainly the saints to whom he felt the strongest devotion were the three depicted in the Diptych. Significantly the only one of the trio in bodily contact with him is St John the Baptist. Richard came to the throne on the eve of the Vigil of the Feast of St John the Baptist's Birth, 24 June; and, if the Kirkstall chronicler is to be believed, he sought the Baptist's protection for one of the most momentous decisions of his life—the arrest of the former Appellant Lords in 1397. According to the chronicler, it was 'around the Feast of the Birth of St John the Baptist [1397] that it was announced from the King's side that all members of the court should prepare to ride with him [to Pleshey]'.[2] Richard was also devoted to St Edmund, the outermost of the saints shown on the panel. St Edmund, a ninth-century king of East Anglia executed by the Danes, bore witness to the Christian traditions of the English royal line; additionally, he stood for Englishness, a significant quality at a time of strong English national feeling. St Edward the Confessor, in the centre of the saintly trinity, also stood for Englishness. Being the last of the Wessex royal line, he provided a legitimizing link with the traditions of the pre-Conquest Old English past. But for Richard he had a particular significance as a 'role model'. In the accounts of his life written from the twelfth century onwards, the Confessor was identified above all with the notion of 'peace'. Matthew Paris in his standard life of the saint had praised him for 'his glorious peace'; Ailred of Rievaulx had written that in his reign 'all things had met together in one bond of peace'.[3] Richard

himself, in the final years of his reign, proclaimed that one of his highest ideals was 'peace'. It was by appealing to 'peace' that he justified the arrest of the former Appellants. In a letter to Albert of Bavaria, Count of Holland, he wrote that 'having brought together the right hands of our power...we have adjudged these convicted traitors [the Appellants] to natural or civil deaths, so bringing to our subjects a peace, which may last for ever'.[4] Richard, by procuring the downfall of the former Appellants, was seeking to establish 'peace' in his realm. This was peace in the sense in which it was associated with the Confessor—internal 'peace': in other words, unity. It was a notion that had its origins in, and was inseparable from, Richard's devotion to the Confessor's cult.

The fusion of religious and secular ideas, evident in the symbolism and subject-matter of the Diptych, also found expression in the King's commitment to the suppression of heresy. In Richard's view, as in that of his ministers, heresy was a threat not only to the ecclesiastical but also to the secular order; and measures were accordingly necessary to bring it within the secular competence. In the early and middle years of the reign two measures of importance were taken to bring this about: in 1382 the Chancellor was empowered to issue commissions to the Sheriffs to arrest unorthodox preachers and detain them until their appearance before a Church court; and in 1388 further commissions were issued for the seizure of Wycliffite writings for examination by the Council.[5] Under the powers given to them by these measures, Richard's ministers acted swiftly to stem the spread of heresy, and the King himself lent them his full support. He responded vigorously in 1395 when, during his absence in Ireland, some Lollard sympathizers nailed a manifesto to the doors of Westminster Hall. Walsingham tells how the King made one of the 'Lollard knights' in his service, Sir Richard Stury, swear an oath to abjure the heresy, warning him that if he went back on his word he would have him executed.[6] He also took firm action against lesser officials in his service. A household esquire by the name of John Croft was arrested and examined before the Council as a preliminary to appearing before the King at Windsor on 29 August, when he formally submitted and renounced his heretical opinions.[7] Even after the crisis of 1395 had subsided, Richard kept up the pressure on the heretics. In March 1397 he ordered Sir William Scrope to bring before him for his personal examination all the Lollard detainees in his custody; and there is reason to believe that towards the end of the reign he was contemplating further measures against the heretics.[8] Richard took pride in his vigorous defence of the Church against its enemies. Sometime in 1398 he voiced his fears for the safety of the Church under any other defender than himself. In conversation with Sir William Bagot, one of his councillors, he said that he thought that if his cousin Henry Bolingbroke, the Earl of Derby, became king he would be 'as great a tyrant to the Holy Church as there ever was'. He and his ancestors, by contrast, had been 'good confessors, who never persecuted the Church'.[9] It was doubtless the King's general reputation for orthodoxy that led the Dominican Roger Dymock to present to him a copy of his anti-Lollard *Treatise against the Twelve Errors*[10] in *c.* 1395. While

Richard was certainly boasting when he said, as he did on his tomb inscription in Westminster Abbey, that he had 'laid low the heretics and scattered their friends', it is clear that he had done all that might be expected of him to give the ecclesiastical arm secular backing.[11]

Closely connected in Richard's eyes to the orthodoxy of his people was the matter of their obedience. Obedience was in a sense the secular counterpart of orthodoxy: it was founded on a similar assumption of the acceptance of authority, and it was seen as the essential precondition for the establishment of a united realm. Not surprisingly, it was a concept frequently invoked in speeches by Richard and his ministers. The first major statement of the theme was made by Sir Michael de la Pole, Richard's Chancellor from 1383 to 1386. Addressing Parliament in 1383, when memory of the Great Revolt of 1381 was still fresh in his audience's mind, he said that it was his purpose 'to ordain that the keeping of the peace in the realm and the obedience due to the King from all his subjects be better performed than has been the case hitherto; for the acts of disobedience and rebellion which have recently been committed and which continue from one day to the next to be committed against the lesser servants of the King, such as sheriffs, escheators, collectors of subsidies and others of the same type, were the source and chief cause of the treasonable insurrection recently made by the commons of England…And just as rebellion of this sort was and is the source and commencement of mischief and trouble in the realm, so on the other hand is true obedience to the King and his servants the foundation of all peace and quiet in the realm itself, as appears clearly from the obedience which the gentlemen showed to the King during the insurrection'.[12] De la Pole's speech to Parliament was an eloquent statement of the case for obedience from the government's perspective. Its immediate context was provided by reflection on the causes of treasonable insurrection; but its broader background was probably to be found in de la Pole's recollection of his years in the service of the King's father, the Black Prince. The Black Prince had been a highly assertive ruler, exacting submission and obeisance from subjects or vassals in Aquitaine who had hitherto been little accustomed to such demands.[13] His imperious style had rubbed off onto his servants; and from them it rubbed off in due course onto Richard himself.

It is interesting to observe that Richard was to insist on the performance of obedience in the submissions which he exacted from the Irish chieftains on the occasion of his expedition to Ireland in 1394–95. Donnchadh O'Byrne, for example, in the submission which he made on 18 February 1395, swore 'faithfully to adhere to, serve and obey the King as his liege lord against all men as every faithful man is bound to his liege lord, with every kind of submission, service, obedience and fealty, and to keep his laws, commands and precepts, and continually to obey them without any complaint'.[14] A similar, if not an identical, insistence on obedience is found in the opening speeches which Richard's Chancellors made to Parliament in the later years of the reign. Archbishop Arundel, echoing his master's sentiments in the Parliament of February

1395, declared that subjects had a general duty 'to honour, cherish and obey the King, and to employ all their power in his service'.[15] Arundel's successor Edmund Stafford, Bishop of Exeter, in the 'Revenge' Parliament of 1397 in which Richard's *coup* against the former Appellants was ratified, said that in a well-governed realm 'every subject should be duly obedient to the king and to his laws'.[16]

A century earlier the theme of the subject's obligation of obedience had been stressed by Giles of Rome in his *De Regimine Principum* (*c.* 1277–79), a work with which several of Richard's circle were almost certainly familiar.[17] In Richard's time it was picked up in the *De Quadripartita Regis Specie*, a treatise probably written by John Thorpe and presented to Richard in 1391 or 1392. In a striking passage of this work, the author says that nothing was more likely to force a king to impose penalties on his subjects than an act of disobedience.[18] This was a view that corresponded very closely to Richard's own. Richard, a man with a highly developed sense of regality, saw disobedience as an act of rebellion: this was why he took the action that he did against the former Appellants in 1397. In a letter to Manuel Palaeologus, the Byzantine Emperor, written in 1398, he vented his hatred of what he called the 'wantonness and rebellion' of his enemies among the magnates (i.e. the former Appellants): this had led him, he said, to stretch forth his arm, and to tread on the offenders' necks and grind them down, even to the root, so restoring to his subjects a peace which would last for ever'.[19] In this letter the notion of obedience is drawn together with that of 'peace' noted above[20]—peace in the sense of unity—to produce a doctrine that both justified vengeance against the Appellants and the restoration of prerogative rule by the King.

The exalted notions which Richard articulated either in person or through the medium of his ministers were buttressed in the mid to late-1390s by measures to promote a grander and more exalted image of his monarchy. There is a scatter of references in the sources to indicate that court ritual became more elaborate. In a famous passage, the writer of the Canterbury *Eulogium* described how on solemn festivals Richard 'would have a throne prepared for him in his chamber, on which he would sit ostentatiously from dinner till Vespers, talking to no one but watching everyone; and when his eye fell on anyone, regardless of rank, that person had to bend his knee towards the King'.[21] At the same time there is evidence of a growing appreciation by the King's circle of the value of public ceremony. In 1377, to mark the King's Coronation, and in 1392, following the King's reconciliation with the Londoners who had incurred his disapproval by refusing a loan, magnificent civic triumphs were organized in the streets of London. As the Anonimalle and Westminster writers bear witness, on both occasions the first of the conduits which the King passed was transformed into a Heavenly City on which angels were seated disbursing cups of wine as if at the Eucharist, while on one of the others a throne was placed which was surrounded by three circles of angels symbolizing the three angelic orders in attendance on the Almighty.[22] Though it is difficult to be certain on the point, it

seems likely that the model for these pageants was the *joyeuses entrées* which marked the French kings' entry into the *bonnes villes* of their kingdom.

The general aim of these measures to enrich and elaborate courtly ceremony—namely, to distance the king from his subjects—was also served by the development of a new language of address to the king. Hitherto in England it had been usual to address the king in terms of the language of lordship: thus letters and petitions to the king generally opened '*A tresdroiturell et tresredoute seigneur le Roi*' or, more simply, '*A nostre seigneur le Roi*'. From the early 1390s, however, a more elaborate vocabulary of address was employed. The terms 'highness' and 'majesty' came into regular use. The Treasurer, John Waltham, Bishop of Salisbury, writing to the King in 1394, while opening in the traditional language of lordship, switched to 'highness', 'majesty', and 'your high royal presence' later.[23] A successor of his as Treasurer, Guy Mone, Bishop of St David's, writing to Richard in 1399, addressed the King as '*Treshaut et trespuissant prince et moun redoubte seignur*'—a form of address used by a number of other correspondents.[24] In 1391 the Clerk of Parliament went further still in obsequiousness with this heading for the petitions: '*A tres excellent et tres redoute et tres puissant Prince, et tres gracious Seigneur, nostre Seigneur le Roi...Qe plese a vostre Hautesse et Roiale Mageste...graciousement granter les Petitions*'.[25] It is true that a great deal in these addresses was mere verbiage, designed to flatter the King. But some of the terms, notably those of 'prince' and 'majesty', carried fairly precise connotations. The use of the term 'prince', hitherto rare in England, implied recognition of Richard's role as supreme lawgiver in a sovereign realm. The use of the phrase 'your majesty' recognized the essentially sacral character of his kingship—in other words, that he held his office by the working of Divine grace.[26] Through the clear and deliberate encouragement that he gave to the use of this lofty and elaborate language, which was common in France but virtually unknown in England, Richard was creating a new image of monarchy. He was investing himself with a mystical, almost a God-like quality. He was seeking to elicit from his subjects the kind of responses which hitherto they had reserved for the Deity. In effect, he was buttressing the reality of his power by clothing himself in an illusion of power.

This calculated exercise in deception, brilliantly conceived and executed, did not succeed in its object for very long. In the summer of 1399, only a couple of years after the crushing of the former Appellants, Richard's regime was overthrown when Bolingbroke returned to England. Its principal weakness was to be found in its plethora of internal inconsistencies. Probably the most serious of these related to the matter of the King's self-image. Richard had presented a picture of himself to his subjects as a distant and remote ruler, far removed from his people's everyday concerns. The reality, of course, was very different. In the course of the 1390s Richard had turned himself into a major 'bastard feudal' lord—in other words, into the head of an affinity with members in every shire of the land; and through the activities and misdeeds of his retainers he became involved in the everyday affairs of his subjects to a greater degree than any of

his predecessors had.[27] Scarcely less glaring than this inconsistency was a second one. Richard had placed considerable emphasis in the letters which he wrote to Manuel Palaeologus and the Count of Holland on 'peace' in the sense of unity. From 1397, however, his rule was characterized less by unity than by faction and feud. The crushing of the Appellants represented the triumphant overthrow of one faction by another; and the quarrel between the Duke of Hereford and the Duke of Norfolk in 1398 had its origins in the further plans for revenge of a section of the inner courtier élite itself.[28]

It is doubtful if the 'tyrannical' regime that Richard inaugurated with the destruction of the former Appellants could have survived for much longer than it actually did; its foundations were simply too fragile. Caroline Barron has suggested that the outcome in 1399 might have been different if Richard had been physically present in the realm to rally his forces and lead the resistance to Bolingbroke; but it is doubtful if the King's presence could have made much difference.[29] There is considerable evidence of deep-seated unease in England in Richard's last years. In April 1398 a group of insurgents gathered at Bampton, in Oxfordshire, declaring their purpose to be 'to seek and destroy the King, the peers and the magnates'.[30] In northern England the great Marcher families like the Percies and the Nevilles were increasingly disenchanted by Richard's policy of appointing outsiders like the Duke of Aumerle to major positions in the Marches.[31] Over the previous two years Richard had offended too many of his subjects to be sure of their loyalty and obedience in an emergency. In the short term the measures that he took brought him a degree of security and comfort, but in the longer run they failed to lay the foundations of a new political consensus. Even had he not embarked on his ill-advised visit to Ireland in the summer of 1399 it is doubtful if he could have survived a large-scale and well-organized challenge to his government.

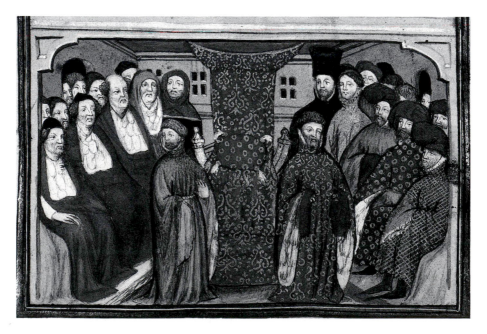

12. Henry Bolingbroke claims the empty throne after Richard II's deposition.
French, mid 15th century. London, British Library, MS Harley 1319, f. 57

II

CHRISTOPHER WILSON

Rulers, Artificers and Shoppers: Richard II's Remodelling of Westminster Hall, 1393–99

DURING THE ONE AND THREE-QUARTER CENTURIES that have elapsed since the architecture of Westminster Hall first began to be studied analytically, it has been the timber roof which has attracted the lion's share of scholarly attention.[1] In a sense this is no more than just, for the huge hammer-beam structure that spans the Hall has long been recognized as the supreme achievement of the tradition of monumental roof carpentry which flourished with unparalleled vigour in late medieval England.[2] Yet nothing can warrant the almost complete failure of architectural historians to discuss other aspects of this great building, which stood for many centuries at one of the nodal points of English national life.[3] So massive an imbalance in research effort clearly cannot be redressed in a single paper, but the present essay is intended as a move in that direction, for it will examine briefly a wide range of problems that are in urgent need of further study. It begins by considering what are probably the most neglected aspects of all, the nature and interaction of the uniquely diverse range of functions fulfilled by Westminster Hall both before and after its remodelling under Richard II.

Halls were by immemorial custom places where lords regularly dined and supped with their households, but Westminster Hall was never intended to be used in that way. Probably from the first foundation of the Palace in the mid eleventh century, the royal household took its daily meals in the first-floor hall which, after the building of Westminster Hall in 1097–99, came to be known as the Lesser or White Hall.[4] In deciding to build a vastly larger second hall on the London side of the existing core buildings of the Palace (see plan on page 35),[5] William II was not succumbing to megalomania, as some twelfth-century historians implied when trying to account for the exceptional size of the new building.[6] The aim was rather to ensure that the most important royal residence in the vicinity of the richest and most populous city of the kingdom was worthy of housing the great feasts which followed not only coronations but the crown-wearings held at the major religious festivals.[7] The ruler's exaltation as 'the figure and image of Christ' on these occasions was not dissipated when he left church and returned to the Palace, for by presiding over a feast wearing his

33

crown and kingly robes he and his hierarchically marshalled guests became an earthly counterpart to the royal court of Heaven.[8] That the glory of regality even extended to the banqueting hall itself was made explicit in the blessing prayer *Prospice* used at coronations after the first anointing.

> 'Look down, Omnipotent God, with favourable gaze on this most glorious king. As Thou didst bless Abraham, Isaac and Jacob, so deign to irrigate and bathe him by Thy potency with abundant blessings of spiritual grace in all its fullness. Grant him from the dew of Heaven and the fatness of earth an abundance of corn, wine and oil and a wealth of all fruits from the bounty of Divine gifts, through long years, so that, while he reigns, there may be healthiness of body in the fatherland and unbroken peace in the kingdom. Grant that the glorious dignity of the royal hall may shine before the eyes of all with the greatest splendour of kingly power and that it may seem to glow with the brightest rays and to glitter as if suffused by illumination of the utmost brilliance'.

How continuously and to what extent Westminster Hall was thought of by medieval English rulers as a sacred place is impossible to gauge, but *Prospice* was used at William the Conqueror's Coronation and those of all his successors.[9] It would seem reasonable to assume that Richard II was fully aware of the words of the coronation service, given his well-attested determination to assert the sacral nature of his kingship at every opportunity.[10]

By the fourteenth century, the kings of England, like many lesser lords, were abandoning their halls to their households and were habitually dining apart in their chambers.[11] However, by continuing to participate periodically in feasts in Westminster Hall, England's rulers retained the capacity to present themselves in the lord's traditional role as feeder as well as leader of his military retinue, a role embodied in the very word 'lord' (from Anglo-Saxon *hlafweard*, keeper of bread). A concern to perpetuate something of the age-old function of the great hall as a place where regular meal-taking in common reinforced the bond between a lord and his men can be detected in Westminster Hall's adherence to two long established usages almost certainly thought of as being linked to good old social collectivities, namely its positioning on the ground floor, where maximum accessibility was assured, and its heating by means of open fires placed centrally below louvers rather than by fireplaces set in the wall behind the high table on the dais.[12]

By Richard II's time, the coronation feast was only the last of three episodes in the making of a king whose setting was Westminster Hall. The first of these came at the end of the procession from the Tower of London through the City, which took up much of the day before the coronation.[13] When the ten-year-old

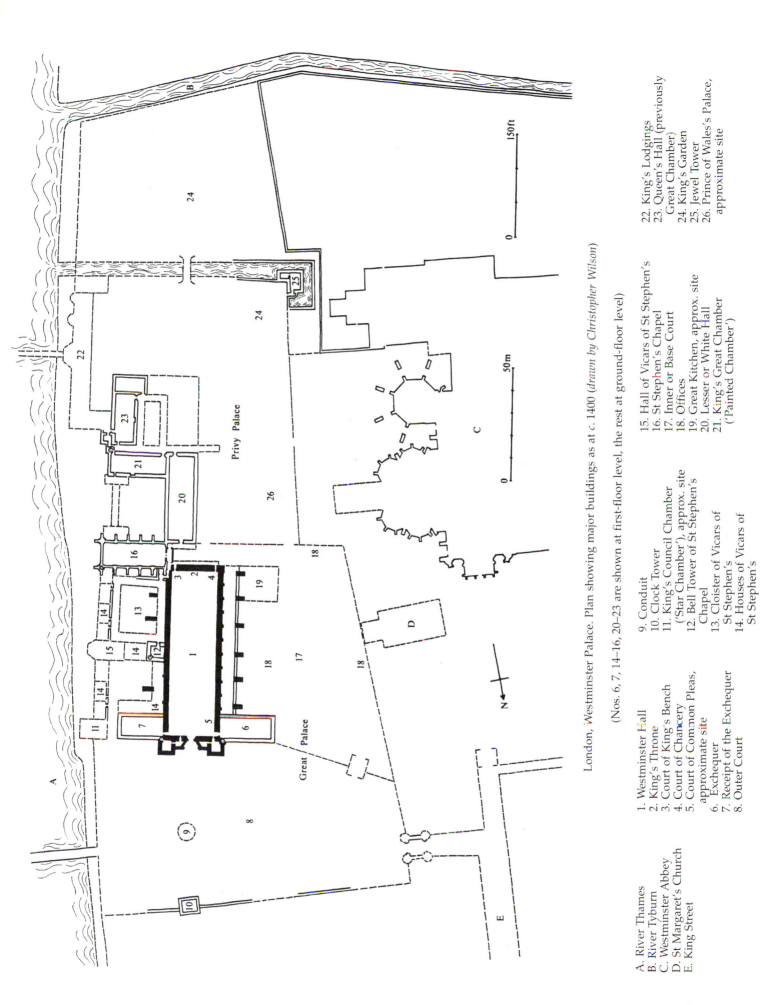

London, Westminster Palace. Plan showing major buildings as at c. 1400 (*drawn by Christopher Wilson*)

(Nos. 6, 7, 14–16, 20–23 are shown at first-floor level, the rest at ground-floor level)

A. River Thames
B. River Tyburn
C. Westminster Abbey
D. St Margaret's Church
E. King Street

1. Westminster Hall
2. King's Throne
3. Court of King's Bench
4. Court of Chancery
5. Court of Common Pleas, approximate site
6. Exchequer
7. Receipt of the Exchequer
8. Outer Court

9. Conduit
10. Clock Tower
11. King's Council Chamber ('Star Chamber'), approx. site
12. Bell Tower of St Stephen's Chapel
13. Cloister of Vicars of St Stephen's
14. Houses of Vicars of St Stephen's

15. Hall of Vicars of St Stephen's
16. St Stephen's Chapel
17. Inner or Base Court
18. Offices
19. Great Kitchen, approx. site
20. Lesser or White Hall
21. King's Great Chamber ('Painted Chamber')

22. King's Lodgings
23. Queen's Hall (previously Great Chamber)
24. King's Garden
25. Jewel Tower
26. Prince of Wales's Palace, approximate site

Richard arrived in the Hall on the eve of his crowning, he made straight for the marble high table and there, together with some of his entourage, took a refreshment of wine and sweetmeats before passing to his chamber in the residential core of the Palace, the Privy Palace.[14] On the morning of every late medieval coronation, in a ceremony whose exact form varied greatly but which was still recognizably an echo of the long-discarded election ritual, the king, surrounded by peers, took his seat for the first time on the marble throne at the centre of the south wall.[15] The destruction of this throne and the survival of Edward I's 'coronation chair' in Westminster Abbey[16] have tended to obscure the status of the seat in the Hall as the royal throne *par excellence*. Its manufacture from marble gave it strong Imperial connotations and its fixed nature made it a symbol of the ruler's continuous presence. There is more than symbolism in the fact that the earliest reference to a marble throne here dates from the reign of Henry III, the king who established Westminster as the permanent seat of English monarchy.[17]

At the opposite end of the spectrum of courtly ceremonial from the solemnities enacted at coronations and crown-wearings were the tournaments held here on the eve and Feast of St Valentine, 1385.[18] Whether these combats were on foot or on horseback is not known; but whatever their exact form, their staging would have been facilitated by the fact that the floor of the Hall was of rammed earth rather than stone paving.[19] The appearance of horses in Westminster Hall was certainly nothing unusual. Perhaps the most surprising instance of their use was at Richard II's coronation feast when, in order to contain the danger of arguments and fights breaking out in an all-male gathering liberally plied with drink, the Hall was patrolled by numbers of household officers mounted on war horses.[20]

It is conceivable that part of the thinking behind William II's addition to Westminster Palace of a second, larger and more generally accessible hall was that it should be used for another purpose which would have been difficult to accommodate in a household dining-hall, namely the dispensing of justice. Many major lords used their halls for judicial purposes, but in the late eleventh century the number of petitioners seeking royal justice is likely to have been small. By Richard II's time, Westminster Hall had become the normal setting for three courts: King's Bench, Chancery and Common Pleas.[21] King's Bench was the superior jurisdiction, being concerned with felonies, trespasses and actions affecting the royal person. It accordingly occupied the most honorific site available: the area of the dais on the right-hand side of the king's throne. The fiction that the king presided personally was maintained in the court's proceedings, which were said to take place *coram rege*—before the king. On certain formal occasions the Chief Justice of the King's Bench even sat in the marble throne himself in order more fully to represent the king's royal authority.[22] In Richard II's reign, the second tribunal normally located in Westminster Hall, the Court of Chancery, was only incipiently a court of law in the same sense as the other two courts, but it resembled King's Bench in representing the king and conse-

quently occupied an only slightly less privileged place on the opposite side of the dais.[23] The hierarchic and symbolic principles governing the placing of the courts were especially evident in relation to the Court of Common Pleas, which, although it transacted much more business than King's Bench, had considerably less status. Hence its placing at the low end of the Hall and on the king's left, where it would obstruct neither the view nor the approach towards King's Bench.[24]

The wooden fittings of the three courts were of necessity sturdy rather than ornamental, since whenever the Hall was required for ceremonial purposes, everything had to be cleared out and, if it was term-time, re-erected in some other part of the Palace.[25] The courts were of course in recess during the major festivals of the Church. There is little likelihood that their timber enclosing walls were solid enough or high enough to prevent the proceedings of one court from being audible in the others, but what makes it absolutely certain that their business was not conducted in the hushed atmosphere of a modern law court is the fact that from at least the 1290s onwards the body of the Hall was lined with numerous shops and perambulated by licensed merchants, the so-called 'goers in the halle', who were female as well as male. The items on sale were of kinds suitable for purchase by those involved in litigation and with business at the Exchequer—typically gloves, hats and other small articles of clothing, but also plate and even, by the early fifteenth century, spectacles. The streets of the town of Westminster and the churchyard of the Abbey teemed with petty retailers, and it is clear that the gates of the Palace were no barrier to this kind of activity, for there were designated pitches at several much-frequented spots in the precinct besides the Hall, all of which generated income for the Keeper of the Palace.[26] Far more of the population of medieval England must have known Westminster Hall in its day-to-day guise of combined law court and bazaar than could ever have seen it functioning as a setting for state ceremonial.[27] This capacity to oscillate between quotidian and display modes was a long-established feature of privileged secular sites, streets as well as buildings. The City of London's main open space—West Chepe or Cheapside—normally housed rows of butchers' and fishmongers' stalls, but these were summarily cleared whenever a ceremonial royal entry was in the offing.[28]

Also much colonized by commerce was the equivalent of Westminster Palace in Paris, the Palais de la Cité. However, in its main buildings at least there was a clearer sense of hierarchy, since the *merciers du Palais* were confined to the gallery linking the main chapel, the hall and the royal apartments, and the courts of law were housed in separate rooms opening off the hall.[29] Toleration of Westminster's indecorous muddle can be related to a variety of factors: simple lack of space for court buildings, and concomitantly for indoor shopping; the desire to preserve the above-mentioned symbolism whereby the Courts of King's Bench and Chancery were visibly associated with the monarch's throne of justice; and, perhaps most fundamentally of all, an awareness on the part of

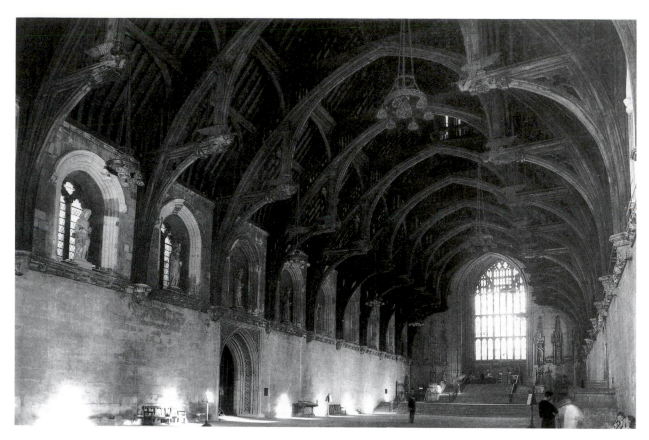

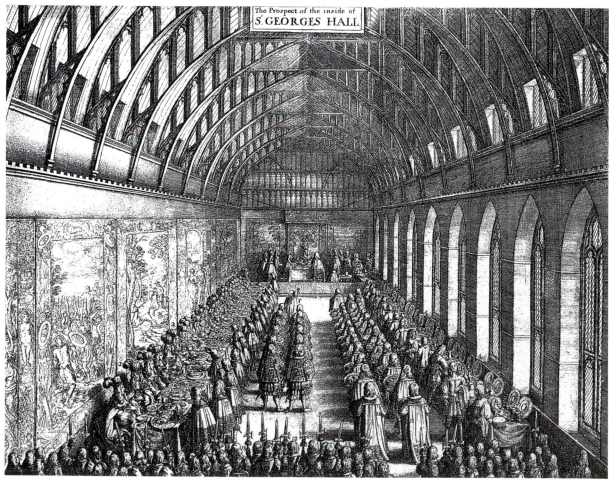

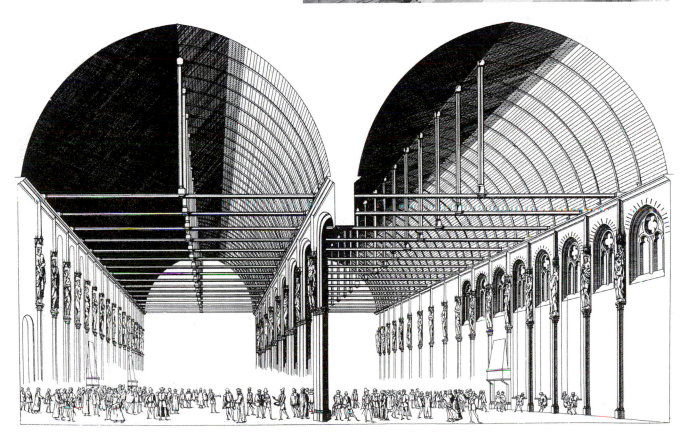

13 (*left above*). Westminster Hall, London. Interior looking south-east

14 (*left below*). Windsor Castle. Great Hall in the Upper Ward. Engraving by Wenceslaus Hollar, 1672

15 (*right*). Hampton Court Palace. Great Hall, dado hung with contemporary tapestries

16 (*below*). Paris, Palais de la Cité. 'Grand'Salle' looking south-east. Engraving by J. A. Du Cerceau, *c.* 1580

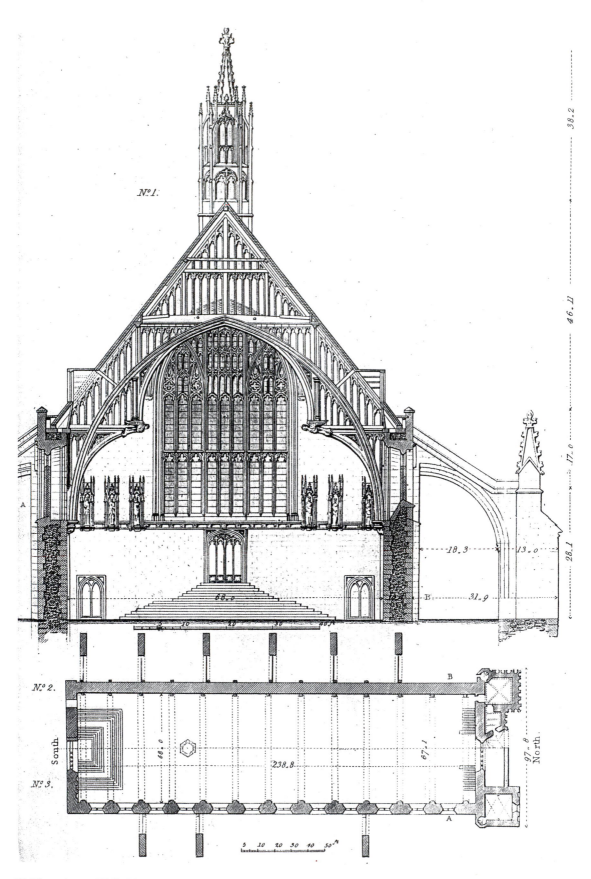

17. Westminster Hall. Plan and cross section. Engraving from J. Britton and A. C. Pugin,
Illustrations of the Public Buildings of London, London, 1825–28

late medieval English kings that to provide permanent, custom-made buildings for the courts would lead inevitably to an erosion of the traditional roles of the Palace as the chief royal residence and ceremonial centre.[30] This had happened at the Palais de la Cité in the mid 1360s, when the Louvre took on the role of principal royal residence in Paris. Westminster was not abandoned to administration, the law and Parliament until 1512, when the Privy Palace was partly gutted by fire, and even after that event the Hall continued to function as the setting for coronation feasts.

The complete rebuilding of the Hall which Richard II ordered in 1393 was not his first intervention. It was preceded by an extensive programme of refurbishment in 1385 whose most important element was the insertion into the south wall of six tall canopied niches each containing the stone figure of a king (see pp. 76-77, *ills. 40, 41*). In fact this scheme represented a change of mind, for its six figures were drawn from a series of thirteen made for the same site, of which the other seven were put into store. It seems safe to concur with the generally held view that both the thirteen-figure and six-figure schemes showed kings of England beginning with St Edward the Confessor and ending with Richard II.[31] The Confessor was not only the founder of Westminster Palace, but patron of the post-Conquest English kings in general and of Richard II in particular. When the Hall was rebuilt in the 1390s the six kings on the south wall were taken down, stored and set up again in two groups of three flanking the great south window.[32] They remain in the Hall today, although their niches were replaced by copies in the nineteenth century (*ills. 17, 18*).[33] The arrangement of the kings within the Romanesque Hall is not revealed in the documents which record their making, but since there is evidence that the south wall contained a row of windows of the same size and at the same level as those lighting the side walls, it seems likely that the niches were in-

18. Westminster Hall. King in the central of three niches to the west of the south window

serted into the piers between the windows and into those at each end of the wall.[34]

Both the statues and their niches were certainly in place some eighteen months before the Hall witnessed a meeting which proved to be one of the first episodes in the central crisis of Richard II's reign. This was the confrontation on 17 November 1387 between the King and the three senior Lords Appellant—the Duke of Gloucester, the Earl of Arundel, and the Earl of Warwick—who came to Westminster with a large retinue to demand the punishment of the alleged traitors among the King's advisors. Richard sat on his throne on the dais, crowned, a sceptre in his hand and wearing his robes of estate, and he was flanked by a large company of magnates, lords and gentry.[35] This vision of regality, backed in more senses than one by the polychromed images of royal ancestors on the south wall, would have had no chance of succeeding in its purpose of inducing awe if the Hall had not first been cleared of the mundane clutter of the courts and shops. This was no doubt done, for there had evidently been a few days in which to make preparations.[36]

The truce achieved at the tense meeting with the Appellants turned out to be a prelude not to peace but to virtual revolution, culminating in the following year with the judicial murder of the 'traitors' and the comprehensive humiliation of Richard and his Queen. Part of Richard's motivation in deciding in 1393 to embark on a complete reconstruction of the Hall may well have been the desire to blot out the memory of how his carefully staged appearance in the refurbished building had ultimately failed to have the desired result of instilling loyalty. Perhaps he was already harbouring thoughts of using his renewed hall of justice as the setting for the final triumph over his tormentors some years hence, when the way would become clear to attaining his goal of restoring the unfettered executive power of the monarchy. In the event the Hall was not ready in time, and the Parliament of September 1397, which saw the Earl of Arundel condemned to death and the Earl of Warwick and the Archbishop of Canterbury sent into exile, was accommodated in a spacious temporary structure built over part of the outer court from which Westminster Hall was entered.[37]

The decision to rebuild Westminster Hall from 1393 was taken at a time when the royal household was beginning to grow rapidly and great quantities of luxury goods of every kind were being acquired for the King's use. This lavish expenditure all served a single policy aim: that of creating splendour worthy of the sacral character of an anointed king's vocation.[38] But it is fair to say that even to a king with a less exalted sense of his regal calling the reconstruction of Westminster Hall would have stood out as an urgent necessity. Richard's predecessor Edward III had bequeathed to him a prodigious number of new or renewed residences,[39] yet at Westminster the Great Hall had apparently remained virtually unaltered since its completion in 1099. To so prestige-conscious and fastidious a king as Richard II it must have seemed deplorable that the building which in any lord's residence was expected to be a showpiece, especially in England, was in the main palace of the kingdom an antiquated structure not only in style but also in the homely covering of its very conspicuous roof—

shingles rather than lead or tiles.[40] Nevertheless, for very cogent reasons, to be considered below, it was decided not to demolish but rather to recast the eleventh-century Hall. This was to influence profoundly the character of the fourteenth-century work.

William II's Hall was in a class of its own by virtue of its huge floor area (which is 240 × 69 feet; 73.1 × 21.1m) and also on account of its architectural treatment. Transcending all pre-existing traditions of great hall design current in north-west Europe, it drew extensively on the most ambitious of medieval architectural genres, the cathedral or greater abbey church. The main borrowing of several in this category was the fenestration, which consisted of windows set at the back of deep recesses and combined with a low wall passage open towards the interior through small paired arches. This scheme was apparently first used in the clerestory of Winchester Cathedral begun in 1079, an extremely ambitious building and one well-known to William II.[41] The window zone of the Hall can also be referred to as a clerestory, for it is set above a very high dado. Elevations of this kind had probably been familiar for a long time from monastic refectories, where the purpose of the dado was essentially the same: to permit lower, adjacent structures to abut the exterior walls without interfering with the fenestration.[42] It is not known what kinds of structure abutted the east side of Westminster Hall in the eleventh century, but on the west side there must always have been kitchens and other service buildings forming a 'base court' (see plan, p. 35).[43] The base court itself was an essential means of communication between the generally accessible outer court, on the London side of Westminster Hall, and the Lesser Hall and other buildings in the Privy Palace.[44] The site of the Palace was much too narrow from east to west to allow a very large hall to be placed in the usual way, that is, along the side of a court, with its entrance at the low or service end of one of its long walls.[45] Hence the quite exceptional arrangement whereby the Hall is entered through one of its end walls. No doubt the placing of the main entrance on the longitudinal axis was regarded as more magnificent than the usual lateral approach, since it was more church-like and also more conducive to processional use in that it was not necessary to turn through ninety degrees after entering in order to move towards the dais.

Although it has generally been assumed that William II's Hall must have been divided by two rows of piers or posts into a central vessel and two narrower side aisles, there are good grounds for thinking that its roof resembled that of Richard II's Hall in being of one clear span.[46] The uniquely wide span of 69 feet (21.1m) would have exceeded English Romanesque norms by not much more than it did those of three centuries later.[47] If the Romanesque Hall was indeed roofed in a single span, admiration of this technical feat is unlikely to have been a significant element in the reception accorded to its remodelling in the 1390s. The response of most contemporaries would surely have centred on the splendour and stylistic modernity of the work. It is telling that Richard II's reign also saw the renewal of the naves of the churches built in the eleventh century for the three richest ecclesiastical corporations of South-East England:

Canterbury and Winchester Cathedrals and Westminster Abbey. In the late fourteenth century the high antiquity of a structure was clearly not perceived as a positive attribute. If owners of such structures could afford to alter or rebuild, they did.

Nevertheless, at Westminster Hall, as in the nave of Winchester Cathedral, very substantial parts of the Romanesque fabric were retained. The eleventh-century lateral walls remained to their full height, new Perpendicular Gothic windows were cut through them, and the surviving parts of old openings were filled in and concealed by means of the minimum of refacing (*ill. 13*). The walls were thickened externally by 19 inches (0.48m) and raised by adding a simple cornice to the wall head. As much as possible of the north and south walls was also retained, but the insertion into each of a window 45 feet (13.7m) high and 30 feet (9.1m) wide necessitated the removal of most of the old windows as well as the gables above. To either side of the fourteenth-century windows Romanesque fenestration was blocked and converted into solid wall.[48] The thinking which led to the retention of so much of the earlier masonry will be discussed below, but even in a major royal building one may presume that there was an interest in minimizing the amount of new stonework required. In the freestone-starved South-East of England sound masonry has nearly always been worth recycling.

If the gables of the eleventh-century end walls also contained windows, which there is reason to think was the case,[49] the light level in Richard II's Hall cannot have been a great deal higher than in William II's. It therefore seems legitimate to ask why the remodelled Hall differs from nearly all the many ambitious halls built in England since *c.* 1220 in not having side walls lit by tall windows extending down almost to floor level (*ill. 14*). Part of the answer must be that the solid dado of the Romanesque Hall had to be retained because it was abutted on the outside by structures even more numerous and substantial than those present when the Hall was first built. One might imagine that it would still have been possible to retain the solid dado but to replace the windows with much higher ones—a type of elevation often used, albeit on a smaller scale, in thirteenth- and fourteenth-century monastic refectories,[50] and occasionally in fourteenth-century secular halls. However, this approach would have had the disadvantage of drawing far more attention than smaller windows would have done to the fact that some parts of the elevations could not be lit on account of the proximity of such high structures as the Exchequer and the bell-tower of St Stephen's Chapel (see plan, p. 35). More fundamentally still, it must have been realized that the dado walls were incapable of supporting a great deal of additional masonry, for their cores are of rubble construction (*ill. 17*) and they lean outwards to an extent which varies along their length. Probably this defect was already evident by the mid 1380s, when 40 tons of Stapleton stone were bought for making one or more flying buttresses on the east side (*ill. 17*).[51] Complete demolition and remodelling of the dado walls was probably never a serious option as it would have been very difficult to carry out without imperilling

the important structures which adjoined them. The retention of the eleventh-century lateral walls to their full height meant that responsibility for devising a design of fitting splendour rested even more completely with the master carpenter than it did in earlier major single-span halls (*ills. 13, 14*).[52] The King's chief master carpenter, Hugh Herland, and his counterpart for masonry, Henry Yevele,[53] were presumably left to thrash out between them the nature and scope of their respective contributions, although of course the patron would have been able to veto their choices had he wished.

Another aspect of the dado walls besides their solidity which appears anomalous in a major late fourteenth-century English building is the absence of blind tracery panelling. This motif was a key feature of the Perpendicular style, and its applicability to the hitherto simply treated lateral elevations of halls had been demonstrated *c.* 1374–77 at Kenilworth Castle, one of the main seats of the King's uncle, John of Gaunt, Duke of Lancaster.[54] Henry Yevele had, admittedly, included plain dados in the outer walls of the nave of Canterbury Cathedral, but those are relieved somewhat by being traversed by vault shafts, and in any case they represent a far smaller proportion of the elevations, which are dominated by large and high windows. The simplicity of the dado zones at Canterbury and Westminster may reasonably be ascribed to Yevele's aesthetic preference for large areas of bare masonry—which also shows itself in the upper parts of the north front of the Hall (*ill. 22*)—but the Westminster dado can also be explained as making provision for the erection of shops during legal term-times, and for the installation of hangings in connection with festive occasions. Richard II is known to have possessed large numbers of the Flemish tapestries which had become *de rigueur* in major late fourteenth-century courts, but it would not be surprising if his collection of this costly type of manufacture was still insufficient or too heterogeneous to clothe the immense wall surfaces of Westminster Hall.[55] Brightly coloured woollen hangings were used here during Edward III's coronation feast in 1327, and decorations of this comparatively inexpensive type would have remained an option open to Richard II.[56]

A recently built royal hall which may have influenced the King or his advisors when requiring that Westminster Hall continue to make provision for hangings is that of *c.* 1362–65 in the Upper Ward of Windsor Castle, one of whose lateral walls was devoid of architectural features except for an entrance door at its low end. The etching by Wenceslaus Hollar which shows Windsor's Great Hall during the Garter Feast of 1663 (*ill. 14*) is a valuable reminder of how much the festive character of such events owed to the capacity of hangings, particularly figural tapestries, to transform simply treated elevations. The acceptance of tapestry as the pre-eminent form of decoration in élite households during the late Middle Ages can only have helped to ensure that the high, bare dados of William II's and Richard II's Westminster Hall became a standard feature of ambitious fifteenth- and sixteenth-century English great halls (*ill. 15*) and that the grand, ecclesiastically inspired panelling of the Kenilworth hall failed to give rise to a new tradition.[57]

There are two main passages of ornament which are integral with the structure of the Hall, and both incorporate stone sculpture for whose overall design Henry Yevele will have been responsible. The cornice between the dado and window zones (*ill. 13*), which is studded with carvings of Richard II's devices, was contracted for in March 1395 by two masons who agreed that they and their '*compaignons*' would complete everything in 46 weeks and would adhere to a template ('*une forme et molde*') furnished by Yevele.[58] There is nothing quite like this cornice in any earlier hall. The idea of making it such a prominent feature of the lateral elevations appears to have grown out of the decision to align horizontally two major structural divisions which were unrelated in other halls (*ill. 14*), namely that between the dado and window zones and that between the corbels and the principal roof-trusses they carry. Because there was no precedent for the manner in which cornice and corbels are linked at Westminster, and because there was a long tradition of decorating corbels with carving, it seems reasonable to suppose that the cornice decoration was conceived as an extension of that on the corbels. The cornice carvings show a degree of variation in proportions and detailing which is unexpected in heraldic art. They also project very boldly from the moulding of the cornice proper.

More representative of the generality of sculpture on Perpendicular buildings are the six kings flanking the south window, each of which is a self-contained figure standing within a niche (*ills. 13, 17, 18*). Except for the king in the westernmost niche, these statues typify English stone figure sculpture of the late Middle Ages in being of only moderate artistic merit. It is tempting to posit a causal link between the latter phenomenon and the establishment of Perpendicular architecture, which is characterized by ensembles of uniform, tall-proportioned compartments,[59] for there seems an inherent probability that the habitual use of imagery within such ensembles would have tended to privilege general effect over quality. The relative values attached to figure sculpture and architecture in the late fourteenth-century King's Works organization are revealed rather starkly in the recorded costs of the figures and the niches: £2 6s. 8d. for the workmanship and stone of each king as against £4 13s. 4d. for just the workmanship of each niche.[60] It is possible that the supplier of the statues, the London marbler Thomas Canon, was merely the contractor, in which case

19. Figures of Hugh Herland, William Wynford, and Simon Membury. Winchester College, east window of chapel

the sculptors who actually made the figures will have taken substantially less than the price charged. Doubtless the workmanship charges for both niches and statues will have been based on some readily justifiable notion such as an estimate of the amount of craftsman's time required.[61] Such clear evidence of the cost of medieval imagery relative to that of its architectural setting is extremely rare, but there exists one further documented instance which suggests that English patrons saw nothing untoward in being asked to pay more for 'frames' than for 'pictures'. This is a list of payments made for the elaborate window inserted in 1336 into the Chapel of Saints Peter and Paul in Canterbury Cathedral, where the masons' workmanship cost £21 17s. 9d. and the stone £5, but the workmanship and materials of the glazier came to only £6 13s. 4d.[62]

That patrons in late medieval England were willing to accord the highest status to the activity which produced the most expensive parts of their buildings is evident from the fact that payments relating to masonry were routinely entered first in formally drafted works accounts. The pre-eminence of the master mason among the head craftsmen in charge of a building project is illustrated with almost diagrammatic clarity in the imagery of a structure erected for William of Wykeham, Bishop of Winchester, the single most lavish patron of architecture in Richard II's reign. At the base of the Tree of Jesse in the east window of Winchester College Chapel (c. 1390–93; renewed 1822) is a series of small kneeling figures of those individuals whom Wykeham considered deserving of commemoration. In the outer two lights on each side are Edward III and Richard II and two images of Wykeham himself, all of them at prayer in sumptuously fitted oratories. In the light to the left of the central light, and kneeling on open ground by the head of the large recumbent figure of Jesse, are, from left to right, the master carpenter (Hugh Herland—his name missing from the inscription scroll), the master mason William Wynford, and the Clerk of Works Simon Membury (ill. 19). Of these three figures, Wynford's occupies the most honorific place, being both central and in the dexter position relative to the sacred imagery above the Jesse. At the feet of the Jesse, and on the sinister side of the other main images, is the glazier of the window, Thomas of Oxford (ill. 20).[63] It is surely significant that in the King's Works, which had employed Wykeham in 1356–61, and which continued to employ Wynford and Herland,

20. Figure of Thomas of Oxford. Winchester College, east window of chapel

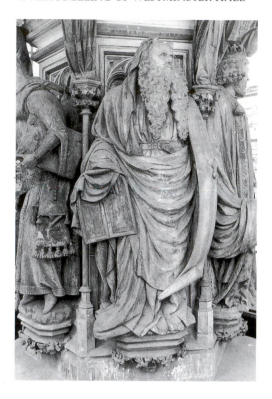

21. Claus Sluter: *Moses*, 1402.
Dijon, Charterhouse of Champmol, Well of Moses

the only figural artist to hold a permanent salaried post in Richard II's reign was a glazier, whose products, like those of the King's master smith and plumber, were of obvious relevance to construction and were needed more or less continuously in order to maintain the royal building stock. In the royal household, the chief glazier ranked as a sergeant whereas the head mason, carpenter, smith, and plumber were all graded as esquires, which is to say lesser gentry.[64] No permanent post of king's sculptor ever existed,[65] yet the omission of a sculptor from the glazing of Wykeham's Chapel does seem a little surprising given the prominence of figure sculpture on the college buildings and the exceptionally high quality of the best preserved piece—the standing Virgin on the outer gatehouse. Here, as in the King's Works, all aspects of stone carving, however 'creative', were evidently held to be subsumed into the category masonry, for which of course the master mason took overall responsibility.[66]

The sculptors recruited from the Low Countries by late fourteenth-century French royal patrons never ranked higher than valets, the rank below sergeants, but it is clear that in practice they occupied a quite different place in the pecking order from their English counterparts. The outstanding sculptor of this period, the Haarlem-born Claus Sluter, whose most important works were done for the Duke of Burgundy, was allowed to modify the pre-existing architectural context of some of his sculptures, was put in charge of masons making components designed by an architect (i.e. a master mason), and on at least one occasion took charge of designing an architectural structure which was to incorporate figures

carved by him.[67] 'Incorporate' is in some respects a misleading word to apply to these bulky and highly individualized figures—the Prophets on the Well of Moses at Champmol (*ill. 21*)—for they so dwarf the arches behind them as to leave no doubt that Sluter was consciously flouting the ancient and still-current tradition of placing standing figures within arcades or niches. In the only documented example of a work commissioned by an English patron from a leading Low Countries sculptor patronized by the King of France, Jean of Liège's tomb of Queen Philippa in Westminster Abbey, the imagery follows convention in being set within niches. But the detailing of these niches indicates that Liège, like Sluter, was his own architect. The pay received by Jean of Liège on completing the work in 1367—£133 6s. 8d. (200 marks)—was undoubtedly far higher than it would have been if a local tomb-maker had been recruited. More than half a century later, in 1421, the London sculptor Robert Broun, who sometimes worked for Henry V, took just £22 13s. 4d. (34 marks) for a tomb made of similar materials to Queen Philippa's but with two effigies rather than one.[68] And Broun's pay, unlike that of Liège's, included the cost of the marble and the alabaster.

The only part of Westminster Hall where the contribution of the master mason predominates is the north front. This is unique in major English medieval hall architecture in being an end wall treated as an impressive entrance façade, for, as was noted above, halls were normally integrated into a range of building forming one side of a court. In this situation it is not entirely surprising that Yevele should have made borrowings of some kind or another from the rich and long-established traditions of major church façade design, yet his extension of the eleventh-century ground plan by the addition of a pair of large towers goes far beyond the norms of hall architecture, and there can be little doubt Yevele and his patron intended that the front as a whole should register with most of its beholders as church-like.[69] A king who placed such emphasis on the sacral aspects of his kingship probably saw no incongruity in this. The lack of influence of the north front on later English architecture is less likely to have been due to the unacceptable nature of the ideology which informed its design than to the fact that there was no scope for further exercises of this kind.

In the context of the outer court of Westminster Palace, the symmetry of the façade and the bulk and forward projection of its towers were of value as ways of reinforcing the visual pre-eminence of the Hall among the irregularly disposed but substantial buildings which flanked it on both sides (*ill. 23*).[70] The towers also permitted the extension of the wall surface to either side of the entrance in order to make space for a long band of twenty-seven niches housing images of kings and queens (*ill. 22*). The inclusion of four niches on the outer face of the north-west tower (*ill. 24*) and only one on the outer face of its north-eastern counterpart was presumably due to an asymmetry in the adjoining buildings, but it was probably also an acknowledgement that the landward approach via the great gate of the Palace, also rebuilt by Richard II, was generally more important in ceremonial terms than that from the river via the water gate

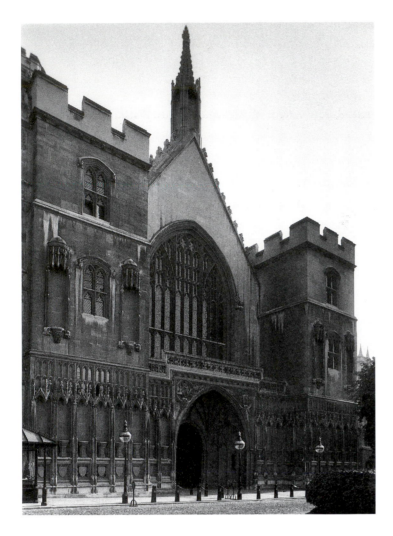

22. Westminster Hall. North front
looking south-west

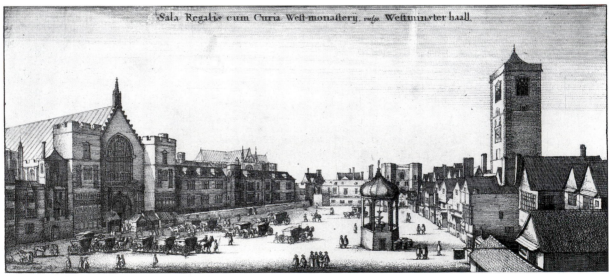

23. Westminster Palace. Outer court looking south-west. Engraving by Wenceslaus Hollar, 1647

(see plan, p. 35). Church façades composed of bands of arcading and image niches had become widely diffused in England since the twelfth century, and consequently it is neither feasible nor necessary to seek specific sources for this feature. Nevertheless, it is worth making the comparison with the earlier four-teenth-century west front of Exeter Cathedral, which exhibits an almost equally extreme contrast between a niche-encrusted lower zone and plainly treated upper parts. The option of placing imagery over the entrance, as at Exeter and on the west porch at Westminster Abbey (the latter probably also designed by Yevele), was no doubt rejected here because it would have reduced the height of the north window and hence the light level inside the Hall. The entrance itself, on the other hand, is remarkably similar to that of the Abbey. Both are examples of what have been dubbed 'welcoming porches' on account of the sense of drawing inwards generated by their canted sides linking the moder-ately sized doorway proper to a much larger outer arch. The earliest known example, that of *c.* 1327 in the choir-screen of Old St Paul's Cathedral,[71] was flanked by image niches in a manner comparable to Westminster Hall.

A less prominent but even more specific reminiscence of St Paul's is the pair of lozenge shapes at the top of the tracery of the north window. These reproduce almost exactly the tracery of the Cathedral's cloister, the earliest known example of Perpendicular architecture in London and the work of William Ramsey, Yevele's most distinguished predecessor as chief royal master mason.[72] The influence of Ramsey's work dominated London architecture for at least 50 years after his death in 1349, although the clearest evidence of this in relation to Yevele is not here but in the nave of Canterbury Cathedral.[73] The north window as a whole is an enlarged and somewhat elaborated version of the east window of

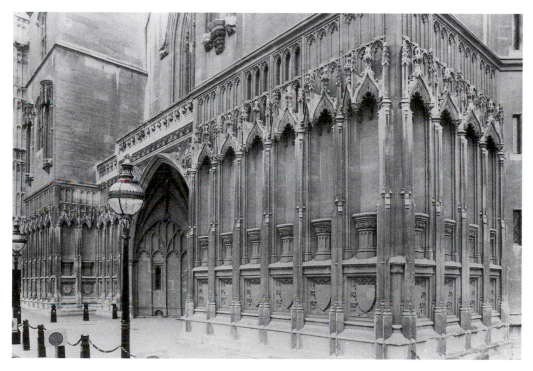

24. Westminster Hall. North front, niches from north-west

Winchester College Chapel, which William Wynford designed around 1387.[74] This indebtedness to obvious sources is characteristic of Yevele's designs. He had been pre-eminent among royal master masons for some 30 years before he started work on Westminster Hall, and in the course of his long and exceptionally productive career there is little sign that he felt the need to modify or develop to any significant extent the vocabulary of the Perpendicular style which he and his contemporaries in the South-East had inherited from William Ramsey.

Of course, most contemporary viewers of the north front would have pondered the minutiae of its architectural detailing far less than its imagery—a series of English kings and queens. On the other hand, at least some users of the Hall might have recognized that the ancestry of the architecture of the entrance porch was related to that of the imagery in that both were offshoots from a venerable tradition of church façade and choir-screen design represented locally by the west front of Westminster Abbey and the *pulpitum* of St Paul's.[75] Unfortunately, the exact scope of the iconography is far from clear. A reference to painting thirteen kings and four queens in this position in 1533 implies that ten out of the twenty-seven niches provided had remained unfilled.[76] Thirteen kings and four queens are not recognizably a coherent iconographic scheme. If, however, the 'four' of the Tudor reference was a slip for fourteen, all twenty-seven niches would have been occupied. A plausible twenty-seven-figure scheme would include all but one of England's kings and queens from Edward the Confessor and Queen Edith to Richard II and Queen Isabelle. In Richard II's reign the most obvious queen to omit would have been Adela of Louvain, Henry I's childless second wife, but when the statues began to be placed in their niches late in 1399 or in 1400, England was ruled by Henry IV, a circumstance which would have necessitated a further editing of queens. Payments were made in 1399–1400 for putting up the seven kings ordered in 1385 for the thirteen-king scheme inside the Hall but stored since then.[77] As was noted earlier, it has generally and quite reasonably been presumed that the thirteen kings began with Edward the Confessor and ended with Richard II. None of the documents puts names to the individual figures, many of which are likely to have been interchangeable. The seven kings stored since 1385 were installed on the north-east tower, which had one niche in its east face and six on its north face, and four further kings were set up, two on either side of the entrance.[78] There are no indications in the extant accounts as to whether figures were put into the niches between the filled ones on the north-east tower and those east of the entrance.[79] An unbroken, east-to-west, sequence of kings starting on the east face of the north-east tower and ending with the second niche to the west of the entrance would run from Edward the Confessor to Henry IV. A left-to-right sequence of queens starting next to the statue of Henry IV, and leaving room for a future queen of this widower monarch, would fit into the remaining niches only if the second queens of Henry I, Edward I and Richard II were omitted.[80] There is a considerable range of possible explanations for the state of the series in 1533, in

1647 when Hollar etched a view of the Great Court showing the six niches on the front of each tower filled (*ill. 23*), and in 1780 when John Carter drew the remains of eight figures newly revealed within the coffee-houses built up against the north front (*ill. 42*).[81] The essential points in the present context are that a left-to-right series starting with kings and continuing with queens was intended by Richard II and Henry IV, and that the full twenty-seven-figure scheme was probably never realized.

In 1533 'greatt kings' filled each of the four large niches on the north faces of the towers at first-floor level (*ill. 22*). Two of these—no doubt representing the Confessor and Richard II—had been put up on the old front in 1385, stored from the mid 1390s and, along with their niches, placed on the north-west tower where they were whitewashed in 1399–1400.[82] Possible candidates for the other two kings include St Edmund, William II and even Edward II, for whose canonization Richard was canvassing vigorously in the 1390s.[83] The identities of the four kings in the great pinnacle on the north gable and of the two kings in the south gable pinnacle are likewise unknown.[84]

If the original thirteen-king scheme of 1385 was to have been installed on the south wall, as one must probably assume, it would have had to be set below the windows, where there would have been no room for tall spires comparable to those which dignify the niches housing the six-king series installed in the 1390s.[85] Such a 'gallery' of kings along the high end of a hall may possibly have had antecedents in fourteenth-century England,[86] but its realization in statuary would have recalled to many the imagery in the other most important royal hall in Northern Europe, the early fourteenth-century *Grand'Salle* in the Palais de la Cité in Paris (*ill. 16*).[87] The chances are that it was this very hall which Richard II had in mind when ordering the refurbishing of Westminster Hall in 1385. Certainly he was aware of the need to match the levels of display achieved by the French Crown, for in 1384 he had complained to Parliament that his household would be put to shame by that of Charles VI if the two monarchs were to meet to ratify the proposed peace treaty between England and France.[88] Apart from the huge size of the *Grand'Salle*, obviously intended to trump William II's Westminster Hall, its most impressive feature was its prodigious series of statues of French kings, starting with the mythical Pharamond. The earliest kings were on the piers of the arcade dividing the hall into two aisles, but most were between the windows of the outer walls. When Philip IV (1285–1314) built the hall, his statue was the forty-first and seventeen empty niches awaited the figures of his successors. The *Grand'Salle* was clearly conceived as an investment for the present and future benefit of French monarchy in general, and the incompleteness of its king series would have enhanced the sense of temporal progression generated by the longitudinal placing of the statues within it.[89]

Quite different ranges of meaning would have been generated by the thirteen-king series planned for Westminster Hall in 1385 and by its successor devised for the façade in the following decade, since both were complete and without implication of future extension. The internal version would have been

visible throughout the length of the Hall and would therefore have registered very clearly as a single unit. In this respect, and in its horizontal band format, it would have resembled a type of altarpiece very widely used in late medieval England.[90] The implication of quasi-Divine status for the living figure enthroned below such an ensemble would have come across clearly even to the least sophisticated viewer. The thirteen-king series planned under Richard II for the north front was physically less elevated and also less altarpiece-like because interrupted by the entrance and not so readily visible simultaneously, but its sacral overtones would have been clear enough. Any thirteen-figure series would have instantly evoked Christ and the Apostles in the minds of contemporary viewers, and in Richard II's mind it was no doubt extremely significant that he was the twelfth successor to England's most important and most recent royal saint. His mystical relationship with the Confessor may well have stemmed from the fact that he was born on the day after the Feast of St Edward's Deposition or burial. This was the Feast of the Epiphany, itself a commemoration of holy kingship. In 1395 Richard began to make use of a new shield of arms on which the arms he inherited as King of England were impaled, like those of a wife, by those of the saint.[91] There is a possibility that his intention, formed around the same time, of not remarrying after the death of his first queen was inspired by the Confessor's supposed virginity.[92] St Edward's arms and the normal royal arms were very prominently paired, though not impaled, on the spandrels of the north entrance, on the roof corbels and on decorative elements that have now disappeared;[93] and this, together with the emphasis on the number thirteen not only in the sculpture of the Hall but also the structure of its roof—which the architects went out of their way to emphasize[94]—suggests rather strongly that, in the mid 1390s at least, Richard II was intent on constructing a monument to the notion that a cycle which had begun with St Edward was ending with him.[95]

Even if this was not the meaning consciously intended by Richard, he must have been aware of personalizing the main non-ecclesiastical site of royal ritual in a way which was unprecedented. Carvings of his badges, including the famous White Hart, recur again and again inside and outside the Hall, but are most prominent in the cornice running between the roof corbels.[96] Personal devices had powdered royal and aristocratic dress and furnishings—including wall-hangings—for almost half a century before 1393, and it was perhaps inevitable that they would eventually invade the architectural settings of courtly life. The use of personal devices at Westminster Hall by Richard II—its novelty must mean that it was at least approved by the King—anticipates by a century the relentless pepperings of badges which the early Tudors lavished on all their buildings. Major Continental examples coeval with Westminster Hall are few and restrained by comparison.[97]

The roof of the Hall also stands out as an exceptional phenomenon when viewed in a Europe-wide context. The largest steeply-pitched timber roofs built on the Continent in the fourteenth century—the *Grand'Salle* in Paris (*ill. 16*), the

halls in the Castles of Montargis and Coucy, and the Palazzo della Ragione in Padua—are in essence tie-beam roofs, technically and aesthetically compara- tively unsophisticated structures which show little awareness on the part of their designers that large-scale roof carpentry possessed an expressive potential com- parable to that of masonry vaulting.[98] All that they have in common with the structure covering Westminster Hall is that they incorporate arched forms derived from stone architecture and evince a concern to maximize interior space by omitting any form of ceiling separating the volume enclosed by the walls from that enclosed by the roof.

The roof of Westminster Hall has been a beneficiary of the growth of interest in late medieval carpentry that has been such a remarkable feature of English architectural historiography during the past forty years. The problems which have preoccupied scholars in that time have been the analysis of the structural design and the search for sources and antecedents.[99] A potential danger of focusing single-mindedly on the latter kind of enquiry is that it can lend a specious air of inevitability to the development whose origins are being sought. In fact there was nothing inevitable about the solution which Hugh Herland adopted at Westminster. The steep pitch and extreme complexity of the roof ran counter to what in the second half of the fourteenth century must have looked set fair to become the predominant type of covering for major halls, namely the tie-beam roof of low pitch. It had probably been used over the other outstanding hall of the period, that of Kenilworth Castle, and it was about to be used over the most ambitious of late fourteenth-century civic halls, St Mary's Guildhall in Coventry.[100] Herland himself had used it over the hall at Winchester College (*ill. 27*) and probably in other buildings as well.[101] Low-pitched tie-beam roofs were also an established feature in major parish church architecture, and their flat- ness, their capacity to receive rich surface decoration, and the 'boxy' quality they impart to the spaces they cover were all very consonant with the aesthetic of Perpendicular masonry architecture.[102] If it had been possible at Westminster Hall to build high lateral walls and thereby achieve a room of upright propor- tions, Herland might well have been content to design a grander version of the roof type he had used at Winchester College. The impracticality of raising the low and potentially unstable lateral walls of the eleventh-century Hall may thus be viewed as the creative grit that gave rise to the pearl among roofs that Herland actually built. And yet the possibility cannot be excluded that the steeply-pitched roof, like central hearths and louvers, was perceived to be part of the traditional imagery of great halls and that as such it proved to be a more powerful influence than current architectural fashion on the formulation of the design. The adoption of a steep pitch for Richard II's roof may even have been due to a wish to maintain a measure of continuity specifically with the roof that it replaced.[103]

An aspect of Herland's approach to his work at Westminster which is recog- nizable even on the basis of a superficial consideration of antecedents is his readiness to exploit the extraordinary diversity of roof types developed in the

25. Westminster Hall. Interior of louver

26. Ely Cathedral. Vault of octagon

27. Winchester College. Roof of hall

28. Winchester College. Wooden vault of chapel

rich tradition of large-scale carpentry established in England during the century before 1393. His fusion of the two most ambitious forms of steeply-pitched roof used over wide spans in the fourteenth century—the hammer-beam roof and the arched-brace and collar roof—was unprecedented and reveals clearly his sense of occasion, his awareness that in being charged with re-roofing Westminster Hall he had been vouchsafed an opportunity to create something altogether exceptional. In this connection it is important to remember that most of the

largest roofs in medieval England were built above the stone vaults of major churches and were therefore not ordinarily visible.

Hugh Herland's accomplishment as a structural designer has never been in doubt, despite disagreements about the nature of the forces acting within his roof. By contrast, his contribution to the late medieval English genre of imitations in timber of ambitious stone structures has hardly been discussed at all.[104] Since the opportunities for any individual master carpenter to design in a complex Gothic idiom were few, many scholars may possibly have entertained the suspicion that in a collaboration between the king's chief architects for stone and timber buildings, Yevele would have made some contribution to the design of the quasi-masonry details of the roof. The evidence of the roof itself weighs against this. For example, the very elongated ogee-arched heads to much of the openwork tracery filling the interstices between the main members find no parallels in Yevele's *oeuvre*. These screen-like elements, which greatly enrich the roof but also emphasize its huge scale, show Herland to have been in some respects a more committed practitioner of the Perpendicular style than Yevele, for they derive from the kind of repetitive blind tracery panelling which was a hallmark of ambitious Perpendicular building but which Yevele seems consistently to have eschewed.[105]

Two other works of Herland's which show him to have been a very enterprising designer of fictive masonry are the vault over the Chapel of Winchester College (*ill. 28*) and the vaulted canopy over the monument of Edward III in Westminster Abbey. Both structures imitate fan vaults, the vault type which, more than any other, takes on the repetitive tracery aspect of Perpendicular elevations. Indeed the Winchester vault is the earliest extant solution to the problem of building fan vaults above rectangular-plan bays, a problem which continued to tax the ingenuity of English master masons for the remainder of the Middle Ages. Fan vaults seem never to have been essayed by Yevele.[106]

Herland's skill as a designer of sophisticated timber structures in the Gothic style was doubtless due in some measure to his familiarity with the work of his predecessors as chief carpenter of the King's Works. The surviving louver out of the two which formerly perched on the roof-ridge of Westminster Hall shows clearly that Herland knew the non-royal works of William Hurley, whom Edward III employed from 1328 until his death in 1354.[107] There is an unmistakable likeness between its fictive vaulting and two-stage construction and Hurley's chief surviving work, the enormously larger superstructure of the octagonal crossing at Ely Cathedral (*ills. 25, 26*).[108] Moreover, the normally invisible structural carpentry of the Ely octagon is by far the largest example of hammer-beam-type construction predating the Westminster roof.[109] The only roof known to have anticipated the openwork tracery at Westminster is that formerly over the hall in the Upper Ward at Windsor (*ills. 13, 14*), designed by William Herland, Hurley's successor in the King's Works and all but certainly the father of Hugh.[110] Just how the reserves of artistic and intellectual capital which architectural designs represented were transmitted from one fourteenth-century generation

to the next we do not know, but fifteenth-century evidence suggests that Hugh Herland could have inherited from William Herland designs by him and also by Hurley, and that drawings relating to royal projects might have remained for very long periods in the custody of the Clerk of the King's Works at Westminster.[111] In attempting to characterize Hugh Herland's achievement at Westminster Hall it therefore seems less appropriate to invoke originality than to point to the evidence suggesting that he conceived his task as being to devise a summation of all that was most impressive in the works of his immediate predecessors.[112]

What conception the medieval architectural patron had of his project is almost always difficult to discern. However, the two features of the roof of Westminster Hall whose inclusion in the design is least likely to have been due to Herland alone are those which can most readily be characterized as original ideas. The great numbers of arched elements of different kinds, like the shield-bearing angels which hover at the end of every hammer-beam, were almost certainly innovations,[113] but what makes it impossible to view them purely as products of Herland's artistic imagination is the central importance of their meaning within the patron's political ideology. There can be little doubt that for Richard II the primary purpose both of the arches and the angels was the same as that of the church-derived elements of the north front: to invest the building most representative of the royal house (in both the genealogical and architectural senses) with celestial resonances appropriate to its status as a principal site of the ceremonial of sacral kingship. Roofs over major buildings had always been thought of as adumbrations of Heaven, but by the late Middle Ages the regular use of vaulting in ambitious churches had probably ensured that heavenly connotations were more securely attached to this type of structure; hence the presence at Westminster of large arches equating to major vault ribs and small repetitive panels approximating to the surface tracery of fan vaults.[114] The angels too were probably a one-off borrowing from another artistic tradition, in this case representations of English kings and princes kneeling before the Trinity and receiving their arms at the hands of angels descending from the skies.[115] More than any other feature of Westminster Hall, its airborne troop of quasi-esquires[116] caught the fancy of contemporaries and soon gave rise to veritable hosts of angels stationed in innumerable roofs and ceilings throughout southern England.[117] If the patron of the renewed Hall had lived to make several decades' use of his investment, which must have been the general expectation until the summer of 1399, there is little likelihood that imagery intended by him to harbinger a new political dispensation would so quickly have shed its original meaning and become transmuted into one of the commonplaces of late medieval English art.

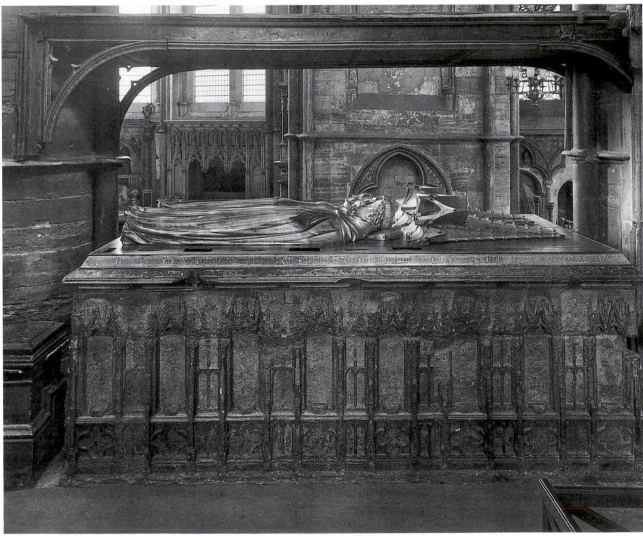

III

PHILLIP LINDLEY

Absolutism and Regal Image
in Ricardian Sculpture

THE OBJECT of this essay is to examine two examples of the sculptural
patronage of King Richard II: the double tomb to the King and Queen Anne
of Bohemia in Westminster Abbey and the six statues of kings located in niches
in the south wall of Westminster Hall (*ills. 40, 41*). Even such an incomplete view
of Richard's sculptural patronage can be deployed as evidence that a coherent,
if untenable, ideology of kingship underlies and informs the King's com-
missions. Sculpture, no less than the King's other artistic patronage (of which
the Wilton Diptych is the most debated example), can be used to throw light on
Richard's political concerns. Additionally, the essay will consider other issues
raised by an analysis of these sculptures: their integration into their architectural
contexts, their costs, artistic significance and conservation.

Richard II's most celebrated sculptural commission is the double tomb (*ills.
29–30*) which commemorates the King and his beloved first wife, Anne of
Bohemia (d. 7 June 1394).[1] Two principal reasons for the choice of the tomb's
location, on the south side of the Confessor's Chapel in Westminster Abbey, can
be discerned. First, the area around St Edward the Confessor's Shrine was
already ringed with the monuments of previous monarchs and members of the
royal family: Queen Eleanor of Castile (d. 1290), Henry III (d. 1272), Edward I
(d. 1307), Queen Philippa of Hainault (d. 1369), and Edward III (d. 1377) were
all entombed round the Shrine.[2] Richard's will, drawn up on 16 April 1399,
retrospectively testifies to the significance of this area's dynastic associations for
the King. 'We have chosen', it reads, 'a royal burial in the Church of Saint Peter
at Westminster among our ancestors, Kings of England of famous memory; and
in the monument which we have caused to be erected as a memorial for us and
for Anne of glorious remembrance once Queen of England our consort'.[3]

St Edward's Shrine also had quite specific, personal, resonances for Richard:
it was here, for instance, on 15 June 1381, that the fourteen-year-old monarch
had prayed before riding out to meet the rebels at Smithfield.[4] After the
'Revenge' Parliament of 1397–98, Richard was to force the prelates and lords to
swear one by one on the Shrine to maintain the statutes and judgements of the
Parliament.[5] Richard's deployment of the Saint-King Edward and his use of his
royal ancestors to buttress his own cause are two key elements in the King's
sculptural patronage. At Westminster, both elements were combined.

29-30 (*left*). Double tomb of Richard II and Anne of Bohemia,
commissioned 1395, in the ambulatory of Westminster Abbey.
(*In situ the head of Christ in Majesty of the tester
is located above Richard and Anne's heads*)

Richard provided a magnificent funeral service for Queen Anne on 3 August 1394. Her obsequies included a funeral effigy (of which only the head now survives, in Westminster Abbey): this was the first funeral effigy to be provided for a Queen of England and only the third one—after those of Edward II and Edward III—ever produced.[6] The wooden image was shipped up from London, where it had been carved, to the Palace of Sheen, where Anne had died.[7] The effigy representing the deceased Queen was displayed during the funeral ceremonies above the encoffined corpse. At Westminster it was exhibited beneath a large hearse, lavishly illuminated with candles.[8] No fewer than three more hearses—at Wandsworth, Southwark and St Paul's—were provided for exequies described by a (hostile) chronicler as the greatest hitherto seen in England.[9] At the funeral service in Westminster Abbey, Richard struck the Earl of Arundel for showing insufficient respect.[10] In this liminal moment—both in the sense of the definitive parting between the King and Queen, and in the political sense as the King lost an important confidant and *mediatrix*—the intertwining of Richard's sense of loss (accentuated by the presence of Anne's portrait effigy) and his sensitivity to the proper commemoration of royalty are revealed. Of course, the exequies of the royal family had already become sophisticated liturgical ceremonies under Edward III[11] but Richard's actions seem to mark an intensification of concern. In the fourteenth year of his reign he had what must have been a sumptuous monument—for it cost £66 13s. 4d.—with a marble tomb-chest, placed over the burial place of Edward, his elder brother (d. 1371), at King's Langley. Two years later an iron screen was placed round it at a further cost of 40 marks.[12] Richard also brought back Robert de Vere's body to England for honourable burial at Earls Colne in Essex, three years after de Vere had died in exile.[13]

Not long after Queen Anne's funeral, Richard took steps to provide her with a permanent memorial. The monument which he commissioned was a double tomb, for himself and Anne, the first such tomb for royalty in England.[14] Richard, aged only 27, thus became the first English monarch to contract for his own tomb since Henry III. Besides the new fashion for double tombs, and Richard's possible emulation of recent French practice, a further factor in the King's decision to commission a double monument—quite aside from his genuine desire to be buried beside his wife—may have been the fact that all the available space would now be occupied by the tombs of kings or their consorts, those of other members of the royal family having already been displaced.[15]

On 1 April 1395 the King's Privy Seal was attached to an indenture with the masons Henry Yevele and Stephen Lote for a tomb-chest to be made of fine Purbeck marble, from an agreed pattern they had furnished.[16] The tomb-chest was to have six niches on each side and spaces for escutcheons below. Its location was fixed and its height was to match that of Edward III's tomb (the tomb-chest of which was also by Yevele and Lote). It was to be set up by Michaelmas 1397 and the masons were to receive £250 for it with a £20 bonus if the work were well and loyally done.[17] A little more than three weeks later, on 24 April 1395, a

31 (*right*). Richard II and Anne of Bohemia. Double tomb in Westminster Abbey

second contract was sealed, with Nicholas Broker and Godfrey Prest, two London coppersmiths, for the gilt-latten work: these elements were to be produced according to a pattern shown to them and not, therefore, supplied by them ('*selonc un Patron as ditz Nicholas et Godfrey monstrez, q'or est esteant en la garde del Tresorer*').[18] The components for which they contracted comprised the following:

> Two crowned images, with their right hands joined together, sceptres in their left hands and an orb surmounted by a cross between them. One effigy was to be modelled on the King ('*conterfait le Corps de nostre dit Seignur le Roy*'), the other on the deceased Queen.
>
> A table of gilt-latten on which the effigies were to lie, with a *Frette* (engraved design) of fleurs-de-lis, lions, eagles and leopards.
>
> Canopies with double pilasters ('*Tabernacles, appelles Hovels, ove Gabletz, de dit Metall endorrez, as Testes, ove doubles Jambes a chescune partie*') over the two effigies.
>
> Two lions to go under the feet of the King and an eagle and a leopard at the feet of the Queen's effigy.
>
> Twelve images of various saints, whose identity the King or Treasurer would designate, to be placed on either side of the tomb, and eight angels around the said tomb.
>
> The inscriptions to be engraved round the tomb, the text of which would be supplied to the two coppersmiths.
>
> Enamelled gilt-latten escutcheons or coats of arms to be placed around the tomb (the number, size and exact placing is not specified, but this must have included the five large ones which were to be placed on the base of the ambulatory side).

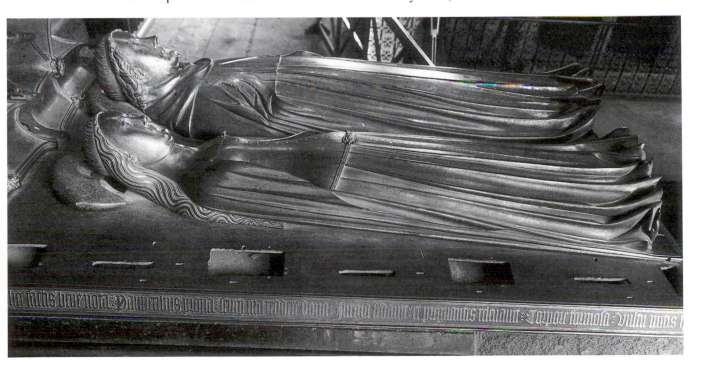

These details must have been shown on the pattern agreed between the Treasurer, Roger Walden, and the two men; the contract was to be performed within two years from the Michaelmas after signing, for £400.[19] Payments were to be made at regular intervals, and are recorded in Issues of the Exchequer.[20]

The contract poses a number of questions. One important point which has escaped comment is the fact that saints—not the customary weepers (weeping relatives)—are specified. If this is not simply an error (and since the word is repeated, it is most unlikely, though it is contradicted by item 7, for escutcheons would accompany relatives not saints) Richard's monument was intended to differ from all the other tombs of royalty within the Abbey. The idea of studding the tomb-chest with saints rather than with members of the royal family anticipates Torrigiano's tomb for Henry VII and Queen Elizabeth at Westminster, where the first Tudor monarch's monument transforms his defective genealogical claim to the throne into a spiritual approval of it. The immediate proximity of Richard's tomb to that of Edward III (on which it was explicitly modelled), where the monarch's children are so prominently featured, surely justifies our interpreting Richard's contrasting intention to surround himself with saints both as a stress on the royal couple's childlessness and as evidence of the King's propensity to envisage himself in the context of a heavenly court rather than his earthly one. The novelty of the tomb's format—which seems to echo episcopal tomb-chests—may well have been rejected for it seems likely that the internal contradiction of including both escutcheons and saints was resolved by the saints' substitution by weeping relatives.[21] Unfortunately, there seems to be no evidence of the identity of these small images: the means of fixing the weepers and the small escutcheons to the tomb-chest differed from that employed in Edward III's monument (where they seem to have been retained with a pin through a retaining peg) and evidently made the bronze components easier to steal. Even the five large escutcheons, however, placed on the basement on the ambulatory side, and more securely fixed in place, have also been removed. The tomb-chest is longer than that of Edward III and has housings for *eight* weepers (not the six envisaged in the contracts) per side (it is perhaps possible that weepers were placed on one side and saints on the other). The eight angels were located in the lateral pinnacles (also now lost), their positions marked by their stippled haloes and fixing points on the base-plate (*ill. 32*). This arrangement and number of angels corresponds to Edward III's monument, though the small canopies above the angels appear to have been much more elaborate than those of the earlier tomb.

The choice of materials—gilt-latten and Purbeck marble—and the close modelling of the tomb-chest on that of Edward III, resonated intentionally within the Plantagenet mausoleum: gilt-latten effigies commemorated Henry III, Eleanor of Castile and Edward III. A different choice of material had been made by Philippa of Hainault, whose marble effigy, reflecting the recent monuments of the French royal family, was carved by the sculptor Jean de Liège in 1367.[22] An unflatteringly realistic portrait, it lay on a dark marble tomb-chest, the sides

adorned with weepers housed under canopies of the same material as the effigy; the complex arrangement (and extraordinarily skilful handling) has been interpreted as marking a development towards the open arcade with smoothly flowing funeral processions developed by Claus Sluter in the tomb of Philip the Bold at Dijon.[23] As early as 31 May 1376 John Orchard was supplying six small copper angels to be placed round Philippa's tomb.[24] We do not know exactly where these were placed but they may have been intended to enhance the tomb's material splendour: metalwork had already been employed by Jean de Liège on the tomb, for the wings of the small angels of the tomb-chest, and for the netting over the queen's caul. The most recent tomb at Westminster was, of course, that of Edward III. Marble for this tomb-chest was shipped in 1386 and, if the procedure adopted for Richard and Anne's tomb was similar to that for Edward, this suggests that the latter's gilt-latten effigy could be dated as late as *c.* 1386 too.[25] Richard certainly concerned himself with his grandfather's tomb—this attention is explicitly reflected in the modelling of many details of the new tomb-chest as well as its general proportions and height—and it is likely that he paid for it. It could be argued that Richard—perhaps influenced by his father's tomb at Canterbury—revived the taste for gilt-bronze and Purbeck-marble tomb monuments at Westminster.

The patterns for the double tomb of Anne and Richard were presumably agreed, as Selby Whittingham argued, before the King left England for Ireland in September 1394.[26] Realistic portraits were certainly intended: the effigy of the King was to be '*conterfait le corps de nostre dit Seignur le Roy*' and in the payments the effigies are specified as being made '*ad similitudinem dictorum nuper Regis et Regine Anne contrafact*[am]'.[27] It is difficult to concur with Lawrence Stone's judgement that the details of Richard's head 'show some recession from the

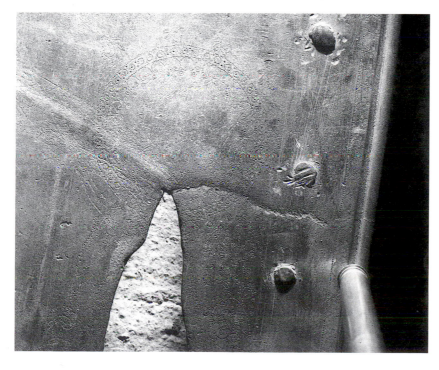

32. Stippled halo of lost figure of angel. Base-plate of Richard II and Anne of Bohemia's tomb effigies in Westminster Abbey

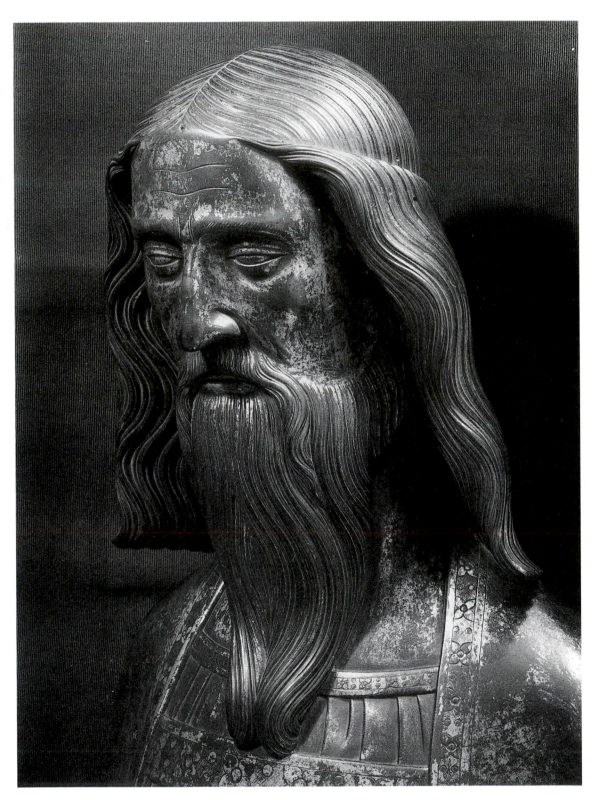

33. Head of Edward III from his tomb effigy. Westminster Abbey

34. Head of Richard II from his tomb effigy. Westminster Abbey

35. Heads of Richard II and Anne of Bohemia from their tomb effigies. Westminster Abbey

realism' of that of Edward III.[28] On the contrary, the head by Broker and Prest appears to mark a definite move towards realistic representation, away from the more austerely idealized head of Edward III (*ills. 33, 34*). The stylistic distinctions between Edward III's effigy and that of his grandson are marked enough for it to be certain that—although the same masons provided the two tomb-chests—different artists were responsible for the effigies. The differences affect not just the figure style, but also the architectural repertoire, in the format and detailing of the canopy work in which the effigies are housed. This judgement can be confirmed by a consideration of the numerous design and technical differences between the effigies. That of Edward III was cast in a single piece (except for the hands, crown and other details) about 12mm. thick. Anne of Bohemia's effigy is about double that thickness and a large portion of the front of the body had to be recast after initial failures; the arms were cast separately.

68

Clearly, if the same men had produced Edward's effigy a few years earlier, we should expect very similar techniques to have been employed. Richard II's effigy is about 9mm. thick with the arms again separate. The head and hood of Richard's effigy were, however, cast as separate elements from the main body of the figure (*ill. 35*).[29] The changed technique adopted for Richard's effigy indicates that Anne's figure must have been the first to be produced. The coppersmiths evidently experienced difficulties in casting the Queen's effigy essentially as a single trunk (accessories such as Anne's brooches were riveted on).[30] It was clearly simpler to cast the figure in separate sections. A similar technique was adopted for the later gilt-bronze effigy of Richard Beauchamp, Earl of Warwick, also the product of London craftsmen, and made from no fewer than seven separately cast pieces.[31] Dillian Gordon makes the stimulating suggestion that the technique adopted for Richard's effigy means that the bust section could reflect the King's appearance in 1398: for the gilding seems to have taken place only between 7 December 1398 and 14 April 1399.[32] However, in March 1396 Richard stood the craftsmen a drink 'for forming two images of copper, in likeness of the King and Queen', an act which suggests that casting of the main components of the effigies was already complete.[33] It seems probable that the period between March 1396 and December 1398 would have been filled by the production of all the other cast components—the angels, weepers, canopies, pinnacles, base-plate, beast foot-rests and so on.[34] The tomb effigy head is close to the appearance of the Westminster Abbey portrait (apparently commissioned to stand in the choir of the church in December 1395) and probably represents Richard's appearance in 1395.[35] Gordon ventures the hypothesis that the designer of the pattern for the effigies was the artist of the Wilton Diptych.[36] Certainly, what we know about the collaborative techniques employed for other English gilt-bronze effigies indicates that a painter was almost always employed to furnish the designs for the latten workers.[37]

The chasing of the effigies must date from 1399.[38] The robes of the King are powdered with the letters 'R' and 'A' and three badges: the White Hart, the broom plant and the rising sun (*ills. 36, 39*).[39] This splendid texturing of the gilt surfaces, analogous to the surface detailing of the Wilton Diptych, sharply differentiates the effigies from those of Edward III or the Black Prince in Canterbury Cathedral. The powdering of surfaces is not mentioned in the indenture for the production of the effigies and this may reflect the novelty of the technique in England.[40] The huge cost of gilding the effigies—three times that laid down in the contract—must have included the laborious and skilled job of chasing the details. Doodles by the artist, including trial letters, foliage and a small caricature head can be seen in an area where the cast architectural elements have been removed (*ill. 38*).[41] The masterly tooling—which extends to details such as the fictive masonry and shingles of the canopy, and the trefoil-headed blind panelling engraved on the base-plate behind the canopy—reminds us that Broker and Prest were major figures in the production of monumental brasses in this period.[42]

36. Detail of chasing on Richard II's robes on his tomb effigy. Westminster Abbey

37. Detail of chasing on Anne of Bohemia's robes on her tomb effigy. Westminster Abbey

38. Base-plate of Richard II and Anne of Bohemia's tomb effigies showing engraved doodles and trial letters. Westminster Abbey

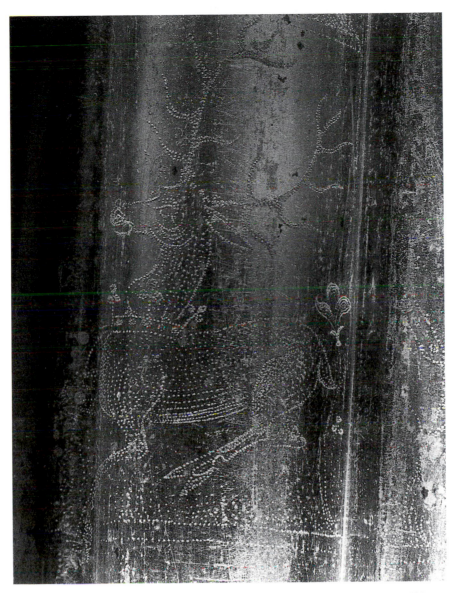

39. Detail of chasing of White Hart on Richard II's tomb effigy. Westminster Abbey

The badges of the White Hart, the broom cod, and the rising sun are exhaustively discussed elsewhere in this volume and need no further comment here.[43] The use of badges was not, of course, a Ricardian innovation and had been popularized in the reign of Edward III, but these were the first royal monuments to have the badges represented on the effigies. Queen Anne's mantle is powdered with the letters 'R' and 'A' intermixed with lime leaves. The bodice is powdered with the same letters on a smaller scale alternating with a floral pattern; the gown, or skirt below the belt, is powdered with the letters 'R' and 'A' crowned and small vine leaves but the main motifs are her badges (*ill. 37*). These are the ostrich, collared and chained and bearing a nail in its beak,

alternating with knots, the badge of Wenceslas IV.[44] The canopy above Richard's head is powdered with harts, like that on the reverse of the Wilton Diptych, flanking the royal arms impaled with those of the Confessor;[45] the canopy over the Queen has France and England quarterly impaling Bohemia with eagles as supporters. Although the use of badges on clothing was not new, the giving of badges such as those which adorn the effigies was an extremely contentious issue in Richard's reign. Nigel Saul has shown that the bearing of badges, like wearing livery, was a form of labelling which 'served important symbolic and practical purposes: it defined status; it gave visible expression to the bond between lord and man; and it supplied a means by which one lord's followers could be told apart from another's'.[46] It is this factor which makes the wearing by the angelic hierarchy of the White Hart badge and broom cod collar—implying a feudal relationship with the King—so extraordinary a feature of the Wilton Diptych. The affinity-building policies of Richard II in the later years of his reign aroused a great deal of opposition and the Commons' preoccupation with the issue implied a frank criticism that 'ruling a kingdom was a different art from managing an affinity'.[47] The studding of Richard and Anne's effigies with their badges highlights the fact that the King was in the 1390s simultaneously attempting to build up his own affinity: favouritism to those who bore his device indicated a particularist attitude at odds with the monarch's duty to maintain the unity of the realm.[48]

Some of Richard's central concerns are revealed in the tomb's epitaph. Its strident language in Leonine hexameters is without parallel in England:

> 'Prudent and elegant, Richard the second by right, conquered by fate, lies here depicted under this marble. He was truthful in discourse and full of reason: Tall in body, he was prudent in mind as Homer. He favoured the Church, he overthrew the proud and threw down whoever violated the royal prerogative [*regalia* also means the regalia of kingship]. He crushed heretics and laid low their friends. Oh merciful Christ to whom he was devoted; Oh Baptist, whom he venerated, may you by your prayers save him. Under this broad stone Anne now lies entombed. While she lived, she was the wife of Richard the Second. She was devoted to Christ. She was well known for her good deeds: she was prone to give gifts to the poor. She calmed quarrels and helped pregnant women. Beautiful in body, gentle and fair in expression, she offered aid to widows, and medicine to the sick: She died in the year 1394, the seventh of June. Amen'.[49]

and makes a striking contrast with that of Edward III:

'Here is the glory of the English and the flower of past kings –
the model for future ones – merciful king and peace-bringer to
the people – Edward III – he reigned for fifty years – the invin-
cible leopard – a powerful Maccabean king in war – successful in
life – he revived the kingdom through honesty – he ruled potent
in arms – may he now be a heavenly king in Heaven'.[50]

Edward's epitaph makes much of his kingly virtues and in particular his pro-
wess in war. By contrast, Richard's epitaph, dictated between 1395 and 1398,
emphasizes his right to the throne, his wisdom, his support of the Church and
destruction of heretics, and his abasement of those who violated the regalia.
These emphases reflect several key aspects of Richard's self-image as King: his
vanity about his personal appearance, his confidence in the rightness of his
judgements, and his dedication to the eradication of heresy. When he returned
from Ireland in 1395 to crush the Lollards, he was presented by Roger Dymok,
a prominent Dominican friar, with a treatise refuting Wycliffe's heresies.[51]

By far the most interesting aspect of the epitaph for our purpose, though, is
its stress on the royal prerogative. The events of the 'Wonderful' Parliament and
its sequences in 1387–88 had seen the nadir of Richard's power.[52] Although the
years after May 1389, when Richard declared that he had reached the age of
maturity and would cast off the control of others, have been described as fairly
peaceful, there is some support for the contention of the Kirkstall chronicler that
Richard was deliberately planning revenge for his humiliation, building up the
support of the two younger Appellants and working to isolate Gloucester, Arun-
del and Warwick.[53] The 'Wonderful' Parliament of 1386 had raised the menacing
precedent of Edward II's being judged in Parliament: to counteract this dan-
gerous spectre, Richard was simultaneously working towards Edward's canoni-
zation.[54] In 1390 he visited Gloucester Cathedral where Edward lay buried and
on 24 April 1395 sent a book of the Miracles of Edward II to Pope Urban VI.[55]
The 1391 petition for the King's full enjoyment of his rights specifically men-
tioned the restrictions placed on the liberty and freedom of the Crown in the
time of Edward II and declared that statutes or ordinances which restricted the
ruler's 'Regalie, Liberte et Dignite Roiale' should be annulled.[56] Royal prerogative
was the important issue: the control of patronage, administration and the law.

The tomb inscription may be contemporary with Richard's 1397–98 triumph:
if earlier, it seems to forecast his actions. By the end of August 1397, Richard
had successfully concluded his struggle with the City of London and had raised
as much as £30,000 from the City.[57] In July 1397 Gloucester, Arundel and War-
wick were arrested. Gloucester was dispatched to Calais where he died soon
after, probably murdered. Arundel and Warwick were appealed in the Parlia-
ment of September 1397.[58] Proceedings took place in a temporary wooden hall
built by order of the King at Westminster, for the Great Hall was under recon-
struction (see Wilson, p. 42).[59] The King, seated on a throne of unusual height
to emphasize the royal majesty, had, according to Adam of Usk's *Chronicon*,

surrounded the Parliament House with archers.[60] Arundel was beheaded and Warwick's sentence, after his miserable confession, commuted to exile. After the Shrewsbury Parliament, Hereford and Norfolk were exiled, on 16 September 1398, and in early 1399, on the death of John of Gaunt, Duke of Lancaster (3 February 1399), Richard sequestered the estate Hereford inherited from his father.[61] Richard saw kingship as above the political and legal restrictions imposed by the law. In the opening speech to Parliament on 17 September 1397, Edmund Stafford, Bishop of Exeter, took for his theme the words of Ezekiel: 'There shall be one King over all'.[62] It is not without significance that Richard's tomb effigy gazes up at a tester painted with images of a seated God the Father enthroned and the Coronation of the Virgin: the choice of images of coronation and the enthroned Deity—the one King over all—no less than the tomb's epitaph reveals Richard's obsession with the maintenance of royal prerogative, the issue which had been crucial in the 1387 declaration of the judges.[63]

Richard II's tomb manifests a distinctive iconography of kingship, one which seeks to buttress his position by deploying the full majesty of his royal and saintly predecessors. If, as seems likely, he was also responsible for commissioning the tomb of Edward III, the evidence for viewing Richard's own tomb as part of a deliberate attempt to augment and enhance the royal mausoleum round the Confessor's Shrine would be reinforced. The careful selection of regal qualities in Richard's epitaph, its emphasis on the royal prerogative, the King's wisdom and his support for the Church, add substance to the contention that Richard's tomb must be understood in the context of his distinctive image of his own kingship.

Richard's patronage of sculpture in Westminster Hall throws further light on his attempt to enhance his regal image and, like the tomb or the Wilton Diptych, can only really be understood against the political, personal and ideological background of Richard's reign. In 1393—during his ultimately successful struggle with London—the wardens of London Bridge, at Richard's express command, commissioned from the London mason and sculptor Thomas Wrek two freestone statues of the King and Queen to be placed above the stone gate of London Bridge. The statues were housed in niches and were accompanied by escutcheons of the royal couple and of St Edward the Confessor. All the stonework was expensively painted, while the surround was whitened with plaster to show off the statues and shields to better effect. In their hands the statues bore gilt-latten sceptres. The total cost to the bridge-wardens of this royal imagery was £37 0s. 10d.[64] However, Richard's deployment of figure-sculpture to reinforce the potency of his royal image is nowhere more evident than in his sculptural commissions for Westminster Hall (ills. 40, 41).

At the beginning of his reign, the great twelve-bay Romanesque Hall at Westminster looked much as it had under William II. A major problem in its usage must have been that the interior space was encumbered with rows of piers supporting the roofs, dividing it into a nave and aisles.[65] The documentation is slightly confusing, but it appears that Richard commissioned thirteen statues of

kings to stand in the Hall early in 1385.[66] The marbler Thomas Canon received a total of £30 6s. 8d. for 'thirteen stone images in the likeness of kings by the order of the King and Council including the stone of each image by task-work 46s. 8d. each'. Canon charged a further 66s. 8d. each for two larger statues of kings to be placed above the door of the Hall.[67] Subsequent entries in the same accounts, however, reveal a major change of plan. Canon received 9s. 5d. for making a container for no more than eight images to bring them from his workshop to the Palace. These eight images comprised the two large statues of kings and six of the thirteen other figures. Walter Walton produced 'six stone tabernacles for six images of kings aforesaid placed in the Great Hall at £4 13s. 4d. each' and received a further £18 for 'two stone tabernacles for two images of kings over the Great Hall costing £9 each'.[68] The painter Nicholas Tryer was subsequently paid £8 13s. 4d. for painting the six images in their niches and a further £5 for the two larger figures.[69]

The thirteen figures first commissioned can readily be identified: they doubtless represented Kings of England from Edward the Confessor through to Richard II (and the two large ones were presumably Richard and Edward the Confessor). Although the iconographic programme is comprehensible, the intended placing for these images is not so clear. One possible model is Philip the Fair's *Grand'Salle* in the Palais de la Cité in Paris.[70] The renown of the sequence of kings in the Parisian hall may have had some influence on Richard; however, the location of the statues of French monarchs on the piers and on the lateral walls seems a most unlikely specific model. If the figures were to be arranged inside the building as an image screen, Richard was, in effect, transferring the iconography of a cathedral *pulpitum* to a secular hall.[71] Cathedral *pulpita*—such as those at Salisbury or Wells Cathedrals—were adorned with images of kings, whose positioning was especially appropriate given that the genealogy of Christ was read from the choir-screen. Richard seems to have been appropriating this model to form a potent backdrop to his throne.[72] Another influence on Richard may have been a model such as the cycle of English monarchs up to and including Edward III recently intruded into the west front of Lincoln Cathedral.[73] From the documents, it is certain that the thirteen-image cycle at Westminster was at first intended for an interior location. But Richard seems rapidly to have changed his mind: seven of the thirteen figures were consigned to store, where they remained until 1400, whilst the remaining six were now placed in splendid niches[74] set into the south wall of the Hall, flanking the royal dais (*ills. 40, 41*). The statues must have been identified by painted inscriptions on their bases, just as the kings are on the early to mid fifteenth-century *pulpitum* of York Minster.[75] Without such inscriptions it is impossible to identify the Westminster figures (*ills. 43–48*). William Vertue claims five of them as Edward the Confessor, William the Conqueror, William Rufus, Henry I and Stephen, but there is no more evidence for his guess than for Ruben D'Moundt's conjecture that they were William Rufus, Henry I, Stephen, Henry II, Richard I and John.[76] If they were intended to represent Richard's most recent predecessors, they should be

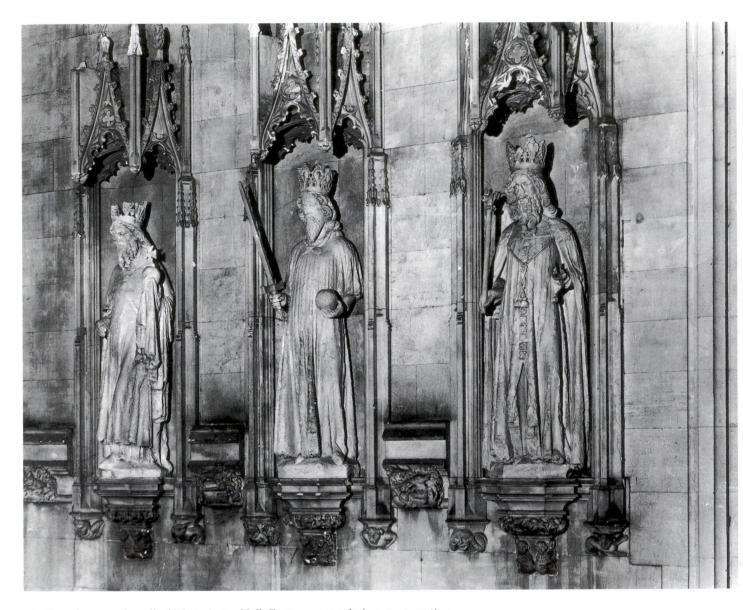

40. Kings from south wall of Westminster Hall. Eastern group, before conservation

identified as Richard I, John, Henry III, and Edward I, II and III. However, it is not evident that the six kings, once they had been removed from the historical cycle of thirteen figures, necessarily represented a simple chronological sequence. Their individual identities, in the absence of recognizable portraiture details, cannot be recovered. The very fact that six figures could simply be redeployed from the original programme tends to indicate that none of the images (with the probable exceptions of Edward III and Richard II, for which portraits might have been required) was ever more than a generic representation of a king. The figures were drawn by John Carter for engraving in his *Specimens of the Ancient Sculpture and Painting now Remaining in England* and he shows them in different positions from those which they occupy today: the switching of the

76

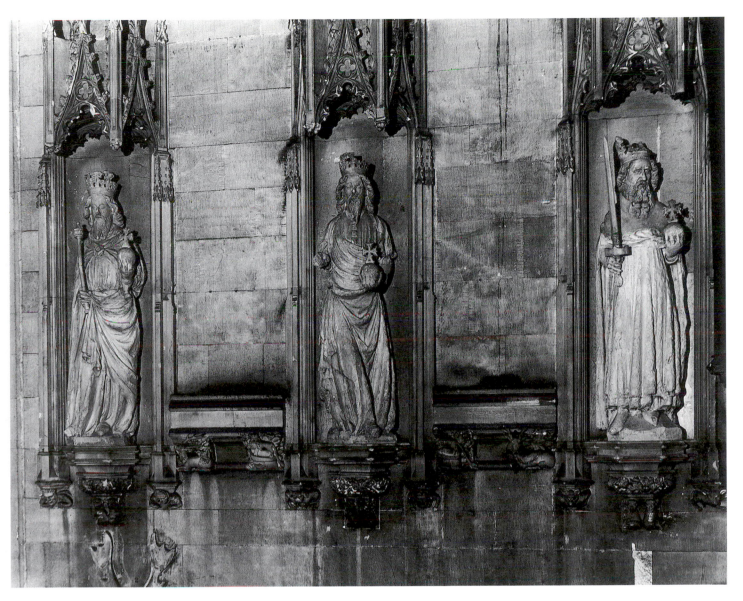

41. Kings from south wall of Westminster Hall. Western group, before conservation

figures doubtless took place when their attributes were (rather unfortunately) restored (*ill. 42*).[77] So their medieval sequence in the wall niches has anyway been disrupted.

The reason for Richard's change of mind may be that he had already determined on a grand reconstruction of the whole Hall rather than on a little cosmetic updating.[78] The major remodelling of the Hall's masonry was a prelude to the construction of Hugh Herland's splendid hammer-beam roof, with its hammer-beam angels carrying shields. These angels were also produced by task-work and amongst those responsible for them was William Canon, a sculptor who was presumably a close relative of Thomas Canon.[79] The entrance front of the Hall was entirely remodelled in a manner close to the west front of Exeter

77

Cathedral, on which work had recently resumed, and in 1400–01 the seven statues carved a decade and a half earlier were brought out of store and placed on it.[80] The façade and its sculpture (five of the large images apparently from the front are preserved inside Westminster Hall, in the eastern window embrasures) receive detailed attention from Christopher Wilson elsewhere in this volume (see pp. 49-54) and I want instead to consider the style of the six figures put in place inside the Hall in Richard's reign.

Thomas Canon must have been the head of a workshop: he is described as a marbler himself and, whether or not he was also a competent sculptor in freestone, he will have employed other sculptors to help perform such a large commission (just as a group of sculptors was later employed at York to carve the kings of the choir-screen).[81] The description of him as a marbler in the documents may imply that his customary business was in the provision of Purbeck marble for architectural furniture. More probably he was involved in the monumental brass trade (or possibly in both trades), for brasses were generally fixed in marble matrices. Such occupations suggest that he may have been a sculptor contractor, able to fulfil large-scale contracts and perhaps with sculptors and masons subcontracting from him. Whatever the case, the sculptures were certainly carved in his shop, whence they were later shipped to Westminster Hall. The style of the six kings, all of which have recently been conserved,

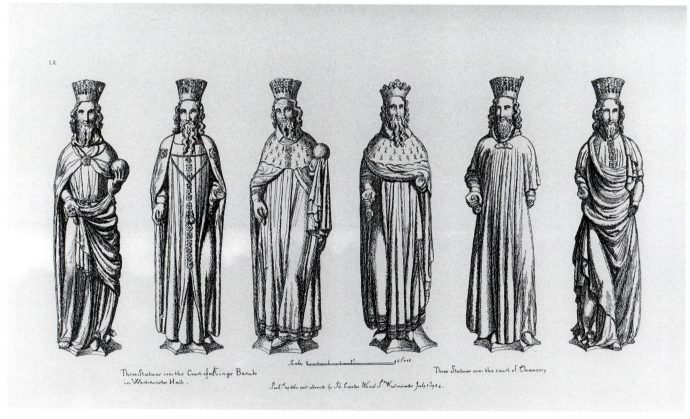

42. Westminster Kings, engraving by John Carter, late 18th century

demonstrates that more than one man was responsible for carving them (*ills. 43–48*). Five of the figures are stylistically very similar to one another: the considerable variations in the drapery treatment barely mask the underlying similarity of form (*ills. 43–48 and 49*). The heads in particular, with their wavy hair, beards and moustaches, give the impression of a single sculptor's work, though it is more likely that two sculptors working in very closely allied styles were responsible (*compare ills. 43, 44 and 48 with 46 and 47*).[82] These figures are not 'crude and clumsy' works, as Stone disparagingly termed them:[83] Stone, of course, was judging the figures before their conservation removed the thick layer of gesso which clogged all their surfaces. It is also the case that the nineteenth-century attributes have a distorting effect on the appearance of the images: Carter's engraving published in the late eighteenth century shows us clearly which elements have been subsequently restored.[84] Two of the figures have cross-legged stances, a transposition of the seated cross-legged pose seen at Exeter, Lincoln and elsewhere into a standing form. They reveal, in a rather extreme form, the two-dimensional torsion which had been characteristic of mid-century sculpture such as that at Exeter.[85] The peculiar dragging of the draperies across the torso seen in one of the cross-legged figures—a device which ultimately goes back to the Pucelle-influenced style of the 1320s and 1330s—can be closely paralleled in the near-contemporary figure of the Virgin from Winchester College.[86] Often the poses are swaying, sometimes slightly hip-shot, though they do not possess that attempt to interrelate the figures which is seen at Lincoln Cathedral. The surface detailing, which survives in good condition on some of the sculptures, reveals accomplished, if rather bland, handling. The remaining figure, however, is remarkably different from the other five. The difference is exhibited not so much in the general figure or drapery style—though it *is* different, in the manner in which the front of the gown is looped over the left arm, and the feet point downwards on their base—but rather in the way that the physiognomy is rendered.[87] Although the hair style, in thick, wavy tubular curls, is similar to that of the other kings and the curly moustache and bifurcated beard can be paralleled, the furrowed, frowning, brow and solemnity of the head give this figure a pensiveness which markedly differentiates the figure from its more routine and undifferentiated fellows. It is as if the sculptor was trying to assimilate his figure style to new French developments (perhaps influenced directly by Jean de Liège's magnificent tomb in the Abbey), where a preoccupation with realism is tempered by an expressive quality.[88] What is also clear, however, is that these figures are some distance, qualitatively speaking, from the innovations in figure-sculpture occurring in France in the hands of sculptors such as André Beauneveu or, later, Claus Sluter.

A peculiarity of this and four of the other figures is that the tall crowns have been carved from separate pieces of stone of a different material. The statues are carved from Reigate stone, whilst the crowns are of Totternhoe, a chalky stone which is easily carved (all the crowns have been extensively damaged). There can be no doubt that this feature is original: the tops of the heads are flat

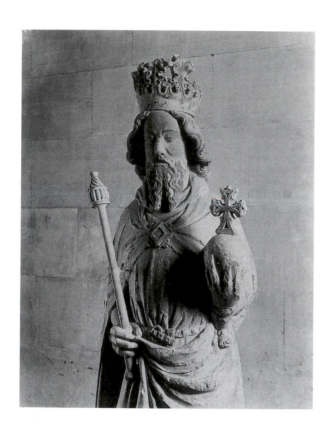

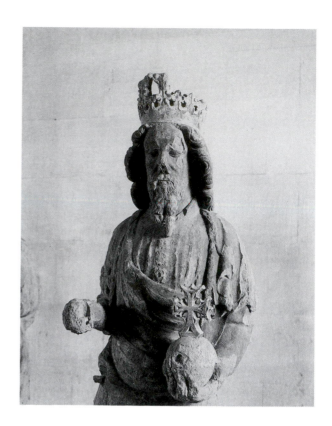

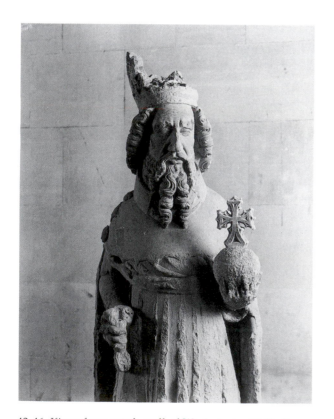

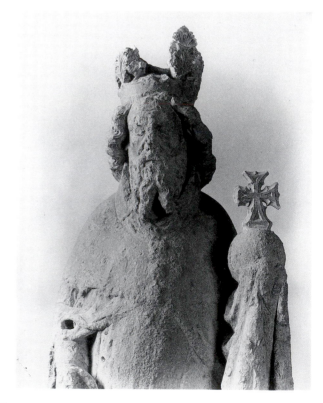

43-46. Kings from south wall of Westminster Hall after conservation

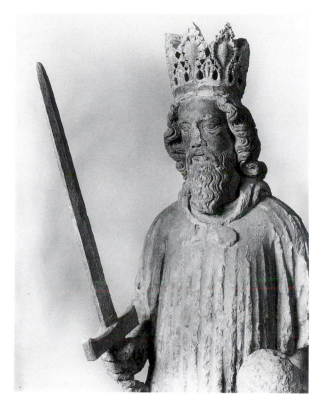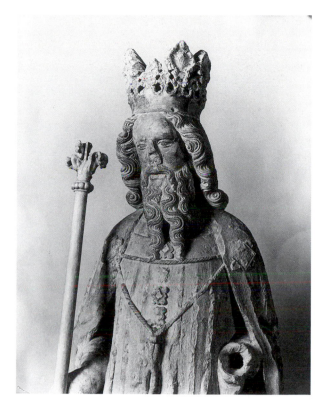

47–48. Kings from south wall of Westminster Hall after conservation

and designed to receive the crowns. There are a number of possible explanations for this feature. First, the carving of the crowns is a mechanical exercise which could safely be entrusted to an apprentice. Secondly, the height of the crowns and their fragility—a consequence of the drilled and undercut foliate forms— might suggest the wisdom of carving them separately. This would make the statues easier to handle and to place within the niches. Furthermore, the characteristics of the Totternhoe stone might also make it easier to sculpt than Reigate stone. Consideration of the sixth statue, which uniquely has the crown carved integrally with the rest of the figure, suggests one final possible reason: the other blocks of Reigate stone may have been shorter than was required.[89] This last image is in very poor condition and has a large number of pieced-in sections (*ill. 50*), many of which appear to be medieval repairs, perhaps made when the figure was damaged during handling. This damage would, of course, have been hidden under the polychromy applied by Nicholas Tryer, which would also have masked the stylistic divergence of one of the kings.

For Richard, of course, what was important was that the kings provided a suitable backdrop to the royal throne, a buttressing of his position by stressing his genealogy, and a remarkably theatrical deployment of the regal image in support of his position. Commissioned in 1385, they articulated Richard's emphasis on the majesty of kingship shortly before his opponents threatened him

81

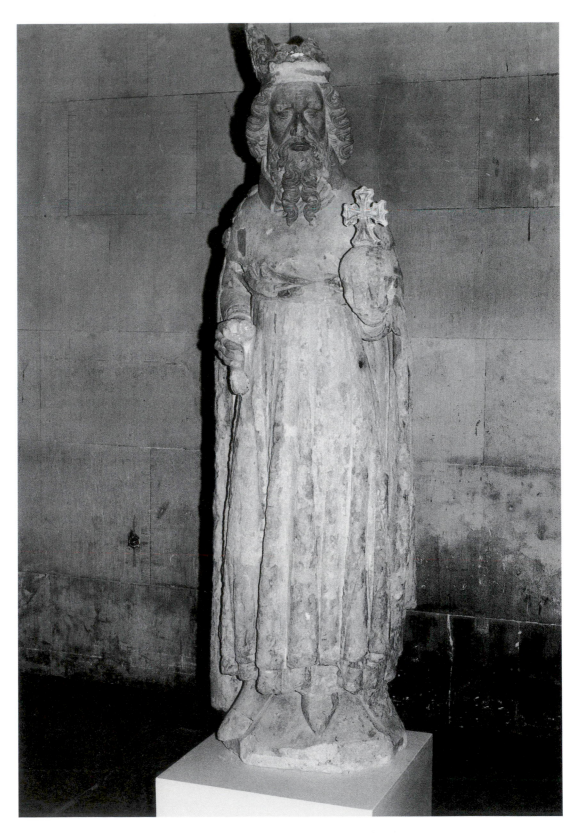

49. King from south wall of Westminster Hall, after conservation

with deposition.[90] Ten years later, when Richard commissioned the double tomb-monument for Westminster Abbey, and with work on Westminster Hall drawing towards completion, he must have been confident that he had finally crushed the opposition. Fundamentally, though, Richard's position rested on military power and on the support of his nobility, not on an iconography of kingship. It is one of the many ironies of Richard's reign that after his deposition and murder he was buried at King's Langley, not beside his wife in the splendid tomb at Westminster,[91] and that he was never to see the remaining seven kings taken out of store and installed on the imposing new entrance front of Westminster Hall. Instead, they formed part of a façade which welcomed a new dynasty to dispense justice and good government.

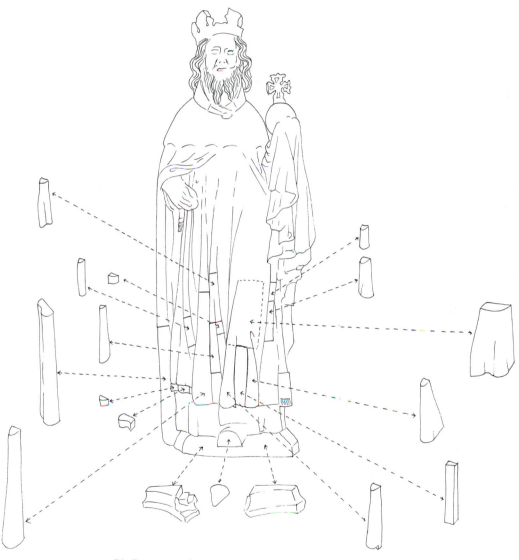

50. Drawing of King (*ill. 46*) showing 'pierced-in' parts

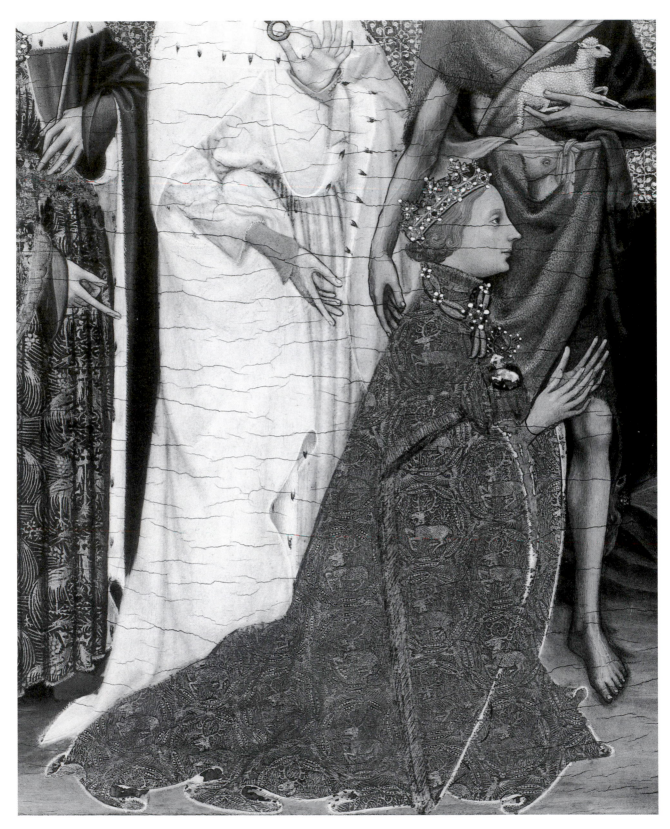

51. Richard II kneeling, detail from the Wilton Diptych

KAY STANILAND

Extravagance or Regal Necessity?
The Clothing of Richard II

EXTRAVAGANCE was a criticism that was levelled at Richard II in his lifetime and has continued to be associated with him ever since. But is it really merited? The writings of the historians Joan Evans and Gervase Mathew have been influential in helping to establish and disseminate the tradition that Richard II was extravagant in his dress.[1] However, they judged the King's sartorial preferences in isolation, disregarding the evidence relating to the dress of his contemporaries and near contemporaries, and failed to establish why they regarded his spending on dress as particularly excessive. When viewed within the broader framework of several centuries of royal clothing, Richard II emerges as fairly conservative, continuing or emulating rather than innovating. Evidence from the Great Wardrobe Accounts of Edward III provides a new standard for judgement: Richard does not compare well, lacking the imaginative and creative skills of his gregarious grandfather when still a young man. The high spending cited by historians was in fact begun by his grandfather and was continued, for a few years at least, by Henry IV; national and international trends also influenced much fashionable change.

Few historians have felt compelled to examine the King's personality, his suggested role as a fashion leader, his own concept of his image as King, or the precise nature of his high spending of the 1390s. Richard's expenditure has received no critical evaluation and instead has become embroidered through the misinterpretation of evidence and the use of misattributed documents. More importantly, there remains a crucial and substantial body of information within the accounting documents of the Great Wardrobe which has been almost completely ignored. This, surely, is the source which must be thoroughly explored and evaluated if we are to judge the accuracy of Richard's contemporaries and critics.

This paper argues that current perceptions of Richard II as a 'dilettante of genius' responsible for the 'foppish dress worn by himself and for the quickly changing fashions of his court' need to be modified, if not totally annihilated.[2] Strongly influenced by the adverse comments of chroniclers of his reign, historians have accepted extravagance as an intrinsic characteristic of Richard II. However, this mixture of authentic detail and biased propaganda found in the chronicles is dangerous and should be approached with caution.[3] Whilst it is

85

true that they have originated much censure of Richard II, their statements probably fairly reflected the views of the King's opponents and critics. These chroniclers are also well known to dress-historians for their pungent denunciations of novelties in contemporary dress, old-fashioned reactionaries whose views have been quoted frequently and have influenced later concepts of the fourteenth century. One example which neatly unites these two aspects is the allegation, by the Monk of Evesham, that Richard owned a garment valued at 30,000 marks (£20,000). This is a grossly inflated figure out of all proportion to the demonstrable costs for the King's clothing. Presumably the monk himself thought so, for he reported it as rumour only and not as fact. Yet it is frequently presented as fact, disassociated from its original context, an interesting one in itself.[4]

The elegant royal image of the richly dressed and youthful King on the Wilton Diptych (*col. pl. 2*), has not unreasonably, appeared to give credence to such a claim. So, too, did a Wardrobe Account dating to the King's sixteenth and seventeenth regnal years, 1393–94, which was eagerly but uncritically published because it contained references to the King's badge of the White Hart. So persuasive was the accompanying discussion of its contents that few have realized that the listed clothing and jewels were not provided for the King at all, but rather for his young and preferred heir, Roger Mortimer, fourth Earl of March (1374–98).[5] The new attribution increases rather than decreases the value of the document, as it provides a rare insight into the clothing of one of Richard's young and very fashionably dressed courtiers. It also means that all references associating its contents with Richard II must now be discounted.[6]

Two further traditions need to be discussed briefly here to show the way in which Richard's persona has continued to suffer from misattributed accretions. One is the belief that he invented the handkerchief; the other that, as a leading gourmet of the day, he introduced radical changes into court dishes. It is true that the first reference to what seem to be handkerchiefs appears in his Wardrobe Accounts of 1385–86, but it is untrue that they were invented by the King.[7] A healthy corpus of information about this accessory reveals that handkerchiefs were in use from the early fourteenth century in Italy and France; they were well attested in England in the fifteenth century, but whether used before is not certain.[8] What intrigued Maud Clarke was the fact that the Great Wardrobe clerks seemed to have no word for such a refined possession: *parvis peciis factis ad liberandum domino regi ad portandum in manu suo pro naso suo tergendo et mundando* is how they described the fate of three pairs of very fine linen sheets purchased for £7 by the King's tailor.[9] Such a need is never referred to again in surviving documents of the reign; it may possibly relate to the King's grief at his mother's death. It seems unlikely that we shall ever know.

An early accumulation of recipes in English which are associated in their title with Richard's master cook are extremely well known following their publication in the late eighteenth century, and this has given rise to his reputation as a gourmet.[10] We now know that this manuscript is predated by a not inconsider-

able number of other manuscripts in English and, more importantly, in Latin or French. The editors of these English texts have commented that 'the menu of the English upper classes seems to have been much the same from the twelfth century well into the sixteenth'. They detect some differences between 'four-teenth-century dishes and later recipes retaining the same names', but not enough to suggest changes influenced by anyone who can be named, like Richard II for example.[11]

That Richard II on occasion wore ornate and costly garments cannot be denied. Examination of the Great Wardrobe Accounts of the reign reveals quantities of cloths of gold, velvets and other silks, fine furs, gold and silver threads or pearls for embroideries, and a variety of accessories and trimmings which would seem to confirm extravagance as one of the King's idiosyncrasies. But entries recording just such courtly luxuries are encountered in this group of accounts at almost any time from 1300 onwards, since it was customary for medieval and later monarchs and their families to wear clothing of the highest quality possible. In this way they emphasized and maintained their position at the apex of a well-defined hierarchical society. To flout such a powerful tradition required courage and a strong personality; very few English kings are known to have abstained from the practice.

Textile possessions not only acted as indicators of wealth and status, but they also formed valuable portable assets, like jewellery and plate, which could be employed for diplomatic purposes or as indicators of favour, esteem or affection. Inventories of the fourteenth century reveal something of the way in which commodities like bed-hangings, tapestries, chapel vestments or clothing moved from owner to owner in a manner not entirely dissimilar to the gift-giving customs of tribal or peasant societies or, nearer home, to the Viking practice of possessing goods of a suitably high quality which could be presented to recipients of a similar status, or to those one especially wished to honour.[12]

Succeeding to the English throne in 1377, Richard inherited from his grandfather a court-life rich in colourful ceremony, albeit one which had somewhat passed its peak. Furthermore it was a court where, as Earl of Chester and then Prince of Wales, he had already witnessed or participated in a number of ceremonies. In the last year of his own life, the elderly and frail Edward III had tried to ensure that his grandson was firmly established as his successor. Presumably in preparation for Richard's presentation to Parliament, shortly before the death of his father the Black Prince in June 1376, a quantity of rich black cloths of gold, silk, wool and pured minever were released to his tailor to be made into clothes for the young Prince at his grandfather's expense. Then for his father's funeral he was provided with more garments of black cloth of gold and pured minever. It seems likely that Richard remained in this sombre garb into the autumn, certainly whilst he travelled with his young uncle Thomas of Woodstock to make extensive offerings of cloths of gold in memory of his father at various churches in London and Kent. In November 1376 he was created Prince of Wales, and for the festivities of Christmas and Epiphany Richard was

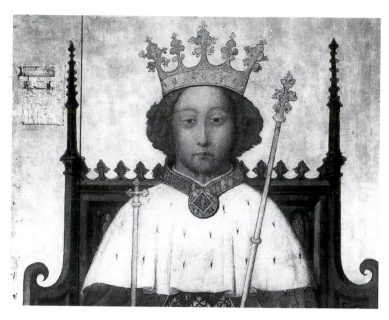

52. Detail of of Richard II Enthroned. London, Westminster Abbey

provided with a number of silk garments, again gifts from the king. Edward III always presented an impressive image at these festivities, dressed on this occasion in cloth of gold lined with pured minever and with a *mantlett.* of 114 ermines. Probably amongst Richard's rich silk Christmas garments may be found those he wore to open the January Parliament in place of his grandfather. The latter's last ceremonial act was Richard's induction as a Knight of the Order of the Garter at a lavish ceremony at Windsor in April, in the company of Thomas of Woodstock, Ralph Stafford, and nine others.[13]

Thus was Richard prepared for his imminent kingship. The garments provided for him in the first year of his reign closely reflect customs already prevailing at court. We may assume that the selection of these garments was probably made by his mother and her close circle of advisers like Simon Burley or Guichard d'Angle, drawing upon the expertise of the officers of the Great Wardrobe or others knowledgeable in court protocol. The initial concept of Richard's regal image was thus based on older precepts. What cannot be determined is the contribution of preferences or ideas from the new King himself.

'Robes' (sets of matching garments) of various cloths of gold, were seen as appropriate for the important religious feasts, court festivities, and for Richard's appearances at the first Parliament of his reign. The two 'robes' of red or blue cloths of gold made for the various sessions of Parliament at Westminster in September 1377 comprised ten garments in all, and required 1,594 skins of pured minever as linings; each 'robe' included an ermine-edged cloak, and a mantlett. of 36 ermine skins. Richard is wearing just such a *mantlett.* in the portrait of himself enthroned in Westminster Abbey (*ill. 52*) and these status-giving accessories are also worn by the Saints Edmund and Edward in the Wilton Diptych (*ill. 53*). Distinctive regal dress, together with peers' robes, seems to have begun to evolve in France and England earlier in the fourteenth century, and there are hints of such official dress in the garments created for Richard's

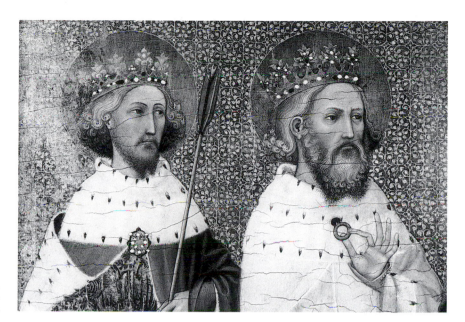

53. Saints Edmund and Edward the Confessor, from the Wilton Diptych

early formal appearances. In the light of later developments one might regard the long cloak of fine cloth (*scarletta*), lined with 702 pured minever skins—nearly twice the size of cloaks ordinarily made for Richard at this time—as another garment which, by virtue of its size, emphasized his regal status; it was trimmed with only two ermine skins, probably at the neck edge. Also provided for this session of Parliament was a *capp.* of fine cloth trimmed with sixteen skins of pured minever and five ermines, and embellished with a gold button with a silk tassel.[14] It is tempting to envisage this as another piece of official dress, an early cap of estate of the type which has now become integrated with a crown frame, as in the present State Crown. They were a fashionable and decorative alternative to the ubiquitous hood at this time, but the form and usage of the *capp.*, like that of so many medieval garments, have not yet been positively identified.

In the course of his first regnal year Richard's tailor provided him with some 87 garments, plus matching hoods, hose and other small accessories, and underwear. Edward III, early in his reign, had likewise been provided annually with between 60 and 100 garments, to which must be added the considerable quantities of jousting tunics and horsecovers created by his armourers, whilst his young wife Philippa of Hainault seems to have been furnished with between 70 and 75 garments annually. Richard's counterpart Charles VI of France was provided with about 70 garments in the eighteen months following 1 January 1386, none of which were for jousts, whilst his young son Louis of France, Duc de Touraine, (later Duc d'Orléans), had some 41 garments in the same period, mostly, it would appear, miniature versions of his father's garments; in a six month period after 15 December 1386, the Queen of France was provided by her tailor with 49 garments, plus hoods and hose, and linen underwear. Thus it can be seen that the size of Richard's wardrobe at this time was similar to that of his predecessor and of his royal or noble contemporaries.[15]

In the second year of the reign, 1378–79, Walter Rauf provided his master with approximately 79 garments, in a sequence similar to that in the previous year: i.e. for Parliament, the Feasts of All Saints, Christmas and Epiphany, Easter, St George, and Pentecost, plus garments for winter or summer wear, for riding or hunting, or for no specified purpose. Once again festal 'robes' were predominantly of rich cloths of gold, whilst fine cloths, often of the quality termed *scarletta*, were employed for less august occasions. Rarely at this time are there any of the embroidered garments frequently listed in his grandfather's reign. For his first Christmas as King, however, Richard wore a tunic and hood of *scarletta* embroidered with ships fashioned in pearls and gold thread. Perhaps, too, the fine cloth hood embroidered with *bezants* (coin-like ornaments) and the letter 'J' with crowns of pearls, made at the same time, was something he especially requested, to honour his mother, Joan of Kent.

Were the indoor jousts held at Windsor as part of an impressive and varied set of entertainments during the festivities of Christmas and Epiphany actually Richard's choice for celebrating his eleventh birthday? Possibly they were, before any difficulties of physical strength altered his attitude to jousting. For a joust on the eve of Epiphany he had a tunic, leg coverings and horsecover of cloth of gold worked with gold suns. For another on the day after Epiphany he was equipped with tunic and horsecovers of fine red silk stamped with gold suns, and a helmet with a crest of twenty ostrich plumes.[16] It is notable that the exercise was apparently not repeated the following Christmas, although it is certain that Richard was fully trained in horsemanship, capable of holding his own for purposes of war at least. Certainly the accounts contain few references to jousting gear, supporting the belief that Richard failed to inherit his father's and grandfather's enthusiasm for the sport.

At this point there is a gap in the documents which supply the detailed information about clothing and textile provisions. The next group cover the years 1385–88 and they reveal a number of differences, some of which must be due to changes in fashions and in court customs, but others may be assumed to reflect the distinctive preferences of the now eighteen- to twenty-year-old King. A move from the customary cloth of gold for festal robes can be discerned, for example: of the eleven garments supplied to the King for Christmas 1385 only four were cloth of gold. Two more were of rich silks, one was of black satin embroidered with gold letters, whilst four were of fine cloth; none were in the form of 'robes'. In the course of 1385–86 Walter Rauf made 73 garments for the King, and once more far fewer 'robes' were provided for feasts or other solemn occasions. It is indeed valuable to be able to look across to France at this time and discover that Charles VI still maintained quite a large proportion of 'robes'; otherwise the allocations of cloth, furs and use of embroidery are comparable.[17]

A number of especially impressive garments were created for Richard's use in these years. Although not relating directly to the Wilton Diptych they are important for the picture they give of the adult King now, presumably, fully determining the form of his clothes, responsible for their expense or elaboration,

and involved in creating his own regal image. A few instances only must suffice to demonstrate the form this took.

The period covered was heralded by customary court activities of the kind previously outlined. Then in the late spring the King set off for Scotland to counteract an invasion instigated by the French, making York his base. It was a period marred by death and sadness which would linger on his return South. He took with him some ornate outfits including several horsecovers and garments embroidered with his quartered arms or his badges, one of which was of red satin worked with gold suns and clouds of silver with blue silk. How and when these outfits were worn is not known, but certainly there would have been processions, entries and other formal occasions when such imposing gear, underlining the King's status and distinguishing his person in large public gatherings, would give visual substance to his regal and political powers.[18]

The deaths which somewhat overshadowed this Scottish campaign were those of the King's friend Ralph Stafford and of his mother. Stafford was killed in a brawl with the King's half-brother John Holland as the English forces were gathering in the North, and Richard was compelled to send this half-brother into exile for the murder, despite his mother's pleadings. She died in August, during the course of the campaign, broken-hearted, it was said, by the preceding events. The adoption of black for mourning and the lavish disbursement of mourning liveries throughout the royal household were already familiar to Richard and it was a custom which he manipulated to great effect in the succeeding months. An account for cloths, furs and trimmings delivered from the Great Wardrobe to his tailor reveals that the King adopted black for a large part of this regnal year and it may not be unreasonable to infer that this intensely sober visual demonstration of his double loss, including a totally black Lent in 1386, expressed deep personal emotion. This is the same account which includes the reference to what are assumed to have been handkerchiefs, as we have seen. It also includes black silk bed-hangings and black worsted wall-hangings for Richard's use after his mother's death. The King also ordered an impressive anniversary ceremony at King's Langley for Ralph Stafford in May 1386 for which his painter Gilbert Prince stamped many heraldic banners bearing the devices of the King, his family and a sizeable proportion of his close adherents.[19] This was a particularly forceful way of demonstrating political allegiances and unity.

Although Christmas 1385 found Richard wearing the coloured cloths of gold and rich silks traditional for such occasions, entries for a black satin *gouna* and hood embroidered with gold letters, and especially for other garments of black or white cloth or silk suggest a sombre appearance on less public occasions. For the succeeding Feast of the Purification of the Virgin (2 February 1386) he ordered a long *gouna* of red velvet embroidered with harts in pearls and crowns in gold thread, with a pured minever lining and ermine edgings. This is the earliest known public use of harts by Richard as King, but in fact harts appear as motifs in the last year of the previous reign and it is possible that they may have been a tribute to Richard as Prince of Wales.[20] Heads of harts were worked

in gold on a blue silk bed-cover and back panel (*dorsor.*) for Edward III, whilst harts, violets and wreaths appeared on a red velvet saddle given to his eldest daughter Isabella, Countess of Bedford. So too do gold suns, with silver letters, on a blue saddle-cloth also given to her by her father. More telling, perhaps, was the inclusion of *cervis iacent super terragium* amongst motifs adorning another bed-cover and wall-hangings of red worsted made to match a set of silk bed-hangings belonging to Edward III at the Palace of Westminster.[21] It is possible that this equipment relates to Richard's appearance before Parliament at Westminster late in January 1377 just months before his own accession. The provision of such ornate furnishings for major political occasions, where formal ceremonies would be enacted in suitably impressive surroundings, is widely attested. Likewise Edward III is well known for his employment of a variety of symbols throughout his reign, the Garter motif being the most famous and lasting example.

Whatever his private inclinations were with regard to jousting, Richard is known to have made a few public appearances at jousts at Smithfield, apparently wearing gold suns on each occasion. The Great Wardrobe Accounts reveal that for such a joust in March 1386 the King appeared equipped in a most impressive manner. His embroiderer John de Strawesburgh worked suns in gold and silks on a short red satin *gouna*, and also on fine wool hose. For the King's war-horse coverings of fine red silk stamped with gold suns and silver and blue clouds, within a border of crowns, were prepared by the King's painter Gilbert Prince, who also provided a crown—presumably for the King's helmet—and a crest of a large gold sun and silver cloud. A saddle, in the Bohemian style, was provided by the King's armourer William Snell, together with a shield and other horse harness. It is possible that the short *gouna* was used for accompanying ceremonials, for elsewhere in the accounts plates covered with red velvet were acquired by the armourer, though not specifically for this occasion; to complete whatever outfit was worn, Gilbert Prince painted red a breast-plate, arm defences and gauntlet, and lance to be used with the sun-crested helmet.[22] Presented with this impressive red ensemble, the image of Gawain's Green Knight inevitably springs to the modern mind; so, too, does that later Sun King, Louis XIV. It was certainly a very powerful image. Was its effect to strike more envy than admiration in the hearts of the onlookers or the King's critics?

Richard's ostentatiously rich dressing for his public or formal court appearances was by no means a new departure and parallels can be found amongst his English and Continental peers. The need to maintain an appropriately high standard of dressing in a climate of rapidly increasing luxury was almost certainly one motivating factor. So, too, may have been the reassurance and sense of authority which such possessions could provide in the hostile environment of the English court. The costs necessarily involved in maintaining such a standard can be demonstrated from the accounts. The red velvet *gouna* for the 1386 Feast of the Purification of the Virgin discussed above absorbed the attentions, over a five to six week period, of a team of 47 workpeople, resulting in a

labour bill for the embroidery alone of £21 12s. 10½d.[23] The cost of the velvet, pearls and gold thread would certainly have doubled or trebled the final total. But still it would not have reached the rumoured figure of 30,000 marks reported by the Monk of Evesham. Much more expensive, it would seem, was an embroidered horsecover presented by Richard to the exiled King Leo of Armenia which cost £41 6s. 8d. for the labour of the embroidery.[24] The other recorded textile gifts to this visitor are relatively modest, but it is perhaps not surprising that rumours of Richard's generosity spread and fuelled his opponent's hostility. But, again, similar high costs could be cited from the reign of Edward III.

These first dozen or so years are viewed as moderate in Great Wardrobe expenditure when they are compared with the greatly increased annual totals of the 1390s; a statistical table published recently by Given-Wilson illustrates this trend particularly clearly. This increased spending can be shown to be the result of extensive acquisitions of quantities of cloths, silks and furs for the use of the King: 'the conspicuous consumption of luxury goods which Richard was accused of by both Thomas Haxey and the chroniclers'.[25] The lack of detailed records for this period poses considerable problems to historians seeking to explain this phenomenon of escalating expenditure.

It seems that mere whim or compulsive extravagance are unsatisfactory and inconclusive inferences to draw from these totals. They reveal also the intriguing fact that similarly high levels of expenditure were maintained by Henry IV in the first four years of his reign: 'extravagance which he evidently thought befitting to his new station', as Given-Wilson describes it. Thus we return to the original charges of prodigal spending, levelled in a rather disapproving fashion both by contemporaries and by modern commentators. Are they merited? Did kings like Edward III, Richard II and Henry IV share motivations quite beyond the capricious and, seemingly, imprudent? What boundaries may we identify between acceptable and unacceptable spending? What standards should be applied when judging issues of this nature? Did the expanding production and trade in such luxury goods as furs or textiles like cloths of gold or velvets, the latter now increasingly enriched with gold, or the rapidly developing tapestry industry, affect levels of expenditure in the late fourteenth or early fifteenth centuries?

When we read of the valuable gifts of tapestries made by the Duke of Burgundy to the Dukes of Lancaster and York in the course of the peace negotiations in 1392–93, and of the chamber of cloth of gold[26] presented to him by Richard in 1396, we are surely taken into the arena of political manoeuvring and manipulation. The raised spending of Richard II in the 1390s, as some historians have more recently noted, is probably much more to be explained by peace negotiations between France and England and Richard's subsequent marriage to Isabelle of France. It would therefore be seen in his eyes at least as a necessary tool of diplomacy, at a level of expense possibly initiated across the English Channel, rather than personal indulgence in passing novelties. The surviving documentation can, I believe, yield a great deal more information on this issue.

54. Badge showing a hart, lodged.
Champlevé enamel on silver, set into a bronze surround, *c.* 1390–99.
Troyes, Musée de la Ville

V

MARIAN CAMPBELL

'White Harts and Coronets': The Jewellery and Plate of Richard II

I
T HAS BECOME A TRUISM to state that Richard II's extravagance was profligate. T. F. Tout commented tartly on his 'inordinate love of luxury, especially in dress and handsome gifts, freely indulged'.[1] Gervase Mathew, basing himself on the evidence of an inventory of 1399, considered that Richard took particular delight in minute and costly objects, and said that 'it is likely that Richard's personal taste for jewels set a fashion at his court'.[2] These views have more recently been challenged by various authors;[3] yet there can be few tasks more difficult than to gauge Richard's preferences and tastes in gold-smiths' work, when the works themselves are largely destroyed, and his re-sponses to them are unknown.

Plate and jewellery were used in the Middle Ages for a variety of rather different purposes. Gold or silver made into jewellery might adorn either sex, while plate made of gold or silver could be used either in church or at table. Both plate and jewellery could be hoarded in case of need, being readily realiz-able sources of cash. Finally, but importantly, they also served to express the wealth and status of an individual. Magnificence was expected of a late medie-val monarch, and the public display of sumptuous plate and jewellery was a proclamation of power.

In the medieval royal courts of Europe there was hardly an event that was not made the occasion for the presentation of gifts, which normally included gold, silver and gems. Betrothals, marriages, births, banquets, the welcoming of emissaries and ambassadors, ceremonial entry into a town by a prince or prin-cess—all such events served as the occasion for giving or exchanging presents. The exchange of gifts at Christmas or the New Year was particularly important, for it was then that the monarch gave presents to his relatives, courtiers and leading officials.[4]

There is no doubt that Richard's contemporaries were struck by the lavish-ness of his court, as vividly described by the chronicler Froissart: 'There was never before any King of England that spent so much in his house as he did by a hundred thousand florins every year; for I was in his court more than a quarter of a year together and…when I departed from him, the King sent me by a knight of his, Sir John Golafre, a goblet of silver gilt weighing two marks of silver, and within it a hundred nobles…wherefore I am bound to pray to God for his soul'.[5]

In 1399 the Commons criticized Richard for his 'ostentation, pomp and vain-glory'.[6] But how far this can be equated with either a lavish or a discriminating patronage of goldsmiths' work is a question that I shall here attempt to explore.

Remarkably enough, there are more surviving pieces of metalwork which can be linked with Richard than with any other medieval English monarch. Yet these pieces number fewer than a dozen, and most are not in the luxury class of goldsmiths' work;[7] the Wilton Diptych adds valuable if somewhat enigmatic evidence to this pool. It is to the documents that we must principally turn, in order to find the fuller story of the nature and extent of Richard's collections of jewellery and plate. Inevitably this is an impressionistic exercise, posing more questions than it provides answers, and what follows is very much a report of work in progress. Questions that might reasonably be asked about Richard's plate and jewels include: what survives of his collections, and who were the makers? How did he choose what to commission or buy? Did he have a court goldsmith? How do his collections compare with those of his predecessor, Edward III, or of his successor, Henry IV?[8] And how do they rate in a European context, bearing in mind that he had contemporaries formidable in wealth and taste? These included the Emperor Charles IV (d. 1378), King of Bohemia and father of his first wife, Anne, and his cousins Charles V of France (d. 1380), Philip the Bold, Duke of Burgundy (d. 1404), and Charles VI of France (d. 1422), father of his second wife, Isabelle.[9]

However, most of these basic questions are difficult to answer coherently, largely because of the nature of the available evidence. The few surviving metal objects associated with Richard are mostly attributable to his reign only by virtue of their decoration with his personal device of the White Hart. The main extant sources of information—documents in the Public Record Office—though co-pious in number, give an incomplete and often confusing picture. A major difficulty is to disentangle what Richard inherited, from what he later acquired, whether by purchase or by special commission or as gifts. The information that can be derived from documents ranges from what was bought and from which goldsmith or merchant, to its weight, its cost and a more or less detailed de-scription of it. More rarely there are indications of its fate, with the name either of the person for whom it was intended as a gift, or of the goldsmith who had acquired it in order to melt it down and refashion it. Differing sorts of informa-tion appears in the three principal categories of Public Record Office material: Issue Rolls, Wardrobe Books and inventories of differing sorts. From the Issue Rolls—of which over a hundred survive for Richard's reign—come details of special purchases and gifts, often jewellery and sometimes expensive.[10] Ward-robe Books, of which there are about a dozen relevant survivors (whole or fragmentary) from between *c.* 1380 and 1396, give considerable detail about plate and costs, but exclude jewellery.[11] The miscellaneous lists and inventories include both jewellery and plate, sometimes described in minute detail, as for example, the gems in the gold *'grande couronne'*, pawned for £10,000 in 1384.[12] But the limitations of this evidence are several, for without a commission to the

goldsmith, or bill from him, or the words *'de novo factus'* (themselves not unambiguous), it is impossible to be sure of the age or provenance of pieces. Inventories of both Richard II and Henry IV include objects that undoubtedly had been made for Edward III since they are variously described as being decorated with his arms, one of his badges or his initial, or are called by his name.[13]

Richard's inheritance of jewellery and plate in 1377 at the age of ten can be assessed approximately. Of what came to him from his father, the Black Prince, we know only that he was bequeathed *'vesselle convenable pur son estat'*[14] and furnishings such as elaborately embroidered beds decorated with his father's ostrich feather badge.[15] A long inventory dated May 1378, just eleven months into the new reign, shows us in detail a part of Richard's inheritance.[16] Over 700 items are described, a mixture of secular and ecclesiastical plate, of gold and of silver, including some composite pieces, of beryl or mazer with precious mounts, sometimes bejewelled, and also numerous drinking vessels; but there is no mention of crowns or of any jewellery. Secular pieces include a silver cup with St Paul and the King of England, 'called Edward'—obviously once the property of his grandfather—and a large gilt-mounted mazer, also called Edward (valued at £33 6s. 8d.).[17] A covered cup of gold has an enamelled white deer lying on a red ground inside it (valued at £18).[18] Crowned 'E's and royal arms mark many pieces, one of a pair of silver pots sports on its cover a white enamelled deer under a tree, and a silver pot *'pur la cusyne'* (valued at £10 9s.) has a deer on the cover.[19] If the deer are indeed badges, they must at this date be for Richard's mother Joan, whose badge was a hind—although we cannot by any means be sure that a deer or hart is always intended as a device rather than simply being ornamental. Other secular objects include a silver dish inscribed *'al is for the best'*, pairs of substantial silver basins, such as those showing King David, and a girl and a wodewose (and weighing over 16lb. and 10lb. respectively),[20] a gilt silver-mounted drinking horn,[21] two jasper, crystal and silver-gilt chessboards,[22] and a silver toaster and gridiron for the kitchen.[23]

Prominent amid the abundant church plate are gold chalices—five in all—the most outstanding of which is gem-encrusted and forms part of a set of gold chapel plate valued at £393 5s. 4d., the most valuable set listed.[24] Images include the Virgin Mary, Saints Gabriel and Michael,[25] a tabernacle of the Trinity and the Virgin Mary, and several *'tables'* or altarpieces, some not of metal but painted or embroidered.[26]

In the year of Edward III's death (1377), an incomplete inventory records crowns and sceptres—part of the regalia—in the treasury of Westminster Abbey, as well as a gold reliquary cross and 31 girdles, and in the treasury at the Tower of London it lists swords, including Curtana, a lion-shaped salt and a golden rose which had been given to Edward I by the Pope.[27] The most notable items in the regalia which Richard inherited were four crowns, of which by far the most valuable was the *'grande couronne'*.[28] It is known, however, that Edward II and Henry IV were crowned not with this but with the so-called St Edward's Crown,[29] and Richard too may have used it in 1377. The crown depicted in the

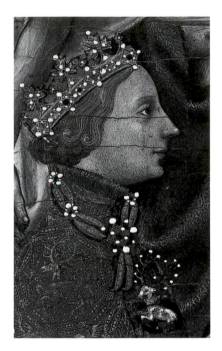

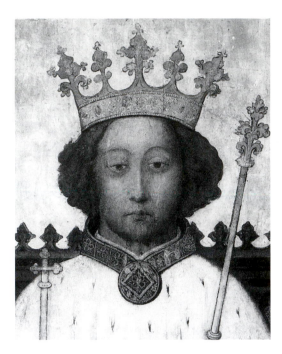

55. Richard II's crown, collar
and badge, from the Wilton Diptych

56. Crown of Richard II Enthroned.
London, Westminster Abbey

Westminster Abbey portrait of him, of about 1394,[30] is markedly large and heavy (*ill. 56*), and is certainly not the St Edward's Crown, while it is also very different from the crown shown on Richard in the Wilton Diptych (*ill. 55*).[31] The 'great crown' may have served chiefly as a source of ready cash, for Richard from time to time pawned it—a practice that he shared with his English predecessors as well as with his wealthier French contemporaries, Charles V and Charles VI.[32] Another inherited crown, also subsequently used as security, was the gold 'crown of Spain', set with a galaxy of gems which were valued at £1,719 13s. 4d., while the metal was worth only £62.[33] The most valuable stone in it seems to have been a '*gross balays*', a ruby of 180 carats, worth £600, comparable in size with the Black Prince's ruby (now reset into the front of the Imperial State Crown).[34] A different type of crown owned by Richard and probably inherited, was one for the '*bacynet du Roy*', which was set with diamonds, sapphires, balas rubies and pearls, and valued in 1384 at £254 22d.[35] Worn over the helm, the crown may have resembled that held by Charles VI's herald, shown standing to the left of the Virgin Mary in a lost reliquary depicted in *ill. 57*.[36]

References to the jewellery inherited by Richard are scattered. Minor pieces, rings and '*nouches*' of low value are listed in 1378 together with loose stones—pearls, emeralds and rubies—and items of plate clearly once Edward's.[37] The following year, 1379, a large loan, of £5,000, was raised on the strength of both plate and jewellery, which included 23 bejewelled gold '*nouches*' or brooches, five of which were decorated with white harts, four with griffins, four with

eagles, and five with white dogs.[38] The brooches with white harts, and perhaps the rest too, are likely to have belonged to Richard's mother Joan. The reference to motifs coloured white suggests that they were enamelled in *ronde bosse*, a technique found in London by the 1370s, and of course depicted on the White Hart badges on the Wilton Diptych.[39] The questions of what use Richard made of his inheritance, and how he supplemented it, are harder to answer.

The everyday needs of life at court, as expressed in plate, were for meals: large numbers of spoons and vessels for eating, drinking and serving were required. In inventories and the surviving Wardrobe Books of the reign we find listed dozens of silver dishes, saucers, salts, cups and spoons, many of them unadorned, the commonest form of decoration being simply the royal arms of England and France quartered, or a leopard or leopard's head. Many of the spoons were embellished with a crowned 'R'.[40] Although Richard's Wardrobe Books and inventories show that there was a steady recycling of broken silver, which was made up into new pieces, the overwhelming impression is nonetheless one of conservatism, with the recurrence of certain objects, sometimes clearly associable with Edward III and his family.

Most of the plain pieces mentioned in a Wardrobe Book of 1369, late in Edward's reign, are of ungilt silver, and many probably continued in use for a while in Richard's household.[41] But by 1390–91 most silver items, however simple, are gilt, and a significant proportion is described as newly made, with a total of six London goldsmiths named as suppliers.[42] Only a spoon and a cup are of pure gold, and almost everything appears to be for practical use—for instance, there is a total of 88 spoons and 349 dishes alone, the majority bearing merely arms or being entirely unadorned. Richard's need for, and use of chapel plate is much more difficult to gauge, since there is little evidence until after the end of his reign. In 1401 about two dozen pieces of his ecclesiastical plate are

57. 18th-century painting showing a reliquary image of the Virgin, with Charles VI and his wife with their herald, in *ronde bosse* enamel on gold of *c*. 1400. Munich, Bayerisches Nationalmuseum

recorded as having been seized at Pembroke Castle in Wales.[43] Most notable among these are a cup of beryl with a silver and enamel foot 'pro sacramento' and a large silver-gilt image of the Trinity weighing nearly 13½lbs.,[44] both of which may have been inherited from Edward.

Only an impressionistic picture is possible of Richard's more particular plate and jewellery purchases, made for his own use and for such occasions as his Coronation, his weddings, and for presents to visiting dignitaries and emissaries, as well as for Christmas and New Year presents to his friends and supporters. Nor should one ignore gifts to him from others, which seem sometimes to have reflected his tastes. For his Coronation in 1377, Richard of course used the regalia, but additional outlay was needed. This appears to have been extremely modest—only two items are specifically linked with the occasion, the repair and burnishing of a cup, salt and jugs at a cost of £1, and the cost of metal and manufacture of four small silver-gilt bells for 39s. 'contra coronacionem', these being perhaps the bells described in the Liber Regalis as topping the silvered poles which supported the processional canopy.[45] Other items on the same bill from Nicholas Twyford were possibly linked with the Coronation: the manufacture, and in some cases repair, of silver girdles, garters and brooches of low value. One of the more expensive items was a single crown of silver gilt, price £6 and destination unstated.[46]

Richard married twice, in 1382 and 1396. A large dowry was paid by the English to secure the hand of his first wife, Anne of Bohemia, but except by inference from the inventory of 1399 discussed below, we know very little of the gifts that passed between Richard and Anne, although we learn that, especially for the occasion, Richard reclaimed from pawn one of his crowns—described as of gold, with ten large and small fleurons, set with balas rubies, emeralds, sapphires, diamonds and large pearls.[47] There is an oblique and tantalizing mention of the jewels that came with Anne from Bohemia in a reference to the loss in England of unspecified 'iocalia' worth £666 13s. 4d. (1,000 marks) by a Bohemian messenger who was bringing them to Anne.[48] Judging from the few extant examples (ill. 58), Bohemian goldsmiths' work was of high quality.[49]

We know a good deal about Richard's presentation of gifts to his second wife, Isabelle, daughter of Charles VI, who had the attraction of bringing with her a substantial trousseau and the enormous dowry of £133,333 6s. 8d., payable over five years.[50] At different stages of Isabelle's ceremonial progress from Calais to London in November 1396 Richard gave her gifts of gold, eighteen in all, amongst them a crown, chaplets, a collar, an altarpiece set with pearls and gems, a girdle, a hart with large pearls and a sapphire, and, most remarkable of all, a rich goblet of Venetian workmanship.[51] Richard had also given out a quantity of gold to Isabelle's father and entourage at Ardres in October of that year, in order to secure the peace with the French, as well as his marriage.[52]

One of Richard's most distinctive innovations was his badge of the White Hart, with golden crown and chain, first distributed by him at Smithfield in 1390,[53] and possibly connected with the winged hart which Charles VI had

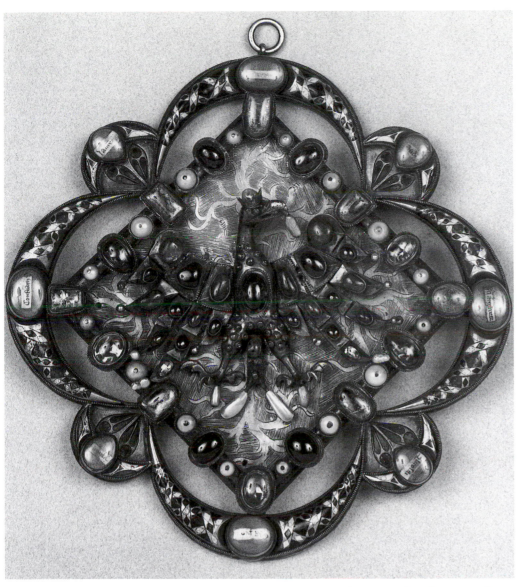

58. Reliquary pendant. Silver gilt, enamel and gems showing the Imperial eagle, crowned. Bohemian *c.* 1350. Paris, Musée de Cluny

adopted by 1382.[54] Numerous lead examples of Richard's badge have been found in Britain,[55] but only one precious metal example is known, that made of *champlevé* enamel on silver, now at Troyes (*ill. 54*).[56] The badge is of course also depicted on the Diptych, where it occurs in two versions: on Richard and on the angels.[57] Clearly there were many possible variants of the badge, price being the determining factor. Here Richard's gifts to emissaries and adherents are interesting. In December 1398 he spent a total of £405 on gold *cervi* (each in the range of £3 to £36) for the Archbishop of Cologne and his entourage; the German knights accompanying him received £3 versions.[58] A few days later Richard is found distributing to eight squires plain silver *cervi* worth a total of only 26s. 8d.[59] And in February 1399 he bought from Hans Doubler for £8 a single gold

hart decorated with pearls in order to give it to Hillar', brother of the Emperor Manuel of Constantinople,[60] who had come to England to seek Richard's support for a crusade against the Turks.

Richard's device of the White Hart seems to have been widely distributed. For example, amongst the brooches owned by Margaret, Duchess of Burgundy, in 1405, was a gold brooch garnished with thirteen pearls of a white hart lying on a bank, with a sapphire set in its head, and two balases, a sapphire, two clusters of eight pearls and two diamonds set in the bank, described as 'being of the device of King Richard of England'.[61] Closer to home, in 1391–92 Henry Bolingbroke, the Earl of Derby, had himself paid £9 to his goldsmiths Herman and Louis to make a gold hind in white enamel in a garter with a collar round its neck,[62] and he again paid Herman in 1395–96 for the repair, re-enamelling, and replacing of pearls on the horns of a large gold stag.[63] A couple of years earlier, Roger Mortimer, Earl of March, paid his goldsmith Wynald a modest 33s. 4d. for a *cervus* of gold set with stones and pearls, and paid 26s. 8d. for two more gold *cerfs* to be mended and re-enamelled.[64]

Some of the elaborate pieces embellished with the White Hart that were owned by Richard's supporters and friends, may originally have been gifts from the King himself. Walter Skirlaw, Bishop of Durham, owned at his death in 1406 a large and heavy silver-gilt cup, enamelled with red and white roses surrounding an engraved hart, and decorated outside with eagles, lions and crowns.[65] Richard's friend Sir John Golafre, who died in 1396, left to the King his White Hart brooch with a rider, set with rubies, sapphires and pearls, and his gold and enamel covered cup, with double roses and a hart with crown and chain lying on the cover. Another gold cup and cover is described as decorated with a white hart and pounced ('*pounsenatus*') with branches of ivy and harts—a description reminiscent of the pounced antlers on the hart in the Wilton Diptych.[66]

Gifts were customarily exchanged at Christmas and the New Year by the King, his family, and members of his household. Evidence about Richard's present-giving survives from various years in his reign, although the fullest lists, for Richard as a child in 1377 and 1378, and for his child-queen Isabelle in 1398, must represent the taste and aspirations of their elders.[67] In 1378 Nicholas Twyford, the London goldsmith, was sole supplier of over 250 pieces at a cost of £202 5s. 4d.[68] The most expensive of these was a gold cup and cover at £26, while the cheapest were three dozen (silver?) rings at 3s. 4d. the lot. Almost all the pieces were described as cups and goblets or rings (about 175 in all), the former being of silver or silver gilt, with just four of gold, while the rings were mostly of gold (at an average value of 5s. each), some being enamelled, and thirty described as '*de forme cristofferis*'. It is tempting to suppose that these are what are now known as iconographical rings, at least one surviving example of which (*ill. 61*) is aptly inscribed '*en neue ane*' ('in the New Year').[69] The decoration of the cups is not especially remarkable: leaves and columbine, acorns, crowns and suns, wreaths and 'babewyns'. Three pieces are said to be of 'the work of Paris'.[70]

59. Signet Seal used by Richard II, c. 1378–99.
London, Public Record Office

60. Badge of a broom cod.
Lead, English, c. 1390.
Museum of London

61. Gold ring engraved and
enamelled with St Christopher,
English, c. 1380–1400.
London, Victoria and Albert Museum

Twenty years later, in 1398, the list of the young Queen Isabelle's presents—presumably ordered for her by Richard—consists entirely of gold, and cost over £507.[71] Almost everything is jewellery, with just a few rings, the rest being mostly brooches and 'tabulae' or miniature altarpieces (as in *ill. 65*), many enamelled or set with gems. Of the seventy-odd objects, the most expensive are an altarpiece at £85 and a gold cup at £66 13s. 4d.; the cheapest is a brooch at 4s. 4d. Decoration on the brooches includes St George, deer, a wodewose and leopard, a damsel, a pelican, an ostrich and a goldfinch, while the altarpieces feature the Passion, the Life of the Virgin, and St George. A number of London goldsmiths seem to have supplied Isabelle on this and other Christmases: Thomas Bouer, William Fitzhugh, Ronald Bussch and John Pallyn.[72]

Richard is known to have spent £890 3s. 7d. on 'certeins ioaulx' bought for Christmas from Drew Barantyn in 1385,[73] and right at the end of his reign in 1399, as much as £96 8s. on a single object, a beryl cross decorated with gems, bought from the Florentine merchant, Anthony Manyn.[74] But at the same time, festive refurbishment might prompt humbler expenditure, such as the mending and gilding of a boat-shaped alms-dish ready for Christmas, as well as the recycling of plate, by, for instance, the addition of escutcheons of the royal arms to candlesticks formerly belonging to John of Gaunt, Duke of Lancaster. These last were then presented by Richard to Westminster Abbey.[75]

Documentary references to objects specified as acquired for Richard himself are sporadic and infrequent. Crowns and seals were presumably mainly for use by the King or within his household, but significant descriptions are rare.[76] Other

103

objects, however, by virtue of their expense may be argued as at least reflecting his taste. We know that Richard bought new gold crowns, including at least one in 1385 and perhaps two in 1391, from the Italian merchants named Balthazar Lumbard and Bartholomew Lumbard of Lucca respectively.[77] One would like to know which of his various crowns he wore in 1398 when described by the *Eulogium* chronicler as sitting silently enthroned in his chamber for long afternoons, expecting genuflection from all those whose eye fell upon him.[78] Of the royal seals commissioned during his reign, only the Great, Privy and Signet Seals might be expected to have attracted discrimination in their design. Such evidence as there is suggests indifference: the design of the Great Seal remained exactly that used by Edward III, with Richard's name substituted for his. Surviving impressions of various Signet Seals (e.g. *ill. 59*) are of no artistic merit.[79] No impression is known of the gold one which was made by Nicholas Twyford, for which he was paid 11s. 8d. in 1378.[80]

Occasionally items are described as '*pro persona domini Regis*' but in no further detail, as for example the two gem-embellished gold collars and a '*nouche*' bought for £66 13s. 4d. from Hans Doubler and Drew Barantyn in 1393, or another gold collar with gems bought from Barantyn, at a cost of £40, in 1398.[81] Unspecified jewels costing only £6 are ordered to be distributed '*ad honorem regis*' in 1397.[82] One of the most remarkable purchases '*ad opus et usum domini nostri Regis*' was that of two gold bejewelled plates specified as made in Paris, costing £33, and bought from a certain Assyn de Bellon via the Florentine merchant John Fraunceys in 1398. Elsewhere we learn more detail about this purchase: the 'plates' were in fact a single spice plate with its cover, the foot decorated with leopards and maidens, and the cover with a hart.[83] Bellon was probably one of the Lucchese family long established in Paris as suppliers of rich textiles to the French monarchy.[84]

Other costly objects were acquired from time to time, and probably often given away soon afterwards. A gold and silver gem-set 'Calvary' with the Virgin Mary and St John, was offered to and possibly bought by Richard in December 1390 from Catanus Spynola of Genoa.[85] A beryl pyx, mounted with a sapphire and bearing Richard's distinctive arms, of St Edward and St Edmund, was probably the King's gift to St George's Chapel, Windsor.[86] In 1385 the King owed Drew Barantyn £550 for a jewelled gold collar, destination unstated,[87] whilst in 1398 Barantyn was paid £40 for a collar for the King of France, and £160 for a miniature gold altarpiece or '*tabulette*'.[88] A contemporary chronicler, Walsingham, was particularly critical of the lavishness of Richard's gifts to the French king and his followers in 1396, at the time of the negotiations leading to Isabelle's marriage.[89] A contemporary description of the two monarchs at Ardres is certainly aglitter with golden gifts being exchanged, but it is noteworthy that even here, Richard appears to be indulging in some judicious recycling.[90] Charles received from him a jewelled gold collar worth 5,000 marks, described as of 'the late Queen's livery', perhaps a curious choice in the circumstances, as well as a large gold cup and ewer, valued at 500 marks, made 'in the year 44' (in other

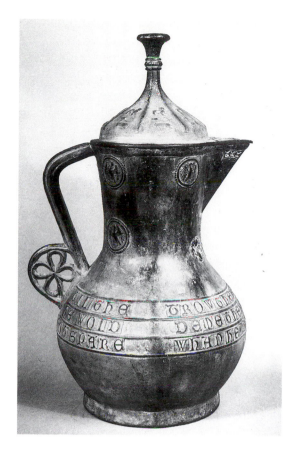

62a & b. Bronze jug with English royal arms, *c.* 1390. London, British Museum

words, from Edward III's reign).[91] Richard's gifts from Charles are more varied and more numerous—for example, a gold bear supporting a '*nef*' with a tiger looking into a mirror at either end, and a number of gem-encrusted '*ymages*' including St Michael, St George and the Trinity.[92]

This is ample illustration of the obvious problem of recognizing in inventory descriptions the many gifts that Richard would have received, foreign or English-made. Amongst such were gifts from the citizens of London in 1392, of jewels showing a boy on a dromedary, and a pelican,[93] and the New Year's gift in 1398 from Philip, Duke of Burgundy, of a gold figure of St Edward holding a ruby.[94] Richard's own gifts might pass through many hands: in 1396 the Duke of Burgundy acquired from a group of Italian merchants some jewels, amongst which was '*un cerf d'or a la devise du Roy D'Angleterre*', which he then proceeded to give away to none other than Henry, Earl of Derby, not long before the latter supplanted Richard and became Henry IV.[95] The 1401–03 inventory of Jean, Duc de Berry, describes two items which perhaps have a Ricardian connection: a pair of silver-gilt pots, the handles engraved with suns, their covers respectively enamelled with a deer and a lion, suggestively similar to the motifs on the bronze Ashanti jug in the British Museum (*ill. 62*).[96]

105

In his will of 1396, William Courtenay, Archbishop of Canterbury, cites a number of items given by the King: a gold reliquary cross set with gems, silver fonts and censers with the King's arms, and a round gold cup 'made in the likeness of feathers' which sounds like one cited in one of Richard's inventories. One might speculate, too, that the cup was originally Anne's—ostrich feathers were one of her badges—and that it was a gift to Courtenay at the time of her Coronation, at which he officiated in 1382.[97]

Richard bought his plate and jewellery from numerous sources. The majority were London goldsmiths, and many were members of the Company of Goldsmiths. Judging by their names, at least two were not Englishmen but came probably from the Low Countries: Raymond Standelf and Hans Doubler.[98] One was very local, presumably to Sheen Palace: James, goldsmith of Hampton.[99] Most of the goldsmiths mentioned in the Wardrobe Books were employed in making new plate from old, carrying out repairs and engraving arms on plate, the latter a dull but rewarding task at 18d. per item, but especially necessary after Richard adopted new arms—those of Edward impaled with the royal arms—in about 1395.[100] Although the records are not complete, the impression they give is one of carefulness in spending if not of thrift. The Wardrobe Books do however show both Richard's outlay and the number of goldsmiths that he patronized to be rising in the 1390s. An early book, covering the period *c.* 1380–86, names only two goldsmiths, Nicholas Twyford and William Fitzhugh, both London men.[101] Twyford is elsewhere, in 1381, called *'aurifaber regis'*,[102] and early in the King's reign he refurbished plate for the Coronation and supplied Christmas presents.[103] He was also a major supplier to both the Black Prince and John of Gaunt, the King's father and uncle respectively.[104] Fitzhugh is a lesser-known figure, who features in the records of the Goldsmiths' Company mainly as a wrongdoer, being several times fined and imprisoned for substandard work.[105] By about 1393, the goldsmiths named in the Wardrobe Books alone have risen in number to sixteen, and include Thomas Polle, a substantial property owner in the City of London and a leading and politically active member of the Goldsmiths' Company.[106]

A more colourful but sketchier picture of Richard's suppliers emerges from royal inventories and the Issue Rolls. These show jewellers and merchants joining such major English goldsmiths as Christopher Tildesley and Drew Barantyn,[107] as well as specialist engravers like Peter Hiltoft and William Geyton, both 'King's engravers' of the Tower of London.[108] Tildesley is named *'aurifaber regis'* in 1398, and as such was to receive 12d. per day and the King's livery at Christmas.[109] He clearly acted as quasi-banker, as well as receiving valuable jewellery commissions from both Richard and later Henry.[110] Drew Barantyn had conveniently married Twyford's widow, though he lacked Twyford's official status, and he was a major property holder in the City of London, as well as prominent in the Goldsmiths' Company.[111]

Although London goldsmiths predominate, Richard's suppliers were international. Costly items might be bought from itinerant Italian merchants from

Florence, Lucca or Genoa, whose trading role supplemented their activities in banking and money-lending to the Crown.[112] Parisian work was acquired not only via London goldsmiths like Twyford, but also directly, as well as in the form of presents, particularly at the time of Richard's second marriage in 1396.[113] A few more permanent Italian influences can be detected elsewhere—Richard Davy, armourer in the Tower of London,[114] was trained in Lombardy, and two Italian goldsmiths, Egidio and Lodevico de Turry, were resident in London.[115]

Bohemian pieces are likely to have come as wedding presents with Anne in 1382, and may be those featured in an inventory of 1399 as bearing the arms of the Holy Roman Emperor (either her father or brother).[116] We also know that on her way to England in 1381, the city of Nuremberg gave her two 'kopf pokal', cups of silver gilt, probably made by the goldsmithing family of Groland,[117] and that her entourage included a certain Herman of Prague, armourer.[118] Richard inherited a few fabulously valuable Spanish pieces—a gold sword, saddle, stirrups and palet (a sort of helmet) and a silver and enamel altarpiece—all of them pawned early in his reign.[119] An intriguing object of uncertain origin is the silver 'nef' engraved with letters of 'sarzinesse', valued at £141 in 1384.[120] Could this have been a Moorish object reused, or (perhaps more likely) a Spanish piece with a Cufic inscription?

The majority of the surviving metal objects associated with Richard are assumed to have been his by virtue of the presence on them of his arms, his name, or his badge of the White Hart with a gold crown and chain around its neck.[121] This motif decorates three objects of unknown provenance: the badge that is now in the museum in Troyes (*ill. 54*),[122] and gilt copper quadrants, dated 1398 and 1399, in Dorchester Museum and in the British Museum (*ill. 63*).[123] The cast bronze

63. Gilt brass quadrant, engraved with a hart lodged and a hare on the reverse.
Dated 1399. London, British Museum

Ashanti jug, also in the British Museum (*ill. 62*),[124] is decorated with harts—apparently uncrowned, but they are very worn—and other English royal badges: lions, griffins and crowns. Of the four impressions of different Signet Seals (whose original metal is unknown but may be surmised to have been gold or silver), three bear Richard's name[125] and one (*ill. 59*) has the royal arms impaled with those of Edward the Confessor, as adopted by him *c.* 1395.[126]

But the sparkling centrepiece of this otherwise paltry collection, the so-called Crown of Blanche (*col. pl. 20 and ill. 64*), bears none of these symbols.[127] Almost certainly it was taken from England as part of the dowry of Henry IV's daughter Blanche, on her marriage to Ludwig of Bavaria in 1401.[128] It appears in the inventory dated 1399 of Richard's jewels and plate, and although no indication of its original ownership is given, the most plausible owner must be Anne, who may have brought it with her from Bohemia on her marriage to Richard in 1382.[129] Of gold, the crown is set with balas rubies, sapphires, diamonds, emeralds, pearls and enamels, and was designed so that six tall fleurons with pearled edges alternate with six smaller ones. The crown is the surviving masterpiece of Gothic jewellery, yet it has proved impossible to establish exactly where or when it was made, and its International Style has enjoyed attributions variously to Venice, Bohemia, Paris and London.[130]

The crown has no real parallels, but two stylistic features of it are perhaps worth noting. Firstly, the hexagonal shapes of the enamel frames set onto the circlet (*ill. 64*) seem close in style, as do the gem-settings, to the one remaining brooch, of distinctive form, on Anne's effigy (*ill. 67*) in Westminster Abbey.[131] Secondly, the overall design and palette of colours used for the gems in the crown, and in particular the alternation of red and blue stones around the circlet, and the use of pearls to tip the large fleurons, seem more than coincidentally similar to those of the crown worn by Richard on the Wilton Diptych (*ill. 55*). Similar, but not the same; the depiction of Richard's crown is precise and distinctive, in contrast to the stylized crowns worn by the two saints behind him, and this suggests that it may have been inspired by a real crown. Is it possible that the pair to the Crown of Blanche—or of Anne—resembled that worn in the Diptych by Richard?[132]

The precise pictorial detail of the Diptych provides other clues to Richard's taste in jewellery. Around his neck, like those of the angels, is a collar of paired golden broom cods; his is the more elaborate, being studded with pearls and jewels. A collar of broom cods was the personal device of King Charles VI of France, who gave them away as a mark of friendship. He gave one to Richard, his future son-in-law, at Ardres in 1396.[133] The only survivals of these grand and costly collars are in the form of imitation broom cods in lead, some of which have been found in London, and one of which is now in the Museum of London (*ill. 60*).[134] The Diptych also shows Richard wearing a prominent brooch in the form of his personal badge, a White Hart with a gold crown and chain around its neck, the twelve branches of its black antlers tipped with tiny pearls. The way in which the body of the hart is painted—the paint is clearly raised above

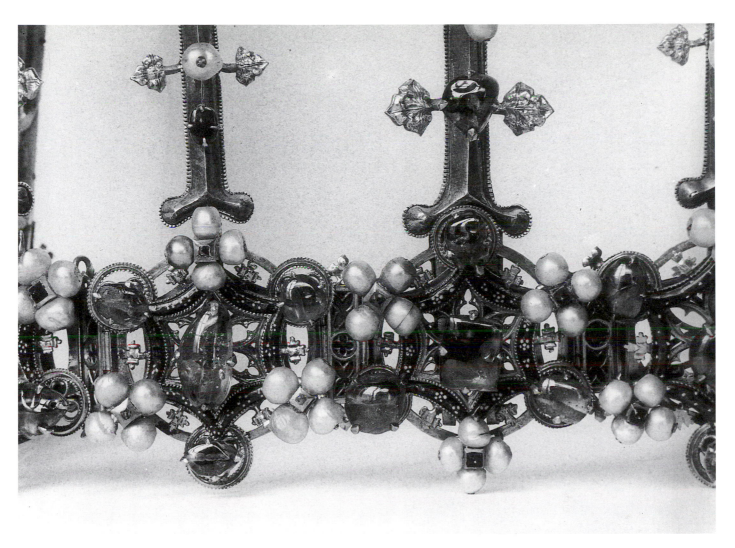

64. Detail of Crown of Blanche of Castile. Gold with enamel, pearls, rubies, sapphires and diamonds, *c.* 1380, Munich, Residenz, Schatzkammer

the surrounding area—suggests that it is of *ronde bosse* enamel, then the latest and most fashionable type of enamelling, perfected by Parisian goldsmiths in *c.* 1370 as an ideal way of colouring jewels in the round.[135] Although the angels also wear White Hart brooches, these are clearly inferior ones. Their painting is flatter and their small antlers lack pearls. As is well known, a close parallel to these brooches is the Dunstable Swan Jewel, of gold with *ronde bosse* enamel of *c.* 1400, now in the British Museum,[136] and in its turn close in genre and style to the drawing of a cheetah brooch attributed to Giovanni de' Grassi, *c.* 1400[137]—an interesting demonstration of the International Style shown by jewellery of this date.

There is a further important feature of the Diptych which has a bearing on the art of the goldsmith: the wonderfully fine pouncing or stippling of the hart's antlers, the Christ Child's mantle and the gold backgrounds to the figures. Just as with the Master of the Westminster Retable a century before, in the painting of the Wilton Diptych one senses a conscious striving for the sumptuous effect

of gold and enamel. Pouncing or *pointillé*, often juxtaposed with enamel, was by this date the norm in Paris for goldsmiths' work of high quality, such as the miniature altarpiece, now in Amsterdam, which combines *ronde bosse* and translucent enamel with sophisticated *pointillé* (*ills. 65, 66*).[138] That such work was known also in England is shown by reference to it in contemporary wills and inventories,[139] and in pieces such as the gold Clare Cross of *c.* 1400, on loan to the British Museum,[140] and, above all, on the tomb of Anne and Richard themselves, where the canopy and effigies are liberally sprinkled with their badges and arms in *pointillé* (*ill. 67*). In sum, the art of the goldsmith permeates both the style and the content of the Diptych to a notable extent: in its exceptional rendering of *ronde bosse* enamel, in its use of *pointillé*, and in its precisely observed depiction of jewellery. It is surely possible that the inspiration behind this great painting was an actual piece in Richard's own collection—which we know to have included golden saints and enamelled '*ymages*', like those of Charles VI (*ill. 57*).[141]

The evidence for Richard's real annual expenditure on his household has recently been re-examined[142] (see Staniland, p. 93), and the general conclusion seems to be that Richard was at first hard up, but that from 1390 onwards there was a marked rise in his liquidity, notably assisted by complex financial arrangements—including forced loans, fines, and the pledging of jewels and plate.[143] From 1395, it has plausibly been argued, his household became excessively large and excessively costly—although that of his successor Henry IV was at times

67. Detail of Queen Anne's dress
with surface decoration in *pointillé*,
from the tomb of Richard II and
Anne of Bohemia in Westminster Abbey

as large or larger, and as costly.[144] Although the nature of the evidence makes any exact comparison difficult, it appears that Richard's spending may even have been on a par with that of the King of France. But judged from the evidence of the Wardrobe Accounts and Issue Rolls, Richard's outlay on goldsmiths and their work appears relatively slight by comparison with that on luxurious cloths and tailors (see Staniland, pp. 88-90 and pp. 92–3). Certainly, by the end of his reign his spending on plate and jewellery was higher, and his net of patronage wider, than they had been at the beginning, although the distribution of his innovation—the badge of the White Hart, in its various gold and silver forms— does not seem overall to have been a significant drain on expenditure. There is some evidence that the collections that Richard had inherited from Edward III—especially of church plate—had in large part been recycled or lost by the time Henry IV became King of England.[145] And Henry too dealt swiftly with his inheritance from Richard, all the while continuing to patronize many of the same goldsmiths.[146]

The royal jewels and plate—over 350 items—were handed over to Henry IV in November 1399, and amongst them can be found some further evidence, albeit difficult to interpret, about the collection that Richard had accumulated over 22 years.[147] Inconveniently for the modern student, the record of the collection made at this date is not directly comparable with that of 1378, and by contrast with it, there is for example a predominance of jewellery and secular plate, with relatively little church plate, and only about three dozen gold items.

65 (*left*). Triptych of *Man of Sorrows* in *ronde bosse* enamel, with the Virgin and St John in translucent enamel. Paris, *c.* 1380. Amsterdam, Rijksmuseum

66 (*left*). Triptych (reverse). *The Dormition and Assumption of the Virgin*, executed in *pointillé*

The numerous jewelled brooches are decorated with motifs which include a queen, a white doe, a white falcon on a perch, a white eagle with a falcon, an eagle seizing a doe, a griffin seizing a doe, a white angel holding a sapphire, a reindeer on a green bank with a sapphire set between its horns, a gold rose set with a balas ruby and little pearls encircled by 33 other pearls, a white flower set with a balas ruby in the centre of a great gold brooch whose spandrels were set with sapphires, clusters of pearls, and diamonds, a gold child seated on a leopard, a maiden and a unicorn, a black eagle standing on a green terrace, and a hart lying under a tree with 27 pearls hanging from the branches and from its horns.

Most of the items listed in the indenture of 1399 give no clue as to their first owner or patron, but the last item may well have belonged to Richard, whilst the eagles and griffins could have been either his or Edward III's. Silver ewers with dragons, on one of which a queen is riding (nos. 20 and 21), are surely inherited from Edward III, as are the gold chalice, paten and cruets (nos. 3 and 4).[148] Pieces perhaps more obviously Richard's are the gold salt with the deer's head (no. 150), and girdles with deer heads (no. 158) and with bells and the letters 'A' and 'R' (nos. 163, 167). Some of the objects are described as being with arms of the King and Emperor—that is, with the eagle displayed (as in *ill. 58*)—and so can probably be attributed to Anne of Bohemia's father, the Emperor Charles IV. Others (nos. 51, 122, 151) had the arms of the King and Queen for either Richard and Anne of Bohemia or Isabelle. The collars listed illustrate different periods of Richard's reign. Two clearly belonged to Anne, because they are embellished with her badges. One (no. 185) has an ostrich feather and pearls, the other (no. 334) a livery collar with branches of rosemary decorated with pearls. Another series of collars is described as that of the livery of the Kings of France (nos. 307, 332, 333). All are collars of *genestres* or broom cod, again richly jewelled. One (no. 332) is described as made up of nine pieces decorated with *genestre* and the others were probably similar. Charles VI of France had of course given a gold collar to Richard II in 1396, and four more collars to members of Richard's entourage at Ardres, and yet two more came to England with Isabelle in 1396.[149] It is notable that the only piece in the whole inventory of 1399 of which both maker and town of origin are given is the large 'spice plate' (no. 265) said to have been made in Paris by Assyn de Bellon, whose purchase for £33 is set out in the Issue Rolls (see above, p. 104).[150]

Full of detail though the inventory is, it presents only a shadowy and uncertain picture of Richard's collection. The tablets with St John the Baptist and St George and St Christopher (nos. 228, 245) are similar to two in Isabelle's Christmas list of 1398, and the gifts presented to Richard by Charles VI at Ardres in 1396 may very tentatively be identified with the gold Trinity '*table*' (no. 250) and the gold Virgin Mary (no. 216).[151] But what of the gold *hanap* from the King of France (no. 315)? This could equally be either that inherited from Edward III, or the one given to Richard by Charles VI, an illustration of the fundamental difficulty inherent in this sort of detective game.

A good deal of Richard's plate was lost on his last expedition to Ireland, and the individuals who were held responsible, as well as some of the items, are briefly listed in an Enrolled Account of 1399.[152] Further oblique light on Richard's collection is shed by other inventories of Henry IV, which illustrate how swiftly the new monarch recycled his inheritance.[153] Jewellery went towards alterations on crowns, one instance being the gem-set hart brooch which was converted in 1402, on Henry's instructions, into a new '*ouvrage*' or section for the crown of his daughter Blanche (discussed above).[154] The crown—which the 1399 inventory describes as of eleven sections—is certainly now of twelve sections, and the one section link most visibly different from the rest is generally considered of much later date.[155] Elsewhere, Henry is mentioned as giving a large object weighing two pounds—with clear Ricardian links and decorated with harts and '*arbres de genestres*'—to the Mayor of London as his coronation present.[156] Another piece, weighing over one pound, was entrusted to the knight Syglym for Henry's daughter Blanche in Germany; it included four enamelled harts, an enamelled tree, the Trinity, St George, St John and St Elizabeth, and is curiously reminiscent of an '*ymage*', now destroyed, known to have been in the Bavarian Royal Collection by *c.* 1405.[157]

By the reign of Henry VIII, a hundred or so years later, only one item in the royal inventories is recognizable as Richard's: a substantial gold enamelled and jewelled cross, weighing 74oz., with images of St John the Baptist and the Virgin Mary, and supported by six white harts with chained crowns around their necks.[158]

Where patronage of contemporary goldsmiths is concerned, the documentation for Richard's expenditure is a disappointment. It is difficult to discern in his outlay any clues about his particular preferences, or any signs that he was keen to cultivate his own taste or to buy the best, as were Charles V, and Jean de Berry in France, or in England, Edward III and John of Gaunt.[159] Certainly there are indications that like his royal contemporaries, Richard had a fondness for precious metals and gems—but their form seems to have been of lesser importance. Unlike John of Gaunt or the Black Prince, there is little evidence that Richard often bought from French or German goldsmiths, although these were probably the most fashionable and were certainly active in London at the time.[160] Richard's preoccupation may rather have been with the lustre reflected on him by precious materials, and in his search for magnificence he used these for political ends—hardly a novel aim in the Europe of the day.

By way of conclusion, it is of interest to look at Richard's own final view of his possessions and their disposition as shown by his will, dated 16 April 1399, even though of course it was not carried out.[161] With notable and pious generosity, he wished each Catholic king to have a gold cup or bowl worth £45. For himself he wished to be interred in white velvet or satin, *more regio*, to wear a gilded though not a gem-set crown and sceptre, and to wear on his finger (again 'in kingly manner'), a ring with a stone—unspecified—worth 20 marks.[162] The will seems to be a blend of the egocentric and the impersonal—unusually there

are no personal bequests to friends and relatives, other than of money. His crown and plate, secular and chapel, he left conventionally, to his successor, whilst his brooches, circlets and jewels were to be sold to fund the completion of the nave of Westminster Abbey. Indeed the key to Richard's taste may simply lie in those words, *more regio*.

POSTSCRIPT

In the course of production of this book, an article has been published on the Diptych which draws attention to an inventory clearly of Richard's goldsmiths' work, hitherto unpublished.[163] A roll 40 membranes long, it is the work of various scribes, compiled after January 1398.[164] The inventory is one of the most important for Richard's reign, indeed outstanding amongst medieval inventories of English royal goldsmiths' work, far richer than that of Henry V.[165] It includes jewellery and plate for both secular and liturgical use, and is outstandingly rich in gold. There are, for example, seven membranes solely devoted to gold cups (a total of about 175), often embellished with gems or enamel. A very full picture of Richard's circle can be formed from the details given about the donors of objects—many presumably given at Christmas or the New Year, but some as diplomatic offerings. Clearly identifiable are the rich gifts presented to Richard in 1396 at Ardres by the Dukes of Berry and Burgundy and the King of France, most notably the great gold image of St Michael, worth £1,064. The most valuable of all the pieces listed is the great gold and gem-set crown weighing over 13lb. and valued at over £33,000.[166]

The hierarchical arrangement of the inventory—listing first gold, then silver gilt, then silver; and the categorization by types, dividing jewellery into crowns, coronals and 'small jewels', separating table plate from chapel plate—is a method familiar from the great French Royal Collections, notably those of Charles V (1380) and the Duc de Berry (1406–16), but is not otherwise found in England before the great inventories of Henry VIII in the sixteenth century.[167] This inventory evidently represents more than just the substantial number of gifts to Richard and contains pieces which are in the well-known but far shorter 1399 royal indenture discussed above, known to be made up of the collections of Richard, Anne, the Duke of Gloucester and the Duchess of Kent.[168] Many of Richard's circle died during 1397–99, and their possessions came to him. Into this category must come the cup inscribed 'God graunt him good ende', which had belonged to Thomas Holland, Duke of Surrey, and perhaps also those pieces inscribed *'sauns departier'*, which may be linked with Sir John Golafre (d. 1396).[169] The inventory documents just that accumulation of material wealth for which Richard drew the critical comment of his contemporaries, and which has hitherto been hard to detail. Its full and speedy publication is much to be hoped for.

VI

SHELAGH MITCHELL

Richard II: Kingship and the Cult of Saints

G RANT OUT OF DEVOTION to the Shrine of Edward the Confessor';
'Grant out of regard for St Edmund…'; '…in honour of God and St Ri-
chard'.[1] These are just three examples of Richard II stating a devotion to saints.
Since Richard's piety has not hitherto been the focus of a particular study, it is
difficult to judge between his devotion and his use of formulaic words. It is
known that Richard had a devotion to the saints, that this was observable at
crucial moments in his reign and was pivotal to his view of kingship. The Wilton
Diptych bears strong visual testimony to this. The two interior panels show
Richard being presented to the Virgin and Child by Saints Edmund, Edward
the Confessor and John the Baptist. The very personal nature of this iconography
and its significance for his kingship is explored in this paper in the context of
his religious devotion.

On the Diptych the Confessor is shown with his usual symbol of a ring, an
allusion to the miracle which connects him to St John the Evangelist.[2] There
exists an undated letter from the Abbot of Westminster, Nicholas Litlyngton, in
which he states that due to old age and weakness he is unable to come in person
with the sacred ring of St Edward.[3] From this we might infer that Richard had
asked for the ring before the abbot died in November 1386, the very year when
a commission had been imposed by Parliament upon Richard and his household
subjected to scrutiny and change. By asking for custody of the Confessor's ring
at this time Richard was seeking to strengthen his own position by association
with the ideal of kingship for which the Confessor stood. Indeed Richard's
associations with the Confessor can be seen as early as 1384, when he had a robe
of seven garments made for the Feast of the Translation of St Edward.[4] Richard
continued this association. In 1388 he presented a ruby ring to the Confessor's
Shrine.[5] In 1389 he made a grant to Nicholas Adams for carrying 'our banner of
St Edward' on the expedition of 1385 to Scotland.[6] That Richard especially
remembered St Edward's banner is significant because the cross of St George
and the banners of Saints Edmund and Etheldreda were also carried on the 1385
expedition. Again in 1389 Richard made an annual grant of £100 towards 'the
new works', namely the continuation of the building of the nave of Westminster
Abbey 'out of a devotion to the Shrine of Edward the Confessor'.[7] However,
these grants need to be seen in conjunction with Richard's actual devotions to

115

the Confessor. Unfortunately only a few early Wardrobe Books exist;[8] but a study of these, combined with the accounts of the Sacrist of Westminster Abbey, have highlighted the fact that it was only in 1389 that Richard especially marked the Feast of the Confessor, 13 October. On this occasion the Wardrobe Book showed that half a mark of the King's alms was given to the Dominican preacher John Depyng in the chapel of the King's Manor of Eltham.[9] In 1390 Richard visited the Abbey for the Confessor's Feast when he and his chapel attended Prime, Vespers and Compline, staying for Matins at midnight and the procession and high mass following, during which Richard sat in the choir wearing his crown.[10] This is a prolonged act of devotion which, together with his other remembrances of the feast, give substance to Richard's earlier associations with the Confessor. It makes it possible to say that Richard's devotion to the Confessor became more noticeable from about the time he assumed his majority.

These devotions can be seen to intensify from about 1392, when Richard took part in three days of religious rituals for the Confessor's Feast. On the eve of the vigil of the feast he, and some of his clerks, walked barefoot from the Tothill Gate to St James's Hospital, on to Charing Cross and then to St Peter's West-minster (Westminster Abbey) where they made their devotions.[11] On the vigil of the feast the King and his chapel attended Vespers at the Abbey and stayed for Matins at midnight and for the high mass the following day, the feast-day itself, when his Wardrobe Book records that he gave the preacher, John Depyng, £1.[12] In 1395 this same preacher again received £1 for preaching on this same feast-day in the chapel of the Manor of Havering.[13] These years show evidence of Richard's increased devotion. The Wardrobe Books for 1392 and 1395 also note the Confessor's Feast in the margin of the folios which record the daily expenses.[14] Furthermore, the Wardrobe Book for the period October 1392 to September 1393 was the first to record both the principal as well as the subsidiary feasts, 13 October and 5 January. 5 January 1393 was noted as being 'the Feast of St Edward the Confessor and the Vigil of the Epiphany'. John Depyng preached at the Manor of Eltham where he was given £1 of the King's alms.[15] In 1396 the subsidiary feast, 5 January, was again observed, this time at the Church of the Friars Preachers at Langley where John Depyng received the larger sum of £2 for preaching at a high mass in the King's presence; this day was noted only as the 'Day of St Edward the Confessor', not also as the Vigil of the Epiphany.[16] That Richard celebrated both Feasts of the Confessor is sig-nificant since the Confessor's Feast-Days were not similarly noted in the Ward-robe Books of Edward III,[17] although of course Edward did visit the Confessor's Shrine and make offerings.[18] From Richard's observation of both these feasts, we can deduce the growing intensity of his devotions.

Richard's devotion can also be seen when he visited the Confessor's Shrine in times of crisis. Except for his visit to the Shrine of Our Lady in Westminster Abbey in 1381,[19] it is noteworthy that he did not visit other shrines at times of crisis. The visits to the Confessor's Shrine took place during the Peasants Revolt of 1381; in November 1387, just prior to the battle of Radcot Bridge when

Richard's forces were defeated by the Appellant Lords; at the reconciliation ceremony with the City of London in 1392; and the oath-swearing ceremony at the Shrine after the 1397 Parliament. In November 1387 Richard sought, and was assured of, the Londoners' support. He then entered the city and walked, barefoot, from the Mews at Charing to Westminster Abbey where he made his devotions.[20] During the reconciliation ceremony of 1392 the King and Queen processed through London into Westminster Abbey. The choir sang *Agnus in altari*, which is the response in the mass for St Edward the Confessor. After the collect for the King, the convent went to the Shrine of the Confessor and sang the antiphon *Ave Sancte Rex Edwarde*.[21] This ceremony is dated 21 August, a date with no obvious connections to the Confessor. Yet a connection can be made precisely because of the use of *Agnus in altari* and *Ave Sancte Rex Edwarde*. Such a connection was made very plain in the statues which the citizens had to erect as part of the reconciliation—statues of the King and Queen together with the arms of the Confessor.[22]

Linking himself to the Confessor was an important aspect of Richard's perception of his kingship. Such a perception was given supremacy of place in the iconography of the reign when Richard publicly adopted new arms in 1397. These were the arms of England impaled with the arms of the Confessor.[23] Impaling symbolized a personal relationship, more usually a marriage or the mystic union of a bishop and his diocese. Yet at this time Richard allowed the five new dukes he had created, also variously to assume the arms of the Confessor.[24] Thus Richard was forming a group around the throne and marking it out with a visual sign which linked them all to him, to each other, and to the Confessor. However, the use of the impaled arms can be taken back to the previous year; the accounting period September 1395 to September 1396, as John Harvey extensively showed, records very many silver vessels, newly made, to show the arms of England impaled with the Confessor's arms.[25] Richard's signet, which he called 'our signet of St Edward' also bore the impaled arms and this was in use by 1395.[26] The King had used visual signs before, even as early as the Scottish campaign of 1385,[27] and his last Great Wardrobe Account mentions a red velvet mantel with 'the arms of the King and St Edward'.[28] The message Richard was conveying by this imagery was one of association. This association of course had very deep roots since the coronation regalia used by Richard was associated with the Confessor.[29]

Association with the Confessor was also expressed verbally. In 1389 Richard invoked the curse of the Confessor on any who objected to his grant of £1,000 per year to Leo of Armenia.[30] He uttered the same curse when making a grant to his favourite, the otherwise unpopular, Robert de Vere: 'the curse of God, St Edward and the King on any who do or attempt aught against this grant'.[31] This grant for the lordship of Queenborough, a royal castle, was made jointly to de Vere and the King with the former getting the castle in tail male if the King predeceased him. That the grant was made by signet-letter indicates it was the King's personal wish, made without opportunity for outside objection. The

117

curse can thus be interpreted as pre-emptive, as Richard's attempt to secure protection from criticism. Of more significance is that by the wording of the curse Richard involved the Confessor in his actions. Such an involvement can be seen again, in the creation of de Vere's new titles. He was made Marquis of Dublin in December 1385 and Duke of Ireland on 13 October 1386.[32] He was also allowed to bear the augmentation of three golden crowns on his coat of arms.[33] 13 October is the principal Feast-Day of the Confessor and three golden crowns are the arms of St Edmund. Three golden crowns were also used by the English to refer to Ireland.[34] Since de Vere was only allowed to bear this augmentation for as long as he held the lordship of Ireland, it can be suggested that the augmentation had a dual significance: reference to Ireland but with special reference to St Edmund. When it is remembered that one of Richard's styles as King of England was 'Lord of Ireland', the giving of the lordship of Ireland to de Vere can be interpreted as a sharing of the King's regality—a serious matter which might have aroused criticism. This therefore was a political action for which Richard sought the sanction of both the English royal saints, Edward and Edmund.

Richard's association with St Edmund is not as obvious as his association with the Confessor. Yet we know that he visited Bury St Edmunds on his pilgrimage of 1383[35] and that in 1390 he visited Westminster Abbey for the Feast of St Edmund, King and Martyr, 20 November, arriving for Vespers on the vigil of the feast and staying for the high mass on the following day.[36] In 1391 he gave the Abbey a tenement to provide funds for the burning of 62 candles each weighing one pound for the four Feasts of the Passion of St Edmund as well as the Feasts of St Thomas of Canterbury.[37] He also gave banners of St Edmund to the Abbey.[38] The Diptych, however, highlights the link between Richard and Edmund: they are the only two figures on the left-hand panel shown in clothing rich with symbolism. Such visual treatment links these two figures and although the symbols on Edmund's tunic are difficult to identify with ornithological precision, they must have a significance because they are clearly depicted despite the heavy folds of the drapery: they are meant to be seen. The two birds within one crown with a sunburst between their necks (*ill. 103*) are very possibly cranes which were abundant in East Anglia, St Edmund's territory, before the fens were drained (see Monnas, p. 169 and n. 25); a sunburst is one of the King's known badges[39] and occurs in the pouncing of Richard's robe on his tomb effigy (*ill. 98*). The combination of these symbols on Edmund's tunic again reinforces the link between Richard and Edmund.[40]

The problem, however, is to know what St Edmund represented to Richard. It is accepted that Edmund was a king and that he died for his faith and for refusing to accept foreign overlordship.[41] A fourteenth-century motet from Bury, also preserved in the Worcester and Salisbury Antiphonals, describes Edmund as a warrior king and as an English king: '*Ave Rex gentis Angelorum, miles regis Angelorum...*'[42] Richard needed to identify with an English kingship since his policy towards France emphasized peace and not war. Such a policy could be

misinterpreted. Walsingham speaks of fears that Richard would sell out to the French.[43] Identification with Edmund could be used to allay such fears. For other reasons too Richard needed to identify with the cult of a sanctified king. In 1387 Richard had been threatened with the fate of Edward II, that is, deposition. It is thought that he might indeed have been deposed for a short while.[44] Richard sought to have Edward II canonized and this can be interpreted as an attempt to harness any authority implicit in the cult of a sanctified king, not only to safeguard his own position but also to redeem his great-grandfather's deposition.[45] At this point it is interesting to note that the contents of Henry V's Chapel included one 'berill' in the manner of a cross containing a relic of 'St Edward of Carnarvan'; Edward II's sanctity seems to have been accepted by Richard's successors.[46] Although Richard's efforts at having his great-grandfather canonized were unsuccessful, Edmund was certainly revered as a king, a martyr and a saint. Richard shared a real link with Edmund in that he was created Prince of Wales, Duke of Cornwall and Earl of Chester on St Edmund's Day, 20 November 1376.[47] If association with Edmund is to do with 'kingship' it is also to do with seeking the protection of a dead but sanctified king both for Richard and Edward II.

On a separate occasion, Richard again associated himself with a dead and sanctified king. Another Edward, known as King and Martyr, the son of King Edgar, was especially mentioned in the Wardrobe Book's list of Alms and Oblations for his Feast-Day in 1393 when the King gave John Depyng £1 for preaching in the chapel at Sheen.[48] In 1396 this same Feast of Edward, King and Martyr, is mentioned in the margin of the daily expenses.[49] In 1395 Richard gave the Prior and Convent of Christ Church, Canterbury, a discharge from all rights he had in corrodies in consideration for that church observing the principal Feasts of St Edward, King and Martyr, also stipulating that at each feast, immediately after the prayer for the day, a prayer for the good estate of the King should be said.[50] Edward the Martyr had been murdered at Corfe Castle as a result of magnate faction. A murdered king might by definition be an unsuccessful king and thus not someone with whom to be identified. Yet Richard makes connections between himself and the murdered king and in 1395 he stated 'special devotion' to another murdered king. This was Ethelbert of East Anglia who was killed for political reasons. Ethelbert was patron of Hereford Cathedral and so mention of him in a grant to the Prior and Convent of Hereford might well be formulaic.[51] However, it is also possible that mention of a martyred king fitted into Richard's political use of the cult of saints to buttress his own position by removing any blot from his family history. If a deposed or murdered king became a martyr and a saint, what message did that hold for the King's enemies?[52]

The other saint Richard chiefly identified with was John the Baptist. On the Diptych the Baptist is shown with Edmund and the Confessor. It was not unusual for previous Kings of England to depict the two royal saints, but it was unusual for the Confessor and the Baptist to be shown together: the Confessor

was usually shown with the Evangelist.[53] Richard's substitution of the Baptist must therefore be seen as a personal statement. He had made a similar statement before, when in 1389 he gave a complete set of vestments to Westminster Abbey in honour of the Confessor.[54] The orphrey of the chasuble showed the embroidered arms of the King and Queen and the Confessor as well as depictions of an abbess, the Trinity, the Virgin, St Edmund, St Edward the Confessor and, significantly, John the Baptist. There are other indications of Richard's devotion to the Baptist. He acquired two relics of the Baptist[55] and in 1391 asked for an annual obit for himself and Anne at the Altar of John the Baptist in Westminster Abbey. On that occasion he also asked for prayers to be said for the good estate of the King and Queen at the same altar on the anniversary of his Coronation.[56] The Baptist is also referred to in Richard's epitaph[57] and the Londoners must have been aware of Richard's devotion since they staged a tableau of the Baptist in the 1392 reconciliation ceremonies.[58] A thorough search of the Warrants for Issue has revealed that in July 1380 Richard paid for two images, one of the Baptist and one of the Evangelist, for his own use in his chapel.[59] We know that the Feast of the Evangelist was one of the four greater feasts when Richard offered gold.[60] He therefore did not ignore traditional ties to the Evangelist and so it is all the more significant that he chose to have himself depicted with the Baptist on the Diptych.

The best evidence of Richard's devotion to the Baptist comes from the various Wardrobe Accounts. For Christmas 1386 Richard had a gown embroidered with a raven and with 'J.B.' on the left cuff; these initials emerging out of a golden pyx.[61] A pyx is a casket for the host and a raven is the symbol for Elijah. The depiction of the pyx and the raven together strongly suggest that the 'J.B.' stands for John the Baptist. In terms of biblical exegesis the Baptist was seen as another Elijah. The ideas here centre on 'typology'; Elijah is the 'prototype' of the Baptist.[62] Elijah called people to repentance; he lived in the desert; he was fed by ravens; and he was supposed to come again before the advent of the Messiah. John the Baptist called for repentance; he lived in the wilderness; he foretold the coming of the Messiah; and indeed he was asked if he was Elijah returned. God provided for Elijah who was fed by ravens just as the followers of Christ are provided for with the spiritual food of His body, the host in the pyx. While these connections are not instantly recognizable to us today they must have been realized by Richard and his courtiers or he would not have used this particular combination of symbols. That such symbolism was used for Christmas 1386 is significant on two counts. Firstly, the iconography itself tells us that Richard's devotion to the Baptist was well developed by this date and we also know of his devotions to St Edmund and the Confessor from this same period. Such evidence provides a window into the formation of Richard's particular cult of saints, namely, the royal saints of English kingship and a personal patron saint who was integral to messianic kingship. Secondly, the iconography of this gown is important for the political statement it makes: its use at Christmas 1386 followed the imposition of a commission upon Richard and the removal of some

68. *St John the Baptist* (head missing).
Pewter Pilgrim badge,
14th century (4.5 cm high).
Museum of London

of his household, including his confessor.[63] At a time when he needed to sustain his position in the face of opposition Richard utilized the cult of saints to manifest a kingship both sacral and messianic; sacral because of obvious connections to the English royal saints, and messianic because of connections to John the Baptist.[64]

These connections with John the Baptist are further in evidence in the Great Wardrobe Accounts for the Baptist's Day of the tenth year, 1386,[65] when Richard had a gown and hood of the livery of the Fraternity of John the Baptist.[66] The Wardrobe Book for 1390 tells us that special alms were given to the Augustinian preacher Thomas Wynterton on the Baptist's Day, 24 June.[67] There is also evidence that this day was especially marked out in the daily expenses section of the 1393 Wardrobe Book,[68] while in 1396 the Baptist's Day was recorded in two sections, the daily expenses and the Alms and Oblations.[69] Although the inclusion of such a well-known day[70] has to be judged carefully, it must be significant for the Baptist's Day was not specially recorded in either of these sections in Edward III's Wardrobe Books.[71] It must also be remembered that Richard acceded to the throne on the eve of the Vigil of the Baptist's Day and he was born on the Feast of the Epiphany. In the Western Church the litany for this feast, although centring on the Magi, gives a place to John as the Baptizer of Christ.

69. Roof boss in the Chapel of St Mary of the Pew. London, Westminster Abbey

This association of the Baptist and the Epiphany would indeed make the Baptist an obvious patron for Richard.[72] That he probably felt this special patronage is suggested by the fact that, by the end of the reign, Richard had his own livery of *Internatos* which was worn by his clerks on St John the Baptist's Day. *Internatos* is the antiphon for the Feast of the Baptist.[73] This can be interpreted as Richard having his own livery of the Baptist and it is good evidence that his cult of the Baptist was fully developed by the late 1390s. Since the Baptist was integral to messianic kingship, his role as Richard's personal patron suggests the notion of a 'messianic' kingship for Richard. Certainly the Diptych represents Richard as the personification of England and English sacral kingship. Also on the Diptych we see the Baptist as the only figure who physically touches Richard, a visual indication of a special patronage.[74]

The Diptych offers evidence of Richard's devotion to other cults as well. The positioning of the Three Kings, two standing and one kneeling, having offered a gift to the Virgin and Child reflects the Epiphany scene of the coming of the Magi (see Pujmanová, p. 262). Neither is John the Baptist out of place in such a scene since it was the Baptist who foretold the coming of the Messiah, the one

122

whom the Magi were seeking. According to a chronicler, three kings were present when Richard was born on the Feast of the Epiphany.[75] Richard gave a relic of the Holy Innocents to York Minster to help with fund-raising for their building work.[76] The cult of the Holy Innocents is tangential to the cult of the Magi since the Massacre of the Innocents was a result of the coming of the Magi. In Richard's reign the glass work at York Minster showed the arms of the two royal saints as well as representations of the Magi.[77] The bones of the Magi were the relics of Cologne Cathedral where in 1338 Richard's grandfather, Edward III, had been declared Vicar General of the Empire;[78] Richard was Edward's heir. Richard offered gold, frankincense and myrrh on the Feast of the Epiphany.[79] Edward III had also offered gold, frankincense and myrrh. However, he did not do this consistently whereas Richard did.[80] It is also of significance that when the Chancellor introduced Richard to Edward III's last Parliament, he likened England to Israel and said that Richard was the long awaited heir and that he should be welcomed as the 'Three King's of Cologne' welcomed the Christ Child. This is an explicit connection to the Magi.[81] For all these reasons a devotion to the cult of the Magi and the cult of the Holy Innocents can also be ascribed to Richard.

In ascribing these cults to Richard we should also note the connection with the Confessor. All Richard's Wardrobe Books record the Feast of the Epiphany but the last two books record the vigil of the feast as well, describing it as the Feast of the Confessor.[82] The Vigil, 5 January, is the day the Confessor died. Shortly before, on 28 December 1065, he had dedicated Westminster Abbey. 28 December is the Feast of the Holy Innocents. Thus the Confessor can be linked to both the Feast of the Epiphany and that of the Holy Innocents. Richard's links with the Epiphany are thus further reinforced and this emphasizes the importance of the Confessor and the centrality of Westminster Abbey to Richard. It was Francis Wormald who first pointed out that the Abbey has chapels to the Confessor, Edmund and the Baptist.[83] If this lends a unity to Richard's devotions, the place of the Virgin must also be considered, for historically the Virgin cannot be separated from the life of Christ or that of the Baptist. The Feast of the Purification of the Virgin was one of the four major feasts which always opened the lists of Alms and Oblations; it was one of the four feasts when Richard offered gold.[84] Edward III had also done this[85] and worshipped at shrines of the Virgin,[86] as Richard did.[87] This makes Richard's personal devotions difficult to judge, especially since the cult of the Virgin was so very strong in the Church as a whole. But further evidence of Richard's Marian devotions have been discovered. During the 1390s the Wardrobe Books record additional Feasts of the Virgin. The Feast of the Annunciation, 25 March, was added in 1390;[88] the Feast of the Assumption, 15 August, was added in 1393;[89] and the Feast of the Conception, 8 December, in 1395.[90] In the last two Wardrobe Books the Feast of the Purification was mentioned twice.[91] Furthermore at the Feast of the Purification Richard always gave five gold nobles, a larger sum than he gave at any of the other feasts when gold was offered.[92] The recording of three additional

Feasts of the Virgin during the later part of Richard's reign is surely indicative of his personal devotion.

A personal devotion to the Virgin is also suggested in other ways. For example, Richard was much influenced by the Dominicans who, in common with other Orders, held the Virgin Mary in high regard.[93] Richard's confessors, Thomas Rushook, Alexander Bache and John Burghill, belonged to the Dominican Order as did many of the preachers he heard.[94] Moreover, it is known that for his private devotions Richard used the Dominican Hours.[95] A specific association of Richard with the cult of the Virgin was made as early as 1386 when the Bishop of Bangor offered to celebrate a Mass of the Virgin in perpetuity at Bangor Cathedral for the King's good estate with the prayer *'Quaesumus omnipotens deus ut famulus tuus Rex noster Ricardus qui in tua miseracione suscepit regni gubernacula...'*[96] One of the King's advowsons had been appropriated without licence and this mass was offered in settlement. Although we cannot be sure of the negotiations involved, the important aspects of this settlement are first that only the King is mentioned even though in 1386 he was already married. Second, that the year was 1386, the year Richard's rule was challenged,[97] and the language of the enrolment is heavy with references to Richard's 'regalia' which in this instance must mean his 'regality'. It is therefore of note that the settlement offered by the bishop was a Mass of the Virgin which focused solely on Richard in his role of governing the kingdom. Thus it might be said that Richard saw himself as a ruler under the special protection of God and the Virgin. The idea of the King of England in special relationship to the Virgin can also be seen from a variant form of the St Edmund motet already mentioned: *'Ave regina celorum, mater regis Angelorum...'*[98] According to one authority, the earliest source of this 'Marian' form dates from the fourteenth century but there is also evidence that a two-part setting existed from the early thirteenth century. The Marian form became popular, continued into the fifteenth century and also became the burden of a fifteenth-century English carol.[99] Perhaps this indicates that in popular thought the King of England and the Virgin Mary were especially linked. The visual evidence of the Diptych suggests that Richard did indeed see himself, the King of England, in a special association with Mary, the Queen of Heaven.

In conclusion, it can be argued that Richard had a special affiliation to each figure on the Diptych. The documentary evidence has shown his devotion to the saints as well as his practice of religion; this is reinforced by the pictorial evidence of the Diptych itself which clearly represents Richard in his practice of the cult of saints. On another level, the pictorial evidence also shows Richard as the personification of England and English kingship. This is the personal statement of the interior panels of the Diptych and as such it leaves us with very little doubt that Richard alone could have commissioned the painting. It also leaves us with very little doubt that the Diptych is the visual expression of Richard's own high view of his religion and his kingship.

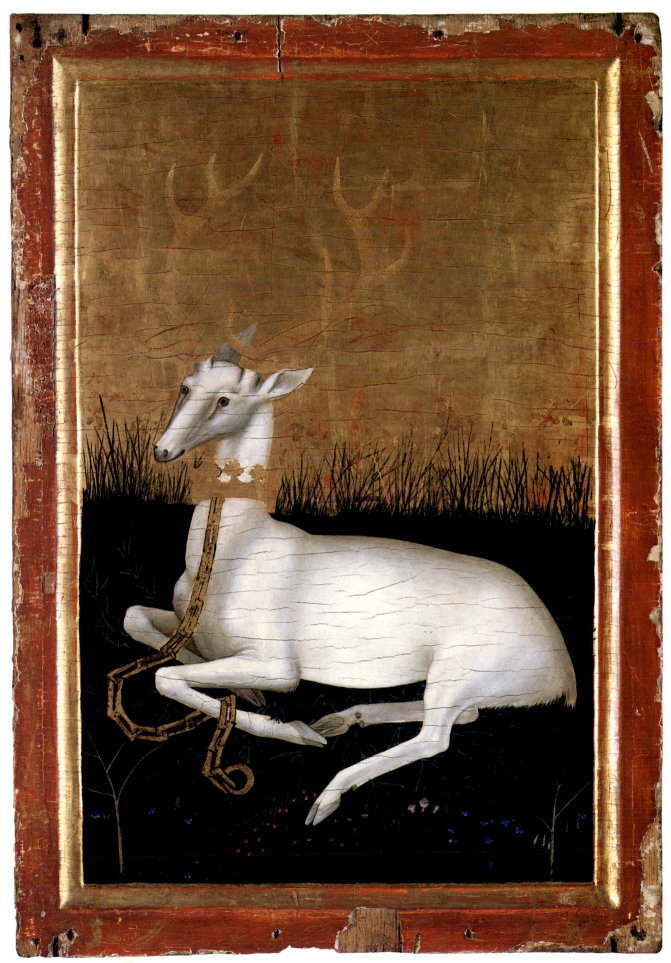

Pl. 1. The White Hart. Exterior left wing of the Wilton Diptych

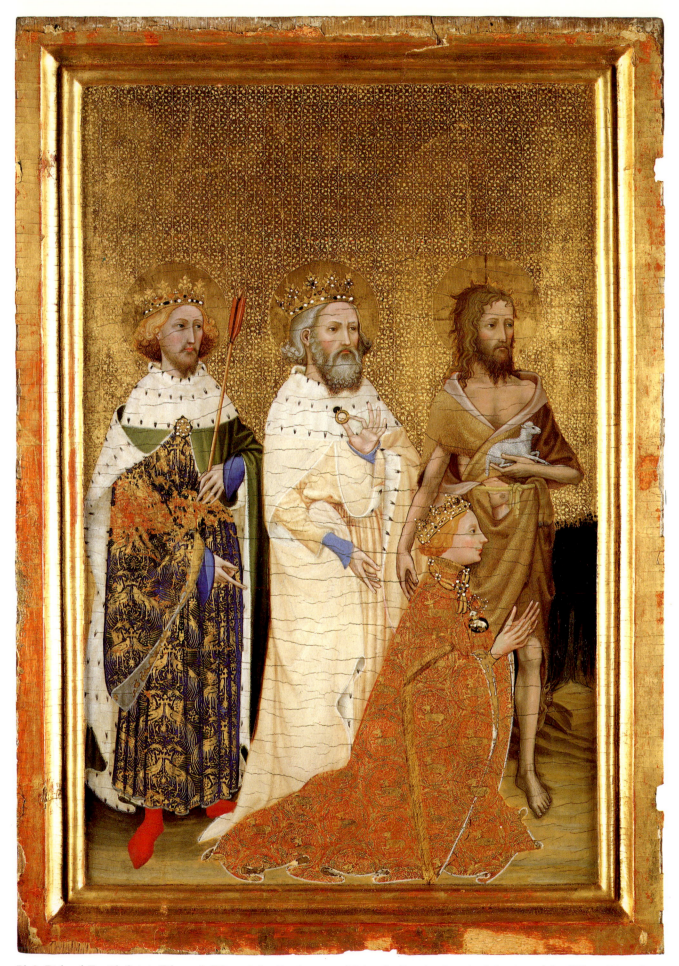

Pl. 2. Richard II with Saints Edmund, Edward the Confessor and John the Baptist. Interior left wing of the Wilton Diptych

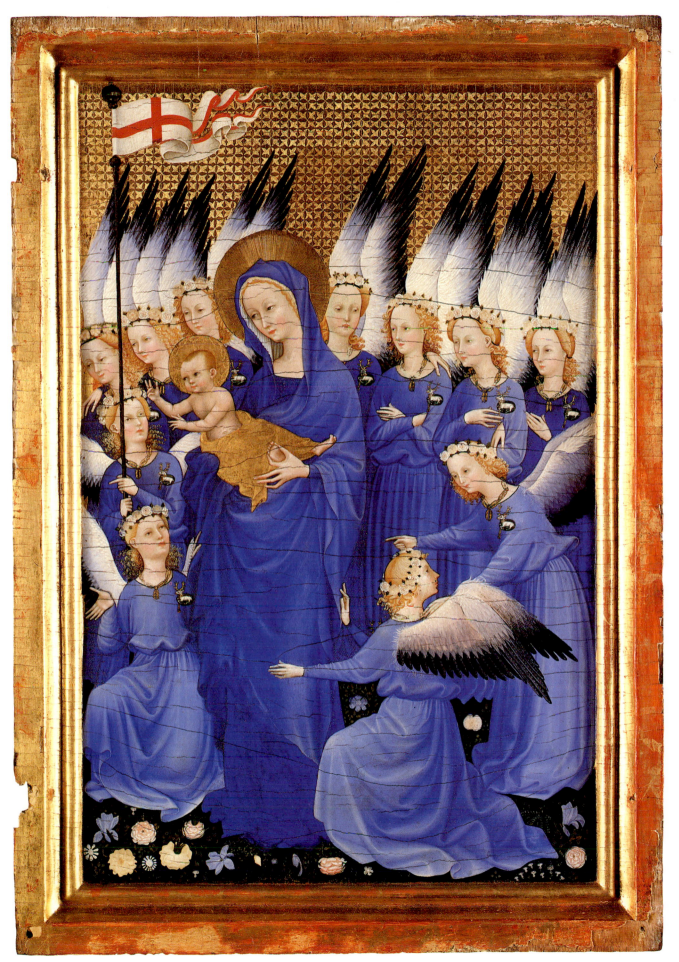

Pl. 3. The Virgin and Child with Angels. Interior right wing of the Wilton Diptych

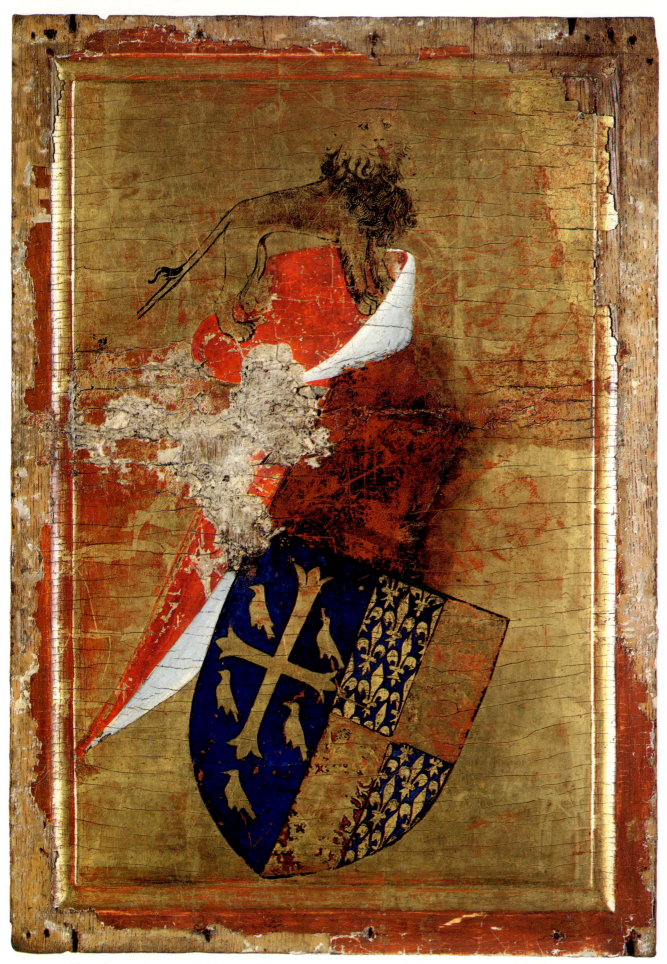

Pl. 4. The royal arms of England and France ancient impaled with the arms of Edward the Confessor.
Exterior right wing of the Wilton Diptych

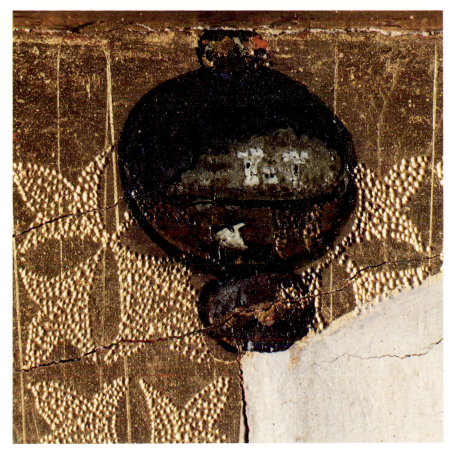

Pl. 5. The orb at the top of the banner in the Wilton Diptych

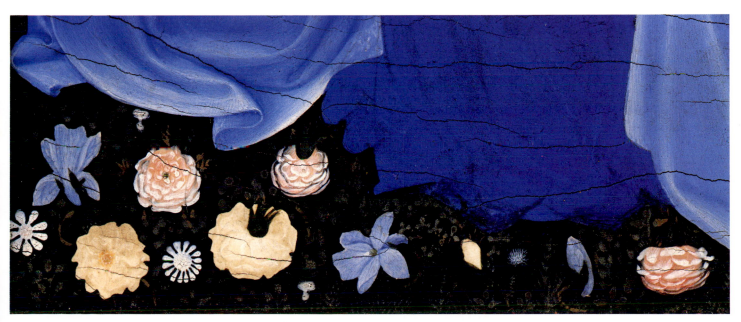

Pl. 6. Detail of flowers strewn beneath the Virgin in the interior right wing of the Wilton Diptych

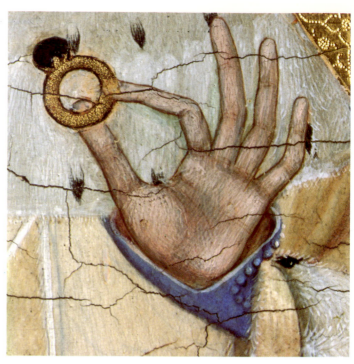

Pl. 7. Detail of St Edmund's brooch.
Interior left wing of the Wilton Diptych

Pl. 8. Detail of St Edward's left hand and ring.
Interior left wing of the Wilton Diptych

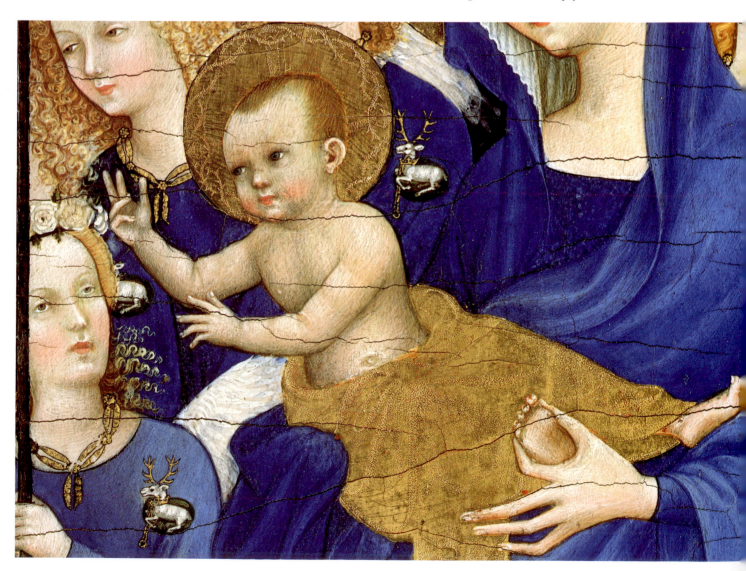

Pl. 10. Design on St Edmund's robe of lapis lazuli untramarine.
Interior left wing of the Wilton Diptych

Pl. 11. The White Hart design on Richard II's robe.
Interior left wing of the Wilton Diptych

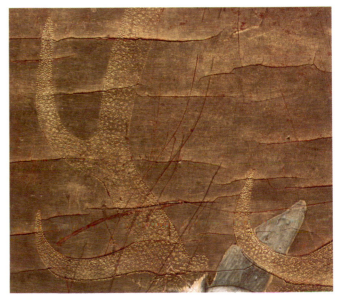

Pl. 12. Stippled gold-leaf floral pattern
on the interior left wing of the Wilton Diptych

Pl. 13. Detail of the Hart's antlers
from the exterior left wing of the Wilton Diptych

Pl. 9. The Virgin holding the Child. Detail of the interior right wing of the Wilton Diptych

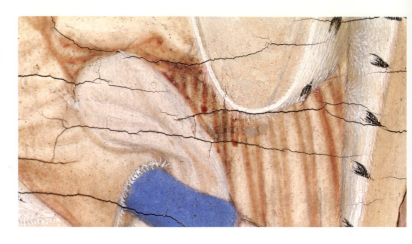

Pl. 14. Detail of St Edward's robe showing how the red lake pigments have faded, lines of brownish-red glaze surviving in the shadows and folds.

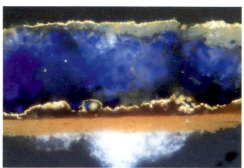

Pl. 15. Cross-sections of paint in the Wilton Diptych

a) Cross-section of mordant gilding from the blue of the shield on the heraldic panel. The lowest layers are the chalk ground, the orange-red bole for water gilding, and gold leaf. Over these are the thick layer of natural ultramarine blue (bound in glue medium) with a thinner greyish-brown mordant (bound in egg) on top. The final layer of gold leaf attached to the mordant layer is also visible. (Magnification 280×)

b) Dark, translucent blue-green paint layer of indigo over gilded background, representing iris leaves on the White Hart panel. The sample is photographed under the microscope from the top surface, and shows the reflection of light from the gold leaf through the paint. A trace of red-brown bole and chalk ground beneath the gold is also visible. (Magnification 210×)

c) Light grey-green of a small leaf, from the foregound of the Virgin and Child panel, lower edge. The paint here just overlaps the gilding on the integral frame. Over the gold leaf is a dense underlayer of charcoal black, followed by a mid-green composed of indigo and orpiment (mineral arsenic trisulphide). The uppermost paint layer is mainly orpiment with a little indigo. (Magnification 425×)

d) Cross-section from the grey paint of the Hart. On the chalk ground there are two layers of paint: a lower light greyish brown composed of white, yellow earth and black, and over this a very pale grey. The paint medium was identified as egg tempera. (Magnification 400×)

VII

ASHOK ROY

The Technique of the Wilton Diptych

THIS CONTRIBUTION concerns itself with the technique of the painting of the Wilton Diptych and what light technical analysis can shed on the origin of the painter and the painting. It is not known when precisely the Diptych was painted nor who painted it. Before the recent physical study,[1] even the fundamental questions of the nature of the support, the character of the ground and the identity of the paint medium of the Diptych were unknown. The medium of the painting is particularly interesting for its connection to a technical tradition from which the Diptych might come. The unusual colour quality and light, matt tone of the paint surface evidently intrigued observers in the eighteenth century when two brass plates were fixed to the lower edges of the frames, one of which bore the inscription 'INVENTION OF PAINTING IN OYLE 1410. THIS WAS PAINTED BEFORE, IN THE BEGINING OF RICD: 2d: 1377'.[2] Horace Walpole's opinion on the subject is mentioned in John Britton's *The Beauties of Wiltshire* when the Diptych was at Wilton House. Walpole's comment is indicative: 'The short quaere would be, with what is the picture in question painted?—To that I can only reply, that it is covered with glass, and is too great a curiosity to have experiments made upon it. It is painted on a bright golden ground, the colours of the utmost freshness and not grown black as *oil-colours* would be...all of which indicate that it is miniature',[3] by which he meant that very likely the Wilton Diptych was painted in gum arabic medium in the manner described by Nicholas Hilliard.[4] In confirmation, Britton also quotes a further description by an artist working at Wilton House, Thomas Phillips, based on his examination of the painting in 1800: '*It is certainly painted in water-colours*, on a gilt ground, which is left in a most ingenious manner for the ornaments of the draperies [the passages in *sgraffito*]'.[5]

In spite of Walpole's injunction, experiments were made on the Wilton Diptych in 1992–93 and the opportunity to resolve some of these questions by technical analysis was afforded by conservation treatment of the painting, arising principally from the need to consolidate loose and flaking paint, ground and gilding. At the same time the opportunity was taken by Martin Wyld, the Chief Restorer at the National Gallery, to remove nineteenth-century oil gilding from the frame mouldings and to clean the painted and gilded surfaces.[6] In conjunction with this treatment a full photographic survey of the picture was made at various degrees of magnification; infra-red reflectograms were recorded and composite mosaics made[7] and new X-ray photographs were taken.[8] The

availability of the painting in the conservation studio allowed the Wilton Diptych to be studied under ideal conditions—with the unaided eye and with the stereomicroscope—and enabled a range of samples to be taken for microscopical and chemical analysis to record the materials and techniques of the painting.

From the results of this examination, the basic structure of the Wilton Diptych is straightforward to describe. The two panels are oak[9] with integral carved frames, linked by original gilded iron hinges;[10] the wood panel surfaces are coated with a white natural chalk ground[11] bound in glue[12] and the backgrounds and frames are water-gilded over red-brown bole. The pigments were determined to have been applied in a medium of whole egg.[13] This summary description is extended in a more detailed record of the results of analysis in Tables 1 and 2 (pp. 133–5).

The method of working in the production of the Diptych can also be summarized briefly. The panels were first coated on both sides with a mat of cut parchment fibres in glue,[14] presumably to strengthen the structure of the wood in a way similar to that in which linen textiles were used to reinforce panels of poplar wood in Italy.[15] The ground of natural chalk in animal glue was laid on and smoothed down when it was dry. The outlines of the principal parts of each composition were incised into the chalk ground with a stylus to indicate the limits of the intended leaf gilding.[16] The compositions, particularly the draperies, faces and hands of the principal figures, were drawn in some detail directly on to the white ground using a fine line, probably of ink, but possibly of metalpoint: perhaps both were used.[17] The next stage was to gild the backgrounds and frames over a thin layer of red-brown bole, burnish the gold leaf and decorate it with very finely worked inscribed lines, punching and stippling. Silver leaf, now tarnished and abraded, was presumably applied at this point over a layer of bole[18] for the helm on the heraldic panel and for part of the small but important detail of the orb at the top of the banner on the Virgin and Child panel.[19] It is evident from examination under the stereomicroscope that the elaborate tooling of the gold leaf was carried out both before and after the painting stage, although the grid ruled to guide the foliate patterns punched into the gilded backgrounds to the Virgin and Child and to Richard was inscribed before painting.[20] The drawing was followed quite closely in the painting stage, except for small modifications to the hands of two of the angels and a general reduction in scale of the broom cod collars and small shifts in their positions and those of the White Hart badges worn by the angels.[21] The late stages would have been the *sgraffito* designs for Richard's cloak and that worn by St Edmund, and the small-scale details executed in mordant gilding[22] such as the broom cod collars, the antlers and the chains of the White Hart badges. Finally came the thin outlining in dark paint and the application of final glazes such as the jewels on the crowns. Also part of the last stage of execution was the use of thick lead white paint to create the pearls which decorate the crowns, St Edmund's jewelled clasp (*col. pl. 7*), and the antlers of Richard's badge of the White Hart (*ill. 55*).

There can be no disagreement that the Wilton Diptych is extraordinarily well-preserved for a panel of its age; but for any painting of great age, in addition to obvious gross forms of damage, certain more elusive changes in appearance are inevitable. It is immediately clear that there is a large loss of paint and ground down to the fibres coating the panel in the heraldic panel[23] and that the silver leaf of the helm on the same panel is totally tarnished and greatly abraded. There is also obvious paint loss in St Edmund's blue and gold *sgraffito* drapery and loss through flaking from the face of the angel immediately to the left of the Virgin (*col. pl. 3*). But as well as the network of age cracks through ground and paint extending over the entirety of the painted parts of the composition, there are other more subtle changes in appearance in the Wilton Diptych which have only emerged recently through close scrutiny of the picture's surface and through microscopic examination of samples. Some of these changes are perhaps worth noting here. They include, on the panel showing Richard II: the bleaching by the action of light of St Edward's once pink robe;[24] a thin layer of surface discoloration in the orange-red vermilion of Richard's *sgraffito* cloak, lending it a duller and browner appearance than it was originally painted;[25] and the loss caused by abrasion and fading of thin yellow-green glazes which were applied in backward sweeping lines on Richard's cloak, which gave the textile an extra layer of modelling when it was first painted (*col. pl. 2*).[26] On the Virgin and Child panel, there is some brown discoloration of green glazes used as the background to the White Hart badges and for the foliage of the angels' chaplets (*col. pl. 3*);[27] there is fading of red lake in the roses, both in the flower-strewn foreground and in the chaplets; and there is blanching and loss of colour in the foliage greens that contain orpiment and indigo (as used also in the foreground of the hart panel and similarly affected).[28] The tarnished condition of the silver leaf of the orb on top of the shaft of the banner is far less obvious than that of the helm on the reverse. On the heraldic panel, there is some darkening of vermilion in the cap of maintenance, although it is not severe. On the panel showing the hart, yellow glazes for the iris flowers over gold leaf have all but vanished,[29] and there is a shift to a more blue-green colour in the branches of rosemary on which the hart rests as a result of loss of the yellow component in the paint layer.[30]

In contrast to these changes, the brilliant blues of the draperies of the Virgin and the angels painted in lapis lazuli ultramarine can be appreciated as substantially unaltered over the course of 600 years. Where it is not abraded by wearing, the burnished gold leaf decorated with punching is also beautifully preserved.

One of the striking characteristics of the Wilton Diptych is its great refinement and meticulously detailed execution. Some of this complexity is revealed only by analytical study of the technique. For example, the painter of the Diptych's use of green is particularly elaborate. In the survey of paint samples summarized in Table 1 (pp. 133–4), there are no fewer than eight distinct methods in the constitution of green paint, when the undermodelling of the flesh in green earth

is included. The other seven examples are for the comparatively large area of St Edmund's green cloak, and the remainder on a small scale for foliage paint constituted to give a wide variety of hues. One of the painter's choices within this array is revealing in its close similarity in technique to foliage greens in fourteenth-century manuscript illumination. An example can be found in D. V. Thompson's translation from a French manuscript dating from the end of the fourteenth century (London, British Library MS Sloane 1754), although this is dependent on earlier sources. The method cited is to make a 'corn flag [*gladium*] green', which requires you to, 'mix orpiment with indigo, put in the shadows with black, and hatch the lights with orpiment',[31] precisely the technique used for some of the foliage on the Wilton Diptych. In the same manuscript, to make a 'colour like French green', the mixture of azurite, white and yellow lake is recommended and this same mixture is found on the branches of rosemary depicted on the hart panel.[32]

Perhaps the most significant finding from the present study has been the identification of the method of flesh painting employed in the Wilton Diptych, which closely mirrors Italian practice of the same period. First came an unmodelled layer of pale bluish-green, based on white pigment mixed with green earth (*terra verde*). This was then covered with fine hatched brushstrokes of pinkish paint simply made from lead white lightly tinted with vermilion. The paint layers were bound in egg tempera. All these features are wholly typical of Italian panel painting practice of the late fourteenth century, which is described in detail in Cennino Cennini's *Craftsman's Handbook*.[33] In Italian panels, of course, poplar would have been used instead of the oak of the Diptych and gesso, that is, calcium sulphate, would have been the ground instead of chalk. Several other features of the technique of the Wilton Diptych correspond closely to Italian methods, for example the *sgraffito* techniques and certain of the pigment choices and pigment combinations, particularly the use of *giallorino* (lead-tin yellow type II)[34] and the greens mixed from azurite with yellow lake (see Table 1).[35] It is reasonable to ask, however, whether the painting techniques noted here are exclusively Italian, or were in fact widespread in European court art. By the nature of the kind of patronage involved, it is reasonable to suppose that itinerant artists would exchange notes on techniques and perhaps also actually exchange their materials as they moved between different centres.

One difficulty in correlating the technique of the Wilton Diptych with that of contemporary panel paintings, other than those produced in Italy, is the comparative rarity of examples and even less commonly published analyses of technique based on scientific methods. Certain conclusions are easy to draw from the present investigation. The use of oak panels coated with natural chalk grounds is distinctively Northern European, while the paint medium and green undermodelling for flesh tones is Southern in its general usage and, ultimately, Byzantine in origin. As more technical results are acquired by reliable methods, it is beginning to emerge that for painting on panel in the fourteenth century the clear division between the use of egg tempera medium in Italy and drying

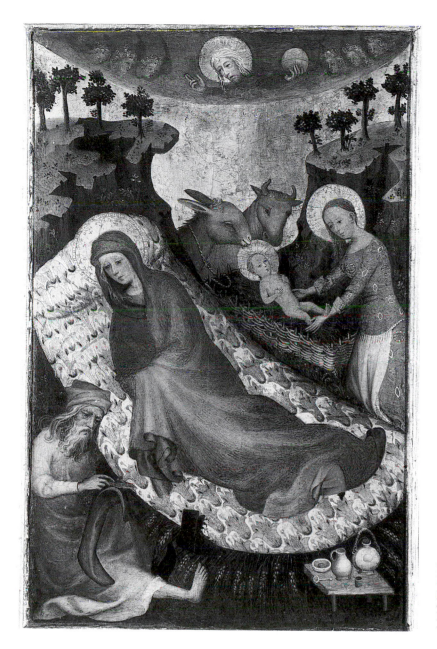

70. *Nativity*.
Interior of a quadriptych,
probably Netherlandish,
c. 1400. Antwerp,
Museum Meyer
van den Bergh

oils in Northern Europe is a considerable oversimplification. It is true that some
of the earliest surviving panel paintings from Northern Europe have been con-
firmed by analysis to have been painted using a pure drying oil technique,
specifically one based on linseed oil. These include provincial works of the mid
and later thirteenth century such as the Norwegian altar-frontals from Tingel-
stad and important and elaborate paintings such as the Westminster Retable,[36]
perhaps datable to the 1280s. There are complications, however. Paintings ex-
ecuted partly in oil, with egg tempera underpaints seem to have been common
in the Netherlands and the Rhineland in the early fifteenth century,[37] but it is
not certain whether this technique developed from an earlier, purer form of oil

129

painting, or one in which the oil medium and egg were combined to make an oil–protein emulsion.[38] Early studies have suggested that a mixed technique may have been used for a small quadriptych of the general scale of the Wilton Diptych dating from *c.* 1400, at one time in Dijon and thought to have been made for Philip the Bold and now divided between Antwerp (Museum Mayer van den Bergh, *ill. 70*) and the Walters Art Gallery in Baltimore. This small painting is probably Netherlandish, or from the Rhineland, and, unusually, has been analysed fully.[39] The panels are oak, but there is no reinforcing layer of linen or of fibres. The grounds are natural chalk but, unlike the paint medium of the Wilton Diptych which is egg, the paint medium is based on linseed oil. There is extensive use of high-quality lapis lazuli ultramarine for the blues. In contrast, also, to the Wilton Diptych, the flesh paints have no green undermodelling; instead the whole composition is worked over a thin *imprimitura* composed of lead white mixed with chalk.[40]

Also comparable in date to the Wilton Diptych, although not in scale, are the painted outer wings of the Dijon Altarpiece, by the Flemish painter Melchior Broederlam, designed for Philip the Bold's Carthusian monastery near Dijon (*ills. 71–72*). Paint samples from these panels have been studied by Leopold Kockaert, who concluded that the medium was mainly proteinaceous and based on egg, although some passages in oil were detected, mainly in red glazes for draperies, and some of the egg tempera paints appeared also to contain an

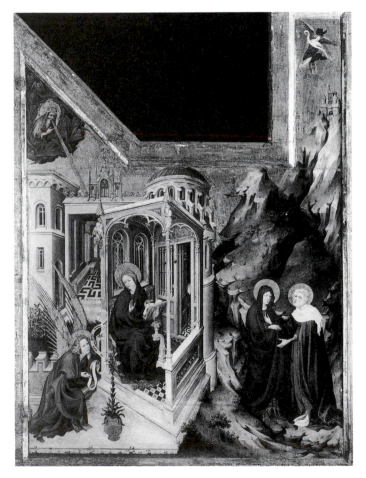
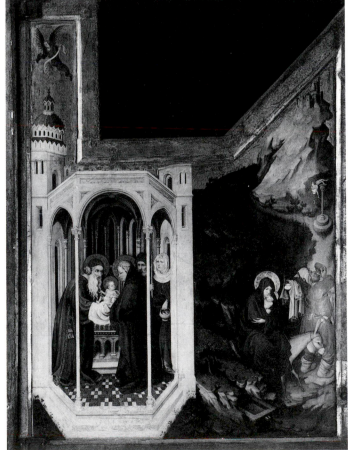

71-72. Melchior Broederlam: *Annunciation and Visitation; Presentation and Flight into Egypt.*
Outer wings of the Dijon Altarpiece. Dijon, Musée des Beaux-Arts

73. Attrib. to Jean Malouel:
Lamentation of the Holy Trinity.
Paris, Musée du Louvre

addition of drying oil.[41] Particularly interesting is the structure of the flesh tones which are underpainted with green, although not green earth, but rather with a green pigment based on copper.[42] Therefore, unlike the painter of the Wilton Diptych, Broederlam was emulating the look of an Italian panel without knowing precisely how the effect was achieved.

Of the few surviving Burgundian works on panel, for example the Louvre Tondo in Paris depicting the Lamentation of the Holy Trinity, perhaps by Jean Malouel (*ill. 73*), the technique, judging from superficial examination, seems

131

remote from that of the Wilton Diptych and although the paint has a semi-matt appearance and hatched brushstrokes which are perhaps attributable to tempera, surface examination of the flesh tones does not betray the use of green undermodelling.[43]

It has been argued that the Wilton Diptych has associations with Bohemian art (see Pujmanová, pp. 247–266),[44] largely because of Anne of Bohemia's marriage to Richard and the presence of her retinue in London. It has been suggested by Dillian Gordon that the elegant and sinuous pose of the Virgin in the painting, and the way she holds the Child's foot, may derive from Bohemian wood or stone polychrome sculpture of the type exemplified by the Krumlov Madonna in the Kunsthistorisches Museum in Vienna (*ill. 166*).[45] Some analytical studies of Bohemian panel paintings are beginning to reach a wider audience, and these suggest the paintings of the period of the Wilton Diptych are very varied in technique,[46] finding connections with both Northern and Southern practice. For example, in Bohemian panels there seem to be two quite distinct techniques in representing flesh: one, where it is modelled over a thin layer of lead white, as in some of the paintings connected with the Burgundian court and those from further North. The second technique is closer to Italian methods, or those from the East, where the flesh is underpainted in tones of green or translucent brown, as in the panels produced by the workshop of the Master of Wittingau.[47] This style was clearly widely exploited since distinctly green shadows for flesh tones are used on a minute scale in fourteenth-century Bohemian illuminated manuscripts.[48] Furthermore, in Bohemia, it appears that egg tempera and oil techniques for painting on panel were being exploited concurrently as early as Master Theodoric's production.[49] The paint was laid over white calcium carbonate grounds, or grey silicaceous primings, on panels reinforced with linen, but using a wide range of wood types as supports and a correspondingly wide range of palette.

The technique of the Wilton Diptych fits none of these models precisely and we may always be compelled to regard it as a unique survivor from a very skilled hand. However, there is now greater interest in the International Court Style than ever and the origins of the painting techniques employed that produced the highly refined effects involved. These questions form a central part of our understanding of the technical development of European painting on panel and the Wilton Diptych demonstrates decisively the international character of painting practice at the end of the fourteenth century.

Table 1: The Pigments used in the Wilton Diptych

Richard II with Saints Edmund, Edward the Confessor and John the Baptist

White of St Edmund's cloak:	lead white
Green of St Edmund's cloak:	azurite, yellow lake, white and some yellow ochre
Scarlet of St Edmund's buskins:	vermilion
St Edmund's blue *sgraffito* gown:	lapis lazuli ultramarine with white
Pink of St Edward's cloak and gown:	red lake with white; shadows of pure red lake
Green underpaint for flesh of St Edward's hand:	green earth (*terra verde*) with lead white
Flesh paint:	lead white with vermilion
Orange-red of Richard's cloak:	vermilion (discoloured at surface)
Thin yellow-green glaze on Richard's cloak:	not identified, perhaps a lake (contains copper)
White 'pearl' decorations:	lead white
Blackish-green foliage of background forest:	yellow ochre over charcoal black

The Virgin and Child with Angels

White of angel's wing:	lead white
Cool grey of angel's wing:	white, ultramarine and black
Draperies of the Virgin and angels:	lapis lazuli ultramarine with white
Flesh paint:	vermilion with white over underpaint of green earth mixed with white
Green glazes on angels' chaplets and White Hart badges:	translucent pigment based on copper (perhaps 'copper resinate')
Red of banner:	vermilion
Dark brown of sea within orb:	degraded silver leaf
Black background for foliage:	charcoal black
Pale pink roses, foreground:	faded red lake
Grey green foliage scattered in foreground:	mineral orpiment (faded) with a little indigo over orpiment combined with a higher proportion of indigo.

Table 1 (continued)

The White Hart (exterior of left wing)

White body of hart:	lead white
Grey shadow on hart's haunch:	lead white over warm grey of white, black and yellow ochre
Yellow glaze of iris flowers over gold background:	yellow lake (calcium-containing substrate)
Dark green glaze of iris leaves:	indigo glaze over gold leaf background
Black background for foliage:	charcoal black
Pale pink flowers, foreground:	red lake (faded) with white
Blue-green of branches of rosemary:	azurite, white and yellow lake
Yellow-green fern, lower left corner:	lead-tin yellow 'type II' (*giallorino*), white and azurite
Grey-green foliage scattered in foreground:	mineral orpiment (faded) with a little indigo, over orpiment combined with a higher proportion of indigo

The Royal Arms of England and France (exterior of right wing)

Black of lion's mane:	finely-ground carbon black pigment
Scarlet of cap of maintenance:	vermilion
White of cap of maintenance:	lead white
Grey of cap of maintenance:	lead white over warm grey of white, black and yellow ochre
Black of helm:	degraded silver leaf
Blue background to shield:	lapis lazuli ultramarine
Brown of mordant gilding on shield:	contains lead white and yellow-brown ochre
Red background to lions:	red lake
Black outline on shield:	finely-ground carbon black (probably charcoal)

Table 2: Medium Analysis of the Wilton Diptych[13]

Richard II with Saints Edmund, Edward the Confessor and John the Baptist

1. St Edmund's green cloak	Egg
2. White of angel's wing	Egg
3. Deep blue of angel's drapery	Egg
4. Greenish-black foliage, bottom edge	Egg

The Virgin and Child with Angels

5. Greenish-black foliage, edge	Egg

The Royal Arms of England and France (exterior of right wing)

6. Red glaze over gold on shield	Egg
7. Blue of fleurs-de-lis design	Egg
8. Mordant for gold from fleurs-de-lis	Egg
9. Black paint from outline of lion	Egg

74. *Mary de Bohun before the Virgin and Child*. Bohun Psalter and Hours.
Oxford, Bodleian Library, MS Auct. D. 4. 4, f. 181v

VIII

LUCY FREEMAN SANDLER

The Wilton Diptych and Images of Devotion in Illuminated Manuscripts

IMAGES OF A CHRISTIAN WORSHIPPER before the object of his or her devotion—the Deity, the Virgin, a saint—are such commonplaces of medieval art that we have long since forgotten just how great an imaginative leap such conjunctions of the human and the holy represent. Giving visible form to the Deity or a holy being is familiar from the art of Greece and Rome as are representations re-enacting religious sacrifice, but literally putting the worshipped and the worshipper together in the picture is, it seems to me, an innovation of the Middle Ages. The conjunction of a sacred and a human being raises a number of questions of interpretation and purpose. What, for instance, does the worshipper shown in the image 'see'—the object of worship miraculously materialized, or a simulacrum, that is, an icon, or the depiction of an image in the mind, visually realized for the benefit of the viewer of the work of art? And what was the purpose of such works of art in any case? Were they records of devotion, surrogates, perpetual memorials, in other words, were they autobiographical, showing something about the worshipper, or did they carry messages to the viewer, either the worshipper represented in the image, or others?[1]

While these questions relate to the Wilton Diptych, in Northern Europe up to almost the middle of the fifteenth century the materials for their consideration come primarily, not from panel paintings, but from illuminated manuscripts. Consequently, this contribution is intended to 'surround' the Wilton Diptych with images of religious devotion drawn from manuscripts. Consideration of such features as figural relationships, poses, gestures, attributes, and setting in representations of religious devotion from fourteenth- and early fifteenth-century manuscripts of various origins may broaden the context in which we view the Wilton Diptych and enrich our understanding of its meaning.

Many representations of religious devotion in manuscripts are on pages with text and historiated initial letters. Such pages offer a wide range of possibilities for positioning the worshipper in relation to the object of devotion. Quite typical is the placement of the person in prayer outside the frame of an initial whose field is filled with the image of the Deity, as in the Psalter of Stephen of Derby, a book of the third quarter of the fourteenth century (ill. 75).[2] Stephen, an Augustinian Canon of the Cathedral Church of the Holy Trinity, Dublin, in near

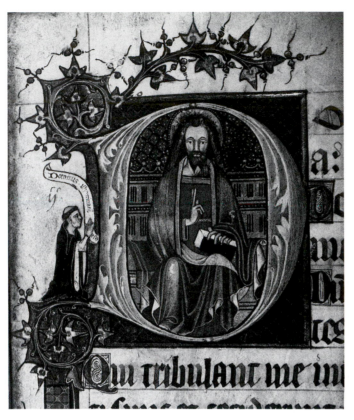

75. Initial D with Stephen of Derby in prayer before the Deity. Psalter of Stephen of Derby. Oxford, Bodleian Library, MS Rawl. G. 185, f. 20

profile, is barred literally from the much larger, fixed and iconic image of the Lord, who issues a universal, impersonal blessing, as if completely unaware of the petitioner. Illustrations of this sort suggest that the depiction of the Deity corresponds to a mental image, an image both aroused by and giving reinforcement to the adjacent words of the text of Psalm 26: 'The Lord is my light and my salvation, whom then shall I fear?'

The line between worshipper and object of worship can be breached however even when the worshipper is outside the initial frame. For example, Matins in the Bohun Hours now in Copenhagen, datable to the 1380s (*ill. 76*), begins with an initial of the Annunciation.[3] In a cutaway tower to the left of the initial, Mary de Bohun, wife of the future Henry IV, clad in the arms of England and Bohun, kneels at a prayer-stand with hands resting on an open book; across the transparent frame of the initial, with its armorial background, in a similar crenellated setting, is the seated Virgin, herself resting a hand on an open book as she acknowledges the announcement of the Angel. The figures are linked by gesture, by activity, and by setting.

The worshipper may be also enclosed in an initial separate from but in proximity to a framed miniature. The paired initial and miniature from Sext of the Hours of the Holy Spirit in the early fifteenth-century *Grandes Heures* of Jean, Duc de Berry (*ill. 77*),[4] shows him twice, once below in the initial where his guardian angel urges him with a gesture to gaze upward, beyond the initial into the miniature, where he can see his own future reception at the Gate of Heaven

138

76. Initial D with Mary de Bohun in prayer before the *Annunciation*. Bohun Hours. Copenhagen, Kongelige Bibliotek, MS Thott. 547.4[0], f. 1

77. *Jean de Berry received in Paradise*; (below) *Jean de Berry and his guardian angel*. *Grandes Heures* of Jean de Berry. Paris, Bibliothèque Nationale, MS lat. 919, detail of f. 96

by St Peter. As in the Copenhagen Hours, the miniature frames an event, but here it is an event in which the worshipper imagines himself to play a major role.

When manuscript images of religious devotion are painted on pages without text, as for instance on frontispieces, or within miniature cycles, differentiation of the space of the worshipper and the space of the object of devotion sometimes occurs, just as on pages with illustrations in margins and in the text. The frame of the miniature encloses the sacred figure and the page-margin beyond is the arena of the human worshipper, as for example, in the miniature of the Agony in the Garden in the Taymouth Hours of the second quarter of the fourteenth century (*ill. 78*).[5] An early fifteenth-century counterpart is a miniature attributed to Hermann Scheerre depicting worshippers and the Annunciation in the Beaufort Hours in the British Library (*col. pl. 17*).[6] But in contrast to the simple fourteenth-century pattern of separation and parallelism in the Taymouth Hours, the presentation of the Scheerre miniature is subtle and complex. Within an octagonal stone structure evoking the Temple in Jerusalem the angel's salutation spirals upward on a scroll while the Virgin's response is legible on the pages of her open prayer-book. The angel has just alighted, so to speak, a bit of his robe overlapping the forward edge of the architectural enclosure. The two worshippers are on either side, clearly in the margin since they kneel amidst decorative foliage. Nevertheless, at the same time the marginal plane is transformed into a space, a kind of antechamber. The human worshippers are posed as privileged spectators at the event within the frame, although they 'see' with mental, contemplative vision, their physical eyes focused outward, away from the angel and the Virgin. But the couple is also joined with the Virgin in devotion through the repetition of the book resting open on the prayer-stands of all three figures.

Very much like the miniature in the Beaufort Hours is another painting attributed to Scheerre from a Book of Hours in the Bodleian Library, Oxford, showing a couple in devotion before the Transfigured Christ (*ill. 79*).[7] Within the miniature frame is a green ground area with black tufts and a deep blue 'sky' in which an equally blue apparition of Christ surrounded by a golden linear radiance floats above the heads of the worshippers. The worshippers kneel below the miniature, in the space of the margin, and their positions suggest that the image they are venerating is not only above but also behind them, seen—as before—not with physical but with mental eyes. Nevertheless, the barrier between human and Divine has been reduced in a remarkable way since the orange miniature frame has only three sides, like a doorway—an opening into the sacred world. Above, the speech scroll of the Lord says 'He who sees Jesus sees also the Father; I in the Father and the Father in me and the Holy Spirit proceeding from both' and the response of the couple below, 'Blessed be the holy indivisible Trinity and its mercy',[8] form a verbal link echoing the spatial link between the two parts of the picture.

Conjunction between worshippers and the objects of their devotion that involves placement of figures in the page-margins is the special province of book

78. Worshippers below the *Agony in the Garden*.
Taymouth Hours. London, British Library,
MS Yates Thompson 13, f. 118v

illustration. Many fourteenth- and early fifteenth-century manuscript images of religious devotion however are entirely contained within frames, either initial frames or miniature frames. An example of the first is the pair of worshippers in the Matins initial of a Book of Hours of the 1380s in Keble College, Oxford (*ill. 81*).[9] Although jammed together with the enthroned Virgin and Child, the man and his wife are separated from them physically by their speech scrolls, which carry the words, 'Mother of God, remember me'.[10] Close as the figures are physically, metaphorically these scrolls carry the words of adoration to a being beyond human grasp.

As for images of devotion in framed miniatures, if there is a standard format, it comprises a kneeling worshipper, often a prayer-stand with an open book, and the sacred being, which, since most such images are associated with Hours of the Virgin, is a seated, or less often standing figure of Mary with the Christ Child. Yet within the formulaic a wide range of conjunctions and interactions can be detected, and it is the study of these that provides a background to such unique representations as the one in the Wilton Diptych. Four variants of the end of the fourteenth and the beginning of the fifteenth century may serve as cases in point. The first example is a Book of Hours in the Bodleian Library in which the woman in prayer wears a chaplet (*ill. 82*).[11] Her body turns outward

141

79. Worshippers before the *Transfigured Christ*.
Book of Hours. Oxford, Bodleian Library,
MS Lat. liturg. f. 2, f. 2v

80. Worshipper before the *Virgin and Child*.
Carew-Poyntz Hours, Cambridge,
Fitzwilliam Museum MS 48, f. 86

toward the viewer, as does the prayer-stand with its open book; the Virgin,
enthroned axially and frontally, is behind the worshipper, and she and the Child
are absorbed in each other, as their poses and gestures show. The Virgin is
literally the image 'at the back of the mind' of the woman. Despite its frame,
because of the pose and placement of the woman, the image is not self-con-
tained; it depends for completion on a viewer, the worshipper herself perhaps,
who is identical with the reader of the words of the adjacent text, that is, the
owner of the book.

The second example is a miniature of *c.* 1390 in the Carew-Poyntz Hours in
the Fitzwilliam Museum, Cambridge (*ill. 80*), a manuscript whose illustration
was executed over a period of nearly a hundred years, starting around the
middle of the fourteenth century.[12] At the opening of Matins a nobly-dressed
woman, this time without prayer-stand or book, kneels to the left and in front
of the frontal bench-throne of the Virgin. Again, the worshipper is posed at an
oblique angle so that her head and body face outward, but here both the Virgin

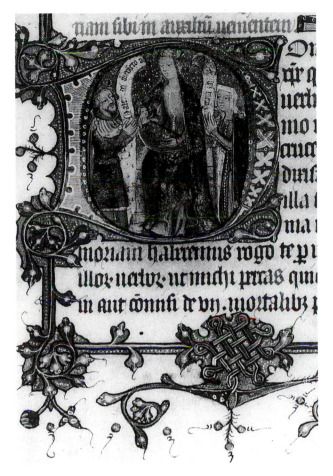

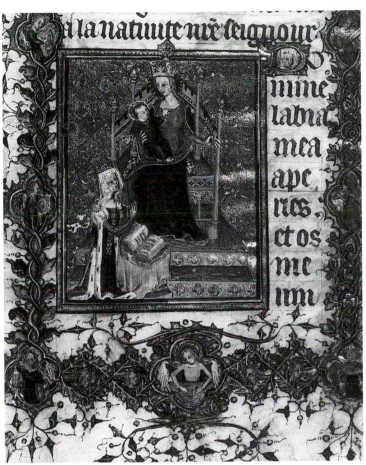

81. Initial D with Worshippers
before the *Virgin and Child*. Book of Hours.
Oxford, Keble College, MS 47, f. 9

82. Worshipper before the *Virgin and Child*.
Book of Hours. Oxford, Bodleian Library,
MS Laud Misc. 188, f. 1

and the Christ Child 'see' the woman, and in a remarkable twist, the Child, reclining comfortably against the Virgin's right arm, turns his head and his arm to bless the supplicant.

The third example is the Bohun Psalter and Hours in the Bodleian Library, a manuscript of *c.* 1380 containing a Matins miniature showing Mary de Bohun, again in the heraldic garments of England and Bohun, presented to the Virgin by her personal saint, Mary Magdalene, identified by her characteristic unguent jar (*ill. 74*).[13] Both Mary de Bohun and her saint are oblique in pose, but this time Mary's scroll, with the words 'Have mercy on me Son of God', curves upward toward the standing Christ Child, who bends down to catch the coiled end in his hand, and the Virgin herself has turned her entire body toward the worshipper. This miniature typifies precisely the 'imaginative leap' that gives a tangible form to the communion between human and sacred beings.

The final example is the Nevill Hours of the early fifteenth century, now in Berkeley Castle, Gloucestershire, with one of the very rare late fourteenth- or

143

83. Worshipper before the *Virgin and Child.*
Nevill Hours. Gloucestershire,
Berkeley Castle, f. 7v

early fifteenth-century English depictions in a Book of Hours of a male wor-
shipper before the Virgin (*ill. 83*).[14] Strictly speaking the miniature falls into the
pattern discussed earlier, where the worshipper is outside the frame of the
miniature, since it should be noted that the cushion on which he kneels overlaps
the border. In other ways the image is quite similar to those in the Carew-Poyntz
Hours or the Bohun Hours in the Bodleian, if however more intense in the focus
of the sacred beings on the worshipper. Both the Virgin and her draped bench
are turned toward the supplicant, and the Christ Child almost crawls out of the
Virgin's lap in eagerness to bless the man. He is seen, and the image serves as
proof, even though, with his eyes lifted upward, he cannot 'see' in a physical
sense.

These English miniatures of the late fourteenth and early fifteenth century
represent a kind of private religious devotion far removed from the courtly
ceremonial of the Wilton Diptych, in which the worshipper is backed by saintly
supporters and the Virgin surrounded by angels. Nevertheless, in one way

144

Richard's relation to the Virgin, the object of his devotion, is far more private and intense than anything we have discussed up to now, and this is manifested in his pose. Unlike all the English manuscript examples cited, Richard kneels in what would be called a pure profile, every part of his body—head, hands, torso and legs—aligned perfectly parallel to the picture plane. He literally cannot 'see' anything but the Virgin and Christ, and the only echo of the conventional pose of the worshipper, in which the glance is outward, if anywhere, toward the viewer of the image, is that Richard's head is not lifted up toward the larger-than-life holy figure. Thus there remains the implication that the Virgin is a mental apparition.

Now what is the pedigree of Richard's pose? Profile worshippers certainly appear in Italian panel painting in the early fourteenth century, as in Simone Martini's work of *c.* 1317 showing St Louis of Toulouse crowning Robert of Anjou.[15] In the North, one striking manuscript example occurs as early as the 1360s, the miniature for Psalm 109 in the Breviary of Charles V (*ill. 84*).[16] There, the profile kneeling monarch is invited by the Lord to sit at his right hand, a literal illustration of the opening words, 'The Lord said to my lord, sit thou at my right hand' an image extraordinary in interpreting the text not in relation to the biblical King David but the contemporary King Charles, perfectly recognizable by his physiognomy.[17] By the late fourteenth century, profile worshippers are not rare in Northern European manuscript images outside England: the *Petites Heures* of Jean, Duc de Berry, painted over an extended period from about 1375 to 1385, has numerous examples (*ill. 85*).[18]

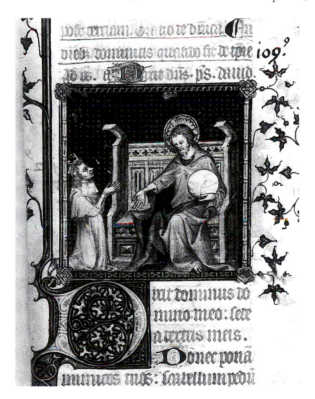

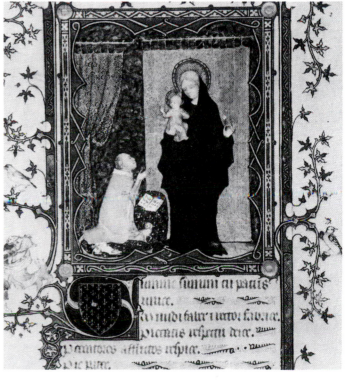

84. *Charles V in prayer before the Deity.*
Breviary of Charles V. Paris,
Bibliothèque Nationale, MS lat. 1052, f. 261

85. *Jean de Berry before the Virgin and Child.*
Petites Heures of Jean de Berry, Paris,
Bibliothèque Nationale MS lat. 18014, f. 97v

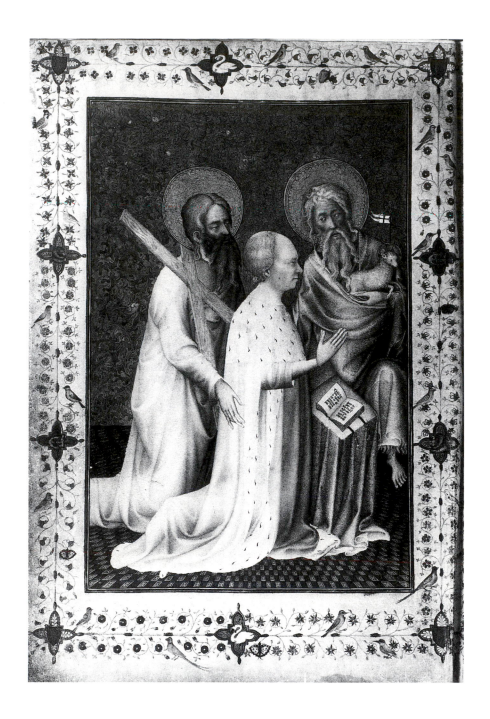

In the most frequently cited manuscript parallel to the Wilton Diptych—that is, the facing miniatures of Jean de Berry and the enthroned Virgin and Child inserted in the Brussels Hours[19]—the donor kneels in a virtually identical profile pose, even to the angle of his head (*ill. 86*). The 'meaning' of this work, however, does not go beyond the conventional: there is a respectful distance between the solemn figure of the Duc de Berry and the Virgin and Child, who are sheltered

within the high sides of the throne; the profile Child, much as he faces the donor, concentrates on nursing at the Virgin's breast and writing on the scroll; it also seems worth noting that the saints, who do present Jean de Berry to the Virgin with caring gestures, kneel before her just as he does. In fact, the very parallels with the Wilton Diptych call attention to the contrasts: the highly personal character of the painted panels; the uniqueness of Richard, the only entirely

147

86-87 (*left and above*). *Jean de Berry presented to the Virgin and Child by Saints John the Baptist and Andrew.*
Très Belles Heures de Jean de Berry. Brussels, Bibliothèque Royale, MS 11060–61, pp. 10–11

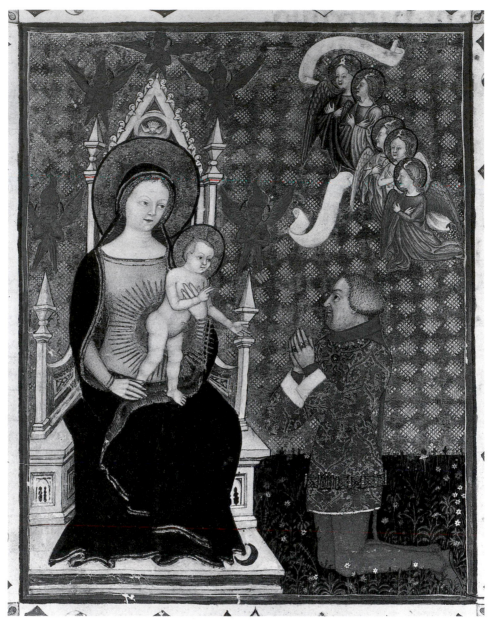

88. Worshipper before the *Virgin and Child*. Lombard Hours and Missal.
Paris, Bibliothèque Nationale, MS lat. 757, f. 109v

profile figure, to whom all the intercessors in the foreground plane are pointing,
not just the saints on the left but the angels on the right as well; the acknow-
ledgement of Richard by the Virgin and especially the Child; of course, the
profusion of personal and national emblems and devices; and finally, the com-
plete differentiation of the settings of the two parts of the Diptych.

Where is Richard in the Wilton Diptych and where is the Virgin? For many
manuscript images of devotion this question does not really arise; when the
image is in the context of a prayer-book, it is no surprise to find that the

worshipper is shown in the physical context in which prayer takes place, a room, a private chapel.[20] But Richard is, as has been often observed, in an earthly 'wasteland' and the Virgin is in Heaven.[21] The desert setting carries associations with the Last Days, the end of earthly time, and the Resurrection of the Dead,[22] and, it might be noted, it also suggests the desert in which Richard's personal saint, John the Baptist, preached.[23] The flower garden denotes not only Paradise, but is a setting particular to the Virgin (see Fisher, p. 155).[24] Occasionally, manuscript images show the worshipper together with the Virgin in such a garden setting, as in the Lombard Hours and Missal of the 1380s now at the Bibliothèque Nationale, made for an individual in the circle of Giangaleazzo Visconti (*ill. 88*).[25] In this case it is fairly certain that the worshipper has not already joined the Virgin in Paradise; the setting instead suggests that his present devotion to the Virgin has elicited her favour—an invitation to enter her special domain.

Occasionally too, manuscript images of religious devotion are set in empty desert landscapes, where again the setting pertains to the object of devotion, as in the miniature from the Prayer-Book of Bonne of Luxembourg of the 1340s that shows Bonne and Jean le Bon before the Crucified Christ (*ill. 89*).[26] But a similar setting may also carry a meaning relevant to prospective death and future salvation of the worshipper. In the *Très Belles Heures de Notre Dame*, made for Jean, Duc de Berry, either between 1380 and 1390 or between 1404 and 1407,[27] the prayer to the Virgin and St John the Evangelist, '*O intemerata*', is illustrated with a *bas-de-page* scene of Jean de Berry kneeling on bare ground before a

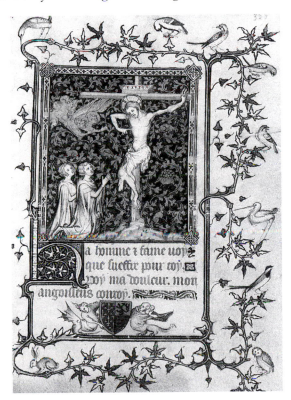

89. Jean le Bon and Bonne of Luxembourg
before the Crucified Christ.
Prayer-Book of Bonne of Luxembourg.
New York, The Metropolitan Museum of Art,
The Cloisters, Inv. 69.88, f. 329

149

90. *Jean de Berry before a Vision of Heaven. Très Belles Heures de Notre Dame.*
Paris, Musée du Louvre, Cabinet des Dessins, RF 2024 (f. 4), *bas-de-page*

91. *Giangaleazzo Visconti received in Heaven.* Eulogy of Giangaleazzo Visconti.
Paris, Bibliothèque Nationale, MS lat. 5088, f. 1

radiant, cloud-circled Vision of Heaven, in which John the Baptist and the Virgin call the attention of the Deity to the supplicant (*ill. 90*).[28] In the miniature illustrating the prayer to his guardian angel in the *Petites Heures*, Jean de Berry's guardian angel leads him through a rough, empty landscape, undoubtedly visualizing his future passage from earth to Heaven.[29]

Protecting and interceding saints and angels, such a prominent feature of the Wilton Diptych, are found in various forms in fourteenth- and early fifteenth-century manuscripts. Mary Magdalene and Mary de Bohun in the Bodleian Hours have already been noted, for example, but two further examples, each as striking in its own way as the Wilton Diptych, warrant consideration. The first is Michelino da Besozzo's illustration of the text of the eulogy given at the funeral of Giangaleazzo Visconti in 1402 (*ill. 91*).[30] It shows Giangaleazzo kneeling in pure profile, head bowed, hands clasped in prayer before the seated Virgin, who holds the Christ Child, blessing and placing a crown on Giangaleazzo's head. The event takes place in Heaven, a setting indicated by a host of monochrome angels whose wings form a semicircular arc, and an outer ring of larger angels holding standards and a shield all with Visconti armorials. Immediately surrounding Giangaleazzo and the Virgin are twelve female personifications of his virtues, which were eulogized in the funeral oration. As in the Wilton Diptych, the angels—and the virtues—are enlisted as supporters or attendants of a human master at the Heavenly Court. Of course, Giangaleazzo has already been received in Paradise; Richard's way is being prepared so to speak by his angels, but his entrance lies in the future.

A second example is from the Hours of Maréchal de Boucicaut in the Musée Jacquemart André in Paris, a work of the first decade of the fifteenth century.[31] The miniature (*ill. 92*) shows the Adoration of the Virgin and Child by the Maréchal and his wife. Above, is a celestial Vision of the Virgin of the Apocalypse, with solar radiance and silver crescent moon, accompanied by half-length angels holding shields formerly painted with the Boucicaut arms, and below, a rich, worldly setting, with the Maréchal and his wife, and, by another of those imaginative conjunctions of human and holy, the guardian angel of the Maréchal, who serves as his *valet d'armes*, holding his helmet and his standard, its waving pennant raised up into the heavenly half of the composition. Millard Meiss pointed out that the armorial profusion of this miniature was intended to proclaim the military prowess of the man who was the Marshal of France and the noble connections he had attained through his marriage with Antoinette de Turenne. Meiss went on to say however that 'Not even kings were wont to invoke angels as personal pages...to dress them in their colours'.[32] Ironically, no more apt description of the Wilton Diptych angels could have been written.

But although the angels in the Wilton Diptych wear the retainer's badge of the White Hart, the standard carried by one of their company bears not the personal arms of Richard but the red cross that is a national symbol and represents at the same time the symbol of the Resurrection of Christ (see also Morgan, pp. 179ff., for a different view). As we know, the banner of St George became

151

92. *Maréchal de Boucicaut and his wife before a Vision of the Virgin of the Apocalypse.*
Boucicaut Hours. Paris, Musée Jacquemart André, MS 2, f. 26v

increasingly popular as a symbol of England during the reign of Richard II,[33] and the placement of England under the protection of the Virgin is certainly one of the central themes of the Wilton Diptych. I know of no manuscript analogues to the motif of the national standard under the protection of the Virgin, but the idea of England as the *dos Mariae*[34] is not unknown in manuscripts, although in a different form. In his discussion of a Psalter of 1325–35 in the Bodleian Library, Jonathan Alexander made the important observation that the initial for Psalm 119, which shows a man clothed in the damaged arms of Montreuil against a background divided quarterly by the arms of England and France (*ill. 93*), may represent Edward III, who was Lord of Montreuil in Normandy, and Alexander further noted that the Virgin adored by this figure holds a bird-topped rod, one of the insignia of the rulers of England.[35] We can conclude that this image represents the Virgin as the protector of the realm, and even further, we may venture to interpret the man's open hands as a gesture of offering, like that of Richard II in the Wilton Diptych.

An echo, or a reprise of the idea of the Virgin as the protector of England is found in a fifteenth-century addition to the mid fourteenth-century French Hours of Jeanne II of Navarre, the addition possibly made for Catherine, wife of Henry V.[36] The miniature (*ill. 94*) shows a queen with a kind of crown-cum-

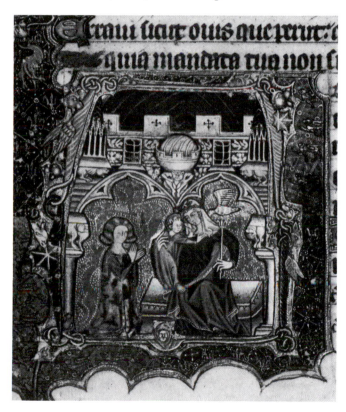

93. Edward III before the *Virgin and Child.*
Psalter, Oxford, Bodleian Library MS Douce 131, f. 126

halo wearing a garment once decorated with the arms of England, now in a very damaged condition. Behind her is a framed image in two sections, earth below, and above, the Trinity and the Virgin and Child enthroned jointly in Heaven. Prominently silhouetted against the gold background is the white bird-finial of the Virgin's rod. The miniature thus restates an idea of English kingship cherished by Richard II, and it is a humble though significant token of its survival into the time of Henry V, the ruler who restored the honour of his deposed predecessor.

The Wilton Diptych is a self-contained painting, not a manuscript miniature that must be understood in relation to a written text. Consequently, the Diptych could be discussed in the context of the altarpiece. But large altarpieces often belong to institutions, not individuals, and the images of individual worshippers they include represent donors, not owners. The Wilton Diptych, as a portable altarpiece, does not fit into this mould. It is closer to manuscript miniatures than to public altarpieces; its scale suggests personal use; and we have seen how its components have analogues in images that are inserted in devotional texts, even Richard's gesture of offering rather than supplication. So when this Diptych was opened on an altar in a small chamber, whether the Chapel of Our Lady of the Pew in Westminster Abbey, or elsewhere,[37] it served to focus Richard's own meditation, to re-enact his devotion, whether he was present or not, to proclaim to himself the certainty of his prospective welcome in Heaven, and finally, to reinforce his idea of earthly kingship under heavenly protection.

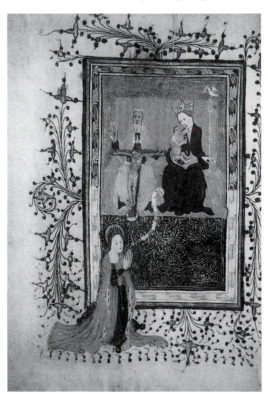

94. Queen of England before the *Trinity and the Virgin and Child.* Hours of Jeanne II de Navarre. Paris, Bibliothèque Nationale, MS nouv. acqu. lat. 3145, f. 3v

IX

CELIA FISHER

A Study of the Plants and Flowers
in the Wilton Diptych

T HE WILTON DIPTYCH is an early example of paintings that depict the
Virgin among flowers, a setting associated with Paradise. The word 'para-
dise' originated when the kings of ancient Persia enclosed for themselves park-
lands and orchards. The association of gardens and Heaven was always close
for people surrounded by desert; the biblical Garden of Eden derived from the
same tradition. In the course of its development between garden and holy place,
the name 'paradise' was also given to the forecourt or atrium of the Early
Christian basilica. This was often planted as a garden, and so in time any small
cloister garden used for meditation and to provide flowers for the church could
be a paradise.[1]

The Netherlandish artist Melchior Broederlam, whose Dijon Altarpiece (*ills.
71–72*) dating from the 1390s is contemporary with the Wilton Diptych, also
placed the Virgin in a garden setting. The painted wing of the Annunciation
shows Mary in a retreat which seems to be a blend of chapel and garden
pavilion, and the tiny herber with its rose hedge and flower-strewn grass may
well be a paradise on which her eyes rest when she raises them from reading.
Another way in which Broederlam's Dijon Altarpiece is close to the Wilton
Diptych is in creating a strong contrast between the Virgin's paradise and the
outside world. Richard, although surrounded by saints and obviously in com-
munion with the Virgin, is still set in a hard barren world. Similarly in Broeder-
lam's painting the Annunciation is contrasted with the Visitation where Mary
sets out to meet her cousin Elizabeth, mother of John the Baptist, and they are
placed in a bare rocky landscape signifying the everyday world.

There is also a possibility that the symbolism of the Virgin in a garden, which
became such a popular theme with painters of the fifteenth century, especially
in the Netherlands, had to do with the *hortus conclusus* of her virginity. Rupert
of Deutz, in about 1120, first analysed the Virgin birth in terms of the *hortus
conclusus* and *fons signatus*, and by the fifteenth century when the cult of the
Virgin was at its height, devotional hymns and commentaries, including the
Latin liturgy for 15 August, the Feast of the Assumption, often compared her to
the new Eve, offering the apples of redemption in a garden where there was no
sin.[2] Medieval symbolism was often multi-layered, and the *hortus conclusus* was
probably part of the association, but perhaps not the main one. In Broederlam's

155

Annunciation the tiny garden is enclosed, although Mary is not actually in it, and neither is the lily symbolizing her purity, which is placed more prominently in a vase.

In the Wilton Diptych the garden is so crowded, albeit with angels, that it becomes harder to interpret it as a *hortus conclusus*. Other early examples showing the Virgin among flowers, all approximately dated to the 1420s or 1430s, too late to have influenced the Wilton Diptych, nevertheless show similar concepts being used by artists in different countries. The Milanese Stephano da Zevio's painting of the Virgin and Child in a Rose Garden (Verona, Museo di Castelvecchio) shows a thickly hedged garden more definitely enclosed than in the Wilton Diptych but likewise bustling with angels. A close follower of the Netherlandish artist Robert Campin, possibly copying a lost original by his master, depicted the Virgin and Child in a Garden with Saints (Washington, National Gallery of Art, *ill. 95*). It is certainly enclosed, and its high walls and gothic doorway could represent a real little paradise garden attached to a monastery or church, but again it is crowded with other figures besides the Virgin. The anonymous Rhineland Master of the Paradise Garden (Frankfurt, Städelsches Kunstinstitut), included female saints, the Archangel Michael and even devils. In all these paintings the associations with Paradise appear to be stronger than with the *hortus conclusus*.

95. Follower of Robert Campin: *Virgin and Child in a garden with Saints.*
Washington DC, National Gallery of Art

96. Master of the St Bartholomew Altarpiece: *Virgin and Child with musical angels*, mid 1480s(?). London, National Gallery

In the Middle Ages, biblical and devotional literature had a rich vein of garden allusions, and since the majority of medieval botanical writers were in holy orders, their commentaries on the religious symbolism of plants and gardens were an integral part of the medieval Christian heritage and thought processes.[3] At the end of the fourteenth century, when the Wilton Diptych was produced, this tradition was introduced into paintings as part of their religious iconography.

This is true also of the realistic representation of flowers, but before identifying them it should be noted that in the Wilton Diptych the main flowers are not actually growing, they are scattered. This is unusual but not unique and it is probably intended to give them special significance. There is another example of this, the Virgin and Child with Angels (London, National Gallery, *ill. 96*) by the German Master of St Bartholomew, probably mid 1480s. Here the Virgin is seated in a church with flowers strewn on the tiles at her feet. The main flowers are stocks (*Matthiola incana*)—four-petalled, cruciferous flowers—and therefore a symbolic reminder of the Crucifixion to come. There is also a daisy (*Bellis perennis*), as in the Wilton Diptych, and a columbine (*Aquilegia vulgaris*).

The strewing of flowers has an ancient history, but not a very respectable one. Cleopatra spread them at Anthony's feet. Seneca complained bitterly about the orgies where rose petals were scattered, and the Emperor Elagabalus nearly suffocated his guests with them on one unpleasant occasion. Botticelli's paintings of the Birth of Venus and Primavera (Florence, Uffizi) echo the classical tradition that roses were originally the flowers of lovers. But the Early Christian Fathers were adept at overlaying customs they found dubious with religious rituals and symbolism, and long before the Wilton Diptych, roses had become associated with the Virgin. One of the favourite poetic descriptions for her was a rose without a thorn. There is no specific evidence that strewing flowers before the image of the Virgin was a common practice in the later Middle Ages, but it seems very likely that at Whitsun (which fell in June before the reform of the calendar) roses would be in their early bloom and might be scattered at the feet of a statue of the Virgin, either as it was carried in procession, or inside the church.

Although the flowers in the Wilton Diptych are stylized (*col. pl. 6*), they are certainly intended to be individually recognizable, and this realism is a new departure in medieval painting. In fact, the botanical illustrations in herbals, intended as a guide to identifying plants, were generally less easy to recognize than these,[4] but the new realism also influenced the decorative borders of certain illuminated manuscripts. In a luxurious Book of Hours in Brussels (Bibliothèque Royale MS 11060–61) made for Jean, Duc de Berry, the dedicatory miniature shows him being presented to the Virgin by his patron saints in a manner reminiscent of Richard II in the Wilton Diptych (see *ills. 86–87*). In the borders are medallions containing the swan and the bear which were his emblems, and delicate scrolls of leaves and stems enclosing a variety of tiny flowers. As in the Wilton Diptych, they are stylized yet recognizable, including roses, columbines,

violets, daisies and cornflowers. This may be the manuscript referred to in Berry's inventory of 1401–02 as *'une tres belles heures tres richement enlumines et ystories de la main de jacquemart de edin'*. This is not certain and neither therefore is the date, but it is close in time and style to the Wilton Diptych. Although it is undoubtedly a French manuscript, its miniatures show an Italian influence, and so may its borders.[5] Certainly the most decorative and varied flower borders of this period appeared in an Italian manuscript—Michelino da Besozzo's Book of Hours now in New York (Pierpont Morgan Library MS M. 944), thought to have been produced *c.* 1410.[6] Each miniature and its facing text border is patterned with flowers. Although some may be symbolically linked with the subject of the miniature, others are not; for instance broom flowers and pods surround St Peter with whom they have no special link. This suggests that here, and in the Berry manuscript, perhaps even in the Wilton Diptych, artists had already reached the stage when flowers could be purely decorative, rather than symbolic.

In Michelino da Besozzo's Hours, violets (*Viola sp.*), which were often linked with the Virgin, appear instead with St Blasius. These violets, and the way in which the artist depicts them from several strange angles, are a vital clue that the four pale blue flowers of the Wilton Diptych are violets.[7] This is subject to dispute since they have previously been identified as irises, most likely *Iris pallida*.[8] As they appear to be the same size as the roses, or larger, irises initially have a more convincing claim than violets. But early artists often depicted flowers which are very different sizes in real life, much the same size in their paintings, just as they put flowers of different seasons side by side. In the Duc de Berry's manuscript, all the flowers round the border are the same size. This practice may have arisen from using sketches of flowers, which would have already reduced them to similar sizes on paper, or it may have been a convention to show they were of equal symbolic importance.

Hugo van der Goes's Portinari Altarpiece in the Uffizi, produced during the 1470s, also shows flowers associated with the Virgin. The purple irises referring to the Sorrows of the Virgin are there, but in a vase, like the lily, the columbines and the pinks. It is the violets that are scattered. This may refer to a particular festive practice. Lady Day, the celebration of the Annunciation, falls on 25 March. Nowadays the nearest popular church festival to this date is Mothering Sunday, and bunches of violets are still given out in churches. Possibly in the fourteenth century they were scattered before the Virgin; the flowers with their drooping heads were symbolic of her sweetness and humility, their purple colouring, like the irises, was associated with royalty and with mourning.[9]

The problem of the pale blue colour of these flowers in the Wilton Diptych may be due to a fugitive red pigment. Analysis has shown that this was definitely the case with Edward the Confessor's cream coloured cloak, which was originally pink, and it is probably also the case with the roses, whose appearance, like the violets, is a little deceptive.[10] There were double roses in the Middle Ages, though perhaps here the doubleness is exaggerated. All medieval roses retained their stamens; there were as yet no cabbage roses where the stamens

and the fertility of the rose became lost in a mass of petals. The best known medieval roses in England were the red *Rosa gallica* and the white *Rosa alba*; the damask rose may have been known, but in the reign of Henry VIII it was described as a new introduction.[11] Probably the pink roses of the Wilton Diptych were originally a richer red, although the *Rosa gallica* has pink varieties. But the roses which appear to be a creamy, almost yellow colour, must originally have been white since no yellow rose was known in England at this time.[12]

Roses also appear in the chaplets around the angels' heads; again they appear to be pink and cream but here we can be even more sure that they were originally red and white. Richard II's inventories include chaplets of enamelled red and white roses.[13] Evidently he favoured them, but here the roses are real and the chaplets seem to be constructed on a base of leaves or even moss and grass. There is a theory that the origin of the rosary was literally a garland of roses.[14] Possibly when the pagan rites of early summer were transmuted into Christian festivals, the Virgin Mary took over from the Queen of the May a garland of red and white flowers which could have been roses, before the reform of the calendar set the seasons back by twelve days. In Chaucer's *Romance of the Rose* the lover, on entering the garden, is instructed to:

> Have hat of flowers fresh as May
> Chaplet of roses of Whitsunday[15]

which shows that Chaucer retained the ambivalence of the rose as the flower of lovers and of religious observance. Possibly it was at Whitsun that roses were also strewn before the image of the Virgin.[16]

By the thirteenth century, a number of little fables began to circulate about the Virgin appearing before a praying monk, or friar or knight, taking the prayers or the words of *Ave Maria* from his lips, and turning them into roses which she made into a garland. In some versions she put the garland on her own head, other times on the head of her votary.[17] No trace of the story is to be found in English sources, but it was especially popular in Germany. A German altarpiece dating from *c.* 1500 shows the Virgin crowned with red and white roses. It is attributed to the Master of St Severin and is in the Church of St Andreas in Cologne.[18]

The other flowers around the Virgin's feet in the Wilton Diptych include daisies. Assuming the one with more petals is the common daisy, the other could well be a species with fewer and larger petals such as camomile (*Anthemis nobilis*), feverfew (*Chrysanthemum parthenium*) or the ox-eye daisy (*Chrysanthemum leucanthemum*). The latter was in fact in Germany a flower of John the Baptist, but this association is not recorded in England.[19] Daisies were Chaucer's favourite flower; one appears in his portrait, and in the *Legend of Good Women* he wrote:

> Of all the flowers in the mede
> Than I love most these flowers white and rede
> Swiche as men callen daisies.[20]

Perhaps they were something of a cult flower at the English court. Like most common and well-loved flowers, the daisy has also been associated with the Virgin.[21]

In the Diptych, flowers that are not scattered but growing are harder to identify. The blue flower under the angel's arm to the right of the Virgin has six petals, which no well-known blue flower has; five is the usual number. It is most like a periwinkle (*Vinca major*); speedwell (*Veronica chamaedrys*) is a possible alternative but that has only four petals, or it could be blue meadow cranesbill (*Geranium pratense*), which was sometimes known as *Gratia Dei*, and which does have strongly marked veins on the petals. However, the little dark green leaves against which the flower appears are more like periwinkle leaves, although they are disproportionately small for the flower. Periwinkles were associated with love and with immortality, so they would be appropriate here, and possibly linked with the memory of Anne of Bohemia.[22]

The tracery of leaves which forms a background to all the flowers is varied, and seems to include tripartite clover leaves, symbol of the Trinity. The little blue thistle flower in the centre foreground is growing on a stem, though one could hardly claim the leaves are discernible as thistles. Here again the original purple seems to have faded to blue—like the violets. To the right is a fern; a recently published inventory describes three collars in the form of ferns, which have been newly identified as a device of Anne of Bohemia.[23] The type of fern is not specified and in the Diptych this could be the common fern (*Dryopteris*), but that has no appropriate symbolism, or possibly the maiden-hair fern (*Asplenium*) which would link it with the Virgin.

As for the mushrooms, there is some doubt whether they are mushrooms, and if they are, even more doubt about what they are doing here. Their shape most resembles *amanita* toadstools with the stem growing out of a basal *volva* and scales on the caps.[24] Their hallucinogenic qualities were certainly understood, but it is doubtful that this is the reason why they are included here.

The White Hart is also depicted in a flowery meadow, and although all the plants here are growing, none scattered, there is at least one important emblematic plant, namely the rosemary on which the hart is lying. Presumably the main reason for its appearance is that it was the badge of Anne of Bohemia, which Richard adopted as his own. A collar of rosemary, described as the livery of the dead Queen, was itemized in the royal possessions in 1400, and in 1395 Richard gave his father-in-law, Charles VI of France, a collar of the livery of his dead wife, which may have been rosemary.[25]

In a wider context than Richard's, rosemary became a plant of love and remembrance. In classical times students twined garlands of rosemary in their hair to refresh their memories when studying. The Tudors, or at least John Gerard, knew that 'rosemary for remembrance' originally had this perfectly practical meaning. However, by the sixteenth century, it was more symbolically a plant of weddings and funerals. Shakespeare used it this way in *Romeo and Juliet*.[26]

All this makes it singularly appropriate for Richard's own marital life in the 1390s, although one cannot be certain that the Elizabethan sentiments were in existence two hundred years earlier, especially since, as John Harvey's research shows, rosemary was then a newly introduced plant in England.[27] It is very likely that the Romans introduced it, but it seems to have died out, and to have been reintroduced by Philippa of Hainault, Edward III's wife, in about 1340. Queen Philippa received the cuttings from her mother, together with a Latin treatise on its uses, which was translated into English by Friar Henry Daniel, who added his own advice on how best to propagate and care for it. When Anne of Bohemia arrived in England 40 years later, this vigorous bush may still have been considered quite rare.

The other emblematic plant in the White Hart panel is the iris, seen in outline against the gold background. This is the yellow water iris (*Iris pseudacorus*) which legend linked very closely with the Kings of France. In the sixth century Clovis, King of the Franks, was caught on the wrong side of the Rhine by a large army of Goths, but seeing a line of yellow iris growing out into the river he realized he could ford it and so escape to safety. In gratitude, he and his descendants adopted the iris as their badge. During the crusades, Louis VII revived its use and it became the *fleur de Louis*, hence *fleur de luce* or fleur-de-lis, the royal flower of France.[28] So, as with the broom cods, the irises may contain a reference to the French royal house.

The other flowers depicted in the panel showing the hart are painted with such detail one feels obliged at least to conjecture what they may be. The little blue flowers are probably speedwells (*Veronica chamaedrys*). On close inspection, they mostly have four petals—as speedwells have—and the little leafy stems on which they are growing are more like speedwells than anything else. However, they might be forget-me-not (*Myosotis palustris*) with the five petals and yellow centres which these have—and in fact both flowers are traditionally plants of remembrance. In Old French, our forget-me-not, was *ne m'oubliez mye*, and in Middle High German *vergiz min niht*.[29] Richard may have known this, but there is no sign it was part of English plant lore until Victorian times. On the other hand, in the 1390s speedwell was used as a badge by Henry Bolingbroke, Earl of Derby, Richard's cousin and successor, with the motto '*Souvienne vous de moi*'.[30] Also for the Tudor herbalist Henry Lyte it was the speedwell that had the local name 'forget-me-not'.[31] Considering this argument it seems more likely that the flowers here are speedwells, and that they have the meaning of remembrance.

The tiny red flowers may perhaps be flowers of Adonis (*Adonis annua*), the little red anemones of the Eastern Mediterranean, which were linked to the rebirth of spring and the dead god.[32] They are growing on stems which have leaves all the way up, but they are not distinguishable as anemone leaves. The association of these flowers with the Holy Land and the Resurrection could be important, assuming it was known, and it is very likely that it was. There are several ferns, one like the fern in the Virgin panel although less distinct, but on either side of the panel the plants look more like bracken (*Pteris aquilina*).[33] In

fifteenth-century Netherlandish paintings, ferns often appear in paintings of John the Baptist in the wilderness and alongside other male saints like Peter and Christopher, so there may be a forgotten link there.[34] If you cut a stem of bracken you may see the Greek letter 'X' which is the initial of Christ. But the problem with symbolism is that there is no way of knowing precisely what the artist had in mind, and twentieth-century interpretations are often tenuous. It is more certain that these are meant to be real plants, and identifiable to a fourteenth-century eye. In the corners of the panel, near the bracken, grape hyacinths may be seen (*Muscari racemosum*), and on the right possibly foxgloves (*Digitalis purpurea*).

More toadstools appear under the hart's back legs. They are not the same as those on the panel with the Virgin, and their identity is still less certain. It has been suggested that they are little pink flowers, and their colour is a faded red lake,[35] but their stems look very fungoid.

In the absence of comparable surviving English paintings, any attempt to analyse the symbolic meanings of the plants in the Wilton Diptych is of necessity based upon European tradition. However, the other realistic representations of flowers and flowery settings discussed in this paper are at best contemporary, and generally later. The realistic and refined depictions of flowers and plants in the Diptych bear out the evidence of the treatment of the figures and other decorative details that this was the work of a highly sophisticated court artist.

Detail of flowers
from the White Hart panel of the Wilton Diptych

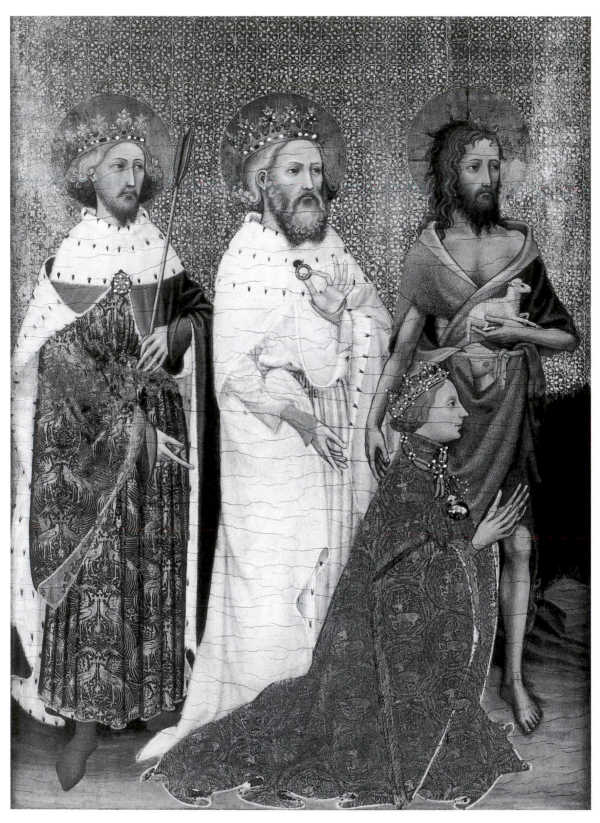

97. Richard II with Saints Edmund, Edward the Confessor and John the Baptist.
Wilton Diptych, interior left wing

X

LISA MONNAS

Fit for a King: Figured Silks shown in the Wilton Diptych

THE ELABORATE APPAREL worn by the three kings in the Wilton Diptych mirrors the courtly splendour of Ricardian dress (*ill. 97*). The robes seem to be almost textbook illustrations of the contemporary, satirical description in the poem *Richard the Redeless* of robes whose 'slevis slide on the erthe' with 'elbows adown to the helis'.[1] Far from being a random show of magnificence, the dress in the Wilton Diptych is arranged according to a careful scale of values. In the Paradise scene on the right, the Virgin is singled out among the angels by the depth of the expensive ultramarine pigment of her mantle, while Christ is wrapped, as befits the King of Kings, in a cloth of pure gold. On the opposite panel of the Diptych, in contrast to St John the Baptist's ragged camel-skin, the three kings wear robes of expensive cloth. Among the 'earthly' kings, Richard II is distinguished from his saintly predecessors by wearing the most sumptuous robe made entirely from cloth of gold.[2] (see Pujmanová, p. 265) This pictorial hierarchy mirrors the way in which dress—and especially courtly dress—was orchestrated in the late Middle Ages.

Besides proclaiming their wearers' high estate, the emblematic gold designs on the clothing of St Edmund and King Richard are integral to the meaning of the painting. In the case of Richard II, the broom cod collar, worn around his neck and featured on the textile of his robe (*col. pl. 2*), has played a crucial part in dating the painting to the period following the beginning of the negotiations for his marriage to Isabelle of France in 1395 (see Gordon, p. 20).[3]

Were the patterns shown on the robes based upon real textiles or were they invented to suit the iconography of the Wilton Diptych? In a painting that is so rich in symbolic content, it would be reckless to assert that the figured textiles must have been real items, directly observed. The lack of foreshortening in the *sgraffito* patterns, the fact that not all of the eagles on Richard's robe look in the same direction, and that the design of St Edmund's gown includes an extra motif in one place, seem to reinforce the conclusion that these textiles were not rendered 'from the life'.[4] Yet to judge their authenticity on the basis of such narrow criteria, with reference to this painting alone, would be simplistic. Some unfore-shortened, 'unrealistic' textiles in other fourteenth-century paintings were undoubtedly based upon real models, while some of the most convincing fifteenth-century renderings can be shown to be invented or distorted.[5]

Fortunately, Richard II's Wardrobe Accounts provide ample testimony that he possessed a succession of magnificent outfits whose highly personal decoration was as carefully selected as that of the robes in the painting. In this paper, the textiles shown in the Wilton Diptych will be discussed in relation to the embroidered and woven silks which are documented as worn by Richard II in his Great Wardrobe Accounts.[6]

The task of obtaining cloth was the province of the officers of the Great Wardrobe, but it seems likely that, from among their purchases, the king would have personally selected the silks which he would wear. Although no document exists to confirm that Richard II did this, it is known, for example, that his great-grandfather, Edward II, wanted to approve a cloth of gold destined for use in his chapel.[7] Richard II's successor, Henry IV, was apparently shown cloth on a regular basis. Besides the normal accounts for furnishings and clothing following the monarch to his various residences, there are records of expenses for the transport of precious velvet and cloth of gold, accompanied by an armed escort specifically to 'show to our lord the king'.[8] It is hard to believe that Richard II would not have taken a similar interest in his prospective clothing.

The silks consumed by the royal household were purchased from a small circle of suppliers—including the London mercers John Wodecok, Thomas Roos and their celebrated contemporary, Richard Whittington, and 'Lombards' such as John Foulcher and Lodewyco Anguill'.[9] While London had a flourishing local industry producing silk trimmings and embroidery, there was no silk-weaving industry in England and the silk textiles were imported. The international flavour of these silks is indicated by the Great Wardrobe Accounts, which list *'pann' adaur' de damasc''*, *'pann' de colon''*, *'pann' s[er]ici moresk''* (from Spain?) and *'pann' adaur' de cipre''*, both *'pann' adaur' de Luk''* and *'sindon de Luk''*.[10] It is likely that most of the silk cloths were imported from Italy, the leading producer of silk fabrics in Europe, of which Lucca had been the principal silk-weaving centre. Although she lost something of her pre-eminence during the fourteenth century, the reputation of her silks remained so high that only Lucca is given as a place of origin for the silks from Italy in Richard II's Wardrobe Accounts.

During the last decades of the fourteenth century, these Italian silks offered a rich harvest of exquisite designs, fusing the exoticism of 'tartar' silks imported from the East with the humour found in the border decorations of contemporary manuscripts. The diversity of designs supplied to the Great Wardrobe would have included, besides heraldic or emblematic subjects, silks figured with ecclesiastical motifs and others woven with fantastic designs of mythical beasts as well as with scenes of courtly romance and of the chase.[11] Plain silks—velvet, satin, taffeta, *tartaryn* and *sindon*—were also used by the royal Wardrobe in enormous quantities. These could be embellished with embroidery, or else have designs 'stamped' upon them. The ground for these stamped designs was usually *tartaryn*, one of the less expensive silks. Stamping was normally reserved for ephemeral items employed for particular celebrations. This type of decora-

tion represented a cheap and fast way of creating the innumerable furnishings and outfits required for the courtly ceremonies and set-piece entertainments in which the king featured as the lavishly dressed central figure.[12]

An example of the careful economic control which was exercised within the Great Wardrobe can be found in Richard II's first games (*hastilud'*) at Windsor after his accession. On 5 January 1378, on the eve of his eleventh birthday, the Feast of the Epiphany, the young king took part in a dazzling display for which he wore the sun as his emblem. While his three knightly supporters were clothed in *tartaryn* stamped with golden suns, Richard wore a far more splendid version. He was dressed in cloth of gold woven with golden suns, riding upon a horse with trappings made of the same cloth. Unusually, even his legs were covered in this cloth of gold. For the games on the day following Epiphany, Richard, like his attendants, wore *tartaryn* stamped with golden suns.[13]

The cloth woven with suns worn by Richard, which may have been specially commissioned, was particularly impressive. It was *racamas*, one of the heaviest of all the lampas cloths of gold.[14] During the reign of Edward III, *racamas* featured as the finest clothing for the king and his immediate family. By the late fourteenth century, this stiff, heavy cloth, described as *'pann' adaur solemn' '*, was

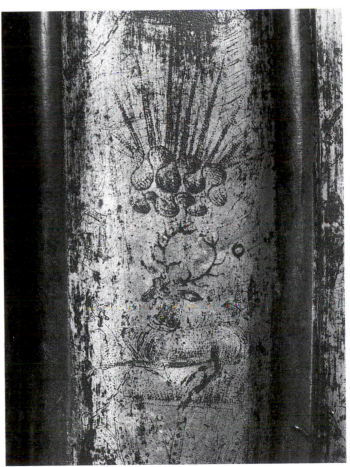

98. Tomb of Richard II, showing detail of the rising sun and the White Hart. London, Westminster Abbey

seldom worn at court, even by the king himself. Figured velvets were beginning to oust the lampas weaves as the most luxurious cloths to wear. Of the lampas silks, the king most frequently wore *bawdekyn*, a slightly lighter fabric than *racamas*.[15] The latter was normally reserved for splendid furnishings or for important oblations.[16]

The sun device which featured so prominently in 1378 was worn again by Richard II at games held at Smithfield in March, 1386.[17] Although Richard sometimes wore the sun in splendour, on this occasion, from the description given in the Wardrobe Accounts, we can be certain that it was the sun rising from clouds.[18] Both Richard II's father, the Black Prince, and his grandfather, Edward III, are known to have worn this device.[19] In discussing Richard II's tomb effigy, J. G. Nichols observed that 'it is clear from the statue before us that at the time when Richard II erected this monument…the rising sun was one of his customary badges' (*ill. 98*).[20] The tomb was commissioned in 1395, but the Great Wardrobe Accounts show that Richard II wore this device over ten years earlier.

The rising sun is never described in these Wardrobe Accounts as a badge, but it was used by Richard from the early 1380s in precisely the same circumstances as the ostrich feather. The latter, a badge worn by the Black Prince and derived from Richard's grandmother, Philippa of Hainault, is, from its earliest mention in Richard II's Great Wardrobe Accounts in 1383–84 invariably referred to as 'the King's badge'.[21] Both emblems featured prominently upon Richard II's jacks. These were military garments, worn in pairs: a loose-fitting '*jak volant*' and a '*jak strict*', a tight-fitting, padded, quilted jacket.[22] As befitted clothing intended for a very public role, the king's jacks were decorated either with the royal coat of arms or with Richard's personal badges. The king needed several sets of jacks a year, and the surviving Livery Rolls, which cover the years up to 1387 in greatest detail, describe them as always bearing the same three designs: the king's arms (*ill. 99*), ostrich feathers (*ill. 100*) or a sun emerging from clouds.[23] Illustration no. 99, a French fifteenth-century miniature in Froissart's Chronicle, shows Richard II setting out for Ireland in 1395 wearing over his armour a loose-fitting garment blazoned with his arms. This may not accurately depict an English *jak volant* of the late fourteenth century, but it does reflect the splendour and importance of such military textile garments.

The sun was sometimes worn together with the ostrich feather. In 1385, suns were embroidered in conjunction with ostrich feathers upon a ceremonial sword-sheath and belt. This magnificent item, made from black velvet and embroidered in gold and silver thread was to house a sword carried before the king at Christmas.[24]

A sun motif is incorporated into the textile of the gown worn by St Edmund in the Wilton Diptych (*ill. 103*). St Edmund's blue textile has a design of paired golden birds, their necks linked by crowns, with a pendant sun between them. Although the birds resemble the phoenixes found on contemporary Italian silks, their legs are rather long. John Harvey has identified these birds as demoiselle

cranes *(Anthropoides virgo* or *Grus virgo)*, and suggests that they were intended as a specific reference to the Virgin.[25] His interpretation is supported by the fact that St Edmund's blue gown links him visually with the Virgin.

At a time when the wearing of personal and heraldic devices represented a public weather-vane of loyalty and of political aspirations, the design upon Richard's robe in the Wilton Diptych represented a crucial distillation of emblems which he had acquired through inheritance and through his own alliances *(col. pl. 11)*. Richard's badge of the White Hart is thought to have been derived from his mother, Princess Joan of Kent, who reputedly had as her emblem a white hind. The rosemary upon which the hart lies is the livery of his first wife, Anne of Bohemia; the eagle refers to the fact that she was the daughter of Emperor Charles IV. The broom cods stem from Richard's second marriage, with Isabelle, the daughter of Charles VI of France.[26] To the contemporary eye, this striking combination of the hart lodged encircled by a broom cod must have recalled the French monarch's personal emblems of the *cosse de genêt* and *cerf volant* (see Morgan, p. 185 and *ill. 111).*[27]

The Great Wardrobe Accounts show that Richard II wore garments and possessed items decorated with harts—such as a bed inherited from Edward III—well before he is thought to have publicly adopted this motif for his badge in 1390.[28] The first surviving account of Richard ordering a magnificent garment embellished with white harts concerns clothing ordered for the Feast of the

99. Richard II setting out for Ireland.
Froissart's Chronicles, French, late 15th century.
London, British Library, MS Harley 4380, f. 166v

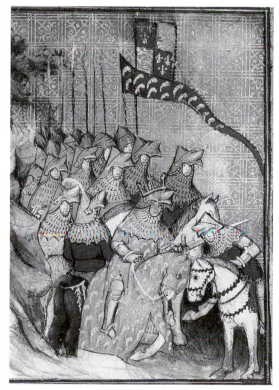

100. Richard II knighting Henry of Monmouth.
French, mid 15th century.
London, British Library, MS Harley 1319, f. 5

Purification of the Virgin on 2 February 1386. The garment in question was a long gown and matching hood of red velvet embroidered with harts worked in pearls with antlers of Cyprus gold and silk, with chains of gilt silver hanging around their necks.[29] For Easter of the same year (22 April), two matching outfits were ordered for Richard II and his Queen, consisting of long gowns and hoods of blue velvet embroidered with white harts lying beneath trees stitched in gold and coloured silks with scrolls bearing 'diverse sayings' curled around a tree.[30]

Neither one of the gowns ordered for the king in 1386 corresponds to the iconography of the fabric in the Wilton Diptych—most notably in the absence of broom cods. In the Wardrobe Accounts, the description most reminiscent of the textile in the Wilton Diptych is the one cited by John Harvey, found upon gowns worn by twenty ladies for the *hastilud'* of January 1396–97.[31] These were made of red *tartaryn* stamped by Thomas Litlington with designs of white harts of silver, with golden crowns and chains, lying among broom plants or cods. These were, of course, ephemeral outfits created especially for attendant figures at the games, unlike the magnificent robe, fringed with gold, worn by Richard II in the painting. If this robe did exist, the fact that it cannot be traced in his Wardrobe Accounts may be due to the fact that the Livery Roll covering the crucial years 1394–98 is almost ruined, surviving only as one, poorly legible membrane.[32]

A single mention of an expensive red garment—a 'slop'—woven with harts of Cyprus gold occurs in an undated inventory of Richard II's jewels and plate.[33] The exact garment denoted by a 'slop' is uncertain, but it was undoubtedly very splendid. In the fragmentary Livery Roll of 1394–98, there is another slop, made of black satin, embroidered with the badge of the king.[34] The black ground suggests that the badge in question was the ostrich feather which, according to the descriptions given in the Great Wardrobe Accounts, was consistently displayed upon a black field.

How were the textiles shown in the Wilton Diptych decorated? If the artist was following real models, the choice of repeating patterns, entirely in gold, suggests woven, rather than embroidered, cloth. The elaborate embroideries recorded in Richard II's Wardrobe Accounts, like the contemporary production for the French royal Wardrobe, incorporated polychrome effects, created by applied silk motifs embellished with gold, silver and coloured silk thread and with pearls.[35] The most sumptuous woven silk obtainable at that time was velvet cloth of gold and Richard II's Wardrobe Accounts show that he wore many figured velvets, including some with gold designs.[36] The magnificent fabric of the chasuble at Lyon, perhaps woven for Charles VI of France or his immediate circle, is a beautiful example of these early figured velvets (*ill. 101*).[37] At this date, however, the fineness of the details in both St Edmund's and King Richard's textiles suggests a lampas rather than a velvet weave (*col. pl. 11, ills. 104, 106*).

To have silk cloths specially woven normally meant that the designs would have been drawn up in England and then forwarded to Italy, with slow and uncertain results. Embroidery, a flexible means of decoration which could be

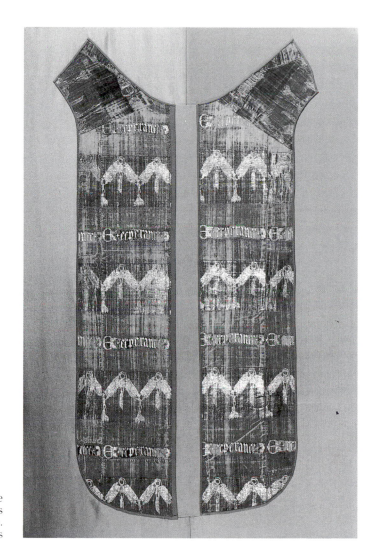

101. Polychrome, brocaded velvet chasuble
woven with broom cods
and belts of esperance.
Lyon, Musée Historique des Tissus

executed by craftsmen within the Great Wardrobe, might seem to have been preferable. Yet surviving examples—such as the thirteenth-century seal bag in Westminster Abbey woven with the leopards of England—show that heraldic textiles were commissioned by English monarchs before the reign of Richard II.[38] The problem of distance was overcome by Richard, who took the unusual step of installing an Italian cloth of gold weaver from Lucca in his own household, whom he commissioned to weave emblematic designs.

On 7 September 1385, Bendenell de Beek was granted 'during pleasure…the office of worker of the King's gold cloths', receiving 12d. daily 'for himself and his yeoman'.[39] An entry in the Issue Roll for 7 February 1386 records the purchase for the large sum of £9 11s. 4d., of certain 'instruments' (presumably a loom) to enable Bendenell to exercise his craft.[40] In the same month, a livery was issued to 'Baldewyno of Lucca, weaver of cloth of gold'. As the date coincides with the purchase of equipment for 'Bendenell de Beek', and only one cloth of gold

weaver is referred to in each set of documents, for the moment, it is presumed that they are the same person.[41] For his livery, Baldewyno received a long woollen gown and hood, one pair of hose and a pair of robes of linen.[42] Ironically, the weaver of Richard II's finest cloth was not of sufficiently high status to be allotted any silk for himself.

In Italy, successful master weavers maintained a commercially viable flow of production by operating several looms from one workshop, assisted by both journeyman weavers and apprentices. Yet there is no indication of any such large-scale operation in Richard II's Great Wardrobe. Bendenell/Baldewyno is recorded as being assisted by just one yeoman valet, presumably his draw-boy. Evidently Richard II was not attempting to foster a native silk industry in England: the weaver had been installed purely to serve his personal needs. In the Livery Rolls, there is only one entry for cloth which may tentatively be ascribed to Baldewyno/Bendenell. This is a white *bawdekyn* silk woven with Cyprus gold, destined to be made into a gown and hood for Easter 1386, described as 'made in England'.[43]

Bendenell/Baldewyno wove cloth to designs drawn up by Richard II's painter, Gilbert Prince. In the Keeper's Expenses Roll of 1385–87, Gilbert Prince was paid for 'three patterns made by him for three circles of ostrich plumes and crowns of which two have the coat of arms of our Lord King and one with the helm of the King in the middle' to deliver to the *tapicer 'pro exemplis suis ad op'at' tapet' lana'*.[44] Following this entry, he was paid 'for two other patterns consisting of letters of gold to deliver to the weaver of cloth of gold'. For each of these designs—for the wool and the silk alike—the painter received a standard rate of two shillings.[45] Richard II wore numerous outfits embellished with whole phrases, individual words or letters, usually embroidered rather than woven.[46] Both his tomb effigy and the Westminster Abbey portrait show him wearing textiles with letters (*ill. 120, col. pl. 23*). Unfortunately, the description of the design to be provided by Gilbert Prince is so brief that it cannot be identified as the cloth in the Westminster Abbey portrait.

Knowing that Richard II employed a cloth of gold weaver to create his own textiles, it is tempting to speculate whether Bendenell/Baldewyno could have woven the figured silks in the Wilton Diptych. Unfortunately, in 1390/91 the weaver complained that he was not receiving enough work and was almost reduced to beggary; in 1393 he left the king's service, three years before Richard's marriage to Isabelle of France.[47] His precipitate departure makes it too early for him to have woven Richard II's textile with its broom cod roundels. He could, however, have woven St Edmund's silk.

The design of St Edmund's textile (*ill. 103*) shows affinities with contemporary Italian silks. The articulation of the design by the fanning rays of the birds' tails is reminiscent of a group of silks ascribed to Lucca by Otto von Falke (*ill. 104*).[48] Silks with imaginative animal designs are listed by late fourteenth-century English inventories, such as the 1388 inventory of Westminster Abbey, but these brief entries cannot give any idea of the style of the designs.[49] Fortunately,

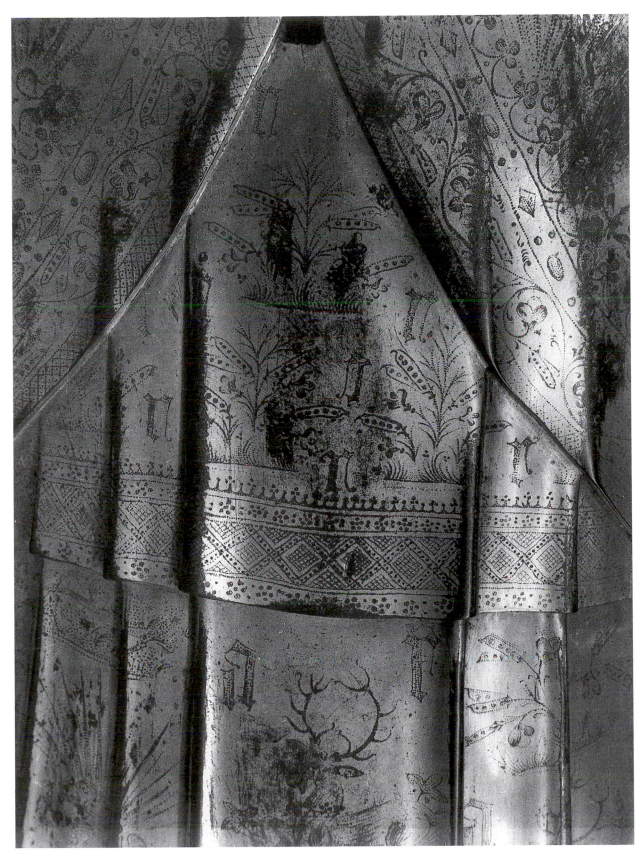

102. Detail of the pouncing showing broom cods and the letters 'r' and 'a'
on Richard II's robes on his tomb effigy. London, Westminster Abbey

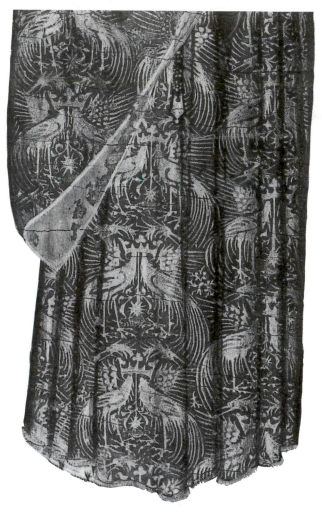

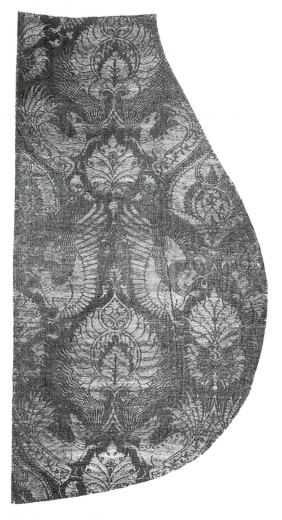

103. Detail of St Edmund's gown in the Wilton Diptych

104. Fragment of lampas silk with a design of exotic beasts. Italian, second half of 14th century. London, Victoria and Albert Museum

the discovery of a fragment of lampas silk from the Watergate site excavations in London, from a level datable to the 1380s, which is comparable in style to some of the silks illustrated by von Falke, offers confirmation that silks of this type were worn in London during this period.[50] Von Falke's attribution of these silks to Lucca would seem to offer a marvellous link with Richard II's Lucchese weaver. Unfortunately, his attribution was not based on any firm archaeological or documentary evidence, rendering this particular connection insubstantial.

In contrast to St Edmund's textile, which fits neatly into an existing group of contemporary silks, the fabric worn by King Richard stands out for its stately and highly personal design. The decision to exploit the shape of the livery collars to form a roundel design looks obvious with hindsight, but was by no means the only possible solution (*ills. 101, 102*). Up to *c.* 1300, the roundel design had been the predominant decorative scheme for European textiles for several cen-

174

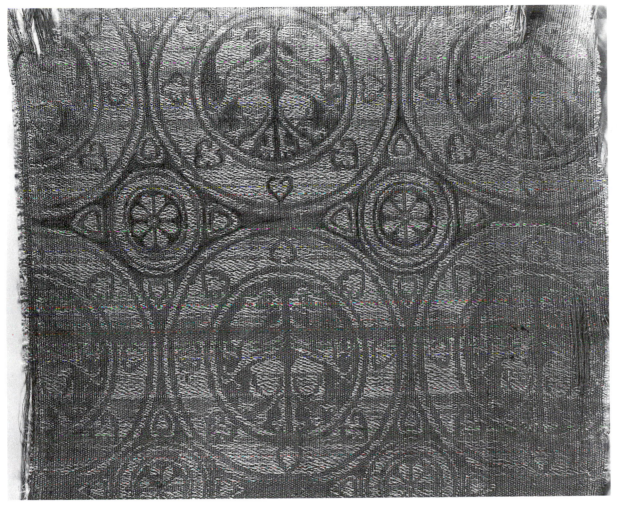

105. Fragment of half-silk samite with a design of roundels containing addorsed griffins. Spanish or Italian, 13th century. London, Victoria and Albert Museum

turies, and this could well have been viewed in the late fourteenth century as a highly traditional choice. The roundel schema might even have recalled fabrics worn by the Holy Roman Emperors, such as Henry VII (d. 1313), whose tomb at Pisa shows him dressed in fabrics with roundels containing eagles.[51] This impression is reinforced by the eagles which are incorporated into Richard's textile. Given the fact that Richard had not only married the daughter of Emperor Charles IV (d. 1378), but also aspired to the Imperial Crown himself, this allusion may have been intentional.[52]

Although it recalls an established format, the pattern distribution of the Wilton Diptych textile is not archaic, but conforms to developments in late fourteenth-century Italian silk design. During the thirteenth century, roundel designs tended to be arranged with each element placed neatly above the other in static rows (*ill. 105*). In the next century, this type of design was invested with

175

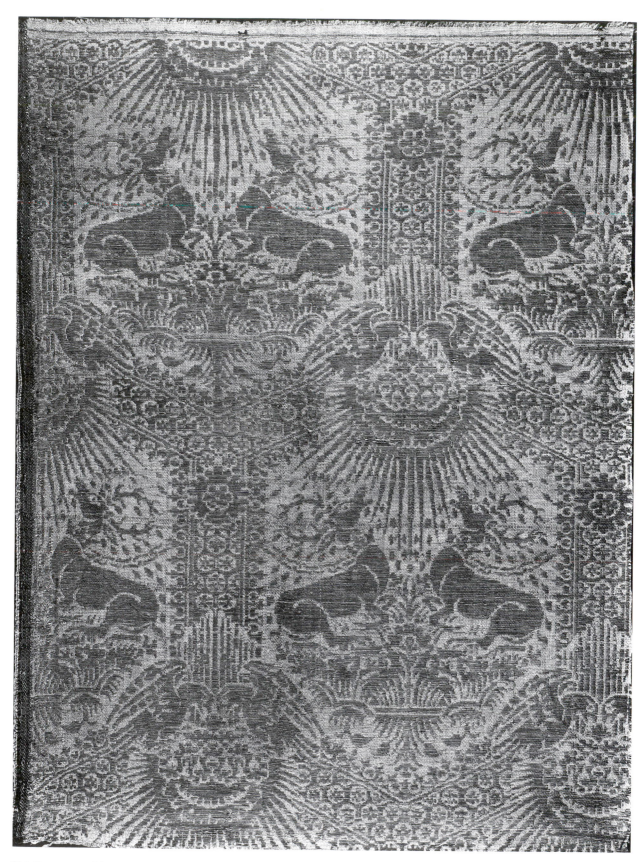

106. Fragment of lampas silk, with a design of chained harts, eagles and sun descending from clouds. Italian, early 15th century. Chicago, Art Institute, Gift of Mrs Charles H. Worcester

a new dynamism, by virtue of being arranged in a half-drop repeat, just as we see on Richard II's robe.

Variations on this scheme can be found in existing silks such as the one seen in illustration no. 106. Because this silk has elements which could be connected with Richard II—chained harts, eagles and sunbursts—it is tempting to try to link this silk with Richard himself. There are difficulties in this. Several examples of this silk exist in various museums, but none of these has a traceable English provenance, and they are now generally ascribed upon stylistic grounds to the early fifteenth century.[53]

A comparison of the existing hart silk with the design painted in the Wilton Diptych is nevertheless instructive. The existing silk was evidently designed by someone familiar with weaving, in all likelihood a professional textile designer, because it contains a central axis of symmetry. In a draw-loom, the pattern was created by means of a figure harness controlled by lashes pulled by the draw-boy. If there is a reverse repeat, such as we see in illustration no. 106, and on the robe of St Edmund (*ill. 103*), the number of lashes used to create the design can be reduced by half. This represents a considerable economy of labour. In contrast, the pattern of Richard II's textile lacks a central axis of symmetry, making it far more laborious to weave.

This is exactly what one might expect of a silk designed by a court painter who had little or no familiarity with the workings of a draw-loom, and no access to a royal weaver for consultation. It is a typical feature of the most expensive, specially commissioned heraldic textiles of this period (*ill. 101*). If the textile worn by Richard II in the Wilton Diptych was drawn from a real example, then it is likely to have been woven in Italy to a design created either by Gilbert Prince or his successor Thomas Litlington. The result was a costly fabric, with a quintessentially Ricardian design.

Within very few years of the execution of his serene portrait in the Wilton Diptych, Richard II was deposed and died imprisoned in Pontefract Castle. The Livery Rolls, which form the basis of this study, give an unruffled account of the regular provision of magnificent garments for the king and his court, which sits oddly at variance with the turbulent political events of his reign. There does emerge, however, a picture of careful control by the king of the emblems and devices which he wore. Although Richard was following contemporary usage in blazoning his coat of arms and personal devices upon his dress and furnishings, his unusual action of employing his own cloth of gold weaver speaks volumes about the level of royal concern for control of his public image. Although we no longer have even a fragment of one of the splendid garments worn by Richard II in the Wilton Diptych, it is possible to confirm from the documents that such garments were typical of what was being worn by Richard and that these specific robes could very well have existed.

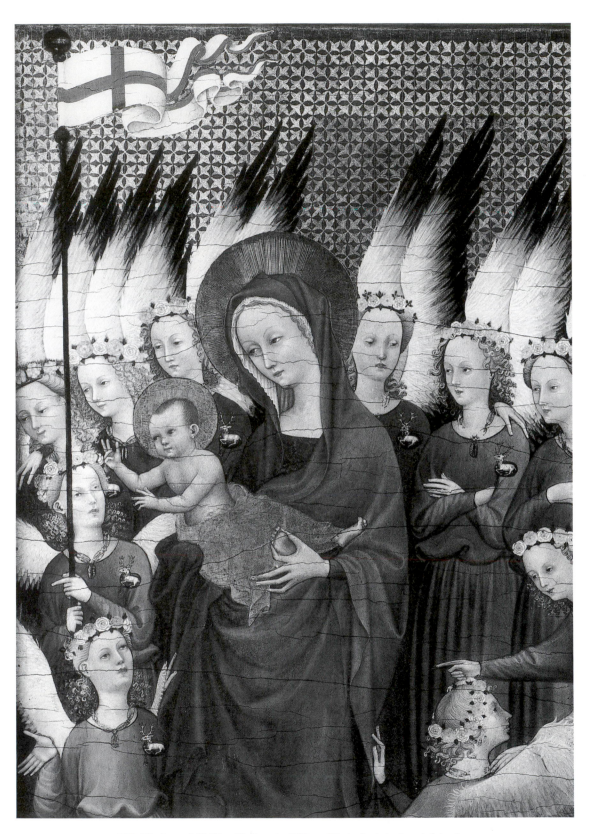

107. *Virgin and Child with Angels*. Wilton Diptych, interior right wing

XI

NIGEL MORGAN

The Signification of the Banner
in the Wilton Diptych

T WILL BE ARGUED here that the moment of narrative action repre-
sented in the Wilton Diptych is the blessing of the banner bearing a red cross
on a white ground by the Christ Child, and the involvement of the Virgin, angels
and King Richard in this ritual act. In many interpretations of the iconography
of the painting the signification of this banner or standard has often been
neglected, or at least has been treated with insufficient comment or explanation
of this action of its blessing, a subject seemingly unique for a devotional diptych.
In some interpretations of the action of the benediction by the Christ Child this
is seen as directed specifically towards the King and not towards the banner.
There seems little doubt that the pose and glance of the Child indicate rather
that His concentration, in the manner of a small child totally absorbed in an
object placed before him, is on the blessing of the shaft of the standard. The
angel who holds the shaft looks up at the Christ Child and points with a finger
down towards the King, and this seems to imply the King as owner and recipient
of the banner. A definition of the significance of this banner to the King, and its
integral role in an interpretation of the iconography of the painting as a whole
is presented in this paper in the belief that it provides an essential key to our
understanding of the work.

In making any interpretation of the meaning of the painting after a hundred
years of scholarly discussion relating to it, a great debt is due to much that has
been established with convincing argument and documentation in the past. In
writing about the Wilton Diptych it seems as if one is hardly making any single
new interpretation but is reassembling with different emphasis and reasoning
what has already been said. While disagreeing with the overall conclusions in
many of these articles, or with occasional arguments they contain which seem
to be flawed, there is agreement often with most of the individual parts of the
evidence and their evaluation.[1]

Those who, following Maud Clarke, have emphasized the significance of the
banner as a reference to a crusading enterprise, have indeed focused on this
essential element in the picture, but an alternative view of the function of the
banner will here be presented.[2]

To define more precisely the point of narrative action, it seems that it is at
the moment when the Christ Child is completing His blessing of the banner,

and Richard with his hands open is about to receive back this standard which he has handed over to be blessed.[3] Saints Edmund and Edward, and the angel holding the banner all point to Richard as the recipient of the blessed banner. Even if the Child's glance might be interpreted as incorporating the King as well as the banner in His blessing, the intention of the established liturgical ceremony on which this action is based, which would be well-known to any beholder in the late fourteenth century, is a blessing of an object rather than of its owner. The rite of the blessing of a banner is found in Pontificals, included among the episcopal benedictions of objects, which are distinct from blessings of the persons who put the objects into operation. In the contemporary late fourteenth-century Pontifical in Cambridge (Corpus Christi College MS 79, f. 219, *ill. 108*), the rubric of the blessing is *'Benedictio vexillorum processionalium vel militarium'*.[4] The same blessing could be used either for a processional banner for liturgical ceremonies or a military standard borne in war. In the Corpus Pontifical the blessing is illustrated by three banners, one being as in the Diptych *argent a cross gules*.[5] This blessing, which in England goes back to Pontificals of Anglo-Saxon pre-Conquest times, is among those blessings of objects used in war, the sword and lance, but as the rubric indicates, the same blessing was used for banners for processional use.[6]

The origins of these texts are almost certainly in Continental Pontificals of the tenth century.[7] The very extensive use of standards and banners in the later Middle Ages must doubtless have led to frequent use of this blessing at the commencement of expeditions of war as well as for those for processional use by the Church. In France the blessing of the royal and national standard, the oriflamme, used the same prayer form as in the English Pontificals, *'Inclina Domine Jesu, salvator omnium et redemptor'*, only modified by the addition of the names of St Denis and his companions.[8] A special feature of the French coronation rite involved the blessing of the oriflamme, but there was no parallel in the English coronation ceremony.[9] For the English, the equivalent battle standards to the oriflamme were the old standard of the golden dragon on a red ground, which was probably gradually subordinated from the late thirteenth century to the standard bearing *argent a cross gules*, traditionally considered as the banner of St George.[10] Certainly by the mid fourteenth century, St George was viewed as 'the blessed George, the most invincible athlete of Christ, whose name and protection the English race invoke as that of their peculiar patron, in war especially' as a 1351 royal document proclaims him (e.g. see *ill. 110*).[11] The banner in the Diptych assuredly represents the banner of St George and certainly in no sense is it the banner borne by Christ at the Resurrection as has been claimed by some authors.[12] It would be iconographically very odd for the Christ as a Child to bless a banner representing His own Resurrection in the context of the imagery of the Diptych.[13] What could such a blessing possibly signify?

The principal figures in the painting are Richard, the Virgin Mary and the Christ Child grouped around the standard of St George whose standard bearer is an angel. Whatever interpretation is to be made of the Diptych, it has always

108. The three banners. Pontifical.
Cambridge, Corpus Christi College,
MS 79, f. 219

109. Bishop blessing a knight.
Pontifical. Paris, Bibliothèque Ste-Geneviève,
MS 143, f. 181v

to be remembered that it is first and foremost a personal devotional painting
for the use of Richard, the donor figure. Its location, or locations if it was carried
around as part of the King's baggage, in view of its size and form, was probably
either a small private side chapel within a chapel in the royal residences, or in
an oratory close to the King's living quarters.[14] In no sense can any interpretation
of the iconography stressing a public, propagandistic and political function be
suitable for such an object. The person who instructed the artist on the esoteric
symbolic imagery of the work, perhaps a royal chaplain or advisor, must have
been acquainted with the sort of imagery which the King either wanted as his
expressed wish or was known to have favoured. Insomuch as there may be
overtones of meaning alluding to political ambitions and aspirations, the 'pub-
lic' who contemplated the image were likely only to have been the King and his
intimate circle. The one sizeable group to which this definition might be ex-
tended are Richard's fellow companions of the Order of the Garter, whose
appointments had been so carefully manipulated by him.[15] It is not out of the
question to consider the Diptych, particularly in view of its association with the
banner of St George, patron of the Order, as an image used for their chapel at
Windsor. Another plausible location, if the Diptych was permanently placed,
would be the King's private royal Chapel of Our Lady of the Pew in St Stephen's
Chapel, Westminster.[16] These locations can only be the object of speculation for
it seems unlikely that any definite evidence will ever come to light.

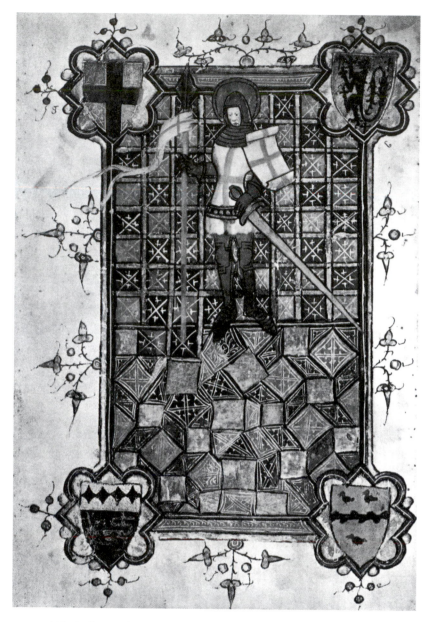

110. *St George*. Sarum Hours, *c.* 1390. Present location unknown

Visual evidence for the use of standards bearing the cross of St George by the English does not survive from the time of the Diptych. A Flemish illustrated version of Froissart's Chronicle of some 50 years later shows Richard confronting the rebels at Blackheath in 1381 with the insurgents carrying two standards of the golden dragon and the cross of St George.[17] The golden dragon had been used since Anglo-Saxon times and probably was of less significance than the banner of St George in the fourteenth and fifteenth centuries.[18] In Henry III's

time this golden dragon standard was housed in Westminster Abbey.[19] The order for a new one was made in 1244: 'to cause a dragon to be made in the fashion of a standard, of red silk sparkling over with gold, the tongue of which should be made to resemble burning fire, and to appear to be continually moving…and to place it in the Church of St Peter, Westminster'. This would be analogous to the placing of the oriflamme in Saint-Denis when not in use at war.[20] Probably from Edward I's time onward the dragon standard was accompanied by the standard of St George as a battle flag, but further extensive research on inventories is needed to assess the evidence of its use before the period of Richard II.[21] Pennoncels, the tiny triangular flags placed at the head of the lances of foot soldiers, and bracers, bands on left forearms of archers, both bearing the cross of St George, are mentioned in the Exchequer Accounts of 1277 for use in Edward I's war against the Welsh.[22] A banner of St George is mentioned in the Caerlavarock Roll of 1300, the account of the heraldic devices borne by the knights at the siege of Caerlavarock.[23] The use of the banner is specifically associated with the monarch himself for the text says that 'the king caused his banner and those of St Edmund, St George and St Edward to be displayed'. The monarch's banner at this time presumably refers to the royal arms, but might at a later date refer to his emblem. Whether the banners of the saints represented them as figures or by their heraldic devices is not specified. It is of significance that the same combination of royal patron saints as Edward I caused to be displayed at Caerlavarock, with the addition of St John the Baptist, are those associated with Richard on the Diptych.

By the time of Richard II, the evidence for use of St George's banner by the English in a military context is more extensive. The clearest statement is in the Ordinances of War in London (British Library MS Cotton Nero D. VI) made by Richard at Durham in 1385 in connection with the war against the Scots.[24] They refer to the 'baner' of St George in the section on the penalties 'for them that make themselves captains to withdraw men from the host' and rule that 'no man is to be so bold as to raise the baner or pennon of St George…to withdraw men out of the host'. The implication is that the troops saw the banner of St George as a rallying flag, specially distinguished from the numerous individual baronial banners. Ninety-two standards of St George were issued for the Scottish expedition of 1385.[25] The second significant text in the 1385 Ordinances states that all the men were to wear the cross of St George on their clothing before and behind.[26] A mid fifteenth-century French illustrated version of the *Chroniques d'Enguerrand de Monstrelet* indeed shows the English troops wearing them in this manner.[27]

The standards of St George, the golden dragon and the French oriflamme were not personal standards but national standards, directly associated with the King and his authority.[28] The oriflamme had a special character both sacred and royal, and it is likely that the cross of St George as the emblem of a saint and also of the King's personal chivalric Order had something of this significance for the English. The 'captains' whom the Ordinances of 1385 forbade to use the

banner of St George to withdraw men from the host would, in using the banner, have been using it as an instrument to bring about desertion from the national army or opposition to it, and in consequence also rebellion against the King's authority over the army as a whole. The army must be united under the banner which was its standard, and the standard was not to be used as a means to cause division and desertion.[29] As personal military standards developed in the late fourteenth century, the cross of St George would be on their 'hoist' as it is called, and the individual badge and emblems of the knight on the 'fly'.[30] It was common to all personal standards and was the symbol of the unity of the nation. A Tudor Banner Book provides some evidence that Richard II's personal standard incorporated on the 'fly' as his badge and emblem the white hart and the sun in splendour.[31]

Contemporary evidence for the banner of St George as a symbol of the authority of the King is found in the account by the Westminster chronicler of the battle of Radcot Bridge in 1387 in which Robert de Vere, Duke of Ireland, attempts to overthrow the Appellants who had opposed and persecuted Richard:[32] 'At the sight of them the Duke roused the fighting spirit of his troops and, raising the standard of St George, disposed his lines in battle order'.[33] When, after the defeat of de Vere, the Appellants have articles drawn up condemning him, they specifically refer to his presumption in raising 'the King's banner': 'The said Duke of Ireland rode forth with great power and force of men at arms and archers from the counties aforesaid through the realm until they came to a place called Radcot Bridge near Cotswold, and accroaching to himself royal power he caused the King's banner to be displayed in his company, contrary to the dignity of the King and his Crown'.[34] Significant indeed is this passage in relation to the 1385 Ordinances of two years earlier which refer to 'captains' who raise the banner of St George to withdraw men from the host. De Vere's army, in the hypocritical view of the Appellants was a rebellious force usurping the King's authority which of course they viewed as under their control.

The significance of the raising of the banner of St George by de Vere at Radcot Bridge must have been great because the incident is again referred to at the time of Richard's deposition in 1399. In the articles drawn up by Parliament in September of 1399 given in Walsingham's Annals of Richard II, the Radcot Bridge incident is thus described:[35] 'The King then secretly sent the Duke of Ireland with his letters and his standard into Cheshire in order to raise to arms there a great number of men, and he incited them to rise up against the said lords and magnates of the kingdom and servants of the republic, in setting up his standard against the peace which he had publicly sworn to keep'.[36]

If these texts can be accepted as providing evidence for the use of the banner of St George as a national standard representing the authority of the King, then the blessing of this standard as the central feature of the Diptych has special significance. The recent discovery, presented in Dillian Gordon's article, that the orb surmounting the banner has depicted upon it the symbol of England,

reinforces the symbolism of the banner as the standard of the English nation over which the King has authority to rule.[37] Gordon has quite rightly revived and re-emphasized the interpretation of Fathers Coupe, Thurston and Allen that part of the Diptych's devotional meaning is in the banner, representing England, presented to the Virgin. On the evidence of a lost painting once in the English College in Rome, in which the King is presented to the Virgin by St George, England had, since Richard II's time, been referred to in prayers as her dowry.[38] The Virgin in holding the Christ Child who blesses the banner is also closely associated with this banner representing the English nation over which she rules and is protector. The lost painting in Rome had the inscription 'This is your dowry O Holy Virgin, wherefore Mary may you rule over it'.[39] In devotional terms Mary's role in the picture must be of major importance, since her figure dominates the right-hand side of the Diptych just as Richard's does the left. Although the essential action is the blessing of the banner by the Child, the figure which supports Him and dominates by virtue of size is that of the Virgin.[40] The rose garlands on the angels' heads may allude to the custom in May of adorning images of the Virgin and their surrounds with roses or other flowers (see also Fisher, p. 160).[41] Gordon is correct in suggesting the Virgin's protection of the land of England is implied in view of her proximity to the banner.[42] It is the King's banner which having been given to be blessed by the Child is symbolically to be returned, conveying Divine authority to this symbol of the King's rule, authority and military power over England. Richard's hands are opened to receive it rather than to receive the Christ Child's foot to kiss as some have suggested.[43]

The symbol of the hart, so prominent in the Diptych, can also be seen as referring to the King's power both in the emblematic sense of its use as a badge of the King's supporters and in its allegorical significance. As John Harvey has exhaustively demonstrated, the white hart badge was first distributed in 1390 at the Smithfield Tournament and from that time on becomes publicly displayed in sculpture and painting in royal buildings such as Westminster Hall (see Wilson, p. 54) or places in which Richard wished to assert his authority.[44] Its link with the broom cod collars, absorbed into Richard's personal emblematica from *c.* 1395, is not only on the Diptych and on Richard's tomb, but also by 1396 it was being used by Richard's closest adherents such as Sir John Golafre on whose fragmentary brass in Westminster Abbey it occurs.[45] Also certainly by the time of his tomb, commissioned in 1395, the rising sun was being used as another emblem for Richard.[46] A common feature of these three emblems, the white hart, the broom cod and the sun was that they were also emblems of the King of France. The hart paralleled in the winged *cerf volant* (*ill. 111*), the broom cod originated as a French royal livery collar, and the sun had been adopted as an emblem by Charles VI shortly after 1382.[47] Richard and his circle may well have also taken over the contemporary French allegorical interpretations of some of these emblems, above all that of the white hart. As Michael Bath has shown, the white hart has widespread allegorical significance, above all through the legend

of Caesar's deer which resulted in the stag being seen as a symbol of the longevity of a dynasty.[48] Both the Duc de Berry in his Sainte-Chapelle at Bourges and Charles V in the Palais de la Cité in Paris had statues of stags set up. That of Jean de Berry was set beside the tombs of his ancestors in the ante-chapel, and that of Charles V, newly painted in 1364, was set beside statues of the Kings of France.[49] The contemporary French poet Eustache Deschamps in his allegorical political poems for Charles VI uses the image of the stag driving out marauders from the forest as an allegory of the monarch suppressing evil people in his kingdom.[50] This contemporary French royal symbolism of the stag in some form was almost certainly known to Richard and his court whose French contacts and reading of French literature are well documented. Froissart narrates that on his visit to England in 1395 he gave Richard a volume of his own French poems.[51] Unfortunately, the lists of Richard's books are not specific enough to provide evidence as to whether he read the works of Eustache Deschamps.[52] The gestures of Saints Edmund and Edward pointing to Richard emphasize his close link with them, and this could be connected with the symbolism of the stag of the long-living dynasty.[53] It cannot be excluded that St Edward might be represented with facial features intended as idealized versions of those of his grandfather Edward III, and St Edmund those of his father, the Black Prince, as some have suggested.[54] Such personal family portraits would strengthen the ancestry imagery, but this theory is not completely convincing.

A further relevant contemporary document on the emblematic meaning which may have been attached by Richard and his circle to the hart is the section *De Cervo* in the *c.* 1394 *Tractatus de Armis* of Johannes de Bado Aureo, possibly to be identified with John Trevor, Bishop of St Asaph (1390–1405).[55] This was compiled at the request of Queen Anne and completed shortly after she died. The attributes given to the hart are that he is able to resist all beasts who come against him, and that he who bears the hart on his arms is prudent and subtle in war.

Several of the interpretations of the Diptych have seen allusions to the coronation vesture and regalia in the figures of Richard and the two royal saints.[56] It is indeed true that these three figures, all Kings of England, wear and hold garments or objects in a general sense similar in form to the vestments and regalia of the coronation for the series of ceremonies in the rite.[57] St Edward's long-sleeved pale pink garment may represent the alb-like *colobium sindonis*, St Edmund's wide-sleeved blue and gold garment worn under his mantle is the supertunicle, and his prominent red shoes, the buskins (see Mitchell, VI, note 29).[58] Richard's cope-like mantle resembles the *pallium regale* which the *Liber Regalis* tells us had golden eagles on it, as does Richard's mantle but with the addition of his emblems, the white hart and broom cod collar.[59] Perhaps significantly, in view of Richard's political aspirations, the mantle combines the emblems of the white hart for England, the broom cod for France and the Imperial eagle for Germany. The first, perhaps relevant to his marriage in 1396 to Isabelle of France and the resulting peace between the two countries, and the

eagles to his aspirations to become the German Emperor in the spring of 1397.[60]

As well as these possible allusions to the coronation vestments, others referring to the regalia are also present.[61] Richard perhaps is wearing the 'old' coronation crown with which the monarch was crowned, whose crosses come directly from the band without being raised-up on finials (see Campbell, pp. 97–8).[62] Saints Edmund and Edward wear the modern late fourteenth-century type of crowns with higher finials, perhaps resembling the crown which the King of England wore at the end of the rite and which Richard is wearing in the Westminster portrait, which was different from the crown used for the crowning. The coronation ring is held by Edward, the arrow of Edmund's martyrdom is held in the manner of a sceptre. Only the orb is lacking from the essential regalia, and on the right-hand of the Diptych it is an orb that surmounts the banner symbolizing the English nation over which Richard rules. If, as so often in late medieval works of art, layers of meaning are presented, it seems that there is perhaps a case for seeing allusions to the coronation in the vesture and emblems of the painting.

All the observations made concerning allegory and symbolism stand or fall insomuch as they add up, or fail to do so, in an overall interpretation. In summary I have attempted to argue for the banner of St George as a symbol of the English nation with a personal association with the authority and military power of the King. King Richard, surrounded by symbolic allusions to the sacred panoply of his coronation vesture and regalia, is about to receive this standard of England which has been blessed by the Great High Priest Himself held by the Blessed Virgin, protectress of the land of England, her dowry. Richard is given Divine blessing for his authority, and the royal saints who support him emphasize his dynastic right made sacred through the rite of his Coronation.[63] If there is concern over the youthful appearance of Richard, it may indeed be deliberately commemorative of that Coronation in representing him as a youth without the moustache and beard which he is thought to have adopted at least from 1394.[64] His power in the military sense is confirmed through the blessing of the banner. The emblematica, the white hart and the broom cods intertwined so to speak, may well allude to the post-1396 peace with France. These emblems are adopted for Richard's personal use, and the wearing of them by the blue-clad angels may signify them as the personal guardian angels of the King and his supporters.[65]

In the light of this reading, the Wilton Diptych is a painting in which the devotional message is one of complete confidence in the support of Christ, His Mother, the angels and the three saints for the King. It would well fit the brief triumphal period of eighteen months after the final victory over the Appellants, Gloucester, Arundel and Warwick in September 1397 and before Richard's departure for Ireland in the spring of 1399. This would be the time of the triumphal celebration by Richard and his intimates when the King had achieved absolute authority in his rule.[66] If the blessing of the banner is an essential key to understanding the Diptych's meaning, as I have argued, then the prayer in a contem-

porary English Pontifical for the blessing of a military banner pleads for Divine support for the King in order that he may triumph over his adversaries:

> 'Bend down your ears of pity O Lord Jesus, saviour and redeemer of all, to the prayers of our humility, and by the intervention of blessed Michael your archangel and all the heavenly Virtues, give us the aid of your right arm, just as you blessed Abraham triumphant against the five kings, and King David in praise of your name achieved victories, so bless and sanctify this banner which is carried for the protection of Holy Church against the fury of its enemies, so that the faithful and the defenders of the people of God who follow it, may rejoice in having achieved triumph and victory over their adversaries in your name, and by the virtue of the Holy Cross'.[67]

In 1398, the year of the King's triumph, when it seems very likely that the Diptych could have been painted, Richard, in his devotions before it, could assuredly feel confident and grateful that he had indeed received Divine support for his rule over England, an authority of which the banner is a symbol. It is a tragic irony that shortly after the painting had been completed, in the subsequent events of the last year of his reign, the Divine support for Richard's power as King, which the Diptych seems confidently to assert, was to be withdrawn.

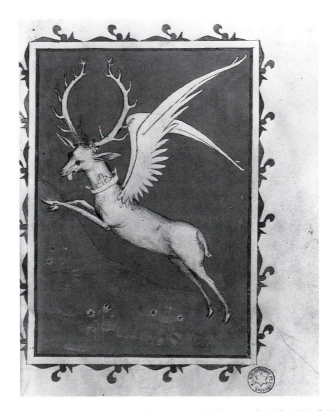

111. Winged hart. Paris, Bibliothèque de l'Arsenal, MS 2682, f. 34

XII

MAURICE KEEN

The Wilton Diptych:
The Case for a Crusading Context

T HIS ARTICLE will present the case for a crusading context for the Wilton Diptych, stressing the word context. A number of scholars have in the past argued that the Diptych is a crusader icon.[1] To argue that the work has or may have a crusading context is not the same as to say that it is a 'crusader icon'.[2] In the light of the new considerations raised by the tiny image painted on the orb at the head of the banner in the picture, there now seems reason to doubt whether there is any one clear, single and exclusive explanation of its commissioning and its symbolism. But its commissioning must have had a context, it is clear, and it will here be argued that the crusading ideal is part of that context.

The argument that this is so depends on accepting two general assumptions. The first is that it was commissioned by or for Richard II. The second is that it was painted in the late 1390s, between 1395 and 1399. Not everyone has accepted these assumptions, but it seems fair to say that most scholars have: limitations of space preclude any detailed discussion of the evidence that supports them, which was set out with admirable clarity by John Harvey in 1961.[3] It must, however, be made clear at the start that if those assumptions are rejected, the case for a crusading context falls to the ground with them. The case relates principally to three features of the painting: the broom cod device, the Symbols of the Passion, and the coat of arms on the external panel showing the arms of England and France quarterly impaling the arms of Edward the Confessor. The first and last of these, it should be noted, have a direct relevance to the dating of the picture which is germane to the argument.

The first things to consider are the broom cods which are important both for context and for dating. They are very prominent in the decoration of the picture, encircling the harts of Richard II's livery badge on his robe and forming the links of the collar about his neck (*col. pl. 2*). The broom cod was the livery of the King of France, Charles VI. In 1395, in the period of the negotiations between France and England that culminated in the marriage of Isabelle of France, Charles VI's six-year-old daughter, to Richard II as his second wife, Charles made a gift of collars of broom of his livery to Richard II, and to his uncles of Lancaster, York and Gloucester.[4] It is extremely unlikely that Richard used the broom cod as a personal emblem before that date: after it, it is very clear that

he did. Broom cods appear on the robe of his tomb effigy in Westminster Abbey (*ill. 102*) and collars of broom are mentioned in the inventory of his treasures.[5] In January 1397 Richard paid for gowns for twenty ladies to lead twenty armed men to the tournament at Smithfield, whose decoration sounds strongly reminiscent of the royal robe of the Diptych: 'twenty long gowns of red *tartaryn* with white harts of silver with gold crowns and chains and broom plants'.[6]

The broom cods, in combination with the White Hart, were also prominent earlier in the pageantry of the ceremonies surrounding Isabelle's marriage, and the combination was clearly a token of amity. When the two monarchs met at Ardres in October 1396 to finalize the arrangements, both appeared in robes of red velvet, with a hart on the sleeve, and wearing collars of the broom cod livery of France.[7]

Though the broom cods of Richard's collar in the Diptych, and of other collars subsequently owned by him, are not of precisely the same design as those of Charles VI's collars,[8] they are nevertheless always referred to—for instance in the inventory of Richard's treasures made after his death—as collars of the livery of the King of France.[9] All the references to them confirm the suggestion that the Diptych must be associated with the period of *rapprochement* between England and France in the late years of Richard's reign, that is to say, the years 1395–99. The absence in the Diptych of any direct pictorial reference to a consort of the King may point to a date for its design before the marriage to Isabelle, in late 1396.

If the Diptych is to be associated at all closely with the *rapprochement* between France and England—as its combination of broom cods with the White Hart seems to suggest it should be—then that is in itself arguably a crusading context. In the negotiations between the two kingdoms the quest for a permanent cessation of hostilities in their bitter and destructive quarrel was inextricably enmeshed with two other issues, projects for Anglo-French co-operation in ending the Schism in the papacy and projects for a crusade.[10] Under cover of repeatedly extended truces, negotiations toward a peace were more or less continuously sustained from 1389. Hopes that this prospective peace would pave the way for a joint Anglo-French crusade against the Turk first appear explicitly at the time of the conference held at Amiens in 1391: there was further discussion of the project at Leulinghen in 1393.[11] In 1394 John Holland, Richard's half-brother, was on embassy to the court of Sigismund of Hungary, the Catholic ruler most directly threatened by the Ottoman advance, and a French embassy was despatched to the same court at the same time.[12] In June of that year Charles VI's uncle, Philip the Duke of Burgundy, told his cousin William of Namur that he was seeking funds to prepare for a crusade which would be led by himself, John of Gaunt (Duke of Lancaster), and Louis of Orléans.[13] Plans were going forward, hardening, and on an Anglo-French cooperative basis.

In 1395 the pace of negotiations accelerated sharply. In March a French embassy, with proposals for a French marriage, found Richard in Ireland. They were well received and a little later, in May, were followed by a second embassy,

he pourc · de la vraye paix et amo

112. Philippe de Mézières presents his letter to Richard II.
London, British Library, MS Royal 20 B.VI, f. 2

in which one Robert the Hermit figured prominently.[14] He brought with him firm proposals for a marriage to Isabelle of France, and a letter from Charles VI urging on Richard the project of a crusade: 'then, fair brother, it will be a fit moment that you and I, for the propitiation of the sins of our ancestors, should undertake a crusade to succour our fellow Christians and the Holy Land, first won by the precious blood of the Lamb'.[15] Robert also brought, it would seem, a presentation copy of Philippe de Mézières' *Epistre au Roy Richart*, a propaganda piece commissioned by Charles to urge on Richard the combined objects of a French marriage, a lasting settlement between the two kingdoms and a crusade.[16] By July Richard's envoys were on their way to France with his favourable reaction: and from there the way led directly forward to the conclusion in March 1396 of a 28-year truce between the kingdoms, and the marriage of Richard and Isabelle.[17] At the same time plans for crusade were pushed forward: and in the summer of 1396 what was intended to be the advance guard, led by Philip of Burgundy's son John and including some English troops,[18] set out for Hungary and for overwhelming defeat at Nicopolis in September. Crusading was thus very much part of the context of the Anglo-French exchanges of these years, of the new amity which the combination of broom cods with the White Hart, in the Diptych and elsewhere, betokens.

The Symbols of the Passion in the Diptych are the next thing to consider. Here the *Epistre au Roy Richart*, that Robert the Hermit brought to England, is imme-

191

113. Banner of the Order of the Passion. London, British Library, MS Royal 20 B.VI, f. 35

diately relevant. An illumination on folio 2 of the de luxe presentation manuscript of the letter shows the 'old solitary', as de Mézières—the author—refers to himself, with the red cross banner of his crusading Order of the Passion in his hand, kneeling before Richard to present a book (*ill. 112*).[19] Facing it, on the opposite page, another illumination shows the Crown of Thorns between the Crowns of France and England (col. pl. 16).[20] There are significant analogues here with the symbolism of the Diptych. In the Diptych, the emblems of the Passion are prominent. The Crown of Thorns and the Nails of the Cross are stippled within the nimbus of the Christ Child. The banner of the Diptych is very different from the banner that de Mézières holds in the illumination in the *Epistre*, it is true: but its design is decidedly similar to the Resurrection banner of the Lamb of God on the medallion at the intersection of the red cross of the Passion Order's banner depicted on folio 35 of the *Epistre*, under the words 'how the old solitary presented to the King of England a new Order of Chivalry of the Cross which shall be sent to the Holy Land, in advance of the two kings who by the Grace of God will make the Holy Passage' (*ill. 113*).[21] That banner is surmounted by a cross, not by an orb as in the Diptych: but here it should be remembered that the recent cleaning of the painting, which revealed the design

192

on the orb, also revealed that a cross had been originally projected to surmount the banner, but was not finally painted in.[22]

Philippe de Mézières, author of the *Epistre*, was probably the most notable and certainly the most prolific propagandist of the crusade of the later fourteenth century.[23] A former Chancellor to King Peter of Cyprus, he became a Councillor to Charles V of France and tutor to his son Charles (VI): in 1380 he retired into the Convent of the Celestines in Paris (whence 'the old solitary'), but continued to write voluminously to advise his former charge. The Order of the Passion and its crusading role was a project that he began to nurture in the 1360s. The old crusading Orders of the Temple and the Hospital furnished the example that inspired him; but his new model was modified by the example of the new secular Orders of Chivalry—such as the Garter, the Knot of Naples and the Sword of Cyprus—whose companions were not committed to celibacy or renunciation of the world in the way of the Templars and Hospitallers.[24] His hope was to enrol in his new Order, and so commit to the crusading ideal, princes, lords and knights of Christendom: and a substantial number of leading aristocrats of France and England were by the mid 1390s formally enrolled in it.

Chief among the four 'evangelists' whom Philippe commissioned (at some date after 1385) to propagate his project were Robert the Hermit, mentioned above assisting in the negotiations between Charles VI and Richard II, and Otto de Granson, a Burgundian knight who came to have close connections with both Richard II and John of Gaunt and who accompanied Henry Bolingbroke, Earl of Derby, on his crusade to Prussia in 1392.[25] The name of the Order, the Passion, was no doubt inspired by the contemporary notion, almost a *topos* of crusading propaganda, that Christ by his Passion had won the Holy Land for his Christian people, an idea sharply pointed up by Charles VI in his letter of May 1395 to Richard II, in its allusion to the 'Holy Land first won for us by the precious blood of the Lamb'[26]—the Lamb that in the Diptych is couched in the arm of the Baptist.

It cannot be concluded from this that the Wilton Diptych is emblematic of Richard II's involvement with a dedication to de Mézières' Order. If it were, he would surely—as has been argued—be depicted in the robes of a prince of that Order, as they are shown in the copy of de Mézières' *Abrégeance* of the Rules of his Order that belonged to Richard's half-brother, John Holland (Oxford, Bodleian Library MS Ashmole 813). In fact, there is no surviving portrait of a real prince or king painted in those robes, or carrying the banner of the Order of the Passion.[27] What may be concluded is that the Diptych's symbolism is rich with signs and emblems redolent of the Christian and crusading propaganda that de Mézières, among others, was doing so much to promote and propagate in the context of the *rapprochement* between France and England about the time that it was painted. The broom cods of Charles of France linked with and encircling the White Hart of Richard of England, the red cross standard that is at once an emblem of the Resurrection and the banner of George, patron saint of England

and of Christian knighthood, the Crown of Thorns of the Passion in the Christ Child's halo, the Lamb, whose blood had made Palestine a Christian heritage, in the Baptist's arm, all contribute to the painting's overtones of contemporary crusading aspiration which a contemporary viewer would not have missed. It can be argued further that they would probably not have been combined in such an evocative way if the painting had been executed at a time when crusading aspirations were less thick in the air than they were in the mid 1390s, both in France and England.

This leads directly to the shield of arms on the external panel of the Diptych, which displays the arms of Edward the Confessor[28] impaling the arms of England and France quarterly (*col. pl. 4*). This heraldic marshalling—like the broom cods—is significant for purposes of dating, confirming what the broom cods suggest in that regard. Richard's attachment to the cult of the Confessor is well attested (see Mitchell, pp. 115ff.); and the Confessor's arms appear, for instance, on a rich chasuble presented by Richard and his first Queen, Anne, to Westminster Abbey in 1389.[29] In 1394 we know that in Ireland Richard displayed as his standard a banner of the arms of Edward the Confessor.[30] But we do not hear of his using the arms of the Confessor impaling his own arms until 1395. The Wardrobe Books record in September 1395 that the impaled arms were inscribed then on new plate purchased for the King; and they appear impaled on his Signet Seal for the first time in that year.[31] From then on to the end of his reign there are repeated references to his use of these impaled arms; in stained glass, for instance, on the canopy of his effigy in Westminster Abbey, on his banner as depicted on the sepulchral brass of his standard bearer, Simon Felbrigg (*ill. 114*).[32] He also allowed the five new dukes created after the royalist triumph of 1397 to impale the arms of the Confessor, that is Hereford, Norfolk, Aumerle, Surrey and Exeter (these last two being his Holland kinsmen).[33] Edward of Rutland, Duke of Aumerle, had actually used these impaled arms before that date, since they appear on his seal as Admiral of England in 1396.[34] The impaled arms of the Confessor thus seem to have had a special significance in the intimate royal circle.

The names of the royal intimates mentioned above are also significant in another way. John Holland, Earl of Huntingdon and Duke of Exeter, Thomas Mowbray, Earl Marshal and Duke of Norfolk, and Edward of Rutland, Duke of Aumerle, together with his father, the Duke of York, were all associated with the Order of the Passion. The King's uncles, the Dukes of Lancaster and Gloucester, and his half-brother, John Holland, were its English patrons. Among its known English enrolled members were York, Rutland and Mowbray; the Lord Despenser, who was another who was prominent in the royalist triumph of 1397 and created then Earl of Gloucester; and the chamber knights Lewis Clifford, Richard Abberbury, Richard Cholmwick, John Harleston and Simon Felbrigg— the same Simon Felbrigg whose brass (see *ill. 114*)shows him bearing Richard II's standard, with the Confessor's arms impaling the royal arms of England and France.[35]

114. Memorial brass in
Felbrigg Church (Norfolk)
of Richard II's standard bearer,
Sir Simon Felbrigg (d. 1443) and his wife (d. 1416),
19th-century engraving

There is no suggestion here of a direct connection between the use of these impaled arms and the Order of the Passion. But there seems to be a significant overlap between the intimate royalist circle of Richard II and the prominent Englishmen of the time who are known to have had crusading interests and aspirations. There were other knights of Richard's chamber besides those who were enrolled in the Passion Order who are known to have been actively interested in crusading projects: John Golafre, on whose sepulchral brass appears the White Hart;[36] Janico Dartasso, the Gascon who in 1399 refused to put aside Richard II's livery when ordered to by Bolingbroke;[37] John Montagu, Earl of Salisbury, who was lynched after the Ricardian rising against Henry IV in 1400;[38] and Lewis Clifford's friends, William Neville and John Clanvowe, who both died in the East in 1391.[39] This interest in crusading in Richard's close court circle, among those who were of the Order of the Passion and among others too, seems to me directly relevant to the Diptych.

195

The Diptych appears to be designed as an altarpiece and to be portable, and to have been commissioned for Richard personally. Who were likely to be about him at his prayers before it, in the Confessor's Chapel in Westminster Abbey or in the private chapel of one of his manors? Just the sort of men named above. On such men the crusading resonances of its symbolism, of the red cross of the banner, of the Crown of Thorns, of the Lamb slain for us, would have not been lost.

There are other resonances besides these in the Diptych, other layers of symbolism, of course. If it should be called an icon of anything, it could be called an icon of Richard II's English Christian kingship. The English royal saints, Edmund and Edward, the orb on the banner with its microscopic image of England as the dower of the Virgin, are emblematic of its Englishness.[40] The white harts attach it to Richard personally and to his personal circle. But in the later Middle Ages to be King of England was not *just* to be King of England; it was also to be one of the princes of Christendom, the natural leaders of Christian chivalry, whose highest aspiration was crusade. Among English monarchs of the later Middle Ages, Edward I had been a crusader, Edward III in his early days had proclaimed an intention to crusade, and Henry IV, before he was King of England, had fought the infidel in Prussia. Henry V declared on his deathbed that it had been his ambition, when his business in France was completed, to rebuild the walls of Jerusalem.[41] During the reign of Richard II, in particular, new opportunities seemed to open for achieving something in the East where so much had been lost, and stirred more keenly than usual the chivalric aspirations of the knights of England and France in the very period when the Diptych was probably painted. They stirred in particular a number of aristocrats and knights identified as of the intimate court circle of Richard II in the mid 1390s. In conclusion, the Wilton Diptych, although it may not be a crusading *icon*, does have a crusading context. Crusading aspiration may be only one of the layers in the meaning of Christian kingship that it seeks to convey; but it is a significant one.

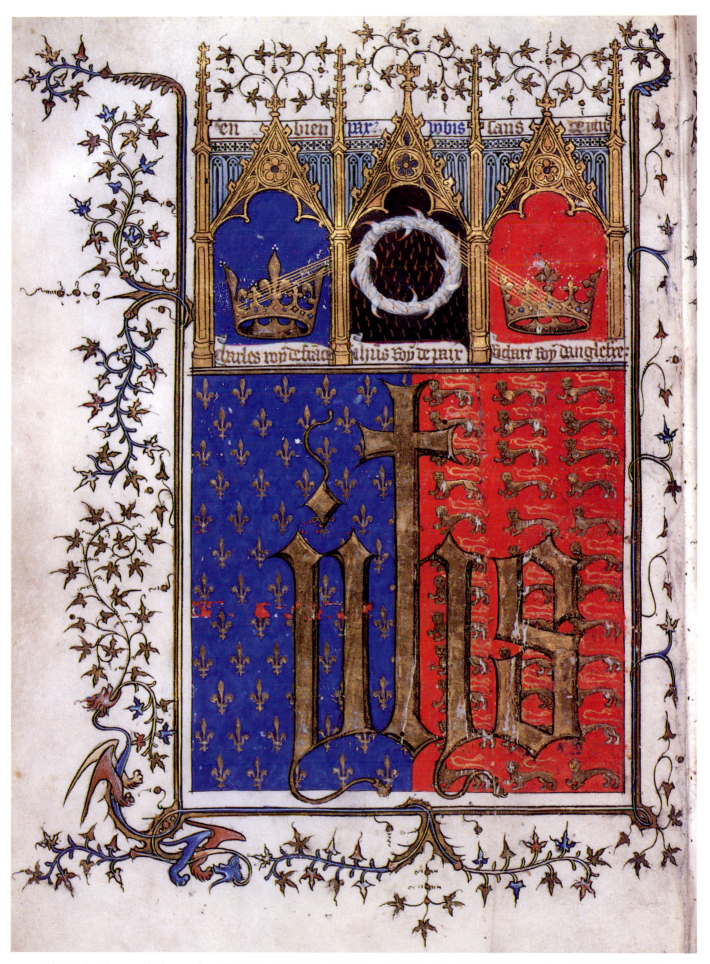

Pl. 16. The Crown of Thorns, from the *Epître de Philippe Mézières*, c.1395. London, British Library, Royal MS 20 B. VI, f. 1v

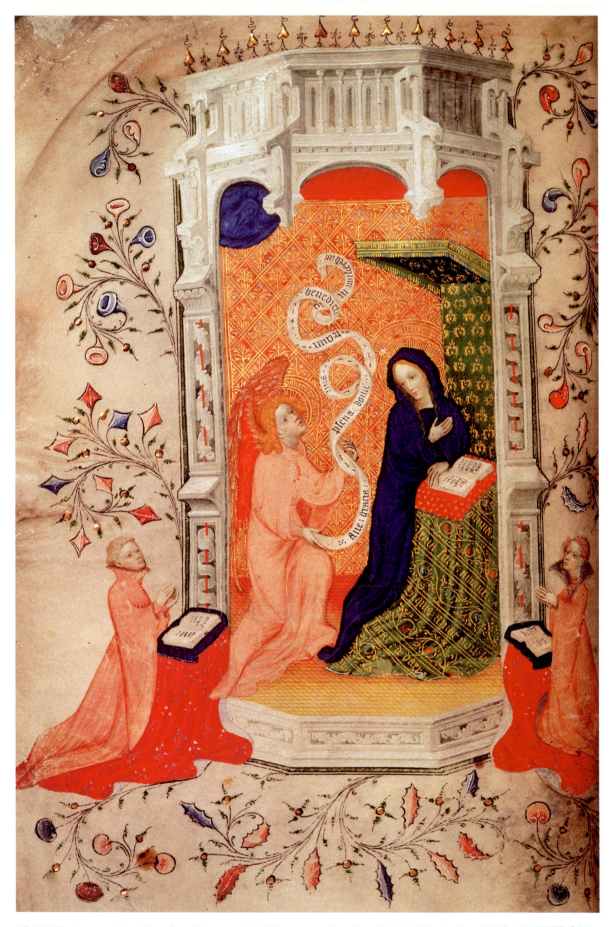

Pl. 17. *The Annunciation*. Beaufort Hours, early 15th century. London, British Library, Royal MS 2 A. XVIII, f. 23v

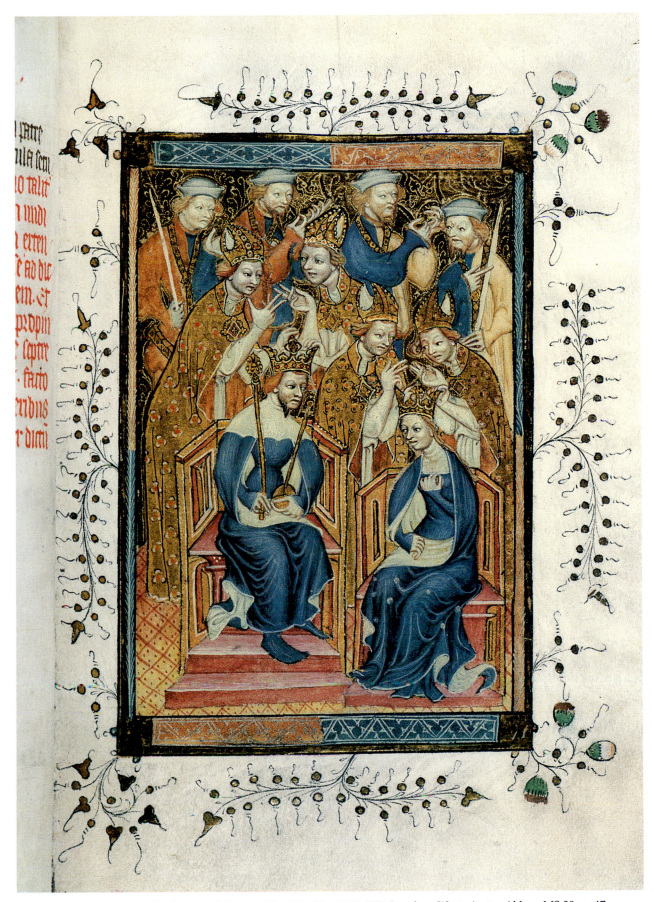

Pl. 18. Coronation of a King and Queen. *Liber Regalis, c.*1390-9(?). London, Westminster Abbey, MS 38, p. 47

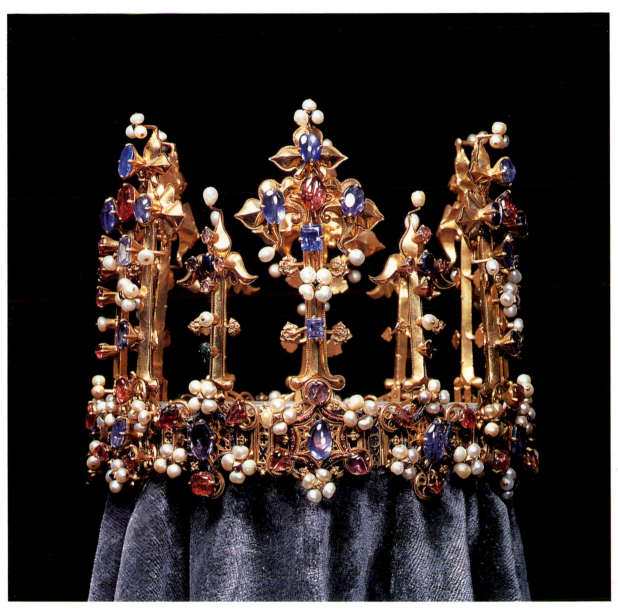

Pl. 20. Crown of Blanche of Castile. French, *c.*1380. Munich, Residenz, Schatzkammer

Pl. 19. Richard II kneeling before St John the Baptist. Stained glass, *c.*1393. Winchester College

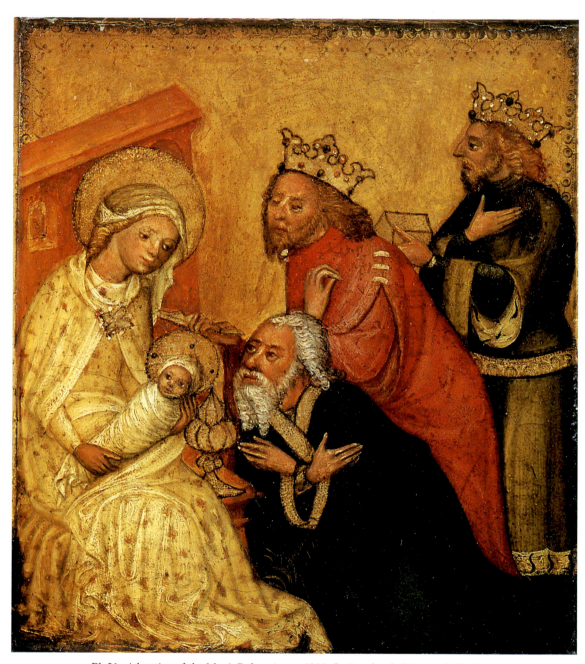

Pl. 21. *Adoration of the Magi.* Bohemian, *c.*1380. Switzerland, Private Collection

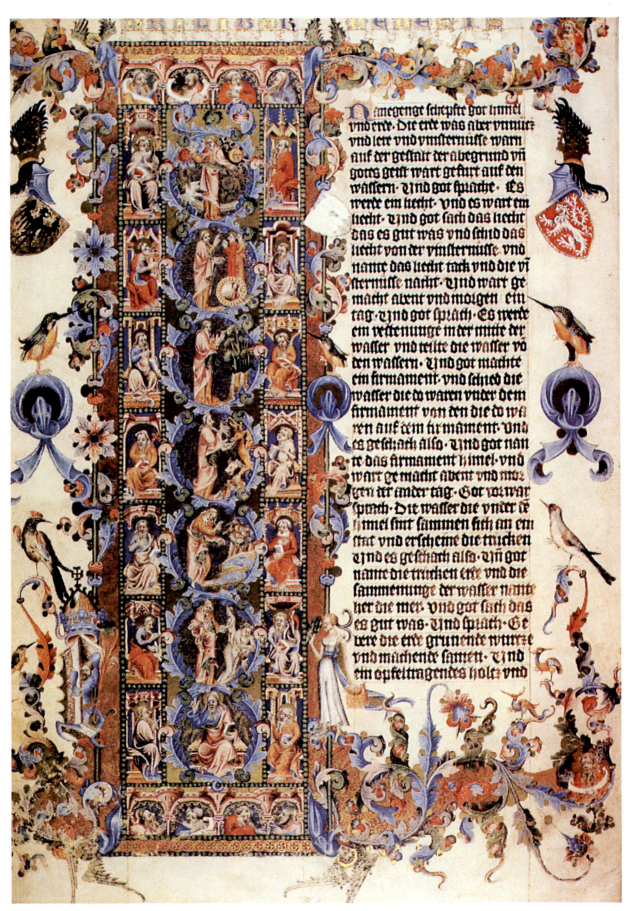

Pl. 22. Opening of the Book of Genesis. Bible of Wenceslas IV, vol. 1, f. 2v.
Vienna, Österreichische Nationalbibliothek, Cod. 2759-64

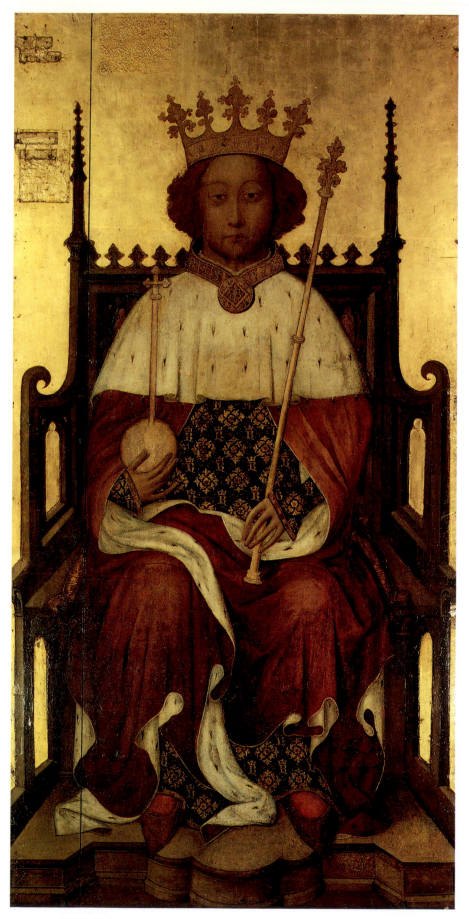

Pl. 23. Richard II Enthroned, *c*.1395(?). London, Westminster Abbey

XIII

JONATHAN J. G. ALEXANDER

The Portrait of Richard II
in Westminster Abbey

T HE WESTMINSTER ABBEY portrait of Richard II has not received as much scholarly attention as the Wilton Diptych, yet it is at least as remarkable a survival in the context of European art of its period. Various things have been against it, above all its state of preservation and the damage inflicted by the nineteenth-century and earlier restorations.[1]

At the time of the *Age of Chivalry* exhibition in 1987, when the Dean and Chapter of Westminster generously agreed to lend the portrait to Burlington House, we were fortunate to obtain conservation advice from the Hamilton Kerr Institute.[2] In order to examine the portrait while it was still in the Abbey, Ian McClure brought a portable infra-red reflectography lamp which made it clear that the underdrawing of the painting became highly visible through this method of examination. Permission was obtained for the portrait to go to the laboratory after the exhibition for further examination, and it is the main purpose of this paper to publish the resulting photograph of the underdrawing (see *col. pl. 23 and ill. 115*).[3]

Before the newly revealed underdrawing is discussed, a review of what appears to be known about the portrait's history and of some of the opinions expressed by scholars is in order. The earliest mentions of the portrait so far found are Speed's of 1611 and Weever's of 1631.[4] Both writers locate the portrait 'at the upper end of the quire', but give no other useful information. It is subsequently represented in Sandford's view of the choir at the Coronation of James II in 1687.[5] At that time it was attached to the end of the choir stalls on the south side at the east end of the Dean's row where it is also located by Dart in 1723.[6]

No firm evidence as to where the portrait was originally placed has so far been discovered. In an Abbey inventory of 1388 there is a reference to a textile (*'pannus'*) of various colours for covering the King's pew (*'cawagium'*) near the Great Altar.[7] It is thought that the King's pew was placed in the Sanctuary on the south side, where the tomb of Queen Anne of Cleves (d. 1557) now is. If the portrait was part of a stall or throne in the pew, it could have been detached when Anne of Cleves' tomb replaced the King's *cawagium*. F. Hepburn has collected several significant references to the painting of images of kings on the backs of chairs.[8]

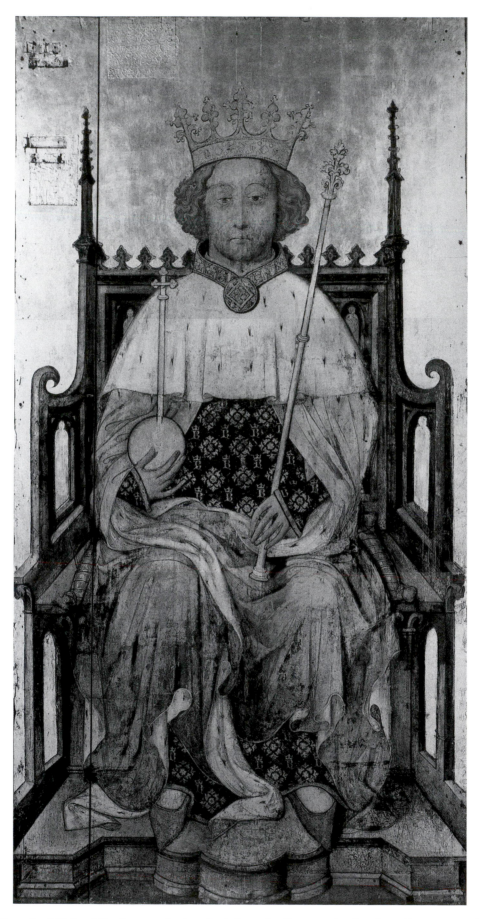

115. Portrait of Richard II, photographed under infra-red reflectography. London, Westminster Abbey

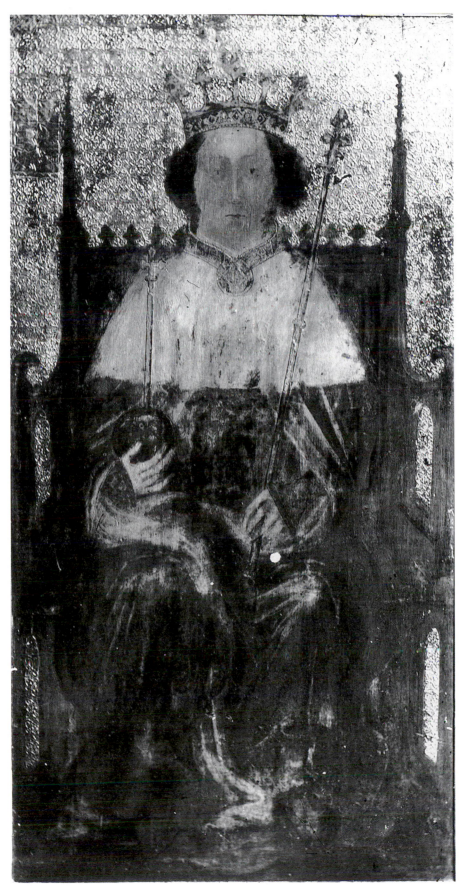

116. Portrait of Richard II, photographed before the 1866 cleaning. London, Westminster Abbey

In his Report to the Dean and Chapter of 18 February 1987 McClure wrote, unaware of these suggestions: 'The planks are glued and dowelled together. The first joint to the right has opened to about 3¹⁄₁₆ inches but is still held by the dowels. This might suggest the panel was built onto a rigid framework before being fitted into its present nineteenth-century frame'. The repaired holes at the top left of the picture have been suggested to be brackets for a hanging lamp, another possible indication that the portrait was at some time part of a permanent structure and thus not in origin an independent panel painting.[9]

The medieval choir stalls were replaced in 1775 and the portrait was then removed to the Jerusalem Chamber.[10] It was shown in the Manchester Exhibition of 1857 and it was as a result of the interest occasioned then that the painting was cleaned and restored under the supervision of the painter George Richmond by Messrs Henry Merritt and Chance in 1866. Sir George Scharf in his admirable article gave a detailed account of the work as well as listing earlier reproductions of the portrait and surveying the evidence as to earlier repaintings. One restoration by Captain Broome in 1732 was probably responsible for the repainting of the King's face and the addition of shadows from the regalia, which were subsequently removed in 1866. Another cleaning by Charles Muss of *c.* 1823 is recorded.

During the 1866 cleaning a diaper background was also removed, except for the small area surviving at the top left of the picture. Scharf noted that the diaper was carelessly applied and that it obscured various parts of the figure of the King. The orb, the crown and the sceptre as they are today were also uncovered beneath regilding. A photographic negative, preserved in the Victoria and Albert Museum in London, was taken before the cleaning (*ill. 116*).[11] Scharf's drawings also show the portrait before and after cleaning and in particular the leaf forms on the orb and the pine cone on the sceptre, which he considered suspect, and the different form of crown. There is now a declivity all around the figure, still easily visible, as if some of the surface had been removed prior to the application of the gilt gesso pattern, and Scharf used this as a further argument that the pattern was a later addition. In the 1866 restoration the diaper was considered to be probably added in the Tudor period, which might correspond with the suggested removal from the King's *cawagium*.[12]

However, some authorities, including W. R. Lethaby, have considered the diaper original.[13] A patterned gold ground is normal for a picture of this date. Raised gesso work does indeed appear on the tester of Richard II's tomb, where it is surely original.[14] The question of the date of the diaper fragment, therefore, needs a more thorough investigation to compare it with these and other contemporary examples.

There are two other pieces of written evidence which have been considered to have a bearing on the portrait's history. The first is the payment in the Issue Rolls dated 15 December 1395 to 'Master Peter [Combes], Sacrist, by the hand of John Haxey in discharge of £20 which the Lord King commanded to be paid to him for painting the covering [*cooperture*] of the tomb of Queen Anne, late

Queen of England, buried within the same church...and for the painting of a certain counterfeit image [*ymaginis contrafacte*] of a king [*unius regis*] in the choir of the church' (see Tudor-Craig, p. 209).[15] The words *ymaginis contrafacte* could refer to either a painting or a carved statue, but perhaps the latter is more likely.[16] In any case, we may note that the *ymago* is not specified as being of King Richard, only of a (*unius*) king. As Hepburn says, this is odd, and not the case in for example the documents for Richard's tomb, where it is not of a (*unius*) king but simply of *the* king (*regis*) always.[17]

The second reference, which has caused a great deal of confusion in the earlier literature, is William Lambarde's account of a conversation with Queen Elizabeth in 1601 during which she told him of a portrait of Richard II which she had been given by Lord Lumley and which she had had put with her pictures at Westminster. Hepburn points out that in 1683 Keepe mentions two similar portraits, one in the Abbey, the other at Hampton Court.[18] If, as seems likely, the latter was Lord Lumley's gift to the Queen, then it cannot have been the Westminster portrait which there is no reason, therefore, to think has ever left the Abbey.

Turning now to opinions on the style, date and artist of the Westminster portrait, Scharf, though he compares the throne to that shown in the coronation miniature of the Missal of Abbot Litlyngton paid for in 1383, does not speculate on the artist's identity.[19] He does, however, refer to the theory of Dart followed by J. P. Neale that the portrait was painted to commemorate the visit of Richard and Anne of Bohemia to the Abbey on 13 October 1390, the Feast of the Translation of St Edward, when, as described by the Monk of Westminster, they attended the celebration of mass each wearing their crown.[20] Many authorities have since accepted this suggestion for the portrait's date, though, of course, it is in no way conclusive.

As with the Wilton Diptych, discussion of the date has often involved guesses as to the likely age of the sitter, especially given the presence of a beard.[21] No one since Waagen in 1857 seems to have considered the portrait to be either posthumous or, as so many royal portraits are, a later copy.[22] Waagen's opinion when he saw the portrait during the Manchester Exhibition that the style was too advanced to be contemporary was shared by Alfred Woltmann, author of a monograph on Holbein, writing in the same year.[23] No doubt they both were misled by the eighteenth-century repainting by Captain Broome, at that time not yet removed.

There have also been a number of guesses as to the artist's identity. Sydney Cockerell in 1906 proposed André Beauneveu, invoking the reference by Froissart to work in England by Beauneveu and comparing stylistically the Virgin and Child in the Pierpont Morgan Pattern Book (*ill. 117*).[24] This had just been published for the first time by Roger Fry with an attribution to Beauneveu, comparing the figures documented as by him in Jean de Berry's Psalter.[25] The finest drawings in the pattern book, which is anonymous and undocumented, have more recently been tentatively attributed by Millard Meiss to Jacquemart

117. *Virgin and Child*.
Drawing in Pattern Book, *c.* 1400.
New York, Pierpont Morgan Library, M. 346, f. 1v

118. Seated figure.
Drawing in Pepysian Pattern Book.
Cambridge, Magdalene College MS 1916, f. 7v

de Hesdin, also painter to the Duc de Berry.[26] Lethaby in 1906 produced another name, that of Herebrecht (or Herebright) of Cologne, citizen and painter of London, who worked at St Paul's Cathedral in the later 1390s.[27] The name of Gilbert Prince, King's Painter, which has been widely canvassed more recently, was introduced by William Shaw in 1934.[28] Shaw connected the portrait with payments of £220 made in the Wardrobe Accounts of 1382–86. For this he had to put the King's age at fifteen in the portrait, which is surely implausible. Prince had been replaced as King's Painter by Thomas Litlington by January 1397.[29]

We may now turn to the new infra-red photograph (*ill. 115*). It undoubtedly gives a much better indication of the original quality of the painting. Though the portrait even in its present state remains an imposing work, its surface is flattened out with a lack of nuance and modelling, making it dull and lifeless in its details. The vitality of the underdrawing is particularly striking in the hair and in the drapery folds. The monumentality and sensitivity of the drawing shows that it was the work of a major artist.

202

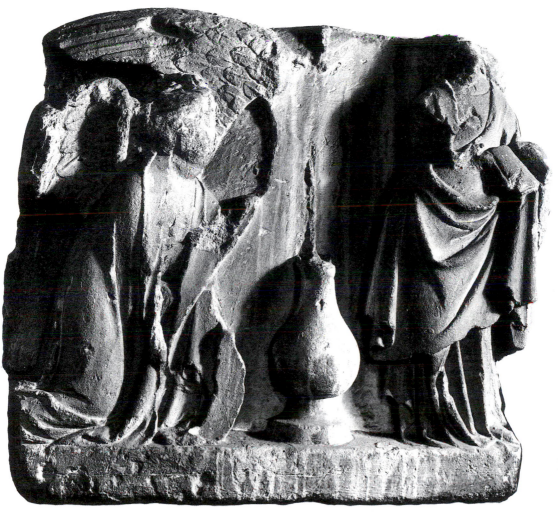

119. *Annunciation*. Oxford, New College, fragment of the Chapel reredos

Stylistic analysis of the spatial representation of the seated figure as seen in the new photograph supports a later rather than an earlier date in Richard's reign. Two works made for the powerful Chancellor and wealthy prelate, William of Wykeham, Bishop of Winchester, may first be compared. The fragments of the reredos made for the chapel of the Bishop's foundation of New College, Oxford, *c.* 1380–86, show carving of very high quality (*ill. 119*).[30] Compared to the seated Richard the figures are, however, comparatively insubstantial. They taper to the ground line, rather than establishing a firm foothold. The recession of the seated King's thighs and the suggestion of spatial depth of the drapery, especially the fold which crosses the right thigh and falls between the knees, can be contrasted with the much flatter linear folds of the sculpture.

Another of Wykeham's commissions, the stained glass by Master Thomas of Oxford made for the Bishop's twin foundation at Winchester College of *c.* 1393, though it shows a more fully modelled painting style, in the puffy beards and

203

the deep folds of the drapery for example, in terms of the space construction and the stability of the figures once again lacks the monumentality of the Richard portrait.[31]

The drawing style as revealed in the new photograph can also be compared to drawings in three surviving pattern books of the period. The first is the Pepysian Pattern Book in Magdalene College, Cambridge, whose date is of course uncertain.[32] Like many pattern books, stylistic divergencies indicate that either it includes copies of earlier works, or, more likely, that the drawings extend over time from the late fourteenth to the early fifteenth century. There is certainly some similarity to the portrait underdrawing in the moulding of drapery folds and their rich undulation in detail (*ill. 118*). But if we look at the figure as a whole, there is, as with the works for William of Wykeham, a tendency to two-dimensionality and a lack of weight on the ground line.

The same is true of the Bohemian Pattern Book now in Brunswick, likewise undated, but generally assigned to the 1390s.[33] In addition the drawing style there is clearly different with its use of cross-hatching. This gives no support in my view to those who have seen Bohemian links in the portrait.[34] The third pattern book, that already mentioned in the Pierpont Morgan Library, provides the closest comparisons, as Cockerell had already seen. For example there is a similar stability about the seated Virgin there (*ill. 117*), the same skill in handling the spatial depth of the seated figure, and a comparable richness and elegance of drapery folds, for example the folds of the lower body.

We should not leap to conclude that the painter of the portrait of Richard II was French or Netherlandish, however. Rather we must recognize that the portrait belongs with an International Court current which, as the major exhibition *Die Parler* held in Cologne in 1978[35] demonstrated, extended throughout Europe at this same period of the 1390s. This is an artistic mode which circulated among the patrons of the European courts, a style which is for that reason as international as they were. There is in my opinion no possibility of certainty as to the artist's nationality, therefore; but that the King should employ his own painter is entirely plausible. The title was a new one,[36] linked—as the payments for work done which no longer survives make very clear—to court functions and royal propaganda. If the portrait is by one of the two King's Painters, then the preference would be for the younger Thomas Litlington over the older Gilbert Prince who was already active much earlier in St Stephen's Chapel, Westminster.[37]

Distinctions of style at this period can be made more easily in terms of patrons and consumers than of nationality, though inevitably geographical/regional questions are interconnected, since opposed to the International Court Style are the non-court, that is often provincial styles. Provincial should not be applied as a negative, indeed the contrary, as L. M. J. Delaissé long ago showed in relation to Dutch art in this period.[38] Provincial art can be psychologically and iconographically richer, more expressive of social values, more 'realistic'. Similarly in England, though even now we are still rather poorly informed, East

Anglia, York, Bristol may provide us with equally interesting and aesthetically significant artefacts.

In the European context the Westminster portrait is most obviously exceptional because of its great size (2.13 × 1.10m). If its original context was, as suggested above, the King's pew in the Abbey, then it should be compared with, for example, the figures of earlier kings on the nearby sedilia rather than with the first surviving European independent panel portraits, those of Jean le Bon of France and Rudolph of Hapsburg, which are so much smaller and both only head and shoulders.[39] Iconographically it is hard to find any convincing parallel for the portrait. It does not belong to the common genre of donor image with saints, exemplified in the Wilton Diptych.[40] Nor is there any evidence that it formed part of a genealogical sequence, as found in the lost paintings in Emperor Charles IV's Karlstein Castle near Prague (see Pujmanová, pp. 251–2), and also the sculptures of Richard's own Great Hall at Westminster (see Wilson, pp. 52ff. and Lindley, pp. 75ff.).[41] Another monumental context in sculpture would be above a gateway as at Caernarvon Castle, where the seated frontal royal image of Edward I similarly combines authority and symbolic presence.[42]

Nevertheless in spite of its symbolic character, it is still important to emphasize that the Westminster portrait was painted at a key moment of transition in subjectivity, a moment about which Lee Patterson has brilliantly written in relation to Chaucer.[43] The hieratic frontal pose with its emphasis on the regalia of office, as well, perhaps, as its placement in the holy space of the Abbey, refer back to the medieval ideology of kingship. As such the image recalls in formal terms, even if it differs radically in its scale, the frontal image of the King on his Great Seal.[44] It is as much an icon of kingship as a portrait of an individual king. In this it differs from the image for his tomb which is, ironically, so much more lifelike in its suggestion of aging, implying the King's human frailty.[45]

The same period of the late fourteenth century sees the coat of arms representing feudal lineage and the guarantee of family continuity supplemented by the personal badge or emblem which individualizes its owner.[46] Cockerell already drew attention to the similarity of the crowned 'R' on the King's robe, which personalizes Richard, to the crowned 'C' of Charles V of France in the border of the *Parement de Narbonne* in the Louvre of *c.* 1380, where the King of France is shown as kneeling donor.[47] Another example of such an individualizing initial is the crowned 'C' of Casimir the Great (d. 1370) on the doors of the Cathedral of Cracow.[48]

Richard's crowned initial 'R' on the Westminster portrait (*ill. 120*) and his personal badge of the White Hart on the Diptych can be seen, therefore, as exemplary of the developing opposition between a consciousness of birth and inheritance on the one hand and of individual subjectivity on the other. If the portrait in its unbending monumentality can be linked to the King's well-known obsession with his own status in his last years, at the same time these signs of a sense of individual subjectivity are indications of a threat to the old order. A moment of crisis for a particular monarch is also a moment of crisis for the

medieval concept of monarchy. On the one hand is the ideology of kingship as both inherited and holy, an office which raises its recipient above his subjects to a different, supra-mortal plane. On the other are new and in effect revolutionary notions of individuality which imply personal responsibility and thus question the fitness of an individual to govern. There is the option of replacing him by someone better qualified. The works of art of the period, both the Westminster portrait and the Wilton Diptych, encapsulate this opposition in their uneasy combination of the demands of ideological representation with the beginnings of a requirement for individual portrait likeness. In both Diptych and Westminster portrait the former, the ideological requirement, still dominates the latter, the wish for individualization.

120. Detail of crowned initial 'R'
on Richard II's robe from the Westminster Abbey portrait

XIV

PAMELA TUDOR-CRAIG

The Wilton Diptych in the Context of Contemporary English Panel and Wall Painting

THE HINTERLAND of the Wilton Diptych in terms of large-scale painting in this country has more to offer than used to be supposed. From the mid fourteenth century onwards there survive a few painted testers, the earliest of them above the effigy of Sir John Harrington at Cartmel of *c*. 1350.[1] The Christ in Majesty there with the Four Evangelist Symbols has a vigour which is sustained in the fragmentary painting of the Trinity with Evangelist Symbols in this position on the monument to the Black Prince, who died in 1376, in Canterbury Cathedral.[2]

The artist of the Black Prince's tester could have painted the armorial panel on the reverse of the Diptych. Gilbert Prince of St Giles' Cripplegate moved from the patronage of John of Gaunt (Duke of Lancaster), the King's senior uncle and, during Richard's minority, his Chief Councillor, to work for Richard from the moment of his Coronation. According to the documents, the staple of Prince's work for the court was always heraldic. If the royal arms on the outside of the Diptych had been painted before Prince's death in 1376, he would be the prime candidate for their execution. They are the weakest part of the painting. Compare the clumsy martlets, the ill-drawn cross fleury, and the overcrowded leopards with the exquisite treatment of the white hart couchant, even—as appreciated only under extreme magnification—on the badges of the angels. The anomaly would be explicable if the arms were the work of an old man whose prestige gave him the right to paint the shield.

The monuments to Edward III and his wife Philippa of Hainault in Westminster Abbey have no painted testers. His was of architectural form. Hers, if it existed, would have been mutilated at the encroachment of the Chantry of Henry V in 1437. The tester for the tomb of Richard himself and Anne of Bohemia, also in the Abbey, was paid for at the outset of the commission for the monument, on 14 December 1395 (*ill. 29*).[3] Against a rich gilt gesso background, the silhouettes which alone survive are highly evocative. The layout shows a Christ in Majesty enthroned and blessing with his right hand, the orb in his left. Below the Majesty is the Coronation of the Virgin, the archetype of all coronations. At either end of the tester pairs of angels support shields, bearing doubt-

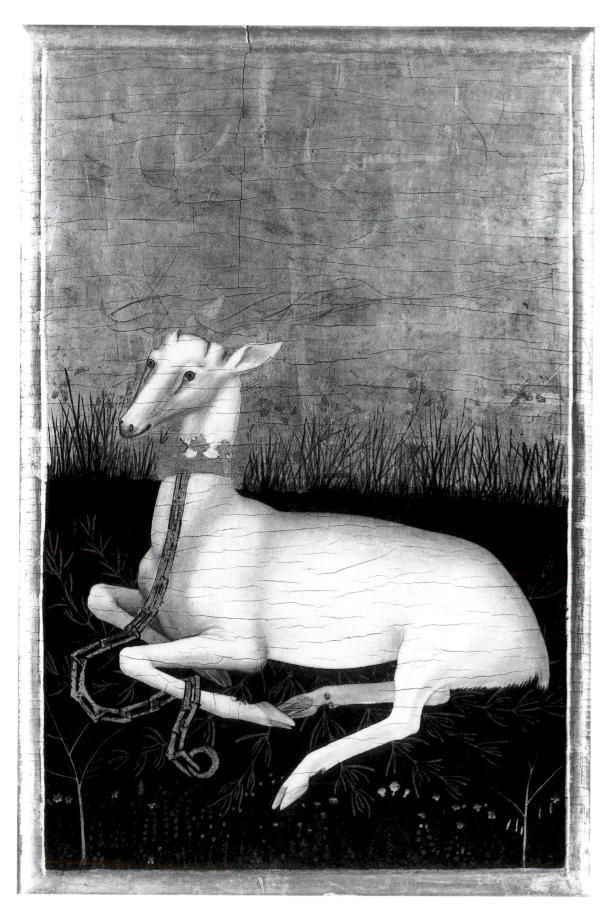

121. The White Hart. Wilton Diptych, exterior left wing

less the arms of Richard and Anne. Richard's arms may have been impaled with those of the Confessor, as they were to be pounced on the gablet above his head, perhaps not finished till 1399. Impaled arms had been used in one of the two corbels with white harts of after 1393 in Westminster Hall.[4] The silhouettes on the tester, the flowery ground where the angels stand, the soft folds of the seated figures, especially of the angels with their drapery bunched above the waist, their gentle inclinations and delicately turned wrists, find parallels in the Diptych.

The tester was itemized in the same account—virtually in the same breath— as the '*Pictura unius ymaginis ad similitudinem unius Regis, contrefacte in choro ecclesie predicte*' discussed elsewhere in this volume (see Alexander, p. 201). In common with many other authors, I equate this document with the portrait of Richard II which has certainly hung in Westminster Abbey since 1631, and almost certainly much longer (*ill. 1, col. pl. 23*). If, as has been suggested elsewhere, the document refers to the painting of a sculpted figure of a king to stand in the choir, and not to a painted panel to be placed in the King's special '*cawagium*' on the south side of the Sanctuary, then that single sculpted figure, presumably lifesize and costing to paint about eight times as much as the ones in Westminster Hall,[5] was an iconographic departure without precedent or parallel. Nor can it be argued that the portrait of Richard II discovered by Lord Lumley may have been a different picture. All the shortened portraits of Richard are dependent on this prototype; none of them are earlier than Lumley's discovery of Richard's portrait, and the full-length copy in the Lumley collection is certainly based on the picture in the Abbey.[6] The hieratic pose of the life-size portrait and its arrangement within the framework of the throne somewhat disguise the fact that the figure is disposed with much the same fluidity of drapery as is suggested in the tester (*ill. 29*), and characteristic of the *Liber Regalis* (*col. pl. 18*).

The relatively small body of late fourteenth-century panel painting carried out in provincial centres in the years 1380–1400[7] has been recently extended by the recognition of a fine screen at the Church of All Saints at Clifton in Bedfordshire as being of the period (*ill. 122*).[8] The dress of the two women saints, Mary Magdalene and, most unusually, Martha, is diagnostic for the date. They wear long fitted sleeves coming over their hands.[9] The Prophets and Apostles at Clifton (*ill. 123*) wear robes comparable with those worn on an Entombment panel[10] and on two panels of Christ before Herod and the Carrying of the Cross, all in Ipswich Christchurch Museum. Ladies with uncovered heads in a lost altarpiece with scenes from the Life of St Nicholas once in Ingham Church, also in Norfolk,[11] recall the Clifton screen or Anne of Bohemia herself in the initial 'R' of the Shrewsbury Charter, dated 1389 (*ill. 2*).[12] Where ladies' head-dresses are worn in the altarpiece formerly at Ingham they are reticulated, as worn by the effigy of Philippa of Hainault, who died in 1369, and by the *donatrix* at the foot of the earlier Crucifixion from St Michael at Plea, Norwich (*ill. 125*).[13] The facial types of this group of paintings accord not at all with the Wilton Diptych,

122-123. *St. Martha and Mary Magdalen; St. Matthias*. From the screen
in the Church of All Saints, Clifton, Bedfordshire

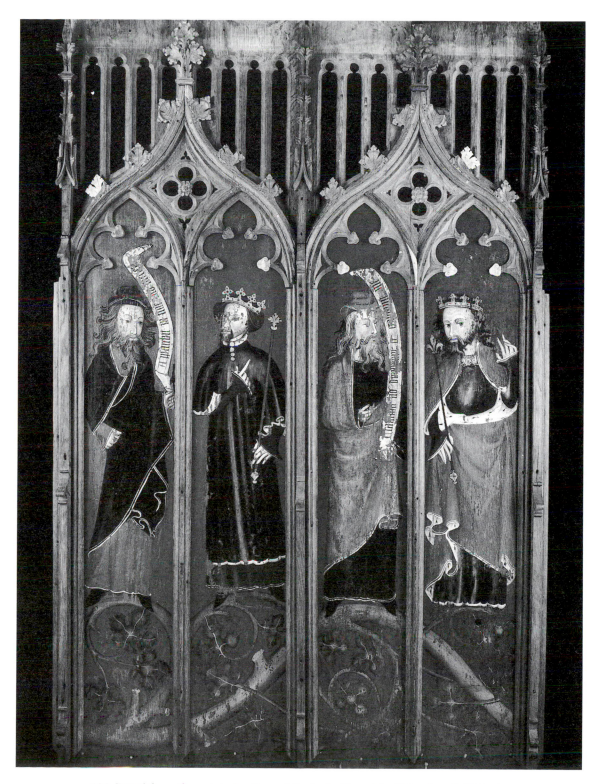

124. Detail from the painted ceiling of the Lady Chapel in Abingdon, St Helen's

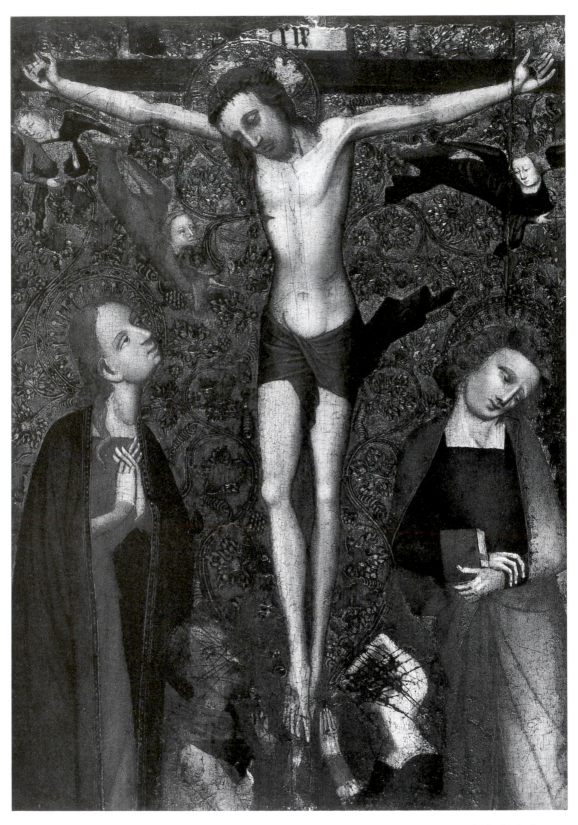

125. *Crucifixion* from the Retable at St Michael at Plea, Norwich, *c.* 1385-90. Norwich Cathedral

126. Head of a girl. Wallpainting, *c.* 1380-90, from Park Farm, now in the Gatehouse of St Osyth's Priory, Essex

127. Head of an Angel, from the Wilton Diptych

but afford striking comparisons with the faces of the *Liber Regalis*. It used to be thought that no painted screens were made before the later fifteenth century: Clifton starts the sequence a hundred years before.

The painted ceiling of the Lady Chapel in St Helen's, Abingdon (*ill. 124*), has been greatly enhanced by a recent programme of cleaning and consolidation. This remarkable scheme of a Jesse Tree is securely anchored by a Papal Indulgence to 1391.[14] The quality of the workmanship is visibly higher than was anticipated. Nevertheless, comparisons are with the Clifton screen rather than with Westminster painting.

The most important addition to the corpus of surviving material is made, however, by the panel painting now in the Colchester Museum, the figure painted on plaster from the same room in Park Farm, near St Osyth's Priory in Essex, and the remaining dismembered fragment of the same scheme now in the Gatehouse of St Osyth's Priory (*ill. 126*).[15] Originally, the paintings were in the one upstairs room at Park Farm, where further ghosts of figures painted on the plaster may still be concealed beneath the present wallpaper.[16] The seated lady on panel was illustrated in 1987,[17] but full publication awaits a careful examination of the now concealed walls. The house appears to have been always a part of the St Osyth's estate. The main body of the structure has been identified as a hall house of *c.* 1350, 16 feet wide with braces at 10 feet intervals.[18] Into this structure a floor has been inserted to provide, on the upper level, a sequence of three rooms, of which the central one was partitioned to allow for an oratory 5

feet deep. It is the entrance archway to this oratory, with painted inscriptions around it and traces of further painting on its right flank, which has been repositioned in the Priory Gatehouse. Further inscriptions in the same black letter script surround the main panel painting, once nearly as tall as the doorway, and now in the Colchester Museum.[19] There are the corners of yet further inscribed scrolls on the figure of a lady in green painted on plaster, also now at Colchester.

The remains of this important scheme, running across both plaster walls and wooden panelling, are of high quality. The large seated figure wears a chaplet of roses, in this case gilt, as do the angels of the Diptych. The lady in a green dress has a gilt orle, an ornamental padded circlet, on her head with a red veil hanging from the back of it, a head-dress worn by Mary, Duchess of Brittany, weeper on the tomb of Edward III, made after 1377. Both figures wear tight-wristed sleeves stretching over the hand, typical of the 1380s and early 1390s. The faces of the ladies of Park Farm can be compared with those of the angels around the Virgin in the Diptych. There are parallels between the strewn meadow of the Diptych's 'Paradise' ground (see Fisher, p. 155) and the floral mead through which the green lady of Park Farm makes her way. For the throne on which the larger figure sits, the closest comparison is the throne of Richard's portrait in Westminster Abbey. Compare the band of cresting along the back, the voided side panels, the tall crocketed pinnacles. Richard II is seated on just such a throne in the illuminated letter 'R' of the Croyland Charter of 1393.[20] The thrones of the Great Seals carry heavy canopies—with one striking exception. Edward III's First Seal of Absence, in use 10 July 1338 till 21 February 1340, shows a throne like that of the Westminster portrait.[21] This seal was delivered by King Edward on his return to William de Kindesby, to be kept in the King's Wardrobe. So it was available for Richard's inspection when he was thinking about an image to convey his presence while he was away. Richard's appearance in the Westminster portrait, especially as seen in the old photograph (*ill. 116*), suggests further comparisons with the St Osyth's heads. The angel flying over the seated lady has windswept crimped locks, almost corkscrew curls, recalling the hair-style of several of the Diptych angels.

The black letter inscriptions with which the Park Farm paintings are liberally provided are difficult to decipher, and contractions are not visible. The largest section is on the scroll over the door-case where '*Hic Deum adora...*' can be made out. A scroll framing the face of the seated lady has a few legible phrases: '*inceperam amo dmi...mei jhu cor...*' The scroll ascending from near the feet of the seated lady, and presumably expressing the prayer of a small donor once kneeling at her feet, reads '*O domina mea mater jhu langueo idefineter...*' Another scroll on the left flank of the door-case itself and climbing once more from the lower part of the panel has a few legible words, including '*dni jhu...amore...dig...*' Even these very partial and tentative transcriptions point towards Latin devotional prayers. The reference to Our Lady establishes the larger figure as representing her. The personal nature of these invocations would be in keeping with the

128. Detail of Gabriel from the *Annunciation*, *c.* 1420, from St Michael at Plea, Norwich. Before restoration

129. Detail of Mary from the *Annunciation*, *c.* 1420, from St Michael at Plea, Norwich. Before restoration

private chapel of an ecclesiastic of rank. In 1397 St Osyth's Priory rose to be an Abbey, when Prior John of London was granted full Pontificals. The honour was lost again in 1403, in which year Abbot John joined a conspiracy to reinstate Richard II.[22] Here is the entrance which may have led to the oratory of a high-ranking ecclesiastic of London origin. We may imagine him turning to the court for an artist at the time of his acclaim in 1397. It is only supposition that Park Farm was the Abbot's Manor on the St Osyth estate. However, these fragments hint at the standard of artistic skill available to Richard's courtiers, church and laymen, and it is a standard not unworthy of the Diptych.

The memory of art in Richard's court lingered into the fifteenth century. Francis Wormald[23] was led to believe the Diptych a posthumous work by comparison with details in the Beaufort Hours[24] of the early fifteenth century (*col. pl. 17*), and in the Psalter and Hours of John, Duke of Bedford,[25] of 1414–23 (*ill. 131*). Comparable magnification of the heads from these manuscripts and the heads of the Diptych, only made possible while the Diptych was recently conserved,[26] reveals a similarly immaculate ordering of the modelling. Not one literally microscopic brush-stroke fails of its control. A similar resemblance in facial modelling pertains in the work of one illuminator engaged on the Coucher

215

130. Initial with Pope Gregory IX.
Coucher Book of Furness Abbey, 1412.
London, Public Record Office, DL 42/3 f. 234v

131. Head of a Queen.
Bedford Hours and Psalter, 1414-23.
London, British Library, MS Add. 42131, f. 8

Book of Furness Abbey, dated 1412 (*ill. 130*).[27] The head in the initial on folio 256 reading '*Omnibus sancte matris…*' and the face of the angel immediately to the left of the Virgin in the Diptych have a real similarity. The shortness of the time span with which we are dealing is acknowledged. A painter 30 years old in 1394 would have been 59 in 1423—had he lived, and Thomas Prince, also known as Thomas Litlington, died in 1401. Recollections in later painting of the peak of achievement in the 1390s hark back to a wider range of prototypes than now survives. The panel of the Annunciation from St Michael at Plea in Norwich (*ills. 128, 129*)[28] may be a work of 1420–30, but the face of the Virgin still recalls her image on the Diptych, and her angel with flying curls resembles both the Diptych angels and the one at Park Farm. The St Michael at Plea angel wears an orle like the green lady of Park Farm: these recollections draw upon a pool of experience of which we have but a few drops, albeit those drops shine like diamonds.

One more work from the centre of Richard's artistic patronage is recorded: an altarpiece in five panels where Richard and Anne offered their realm to the Virgin as her dowry (*ills. 10, 11*; see also Gordon, pp. 23ff). In 1638 it was in the Chapel of the English College in Rome. There is no record of its arrival there. The year 1396, when the College was refounded, will not do as the date of the painting itself, as by then Anne was long dead and Isabelle Queen of England. The possibility that this important painting was not originally intended for Rome, but for Westminster Abbey, would make more sense of the inscription. Where, if not in the Coronation Church, should Richard and Anne wish to make

216

clear their dedication of their kingdom to the Virgin? *'Dos tua Virgo pia haec est'* is cogent within Westminster Abbey—especially within the Lady Chapel—but would be meaningless in Rome.[29]

The discovery of the symbol of the island of England painted in miniature in the knob at the top of the banner of St George in the Diptych brings this painting into the orbit of the works of art in which Richard II strove to express his particular relationship, as a childless monarch, with the realm which had been entrusted to him. He had taken his Coronation Oath facing the High Altar Retable of Westminster Abbey, confronting the image of Christ bearing, in his left hand, a globe on which was painted an orb of the whole universe (*ill. 9*).[30] He would not have taken it in at the time, but as a worshipper in the Sanctuary of the Abbey during Anne's reign, he would have had opportunity to appreciate the significance of his enthronement there. In the Diptych, and in the Rome Altarpiece, he pledged, and received back, the lesser orb of his kingdom of England, with Wales and Scotland and with troublous Ireland, and with the high claim to France. The importance that Richard vested in the actual orb is sufficiently demonstrated by his portrait in the Abbey where, contrary to custom, he carries it in his right hand, and the sceptre in his left. On the Great Seals of Richard's reign and of all before him, the orb is carried in the left hand.

Equally telling is the role played by the orb on Richard's monument (*ill. 29*; see Lindley, p. 63). The tester placed before the sightless eyes of the effigies two icons of kingship: Christ in Majesty holding the orb in his left hand—in the usual way—and blessing them with his right (as on the High Altar), and the Coronation of the Virgin, archetype of all coronations (*ill. 152*). The disposition of the effigies is minutely described in the contract of 1395,[31] where the coppersmiths, Nicholas Broker and Godfrey Prest, were to put the right hands of the couple conjoined; to put in the left hand of each a sceptre, and to place an orb on the bier between them. Upon that bier, which is itself ornamented with a diaper of leopards and fleurs-de-lis in diamonds, the slot to attach the missing orb is empty now. The message is plain: having no heir, they leave the orb on the bier for God to give to the next King of England.

Care must be taken in interpreting the objects discovered in the tomb in 1876.[32] Already in the eighteenth century access for the hand through holes on the south side had been used to insert three tobacco-pipe bowls and a bottle-stamp dated 1763 of John Blair, Prebendary of Westminster 1761–82. At the same time, copper coins and at least one jawbone had been extracted.

Nevertheless, the tomb was not actually opened between 1413, when, at the behest of Henry V, Richard's body at last joined that of his wife, and 1871. Among the relics found in 1871 were two pairs of leather gloves, one much smaller than the other. Going by the crimped edging and length of the wrist, the glove drawn by George Scharf in 1871 could well have been late fourteenth-century. The touching contents included the bell of a dog's collar, a Jew's harp— it is known that Richard and Anne made music together—and an alabaster

217

flower. They also included a pair of staffs, possibly from sceptres, a gilt wooden finial, probably from the head of one of these, and what the finders described as two segments of 'a common leather ball, measuring two and five eighths inches from apex to apex'. Perhaps the ball was a mischievous eighteenth-century insertion; but, if gilded, a leather ball might have served for an orb.

The early twelfth-century Life of St Edward the Confessor refers to the vision of the holy Brihtwald, Bishop of Wiltshire, as he wept for 'the forsaken throne of the kingdom'. He saw in a dream St Peter consecrate 'the image of a seemly man as king', assign him the life of a bachelor, and set the years of his reign by a fixed reckoning of his life. And when the king, even at this juncture asked him who of the generations to come would reign in his kingdom, Peter answers, '*the kingdom of the English belongs to God; and after you He has already provided a king according to His own will...*' (my italics).[33] And so the scene was set for the chaste marriage of Edward the Confessor and his Queen Edith, which Richard and Anne took as their model.

'So these angelic Angles with joined strength and like agreement guard the English bounds...'[34] The play upon Angles and Angels has already been observed (see Gordon, p. 26). Richard himself would have come across it in the same Life of the Confessor, where it is even more convoluted in the Latin. The couplet quoted above from that source provides a text for the gestures of affection deployed between the angels of the Diptych (*col. pl. 3*). The folded arms of the third angel from the left, like the '*di sotto in su*' tilted head of the standard bearing angel, go back to the wider vocabulary of gestures and poses introduced in Italian art almost a century before, but the solidarity of the Wilton Diptych angels is subtly shown. Two of them have their arms round one another's shoulders, and another has an arm through a neighbour's. Whatever the artistic pedigree of these painted gestures, it is clear from the chroniclers that they were deployed and interpreted in Richard's actual court. In January 1394 the Earl of Arundel accused Richard in Parliament of favouring his eldest uncle, the Duke of Lancaster, by being seen constantly walking arm in arm with him—to which Richard replied that he walked thus with all his uncles. On 3 February 1388 the Lords Appellant had entered Parliament 'with their arms virtually intertwined...'[35]

In his letter to Albert of Bavaria, Count of Hainault, of perhaps 1397,[36] which opens with thanks to Him '...in whose hands are not only the hearts, but the bodies of kings and princes...' and mentions hands, protective or rebellious, four more times, Richard again demonstrated his sense of what today would be called 'body language'. The King who was not only the first to dispose his monument in such a way that he lay, as no English monarch had done before him or was to do again until Henry VII, beside his Queen—and even so arranged it that they held hands—would have appreciated the affectionate gestures of the Diptych.

'And blessed that man whom your love prevents. Here where the steps from Sorrow's Vale are laid He mounts to Sion and the sovran king...'[37] The twelfth-

century Life of St Edward incorporates a hymn composed for the dedication of Edith's rebuilt convent at Wilton. It starts with an involved panegyric of the fruits of Edith's virginity, concluding with this promise that the husband whom her love kept a virgin beside her will mount to Heaven. In Richard's case it is his Queen who has mounted first to Heaven, leaving him in the rocky landscape of 'Sorrow's Vale' in contrast to the flowery mead of Sion which the Virgin and her company enjoy in the Diptych. In both the Confessor's and Richard's marriages, it is the connubial virginity which guarantees a swift transition to Heaven. Edith's hymn offers a further bonus: 'But you will make chaste marriage vows, and lie in the sweet arms of everlasting God; whose heavenly seed, in your womb cast, returns…With babes not rending mother's heart with tears, but singing clear angelic odes, or with the harp, you will resound throughout the world…'[38] This is an abbreviation of the poetic conceit which makes up the bulk of the same hymn upon the consecration of the convent at Wilton. The gist of it is that the virgins who are to consecrate their lives at Wilton, following the pattern of their foundress, will be given angels in place of the children they would have borne in normal matrimony.

There have been numerous speculations on the choice of eleven angels to accompany the Virgin in the Diptych. A recently published inventory[39] lists among the chapel furnishings a metal '*tabula*' of the Blessed Virgin Mary and eleven angels, underlining the special significance of the number eleven. If Anne of Bohemia had borne her King a child for every year of their marriage, there would have been eleven at the time of her death. They could, therefore, represent the heavenly progeny promised to Edith's virgins and those who followed their example. There are numerous indications that the married life of Richard and Anne was closely based on that of the Confessor and Edith, including their involvement with the rebuilding of Westminster Abbey and the extravagant humility of both wives in the presence of their husbands.

'The heavenly rite was being performed at the altar, and the sacred elements were held in the priest's hands. And lo,…Christ Jesus himself appeared visibly to both [the Confessor and Earl Leofric] and held his right hand over the king to sketch the sign of the Holy Cross in blessing…The king…showing his reverence for such a blessing by his bodily demeanour…' Since he was fluent in French, Richard probably studied the Life of the Confessor in the thirteenth-century French metrical version, perhaps in the surviving illuminated copy (*ill. 132*).[40] Here the twelfth-century text by Ailred of Rievaulx is altered in the illustration in such a way as to emphasize its Eucharistic content. The Confessor's other vision, the drowning of the King of Denmark, is also placed in the context of the Elevation of the Host. This was, for the medieval layman who seldom received the Consecrated Elements, the climax of the mass, a climax emphasized in the thirteenth-century institution of the Feast of Corpus Christi. The priest, now Archbishop Wulstan, raises the Child in place of the Eucharistic Bread. Ailred's Confessor had bowed his head: now he gazes at the Vision of the Christ Child. The monarch's hands are upraised, not in the normal gesture

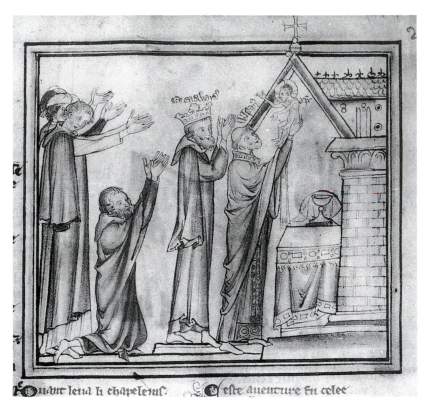

132. Scene from the Life of Saint Edward the Confessor.
Cambridge, University Library, MS Ee. 3. 59, f. 21

of petitionary prayer, palms together, but with the hands separated. The court-iers imitate their ruler. This very special gesture, adopted by the priest at the Canon of the Mass, indicates a moment of revelation. In the Diptych it is given to Richard because he also is witness to the Vision of the Christ Child blessing him. A Eucharistic reference in the Diptych is to be expected. Assuming it was painted for Richard to take on campaign, it will have served as a focus, not only for private prayer, but on a temporary altar set up—if need be—on the day of battle. The document recording that Richard ordered a portable altarpiece when he went to Scotland in 1385 provides a precedent.[41] Richard only needed a small altarpiece when he was travelling beyond his usual range of royal residences, which would have been permanently supplied. If the Diptych had been destined for a permanent position, the outsides of the panels could have been given to sacred subjects, rather than tokens of ownership. A diptych, when closed, is better protected than a triptych, and the need for that protection is declared by the gash on the armigerous panel. This, apparently, has been caused—at least in part—by water penetration.[42] So the travelling Diptych appears to have travelled.

I would have preferred to suggest that the Diptych was made during Ri-chard's widowhood in preparation for his first journey to Ireland in the autumn

220

of 1394. However, it is the consensus of present opinion that the broom cod collar is impossible before negotiations in 1395 for Richard's second marriage. So the second fated expedition to Ireland in 1399 provided an occasion for its use.

John Harvey has traced a hypothetical history of the Diptych from the time of Richard's capture at Conway in 1399 until its appearance in Charles I's catalogue in 1639,[43] with a pedigree giving Lady Jennings and Sir James Palmer as Charles' immediate sources. Harvey established a genealogical connection between Dorothy, Lady Jennings, who died in 1649, and Ralph Rowlett, goldsmith and merchant of the Staple of Calais. Rowlett died in 1543 owning valuables at Gorhambury and the Manor of Hyde in Abbot's Langley which he had bought from the Duke of Norfolk in 1539. Hyde and Gorhambury are within four miles of King's Langley, where Richard was first buried. Lady Jennings' husband's grandfather, Barnard Jennings, citizen and skinner of London, had died in 1552. He had bequeathed to his wife a little chain of gold with a 'harte' of gold hanging from it, and to his brother a standing cup with three harts standing in the top. No doubt precious items from King's Langley filtered through to supporters of Richard II after his death.

There are other threads of possible descent to consider. A copy of Walter of Hilton's *On Perfection* in English belonged to two James Palmers. It is now London, British Library MS Harley 993. A simple mid fifteenth-century book, it contains a colophon: 'this book was made of the goodis of Robert Holond for a common profite. That the Persone that hath this Booke committed to him of the Person that hath the Power to commite it, have the use therof the terme of his Life, prayinge for the Soule of the same Robert [and so on]…from Persoone to Persoone, Man or Woman, as long as the Book endureth'. Robert Holland, with two associates, was active in the dissemination of devotional texts for the 'common profite' in the fifteenth century.[44] Their texts were translated and spread about by the Carthusians, and by Henry V's special foundations, in particular the Brigettine Syon Abbey. At the Dissolution, according to the flyleaf, this manuscript fell into the hands of James Palmer senior, who wrote his name at the end of the text and practised his 'abc' there too. Clearly it was not for him a revered text. However, it was left for a later James Palmer, signing himself 'James Palmer junior', to express his views more fully: 'James Palmer owned this book yet without the least intent to pray for the soul of Robert Holland being a wicked and simple custom of sottishly ignorant Papists'. So here is a book which may have belonged to the James Palmer who was instrumental in bringing the Wilton Diptych to Charles I's attention, and who could have inherited it through a Syonist connection. On 17 April 1539 James Palmer was compensated for loss of lease on land which had belonged to Syon.[45] Three manuscripts from Syon belonged to Thomas, Earl of Arundel.[46] One of them, London, British Library MS Arundel 11, includes four items concerning Abbot John de Wheathampstead of St Albans. As Harvey noted, Ralph Rowlett bought his Manor of Hyde in Abbot's Langley from the Duke of Norfolk, first cousin

to the Arundels and prime enemy of Thomas Cromwell. On 29 January 1539 Elizabeth, Duchess of Norfolk, wrote to Thomas Cromwell as an injured lady. Her husband had taken a harlot, Bess Holand, and will suffer no gentlemen to come to her but Mr Conysbe and Mr Roylett (Rowlett).[47] Ralph Rowlett was merchant to the Staple of Calais, and Sir Thomas Palmer was Porter to the Staple of Calais. Among those who clustered around Thomas Cromwell looking for the loot that slipped through his fingers were several associated with the Staple of Calais. There is no more chilling reading than Thomas Cromwell's lists or 'Remembrances' of the doomed religious houses matched with the list of those to whom he planned to give them.[48] Nor is there any more cold-blooded jockeying for Cromwell's favours than appears throughout the Lisle Letters.[49] In 1539, the year Rowlett acquired his Manor and Cromwell fell, Syon was taken by the king for himself.[50]

The Wilton Diptych would not have been at King's Langley in 1399. Harvey was certain, as am I, that the Diptych went to Ireland with Richard in 1399, witness the damage it has sustained. He suggested that it was borne off to safe-keeping by one of Richard's supporters when the King was captured at Conway. However, Froissart gives a detailed statement of Henry IV's attitude to the possessions found about Richard at the time of his capture.[51] Everything was to be delivered into Henry's hands on pain of hanging for default. The fate of the ruby ring which Richard had given to Westminster Abbey for use in future coronations[52] is a straw in the wind. Richard had pledged never to take it from his kingdom, yet he must have taken it to Ireland. He would not have regarded himself as in breach of his oath in doing so, as he regarded Ireland as part of his kingdom. The ring found its way back to the Abbey, not by the offices of Henry IV, but through Henry V. If Richard had kept that ring about his person to the last, he would have retained his personal altarpiece in the same way. If it therefore passed into the hand of Henry IV, why did it not remain in the Royal Collection? Henry V felt bound to return the ring to the Abbey. What would he have done with the Diptych? Would he not have given it to one of his special foundations to pray for his family and for Richard II? If he did give it to Syon,[53] it would have come adrift in 1539. Henry VIII took no real interest in Syon, using it only as a prison for another of the Norfolk family, the disgraced Katherine Howard, in 1541. If the Diptych had come into the hands of the Norfolk or Arundel families, they would have protected it. But it would seem that it may have been through smaller fry, such as the Rowletts and the Palmers, gatherers of crumbs from royal tables overturned by religious politics, that the Diptych survived.

XV

HANA HLAVÁCKOVÁ

The Bible of Wenceslas IV
in the Context of Court Culture

IN THE PAST it has been argued that art, and especially painting, during the reign of Richard II and Queen Anne of Bohemia was in some way connected to Bohemian painting as a consequence of Richard's marriage in 1382 to Anne, daughter of Charles IV, Holy Roman Emperor and King of Bohemia (1316–78), and sister of King Wenceslas IV (1361–1419).[1] This influence was thought to have come through manuscripts and possibly portable altarpieces brought by Anne from Prague to London. In her doctoral thesis Amanda Simpson completely rejected this theory[2] and Lucy F. Sandler[3] pointed to the fact that Bohemian manuscript illumination seemed to have had little effect on English painting. The examples that most resemble English work, the tale of epic chivalry known as the *Willehalm* and the Bible of Wenceslas IV,[4] have been thought to postdate Anne's arrival in England in 1382, thus virtually eliminating the possibility of direct Bohemian influence.

In this connection, it is of interest to consider if the dating of these manuscripts is in fact correct and how and why they are so dated. I would suggest that work on the Wenceslas Bible started ten years earlier than has hitherto been accepted, at the end of the 1370s or about 1380, just before the departure of Anne for England.

The manuscript of the *Willehalm*, made for Wenceslas, is dated 1387 in the *explicit*: '*Anno Domini millesimo trecentesimo octoagesimo septimo finitus et completus liber iste videlicet marchio Wilhelmus. Illustrissimo principi et domino domino* [sic] *Wenceslao Romanorum regi semper augusto et Boemie regi, domino suo generosissimo*'. Because the Bible has been dated after the second marriage of Wenceslas in 1389, the *Willehalm* has generally been considered the first manuscript from the Wenceslas group. As we shall see, this dating presents some difficulties.

The Wenceslas Bible, written in German,[5] is neither finished nor dated. In the Prologue, Wenceslas and his queen are both mentioned and depicted as donors. It has been supposed that this queen is identifiable as the second wife of Wenceslas, Sophia of Bavaria. This assumption is based on Julius von Schlosser's interpretation[6] of the letter 'E' as the monogram of Wenceslas' wife, which frequently appears next to the letter 'W' in the margins of the manuscript. However, before considering von Schlosser's interpretation of the beautiful and enigmatic marginal decorations in the Wenceslas Bible,[7] it is useful to examine

223

the heraldic evidence for its dating. On three folios of the Bible (f. 2v, *col. pl. 22;* f. 99, *ill. 134;* and f. 177 of the first volume) there are, next to the shields with the Bohemian lion and the Roman eagle depicted many times in the Bible, also shields which were subsequently whited out, evidently those of Wenceslas' wife. Why should these shields have been obliterated? There can be only one explanation: the arms must have been those of Wenceslas' first wife, Johanna, who died in 1386.[8] It is likely that the first volume had been finished by that date. The only coats of arms in the following volumes are those with the Bohemian lion and the Roman eagle. The shield on folio 2v (*col. pl. 22*) is not completely covered by the whitening and we can see that it was identical to the white and blue lozenge shield which adorns the bust of Johanna in the triforium of St Vitus Cathedral in Prague. The identification of the enthroned queen, depicted with her husband in the Prologue of the Bible, as Johanna, is further supported by additional historical evidence: the arms with the Bohemian lion and the Roman eagle, which accompany the royal couple enthroned (*ill. 133*), are those of Wenceslas and Johanna, who was crowned Queen of Bohemia in 1370 (two months after her marriage to Wenceslas) and Queen of the Romans, together with her husband, in 1376.[9] On the other hand, his second wife, Sophia, was crowned Queen of Bohemia only after a lapse of eleven years following her marriage to Wenceslas, that is, in the year 1400 (too late to be marked by the creation of this manuscript). It is also known that, in spite of the fact that he was in Prague at the time, Wenceslas was not present at the coronation of his second wife.[10] Furthermore, Sophia was never crowned Queen of the Romans. In my opinion it is evident that the queen mentioned and depicted in the Prologue of the Bible is Wenceslas' first wife, Johanna, and that work on the Bible began during her lifetime and perhaps continued after her death in 1386. It is understandable that, at this juncture, there was a plan to replace her arms with those of Wenceslas' new wife. The arms of Johanna were probably whited over in the period between her death and Wenceslas' second marriage,[11] most probably before the arms of the new queen were known.[12] We do not know Sophia's personal coat of arms, but her family's arms were probably identical to those of Johanna, for Sophia was Johanna's niece.

The Bible was never finished, probably because of external disrupting circumstances during Wenceslas' unsettled reign,[13] and although she was married to Wenceslas for twenty years, the arms of his second wife were therefore never painted. It is worth noting that, contrary to general opinion, Sophia's position at the court of Prague was far from ideal. This is suggested by the delay to her Coronation, Wenceslas' absence from it and also by the fact that her bust was never added to the portrait gallery in the triforium of St Vitus Cathedral, still unfinished at the time of her marriage.[14]

The acceptance of the earlier dating of the Bible is very important also for the interpretation of the decoration in its margins. The first place in which all the emblems are depicted together is at the beginning of Genesis (f. 2v, *col. pl. 22*).[15] The medallions with the history of the Creation in the initial I (*-n anegenge*

133. King and Queen enthroned and shields with Roman eagle and Bohemian lion.
Bible of Wenceslas IV, vol. 1, f. 2. Vienna, Österreichische Nationalbibliothek, Cod. 2759-64

schepfte got…) are framed by Apostles and Prophets, also by acanthus with flowers and golden berries. These motifs of course are typical not only of this manuscript; they are probably connected with the quotation from Alain de Lille in which he speaks of leaves of history, flowers of allegory and fruits of tropology.[16] Besides the arms, there are also several different emblems relating particularly to Wenceslas. They occur many times, not only in the Bible, but also in other manuscripts of the Wenceslas group: courtiers and bath attendants; pails and bunches of leafy twigs; kingfishers and 'love-knots' (*ill. 135*), veils mostly in blue or white tones, twisted and knotted. Sometimes we find wild men, generally in the role of shield-bearers supporting arms with both the Bohemian lion and the Roman eagle displayed (*ill. 133*). The key to understanding these emblems is the kingfisher, the Halcyon of classical mythology, interpreted by

134. Coat of arms, subsequently whited over. Bible of Wenceslas IV, vol. 1, f. 99. Vienna, Österreichische Nationalbibliothek, Cod. 2759-64

135. Border decoration
with kingfisher and veil.
Bible of Wenceslas IV, vol. 1, f. 2v.
Vienna, Österreichische
Nationalbibliothek, Cod. 2759-64

von Schlosser, following Ovid, as a symbol of marital fidelity. However, in relation to the Creation, the Halcyon also holds a different meaning. In the commentaries on the *Hexaemeron* (Six Days of Creation), beginning with Ambrose, followed by Isidore of Seville, Rabanus Maurus, and many others[17] even down to Comenius in his *Orbis Pictus*,[18] this bird is prominently listed as one of the first animals to be created; since the kingfisher rears its young in the time of tempest and bitter winter, it is also a symbol of fertility. Other symbols in the margins are also linked to fertility: the bath-maiden representing Venus (but more likely Venus *Genetrix* rather than Venus, Goddess of Love); the bunches with the leafy twigs likewise represent fertility. Fertility, however, is only one of many underlying meanings to be found in the marginal decorations.[19] Others stem from the *Hexaemeron*, and the commentaries upon it. We can also examine the veil which von Schlosser called the *'Liebesknoten'*, the knot of love (*ill. 135*). This name brings out only one narrow personal aspect of a much wider meaning: it is a veil, *velum*, twisted and knotted with freely flowing ends. The

227

velum itself has a clear liturgical significance; it symbolizes Heaven, the firmament[20] but also the wholeness of the Universe. This comes out strongly in the illuminations of the small prayer book written and illuminated in Flanders or the Rhineland around 1300, known from a former owner as the 'Rothschild Canticles' (New Haven, Yale University, Beinecke Rare Book and Manuscript Library MS 404); there, on folios 40, 77, 83, 84, 86 and 92, the *velum* veiled the Holy Trinity.[21] The wider implication of the symbolism of the kingfisher, as one of the first created beings, is that it could represent all animate creation.

In the same way we can interpret the large free-standing initials, the monograms 'W' and 'E' which often contain the figures of a courtier (*ill. 137*) and a bath-maiden (*ills. 136, 138*). The letter 'W' has been explained simply as the first letter of Wenceslas' name and this is probably correct. Difficulties posed by the 'E' were solved by von Schlosser with the help of a well-known but complicated notion concerning the identity of the names Sophia and Euphemia. This form of the queen's name is not found in any documents other than the Wenceslas Bible. Von Schlosser tried to support the ambivalence of the 'E' by an extant version of Sophia's name as Ofka, but, in my opinion this is more likely to be a common Czech colloquial form for Sophia–Zofie–Zofka–Ofka. The name Ofka was not unknown in Bohemia at this time; an Ofka can also be found in English

136. Border decoration with bath maiden and a bunch of leafy twigs.
Bible of Wenceslas IV, vol. 1, f. 178. Vienna, Österreichische Nationalbibliothek, Cod. 2759-64

tallem · vnd israhel tzon herren vnd karten wider von

137. Initial E with a courtier. Bible of Wenceslas IV, vol. 2, f. 129v.
Vienna, Österreichische Nationalbibliothek, Cod. 2759-64

138. Shield with Roman eagle, bath maiden and courtier in initial W.
Bible of Wenceslas IV, vol. 1, f. 128. Vienna, Österreichische Nationalbibliothek, Cod. 2759-64

records relating to the Bohemian courtiers of Queen Anne[22]—and this lady could hardly be named Euphemia. Moreover, Euphemia is not directly synonymous with Sophia. The letter 'E' can already be found in Wenceslas' manuscript of the *Willehalm*, which was completed two years before his marriage to Sophia. For an explanation of this fact it would be necessary to suppose that this 'E' was added to the finished manuscript ten years later—but this is quite improbable, because the 'E' is a regular part of many of the ornamental patterns and appears even on the title page. The letters 'W' and 'E' enclose the figures of a courtier (*ill. 137*) and a bath-maiden (*ill. 136*) as if in a pillory, indeed von Schlosser called it 'the pillory of love'. If the 'W' stands for Wenceslas and the 'E' for Sophia, as he maintained, the king should be locked in the 'E' and the queen in the 'W'. In fact, both monarchs inhabit both letters. This suggests that both letters have also some other wider meaning and that they represent some other, significant, dual concept. I therefore suggest 'World and Earth' in their old German form, 'Werld und Erde', which appear several times in the Prologue of the Bible. This suggestion is confirmed by the fact that an identical 'W' appears on the Imperial Seal of Charles IV under his *subpedaneum*.[23] The Emperor has the 'W' (World) as his footstool, similar to the enthroned or crucified Christ whose *subpedaneum* in early medieval ivories is formed by 'Terra'. Similarly, the letter 'W' appears also several times in connection with Emperor Ludwig of Bavaria, where it forms the *incipit* 'W-ir Ludwick' (for example in the title page of the *Oberbayerisches Landrecht Ludwigs*, dated 1346, now Vienna, Österr. Nationalbibliothek Cod. 2786). Nevertheless, it has a very striking form: Ludwig is here depicted enthroned in a huge letter 'W' as in the footrest of the throne.[24] Sometimes an actual sphere is depicted under the feet of kings, often with the inscription '*Terra*'. The bath-maiden may also symbolize the 'Erde' or 'Werld'—in addition to being a representation of Venus, a symbol of fertility; this would be important for the childless king—like the allegorical figure of *Frau Welt* from the manuscript *Gedichte und Lieder* by Hugo von Montfort, illuminated by Heinrich Aurhaym after 1414 (Vatican, Biblioteca Apostolica Vaticana Pal. germ. 329). The 'E' (Earth with crown) is also an ancient and widespread symbol.

Similarly powerful meanings of emblems appear in the illuminated manuscripts of another contemporary court, that of Milan, in the manuscripts written for Giangaleazzo Visconti (see *ill. 91*).[25] Giangaleazzo's personal emblem is a golden sun with a white dove in a blue sky. His court poet, Giovanni di Vanozzo, explained this emblem as a symbol of the virtues of Giangaleazzo: the sun means power, the dove humility and chastity, and the blue sky serenity. According to the same authority, the emblem is also symbolic of the Holy Trinity: the blue sky, *loco de padre*, stands for God the Father; the sun for Christ; and the dove for the Holy Spirit. So it was claimed that all the personal emblems of Giangaleazzo also represent the Holy Trinity.[26]

In the case of the Wenceslas manuscript, I believe that the emblems in the margin are based on the iconography of the days of Creation, the *Hexaemeron*, and that the manuscript of the Wenceslas Bible is the first book in which they

are depicted together. This is why I consider that the first volume of the Bible was finished earlier, even before the *Willehalm* manuscript. From a stylistic point of view, the dating of the first volume of the Bible to the earlier period is fully acceptable. Several references are to be found in the literature which suggest that the enigmatic emblems are signs of a secret Order at the court.[27] This may be possible, but the Orders themselves are not prime sources of symbols; rather do the emblems hold particular meanings for the Orders in the same way as for particular individuals. The single most important meaning comes from the universal, religious ones which stand in the centre of the medieval world and especially court culture.

We can see a very close affinity between the Wenceslas and Visconti manuscripts, an affinity which extends to the manuscripts of the court of Richard II. I hope the earlier dating of the first part of the Wenceslas Bible towards 1380 (the first part was surely finished between 1376—the Coronation of Wenceslas and Johanna as King and Queen of the Romans—and 1386, when Johanna died) will stimulate new research into court culture as a whole, and also into the relationships between individual courts.

Marginal illustration from the Bible of Wenceslas IV, vol. i, f. 99.
Vienna, Österreichische Nationalbibliothek, Cod. 2759-64

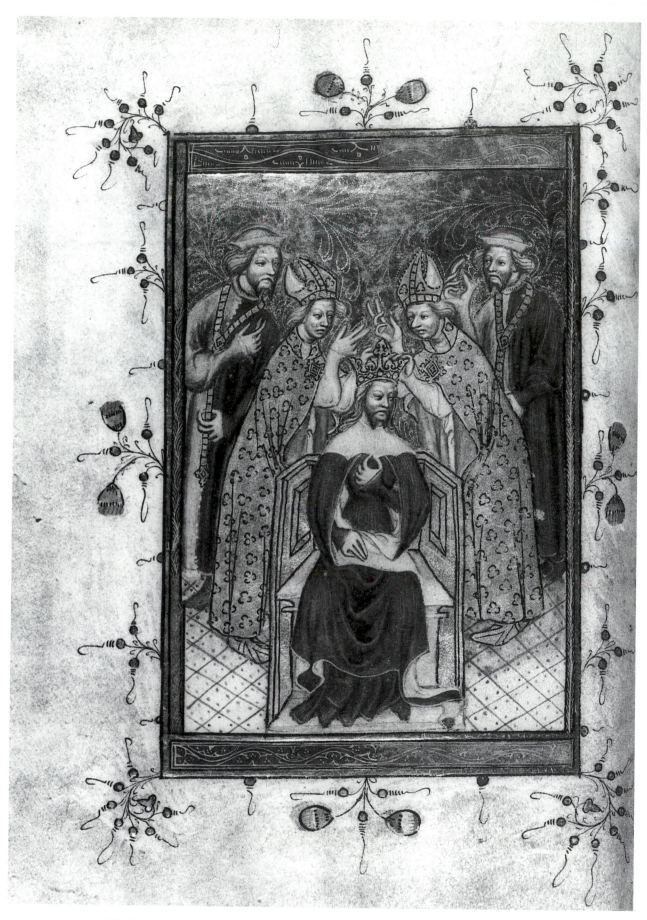

139. Coronation of a King. *Liber Regalis*, London, Westminster Abbey, MS 38, f. 1v

XVI

PAUL BINSKI

The *Liber Regalis*:
Its Date and European Context

THE *LIBER REGALIS* (London, Westminster Abbey MS 38) is one of the curios of English fourteenth-century art. The text, with four highly-finished framed illustrations (*ills. 139-142* and *col. pl. 18*), represents the fourth and final recension of the medieval English Coronation Order, a recension presumably put together at Westminster, and generally believed to have been first used at the Coronation of Edward II in 1308.[1] Westminster Abbey's great Missal (MS 37, *ill. 144*), made for Abbot Nicholas Litlyngton in 1383–84, contains the same Order, and survived, somewhat unusually for English Benedictine Missals, in all probability because of its inclusion of the coronation service.[2] I do not propose here to contribute further to the literature on the Coronation Order as such. My concerns here are primarily with the date of the *Liber Regalis* and with the issue of the stylistic filiation of its pictures: this paper will argue that the *Liber Regalis* was made slightly later than is usually thought—not much earlier, and possibly later, than *c.* 1390—and that the controversy over the 'Bohemian' character of its illustrations deserves reconsideration.

The *Liber Regalis* consists of 34 folios measuring 255 × 175mm., containing the Latin orders for the coronation of a king (f. 1v), a king and a queen (f. 20), and a queen alone (f. 29), and ending with the procedure for the funeral of a king (ff. 33v–34).[3] Each liturgy opens with an appropriate illustration (*ills. 139–142*). The texts combine the directory (things done) in red, and the *ordo* (things said) in black, in a handsome formal script; and each illustration has distinctive tendril ornament around its frame. The workmanship is certainly English.

The manuscript is linked in the first instance to the Litlyngton Missal, which contains the same version of the coronation service, though the *Liber Regalis* itself obviously represents a different genre of book. The Missal, in two volumes, is immense, appropriate to its use at the High Altar of Westminster Abbey, whereas the *Liber Regalis* is in a handy format. Its size and shape more closely resemble another roughly contemporary illustrated copy of the Coronation and Funeral Orders of English origin now in Pamplona (Archivo General de Navarra MS 197, *ill. 145*) which measures 273 × 188mm. and has inhabited decorative borders which correspond closely with those in the Litlyngton Missal (*ill. 144*).[4] Both are therefore similar to, but rather larger than, an illustrated thirteenth-century French version of the Reims Coronation Order (Paris, Bibliothèque

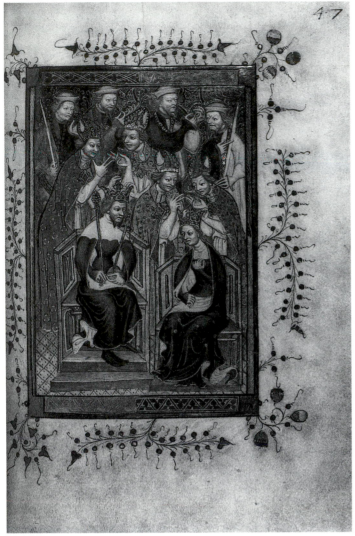

140. Coronation of a King and Queen. *Liber Regalis*,
London, Westminster Abbey, MS 38, f. 20

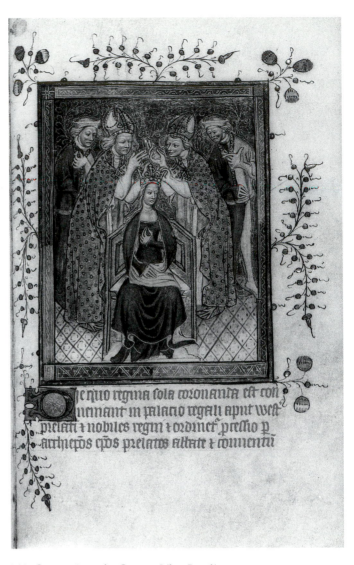

141. Coronation of a Queen. *Liber Regalis*,
London, Westminster Abbey, MS 38, f. 29

Nationale MS lat. 1246), which measures 215 × 150mm.[5] Illustrated orders of this type are, however, uncommon. Those in the *Liber Regalis* and in the manuscript in Pamplona comprise respectively four and three illustrations of little documentary value. With the exception of the illustration of a double coronation in the *Liber Regalis*, which correctly shows the queen's throne a step lower than that of the king, the English illustrations are of a symbolic rather than prescriptive character, offering no supplement to the text. The Capetian Order of *c.* 1250 in the Bibliothèque Nationale (MS lat. 1246) made for the Suffragan Bishop of Châlons-sur-Marne is much fuller, having instead fifteen properly step by step illustrations.[6] That there was a more developed tradition of such coronation

234

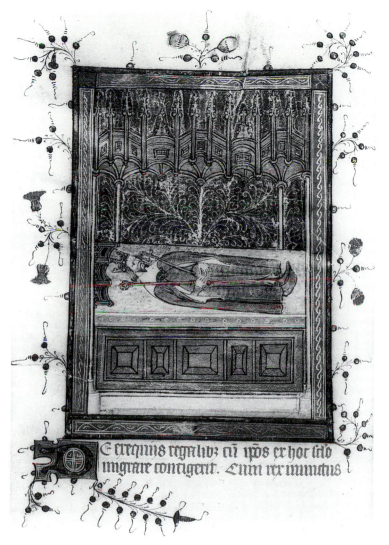

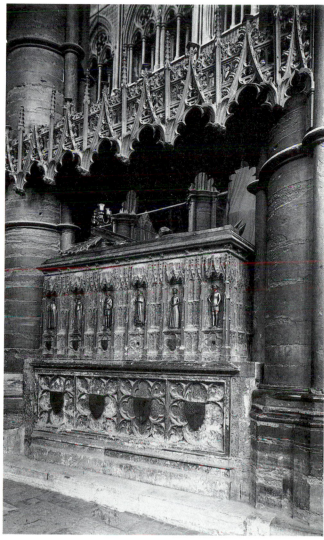

142. Funeral of a King. *Liber Regalis*,
London, Westminster Abbey, MS 38, f. 33v

143. Tomb of Edward III, *c.* 1386.
London, Westminster Abbey

books in France is proved by the largest of all, the Coronation Book of Charles V, pertaining specifically to his Coronation in 1364 (London, British Library MS Cotton Tiberius B. VIII).[7] This has 38 highly distinctive illustrations of the phases of the Order, in the planning of which Charles himself was closely involved.[8] This manuscript is both a commemoration of a specific event, and also a paradigm of the coronation service in which the illustrations offer a narrative supplement to the text.

England apparently did not produce this French type of phased illustrated Coronation Order. The illustrative traditions in works like the *Liber Regalis* and the Litlyngton Missal (the Missal has three illustrations, for the single coronation

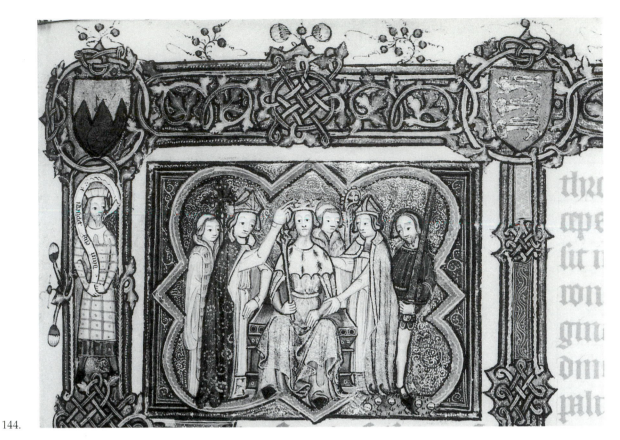

144.

145.

it est ordo secundum quem rex debet coronari
parari ⁊ mungi. In primis apparetur
pulpitum aliquantulum eminens.
inter magnum altare ⁊ chorum eccie
ibi petri Westmoñ videlz contiguum er
onum parte quatuor columpnis pri
opationibz infra crucem eccie predita

146. Coronation of King Edward the Confessor. *Flores Historiarum*, *c.* 1250.
London, British Library, MS Loan 94, f. 115v

of a king and a queen, and for the funeral, ff. 206, 221, 224) are primarily symbolic, and it would be erroneous to take their liturgical content at all literally. On folio 1v of the *Liber Regalis* (*ill. 139*), an enthroned king has a crown placed on his head by two clerics accompanied by two peers in the background; on folio 20 (*ill. 140*) the same prescription is repeated for a double coronation, with peers this time holding rods (mistaken for swords?) and crowns; and on folio 29 (*ill. 141*) a queen is crowned in the same manner as the king earlier on, with peers. The double coronation illustration is particularly formulaic, the archbishops shown crowning the king and queen while in discourse, and the two peers at the centre top of the image, merely repeating the same schema. The coronations of a king on folio 206 of the Litlyngton Missal (*ill. 144*), and on folio 3 of the manuscript in Pamplona (*ill. 145*), a manuscript which depends generally upon the Missal, include sword-bearing peers in the same vein as the mid thirteenth-century illustration of the Coronation of St Edward in the Westminster *Flores Historiarum* in the British Library (MS Loan 94, f. 115v; *ill. 146*).[9] Again, the illustration of a coronation in Cambridge (Corpus Christi College MS 20), containing a French version of the Order used in 1308, is not literally comprehensible in terms of the text's ritual prescriptions.[10] The illustrations in the *Liber Regalis*, therefore, are no more than impressive generalized representations, much in the tradition of English chronicle illustrations of coronations.

What then of the date of the *Liber Regalis*? The proper starting point for this question is clearly the Litlyngton Missal made in 1383–84, the most securely dated and documented English manuscript of the period. As it stands, the *Liber Regalis* contains no internal evidence of date or significant marks of ownership.

144. Coronation of a King. Litlyngton Missal, *c.* 1383-84. London, Westminster Abbey Library

145. Coronation of a King. Coronation and Funeral Orders.
Pamplona, Archivo General de Navarra, MS 197, f. 3

Both this manuscript and the Litlyngton Missal contain, to all intents and purposes, exactly the same texts for the directory and *ordo*.[11] Conventionally, however, the *Liber Regalis* is dated before the Missal, primarily, it would seem, on the basis of an unguarded remark of L. G. W. Legg in his edition of the English coronation orders to the effect that by the addition of marginal notes in the *Liber Regalis* 'the text is brought into conformity with that in the Missal of Nicholas de Litlyngton'.[12] By implication, then, the *Liber Regalis* existed by 1383 and was adapted after the production of the Litlyngton Missal and with reference to it; the *Liber Regalis* was perhaps produced for some specific event prior to 1383, say, the Coronation of Richard II in 1377 or that of Anne of Bohemia in 1382.[13]

This reading of the relationship of the *Liber Regalis* and the Litlyngton Missal is not to my mind absolutely justified, however. The marginal notes in the *Liber Regalis* are of two types: small cursive headings approximately contemporary with the text, which pick up its main points, and a series of post-medieval annotations in a seventeenth-century hand usually identified as that of Archbishop Sancroft (1678–90); these latter follow something close to the Litlyngton Missal.[14] Legg was thus not incorrect to say that the *Liber Regalis* was brought into conformity with the Missal; he simply did not specify that this conformity occurred after the Middle Ages. The medieval cursive headings in the borders of the *Liber Regalis*, however, do not correspond to anything in the Litlyngton Missal which lacks marginal notes of this type; they are not corrections referring to some other textual authority.[15] Though the *Liber Regalis* and the Missal contain the same text, as with all such matters of recension, the texts alone cannot be a criterion of date, since the two works containing them have no objective sequential bearing upon one another. We cannot be certain that they were produced with reference to one another, as opposed to some third common text.

To illustrate this point, we should recall that Westminster Abbey itself preserved several copies of the Coronation Order at this time, identifiable with neither the *Liber Regalis* nor the Litlyngton Missal. For example, among the books listed in the 1388 inventory of Westminster Abbey's vestry is the following reference: '*Octavus et nonus: Liber benedictionales cum coronacione regum et aliis in eisdem contentis*', presumably corresponding with a reference in the 1540 Abbey inventory to 'a Pontificall with a coveryng of clothe of golde and a claspe of sylver ij° folio *Dominum Carnem*. Another Boke of Coronacyons of Kyngs ij° folio *quia non erat*'.[16] The Pontifical in the 1540 inventory is provably the same as a fourteenth-century Westminster manuscript in Oxford (Bodleian Library MS Rawl. C. 425), which contains the same version of the fourth recension of the Coronation Order (ff. 60–83v) and is presumably to be identified with the *Liber benedictionales* mentioned in 1388.[17] The 'Boke of Coronacyons' is not the same as the *Liber Regalis*, however. The seventeenth-century annotator of the *Liber Regalis* was also checking it, doubtless at Westminster, against yet another Pontifical with a similar version of the Order to that in the Litlyngton Missal, but at present not identified.[18] With related variants of the same text available at Westminster Abbey in the 1380s through to the seventeenth century, including

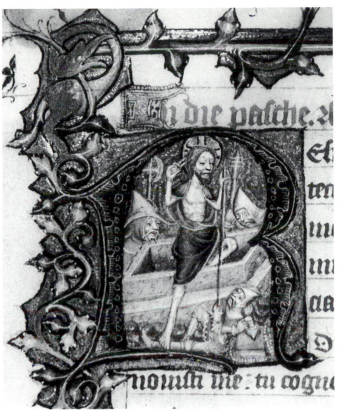

147. King Henry III. Statutes of England, 1388-99. Cambridge, St John's College, MS A.7, f. 1

148. *Resurrection of Christ*. Bergavenny Missal, Use of Sarum, 1388-97. Oxford, Trinity College, MS 8, f. 131v

the Litlyngton Missal, the *Liber Regalis*, and the 1388 manuscript(s), the only conclusion to draw about these versions is that their historical relationship is fluid. If so, we can just as reasonably suppose that the *Liber Regalis* was produced after, and not before the Litlyngton Missal, and hence after 1383.

If the *Liber Regalis* cannot be dated with reference to the Litlyngton Missal, can it be placed by reference to datable works in a similar style of illumination? Two works are directly relevant to this question, and in identifying them I am substantially in agreement with Margaret Rickert's analysis of the *Liber Regalis*'s stylistic filiations.[19]

The first work akin to the *Liber Regalis* is a handsome presentation copy of English Statutes in Cambridge (St John's College MS A. 7) covering the reigns of Henry III to Richard II, with five historiated initials of enthroned kings (*ill. 147*), ending with Richard II receiving the volume from a kneeling cleric.[20] In idiom and technique, the illuminations are strikingly similar to those in the *Liber Regalis*, and the canopies over the kings have detailing similar to that over the effigy in the funeral illustration on folio 33v of the Westminster manuscript (*ill. 142*). The borders also relate to the Litlyngton Missal in their distinctive tendril, ball, and interlace configurations. The volume must date to the period 1388–99 and probably to not long after 1388, the date of the last statute in the collection which is followed by 24 further blank leaves.[21]

The second and most closely related work is the Bergavenny Missal (Oxford, Trinity College MS 8, in the custody of the Bodleian Library).[22] This Missal contains a series of small historiated initials (*ill. 148*), the eleven from folio 131v to folio 248 being, to my mind, the work of a hand virtually identical to the illuminator of the *Liber Regalis*.[23] Lucy F. Sandler has pointed out that the Missal was not produced before 1388 as suggested by Rickert, but rather before 1397, as its calendar contains family notes on folios 4v and 5v probably not written before that year. The hand responsible for the notes closely resembles that of the calendar itself, and from this it seems reasonable to conclude that the Missal was not illuminated before 1388, but probably in the 1390s.

The decisive links to the *Liber Regalis* in the Cambridge Statutes and the Bergavenny Missal are thus with works produced not much before the late 1380s or the 1390s, again rather later than the conventional dating of the Westminster manuscript to the later 1370s or early 1380s, previously supported by correspondingly early dating of the comparable works to the 1380s. It could of course be objected that the *Liber Regalis*, in containing the Coronation Order, was the most prestigious of all these works, and that it may have enjoyed priority over them in time. But there is one final piece of dating evidence which indicates that this is unlikely. It derives from the illustration in the *Liber Regalis* accompanying the text for the royal funeral (ff. 33v–34). This text has corresponding illustrations in the Litlyngton Missal and its dependent, the Pamplona Order.[24] But whereas these respond properly to the text in simply showing a draped funeral bier, that in the *Liber Regalis* departs in depicting a formal royal tomb (*ill. 142*).[25] This is another sign that the illuminators of the *Liber Regalis* were not preoccupied with the exact prescriptions of the Order. The tomb depicted in the manuscript is of a distinct type, closely similar to that of Edward III in Westminster Abbey (*ill. 143*). The effigy resembles Edward III's in depicting the holding of the rod and sceptre, and, like the tomb, the effigy is surmounted by a canopy; yet more striking is the gabled detailing of the tester, not a feature of Westminster tomb designs before that of Edward III which possesses the same type of tester. Though Edward died in 1377 his tomb was not erected until 1386 or later, since in that year its marble components were being shipped to Westminster from Corfe; the tester must have been later still.[26] If the illustration in the *Liber Regalis* is to be seen as a response to the latest royal tomb at Westminster, and its departure in this respect from the Litlyngton Missal and the Pamplona Order could be a sign of deference of this type, then it follows that the *Liber Regalis* too must date to after 1386.

Cumulatively then, the evidence suggests that the *Liber Regalis* may date to after the Litlyngton Missal, and in comparative terms to the later 1380s or 1390s. In so adjusting the date of the manuscript to *c.* 1390, it follows that the broader issue of its patronage and relationship to Continental and specifically Bohemian art may have to be adjusted too.

What, first, are we to say about the patronage of the *Liber Regalis*? The manuscript contains no distinguishing signs of its patronage, or indeed of its

purpose. Of the small group of manuscripts under consideration, only the Litlyngton Missal is personalized by its frequent use of Abbot Litlyngton's monogram. The *Liber Regalis*, though very fine, does not display the royal arms in the manner of the Cambridge Statutes, and though this is not evidence against direct Plantagenet patronage, it could serve to question it: the Bergavenny Missal indicates the occurrence of this idiom outside the immediate royal circle. Richard II, in whose reign the work was presumably made, was interested to an unusual degree in the regalia: for this we have the testimony of the Westminster Chronicle and of Walter of Sudbury's little treatise on the history of the regalia, written for Richard's edification emphatically from a Westminster standpoint.[27] But it is exactly at this point that the *Liber Regalis* fails as a document indicating the kind of interest Richard is likely to have had, since, as has been discussed above, its illustrative handling of liturgical specifics and of the apparatus of the coronation is purely symbolic, in contrast say to Charles V's emblematically-minded Coronation Book. It should also be noted that the prince or princess to be crowned would not have any use whatever for such a book for the duration of the coronation service itself, since the Westminster Order specifically notes that the royal *vade mecum* was not a book at all, but the guiding presence of the Abbot of Westminster, a specific privilege.[28] If the book is 'Ricardian' it could only be so in a general sense.

There are other functional possibilities. One, though unlikely, is that the *Liber Regalis* was a peculiarly fine possession of the monastic library at Westminster for display as an *exemplum* to highly-placed visitors in association with the regalia, or for use by the Abbot during the actual ritual, though as it happens no other monastic book at the Abbey was illuminated in this style.[29] Another is that books of this type were mementos for significant lay participants with privileged duties in the coronation ritual, as perhaps in the case of the earlier Corpus Christi Order, eventually owned by the Countess of Huntingdon whose family had duties in the early part of the service.[30] Here one possible, though extremely tenuous, connection for the *Liber Regalis* would be with the Bohun family. The Bergavenny Missal, from the same circle as the *Liber Regalis* and also linked decoratively to the Bohun Psalter in Oxford (Exeter College MS 47), was owned by William Beauchamp whose wife, Joan Fitzalan, was a cousin of Eleanor de Bohun.[31] The Bohuns enjoyed the post of Lord High Constable at the coronation and were of course eventually allied to the Crown by the first marriage of Henry Bolingbroke, later Henry IV.[32] However, the same objection applies to Bohun or Lancastrian patronage of the *Liber Regalis* as to that of the Plantagenets, namely the lack of any distinguishing marks of ownership, perhaps more keenly felt in the case of a new dynasty.

The fact that there is no more evidence for the patronage of the *Liber Regalis* by Richard or Anne, than for the Bohun family or even Henry IV, all conceivable in art-historical terms, simply indicates that no firm arguments about style can be premised upon a theory of the *Liber Regalis*'s patronage. The manuscript was most probably produced under Plantagenet authority, but there is no reason for

it to have had any particular function beyond a fine and impersonal exemplification of the Westminster rite. We could equally well argue that books of this type were prepared precisely as exemplifications of particular orders for purposes of diplomatic exchange. Though Charles V's Coronation Book is essentially personal in its planning and preoccupations, Charles is known to have possessed in addition eight coronation orders, two foreign and six French; the Pamplona manuscript and the *Liber regie capelle* are both associated with Iberian, not English, ownership; and Charles V's Coronation Book seems eventually to have passed into English hands after 1423, though under different circumstances.[33] Was the *Liber Regalis* similarly left without marks of ownership as a sign of its potential, never realized, as a diplomatic gift in an age increasingly obsessed with the niceties of seigneurial ritual?

The history of the Bohemian debate which has attached especially to the *Liber Regalis* and its presumed association with Anne of Bohemia, is not one which I propose to review extensively here.[34] It began with a broad, and rightly discredited, assertion that Bohemian illumination was a formative influence on English art of the late fourteenth century, and was subsequently whittled down to a debate specifically about the *Liber Regalis* and the possible impact of illumi-

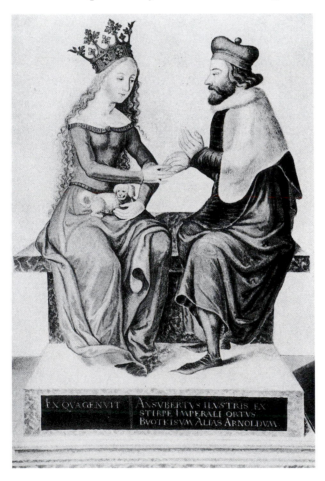

149. Gerberg and Lambert. 16th-century copy of a mid 14th-century genealogical cycle in Karlstein Castle, near Prague

nators within Anne's entourage.[35] Most recently it has been rejected entirely.[36] The principal grounds for this rejection are that the style of the *Liber Regalis* and its relatives is not only unlike Bohemian painting and illuminating, but explicable largely in terms of the development of English painting of the period. I do not share these opinions. With the possible exception of Hand B in the Carmelite Missal (London, British Library MSS Add. 29704–5/44892), whose style is softer and more refined in keeping with the Netherlandish tenor of many of its miniatures, and is anyway part of a famously eclectic book, the *Liber Regalis* stands to one side of English illumination of the period in its technique, colouration and drawing, and general approach to composition. It is extremely hard to see how such an idiom could have developed spontaneously out of the English milieu we are discussing. This is not reason in itself for immediately seeking out Bohemian sources, but it should be noted that the Bohemian issue has itself been coloured by the assumption that the *Liber Regalis* dated to before 1383, so in effect limiting the range of comparisons with Bohemian art to no later than about 1380. For this reason the dating question has been given some priority in this essay: by dating the *Liber Regalis* as late as the 1390s the potential, at least, for new connections emerges, and it is here argued that they can be sought at least in part in Bohemia.

In her study of the Carmelite Missal, Rickert noted, I think correctly, that 'many characteristic features of the peculiar figure types in the *Liber Regalis* are found in Bohemian manuscripts: the awkward positions of the seated figures and of the feet of the standing ones, the voluminous, clinging drapery with many superficial folds, and most of all, the strangely-shaped hands and fingers'.[37] In assessing the complex and somewhat inscrutable links forged in the 1380s or 1390s between the *Liber Regalis* and the Bergavenny and Carmelite Missals, Rickert concluded that links for this group were to be found less in the group of manuscripts made for Johann von Neumarkt or in the later ones for Wenceslas IV, but rather somewhere in between the two.[38] Whether or not this was prompted by her belief that the *Liber Regalis* was 'written perhaps for or soon after the Coronation of Anne of Bohemia', that is, *c.* 1382, is unclear.[39] Any such speculation would have to limit comparison to Bohemian art before *c.* 1380. Here the links are isolated, and are perhaps most evident in monumental painting. One could compare the positioning and manner of the king and queen in the *Liber Regalis*'s double coronation miniature to figures like Gerberg and Lambert from the Karlstein genealogical cycle of the 1350s (*ill. 149*) recorded in a series of sixteenth-century copies now in Vienna and Prague.[40] The *Liber Regalis*'s curious crab-claw hands are anticipated in the mural relic scenes in Karlstein's Lady Chapel, and the features and especially the setting of the eyes of the Woman Clothed with the Sun in the Apocalypse murals in the same place strikingly resemble those of the young cleric to the left of the king in the double coronation in the *Liber Regalis* (*ills. 150, 151*).[41] But generally, Bohemian large-scale art of the period up to about 1380 employs vigorous thick-set figures and round smooth forms, whereas the *Liber Regalis*'s style is slimmer and piquant,

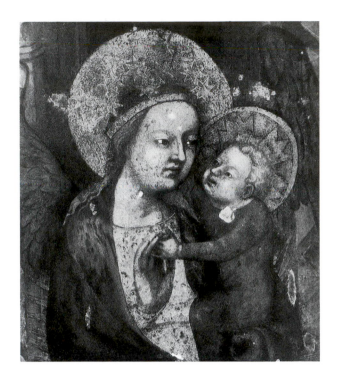

150. *Woman Clothed with the Sun*. Mural, *c.* 1360.
Lady Chapel, Karlstein Castle, near Prague

151. Head of a cleric from the Coronation
of a King and Queen. *Liber Regalis*,
London, Westminster Abbey, MS 38, f. 20

and later-looking. It certainly seems to postdate the works occasionally related
to it, such as the Sternberk Pontifical of *c.* 1380 (Prague, Strahov Monastery,
Library of the Memorial of National Literature MS Dg. I. 19).[42] The 'sly' ex-
pression which Rickert noted in the features in the *Liber Regalis*, deriving from
the pointed noses, receding chins, high cheek-bones and weighty drawn-out
eyelids, already developed by some masters at Karlstein, compares much more
immediately with the later group of works including the Golden Bull of Charles
IV of 1400 (Vienna, Österr. Nationalbibliothek Cod. Vind. 338, *ill. 153*) and the
extraordinary Bible of Wenceslas IV in the same collection (Cod. 2759–64, *ills.
133–138*).[43] These are usually excluded as possible comparisons with the *Liber
Regalis* on grounds of date, but it has recently been argued that the Wenceslas
Bible may date to somewhat earlier than is usually thought, to the earlier 1380s
(see Hlaváčková, pp. 223–31).[44] The technique of the *Liber Regalis* and its rela-
tives is also distinctive, using a very delicate mother-of-pearl shading of pinks,
greens, and whites in flesh tones unlike English illumination of the period, but
again close to some Italian-influenced Bohemian illuminations of *c.* 1390, as in
the Prague Hours (National Museum MS V. H. 36).[45]

 The style of the *Liber Regalis* is explicable at least in part by contacts with
Imperial Bohemian mural painting and illumination up to and including the
1380s, though the links are not literal. In this sense, I would simply refine
Rickert's opinion while supporting its basic tenet, that the style of the *Liber*

244

Regalis represents one particular branch in the genesis of Bohemian painting *c.* 1390. From this heterogeneous group of works, including the *Liber Regalis*, stem the much more refined Bohemian styles of the next generation, as in the Prague Veronica Panel from the circle of the Capuchin Master, the Hasenburk Missal of 1409 (Vienna, Österr. Nationalbibliothek Cod. 1844) and the Vienna Sketch Book.[46] Are the *Liber Regalis* and its associates alone in this inflection in England? Probably not, since the badly decayed but still legible image of the Coronation of the Virgin on the tester of the tomb of Richard II and Anne of Bohemia in Westminster Abbey, executed in 1395–96 (*ill. 152*), bears close comparison in its brittle profiling and composition with exactly contemporary Bohemian panel painting like the so-called Epitaph of Jan de Jeren, dated 1395 or shortly after (Prague, National Gallery).[47]

The tester of Richard II's tomb, like the *Liber Regalis*, points to the possibility of a short-lived and somewhat specialized 'Bohemian episode' at the Plantagenet court, whose nature may, as Nicholas Rogers has cogently argued, reflect less the direct impact of Anne of Bohemia's entourage before her death in 1394 than stimuli proffered by the distinctly eclectic range of metropolitan art, including Italian, Netherlandish and North Germanic (that is, Hamburg and Cologne) styles, in London towards 1400.[48] Bohemian elements formed only a part of this southern English melting-pot of styles. Anne's presence as the representative of an Imperial dynasty whose art patronage was famously hete-

152. *Coronation of the Virgin.*
Detail of tester on tomb of
Richard II and Anne of Bohemia.
London, Westminster Abbey

rogeneous may, of course, have attracted Bohemian painters or their products to London: Plantagenet queens like Isabella and Philippa had had a role in the importation of Continental works of art, either Italian panel paintings or Franco-Flemish sculptures, for several generations.[49] But the position in London in the late fourteenth century was too complex for us to be sure that such specific causal relations were, or need to have been, at work. The artists employed on works like the Litlyngton Missal at Westminster teamed up with illuminators whose influences were more probably Netherlandish, as in the added drawings in the Litlyngton Missal-related Apocalypse in Cambridge (Trinity College MS B. 10. 2).[50] A similar range of connections is found in that great foyer of contemporary artists, the Carmelite Missal. Its indigenous styles, as in Hand C, connect well with the Pamplona Order, its Hand B connects generally with the *Liber Regalis* and the Bergavenny Missal, and its Hand A links up with the Shrewsbury Charter of around 1389–90 (*ill. 2*) showing Richard and Anne, and thence with Netherlandish art.[51] Illuminated royal charters from Richard's reign, a generally neglected and frequently datable source, indicate the diversity of styles associated with the royal administration in this period.[52] The range of Lombard, central Italian, Netherlandish and German-influenced styles at Westminster and in London in the 1390s in fact presents a kind of mirror image to the fabulous internationalism of Luxembourg Prague.

153. Title-page. Golden Bull of Charles IV, 1400.
Vienna, Österreichische Nationalbibliothek, Cod. Vind. 338

XVII

OLGA PUJMANOVÁ

Portraits of Kings depicted as Magi in Bohemian Painting

AN UNKNOWN WORK of Bohemian origin first came to light in 1990 at Christie's in London. The catalogue carries, under No. 45, a colour reproduction of an Adoration of the Magi described as a work of the Bohemian school, dating from around the year 1400 (*col. pl. 21*). The very brief accompanying text specifies the painting as tempera on wood (225 × 205mm.) with the frame forming an integral part of the picture.[1] The painting was acquired for a private collection and the new owner kindly answered my questions.[2] While his extensive and expert account could not provide quite as much information as would have been produced by scientific investigation, it helped me to get a more definite idea of the work.

This Adoration, to be called in this paper the Bucher Adoration of the Magi, was painted by an artist who drew on a variety of archetypes established in Bohemian courtly art. The individual figures in it retain the characteristics of soft-style models which are likewise evoked by the folds of the Virgin's robe. Mary's unostentatious throne is of the same kind as the pews of the saints in the panels by the Bohemian painter Theodoric from the Chapel of the Holy Rood (1365–67) in Charles IV's Karlstein Castle. The figures of the Three Magi may also be compared to Theodoric's saints in terms of robustness. Similarly, the painted surface of the Bucher Adoration overlaps the frame. Both the bottom side and the bottom left edge of the inner frame are here covered with the depiction of grassy terrain interspersed with flowers. The style in which both this vegetation and the individual figures are rendered suggests a somewhat later stage of development, associated rather with the output of the Master of the Trebon Altarpiece. Here I would refer not only to the painting of the frame in the Madonna Aracoeli in Prague (National Gallery, No. O 1457), which was produced *c.* 1390 for the Cathedral of St Vitus, but also to the Adoration in Hluboká (South Bohemian Gallery) which is believed to be the work of that same master dating from *c.* 1380. Naturally, comparison of a monumental painting with a small picture cannot be considered ideal. More convincing is an analogy with the Nathan Crucifixion (Zurich, P. Nathan Collection),[3] the dimensions and square format of which are almost identical to those of the Bucher Adoration. The two works are related not just by their common links with contemporary manuscript production, but also by their unusual iconography

247

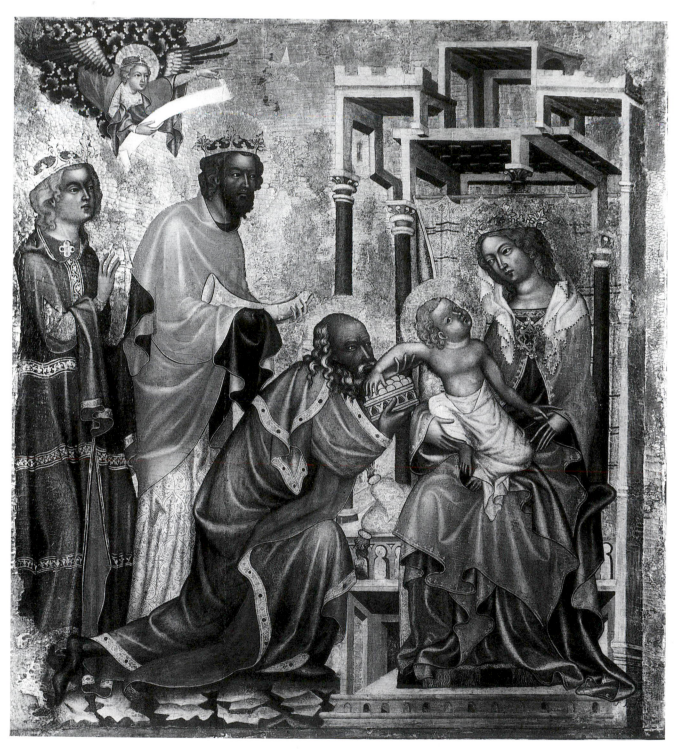

154. *Adoration of the Magi*, from the Vyssí Brod Altarpiece, *c.* 1347. Prague, National Gallery

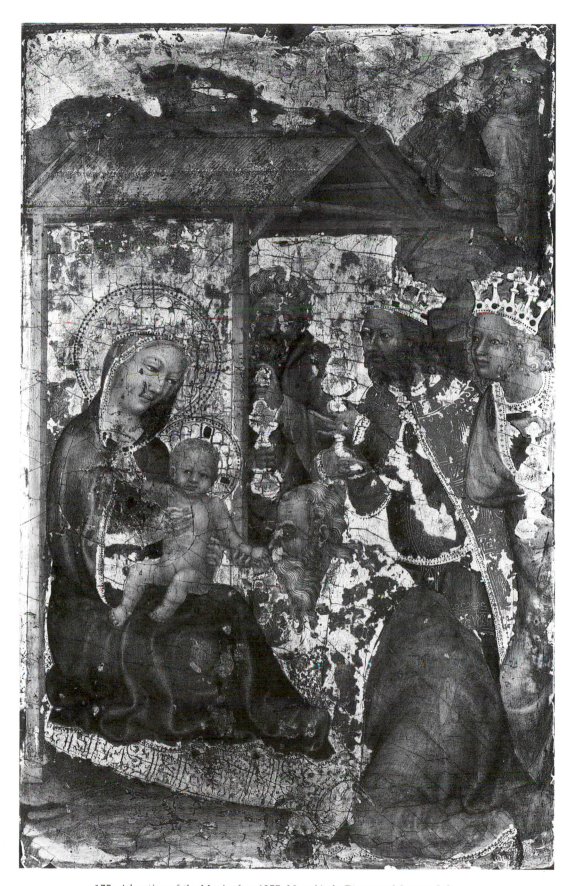

155. *Adoration of the Magi*, after 1355. New York, Pierpont Morgan Library

and by their relationship to contemporary sculpture. In both cases the figures are depicted in closely-knit groups positioned in shallow space, creating the impression of a relief. In the Nathan Crucifixion, sculptural parallels are found in the treatment of the body of Christ and in the figure of the Roman centurion, probably a crypto-portrait of Wenceslas IV (1361-1419); this has a likely counterpart in the figure of the centurion from the Calvary on the tympanum of the Church of Our Lady of the Pool in Prague. The figure of the Virgin in the Bucher Adoration is also sculptural in its treatment. Her white robe is stained with blood and the way in which she carries her new-born Son in her arms resembles the posture in which she is seen embracing the body of the tortured Christ in sculptures of the *Pietà*. For their part, the massive figures of the Magi lack the casual elegance and sophistication of their counterparts in the late fourteenth-century Nathan Crucifixion. For that reason alone, the Bucher Adoration cannot be attributed to the same artist and is somewhat earlier in date. But it was probably produced in the same court workshop which specialized in the production of small-scale tabernacles. The craftsmen working there were most probably painters and illuminators to whom Wenceslas IV showed extraordinary favour. As a lover of fine books, he gave a powerful impetus to the development of the art of book illumination in Bohemia. Accordingly, it is in Wenceslas' sumptuously decorated codices that the closest analogies to the Bucher Adoration can be found. In its treatment of space, rendering of vegetal motifs, types of figures and the folds of their robes, it bears likeness to various illuminations from the epic of chivalry known as the *Willehalm* of 1387–*c*. 1395 (Vienna, Österr. Nationalbibliothek Cod. 2643; see Hlaváčková, p. 223), and more specifically to those miniatures which hark back to the earlier tradition of Bohemian painting.[4]

The Adoration of the Magi was a widely popular subject in medieval art. Of the canonic Gospels, it is described only in Matthew (2:1–12). It tells the story of the three wise men from the East who visited King Herod in Jerusalem and came to pay tribute to the Infant Christ in Bethlehem, bearing him offerings of gold, frankincense and myrrh, whereafter—obeying the instructions they had received in their dreams—they returned to their homeland. Matthew refers to them explicitly as wise men from the East, making no mention of kings. It was only later, in the writings of the Church Fathers, that the Magi came to be described as kings. They were first mentioned by Tertullian (*c*. 160–220 A.D.), whereupon the legend was taken up by others who enriched it with a variety of episodes and fresh motifs successively attached to it over the centuries.[5] The legend of the Epiphany became extremely popular in the twelfth century, when relics of the Magi were discovered in Milan in 1158 and brought to Cologne in 1164, elevating Cologne Cathedral to one of the foremost places of pilgrimage in the Middle Ages. This constituted an important attempt to turn holy relics into an instrument of politics. The Imperial Chancellor and Archbishop of Cologne, Reinald von Dassel, strove thereby to justify the existence of the Empire in the face of claims being raised by both Pope Alexander III and the

Byzantine emperor, Manuel I Comnenus (r. 1143–80). From his correspondence, as well as from other sources of the period, it is apparent that the remains were in fact transferred from vanquished Milan '*ad perpetuam Germaniae gloriam*'.[6]

Just as Christ's Crown of Thorns deposited at the Sainte-Chapelle (consecrated in 1248) was a token for the realm of France, so the relics of the Three Kings acquired the same symbolic import for the German Empire. For centuries they were the destination of both Christian pilgrims and German monarchs whose coronation ceremonies at Aachen would entail the custom of paying respect to the holy remains.

A wash drawing in pen dating from *c.* 1340 depicts the rite being performed by the Emperor Henry VII in January 1309. In the drawing he is depicted flanked by his consort, Margaret, and by his brother Baldwin of Luxembourg, Archbishop and Elector of Trier, all of them forming the head of a procession adoring the remains of the Three Kings displayed in a reliquary on the altar.[7] That, indeed, is the famous *Dreikönigenschrein*, the front of which was decorated with gold and precious stones donated for that purpose by Otto IV of Brunswick on the Feast of the Epiphany in the year 1200.[8] He had himself portrayed on the shrine without a crown joining the Magi bearing gifts to the Infant Christ. Only a short step separates this portrait of Otto IV from the practice which went so far as to identify a contemporary living person with one of the Three Kings in Adoration scenes.[9] This practice appeared for the first time in the fourteenth century in several works related to Charles IV.[10]

The Holy Roman Emperor and King of Bohemia, Charles IV (r. 1347–78), was brought up from a young age at the French royal court. It was also from the French court that he brought his first wife, Blanche de Valois. While still an adolescent, he was sent to defend family interests in Lombardy, Tuscany and Emilia, where he broadened his cultural horizons and at the same time acquired fresh military and political experience. After his return to Bohemia in 1333, he oversaw the development of all aspects of his hereditary kingdom. On his initiative, the arts in Bohemia emulated French and Italian models and for a limited period occupied a leading position in Europe.

The earliest examples of the art of portraiture from the time of Charles IV are in Karlstein Castle, founded in 1348.[11] Only fragments of its original decoration have survived. In the Chapel of the Virgin Mary there is a large-scale wall-painting depicting Charles IV in three scenes separated by an arcade. The first of these shows the emperor with the dauphin, later King Charles V of France, who is presenting the former with a gift from his father, Jean le Bon: a pair of thorns from Christ's Crown from the Sainte-Chapelle. What is depicted here is a real event which took place in 1356. The scene was probably painted shortly afterwards. The second picture shows Charles IV in the company of a monarch whose identity continues to be the subject of dispute.[12] The third scene in the cycle represents the emperor alone, depositing the holy relic in a crystal reliquary cross. All the scenes show Charles IV wearing the Imperial Crown topped by a single, curved bar enclosing a mitre within. The realism and faith-

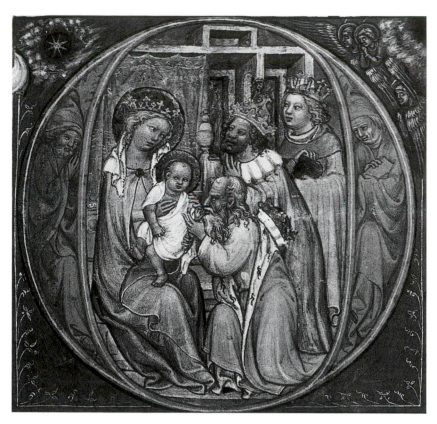

156. Initial O with *Adoration of the Magi.*
Liber Viaticus. Prague,
National Museum Library,
MS XIII A 12, f. 97v

fulness with which the Karlstein Master rendered the emperor correspond to a literary description of Charles's physical appearance by the contemporary Florentine chronicler, Matteo Villani. According to this account, Charles IV was of medium stature—short even by German standards—and hunched. His neck was bent, the forehead being broad and markedly protruding. His hair and beard were black, the eyes large, and the head bald at the front.[13]

Villani's description thus fully agrees with the appearance of Charles IV as shown not only in the Karlstein scenes, but also in a good many later portraits. These include, for instance, a portrait of Charles IV and his third wife, Anne of Svidnik, located above the portal of St Catherine's Chapel in Karlstein, at one time the monarch's private oratory; or a crypto-portrait of the emperor in the Chapel of the Holy Rood. There, on the vaulted ceiling of the Karlstein Castle's most sacred shrine, the court painter, Master Theodoric, immortalized the monarch between 1365 and 1367. Probably at Charles's explicit request, Theodoric embodied the emperor's likeness in the figure of the third and youngest of the kings in his painting of the Adoration (*ill. 157*).[14]

Charles IV was not the first to adopt such an approach. A similar inclusion of the portrait of a living person in a sacred scene had occurred earlier, probably for the first time in Bohemian art, in the Adoration scene from the Vyssí Brod Altarpiece (*ill. 154*). The second king here recalls the Roman centurion depicted in the Crucifixion in the same altarpiece, who is reminiscent, in terms of both his physiognomy and his hunched position, of later portraits of Charles IV. The

157. Master Theodoric, *Adoration of the Magi*, detail of the third king, *c.* 1365-67. Karlstein, Holy Rood Chapel

courtly aspect of the work, among other reasons, suggests that the Vyssí Brod Altarpiece was not actually painted for installation in Vyssí Brod, but was intended rather for the Cathedral of Prague.[15] In all probability, it was commis-

253

sioned to mark the Coronations of Charles IV and Blanche de Valois as King and Queen of Bohemia, which took place in the autumn of 1347.[16] While the representation of Charles IV as one of the Three Kings in the Adoration of the Vyssí Brod Altarpiece is highly probable, it has not been documented. On the other hand, Charles's portrait on a panel in New York (Pierpont Morgan Library) leaves no room for doubt (*ill. 155*). This is evidenced not only by the physiognomy of the second king there, but also—and most significantly—by the depiction of the Imperial eagle in the pattern of his robe. This small panel is part of a diptych, the other wing of which depicts the Death of the Virgin, not the standard Crucifixion. Shown among the Apostles assembled around the dying Mother of God is St Peter wearing a three-tier tiara. This figure could most probably be identified as Pope Innocent IV, whose portrait forms a counterpart to that of Charles IV. The diptych thus represents an apotheosis and a spectacular, if temporary, alliance between Papacy and Empire. It relates to a specific situation and an actual event, namely the Coronation of Charles IV as Holy Roman Emperor in 1355.[17] That event had had its political antecedent in Charles IV's Coronation as King of Lombardy which took place in the Church of St Ambrose in Milan on 6 January 1355. On that day, as every year, a sumptuous Epiphany procession passed through the town with the participation of the Visconti family.[18] The instigation of the procession, with its attendant splendour, was intended to attenuate the gloom caused by the loss of the relics which were by then the pride of Cologne.

The date of Charles's Coronation in Milan was not accidental: the mass for the coronation of German sovereigns would have traditionally involved the Epiphany liturgy and Henry VII also received the Iron Crown on the Day of Epiphany, 1311.[19] Like his grandfather, Charles IV would also have hastened to bow to the first holy kings during his visits to Cologne and on 6 January 1372 he was even presented with part of the head of St Balthazar by Archbishop Frederick of Cologne. Charles was a passionate collector of holy remains and his interest in the relics of the Magi was doubtless motivated by religious considerations, but political interests were also involved. In fact, they account for the occurrence of his portrait in depictions of the Adoration of the Magi which can be seen not only in panel and wall-paintings, but also in book illumination. The illuminator of the Breviary of Jan ze Stredy, the *Liber Viaticus* (Prague, National Museum Library MS XIII A 12, f. 97v), depicted the king in the middle wearing the Imperial Crown to identify him as Charles IV (*ill. 156*).[20] The third king in the same initial probably represents the future Wenceslas IV. A fair-haired youth, he presents the Infant Christ with a nugget of raw gold instead of the precious artefact typical of contemporary treatment of the subject. This unusual iconography has been interpreted as relating to Wenceslas' birth in 1361. Overjoyed at having a son at last, Charles IV donated to Charlemagne's Cathedral at Aachen sixteen talents of gold, an amount equalling the weight of the new-born child.[21]

Wenceslas IV, Charles IV's successor, was much portrayed. Yet no official,

personally commissioned, portrait of him exists.[22] Even the statue representing Wenceslas on the façade of the Bridge Tower in the Old Town of Prague, which came to serve as the prototype for subsequent depictions of him, is yet another artistic eulogy to Charles. While the statue was produced in Parler's workshop in the 1380s, during the reign of Wenceslas, the overall concept of the decoration of the Tower harks back to the era of Charles IV. The statue is contemporary with the bust of Wenceslas in the triforium of St Vitus's Cathedral. Another example is the votive portrait of the Archbishop of Prague, Jan Ocko Vlasim, dating from before 1371, in which Wenceslas is recommended to the Virgin Mary by his namesake, St Wenceslas, the patron of Bohemia.

By commissioning monumental works to be exhibited in highly visible places, Charles IV made sure that his appearance was brought to public notice. In contrast to this, most of the depictions of Wenceslas IV are to be found in the form of miniatures contained in his manuscripts, notably in the Wenceslas Bible (Vienna, Österr. Nationalbibliothek Cod. 2759–64, *ills. 133–138*). These depictions include several majestic portraits, but in most of them his likeness is concealed in a variety of allegories which, together with his numerous emblematic representations, make up his peculiar universe. Most typical of them is the knot combined in various ways with other signs. In some cases the knot is positioned on Wenceslas' head in the form of a wreath inserted beneath his crown as, for instance, on the title page of Exodus (f. 53v of the first volume).[23] Similarly distinguished—by a mantling placed under his Persian cap and elaborately patterned crown—is one of the Three Kings in the Adoration of the Magi in the Saxon Chapel of St Vitus Cathedral. Even though the youthful physiognomy of that figure lacks identifiable features, most likely it also represents King Wenceslas.[24]

By the end of the fourteenth century, the glorification of the Luxembourg sovereign as one of the Three Kings was not exceptional in art associated with the Prague court. Arguably the most interesting evidence of this is furnished by the scene of the Epiphany in the Church of St James in Libis, the rich iconographical decoration of which originated in the spiritual atmosphere of pre-Hussite Bohemia. Here the first of the kings is identified by the Imperial Crown as Charles IV (*ill. 159*). In what is an iconographical innovation, the scene also depicts King David, an angel and the Prophet Isaiah, whose presence is substantiated by a text from the Bible.[25] David's gesture, however, suggests yet another meaning. He is pointing directly at the second king, whose physiognomy corresponds to the features of Wenceslas IV. King David appeals to him to rule with prudence and justice, citing a passage from Psalm 72 (1–4) in which he addresses Solomon.[26] Representations in the immediate vicinity of the Adoration of a Sibyl showing the Virgin in the Sun to Augustus were regarded even in the early literature on the subject as depictions of Queen Sophia and Wenceslas IV (*ill. 158*). The Tiburtine Sibyl wears a knot on her head; and Augustus has a crown topped by a tall arch that is typical of Wenceslas IV's official portraits known from his Bible and his statue on the Bridge Tower. Likewise,

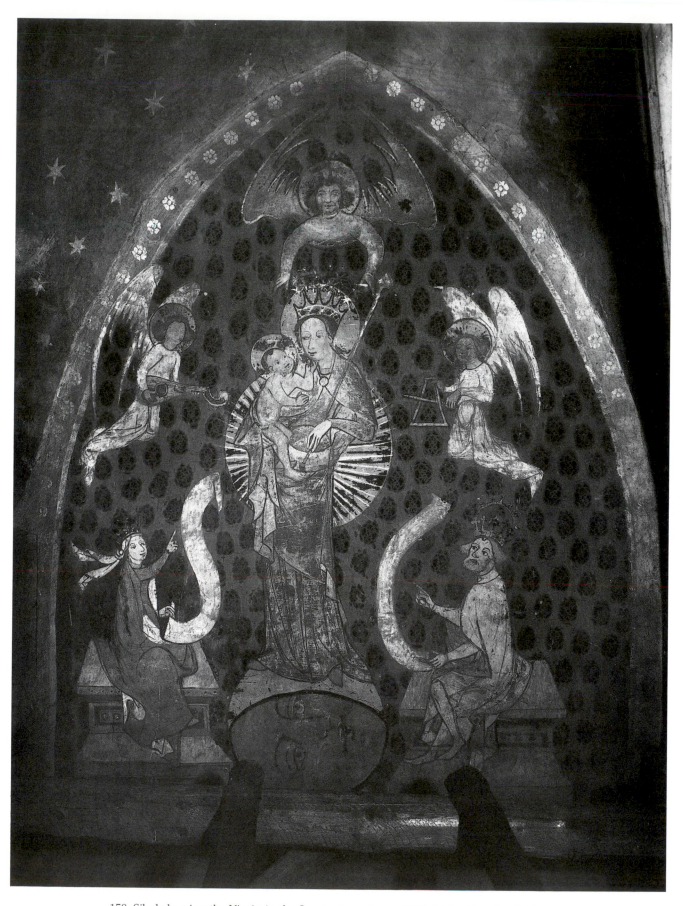

158. Sibyl showing the Virgin in the Sun to Augustus, *c.* 1380. Libis, Church of St James

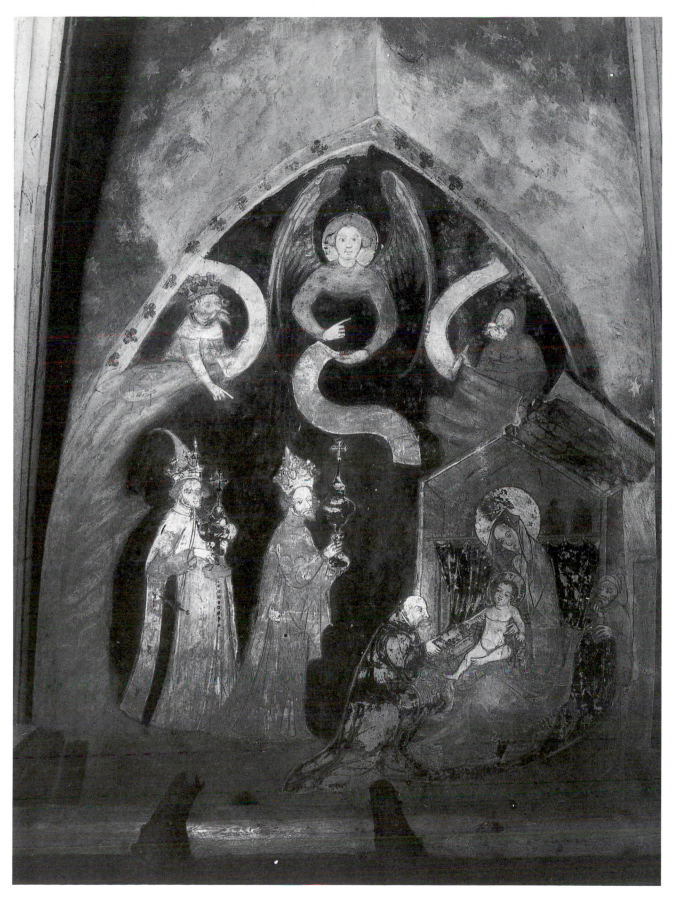

159. *Adoration of the Magi, c.* 1380. Libis, Church of St James

the figure of the Virgin in the Sun may have been inspired by one of the sculptural types of the Virgin Mary. The standing Madonna was one of the most common Marian representations and a harbinger of the new style. The sign of the knot, however, usually associated with the person of Wenceslas IV and his Order of Chivalry, has here none of the standard connotations characteristic of the marginal decoration found in his manuscripts. That the style and heraldic character of the painting is below the standard of courtly art of the period suggests that the decoration of the church was not commissioned by King Wenceslas, but by a member of his Order.[27]

On the basis of the examples discussed above, it may be assumed that the Bucher Adoration also shows the Luxembourg monarchs. Underlying the depiction of the Three Kings in the painting is the artist's marked effort to achieve characterization, even portrait-like distinction. Represented as a grey-haired old man, King Balthazar recalls the realism of the heads of Master Theodoric's saints. The king in the middle is hunched, thereby suggesting Charles IV. Yet his long fair hair casts doubt on the theory identifying this figure as a portrait of the emperor, who was dark-haired. The face, with a high straight brow, broad cheek-bones and a beard divided into two points beneath the chin, would seem rather to suggest the likeness of Wenceslas IV as in his portrait on the Bridge Tower.[28] Most particularly, the figure of the third and youngest of the Magi provides material for interesting conjecture. His aquiline nose and red hair were characteristic features of Sigismund of Luxembourg, known by the soubriquet 'Redhead King'. His prominent position in the picture is indicated by his splendid moss-green robe lined with ermine, bordered with gold and girded with a golden belt, worn over a coat of mail. This figure's physiognomy is reminiscent of that of St Sigismund as depicted in two Bohemian works dating from *c.* 1400, the panel from Dubecek (Prague, National Gallery; *ill. 162*), and the frame of the *St Vitus Madonna* from the Cathedral of St Vitus (*ill. 160*). Just as his half-brother, Wenceslas IV, was probably portrayed with the attributes of St Wenceslas, so on more than one occasion Sigismund's likeness was rendered in representations of his Christian patron, St Sigismund, King of Burgundy, whose remains Charles IV had moved to Prague in 1365 for burial in St Vitus's Cathedral.

If the theory that the third king in the Bucher Adoration represents Sigismund of Luxembourg is accepted, then what we have here is probably the earliest surviving portrait before the iconography for Sigismund became standard as in Pisanello's portrait of the emperor now in Vienna (Kunsthistorisches Museum, No. 2630), and two drawings by the same artist in Paris (Musée du Louvre). In the Vienna portrait, dating from 1433, Pisanello portrayed the old emperor in a fur hat, a feature which became one of his constant attributes.[29] In one of the drawings at the Louvre (Cabinets des Dessins, Cod. Vallardi No. 2339) Sigismund is depicted bare-headed and decorated with the insignia of the Order of the Dragon which he had founded in 1408 with his wife, Barbara of Cilli.[30]

Unlike Charles IV and Wenceslas IV, Sigismund never enjoyed support in his native Bohemia, where he spent only one year at the very end of his life.

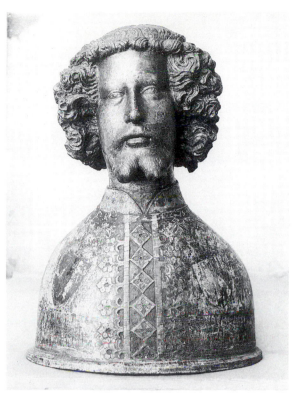

160. St Sigismund. Detail of frame from
St Vitus Madonna. Prague, National Gallery

161. Reliquary bust of a Saint.
Cologne, Basilica of St Ursula

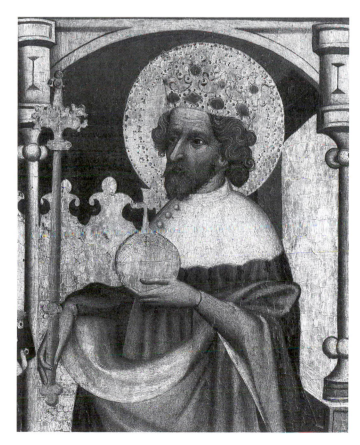

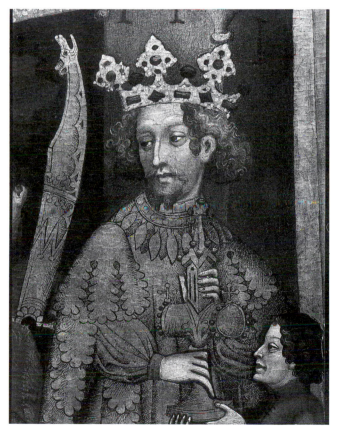

162. Votive panel from Dubecek, *c.* 1400.
Prague, National Gallery

163. Master of the Ortenberg Altarpiece, *Adoration of the Magi*,
detail, *c.* 1325. Darmstadt, Hessisches Landesmuseum

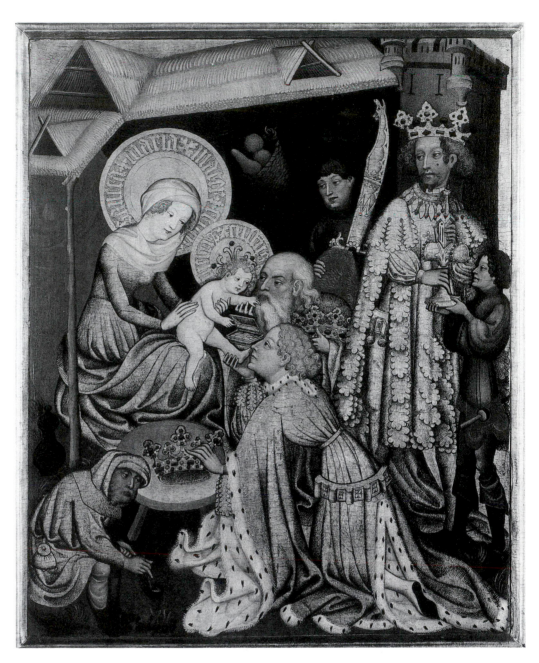

164. Master of the Ortenberg Altarpiece, *Adoration of the Magi, c.* 1325.
Darmstadt, Hessisches Landesmuseum

Although he was crowned in 1420, he actually acceded to the throne in 1436, reigning until 1437. Hungary, which he ruled from 1387 and where he had been brought up since childhood, was not part of the Holy Roman Empire of which he was king (crowned in 1411) and emperor (from 1433). Accordingly, Sigismund spent most of his life travelling. He would journey constantly, touring wherever his monarchic interests and duties called him, a fact which accounts for portraits of him in various places in Germany, Italy and the Netherlands. A

monograph by Bartolom Kéry discussing these portraits lists six Epiphanies containing crypto-portraits of Sigismund.[31] Among them is a drawing from the circle of Jan van Eyck dating from 1415–20 (Amsterdam, Rijksmuseum) where Sigismund, as the third of the kings, holds a fur hat with an upturned brim instead of a crown.[32]

Another portrait of Sigismund, hitherto unknown, may be hidden in the Adoration scene of the Ortenberg Altarpiece (Darmstadt, Hessisches Landesmuseum) dating from *c.* 1425, considered by many a pivotal work of the Rhineland School.[33] Here the face of the king, with his aquiline nose, is rimmed with thick wavy hair, a pattern corresponding to the known portraits of Sigismund based on depictions of St Sigismund. It is similar to the bust of St Sigismund on the carved frame of the St Vitus Madonna in Prague (National Gallery, No. 08777; *ill. 160*)[34] and the related reliquary bust of the saint in the Basilica of St Ursula in Cologne (*ill. 161*). This bust recalls the third king of the Ortenberg Adoration (*ill. 164*) not only in the face, but also in the narrow, sloping shoulders.[35] In the Adoration, the king is wearing a cloak decorated with garlands of oak leaves which he also wears in a contemporary drawing datable to 1420–22 (Kunstsammlungen der Veste Coburg, No. Z 240–K2). He is depicted in the drawing as a tournament knight, victorious over the Hussite heretic who is reaching out his hand for the chalice under the hooves of the horse.[36] In the drawing, Sigismund brandishes a knot, the insignia of the Order of Chivalry founded by Wenceslas IV whom he succeeded as its head after Wenceslas' death in 1419. An allusion to the same Order may perhaps also be detected in the initial 'W' marking an oversized sword painted in the Ortenberg Adoration (*ill. 164*). This sword is topped by a dragon's head which might be a reference to Sigismund's own Hungarian Order.[37] Considered separately, none of this would be enough to identify King Sigismund in the Ortenberg Adoration. However, considered as a group and viewed in conjunction with the theory that the Ortenberg Altarpiece was made in Mainz, the evidence tends to support this conjecture.

It was in Mainz that Sigismund was portrayed as one of the Three Magi in an Adoration painted in the cloister of the Convent of St Margaret.[38] The fresco has not survived but it was described by Eberhardt Windecke (1380–1445) who spent 30 years in the emperor's service.[39] He was a native of Mainz, a city to which Sigismund paid several visits in 1414.[40] On 8 November of that year, Sigismund was crowned King of Rome at Aachen, whence he proceeded to Cologne to pay homage to the remains of the Magi.[41] Sigismund's visit to Mainz, where he stayed, as King of Rome, through December before his departure to the Council of Constance, was clearly the occasion for his depiction in the Adoration painted in the Convent. And one can well imagine that the fresco reflected the experience of this rare visit.

The Ortenberg Adoration (*ill. 164*) gives the effect of a splendid performance by the king and his entourage, not only through the majesty of the standing monarch whose appearance recalls that of Sigismund. The magnificent robe worn by the young kneeling king, as well as the presence of two pages, contrib-

ute to the impression of a courtly ceremony. This scene apparently impressed contemporary spectators more than either the central panel depicting the Holy Family or the left wing showing the Adoration of the Child, as is evident from three fifteenth-century variants.[42] The first, a panel from Lenzburg,[43] is a faithful copy; the Adoration of the Magi auctioned in Cologne[44] differs from its model in several small details; and the picture from Aschaffenburg (Galerie, No. 9272)[45] appears to be a rather loose version of the theme. Consequently, it seems that the different variants, perhaps including the Ortenberg Adoration, might be based on a common model which could easily have been manuscript illumination. Nor can the influence of the Adoration in the Convent of St Margaret be excluded.

Eberhardt Windecke's report on the fresco is exceptionally significant, because it proves that the portrayal of a specific sovereign as one of the Three Kings is not an iconographic invention of art historians. Windecke wrote in his memoirs that Sigismund had been portrayed on account of his physical beauty ('*Seines schönen Angesichts wegen*') but made no mention of the honour of being portrayed as one of the Three Kings coming to venerate the Divine Child. Obviously that was quite clear in his time and needed no special comment. After all, Sigismund of Luxembourg was not the first monarch to have had his portrait made in the biblical context of an Adoration scene. In fact, his crypto-portrait in Mainz can be linked as we have seen with a family tradition established earlier by Charles IV in the diptych in the Pierpont Morgan Library in New York discussed above. The inclusion of portraits in the Adoration of the Magi and in the Death of the Virgin represents a classic example of a contemporary issue being transferred to a religious painting.

Charles IV exploited the political aspect of the cult of the Three Kings of Cologne in the same way as his Imperial predecessors. It was not only German kings and emperors who, following their coronation, made pilgrimages to the shrine of the first kings of Christendom. In addition, the Cologne *Dreiheiligen-schrein* was visited by other royal pilgrims. English monarchs were among the first. In 1332 Edward II travelled to Cologne and in 1338 Edward III did the same[46] and subsequently (between 1350 and 1360) had a large painting made of the Adoration of the Magi for the Chapel of St Stephen, Westminster, beneath which he had himself portrayed in the company of his five sons.[47]

The cult of the Epiphany reached its peak at the English royal court under Richard II (see Mitchell, pp. 122-123). Born on 6 January, the Feast of the Epiphany, Richard was said to have been visited on the day of his birth by three reigning monarchs: the kings of Castile, Portugal and Navarre.[48] Perhaps that joyful occasion was among those referred to in the multiple meanings of the Wilton Diptych:[49] there the Three Kings of England are implicitly Magi. In an Epiphany scene, in addition to its religious aspect, Richard II evidently also assigned a political meaning to the cult of the Three Kings. A similar conclusion may perhaps be drawn from the fact that around 1395 Richard II ordered the payment of a sum to reimburse an extension of the crown of one of the Three

165. Votive panel of Jan Ocko of Vlasim.
Bohemian, after 1370. Prague, National Gallery

Kings in the Adoration from St Stephen's Chapel at Westminster.[50] This would seem to be evidence not so much of Richard's interest in the Magi, but rather of his ambition to glorify himself and/or his family. The enhancement of the crown of one of the Three Kings may well have been meant to denote a crypto-portrait of Richard II or perhaps his great-grandfather Edward II, whose canonization Richard sought throughout the 1390s.[51] Certainly that would have been in conformity with contemporary practice and it is possible that his intervention was inspired by the iconography of the Luxembourg Adorations. Due to their early date and large number, the Luxembourg Epiphanies may be assumed to have been invested with extraordinary significance and to have radiated influence into other parts of Europe. Their impact on the art of the English court may have been due to Richard II's first wife, Anne of Bohemia, daughter of Charles IV and sister of Wenceslas IV, whom she married in 1382. Among other things, she is known to have brought with her to England a manuscript containing the Czech and German translations of the Gospels.[52] It would have been natural for Queen Anne's trousseau to include a picture of the Adoration with crypto-portraits of her relatives. The provenance of small portable objects is obscured by the passage of time. It is perhaps not a coincidence that, after centuries of oblivion, this small work of art from Bohemia depicting the Adoration of the Magi resurfaced in London, the place to which it could very possibly have been brought by Anne of Luxembourg or a member of her retinue.

POSTSCRIPT

Before concluding, we may consider another tentative hypothesis. According to Dillian Gordon, Queen Anne may later have become the owner of a Bohemian statue of the Virgin which was perhaps used as the model for the figure of Mary on the Wilton Diptych. It has been suggested that this is a version of the type of *Schöne Madonna* in which the Virgin is holding the foot of the Christ Child, as in the later statue of the Virgin preserved in Cracow (Museum Narodowe, No. 10315)[53]. This work, like the painting of the Madonna from Augsburg (Staatsgalerie, L. 1053) dating from the period around the year 1400, depicts the Virgin Mary holding only the toes of the Christ Child.[54] In the Wilton Diptych, however, she is holding the entire sole of the foot turned towards the viewer. This motif occurs very frequently both in Italy and in Bohemia around the middle of the fourteenth century.[55] That this motif was not lost from Bohemian art even after the Italianate style faded is shown, *inter alia*, by the Augsburg Madonna mentioned earlier, where the Christ Child has the sole of his left foot turned outwards. We do not yet know what this motif, originally Byzantine, signified. Its clarification could shed light on the Wilton Diptych, where the Child's right sole, turned outwards, is emphasized by the gesture of the Virgin.[56] If we look carefully, we can see that she is not actually holding (or supporting) the foot, but rather displaying it.[57] Her slender fingers encompass it as if it were

264

a jewel set in the gold of Christ's robe. This robe is a further unusual detail of the Wilton Diptych. Contrary to tradition, it is without ornament. Its delicate punching is purely functional, indicating the modelling of the drapery which recalls a piece of precious metal. The punched gold cloth might symbolize the gold which Richard II and his two predecessors placed on the altar not only on the Feast of the Epiphany—thus imitating the Three Kings—but also on Good Friday[58] in connection with another rite perhaps indicated by the left hand of the Virgin. Her gesture is similar to that of St Edward the Confessor pointing at a ring in the left wing of the Diptych. It seems that the two figures are connected by a visual dialogue.

The ring linked to the most famous episode of the legend of St Edward became the latter's attribute.[59] Owing to Richard's intense devotion to Edward the Confessor, it is unlikely that the ring depicted in the Wilton Diptych figures there merely as an attribute of the saint. It might indeed represent the ring with a sapphire and eight rubies reputed to have belonged to St Edward and described in the Westminster Abbey inventory of 1388,[60] but in an alternative interpretation the ring could allude to the ceremony connected with the so-called 'cramp rings' which was specific to the English Court.[61]

The kings of England, like all good medieval Christian rulers, paid homage to the Cross every year on Good Friday. The Adoration of the Cross took place in the chapel of the castle in which they happened to be. In the reigns of the Plantagenets, from the beginning of the fourteenth century, this was enhanced by a special ceremony which we find nowhere else. After the end of the Adoration ceremony, the monarch placed gold on the altar and then immediately took it back again in exchange for some coins. From the precious metal which he sacrificed but then regained, the monarch had rings made which he then gave to the sick. These were no ordinary rings, for it was believed that they could perform miraculous cures. Contemporary sources do not tell us what disease they were meant to treat.[62] Only from a text of the fifteenth century does it emerge that these 'anuli medicinales' had a curative effect on muscle pains and—more especially—epilepsy. For this reason they were—and still are—known as 'cramp rings'.[63] This ceremony is first documented in 1323 by a decree proclaimed by Edward II in York.[64] From then until the death of Mary Tudor, this ceremony was performed on Good Friday by every English monarch.[65] Richard II was no exception. Reliable information on this is provided by the Wardrobe Accounts of 4 April 1393 and 31 March 1396.[66] For a long time, this rite with the medicinal rings added to the prestige of the English rulers and, by the fourteenth century, to that of their wives. In Windsor on 30 March 1369, Philippa of Hainault repeated the prescribed gestures after her husband, Edward III, and placed silver on the altar (gold being appropriate only for the king).[67] Although this is the only documented example which has been preserved, it is nevertheless presumed that analogous cases existed.[68] It is highly probable that Queen Anne did likewise. We know that she travelled around England with Richard II and that she was accorded a role in the formal ceremony

on the Feast-Day of Edward the Confessor (13 October 1390)[69] in Westminster Abbey. Richard II dedicated many gifts to the tomb of this royal saint at the Abbey[70] and always sought refuge there in times of crisis.[71] His cult of Edward the Confessor is perhaps most strikingly documented by the royal coat of arms, into which he had St Edward's emblem incorporated some time around 1395. It is also in this form that the royal coat of arms adorns the Wilton Diptych, painted in the years 1395–99 at the order of Richard II.

Most scholars agree that the Wilton Diptych does not relate to any definite event. It is rather a visual expression of Richard's idea of royal dignity, a 'visual expression of an idea—the idea of kingship'.[72] What could enhance the monarch's dignity more at that time, in the fourteenth century, than the ceremony of the healing rings which was the privilege of the kings of England? Enacting it, the rulers of England believed that they were imitating Edward the Confessor, their famous predecessor, who was considered the originator of the rite.[73] The ceremony always took place on Good Friday, at the time of the Passion, recalled on the Wilton Diptych by two details: the Crown of Thorns and the Three Nails on Christ's halo and the banner of the Resurrection, made unique by the depiction of the island of England. The intermingling of religious and lay ideas and the doubling of meaning are typical of the Wilton Diptych. It is therefore perhaps not too bold to see in it, *inter alia*, a symbolic reference to the purely English ceremony of the cramp rings, something of which the monarchs of other countries could not boast.

In the Luxembourg Adorations the portraits of rulers were motivated by political concerns. Perhaps the 'miraculous curing' of the English monarchs was a manifestation not of their holiness but of their regality.

166. *Virgin and Child* ('The Krumlov Madonna').
Bohemian stone sculpture, *c.* 1390s. Vienna, Kunsthistorisches Museum

THE HOUSE OF PLANTAGENET

Notes to the Text

List of Abbreviations

[*Age of Chivalry*] J. Alexander and P. Binski, eds., *Age of Chivalry. Art in Plantagenet England 1200–1400*, exh. cat., Royal Academy of Arts, London, 1987

[*CChR*] *Calendar of Charter Rolls Preserved in the Public Record Office*, Vol. IV, 1327–41, London, 1912; Vol. V, 1341–1417, London, 1911

[*CCR*] *Calendar of Close Rolls Preserved in the Public Record Office*, Vol. V, 1392–96, London, 1925; Vol. VI, 1396–99, London, 1927

[Clarke, 'Wilton Diptych' in *Fourteenth Century Studies*] M. V. Clarke, 'The Wilton Diptych', *Burlington Magazine*, LVIII, 1931, pp. 283–94. Reprinted in *Fourteenth Century Studies*, eds. L. S. Sutherland and M. McKisack, Oxford, 1937, repr. 1968, pp. 272–92

[Colvin, *King's Works*] H. M. Colvin *et al.*, *The History of the King's Works*, 6 vols., London, 1962–82

[*CPL*] *Calendar of Entries in the Papal Registers relating to Great Britain and Ireland, Papal Letters*, eds. W. H. Bliss and J. A. Tremlow, Vol. V, 1396–1404, London, 1904

[*CPR*] *Calendar of Patent Rolls Preserved in the Public Record Office*, Edward III, Vol. IX, 1350–54, London, 1907; Richard II, Vol. II, 1381–85, London, 1897; Richard II, Vol. III, 1385–89, London, 1900; Richard II, Vol. IV, 1388–92, London, 1902; Richard II, Vol. VI, 1396–99, London, 1909; Henry IV, Vol. I, 1399–1401, London, 1903; Henry IV, Vol. II, 1401–05, London, 1905

[Devon, *Issues*] F. Devon, *Issues of the Exchequer*, London, 1837

[*Die Parler*] *Die Parler und der schöne Stil 1350–1400. Europäische Kunst unter den Luxemburgen*, exh. cat., 5 vols., Cologne, 1978 (Vols. I–III) and 1980 (Vols. IV and V)

[*English Court Culture*] V. J. Scattergood and J. W. Sherborne, eds., *English Court Culture in the Late Middle Ages*, London, 1983

[*Foedera*, ed. Rymer] *Foedera, Conventiones, Literae...*, ed. T. Rymer, 3rd edn, 10 vols., The Hague, 1739–45

[Given-Wilson, *Royal Household*] C. Given-Wilson, *The Royal Household and the King's Affinity. Service, Politics and Finance in England 1360–1413*, New Haven and London, 1986

[Gordon, 'A New Discovery'] D. Gordon, 'A New Discovery in the Wilton Diptych', *Burlington Magazine*, CXXXIV, 1992, pp. 662–67

[Harvey, 'Wilton Diptych'] J. H. Harvey, 'The Wilton Diptych–A Re-examination', *Archaeologia*, XCVIII, 1961, pp. 1–28

[Ilg, 'Goldschmiedearbeiten Richards II'] U. Ilg, 'Ein wiederentdecktes Inventar der Goldschmiedearbeiten Richards II von England und seine Bedeutung für die Ikonographie des Wiltondiptychons', *Pantheon*, LII, 1994, pp. 10–16

[*JWCI*] *Journal of the Warburg and Courtauld Institutes*

[Legg, 'Inventory'] J. W. Legg, 'On an Inventory of the Vestry in Westminster Abbey taken in 1388', *Archaeologia*, LII, 1890, pp. 195–286

[Legg, *Coronation Records*] L. G. W. Legg, ed., *English Coronation Records*, London, 1901

[*Making and Meaning*] D. Gordon, *Making and Meaning: The Wilton Diptych*, London, 1993

[Palgrave, ed., *Kalendars*] F. Palgrave, ed., *The Antient Kalendars and Inventories of the Treasury of His Majesty's Exchequer*, 3 vols., London, 1836

[Palmer, *England, France and Christendom*] J. J. N. Palmer, *England, France and Christendom 1377–99*, London, 1972

[PRO] Public Record Office

[*Reign of Richard II*] F. R. H. Du Boulay and C. M. Barron, eds., *The Reign of Richard II. Essays in Honour of May McKisack*, London, 1971

[*Rotuli Parliamentorum*] *Rotuli Parliamentorum (1278–1552)*, 7 vols., London, 1767–83

[Sandler, *Gothic Manuscripts*] L. F. Sandler, *Gothic Manuscripts 1285–1385 (A Survey of Manuscripts Illuminated in the British Isles, V)*, 2 vols., London, 1986

[WAM] Westminster Abbey Muniments

[*Westminster Chronicle*] *The Westminster Chronicle 1381–1394*, eds. L. C. Hector and B. F. Harvey, Oxford, 1982

[Whittingham, 'Chronology'] S. Whittingham, 'The Chronology of the Portraits of Richard II', *Burlington Magazine*, CXIII, 1971, p. 12–21

Notes

INTRODUCTION

I am grateful to Dr Jenny Stratford and Dr Jane Martindale who read this Introduction and made many helpful suggestions: neither, necessarily, agrees with my conclusions.

1. I have assumed, like most of the contributors to this volume, that the Wilton Diptych was commissioned by Richard II; not everyone would agree with this view.

2. For these aspects of late 14th-century court culture, see R. F. Green, *Poets and Princepleasers: Literature and the English Court in the Late Middle Ages*, Toronto, 1980; Scattergood and Sherborne, eds., *English Court Culture*; and B. Hanawalt, ed., *Chaucer's England: Literature in Historical Context*, Minneapolis, 1992.

3. See Ilg, 'Goldschmiedearbeiten Richards II', pp. 10–16. See also the forthcoming book on badges by Michael Siddons (*Heraldic Badges*, Society of Antiquaries, London).

4. Ilg, 'Goldschmiedearbeiten Richards II', pp. 10–16, cites the inventory of the royal chapel where there were 30 items associated with John the Baptist, nine associated with Edward the Confessor, and one associated with St Edmund.

5. See note 4 above.

6. PRO, E 101/411/9; information kindly supplied by Dr Jenny Stratford.

7. Ilg, 'Goldschmiedearbeiten Richards II', pp. 10–16.

8. Although the portrait has been heavily restored, there seems to be no evidence that the crowned 'R's are not original.

9. See, for example, the painting of the Virgin Feeding the Infant Christ (1409) by the Master of Narni, now in the Museé du Petit Palais, Avignon (No. C1.7496), M. La Clotte and E. Mognetti, *Peinture Italienne. Avignon, Musée du Petit Palais*, 2nd edn, Paris, 1977, no. 148. See also the Magdalene in the San Pier Maggiore Altarpiece, D. Bomford *et al.*, *Art in the Making. Italian Painting before 1400*, London, 1990, pl. 151.

10. See R.W. Pfaff, *New Liturgical Feasts in Late Medieval England*, Oxford, 1970, Chapter 4.

11. Richard may also have been influenced—but this seems less likely—by the statue of Edward I over the gateway at Caernarvon Castle.

12. Nigel Saul develops this point further in 'Richard II and the Vocabulary of Kingship', *English Historical Review*, CX, 1995, pp. 854–77.

THE WILTON DIPTYCH

1. In 1993 the Diptych was cleaned and restored and made the focus of an exhibition entitled *Making and Meaning: The Wilton Diptych*. The accompanying catalogue discussed some of the problems associated with the iconography of the Diptych, presented the results of the scientific analyses made by Ashok Roy of the National Gallery's Scientific Department (see Roy, pp. 125–35). In the catalogue, the Chief Restorer, Martin Wyld, presented an account of the cleaning and restoration of the Diptych.

2. See M. Davies, *National Gallery Catalogues. French School*, 2nd edn, London, 1957, p. 96ff., and Harvey, 'Wilton Diptych', p. 2ff.

3. C. Gambarini, *Description of the Earl of Pembroke's Pictures*, London, 1731, pp. 4 and 61.

4. G. Scharf, *Description of the Wilton House Diptych*, Arundel Society, London, 1882.

5. A comprehensive bibliography on the Wilton Diptych up to 1981 is given by S. Whittingham, 'The Date of the Wilton Diptych', *Gazette des Beaux Arts*, XCVIII, 1981, pp. 148–50.

6. G. Waagen, *Treasures of Art in Great Britain*, London, 1854, Vol. III, pp. 150–51 and id., *A Walk through the Art Treasures Exhibition in Manchester*, London, 1857, p. 2 n. 42.

7. P. A. Lemoisne, *Gothic Painting in France. Fourteenth and Fifteenth Centuries*, Florence and Paris, 1931, pp. 57–8.

8. C. Sterling, *Les Peintres du moyen âge*, Paris, 1942, pp. 20 and 78–9 n. 22.

9. Davies (cited in note 2 above), pp. 92–101.

10. C. Beard, 'The Wilton Diptych–English!', *Connoisseur*, LXXXVIII, 1931, p. 375 and F. H. Cripps-Day, 'The Wilton Diptych–English!', *Connoisseur*, XCI, 1933, pp. 167–69.

11. Clarke, 'Wilton Diptych' in *Fourteenth Century Studies*, pp. 272–92.

12. Harvey, 'Wilton Diptych', pp. 1–28.

13. Ilg, 'Goldschmiedearbeiten Richards II', pp. 10–16, esp. pp. 11–13.

14. Harvey, 'Wilton Diptych', pp. 8–9.

15. W. A. Shaw, 'The Early English School of Portraiture', *Burlington Magazine*, LXV, 1934, pp. 171–84.

16. V. H. Galbraith, 'A New Life of Richard II', *History*, XXVI (104), 1942, p. 223ff. (review of A. Steel, *Richard II*, Cambridge, 1941).

17. E. Panofsky, *Early Netherlandish Painting*, Cambridge, Mass., 1953, Vol. I, p. 118.

18. F. Wormald, 'The Wilton Diptych', *JWCI*, XVII, 1954, pp. 191–203 (reprinted in id., *Collected Writings. II: Studies in English and Continental Art of the Later Middle Ages*, eds. J. J. G. Alexander, T.J. Brown and J. Gibbs, London, 1988, pp. 103–16).

19. M. Galway, 'The Wilton Diptych: A Postscript', *Archaeological Journal*, CVII (for the year 1950, published 1952), pp. 9–14.

20. *Making and Meaning*, p. 24.

21. See L. Cust, 'Portraits of Richard II' in *Exhibition Illustrative of Early English Portraiture*, Burlington Fine Arts Club, London, 1909, pp. 16–19; also T. Borenius and E. W. Tristram, *English Medieval Painting*, Florence, 1927, pp. 27–8.

22. H. Thurston, 'The Wilton Diptych', *The Month*, CLIV, 1929, p. 31 and E. W. Tristram, 'The Wilton Diptych', *The Month*, Vol. I, No. 6, 1949, p. 385.

23. Whittingham (cited in note 5 above), p. 147.

24. Thurston (cited in note 22 above), p. 31.

25. S. J. Ferris, 'The Wilton Diptych and the Absolutism of Richard II', *Journal of the Rocky Mountain Medieval and Renaissance Association*, VIII, 1987, pp. 33–66. I owe this reference to Nigel Morgan.

26. C. T. Wood, 'Richard II and the Wilton Diptych' in *Joan of Arc and Richard III. Sex, Saints, and Government in the Middle Ages*, ed. C. T. Wood, Oxford, 1988, pp. 75–227.

27. Harvey, 'Wilton Diptych', p. 19.

28. Scharf (cited in note 4 above), p. 65ff.

29. Clarke, 'Wilton Diptych' in *Fourteenth Century Studies*, p. 286ff.

30. Palmer, *England, France and Christendom*, pp. 205 and 242–44.

31. See Gordon, 'A New Discovery', pp. 662–67. Everard Green had already argued that the *Dos Mariae* was relevant to the Wilton Diptych before the discovery of the painting in the orb. See the letter to Captain Nevill Wilkinson (Cataloguer of the Wilton House Collection) from the Herald's College dated 17 March 1905 (typescript in the National Gallery Archives).

32. London, British Library, MS Harley 360, f. 98v. The altarpiece was first discussed in relation to the Wilton Diptych by C. Coupe, 'An Old Picture', *The Month*, LXXXIV, 1895, pp. 229–42.

33. S. Petrasancta, *Tesserae Gentilitiae*, Rome, 1638, pp. 677–78.

34. Davies (cited in note 2 above), p. 99 n. 8.

35. See J. Allen, 'A Royal Reredos', *The Venerabile*, XX, 1961, pp. 127–39. Cited by Whittingham, 'Chronology', p. 15.

36. R. W. Lightbown, *Mediaeval European Jewellery*, London, 1992, p. 254.

37. *Making and Meaning*, p. 78.

38. See D. Wilkins, *Concilia Magnae Britannicae*, London, 1737, Vol. III, p. 246. Cited by, amongst others, T. E. Bridgett, *Our Lady's Dowry*, London, 1875, pp. 1 and 217 and E. Waterton, *Pietas Mariana Britannica*, London, 1879, p. 14.

I. RICHARD II'S IDEAS OF KINGSHIP

1. W. Shakespeare, *King Richard II*, I, ii, 37–8; III, ii, 57.

2. C. Given-Wilson, ed., *Chronicles of the Revolution, 1397–1400*, Manchester, 1993, p. 94. For the saints in the Diptych, see *Making and Meaning*, pp. 53–57.

3. H. R. Luard, ed., *Lives of Edward the Confessor*, Rolls Series, London, 1858, pp. 179, 198, 204, 25, 43–44, 50.

4. Harvey, 'Wilton Diptych', pp. 27–28. For further discussion see N. E. Saul, *Richard II*, New Haven and London, 1997, pp. 312, 387-88.

5. *Rotuli Parliamentorum*, Vol. III, pp. 124–5; *CPR 1385–89*, p. 430. For a discussion of the measures against heresy, see H. G. Richardson, 'Heresy and the Lay Power under Richard II', *English Historical Review*, LI, 1936, pp. 1–26.

6. *Annales Ricardi Secundi* in *Chronica et Annales*, ed. H. T. Riley, Rolls Series, London, 1866, p. 183. In July, Stury was ordered to appear before Richard at Eltham on 15 August to answer 'certain matters objected to him' (PRO, E 403/551, 19 July). Presumably these 'certain matters' related to his Lollardy.

7. Richardson (cited in note 5 above), p. 18.

8. *CCR 1396–99*, p. 37. The possibility of further royal measures is suggested by an order to the Bishop of Chichester in October 1397 to arrest all Lollards and other heretics in his diocese and to detain them in prison until the King gave further instructions for their punishment (ibid., p. 158).

9. Given-Wilson (cited in note 2 above), p. 211.

10. Cambridge, Trinity Hall, MS 17, published as *Rogeri Dymmok liber contra XII errores et hereses Lollardorum*, ed. H. S. Cronin, London, 1922.

11. Royal Commission on the Historical Monuments of England, *An Inventory of the Historical Monuments in London. Vol. I, Westminster Abbey*, London, 1924, p. 31.

12. *Rotuli Parliamentorum*, Vol. III, p. 150.

13. The formality of the Black Prince's court can be sensed from the Anonimalle writer's description of the way in which he received members of the Aquitanian nobility: the writer says that he kept them waiting for days on end and then only suffered them to approach him on bended knees, V. H. Galbraith, ed., *The Anonimalle Chronicle 1333 to 1381*, Manchester, 1927, pp. 55–56.

14. E. Curtis, *Richard II in Ireland, 1394–95, and Submissions of the Irish Chiefs*, Oxford, 1927, pp. 61, 153.

15. *Rotuli Parliamentorum*, Vol. III, p. 329.

16. Ibid., p. 347.

17. For Giles's views, see J. Dunbabin, 'Government' in *The Cambridge History of Medieval Political Thought c. 350–c. 1450*, ed. J. H. Burns, Cambridge, 1988, pp. 483–85; and R. H. Jones, *The Royal Policy of Richard II: Absolutism in the Later Middle Ages*, Oxford, 1968, pp. 156–57.

18. J.-P. Genet, ed., *Four English Political Tracts of the Later Middle Ages*, Camden Society, 4th Series, XVIII, London, 1977, pp. 35–36.

19. A. R. Myers, ed., *English Historical Documents. IV: 1327–1485*, London, 1969, pp. 174–75.

20. See pp. 27-28.

21. Given-Wilson (cited in note 2 above), p. 68.

22. Galbraith (cited in note 13 above), p. 108; T. Wright, ed., *Political Poems and Songs*, Rolls Series, 2 vols., London, 1859–61, I, pp. 282–300. For discussion of these ceremonies, see G. Kipling, 'Richard II's "Sumptuous Pageants" and the Idea of the Civic Triumph' in *Pageantry in the Shakespearean Theatre*, ed. D. M. Bergeron, Athens, Ga., 1986, pp. 83–103.

23. M. D. Legge, ed., *Anglo-Norman Letters and Petitions*, Anglo-Norman Text Society, III, Oxford, 1941, no. 24.

24. Ibid., nos. 198, 207.

25. *Rotuli Parliamentorum*, Vol. III, p. 290.

26. For a discussion of these matters, see N. Saul, 'Richard II and the Vocabulary of Kingship', *English Historical Review*, CX, 1995, pp. 854–77.

27. For Richard's creation of an affinity, see Given-Wilson, *Royal Household*, Chapter IV.

28. C. Given-Wilson, 'Richard II, Edward II, and the Lancastrian Inheritance', *English Historical Review*, CIX, 1994, pp. 553–71.

29. C. M. Barron, 'The Deposition of Richard II' in *Politics and Crisis in Fourteenth-Century England*, eds. J. Taylor and W. Childs, Gloucester, 1990, pp. 132–49.

30. E. G. Kimball, ed., *Oxfordshire Sessions of the Peace in the Reign of Richard II*, Oxfordshire Record Society, LIII, 1983, pp. 82–86.

31. J. A. Tuck, 'Richard II and the Border Magnates', *Northern History*, III, 1968, pp. 48–49.

II. THE REMODELLING OF WESTMINSTER HALL

I should like to record my thanks to Malcolm Hay and Alexandra Wedgwood, both of whom gave invaluable practical assistance at Westminster Hall, to Emily Lane, who volunteered to read the text and suggested a number of expository and stylistic improvements, and to Dr Paul Brand, who put me straight on a number of points of legal history. The other scholarly debts I have incurred are acknowledged in the following notes.

1. The scholarly historiography of Westminster Hall begins with the commentary of Edward James Willson in A. Pugin, *Specimens of Gothic Architecture*, 2 vols., London, 1821–23, I, pp. 20–1. The main recent publications on the roof are the following: J. Heyman, 'Westminster Hall Roof', *Proceedings of the Institute of Civil Engineers*, XXXVII, 1967, pp. 137–62; L. Courtenay, 'The Westminster Hall Roof and its 14th-Century Sources', *Journal of the Society of Architectural Historians*, XLIII, 1984, pp. 295–309; L. T. Courtenay and R. Mark, 'The Westminster Hall Roof: A Historiographic and Structural Study', *Journal of the Society of Architectural Historians*, XLVI, 1987, pp. 374–93; and L. T. Courtenay, 'The Westminster Hall Roof: A New Archaeological Source', *Journal of the British Archaeological Association*, CXLIII, 1990, pp. 95–111. An authoritative documentary history of the building and rebuilding of the Hall is in Colvin, *King's Works*, Vol. I, pp. 45–7, 527–33. The masonry architecture of the Hall is discussed briefly in several publications by John Harvey, including *Henry Yevele*, London, 1944, pp. 47–9 and *passim*, and *The Perpendicular Style 1330–1485*, London, 1978, p. 130 and *passim*.

2. Accolades of the roof, and the Hall generally, include the following: 'Sub hiis diebus [i.e. 1397] *Rex fecit reparari, sumptibus excessiuis, magnam aulam Westmonasterii tam in parietibus, fenestris, quam in tecturis et celaturis, mirabilis operis'*, *Historia Vitae et Regni Ricardi Secundi* [c. 1402–13], ed. G. W. Stow, Philadelphia, 1977, p. 137; '...of great length, breadth, largenes and right crafty buyldyng', *The Receyt of the Ladie Kateryne* [c. 1501], ed. G. Kipling, Early English Text Society, Original Series, CCXVI, 1990, p. 55; '...the roof delights the scientific spectator by the intricate and skilful arrangement of its timbers, in which lightness, strength, and ornament are combined in the happiest manner', E. J. Willson (cited in note 1 above), Vol. I, p. 21; '...aussi n'avons-nous [Français] rien, à cette époque, qui puisse être comparé à la grand'salle de l'abbaye [sic] de Westminster comme luxe de construction', E. E. Viollet-le-Duc, *Dictionnaire raisonné de l'architecture française du XI^e au XVI^e siècles*, 10 vols., Paris 1854–68, III, p. 43; and 'probably the finest timber-roofed building in Europe', Royal Commission on the Historical Monuments of England, *An Inventory of the Historical Monuments in London. Vol. II, West London excluding Westminster Abbey*, London, 1925, p. 121.

3. The law courts were transferred to new premises in the Strand in 1883. The last feast held here was that following George IV's Coronation in 1820.

4. The Lesser Hall was slightly less than half as long and wide as Westminster Hall. It was rebuilt or remodelled in the 12th century (Colvin, *King's Works*, Vol. I, pp. 492–3) but, given the Confessor's Norman sympathies and architectural preferences, there seems no reason to doubt that the layout of the core buildings of the Palace in the post-Conquest period maintained continuity with that of the mid 11th century.

5. The suggestion made recently that the outer court to the north of Westminster Hall—now known as New Palace Yard—did not exist before the construction of the main gate in 1287–88 (V. Horsman and B. Davison, 'The New Palace Yard and its Fountains: Excavations in the Palace of Westminster, 1972–74', *Antiquaries Journal*, LXIX, 1989, pp. 279–97 at pp. 279–83) is inherently implausible and is effectively ruled out by the finding of the remains of late 12th- or early 13th-century marble fountain basins reused in the foundations of the 15th-century conduit shown in Wenceslaus Hollar's

1647 view of the court (*ill. 23*). The late dating of the court is doubtless influenced by the suggestion of Sydney Smirke that William II's Hall was entered not from the court but in the usual manner through lateral doors and a screens passage, 'Remarks on the Architectural History of Westminster Hall', *Archaeologia*, XXVI, 1836, pp. 406–21 at p. 410. Smirke's interpretation, which finds an echo in Colvin, *King's Works*, Vol. I, p. 46, is not convincing. The placing of the Hall relative to London, the existence of a highly decorated, unencumbered north front and the fact that the Lesser Hall at Westminster was also entered through its north end wall all argue that the present approach is the same as in the late 11th century. The hall built by Henry I in the Castle of Caen, which is clearly a reduced version of Westminster Hall (J. Mesqui, *Châteaux et enceintes de la France médiévale. De la Défence à la résidence*, 2 vols., Paris, 1991–93, II, pp. 81–2), resembles its prototype in being entered through an end wall whose portal is notably narrow in relation to the wall itself (ibid., figs. 90, 224).

6. Colvin, *King's Works*, Vol. I, p. 45.

7. Westminster Hall was magnificently inaugurated in 1099 at Pentecost, a feast often held at Westminster under the Norman kings. The Elizabethan historian John Stow claims that Richard II celebrated the completion of the Hall with a specially sumptuous series of feasts at Christmas in 1398, *Survey of London* (Everyman edition), London, 1956, pp. 414–15. However, Stow has misread his source, which makes clear that in 1398 Christmas was held at Lichfield, in the bishop's Palace, see *Historia Vitae et Regni Ricardi Secundi* (cited in note 2 above), p. 151. The north front of Westminster Hall was far from complete at the end of 1398, Colvin, *King's Works*, Vol. I, p. 532. The last part of the Hall to be built was the battlemented parapet on the east side, installed in 1405, L. F. Salzman, *Building in England down to 1540. A Documentary History*, Oxford, 1967, p. 91.

8. For the chrism-anointed ruler as image of Christ (or God), see E. H. Kantorowitz, *The King's Two Bodies. A Study in Medieval Political Theology*, Princeton, 1957, pp. 38, 48, 59. William the Conqueror's jester misjudged his contribution to a crown-wearing feast when he mocked the Divine nature of the king's office, D. C. Douglas, *William the Conqueror. The Norman Impact upon England*, London, 1964, p. 258.

9. In *Prospice* the hall also equates to the court and, like the latter term, is an instance of biblically-inspired architectural imagery symbolizing the elevated character of an individual or institution. My translation of the text's '*palatium*' as 'hall' rather than 'palace' accords with widespread medieval usage, although of course '*aula*' was the more commonly used term. The variant '*pallatium*' is applied to both halls of Westminster Palace, as well as to the Palace as a whole, in the *Chronicon Maiorum et Vicecomitum Londoniarum* in *Liber de Antiquis Legibus*, ed. T. Stapleton, Camden Society, XXXIV, London, 1846, pp. 172–3. The text of *Prospice* in the *Liber Regalis* (London, Westminster Abbey, MS 38), a manuscript almost certainly made for Richard II (see Binski, pp. 233 ff.), is printed in Legg, *Coronation Records*, p. 92. In stating that *Prospice* was used at English coronations from William I's onwards, I follow J. L. Nelson, 'The Rites of the Conqueror', *Proceedings of the Battle Conference on Anglo-Norman Studies*, IV (for 1981), Woodbridge, 1982, pp. 117–32, 210–21 at pp. 130–2; id., 'Kingship and Empire' in *The Cambridge History of Medieval Political Thought c. 350–c. 1450*, ed. J. H. Burns, Cambridge, 1988, pp. 211–51 at pp. 217–9.

10. Important evidence of this trait is the probability that he was the last English monarch to use the ancient liturgical chants which acclaimed the Christ-like majesty of the ruler on his arrival in church, E. H. Kantorowitz, *Laudes Regiae. A Study in Liturgical Acclamation and Medieval Ruler Worship*, Berkeley and Los Angeles, 1946, p. 181.

11. The earliest evidence that an English king dined in his chamber appears to be the reference to a new 'oriel' built between 1307 and 1311 next to the Lesser Hall and the Painted Chamber in Westminster Palace. The purpose of this addition was to enable Edward II to be served meals in either room, Colvin, *King's Works*, Vol. II, p. 1042. A valuable discussion of the dining function of the chamber is in M. Girouard, *Life in the English Country House. A Social and Architectural History*, New Haven and London, 1978, pp. 40–54.

12. The only reference to the fire in the hall of Westminster Palace (probably meaning Westminster Hall but possibly the Lesser Hall) which I have encountered occurs in a description of an event of 1412 in *The First Life of King Henry the Fifth*, ed. C. L. Kingsford, Oxford, 1911, p. 12. Although written in 1513, the ac-

count was 'based on contemporary reporting', C. Allmand, *Henry V*, London, 1992, p. 57.

13. Richard II's Coronation appears to be the first for which there is evidence of a procession through the City (see note 14 below), but Edward I had made a formal pre-coronation entry, probably via London Bridge (see note 28 below).

14. *Processus factus ad Coronationem Domini Regis Angliae Ricardi Secundi post Conquaestum, anno regni sui primo* in *Munimenta Gildhallae Londoniensis*, ed. H. T. Riley, Rolls Series, XII, 3 vols., London, 1859–62, II, pp. 456–82 at p. 476. The *Processus* mentions only that the king called for wine, but it can be assumed that he was ordering '*vin et espices*', otherwise known in late medieval England as a 'void'. The writer of the *Processus* was probably a London citizen, and it is not improbable that he failed to recognize this courtly usage. A 13th-century marble trestle from the table on the dais is preserved in the Jewel Tower of Westminster Palace. Stone trestles for the dais table were being made and painted in readiness for Henry IV's Coronation on 13 October 1399, PRO, E 101/473/11 (particulars of Account of the Clerk of the Works of the Great Hall in Westminster Palace for Michaelmas 1398 – 31 October 1399). To be identified as dismountable wooden furniture used in the body of the Hall during feasts are the three long tables with trestles, the two tables called '*dormants*' and the four large benches for the latter, all of which were designated as being for 'the Great Hall'. When not needed, they were evidently stored at the Great Wardrobe near Blackfriars, PRO, E 101/402/12 and PRO, E 101/403/5 (Accounts of the Keeper of the Great Wardrobe, Michaelmas 1392 – Michaelmas 1394 and Michaelmas 1394 – Michaelmas 1397). The '*dormants*' recall that which the most famous Clerk of the King's Works pictured in the Prologue to *The Canterbury Tales* as standing ready covered all day long in the hall of an Epicurean franklin, W. W. Skeat, ed., *The Complete Works of Geoffrey Chaucer*, 7 vols., Oxford, 1894, IV, p. 11, lines 353–4.

15. Edward II was installed in the throne in the Lesser Hall, E. W. Brayley and J. Britton, *The History of the Ancient Palace and Late Houses of Parliament at Westminster*, London, 1836, p. 105. There appears to be no evidence which throne was used for Edward III's installation, but from 1377 Westminster Hall was certainly the setting for this ceremony. It is impossible to concur with the suggestion in Colvin, *King's Works*, Vol. I, p. 545, that a stone bench ran along the full length of the south wall as the latter was pierced by at least one door and probably by two. There seems no reason to doubt that the king's seat was a throne of normal type with a high back and armrests.

16. For this chair, see P. Binski, *Westminster Abbey and the Plantagenets. Kingship and the Representation of Power 1200–1400*, New Haven and London, 1995, pp. 135–9.

17. Colvin, *King's Works*, Vol. I, p. 545, where it is suggested, on grounds not stated, that the throne is unlikely to have been the same as the marble throne in Richard's Hall. The increase in the importance of Westminster under Henry III is discussed in Binski (cited in note 16 above), *passim*.

18. *Westminster Chronicle*, p. 110. The particulars of Account of the Clerk of the King's Works for 1 October 1384 – 5 January 1388 (PRO, E 101/473/2) show payments to carpenters for the lists and for galleries for the King and nobles.

19. In the repairs to the Hall carried out after the burning of Westminster Palace in 1834, the physical make-up of the successive floors was observed before they were dug out. Noted then were the remains of a Purbeck marble pavement taken to be Richard II's because they were overlain by the doors in his work, Smirke (cited in note 5 above), pp. 415–6. Possibly the parts of the floor under the doors were installed during the building process and the rest was never laid. 16th-century references to earthen floors are found in London, British Library, MS Egerton 2358, f. 41v (particulars of Account of the Clerk of the King's Works for Easter 1500 – Easter 1502) and Colvin, *King's Works*, Vol. IV, p. 296. However, at the tournament held on the eve of the King's birthday on 5 January 1378 three knights rode with him in the Great Hall of Windsor Castle (whose floor was either tiled or flagged), Livery Roll, PRO, E 101/404/4, mm. 3 and 4, a reference I owe to Lisa Monnas (see Staniland, p. 90 and note 16; and Monnas, p. 167 and note 13).

20. *Processus* (cited in note 14 above), p. 480.

21. The main hall of the City of London Guildhall also housed more than one court.

22. Colvin, *King's Works*, Vol. I, pp. 544–5.

23. Evidence of the siting of Chancery in the first half of the 14th century is given in B. Wilkinson, *The Chancery under Edward III*, Manchester, 1929, p. 96. Chancery's move towards being a court of equity during Richard II's reign must have been influenced to some extent by its long-standing proximity to the two older tribunals within Westminster Hall.

24. It would appear that hierarchic symbolism has been invoked by legal historians only in order to account for the proximity of the Courts of King's Bench and Chancery to the royal throne and for the occasional use of the throne by the Chief Justice of the King's Bench. The Court of Common Pleas originated as an outgrowth from the Exchequer, which, from the mid 13th century, was housed in a first-floor room entered from the Hall through a door near the north end of its west wall (see plan on p. 35). It is possible that the physical proximity of Common Bench and Exchequer was due in some measure to their institutional connectedness, as is proposed in I. Cooper, 'Westminster Hall', *Journal of the British Archaeological Association*, 3rd Series, I, 1937, pp. 168–228 at pp. 195–6. If this is correct, and if the two institutions had been near neighbours in the late 12th century, when the Exchequer was on the opposite side of the Hall, it becomes possible that the move of the Exchequer in the mid 13th century was made at least partly in order that the Common Bench cease to be a physical and visual obstacle between the main entrance and the Court of King's Bench. The relation between the Hall and the Exchequer and Receipt can be seen as the germ of the present-day role of the Hall as a vestibule to the Houses of Parliament and the Committee Rooms.

25. Ibid., pp. 543–4. The ceiling built over the Court of Chancery late in Henry VI's reign (PRO, E 364/97 rot. C dorse, Enrolled Account of the Clerk of the King's Works for 19 May 1456 – 4 March 1461) was presumably a canopy over the president's seat. For the galleries of the Court of Common Pleas, see J. H. Baker, 'The Pecunes' in id., *The Legal Profession and the Common Law. Historical Essays*, London and Ronceverte, 1986, pp. 171–5. I owe this reference to Dr Paul Brand. An anonymous early 17th-century drawing in the Department of Prints and Drawings of the British Museum showing the Courts of Kings Bench and Chancery overlooked by makeshift-looking galleries is reproduced in Baker (at p. 152) and

in H. M. Colvin, 'Views of the Old Palace of Westminster', *Architectural History*, IX, 1966, pp. 23–184, fig. 44 at p. 89.

26. The presence of merchants in Westminster Hall as early as the 1290s is evident from the record of a suit brought in 1303 by one Alice of Oxford, who claimed to have attended the Court of Common Pleas with her merchandise for a long time, PRO, CP 40/145, m. 90 (Court of Common Pleas, Plea Rolls), another reference I owe to Paul Brand. All the royal law courts had been in the hall of York Castle since 1298, but Alice's claim of long-standing attendance implies clearly that she had been at Westminster Hall before the transfer. For the rents charged in 1339–40 and 1349–50 (8d. a year for a stallholder, 4d. for peripatetic merchants), see 'Minutes from the Inquisitions Post Mortem Relating to Middlesex (MS. Harl. No. 708)' in *The Topographer and Genealogist*, ed. J. G. Nichols, 1846, Vol. I, pp. 330–2, 520–3. By the 1460s the rents had increased greatly (2s. to 3s. 4d. a term for stalls and 4d. to 12d. for peripatetic merchants), 'J. B.', 'The Shops in Westminster Hall', *Gentleman's Magazine*, New Series, XL, July-September 1853, pp. 602–4. In 1402 a London goldsmith received royal licence to travel to any part of the kingdom to sell his wares, with the proviso that if he entered Westminster Palace for this purpose he would pay a sum to be agreed with the Keeper of the Palace, *CPR 1401–05*, p. 35. For the traders in the abbey precinct and town, see G. Rosser, *Medieval Westminster 1200–1540*, Oxford, 1989, pp. 155–6, 161–5 and *passim*.

27. Westminster Hall was not the only large interior space in the medieval metropolis to be used in this way, but at St Paul's Cathedral the incursions of hawkers into the nave were never accepted by the authorities, much less exploited, *Registrum Statutorum et Consuetudinum Ecclesiae Cathedralis Sancti Pauli Londoniensis*, ed. W. S. Simpson, London, 1873, pp. 79, 391–2. The protagonist of the anonymous early 15th-century poem *London Lickpenny*, a poor Kentishman seeking justice in the royal courts, had cause to rue the density of the throng within Westminster Hall, which enabled a thief to snatch his hood, *A Selection from the Minor Poems of Dan John Lydgate*, ed. J. O. Halliwell, London, 1840, pp. 103–7. For robberies and violence in the Hall, see G. O. Sayles, *Select Cases in the Court of King's Bench*, 7 vols., Selden Society, LV, LVII, LVIII, LXXIV, LXXVI, LXXXII,

LXXXVIII, London, 1936–71, III, pp. lxxxi, cxxvii–cxxviii; IV, p. lxxiii n. 3; VII, pp. 88–9; H. G. Richardson, 'Year Books and Plea Rolls as Sources of Historical Information', *Transactions of the Royal Historical Society*, 4th Series, V, 1922, pp. 28–62 at pp. 40–2.

28. The varied functions of halls are discussed in M. Thompson, *The Medieval Hall. The Basis of Secular Domestic Life 600–1600 A.D.*, Aldershot, 1995, *passim*, a work published after the present essay had been written. In 1274 the stalls in West Chepe were torn down on the mayor's orders in preparation for Edward I's entry into the City the day before his Coronation (G. A. Williams, *Medieval London. From Commune to Capital*, London, 1963, p. 246), an event which occasioned elaborate decorations (their form unfortunately unknown) and the substitution of red and white wine for water in the public conduit in West Chepe, *Annales Monastici*, ed. H. R. Luard, Rolls Series, XXXVI, 5 vols., London, 1864–69, IV, p. 259; *Chronique de London depuis l'an 44 Henry III jusqu'à l'an 17 Edward III*, ed. G. J. Aungier, Camden Society, XXVIII, London, 1844, p. 13.

29. The authoritative work is J. Guerout, 'Le Palais de la Cité à Paris dès origines à 1417', *Mémoires de la fédération des sociétés historiques et archéologiques de Paris et de l'Île-de-France*, I, 1949, pp. 57–212; II, 1950, pp. 21–204; III, 1951, pp. 7–101. Merchants had been in the gallery since the reign of Philip IV (1285–1314) if not earlier (ibid., II, pp. 90–1).

30. This point applies *a fortiori* to Parliament, regarded from the mid 1380s to the late 15th century as the highest court.

31. On the Westminster kings, see Lindley in this volume (pp. 61–84) and Colvin, *King's Works*, Vol. I, p. 528. The total of thirteen excludes Harold, believed from the 13th century to have crowned himself.

32. The account of the documentation for the making of the kings in Colvin, *King's Works*, Vol. I, p. 528 may be supplemented by references in Devon, *Issues*, pp. 227, 230 and Salzman (cited in note 7 above), p. 130. The two Privy Seal writs of 1388 referred to in connection with this work in the Clerk of the King's Works' particulars of Account cited in note 18 above, as well as his Enrolled Account for the same period (PRO, E 364/22 rot. C), were issued after the period covered by the account and were clearly in the nature of retrospective authorizations. I am grateful to Dr Nigel Saul for endorsing this interpretation. The receipts section of the particulars includes three payments made in 1385 for the statues within the Hall and also for two on its north front, and 100s. received on 15 May 1385 for painting the kings inside the Hall, see Devon (p. 230). See also note 60 below. The first entry in the particulars relating to the kings (clearly that, even though the iconography is not specified) concerns money received 11 February 1385 'in connection with the making of divers images ordained for the great hall in accordance with the king's will' (see Devon, p. 227), a formulation reflecting the political realities of 1385. By contrast, the entry in the task-work section near the end of this *rotulus*, in which the thirteen statues of kings are said to have been ordered by the King and council, was compiled under the Appellants' regime and after 5 January 1388, when Arnald Brocas, Clerk of the King's Works from 1381, was sacked. For the seven kings out of the thirteen-king series ordered in 1385, which were not installed immediately, see p. 52 of this paper and note 77 below.

33. The spires of the niche canopies were probably cut away to make room for a cornice when the Courts of King's Bench and Chancery were enclosed in the mid 18th century. There is no reason to think that the existing niches do not reproduce the original design. They are similar to but simpler than those of the high altar reredos in Durham Cathedral (Neville screen), *c*. 1372–80, a London-made work generally attributed to Yevele. There are no references to the dismounting and storage of the niches in the surviving accounts for the remodelling of the Hall in the 1390s.

34. A single blocked Romanesque window is shown to the west of the 14th-century south window in Brayley and Britton (cited in note 15 above), pl. X. The placing of the blocked window suggests that there were five openings in the south wall and hence a total of six piers, four between the openings and two in the corners. Clearly, if the Romanesque piers had low openings like those in the analogous parts of the lateral walls, these would have been blocked by any statues and niches inserted into them.

35. *Eulogium Historiarum*, ed. F. S. Haydon, Rolls Series, IX, 3 vols., London, 1856–63, III, p. 384; *Historia Vitae et Regni Ricardi Secundi* (cited in note 2 above), p. 110; *Chronicon Henrici*

Knighton, ed. J. R. Lumby, Rolls Series, XCII, 2 vols., London, 1889–95, II, p. 248; *Westminster Chronicle*, p. 212.

36. As witness the entry in the second Westminster Palace section (m. 19) of the particulars of Account cited in note 18 above: '*Et in vadiis unius carpentarii operanti super factura cuiusdam sedis pro sessione Regis in magna aula tempore quo Dux Gloucestrie et alii magnati venerunt ad ipsum Regem tractandum de pace*'. The reference to the purpose of the meeting is positive to the point of mendacity—Gloucester and the other Appellants had raised an army against the King— but the compiler of the Account was a Clerk of the King's Works who owed his appointment to the Appellants' regime, which had sacked his predecessor, see note 32 above. Presumably the wooden seat supplemented the marble chair, like that made for Anne Boleyn's Coronation in 1533 (Colvin, *King's Works*, Vol. IV, p. 528). The King's use of the traditional seat of justice will have assumed a minatory significance relative to the Appellants, A. Goodman, *The Loyal Conspiracy. The Lords Appellant under Richard II*, London, 1971, pp. 26–7.

37. *Historia Vitae et Regni Ricardi Secundi* (cited in note 2 above), p. 138. The building of the north front was a distinct phase of the work, begun only after the holding of Queen Isabelle's coronation feast in January 1397, and the desire to avoid delaying its completion was no doubt a factor in the decision to hold the specially solemn Parliament of September in the temporary building. Nevertheless, the Court of King's Bench was back in the Hall by Hilary Term 1397 if not before, Sayles (cited in note 27 above), Vol. VII, pp. 82–9.

38. Given-Wilson, *Royal Household*, pp. 81–3, 278. It is suggestive that the rebuilding began around the time that Richard began to insist on increased use of more lofty titles comparable to those used regularly by the kings of France, N. Saul, 'Richard II and the Vocabulary of Kingship', *English Historical Review*, CX, 1995, pp. 854–77.

39. Apart from Westminster Hall, Richard II's main building works at his houses and castles were not particularly numerous or costly. At Sheen Manor he built a timber-framed retreat on the island in the Thames called 'la Nayght'. In progress *c.* 1384–88, this poorly documented house was pulled down in 1394, along with the rest of the Manor—an act of destruction fa-

mous as a manifestation of Richard's grief at the death there of Queen Anne of Bohemia. At the largely timber-framed Old Manor in Windsor Park major remodelling and refurbishment were carried out in 1394–97, probably with the aim of making this the successor to Sheen. The cost was around £1,400, including £289 16s. 6d. paid by contract to Thomas Prince for painting five chambers for the King, a chapel 70 feet (21.3m) long, and two oratories, presumably with specially costly materials. The money to pay Prince came from the late queen's estate. At Portchester Castle a new hall, royal lodgings and service buildings were built from 1396 at a cost of over £1,700 (Colvin, *King's Works*, Vol. II, p. 790), and at Westminster Palace the main gate connecting King Street and the outer court (*ill. 23*) was begun in 1397 but was incomplete by the time of Richard's deposition. The cost of the gate cannot be separated from the expenditure on the Hall and other works accounted for by the Clerk of the Works of Westminster Hall. The cost of the Hall itself has been estimated as £8,000–£10,000, Colvin, *King's Works*, Vol. I, p. 533. The cylindrical keep and barbican of Southampton Castle, built 1378–88 at a cost of £1,991, were clearly not undertaken on Richard II's personal initiative.

40. A telling indication of the status of Westminster Hall in the eyes of a mid 13th-century writer and artist familiar with the royal court is the fact that its roof is shown leaded in the 'model' held by William II in the series of seated kings drawn by Matthew Paris as a 'frontispiece' to his *Historia Anglorum* (London, British Library, MS Royal 14 C VII, f. 8v). As recently as 1385, 10,250 shingles were placed on Westminster Hall, particulars of Account cited in note 18 above. Shingles were not, however, a low-status material, for they cost considerably more than tiles and in the 14th century they were still being used to cover at least two other major metropolitan buildings—the Exchequer adjoining Westminster Hall and the detached belfry of St Paul's Cathedral The roofs of lesser structures within Westminster Palace were still shingled in the late 15th century, but those of the core buildings of the Privy Palace were leaded from the 13th century onwards.

41. The reconstruction of the north and south interior elevations of the 11th-century Hall in Royal Commission on the Historical Monuments of England (cited in note 2 above), p. 122

supersedes earlier essays. A possible influence on the design of the Hall was the aisleless late 11th-century nave of York Minster, which had an unusually wide span (45 feet; 13.7m), a high plain dado, and, almost certainly, a clerestory incorporating a wall passage.

42. The oldest extant English example is the ruinous refectory of Westminster Abbey where, however, there is wall arcading on the dado.

43. This court was called the 'outer little ward' in 1396 (*CPR 1391–96*, p. 741) and '*bassa curia*' in 1501 (particulars of Account cited in note 19 above, ff. 26v, 34v).

44. The most useful account of the distinction between the Great Palace and the Privy Palace is in Colvin, *King's Works*, Vol. I, pp. 534–7, but the boundary between them is shown too far north in boxed plan III (see plan on p. 35).

45. The best preserved late 11th-century example is Scotland's hall in Richmond Castle, North Yorkshire. Westminster Hall did not resemble the latter in being a first-floor hall; the reference to steps in an evocation of the 1099 inaugural feast, written *c.* 1140, may be poetic licence or may refer to the dais, *L'Estoire des Engleis by Geffrei Gaimar*, ed. A. Bell, Anglo-Norman Text Society, XIV–XVI, Oxford, 1960, pp. 189–90, lines 5969–6048.

46. The assumption that the original roof of Westminster Hall must have been borne on two ranges of supports, because no roof of that period could have spanned 69 feet unsupported, was apparently first made by E. J. Willson (cited in note 1 above), Vol. I, p. 20, and has been concurred with by virtually all subsequent writers. There are three main pieces of internal evidence favouring the theory that the 11th-century roof was of a single span. First, the fact that a division of the interior into a wide central vessel and narrow side aisles—the usual arrangement in English aisled great halls—is difficult to reconcile with the known features of the Romanesque front: a narrow central entrance and two very wide flanking recesses (for which see S. Smirke, 'A Further Account of the Original Architecture of Westminster Hall', *Archaeologia*, XXVII, 1838, pp. 135–9 at p. 138). Second, the observation that when the floor was excavated to natural ground level in 1835 no traces of footings for internal supports were found (Smirke, cited in note 5 above, p. 416), an observation which, if correct, effectively rules out masonry arcades.

Third, the lack of documentary references to internal supports in the records of the law courts or in the Enrolled Account of the Clerk of the King's Works for Easter 1396 – Michaelmas 1397 (PRO, E 364/31 rot. F), which includes several entries relating to timber salvaged from the old roof but no mention of timber from internal supports. Such supports, had they ever existed, would have been more substantial than, and almost as long as, any tie-beams in the 11th-century roof. Comparative evidence favouring a single-span reconstruction is as follows: the probability that there was a roof with a span of 60 feet (18.3m) over the hall in the other notably overscaled royal building of the late 11th century, the keep of Colchester Castle (*pace* virtually all writers on the subject, who have assumed that the hall had an eastern aisle); the existence throughout the Middle Ages of tie-beam roofs of much wider span than Westminster Hall in some of the major churches of Rome (admittedly using softwood rather than oak); the existence in the Castle of Caen of a smaller unaisled hall clearly modelled on Westminster (for which see also note 5 above); the lack of parallels in English aisled halls of the 11th to 13th centuries for Westminster's high lateral walls; and the existence of parallels for the latter in a functionally closely related building type, the monastic refectory, which in 11th-century England was invariably unaisled. A single-span roof over Westminster Hall could have been achieved by means of collars or tie-beams formed of more than one piece of oak. The capacity of late 11th-century carpenters to conceive and construct a single-span roof over 21m wide is as likely to have been brought about by pressure from the Hall's exceptionally ambitious patron as by advances in building technique. For the use of dimensions derived from the Early Christian basilicas of Rome in major Anglo-Norman churches contemporary with Westminster Hall, see E. Fernie, *An Architectural History of Norwich Cathedral*, Oxford, 1993, pp. 135–8.

47. Obviously the sample of late 11th-century stone-built halls is so small that to speak of norms is somewhat artificial. Nevertheless, the following must give some sense of the range: Richmond Castle, 28 feet (8.4m); Chepstow Castle, 30 feet (9.1m); Tower of London, 40 feet (12.2m). Colchester Castle's 60 feet (18.3m), like all its major dimensions, is exceptional. Dimensions of 12th- to early 16th-century halls are listed in M. Wood, *The English Mediaeval House*,

London, 1965, pp. 45–6, 62–6. The next widest unaisled 14th-century hall after Westminster, not listed by Wood, appears to have been the London Guildhall of *c.* 1300, whose partly preserved crypt indicates a span of 49 feet (14.8m).

48. See note 34 above.

49. Evidence of wall passages at this level is reported in Smirke (cited in note 46 above), p. 136.

50. For example St Werburgh's Chester (Chester Cathedral) and Worcester Cathedral Priory.

51. Particulars of Account cited in note 18 above. The contraction mark used does not indicate either the singular or the plural.

52. In aisled halls, such as that of *c.* 1222–35 in Winchester Castle, the inclusion of arcades and the relatively small span of the central roof meant that the master mason's share of the work predominated.

53. For Herland's and Yevele's careers, see J. H. Harvey, *English Mediaeval Architects. A Biographical Dictionary down to 1550*, 2nd edn, Gloucester, 1984, pp. 137–41, 358–66.

54. The Accounts of the Duke of Lancaster's Receiver-General for Michaelmas 1376 – Michaelmas 1377 (PRO, DL 28/3/1) show £266 13s. 4d. (400 marks) spent on carpentry and masonry works at Kenilworth and £10 on boards '*pro celure nove aule*', A. Goodman, *John of Gaunt. The Exercise of Princely Power in Fourteenth-Century Europe*, London, 1992, p. 305, where the cost of the boards is incorrectly given as 'over £276'. This and other evidence adduced by Goodman for the dating of Kenilworth hall to *c.* 1374–77 is to be preferred to the usual dating to the late 1380s and early 1390s, which is based on documentary references that do not specifically mention this building. From 1373 William Wintringham (for whom see Harvey, cited in note 53 above, pp. 337–8) was master carpenter to the Duke of Lancaster and was presumably in charge at Kenilworth, but since the dimensions of the extant shell of the late 14th-century hall are effectively identical to those of the hall over which the London carpenter Richard of Felsted contracted in 1347 to build a roof for 250 marks (Salzman, cited in note 7 above, pp. 436–7), there must be a good chance that Wintringham's contribution to the hall was merely the reinstallation of Felsted's expensive and still-new roof.

55. No traces remain of hooks such as would have been needed to hang tapestry in Westminster Hall because all the internal masonry of the dado was renewed in the early 19th century. For the decoration of the Hall with Arras in 1501, see *Receyt of the Ladie Kateryne* (cited in note 2 above), p. 55. There is a tantalizing reference to remains of post-11th-century wall-paintings of some ambition in Smirke (cited in note 5 above), p. 409. An indenture for the release from the Great Wardrobe of numerous pieces of Arras, many woven with gold thread (PRO, E 101/403/19, no. 67), should probably be related to the readying of the hall in the Upper Ward of Windsor Castle (*ill. 14*) for the Garter Feast, held with particular splendour in 1399. The destination of the tapestries is given in the indenture merely as the King's hall. Edward III bequeathed to Richard II a 'large and noble' double set of hangings for his hall, perhaps meaning Westminster Hall, J. Nichols, ed., *A Collection of all the Wills now Known to be Extant of the Kings and Queens of England*, London, 1780, p. 60.

56. The 1327 hangings, which were '*tapetum*' and '*pannum de Candlewykstret*', are listed in the Counter Roll of John de Feriby, Controller of Thomas de Useflete, Clerk of the Great Wardrobe, for expenses incurred at the time of Edward III's Coronation (PRO, E 101/383/6); see the references to a dorser and four costers '*de opere tapicer*' ' for use during visits of the royal family to Eltham, Sheen and Hadleigh and to a dorser and six costers of red worsted for the king's hall at Kennington, particulars of Account of the Keeper of the Great Wardrobe for 1371–73 and (?)1413–14 (PRO, E 101/397/3 and PRO, E 101/406/15) (see Monnas, note 44). The hanging of Westminster Hall with black cloth during Edward III's 'lying in state' in 1377 is noted in N. Saul, *Richard II*, New Haven and London, 1997, pp. 22-23, a work published after the present essay had been written.

57. The only later hall whose walls are consistently treated as tracery panelling is the early 15th-century City of London Guildhall where, exceptionally, feasts were not held and hence, presumably, no tapestries were hung. For the influence of Westminster Hall on late medieval English halls in general, see C. Wilson, 'The Original Design of the City of London Guildhall', *Journal of the British Archaeological Association*, CXXIX, 1976, pp. 1–14 at pp. 7–8.

58. This contract, which was made between the King and John Swallow and Richard Washbourne, is the only survivor of the many which must have been drawn up in relation to the task-works listed in the accounts. It is printed in Salzman (cited in note 7 above), p. 472. The words *'forme'* and *'molde'* clearly refer to one and the same thing, and since it was delivered by the warden of the masons, the intermediary in large projects between the architect and the executant masons, this will almost certainly have been a template to control the section of the cornice and perhaps even the depth of the carving. How Swallow and Washbourne were instructed regarding the spacing of the badges is not made clear in the contract.

59. This characteristic is best exemplified at Westminster Hall by the tracery of the great north and south windows and by the image niches of the north front (*ills. 22 and 24*).

60. The niches cost £28 to make; the Reigate stone used to make them, and the carriage of most of it, cost £7 17s. 10d.; a mason earning 6d. per day spent an unspecified amount of time scappling the stones in the quarry at Reigate; an unspecified proportion of 96 iron crampons, plus lead, and charcoal for melting the latter, was expended on fixing the niches into position; the workmanship and stone of each of the six kings cost £2 6s. 8d.; a box made for conveying these statues, together with two larger kings for the north front, cost 9s. 5d.; the painting (i.e. workmanship and materials) of the six kings cost £8 13s. 4d.; and unspecified sums were paid for scaffolding used to install and paint the kings, particulars of Account cited in note 18 above. The kings inside the Hall and on the north front were repainted in 1533, Colvin, *King's Works*, Vol. IV, p. 290.

61. The statues are clearly by more than one hand (see Lindley, p. 79). Since Canon was a marbler, a trade which often comprehended the making of monumental brasses, he may have been a considerable employer of figural artists as well as a dealer in wrought and unwrought Purbeck marble. In 1386 he took on an apprentice who was to learn stone cutting and carving, D. Knoop and G. P. Jones, *The Mediaeval Mason*, 3rd edn, Manchester, 1967, p. 148. The possibility cannot be excluded that Canon himself did some of the carving of the Westminster kings. On the comparatively few occasions when figural artists who were master craftsmen were employed by the King's Works

on a direct labour basis their pay was normally 1s. a day, the same rate as for a master mason. However, unlike most figural artists who were masters, master masons were able to work for several patrons simultaneously, being far less continuously involved in supervision and not at all involved in the physical process of manufacture. The fact that despite considerable inflation the normal pay-rate for royal master masons never rose from the shilling-a-day paid in Henry III's reign suggests that late medieval kings can have had no realistic expectation of exclusive rights to the services of their master masons.

62. R. Willis, *The Architectural History of Canterbury Cathedral*, London, 1845, pp. 115–6. The cost per square foot works out at about 8d., a rate appropriate to coloured figural glass, albeit not of the exceptionally highly wrought kind used in the west window of York Minster from 1339, which cost 12d. per square foot.

63. For this window and its replacement in the 19th century, see J. H. Harvey and D. G. King, 'Winchester College Stained Glass', *Archaeologia*, CIII, 1971, pp. 149–77.

64. Colvin, *King's Works*, Vol. I, pp. 207–27 *passim*, Vol. II, pp. 1050–2. Artificers were not members of the royal household in the fullest sense in that they were not expected to be continuously present and hence were not normally entitled to lodging and meals. Painters figure very intermittently in the records of the King's Works. They appear to have been attached to the household only while producing and maintaining the heraldic banners and other such trappings needed for a royal journey or military campaign. They were graded as valets (or yeomen) of the king's chamber, a somewhat more honorific rank than that of valet in the offices of the household. 'King's painters' in this sense are discussed in C. Given-Wilson, 'Artists at the English Court c. 1350–1400', a paper delivered to the conference *Merchants and Artists: England and Europe in the Fifteenth Century*, Royal Holloway and Bedford New College, University of London, September 1991. I am most grateful to Dr Given-Wilson for sending me a photocopy of this unpublished paper.

65. The John of Flanders alias John of St Albans who was named 'king's sculptor' when receiving livery of robes in 1251 and 1257 (Harvey, cited in note 53 above, p. 109) clearly belongs

to the same category of occasional appointments as the 'king's painters' mentioned in note 64 above.

66. It is possible that at Winchester, as at Westminster Hall, some at least of the large-scale figure sculpture was contracted for by sculptors who were not part of the waged workforce of masons headed by the master mason. Nevertheless, royal master masons and carpenters sometimes had authority to make contracts with artificers on the king's behalf, Colvin, *King's Works*, Vol. I, p. 186.

67. K. Morand, *Claus Sluter: Artist at the Court of Burgundy*, London, 1991, pp. 71, 81–2, 316–8, 360–3. The translation of '*moles*' as 'models' on p. 318 is incorrect; the reference is to templates. The clearest indications of Sluter's involvement in generating the architectural design of the Well of Moses at Champmol are the payments made in 1398–99 for a plaster tracing floor to enable him to draw out the base of the fountain at full size, ibid., pp. 338–9 and C. Monget, *La Chartreuse de Dijon d'après les documents des Archives de Bourgogne*, 3 vols., Montreuil-sur-Mer and Tournai, 1897–1905, I, pp. 298, 314.

68. Devon, *Issues*, p. 189 and G. M. Bark, 'A London Alabasterer in 1421', *Antiquaries Journal*, XXIX, 1949, pp. 89–91. Admittedly, the tomb by Broun—now destroyed—had fewer weepers than that by Liège, probably 12 as against 34, and the chances are that it was far less elaborately finished. Nevertheless, the disparity in cost remains striking.

69. The towers may be low and small in scale compared to, for example, those projected at Westminster Abbey, but in both respects they resemble the west towers of St Paul's Cathedral. Clearly the spaces created within the towers were in the nature of a bonus rather than the reason for their building. For the functions of the north-east tower rooms, see Cooper (cited in note 24 above), pp. 220–2 and Colvin, *King's Works*, Vol. I, p. 533 n. 6. All the stonework of the north front was replaced in 1819–20. The copies of the niche canopies made then are incorrectly stated to have been set higher than the originals in Colvin, *King's Works*, Vol. VI, p. 502. A change actually made in 1819–20, but apparently not previously noticed in print, is the omission of small image bases from the upper range of panels behind the canopies,

Colvin (cited in note 25 above), pp. 23–184, fig. 34 at p. 80.

70. The forward projection of the towers is primarily a consequence of their having been added to an existing structure. Although the motif is very rare, parallels with the west fronts of Holyrood Abbey in Edinburgh and the Cathedrals of Glasgow, Palermo, and Poitiers cannot be anything more than parallels.

71. *Annales Paulini* in *Chronicles of the Reigns of Edward I and Edward II*, ed. W. Stubbs, Rolls Series, LXXVI, 2 vols., London, 1882–83, I, pp. 255–370 at p. 338.

72. C. Wilson, 'The Origins of the Perpendicular Style and its Development to *c.* 1360', unpublished Ph.D. thesis, Courtauld Institute of Art, University of London, 1980, pp. 204–5, pl. 409.

73. Ibid., p. 226.

74. For an elevation of the destroyed south window of the Hall (a mirror image of the north window), see Pugin (cited in note 1 above), pl. XXXIV. For the Winchester College Chapel east window, see J. H. Harvey, 'Winchester College', *Journal of the British Archaeological Association*, 3rd Series, XXVIII, 1965, pp. 107–28 fig. at p. 112, pl. XXXVIII.

75. For the interchangeability of choir-screens and façade portals, see J. Bony, *French Gothic Architecture of the 12th and 13th Centuries*, Berkeley, 1983, pp. 383–4. Admittedly, the iconography of the 14 figures over the west door of Westminster Abbey is unknown, but French and English precedent, and the status of the Abbey as a royal foundation make it all but certain that they were kings. A likely 14-figure scheme would comprise the supposed founder of the Abbey, King Sebert, its refounder, St Edward, and the post-Conquest kings of England down to Richard II. The kings installed on the choir-screen of St Paul's in the early 17th century are generally assumed to have succeeded an earlier series of the same type. Choir-screens with sculptures of kings survive or are recorded at Canterbury, Durham (where there were also queens), Salisbury, Wells and York Cathedrals and Glastonbury Abbey; indeed there appears to be no evidence that the major niches of choir-screens in the greater English churches ever contained anything other than images of royal rulers.

76. Colvin, *King's Works*, Vol. I, p. 528 n. 4.

77. See p. 41 of this paper and note 78 below. The Enrolled Accounts of the Clerk of the King's Works for the period 23 May 1398 – 29 September 1402 (PRO, E 364/39, rott. A dorse – B dorse at B dorse) show the kings still in stock received and then in stock expended.

78. Payments to two masons for, *inter alia*, installing these statues, and a damaged entry recording payment to the painter Thomas Gloucester for painting four images of kings on either side of the entrance, occur in the task-work section of the particulars of Account of the Clerk of the Works of Westminster Hall, for 1 November 1399 – 26 July 1400, PRO, E 101/473/13.

79. Presumably the four statues of kings on either side of the entrance (see preceding note) were in the niches immediately adjacent to the entrance. For what it is worth, the niche immediately to the east of the entrance contained a statue in 1780; see also note 80 below.

80. William II did not marry. Possible confirmation that this was the scheme followed or intended to be followed under Henry IV is the presence of the arms of France ancient and England quartered below the niche next to the entrance on the east side. None of the other shields to the east of the entrance was ever carved, but since the carved shield occurred beneath the niche which would, on the hypothesis advanced above, have been occupied by the statue of the first bearer of those arms, Edward III, it would seem to have functioned as a kind of marker indicating that to the west all arms would have been the same, whereas to the east all arms—except those attributed to the Confessor—would have been the earlier arms of England, the three leopards.

81. Carter's drawings are reproduced in Colvin (cited in note 25 above), figs. 81–2. Since the physique and costume of Carter's third, fourth and fifth figures on the north face of the east tower are decidedly feminine, the arrangement of 1399–1400 postulated here must have been altered later. Difficult to reconcile with Carter's renderings is the statement of an eye-witness to the disclosure of the statues in 1780 that six were lifesize and two about 4 feet high, J. T. Smith, *Antiquities of Westminster*, London, 1807, pp. 267–8.

82. This task was given to the painter Thomas Gloucester, presumably because it was thought too delicate to be entrusted to the daubers who usually applied whitewash. The payment to Gloucester occurs in the task-work section of the particulars cited in note 78 above.

83. C. Given-Wilson, 'Richard II, Edward II, and the Lancastrian Inheritance', *English Historical Review*, CIX, 1994, pp. 553–71 at pp. 567–71. Clearly, Henry IV is unlikely to have countenanced the designation of one of the large kings as Edward II!

84. Colvin, *King's Works*, Vol. I, p. 533 and n. 1.

85. Flat-topped niches would have been appropriate, but the 13-king scheme appears to have been abandoned before any niches were made as there are no references to their making in the extant accounts. Perhaps the 13-king scheme was dropped because it would have had to be placed low enough on the south wall to risk being impinged upon by the fittings of the two courts on the dais.

86. An anecdote set in the hall of the abbot's lodging at Gloucester Abbey some time in the period 1317–27 centres on comments which the abbot made to Edward II regarding '*depictas figuras regum praedecessorum suorum*' there, *Historia et Cartularium Monasterii Sancti Petri Gloucestriae*, ed. W. H. Hart, Rolls Series, XXXIII, 2 vols., London, 1863–65, I, p. 44. Unfortunately, there is no indication of the placing of these figures but the implication is that they were a series capable of further extension. In December 1317 Edward II paid the London mercer Thomas of Stepney £30 for a great woollen dorser to hang in the Hall on major feasts, which was wrought (in a technique unfortunately not stated in the record) with figures of kings and earls, Brayley and Britton (cited in note 15 above), p. 436. The installation of this hanging behind the dais is implicit in the term 'dorser', and its use in Westminster Hall is made likely by the placing of the payment after one for the king's table there.

87. Guerout (cited in note 29 above), Vol. II, *passim*; U. Bennert, 'Art et propagande politique sous Philippe IV le Bel: le cycle des rois de France dans la Grand'Salle du Palais de la Cité', *Revue de l'Art*, XCVII, 1992, pp. 46–59.

88. Given-Wilson, *Royal Household*, p. 127.

89. The 'Grand'Salle' was perhaps not the obvious site for more specialized meanings as it had no connection with the coronation.

90. Fragmentary examples of this type of altarpiece are still fairly numerous. The most important examples near London to have survived from the period immediately before the start of Richard II's reign are the rood-screen of St Albans Abbey and the reredos in the Chapel of Our Lady Undercroft in Canterbury Cathedral. The great four-tier reredos of New College, Oxford (*c.* 1380) is recognizable as an expansion of a 13-niche reredos containing figures of Christ and the Apostles.

91. *Oeuvres de [Jean] Froissart…Chroniques*, ed. K. de Lettenhove, 25 vols., Brussels, 1870–77, XV, p. 180. The chronicler Thomas Walsingham's placing of his reference to the impaled arms between accounts of events in 1397 suggests that this is when the arms became generally known, Thomas Walsingham, *Historia Anglicana*, ed. H. T. Riley, Rolls Series, XXVIII, 2 vols., London, 1863–64, I, p. 227.

92. C. M. Barron, 'Richard II: Image and Reality' in *Making and Meaning*, pp. 13–9 at p. 18.

93. In 1397–98 four windows were glazed by William Burgh with 12 feet (3.7m) of glass bearing the arms of the King and of St Edward, which was placed in the tracery lights, and with 143¼ feet (44m) of glass (presumably quarries) 'flourished' with birds, PRO, E 101/473/12 (Clerk of the King's Works' particulars of Account for Michaelmas 1397 – Michaelmas 1398). In 1399–1400 Thomas Gloucester painted five vanes (for the louvers?) with the same arms, particulars of Account cited in note 78 above. The only shield of the King's arms impaling the Queen's was to have been on the western of the two sculptured label stops on the inner face of the great south window (destroyed along with the south wall in 1850 but known from a cast of *c.* 1820 in the Sir John Soane Museum, London). The fact that the sinister half of the shield was left uncarved is evidence of a very rapid rate of progress with the stonework of the Hall, for Anne of Bohemia died on 7 June 1394 and the carver of the label stop was presumably instructed to leave the shield incomplete so that a new queen's arms could be carved *in situ* at a later date.

94. The end trusses of the roof were not placed hard up against the end walls, as was normal, but at a considerable distance from them (*ill. 17*). The effect is to emphasize the equality of all 13 trusses and the pairs of angels on them. This feature also allows the end windows to rise higher than the arched braces of the trusses, a relationship which is conspicuous only in drawings of the east-west section that include an elevation of an end window (for example *ill. 17*).

95. Richard's second marriage in 1396 to the seven-year-old Isabelle of France held out the prospect that an heir would be born in ten years or so, but there is evidence that by 1397 Richard was contemplating renouncing his throne in order to become emperor, Given-Wilson (cited in note 83 above), pp. 557–8.

96. On the cornice white harts alternate with helms surmounted by the cap of maintenance (see the outside of the Wilton Diptych), but in some cases the helms are flanked by single feathers, an element found also on Richard's Privy Seal. These two devices are likely to have been thought of by Richard as his mother's and father's, although the cap of maintenance was specially significant here in that it was worn by each king when setting out from the Hall on the morning of his coronation. The carved animals on the east wall all turn to face right, a deviation from the strict rules of heraldry clearly intended to avoid dishonouring the throne and its occupant; see, for example, the eastward-facing leopards of England painted on the north choir wall of Rochester Cathedral *c.* 1300. There are no references in the surviving accounts to painting any of these carvings, but it can be assumed that they were meant to be painted in their heraldic colours. The interior of the Hall was whitewashed in 1397–98, particulars of Account cited in note 93 above.

97. For example, the carpenter's plane on the tympanum of the door at the base of the tower built *c.* 1407–12 by John the Fearless, Duke of Burgundy, at the Hôtel d'Artois in Paris, and the Visconti *raza* (radiant sun) in the approximately contemporary apse tracery of Milan Cathedral. The most insistent use of a personal device on an English building before Westminster Hall must be the vault bosses in the cloister of Westminster Abbey which are carved with the initials 'NL' under a coronet (for Nicholas Litlyngton, Abbot of Westminster 1362–86). Comparable in the degree of personalization, though not in the means used, are the statues of himself and his immediate family placed by Charles V on his main new buildings in and near Paris, none of which individually had the ideological importance of Westminster Hall.

98. The dates and spans of these roofs are as follows: 'Grand'Salle', Paris (destroyed), c. 1301–13, 2 × 14m; Montargis (destroyed), probably late 14th century, 16m; Coucy (destroyed), c. 1385–87, 15m; and Padua, 1306–09, 28m. The ties at Padua take the form not of beams but of iron rods. The roof of the Ridderzaal at The Hague (destroyed), begun before 1296, 18m in span, was, from an English point of view, more advanced, being of arched-brace and collar construction. The 25m-wide Sala del Maggior Consiglio of c. 1362–66 in the Doge's Palace at Venice had a tie-beam roof combined with a flat ceiling.

99. Courtenay, 'Westminster Hall Roof and Sources' (cited in note 1 above), *passim*; Courtenay and Mark (cited in note 1 above), *passim*.

100. The Kenilworth roof was destroyed in the 17th century. Indications that it was a tie-beam roof are the following: the exterior views taken before ruination which show a low-pitched roof (D. Renn, *Kenilworth Castle*, London, 1973, pp. 14, 44); the 1376–77 reference to the hall's boarded *celura* (see note 54 above), a term which usually but not always (see note 2 above) applies to a ceiling-like structure; and the presence of a tie-beam roof at St Mary's Guildhall, Coventry (9km from Kenilworth), a building strongly influenced in other respects by the Kenilworth hall (*Age of Chivalry*, cat. no. 192).

101. Namely the halls in New College, Oxford and the Abbot's House, Westminster Abbey. The suggestion made in Courtenay, 'Westminster Hall Roof and Sources' (cited in note 1 above), pp. 307–8, that New College Chapel had a hammer-beam roof is incorrect, as the original upper limit of the high altar reredos forms an obtusely pointed arch which fitted directly under the 14th-century roof.

102. An early example is in the choir of Holy Trinity, Hull, c. 1340, and the nave roof of the same church is a prime example among the countless tie-beam roofs covering Perpendicular structures.

103. There is no evidence of the pitch of William II's roof, but it is unlikely to have differed greatly from that of its successor. 15th-century parallels for the incorporation of archaic features in major halls whose detailed treatment is up-to-date are the Guildhalls of York and London, the first of three-aisled format, the second with stone transverse arches and two-light-and-transom lateral windows. For the latter, see Wilson (cited in note 57 above), pp. 7–8.

104. The ability of 14th-century English carpenters to produce Gothic designs was no doubt closely connected with the growth during this period in the importance of architecturally treated church fittings. That expertise in both the ornamental and the structural aspects of carpentry was not universal, even at élite level, is indicated by the complete absence of quasi-masonry detailing from the roof of Dartington hall, Devon (A. Emery, *Dartington Hall*, Oxford, 1970, pp. 237–44) and by the clear stylistic evidence that it was the master mason of Exeter Cathedral, Thomas of Witney, rather than the master carpenter who was responsible for the architectural treatment of the complex and very up-to-date bishop's throne there, Harvey (cited in note 53 above), p. 339 and R. K. Morris, 'Thomas of Witney at Exeter, Winchester and Wells' in *Medieval Art and Architecture at Exeter*, ed. F. Kelly (British Archaeological Association Conference Transactions, XI), Leeds, 1991, pp. 57–84 at pp. 58–9. That London was the main centre for structural carpentry with refined Gothic detailing during the 14th century is suggested by the scale of the non-royal patronage enjoyed by the king's chief master carpenters (see pp. 59-9) and by the importation into the Midlands of the London carpenter Richard of Felsted to build the hall roof of Kenilworth Castle in 1347, Salzman (cited in note 7 above), pp. 436–7.

105. At Westminster Hall blind tracery panelling is most conspicuously absent from the north gable; compare, for example, the treatment of wall surfaces above the great west window of Winchester Cathedral. The version of the motif which clads the west towers apparently designed and begun by Yevele at Westminster Abbey is diluted by the introduction of miniature buttresses between the vertical runs of panels.

106. The tomb canopy of Edward III would have been Herland's responsibility *ex officio*, as the tomb chest would have been Yevele's. The tomb is undocumented except for a reference in 1386 to unworked marble intended to be used in its making, *CPR 1385–89*, p. 127. It is possible that Herland learned about fan vaults from his mason colleague at Winchester College, William Wynford. The nearest thing to a fan vault by Yevele is the miniature traceried

vault in the southernmost of the image niches flanking the west porch of Westminster Abbey.

107. For Hurley's career, see Harvey (cited in note 53 above), pp. 154–5.

108. There is no evidence that Herland was ever at Ely. For drawings recording the south louver before its replacement in 1821, see Colvin (cited in note 25 above), figs 46–8.

109. The writers who have discounted this relationship because the Ely trusses do not show all the diagnostic features of hammer-beams seem implicitly to be denying that a designer of Herland's calibre was capable of more subtle responses to earlier works than that of straightforward copying; see Courtenay, 'Westminster Hall Roof and Sources' (cited in note 1 above), pp. 299–301, citing earlier literature. The way in which at Ely the uprights of the lantern frame are joined at mid-height to raking struts rising from the angles of the octagon could well have suggested the manner of joining hammerposts and arched braces at Westminster.

110. For William Herland's career, see Harvey (cited in note 53 above), pp. 142–3.

111. See the designs for Henry V's Manor of Sheen, kept in the stores at Sheen from 1419 to 1466–69, C. Wilson, 'The Designer of Henry VII's Chapel' in *The Reign of Henry VII*, ed. B. Thompson (*Harlaxton Medieval Studies*, V), Stamford, 1995, pp. 133–56 at p. 151.

112. Such a conception would be entirely in the spirit of the many late medieval contracts, admittedly for much more modest undertakings than Westminster Hall, which stipulate that the work commissioned should be as good or better than one or more named exemplars.

113. Antecedents for the Westminster angels in the earlier 14th-century architecture of southeastern England are the following: the heads carved into the ends of the hammer-beams of the earliest extant hammer-beam roof, that of *c.* 1308 over the so-called 'Pilgrims' Hall' in the precinct of Winchester Cathedral; the grotesque wooden caryatids which appear to bear on their backs the arched braces of the roof of *c.* 1341, probably of London workmanship and design, which covers the hall of Penshurst Place, Kent; and the half-length shield-bearing angels on the stone roof corbels in the abbot's hall at Westminster built *c.* 1375. There are angels (non-shield-bearing) on the canopy of Edward III's monument at Westminster, a

work comparable to Westminster Hall not only in being a design of Hugh Herland's but in its heavenly symbolism and in the presence of arched elements springing from the backs of the figures.

114. The possibility that the Westminster Hall roof was made exceptionally rich in arches and decorated with shield-bearing angels in order to enable it to emulate vaulting as a symbol of Heaven has never been mooted in print. It is suggestive that the heaven-invoking term *celatura*, normally used of ceiling-like structures, was applied to the roof shortly after its completion, *Historia Vitae et Regni Ricardi Secundi*, p. 137 (see note 2 above).

115. These images are discussed and illustrated in M. Michael, 'The Iconography of Kingship in the Walter of Milemete Treatise', *JWCI*, LVII, 1994, pp. 35–47, pls. 3a, 7b, 8a, 9a. The approximately triangular shape of shields made them apt symbols of the Trinity, as did the use of triple devices such as leopards of England and the ostrich feathers of the Black Prince. There appears to be no separate study devoted to the history of the shield-bearing angel in late medieval art. Stone examples earlier than Westminster Hall are the label-stops on the entrance to the Chapel of Our Lady of the Pew (*c.* 1360) in Westminster Abbey (*Making and Meaning*, fig. 20), those of *c.* 1380 on the west processional door in the nave of Canterbury Cathedral and the roof corbels in the abbot's hall at Westminster (*c.* 1375). All these examples lack the stylized clouds which the angels have in common with the shield-bearing angel on the badge reproduced on p. 81. The fireplace wall added on the orders of Jean, Duc de Berry, to the hall of the comital Palace of Poitiers, which was in progress by 1398, incorporates six large stone figures of shield-bearing angels, four of which are flying, like the Westminster Hall angels. Of a number of Continental funerary monuments from the period *c.* 1360–80 which incorporate angelic scutifers, probably the most important in relation to the angels of the Westminster Hall roof is the Tournai-made wall tablet of Pierre Saquespée (d. 1348) and his family, now in the Musée Municipal at Arras, on which the angels swoop downwards from puffs of heavenly vapour.

116. The number of the angels (26) may also have possessed chivalric connotations as well as evoking Christ and the Apostles (see p. 54 of this paper), for tournament teams normally

had 13 members and 26 was the number of the Knights of the Garter.

117. Between the early 15th century and the Reformation, angels — both shield-bearing and otherwise — proliferated in ecclesiastical and secular ceilings and roofs, as well as in canopies of many kinds. The chronology and distribution of the motif have yet to be investigated.

III. ABSOLUTISM AND REGAL IMAGE IN RICARDIAN SCULPTURE

I should like to acknowledge the help of Bill Martin and Christopher Weeks who permitted me to examine the first group of three kings from Westminster Hall during conservation in 1991–92 and of Malcolm Hay, Curator of Works of Art at the Palace of Westminster, for giving me access to the figures in 1993, after conservation, prior to their return to their niches, and for reading an early draft of this paper. I should also like to thank Keith Taylor, who was responsible for conservation of the second trio, and who permitted me access to the figures in his workshop. It has never been possible to see all six figures together or to see the conserved figures in good light conditions, so I should emphasize that my comments here must be treated as provisional. J.W. Binns, Christopher Wilson, Mark Ormrod, Sophie Oosterwijk and Julia Watson have kindly commented on earlier drafts of this paper.

1. For the tomb, see L. Stone, *Sculpture in Britain: The Middle Ages*, Harmondsworth, 1972, pp. 193–4. See also W. Burges, 'The Tombs in Westminster Abbey' in Appendix to G. G. Scott, *Gleanings from Westminster Abbey*, 2nd edn, Oxford and London, 1863, pp. 174–6; E. S. Prior and A. Gardner, *An Account of Medieval Figure-Sculpture in England*, Cambridge, 1912, p. 683; and A. Gardner, *English Medieval Sculpture*, Cambridge, 1951, pp. 292–4.

2. In 1395–96 a tomb was moved from near the burial place of the queen and repainted (Devon, *Issues*, p. 262). This may have been the tomb of Blanche of Castile and William of Windsor of 1376 (*Issues*, pp. 199–200); it was not that of the Bohuns as is suggested by A. P. Stanley, 'On an Examination of the Tombs of Richard II and Henry III in Westminster Abbey', *Archaeologia*, XXXXV, 1880, pp. 309 and 317 and id., *Historical Memorials of Westminster Abbey*, London, 1911, p. 125. For the latter tomb, see C. Peers and L. E. Tanner, 'On Some Recent Discoveries in Westminster Abbey', *Archaeologia*, XCIII, 1949, pp. 151–5 and J. D. Tanner, 'Tombs of Royal Babies in Westminster Abbey', *Journal of the British Archaeological Association*, XVI, 1953, pp. 29–35. Tanner suggests that the tomb moved for Richard II and Queen Anne was the Cosmatesque one for Henry III's children now located between the Chapels of St Edmund and St Benedict (p. 29). The displaced tomb could also have been that of John of Eltham which was moved from its position '*entre les Roials*' (where it was probably constructed after August 1339) to the Chapel of St Edmund probably either by Edward III's tomb (*pace* W. R. Lethaby, *Westminster Abbey Re-examined*, London, 1925, p. 281 though he is confused about the document's date) or Richard II's.

3. Translation in J. H. Harvey, *The Plantagenets*, London, 1967, Appendix II, pp. 219–224 (from J. Nichols, ed., *A Collection of all the Wills now Known to be Extant of the Kings and Queens of England*, London, 1780, pp. 191–200, and collated against PRO, E 23/1).

4. C. M. Barron, 'Richard II: Image and Reality' in *Making and Meaning*, p. 15, citing *Westminster Chronicle*, pp. 8–10. Gordon (*Making and Meaning*, pp. 54–55) highlights other important aspects of the cult of the Confessor for Richard, in particular, the use of the saint's regalia in the coronation service. Richard—unlike the first three Edwards—was a generous contributor to the rebuilding of the Confessor's Abbey Church (see R. B. Rackham, 'The Nave of Westminster', *Proceedings of the British Academy*, IV, 1909, pp. 8–12).

5. M. V. Clarke and N. Denholm-Young, 'The Kirkstall Chronicle, 1355–1400', *Bulletin of the John Rylands Library*, XV, 1931, p. 111. Before the high altar, sentence of excommunication was passed against contrariants, and the King gave notice that he was writing to secure papal sanction for the decree of excommunication. See also H. F. Westlake, *Westminster Abbey*, London, 1923, Vol. II, p. 469.

6. See, most recently, P. G. Lindley, 'Queen Anne of Bohemia' in *The Funeral Effigies of Westminster Abbey*, eds. A. Harvey and R. Mortimer, London, 1994, pp. 37–39.

7. Devon, *Issues*, p. 255.

8. 1,500 pounds of wax had been purchased from Suffolk for the candles at a cost of £41 8s. 10d. Compare Edward III's funeral (W. M. Ormrod, 'The Personal Religion of Edward III', *Speculum*, LXIV, 1989, p. 877) where over £280 was spent on torches and candles.

9. Devon, *Issues*, pp. 265–6. Richard gave numerous bequests for commemorating the anniversary of Anne's death. Richard's will also specifies that his own funeral exequies were to be celebrated with no less than four separate hearses 'of royal excellence'.

10. *Johannis de Trokelowe, et Henrici de Blaneforde, Monachorum S. Albani, necnon quorundam anonymorum, Chronica et Annales…Annales Ricardi Secundi et Henrici Quarti, Regum Angliae*, ed. H. T. Riley, Rolls Series, London, 1866, pp. 168–9. At St Paul's, Richard established the Petty Canons as a college of twelve, to meet and dine together in the hall, under the obligation to pray for his soul after death and Anne of Bohemia's, and their ancestors and all faithful departed (J. Evans, *English Art 1307–1461*, Oxford, 1949, p. 188).

11. Ormrod (cited in note 8 above), p. 867.

12. Devon, *Issues*, pp. 244 and 248. Compare the cost of £17 6s. 8d. for the tomb supplied by Henry of Lakenham for Sir Nicholas Loveyne in 1376 (J. Blair, 'Henry Lakenham, Marbler of London, and a Tomb Contract of 1376', *Antiquaries Journal*, LX, 1980, pp. 66–74) or the £40 set aside by John, Earl of Pembroke, in 1372, or the tombs costing £40 (for a double tomb) at Lowick in 1419 and £22 13s. 4d. for Robert Brown's monument to Richard Hertcombe at Bisham Abbey in 1421.

13. *Annales Ricardi Secundi, 1395* (cited in note 10 above), pp. 184–5. The Duchess of York was buried at Langley by the King's order (ibid., p. 169). In 1385, Richard set up a monument to the memory of Princess Joan in the Grey Friars' Church at Stamford (Colvin, *King's Works*, Vol. I, p. 487). Richard also intervened in the burial sites of John Waltham, Bishop of Salisbury (d. 1395); Thomas of Woodstock (d. 1397); and Archbishop William Courtenay (d. 1396).

14. The contracts are PRO, E 101/473/7, printed in *Foedera*, ed. Rymer, Vol. III, Part 4, pp. 105–6. For French monuments, see J. Adhémar *et al.*, 'Les Tombeaux de la collection Gaignières', *Gazette des Beaux-Arts*, LXXXIV, 1974, pp. 3–192; LXXXVIII, 1976, pp. 3–128 and XC,

1977, pp. 1–76. See, in particular, the double tomb of Charles V and Jeanne de Bourbon in F. Baron *et al.*, *Les Fastes du Gothique: le siècle de Charles V*, exh. cat., Grand Palais, Paris, 1981, cat. no. 75, though they do not join hands. The monument has flanking double pinnacles containing figures, a transposition, like the arrangement in Edward III's and Richard and Anne's monuments, of a format familiar from monumental brasses and from stained glass.

15. See note 2 above. Henry V's Chantry Chapel spans the awkward space over the ambulatory and to the east of the Confessor's Shrine, showing the difficulty of finding an appropriate space for a tomb (see W. H. St John Hope, 'The Funeral, Monument and Chantry Chapel of King Henry the Fifth', *Archaeologia*, LXV, 1914, pp. 130–86 and Stone, cited in note 1 above, pp. 205–6). His wife, Katharine de Valois, was buried in Henry III's Lady Chapel (see A. P. Stanley, 'On the Depositions of the Remains of Katharine de Valois, Queen of Henry V, in Westminster Abbey', *Archaeologia*, XXXXVI, 1881, pp. 281–96). For effigies with hands joined, see, for example, the tomb of Thomas Beauchamp, Earl of Warwick (d. 1369).

16. PRO, E 101/473/7 (2), printed in *Foedera*, ed. Rymer, Vol. III, Part 4, pp. 105–6. For Yevele and Lote, see J. H. Harvey, *English Mediaeval Architects*, Gloucester, 1984, q.v.

17. 'Et les dits Masons ferront Measons pur xii Images (C'estassavoir) vi. a l'une coste, et vi. al'autre coste du dite Toumbe, et le remenaunt du dit Toumbe sera fait ove orbes, accordantz et semblables as dites measons pur Ymages, pur accomplier la Toumbe, hors pris espaces pur Escuchons, de Coper et laton endorres, d'estre assignez par avys du dit Tresorer…Et les ditz Masons leveront la dite Toumbe de leyr de la Terre en Hautesse tanque al Hautesse del Toumbe le Tresexcellent et Tresnoble Seignieur le Roy Edward Tierce, n'adgairs Roy d'Engleterre qi Dieu assoile'.

18. As Nigel Ramsay noted (in *Age of Chivalry*, p. 393), Stone (cited in note 1 above, p. 193) has misunderstood the contract here and it does not seem that Broker and Prest designed these components. For the context, see P. Lindley, 'Collaboration and Competition: Torrigiano and Royal Tomb Commissions' in id., *From Gothic to Renaissance: Essays on Sculpture in England*, Stamford, 1995, pp. 47–72.

19. PRO, E 101/473/7 (1), printed in *Foedera*, ed. Rymer, Vol. III, Part 4, p. 106. All the beasts

at the feet of the effigies are now lost, though they all seem to be shown by T. Sandford, *A Genealogical History of the Kings and Queens of England and Monarchs of Great Britain*, London, 1707, p. 203. No weepers or escutcheons can be made out. The motif of the crossed hands, which can be seen in Gaywood's plate of 1665, is first seen in the late 13th-century relief effigies at Winterbourne Bassett.

20. Westlake (cited in note 5 above), Vol. II, p. 470, referring to WAM, MS lib. nig. quat., f. 88v. Devon, *Issues*, pp. 263, 270. Colvin, *King's Works*, Vol. I, p. 488 n. 2 refers to particulars of their account in PRO, E 28/9 July 2 Henry IV and the enrolment on Foreign Account PRO, E 364/35 rot. E. The account submitted by Yevele and Lote, PRO, E 101/473/10 enrolled on Foreign Account PRO, E 364/33 rot. C (d), shows that they only received £233 6s. 8d. See also *Issues*, pp. 258, 264 and Harvey, 'Wilton Diptych', p. 8 n. 6.

21. J. Dart, *Westmonasterium or the History and Antiquities of the Abbey Church of St Peter's Westminster,* 2 vols., London, 1723, Vol. II, p. 45, states that there were then no statues in the niches and I have been unable to find any record of them. (The engraving opposite p. 43 shows Anne with her hands in prayer and Richard with only his right arm, so the reliability of such early engravings is questionable, though the negative evidence—the absence of weepers or escutcheons—is useful). Richard might well have thought of displacing the customary mourning relatives with saints—given the political threats posed by close relatives such as Bolingbroke (Earl of Derby) and Gloucester, exacerbated by the fact that he and Anne were childless. The lost cushions under the images' heads were replaced at the suggestion of Queen Victoria (Stanley, 'Examination', cited in note 2 above, p. 316). There is no evidence to support Gardner's statement (*English Medieval Sculpture*, cited in note 1 above, p. 294) that 'precious stones were set down the middle of the queen's bodice'. Saints also appeared on the tomb-chests of alabaster effigies, but only—to my knowledge—in the 15th century.

22. J. G. Noppen, 'A Tomb and Effigy by Hennequin of Liège', *Burlington Magazine*, LIX, 1931, pp. 114–7; see also Scott (cited in note 1 above), pp. 64–5 and Burges (cited in note 1 above), pp. 169–171; Colvin, *King's Works*, Vol. I, pp. 486–7 and Stone (cited in note 1 above), pp. 192 and 264 n. 56. Ormrod (cited in note 8

above), p. 850 n. 7 and p. 868 n. 113. Edward III met the cost of Philippa's tomb.

23. K. Morand, *Claus Sluter: Artist at the Court of Burgundy*, London, 1991, pp. 68–9.

24. Devon, *Issues*, pp. 199–200; ironwork from the tomb of the late Bishop of London was purchased for reuse round Philippa's tomb and was extended and repainted at the same time. The original alabaster angels had wings of gilt metal.

25. *CPR 1385–89*, p. 127. 3 April 1386, licence for John Forrester, owner of a ship called 'La Margarete', to bring marble for the tomb of Edward III in Westminster Abbey from Poole in Dorset. W. R. Lethaby, *Westminster Abbey and the Kings' Craftsmen*, London, 1906, p. 289, has drawn attention to the fact that John Orchard and Richard Rook acquired a house and garden in Tothill Street, close to the Abbey gates in 1377 'doubtless so as to be near work going on in the palace workshops'.

26. Whittingham, 'Chronology', p. 12.

27. Harvey, 'Wilton Diptych', p. 8 n. 6.

28. Stone (cited in note 1 above), p. 193. The stylistic differences between the effigies tends to support the contention that Orchard may have been responsible for Edward III's effigy. M. Norris, *Monumental Brasses. I: The Memorials*, London, 1977, p. 52, ascribes one style of monumental brasses to Orchard's shop and another to Broker and Prest. See also note 42 below.

29. H. J. Plenderleith and H. Maryon, 'The Royal Bronze Effigies in Westminster Abbey', *Antiquaries Journal*, XXXIX, 1959, pp. 87–90, esp. p. 90. WAM, MS 62495, Plenderleith and Maryon's manuscript report on the Westminster effigies, dating from 1945, adds nothing of interest to the published account. The crown on Richard's head also appears to be a separate element, though this fact is not noted by Plenderleith and Maryon. At the time of writing, neither Richard's nor Anne's effigy is properly located on the backplate (the table of gilt-latten on which they lie).

30. Plenderleith and Maryon (cited in note 29 above), p. 89.

31. P. B. Chatwin, 'The Effigy of Richard Beauchamp at Warwick', *Antiquaries Journal*, VI, 1926, pp. 448–9.

32. *Making and Meaning*, p. 63 n. 9. Harvey, 'Wilton Diptych', p. 8 n. 6 cites PRO, E 101/473/10; PRO, E 364/35 rot. E Foreign Roll 2 Henry IV showing that they had received the full sum of £400 in instalments between 28 April 1395 and 23 July 1397. Between 7 December 1398 and 14 April 1399 a further £300 was paid for gilding.

33. Devon, *Issues*, p. 263. This suggests that the casting of both images had been completed by March 1396. Dillian Gordon's suggestion that the only definite date for its completion is 7 December 1398, when gilding began, though technically feasible, seems unlikely, unless we are to presume that an original head-section was replaced by a newer one two years later.

34. Many of these components—the arms, orb, cushions, crowns, pinnacles, weepers, escutcheons, angels, foot-rests, etc.—have been stolen. The way in which the foot-rest beasts were fixed at the feet of the effigies also differs markedly between Edward III's and the later monument.

35. Harvey, 'Wilton Diptych', p. 12 n. 2; Lindley (cited in note 6 above), p. 32, n. 9.

36. *Making and Meaning*, p. 63 n. 9.

37. Lindley (cited in note 18 above), pp. 47–72.

38. After Charles Stothard's tragic death in 1821, his project of depicting the effigies of all the kings and queens of England was continued by the Hollises. Thomas Hollis discovered the powdered designs, which had been covered by dirt. See the pounced backgrounds of manuscript illumination and on the Coronation Chair.

39. J. G. Nichols, 'Observations on the Heraldic Devices Discovered on the Effigies of Richard the Second and his Queen in Westminster Abbey, and Upon the Mode in which those Ornaments were Executed; including some Remarks on the Surname Plantagenet, and on the Ostrich Feathers of the Prince of Wales', *Archaeologia*, XXIX, 1842, pp. 32–59. The borders of the robes are decorated with a running scroll of the broom plant; at the foot are two rows of ermine spots and the hood is also lined with ermine. The badges of the mantle are interwoven with running lines of small flowers.

40. I owe this suggestion to Neil Stratford. See also his '*De opere punctili*. Beobachtungen zur Punktpunzierung um 1400' in *Das Goldene Rössl*, ed. R. Baumstene, Munich, 1995, pp. 131–45. See also the brass of Thomas Beauchamp (d. 1401) at Warwick (a later example of the 'B' series brasses), with its unique *pointillé* work, very close to that found on the royal effigies. Malcolm Norris indeed ascribes the brass to Broker and Prest (Norris, cited in note 28 above, pp. 52 and 56). The technique was common in 14th-century Italian panel paintings.

41. See the well-known engraving on the underside of the plate on which the effigy of Henry III lies. For early discussions, see Stanley, 'Examination' (cited in note 2 above), p. 322 and pl. XXIII and Lethaby (cited in note 25 above), pp. 285–6 and fig. 96.

42. Norris (cited in note 28 above), pp. 52–3.

43. For an early discussion, see also G. Scharf, *Description of the Wilton House Diptych*, Arundel Society, London, 1882. I am indebted to Kay Staniland for the information that Richard used the badge of the rising sun from early in his reign. The pro-Ricardian *Kirkstall Chronicle* comments on the events of 1397 after describing the beheading of Arundel and death of Gloucester at Calais: 'with admirable and long-lasting patience becoming a King, a certain sun was formerly covered with cloud, that is, the regal majesty [was obscured] by the might of another; but now leaping in arms upon the mountains and passing over the hills, he [the King] has tossed about the clouds and the sun and has brought out the light of the sun more clearly'. Clarke and Denholm-Young (cited in note 5 above), p. 131. The translation is from L. D. Duls, *Richard II in the Early Chronicles*, The Hague, 1975, pp. 94–5.

44. Olga Pujmanová pointed this out to me (Emperor Wenceslas was Anne's brother). The ostrich was seen as a symbol of valour since it digested iron. Queen Anne possessed a collar of branches of rosemary with an ostrich dependant. See Palgrave, ed., *Kalendars*, Vol. III, pp. 341 and 357: '*Item i coler de la livere de la Roigne, que Diex assoille, ove un Ostriche, vii grosses perles et xxxv autres plus petits perles pois' vii unc'*.

45. Clarke, 'Wilton Diptych' in *Fourteenth Century Studies*, pp. 272–92. See also Harvey, 'Wilton Diptych', p. 6 for an illustration of these arms.

46. N. Saul, 'The Commons and the Abolition of Badges', *Parliamentary History*, IX/II, 1990, pp. 302–15, esp. p. 307.

47. Ibid., p. 313.

48. See the comment in T. Wright, ed., *Alliterative Poem on the Deposition of King Richard II*, London, 1838, p. 9: 'Ffor tho that had hertis on hie on her brestis/ Ffor the more partie, I may well avowe,/ They bare hem the bolder ffor her gay broches,/ And busshid with her brestis, and bare adoune the pouere,/ Lieges that loved you the lesse ffor her yvell dedis./ So trouthe to telle, as toune men said,/ Ffor on that ye merkyd, ye missed ten schore/ Of homeliche hertis, that the harme hente'.

49. Royal Commission on the Historical Monuments of England, *An Inventory of the Historical Monuments in London. Vol. I, Westminster Abbey*, London, 1924, p. 31: '*Prudens et Mundus/ Ricardus jure Secundus, per fatum victus/ jacet hic sub marmore pictus. Verax sermone/ fuit, et plenus ratione: Corpore procerus/ animo prudens ut Omerus. Ecclesie favit/ elatos suppeditavit, Quemvis prostravit/ regalia qui violavit. Obruit hereticos/ et eorum stravit amicos. O Clemens Christe/ cui devotus fuit iste; Votis Baptiste/ salves quem pretulit iste. Sub petra lata/ nunc Anna jacet tumulata, Dum vixit mundo/ Ricardo nupta secundo. Christo devota/ fuit hec factis bene nota: Pauperibus prona/ semper sua reddere dona: Jurgia sedavit/ et pregnantes relevavit. Corpore formosa/ vultu mitis speciosa. Prebens solamen viduis, egris medicamen: Anno milleno/ ter C, quarto nonageno Junii septeno/ mensis, migravit amen*'. C. M. Barron, 'Richard II: Image and Reality' in *Making and Meaning*, p. 19, must be correct in thinking that Richard II himself commissioned this epitaph.

50. Royal Commission on the Historical Monuments of England (cited in note 49 above), p. 30: '*Hic decus anglorum flos regum preteritorum/ Forma futurorum/ rex clemens pax populorum/ Tertius Edwardus/ regni complens jubileum/ Invictus pardus/ bellis pollens Machabeus/ prospere dum vixit/ regnum probitate revixit/ armipotens rexit/ jam celo celice rex sit*'.

51. Barron (cited in note 49 above), p. 14. Duls (cited in note 43 above), pp. 8–9, quotes London, British Library, MS Royal 13 C I, f. 117b, that Richard 'loved religion and the clergy, he encouraged architecture, he built the Church of Westminster almost entirely, and left much property by his will to finish what he had begun. He founded the Carthusian monastery near Coventry, and the preaching friars near his Manor of Langley, to pray especially for the repose of the soul of his consort Queen Anne; and by his will bequeathed considerable sums to the Church of Westminster for the celebration of his anniversary in times to come'. See also Harvey, 'Wilton Diptych', p. 18 n. 1.

52. The 'Wonderful' Parliament of October to November 1386 saw the impeachment of Michael de la Pole and a commission of government appointed by the great magnates.

53. Clarke and Denholm-Young (cited in note 5 above), p. 108.

54. Duls (cited in note 43 above), p. 41 item 9, for Richard's question to the justiciars at Nottingham. In 1385 Richard was already seeking Edward II's canonization (S. Whittingham, 'The Date of the Wilton Diptych', *Gazette des Beaux Arts*, XCVIII, 1982, p. 146).

55. M. McKisack, *The Fourteenth Century*, Oxford, 1959, p. 467. Devon, *Issues*, pp. 259 and 264.

56. McKisack (cited in note 55 above), p. 467, citing *Rotuli Parliamentorum*, Vol. III, p. 286 (the relevant clause is no. 13). For the background, see R. H. Jones, *The Royal Policy of Richard II: Absolutism in the Later Middle Ages*, Oxford, 1968.

57. C. M. Barron, 'Richard II and London' in *Reign of Richard II*, p. 200.

58. For the details, see McKisack (cited in note 55 above), pp. 480ff. Sir William Bagot, appointed Speaker at the Parliament of September 1397, described Richard (Duls, cited in note 43 above, p. 112, quoting Fabyan): he cared to live no longer than to see his lords and commons have for him 'as great awe and dread as euer they hadde [for] any of his progenytours, so that it might be cronycled of hym, that none passyd hym of honour and dygnyte'.

59. Colvin, *King's Works*, Vol. I, p. 532.

60. *Chronicon Adae de Usk, 1377–1421*, ed. E. M. Thompson, London, 1904, p. 11 and A. Tuck, *Richard II and the English Nobility*, London, 1973, p. 187.

61. McKisack (cited in note 55 above), p. 490. She notes (pp. 476–7) that Richard cherished fantastic dreams of winning the Imperial Crown.

62. In his will of April 1399, Richard insists that his successor confirm the statutes, ordinances, appointments and judgements of the Parliament of September 1397 which condemned Gloucester, Arundel and Warwick, and that at Coventry of September 1398, in which Bolingbroke and Mowbray were sentenced to exile (Harvey, cited in note 3 above, p. 222).

63. E. W. Tristram, *English Wall Painting of the Fourteenth Century*, London, 1955, pp. 199–200. See also a letter from Richard to Albert of Bavaria, Count of Hainault, cited by John Harvey (and dated by him *c.* 1397), condemning those of his household and intimacy 'who have for long and since we were of tender years traitrously conspired to disinherit our Crown and usurp our royal power...' They have 'wrongfully usurped the royal power by going about among our privy affairs, so that they left us hardly anything beyond the royal name...' He continues, he has 'adjudged them to natural or civil death' and 'caused their punishment to be perpetuated upon their heirs...that posterity may learn what it is to offend the royal majesty...for he is a child of death, who offends the King' (Harvey, 'Wilton Diptych', pp. 27–28). The last remarkable phrase suggests a date after March 1398 (not 1397 as suggested by Harvey).

64. Barron (cited in note 57 above), pp. 195–6 (citing Guildhall Record Office, Bridge House Accounts Roll 12 mm. 8, 9, 10); Harvey, 'Wilton Diptych', p. 5 n. 7 (the citation by Barron is misprinted), cites Corporation of London Records Office, Bridge Masters' Account Rolls 12 (1392–3) xxxiii, xli, xlv, xlvii, xlviii, l, li, lii. The first item, dated Saturday 10 May 1393, reads '*Item solutum Thome Wreuk lathomo in partem solucionis pro factura et operacione ij. ymaginum de Rege et Regina petris liberis ad ponend. supra portam lapideam super Pontem cum iij. Scutis de armis Regis et Regine et Sancti Edwardi et cum grossis tabernaculis per preceptum domini Regis lxs'.* Wrek received £10 in all for the job and a certain painter £20 for painting the images, shields and tabernacles while 20s. was disbursed for '*ij septris de laton. et deauratis emptis pro ymaginibus prescriptis'.* Two years later, in 1395, Richard gave 100 marks to the works of York Minster, a gift commemorated by the carving of a chained hart above the entry to the south choir aisle, beside the great south-east pier of the central crossing (J. H. Harvey, 'Ri-

chard II and York' in *Reign of Richard II*, pp. 207 and 209).

65. Colvin, *King's Works*, Vol. I, pp. 527ff. But see Wilson in this volume (p. 43 and note 46).

66. PRO, E 101/473/2. Although the writ of Privy Seal paying for these 13 figures is dated 4 July 1388, by writ of Privy Seal dated 28 January 1385 a mason was already working at the quarry scappling various pieces of Reigate stone for the 'hovels' or niches '*pro sex ymagines ad similitudinem Regis factae et in fine australi magnae aulae positae et factae'.* These were the stones subsequently carved by Walter Walton.

67. PRO, E 101/473/2. Colvin, *King's Works*, Vol. I, p. 528. '*Et Thomae cannon marbrer pro factura xiij ymaginum lapid' ad similitudinem Regum fact' et ordinat' per Regis et consilium suum ad standum in magna aula ibidem cum inventione petr' pro eisdem cap' pro utroque ymag' ad tasc' xlvs viijd £xxx vjs viijd. Eidem pro factura ij ymaginum ad similitudinem Regis fact' et positarum supra ostium dictae aulae ibidem capiendo per utraque pec' ad tascam lxvjs viijd £vj xiijs iiijd'.* See the cost of the figures of St Edward and St John to be placed on the gable of St Stephen's Chapel. These cost £3 6s. 8d. not including the materials; the stone may have been that purchased from Thomas Bernak of Ryegate at 5s. 6d. each block (6 Edward III). William Patryngton received £2 13s. 4d. for making three figures of kings to stand in tabernacles in the chapel from the King's stone, by task-work. For two images of sergeants at arms, he received £4 each, not including the materials (26 Edward III), see J. T. Smith, *Antiquities of Westminster*, London, 1807, p. 201.

68. 'To Thomas Canon, for a box made for the safe carriage of the aforesaid eight statues, and for their carriage from his house to the Palace of Westminster, 9s. 5d'.

'To Walter Walton for making six niches of stone for the six images of kings aforesaid placed inside the Great Hall costing £4 13s. 4d. each'.

'To the same man for making two tabernacles of stone for two images of kings placed on the gateway of the Great Hall at £9 each, £18'.

The present niches are 19th-century replacements. The greater price of the niches than the figures presumably relates to the amount of skilled man-hours required to carve the respective components. It should be noted that the

niches featured, in addition to complex architectural components (canopies, pinnacles and bases), figural and foliate sculpture corbels. The implications for the niches' greater cost than the figures is discussed by Wilson in this volume (pp. 48–9).

69. 'Et Nicholae Tryer pictori pro pictura sex ymaginum predictarum positarum in dicta magna aula ibidem ad tascam £viij xiijs iiijd. Eidem pro pictura predictarum ij ymaginum positarum supra ostium dictae aulae ibidem ad tascam cs'. The statues were again painted (Colvin, *King's Works*, Vol. IV, p. 290) under James Nedeham.

70. A. Martindale, *Heroes, Ancestors, Relatives and the Birth of the Portrait*, Maarssen, 1988, pp. 25–29. Martindale remarks that the Parisian sequence was both prospective and retrospective and compares the sequence with the painted series in the Sala del Gran Consiglio, Venice, decorated from the 1360s onwards.

71. W. H. St John Hope, 'Quire Screens in English Churches with Special Reference to the Twelfth-century Choir-Screen formerly in the Cathedral Church of Ely', *Archaeologia*, LXVIII, 1916–17, pp. 43–110, is the fundamental study of this subject.

72. A Yorkist text (*Davies's Chronicle*) describes how Richard in 1398 'leet ordeyne and make in his chambir, a trone, wherynne he was wont to sitte fro aftir mete vnto euensong tyme, spekynge to no man, but ouerlokyng alle menn; and yf he loked on eny mann, what astat or degre that evir he were of, he moste knele' (cited in Duls, see note 43 above, p. 112). See also Richard's desire to be re-anointed with the Holy Oil of St Thomas, 'rediscovered' in the time of Edward II. See J. R. S. Phillips, 'Edward II and the Prophets' in *England in the Fourteenth Century* (Proceedings of the 1985 Harlaxton Symposium), ed. W. M. Ormrod, Woodbridge, 1986, pp. 189–201; C. Wilson, 'The Tomb of Henry IV and the Holy Oil of St Thomas of Canterbury' in *Medieval Architecture and its Intellectual Context*, eds. E. C. Fernie and P. Crossley, London, 1990, pp. 181–90.

73. Stone (cited in note 1 above), p. 181.

74. Four more statues of kings for the north front pinnacle were made by William Chaddere (Colvin, *King's Works*, Vol. I, pp. 532–3). The southern gable also had two statues of kings.

75. See Stone (cited in note 1 above), p. 220. For the dating, see C. Barnett, 'Late Medieval Royal Imagery at York Minster', *Medieval Life*, II, 1995, pp. 26–30.

76. *Vertue Notebooks*, Walpole Society, XVIII, 1930, p. 137 (he only identifies five figures).

77. J. Carter, *Specimens of the Ancient Sculpture and Painting now Remaining in England*, revised edn, London, 1887, pl. LX.

78. Colvin, *King's Works*, Vol. I, p. 528.

79. Ibid., pp. 529–30; L. F. Salzman, *Building in England down to 1540. A Documentary History*, Oxford, 1967, pp. 218–9. For illustrations, see Royal Commission on the Historical Monuments of England (cited in note 49 above), pls. 176 and 180. Four of them were carved by Robert Brusyngdon at 26s. 8d. each, four by William Canon at 20s., two more by Brusyngdon at 15s. and six by Peter Davyn and Hubert de Villers at the same rate. It is difficult to explain the variations in price per angel received by the sculptors, given that all the angels appear to be of the same size. Salzman's suggestion (p. 219) that 'after the contracts for the first batch had been given out at the higher price, the Clerk of the Works found that he could get them done much cheaper', seems preferable to Colvin's (*King's Works*, Vol. I, p. 530) that the first four may have been patterns for the rest.

80. Colvin, *King's Works*, Vol. I, p. 533. The five huge figures of kings—each apparently carved from two blocks of stone—surviving inside the Hall and ranged in the window embrasures of the east side deserve some scholarly attention. The statue in Southwark referred to by N. Pevsner, *The Buildings of England: London. Vol. I, The Cities of London and Westminster*, Harmondsworth, 1973, p. 531, is not one of these figures. The cornice sculptures inside the Hall (it is lavishly decorated with the badge of the White Hart and the royal crest of the lion), the label stops and corbels are discussed by Wilson in this volume (p. 48). See also Salzman (cited in note 79 above), pp. 472–3 and PRO, E 101/473/21. Washbourn and Swallow had to have the 26 corbels carved 'solonc le purport d'un Patron a eux monstree par le Tresorer' (*Foedera*, ed. Rymer, Vol. III, Part 4, p. 105).

81. See note 75 above. The Westminster Hall images were shipped from Canon's workshop, so his employees or subcontractors must have worked there.

82. The first king west of the 19th-century stairs (numbered 4 on the rear face, the first from the left in Carter's engraving) holds an orb in his left hand, the cross having been restored to it since Carter drew it (*ills. 42, 43*). The sceptre, apart from a short section below the figure's right hand, is also a restoration. The gloves have tassels. He has shoulder-length wavy hair and a forked beard. He stands in a gentle, swaying pose, slightly hipshot, with the right knee thrust forward and is wearing a cloak fastened at his breast with a lobed diamond-shaped clasp, the hood thrown back. The cloak is dragged across the body by his right hand, producing troughed folds over the left-hand side of the figure and convoluted folds in the hem falling from his fingers. The tunic is fastened at the waist with a thin studded belt. There is a good deal of surface damage (for example to the nose and lower lip, though the face is generally in good condition, and reveals the crow's feet at the side of the eyes), with major losses to areas of the draperies where the stone has exfoliated, a condition apparently exacerbated by the application of limewash or gesso (now removed) to the figures.

The next figure (*ill. 44*) to the right (5, the one on the extreme right in the engraving) has neither hand in Carter's engraving and both appear to be restorations. There is a strange tension in this figure, imparted by the extraordinarily dynamic cross-legged pose, with the right leg brought in front of the left, and the draperies drawn across the upper torso. The cross-legged pose is very unusual in a standing figure, though it had been much used in 13th-century effigial sculpture, and in seated images of kings such as those at Exeter and Lincoln Cathedrals. The tunic, which has a high collar, is studded with buttons like scaled-down versions of the previous figure's clasp. This figure again has curly shoulder-length hair, with bifurcated beard and moustache. Though there is much more damage to this head (for example on the nose, beard, eyebrows and cheeks), it appears to be close stylistically to that of the previous figure, though probably by another hand.

The remaining figure (6, the third from the right in Carter's engraving) of this side is radically different (*ill. 45*). The left hand, the sceptre and the orb are all restorations. The end of the nose is a restoration, but otherwise the face is in good condition except for exfoliation above the eyes. The mouth is slightly open, with a prominent lower lip. The ears are not indicated. The scalloped shoulder cope has three clasps on his right shoulder. The cloak is worn over another garment, which has a fringed hemline, and which is split at one side to reveal further garment below. The sleeves have decorated cuffs with fringes. The back is also differently handled from the other two figures, being roughed-out in a slightly more developed way. The end of the right foot is restored and overhangs the base. The feet are tipped forwards. There is a good deal of surface damage to the draperies. Carter's engraving indicates the shoulder cope was painted with ermine.

Of the remaining three figures, the first (1, the third from the left in Carter's engraving) does not have the crown separately carved as do all the others (*ill. 46*). Only the cross of the orb is a restoration. The figure is in very poor condition, with evidence of considerable contemporary repair to the draperies. These fall in an elaborate cascade from the left hand. The face is badly damaged. The base is also damaged and there is no right foot (nor is one visible in Carter's engraving which again shows the shoulder cope painted with ermine). The next figure (2, the second from the right in Carter's engraving) is less bulky in style, the brow slightly furrowed (*ill. 47*). There is no cloak or cape, the garment falling in straight folds, with small lapels at the throat, the hood thrown back. His left hand and orb are replacements (by reference to Carter: the Conservators, however, think the hand is original), as is the sword above the right hand. The final figure (3, the second from the left in Carter's engraving), is in extremely good condition, with detailing of remarkable quality, though the left hand is lost and had already gone when drawn by Carter (*ill. 48*). The head is in good condition, with the usual curling hair, beard and moustache; the shape of the eyes is slightly different from the others and the drapery treatment, with the cloak spread out over the arms and fastened with a cord whose tassels fall over the heavily studded gown, split at knee level. The apparent stylistic differences between this and four of the other figures are mainly the result of the differing amount of surface detailing left, but it seems likely that two sculptors were responsible for them also.

83. Stone (cited in note 1 above), p. 204.

84. Carter, pl. LX, reproduced in the booklet by M. Hay and R. Kennedy, *The Medieval Kings c. 1388*, London, June and July 1993, p. 10. For the gesso, see A. Gardner, *English Medieval Sculpture*, Cambridge, 1951, p. 231 n. 2.

85. See, most recently, J. P. Allan and S. R. Blaylock, 'The West Front I: The Structural History of the West Front' in *Medieval Art and Architecture at Exeter Cathedral*, ed. F. Kelly, Leeds, 1991, pp. 94–115 and P. Williamson, 'Sculptures of the West Front' in *Exeter Cathedral: A Celebration*, ed. M. Swanton, Exeter, 1991, pp. 75–81.

86. P. Lindley, 'Figure-Sculpture at Winchester in the Fifteenth Century: A New Chronology' in *England in the Fifteenth Century*, ed. D. Williams, Woodbridge, 1987, p. 161. The figure style has many points of contact with the Virgin of the Wilton Diptych. See also the Petersportal of Cologne Cathedral, where some of the Apostles employ a similar device.

87. The fact that the drapery and figure-style is somewhat different from the other figures tends to indicate that the whole figure, and not just the carving of the head, was the responsibility of one individual.

88. R. Didier and R. Recht, 'Paris, Prague, Cologne et la sculpture de la seconde moitié du XIV^e siècle', *Bulletin Monumental*, CXXXVIII, 1980, pp. 173–219. Froissart relates that there were works by André Beauneveu in England (see Alexander, p. 201).

89. Compare the Virgin from the mid 13th-century Annunciation group in Westminster Abbey's Chapter House (P. Williamson, 'The Westminster Abbey Chapter House Annunciation Group', *Burlington Magazine*, CXXX, 1988, p. 123), where the top of the head is also a separate piece of stone (the Virgin is carved from Reigate stone).

90. McKisack (cited in note 55 above), p. 444; Tuck (cited in note 60 above), pp. 103 and 119.

91. This would be even more ironic if J. E. Powell, 'A King's Tomb', *History Today*, October 1965, pp. 713–18, is right in believing that the tomb of Isabel, Duchess of York, was first destined, by Richard himself, prior to 1394, for his own interment. He was reburied at Westminster in 1413.

IV. THE CLOTHING OF RICHARD II

I should like to thank the Wilton Diptych Conference organizers and the editors of the publication for allowing me to present a paper revised in the light of subsequent research.

1. J. Evans, *English Art 1307–1461*, Oxford, 1949, pp. 63, 84 and G. Mathew, *The Court of Richard II*, London, 1968.

2. L. Duls, *Richard II in the Early Chronicles*, The Hague, 1975; B. Bevan, *King Richard II*, London, 1990, p. 86; V. H. Galbraith, 'A New Life of Richard II', *History*, XXVI (104), 1942, p. 225 (review of A. Steel, *Richard II*, Cambridge, 1941).

3. A. Gransden, *Historical Writing in England*, London, 1982, Vol. II, p. 191; see also G. O. Sayles, 'Richard II of England: A Fresh Look', *Proceedings of the American Philosophical Society*, CXV/I, February 1971, pp. 28–31; G. B. Stow, 'Richard II in Thomas Walsingham's Chronicles', *Speculum*, LIX/I, 1984, pp. 68–102.

4. C. Given-Wilson, ed., *Chronicles of the Revolution, 1397–1400*, Manchester, 1993, p. 130; see 'Richard II' in *Dictionary of National Biography*, London, 1909, p. 1042.

5. W. P. Baildon, 'A Wardrobe Account of 16–17 Richard II', *Archaeologia*, LXII, 1911, Vol. I, pp. 497–514; for correct identification, see C. M. Woolgar, *Household Accounts from Medieval England*, Oxford, 1992, Vol. I, pp. 37–8. I am grateful to Nigel Saul for drawing my attention to this reference. The misattribution becomes rather obvious when one compares the entries in this account with the almost contemporary Purchase Roll of 16–18 Richard II, 1392–95, PRO, E 101/402/12 where completely different Great Wardrobe suppliers are cited.

6. Mea culpa! K. Staniland, *The Embroiderers*, London, 1991, p. 48; Evans (cited in note 1 above), p. 84; *Making and Meaning*, p. 49; M. Scott, *A Visual History of Costume, The Fourteenth and Fifteenth Centuries*, London, 1986, p. 50.

7. Galbraith (cited in note 2 above), p. 225 n. 1, seems to have been the first to suggest that the King invented the handkerchief. Mathew (cited in note 1 above), p. 28, commented that 'the invention of the linen handkerchief was for the King's personal use and failed to establish itself in late medieval England'.

8. J. Levillier, 'The Handkerchief in History', *Connoisseur*, XCVI, 1925, pp. 274–8; M. Braun-Ronsdorf, *The History of the Handkerchief*, Leigh-on-Sea, 1967, pp. 12–13.

9. L. S. Sutherland and M. McKisack, eds., *Fourteenth Century Studies*, Oxford, 1937, p. 117 n. 3, quoting PRO, E 101/401/15. Words which the Great Wardrobe clerks could have employed, it seems to me, are *manutergium* (towel), *mappa* (table cloth, hand towel), *sudarium* (napkin), *tuallia* (towel). It has also been suggested that the King may have been suffering from a common cold, nosebleeds, or hay-fever.

10. S. Pegge, *The Forme of Cury*, London, 1780; R. Warner, *Antiquitates Culinariae: Tracts on Culinary Affairs of the Old English*, London, 1791; Bevan (cited in note 2 above), p. 84; Mathew (cited in note 1 above), pp. 23–5.

11. C. V. Hieatt and S. Butler, *Curye On Inglysch*, Early English Text Society, Oxford, 1985, pp. 1–15.

12. Staniland (cited in note 6 above), p. 68; J. W. Sherborne, 'Aspects of Court Culture' in *English Court Culture*, p. 15; Bevan (cited in note 2 above), p. 86; D. Pocock, *Understanding Social Anthropology*, London, 1975, pp. 106–112; A. J. Gurevich, *Categories of Medieval Culture*, London, 1985, pp. 215ff.; id., 'Wealth and Gift-Bestowal in Scandinavia' in *Historical Anthropology of the Middle Ages*, ed. J. Howlett, London, 1992, pp. 177–89.

13. PRO, E 101/397/20.

14. PRO, E 101/400/4.

15. Ibid.; K. Staniland, 'The Great Wardrobe Accounts as a Source for Historians of Fourteenth-Century Clothing and Textiles' in *Ancient and Medieval Textiles*, eds. L. Monnas and H. Granger-Taylor, *Textile History*, XX (2), 1989, pp. 275–81; L. Douët d'Arcq, *Nouveau receuil de comptes de l'argenterie des rois de France*, Paris, 1874, pp. 113–319.

16. PRO, E 101/400/4 (see Wilson, p. 36 and note 19; and Monnas, p. 167 and note 13).

17. PRO, E 101/401/16.

18. PRO, E 101/401/5. The labour costs for the embroidery on this group of items was £111 13s.

19. PRO, E 101/401/16 and PRO, E 101/401/15.

20. *Making and Meaning*, p. 64 n. 36. PRO, E 101/410/16; this account reveals the ornamentation of a blue velvet *gouna* for the Queen with harts and trees; see also *Making and Meaning*, p. 49, for known instances of the wearing of the White Hart. See also Campbell in this volume (pp. 100–101).

21. PRO, E 101/397/20.

22. PRO, E 101/401/15 and PRO, E 101/401/16; the King's embroiderer's name is found variously spelled in the accounts, for example Hans de Strowesburgh in Issue Roll II (PRO, E 101/400/4); see Staniland (cited in note 6 above), pp. 30–50; I am grateful to Claude Blair for advice on the armour involved in this outfit.

23. PRO, E 101/401/15; this team consisted of 4 artists, 19 men and 24 women who worked a total of 674 days.

24. PRO, E 101/401/15; this team consisted of 4 artists, 27 men and 18 women who worked a total of 1,322 days.

25. Given-Wilson, *Royal Household*, p. 82-3; see also C. M. Barron, 'Richard II and London' in *Reign of Richard II*, p. 197.

26. A chamber of cloth of gold presented to the Duke of Burgundy by Richard II in 1396 with ermine bed-coverlets and tapestry wall-hangings; tapestries of the histories of Clovis, the Virgin, and Perceval, some worked in gold; C. Dehaisnes, *Documents et extraits divers concernant l'histoire de l'art…1374–1401*, Lille, 1886, Vol. II, pp. 697, 710, 843.

V. THE JEWELLERY AND PLATE OF RICHARD II

I would like to record thanks to Claude Blair, John Clark, John Cherry, Renate Eikelmann, François Popelin and Nigel Ramsay.

1. T. F. Tout, *Chapters in the Administrative History of Mediaeval England*, 6 vols., Manchester, 1920–33, IV, p. 424.

2. G. Mathew, *The Court of Richard II*, London, 1968, pp. 38–9; also A. Steel, *Richard II*, Cambridge, 1941, p. 7.

3. J. W. Sherborne, 'Aspects of Court Culture' in *English Court Culture*, pp. 7, 21; J. Vale, *Edward III and Chivalry: Chivalric Society and its Context 1270–1350*, Woodbridge, 1982.

4. There is abundant but scattered evidence for this, most importantly at the courts of the kings of France and the dukes of Burgundy. See R. W. Lightbown, *Secular Goldsmiths' Work in Medieval France*, London, 1978, pp. 38, 46, 49, 51, 65, 107; H. David, *Philippe le Hardi: le train somptuaire d'un grand Valois*, Dijon, 1947; R. Vaughan, *Philip the Bold*, London, 1962, esp. Chapter 9; A. de Champeaux and P. Gauchery, *Travaux d'art exécutés pour le Duc de Berry*, Paris, 1894; *Les Fastes du Gothique: le siècle de Charles V*, exh. cat., Grand Palais, Paris, 1981.

5. *Oeuvres de [Jean] Froissart…Chroniques*, ed. K. de Lettenhove, 25 vols., Brussels, 1870–77, XVI, pp. 234, 336–7; I have followed the translation by Lord Berners, intro. W. P. Ker, *Cronycle of Syr John Froissart*, 6 vols., London, 1903, VI, pp. 302–3, 398. See also G. Stow, 'Richard II in Jean Froissart's Chroniques', *Journal of Medieval History*, XI, 1985, pp. 33–45.

6. *Rotuli Parliamentorum*, Vol. III, p. 419. Chroniclers like Thomas Walsingham were consistently critical of Richard's extravagance—the King's gifts to the French at Calais in 1396 he claimed cost over 40,000 marks, see Thomas Walsingham, *Historia Anglicana*, ed. H. T. Riley, Rolls Series, XXVIII, 2 vols., London, 1863–64, I, p. 222. Other instances are cited in G. Stow, 'Chronicles versus Records: The Character of Richard II' in *Documenting the Past: Essays in Medieval History Presented to G. P. Cuttino*, eds. J. S. Hamilton and P. J. Bradley, Woodbridge, 1989, pp. 158–60.

7. There is only one silver piece, the enamel Troyes badge: *Age of Chivalry*, cat. no. 725 and also *ill. 54*. Ricardian objects in copper alloy are discussed in *Age of Chivalry* (cat. nos. 724, 726–7), lead badges with his device in B. Spencer, *Pilgrim Souvenirs and Secular Badges: Salisbury Museum Medieval Catalogue*, Part II, Salisbury, 1990, pp. 97–9, nos. 154–7. There are two copper and enamel roundels bearing the arms of Richard and one of his wives; for that of Richard and Anne in the Museum of London, see J. B. Ward-Perkins, *Medieval Catalogue: London Museum*, London, 1940, p. 122, pl. XXII, 1. That

of Richard and Isabelle in the Department of Medieval and Later Antiquities in the British Museum is unpublished. For seal impressions, see note 79 below.

8. Vale (cited in note 3 above); J. H. Wylie, *A History of England under Henry IV*, 4 vols., London, 1884–98; Given-Wilson, *Royal Household*.

9. See note 1 above, also *Kaiser Karl IV*, exh. cat., Nuremberg (Kaiserburg), Munich, 1978.

10. PRO, E 403/463–563. This comprises almost a complete set for Richard's reign, with gaps in 1395–96, when there are only two rolls (554–5). There is a great deal of miscellaneous, but often detailed, information in these bulky documents, often over 30 membranes long. Time has prevented me from examining more than about 20% of the total.

11. *Descriptive List of the Wardrobe Books, Edward I to Edward IV*, List and Index Society, CLXVIII, 1980: those for Richard date from *c*. 1380–86 and 1395–96, see pp. 122–33. Distinctive items can be recognized in these books again and again over the years; there is a sense of stasis about much of the wardrobe stock as though it rarely went into daily use in the chamber. Clearly some did, however, as evidenced by payments both for repairs and for new plate to replace old.

12. PRO, E 101/400/29, for 9 March, 7 Richard II (1384). The crown is described in detail as being of gold with emeralds, pearls and balas rubies, including facetted '*quarre*' examples, and its weight given as 6lb. 13s. 4d. '*pois d'orfevre*'. Clearly not in regular use, it was much pawned, as earlier by Richard, see *Kalendars*, ed. Palgrave, Vol. III, p. 287, no. 3. Edward III also pawned it: in 1356 it is described as '*nadgaires engage es partie de Flandres*', see Legg, *Coronation Records*, p. 79. By this date it was probably no longer used in the coronation ceremony. It was possibly the Plantagenet crown brought by the Empress Matilda and used in 1189 to crown Richard I, when its great weight was noted, see E. F. Twining, *European Regalia*, London, 1967, pp. 51, 105.

Weights and values (or both) are usually mentioned in inventories, but interpretation is complicated by the use in the 14th century of both Tower (or 'goldsmiths') and Troy pounds, the latter being more common by *c*. 1400. One Troy pound (373.2g.) was made up of 12oz., each ounce being of 31.1g. A Tower pound was

lighter at 349.9g. A mark consisted of eight ounces. See R. D. O'Connor, *The Weights and Measures of England*, London, 1987, pp. 261ff., and R. E. Zupko, *Dictionary of Weights and Measures of the British Isles*, Philadelphia and Oxford, 1985.

13. See notes 17, 19 and 40 below.

14. See *A Collection of all the Wills now Known to be Extant of the Kings and Queens of England*, ed. J. Nichols, London, 1780, p. 68; the Black Prince died on 8 June 1376.

15. Ibid., pp. 69, 72.

16. Oxford, Bodleian Library, MS Eng. hist. c. 775, dated 13 May, 1 Richard II (1378), and headed 'An inventory of the plate and valuables delivered to John Bacoun, clerk, by William Sleford, Dean of Westminster'. Most is silver, much of it gilt, with about 40 items of gold. The most valuable secular items are a gold cup valued at £35 (p. 7) and a silver-gilt 'nef', enamelled, and with the arms of England and France, weighing over 46lb. and worth £66 13s. 4d. (p. 4). Apart from the gold chalices the most valuable ecclesiastical object was the huge alms dish shaped as a 'nef', of silver gilt with eight banners along its sides, engraved with letters of 'sarzinesse', weighing over 70lb. and worth £141 (p. 4).

17. For the Edward cup with St Paul, worth 58s., weighing 46s. 8d., see ibid., p. 9; for the mazer, which weighed over 25lb., see ibid., p. 10.

18. Ibid., p. 7—its weight only 27s.

19. Spoons decorated with crowned 'E's: ibid., pp. 3, 5, 7; pot with a white deer, ibid., p. 1, the pair valued at £22, weight over 11lbs.; kitchen pot weighing 8lb. 15d., ibid., p. 4.

20. For these badges, see T. Willement, *The Armorial Insignia of the Kings and Queens of England*, London, 1821, p. 20, and R. W. Lightbown, *Mediaeval European Jewellery*, London, 1992, p. 167. The 'al is for the best' dish is on p. 1 of Oxford, Bodleian Library, MS Eng. hist. c. 775, valued at £15, weight 9lb. 9s. 8d.; the pairs of basins also p. 1.

21. The horn, valued at £6 13s. 4d. (ibid., p. 4).

22. Described as one large, worth 20s., and one small, worth 10s., both on p. 6 (ibid.). A similar-sounding *scaccarium* of crystal and jasper belonged to Edward II's queen, Isabella: see PRO, E 101/393/4, f. 4.

23. Oxford, Bodleian Library, MS Eng. hist. c. 775, p. 4: the toaster is valued at £4 13s. 4d., the folding gridiron in a leather case, at 102s. They sound very like those described in the 1399 inventory of Henry IV, see Palgrave, ed., *Kalendars*, Vol. III, p. 335, nos. 132-4.

24. Oxford, Bodleian Library, MS Eng. hist. c. 775, p. 5. The most valuable single gold chalice and paten is valued at £50 (including a spoon): see ibid., p. 1. This set of chalice and cruets etc. (ibid., p. 5) made up part of the plate that was pawned in 6 July 1382, securing a loan of £2,779 11s. 6d., see *CPR 1381-85*, p. 149.

25. Oxford, Bodleian Library, MS Eng. hist. c. 775: images of the Virgin Mary on p. 7, at 12lb. worth £24 and on p. 11 at 11lb. 2d. worth £22; St Michael, p. 7, £10, weight 101s. 8d.; and St Gabriel, p. 11, £40, weight 19lb. 9s. 9d.

26. Ibid., pp. 6, 8. Edward III had a large collection of reliquaries and images: W. M. Ormrod, 'The Personal Religion of Edward III', *Speculum*, LXIV, 1989, pp. 853–60.

27. PRO, E 101/334/12, dated 11 January, 50 Edward III (1377), and apparently almost identical with PRO, E 101/335/2, for 1 Richard II, which is damaged and incomplete.

28. See note 12 above.

29. St Edward's Crown, also known as King Alfred's Crown, was probably a two-arched crown, arched over the top, and may have come from the tomb of Edward the Confessor, who had been translated in 1269. Two crowns were always used during the coronation service; the first—for the actual ceremony—was worn during the mass, after which it was removed and replaced by the State Crown for the procession from Westminster Abbey to the Hall. See A. Sutton and P. Hammond, *The Coronation of Richard III*, Gloucester, 1983, pp. 231–2; Twining (cited in note 12 above), pp. 105–6; M. Holmes, 'New Light on St Edward's Crown', *Archaeologia*, XCVII, 1959, pp. 213–23, esp. p. 216; it weighed 79oz. St Edward's regalia was in the custody of Westminster Abbey until the Commonwealth, when it was destroyed. R. W. Lightbown seems to suggest (in C. Blair, ed., *The Crown Jewels*, London, forthcoming, 1998) that St Edward's Crown and the 'grande couronne' were synonymous, although their weights are clearly not the same. The issue is

complicated by the vagueness of medieval terminology, and opinions differ. For good summaries of evidence and opinion, see P. Grierson, 'The Origins of the English Sovereign and the Symbol of the Closed Crown', *British Numismatic Journal*, XXXVIII, 1964, pp. 127–34, and D. Hoak, 'The Iconography of the Crown Imperial' in *Tudor Political Culture*, ed. Dale Hoak, Cambridge, 1994, pp. 54ff.

30. *Age of Chivalry*, cat. no. 713.

31. See note 132 below. The fashionable style of the crown in the Westminster Abbey portrait, with its tall fleurons, suggests a date after *c.* 1380, and it may have been bought by Richard. Compare the crowns on the corbels in All Souls College Chapel, Oxford; see Whittingham, 'Chronology', pp. 12–21.

32. See note 12 above; the crown made for Charles V, '*la tres belle et la meilleure couronne*', had been dismembered by 1417 by Charles VI who also dismembered another crown to fund gifts to Richard and the English at Saint-Omer in 1391, A. Colville, 'La très belle couronne royale' in *Mélanges offerts à Nicolas Iorga*, Paris, 1933, pp. 183–98.

33. *Kalendars*, ed. Palgrave, Vol. III, pp. 309–10; the inventory is undated. In 1378 a loan of £10,000 to Richard by John Philpot and others of London was secured by this crown and two others, as well as gold vessels and a large '*nouche*' with a hart, see *Foedera*, ed. Rymer, Vol. III, Parts 3–4, p. 74.

34. Although the association of this stone with the Black Prince is now thought unlikely (see C. Blair, ed., *The Crown Jewels*, London, forthcoming, 1998), this type of large spinel was being collected at this time, whether by Jean de Berry or the Black Prince, see E. F. Twining, *A History of the Crown Jewels of Europe*, London, 1960, p. 22. For the State Crown, see Twining (cited in note 12 above), pp. 51ff., pl. 16c.

35. PRO, E 101/400/29, dated 9 March, 7 Richard II (1384). The only extant medieval basinet (helmet) with crown is in the Cathedral of St Stanislaus, Cracow, see G. F. Laking, *A Record of European Arms and Armour through Seven Centuries*, 6 vols., London, 1920–22, I, pp. 233–4.

36. T. Müller and E. Steingräber, 'Die französische Goldemailplastik um 1400' in *Münchner Jahrbuch der Bildenden Kunst*, 3rd Series, V, 1954, p. 71, cat. no. 7. Charles VI's kettle-hat, which incorporates a crown, was found in the recent Louvre excavations, and his basinet, now without its original gold crown, is preserved at Chartres Cathedral, see M. Fleury and J.-P. Reverseau, *Casques royaux, fin XIV^e–début XV^e siècle*, Paris, Musée de l'Armée, 1989.

37. PRO, E 101/400/6, August, 2 Richard II (1378), f. 5, for the mazer and cup named 'Edward', f. 2 for a box containing emeralds and rubies, and f. 4 for silver spoons with crowned 'E's. All were apparently listed prior to their sale; many pieces are those seen in Oxford, Bodleian Library, MS Eng. hist. c. 775 (see notes 17 and 19 above).

38. H. T. Riley, *Memorials of London and London Life…A.D. 1276–1419*, London, 1868, pp. 429–30.

39. The standard articles on *ronde bosse* are Müller and Steingräber (cited in note 36 above), pp. 29–79; E. Kovacs, 'Problèmes de style autour de 1400', *Revue de l'art*, XXVIII, 1975, pp. 25ff., and H. Tait, *Catalogue of the Waddesdon Bequest. I: The Jewels*, London, 1986, pp. 22–47. An exhibition of it, focusing upon the Altötting Goldenes Rössl, took place in the Bayerisches Nationalmuseum, Munich, in 1995. See R. Baumstark and R. Eikelmann, eds., *Das Goldene Rössl*, Munich, 1995.

40. The letter 'R' makes an early appearance on Richard's gold signet, for the making of which Nicholas Twyford, goldsmith of London, was paid 6s. 8d. (PRO, E 403/468, 26 April 1378). Spoons with a crowned 'R' occur throughout the reign, for example made by William Fitzhugh, PRO, E 101/402/3 (13 Richard II), f. 9, sold for melting although '*novo fact*' '. The leopard's head on the Shrewsbury bowl is the sterling mark, see M. Campbell, 'The Shrewsbury Bowl', *Antiquaries Journal*, LXVIII, 1988, pp. 312–13.

41. PRO, E 101/396/11, for 43 Edward III, ff. 23–25v.

42. PRO, E 101/402/5, ff. 38–43v. The goldsmiths are Fitzhugh, Polle, Twyford (see notes 104–6 below), Bottesham, Welford and Remmesbury. The gold cup and cover are '*ad modum unius rose*'.

43. PRO, E 368/174, m. 65 d. Earlier caches of church vessels are recorded in 1399 and 1401 in Pembroke and Haverford Castles respectively, deposited either before or after Richard's final expedition to Ireland. See *CPR 1399–1401*,

p. 381, a gold chalice and cross, silver-gilt candlesticks from the Pope and a censer, in the custody of Nicholas Inglefield. At Haverford were vestments and only a gold cross and chalice, and three crowns 'for the body of Christ', *Kalendars*, ed. Palgrave, Vol. III, p. 58, and J. W. Sherborne, 'Richard's Return to Wales in July 1399', *Welsh History Review*, VII, 1974–75, pp. 302–3. See also note 152 below.

44. PRO, E 368/174, m. 65 d., many of the pieces may have been the forfeited goods of Thomas Beauchamp, Earl of Warwick (d. 1397). Also included was an 'arras' of the life of St John the Baptist.

45. PRO, E 403/468, 26 April 1378: half the sum was '*pro factura*'. At the Coronation, the King processed both from the Tower to Westminster Abbey and from the Abbey to Westminster Hall, and a canopy of silk was held over his head by the Barons of the Cinque Ports, see Legg, *Coronation Records*, p. 115.

46. Included also are silver-gilt dog collars, one decorated with ostrich feathers for 26s. 8d. (PRO, E 403/468, 26 April 1378).

47. 1 January, 5 Richard II (1382), cited by Riley (cited in note 38 above), p. 444. The same crown, weighing 4lb. 13s. 4d., was pawned with other items a few months later in 1382 for a total of £2,000, see *Foedera*, ed. Rymer, Vol. III, Part 3, p. 140.

48. PRO, E 403/496, 6 May, 6 Richard II (1382).

49. E. Taburet-Delahaye, *L'Orfèvrerie gothique au Musée de Cluny*, Paris, 1989, cat. no. 131, pp. 248–51, a Bohemian brooch-reliquary of silver gilt and enamel, with gems, *c.* 1350. Also K. Otavsky and E. Poche, 'Prag und Böhmen: Goldschmiedekunst', and J. M. Fritz and S. Czymmek, 'Goldschmiedekunst', both in *Die Parler*, Vol. II, pp. 699–713 and Vol. III, pp. 164–8 respectively, and *Kaiser Karl IV* (cited in note 9 above).

50. L. Mirot, 'Un Trousseau royal à la fin du XIVᵉ siècle', *Mémoires de la Société de l'Histoire de Paris et de l'Île de France*, XXIX, 1902, pp. 125–58; A. Tuck, 'Richard II and the Hundred Years' War' in *Politics and Crisis in Fourteenth-Century England*, eds. J. Taylor and W. Childs, Gloucester, 1990, p. 128 and n. 50.

51. *Chronique de la traison et mort de Richart II*, ed. B. Williams, London, 1846, pp. 108–13.

52. P. Meyer, 'L'Entrevue d'Ardres 1396', *Annuaire-bulletin de la Société de l'Histoire de France*, XVIII, 1881, pp. 209–24. Payments for gifts to the King of France and the Duke of Burgundy appear in the Issue Rolls, PRO, E 403/559, for 11 June 1398 (a gold collar and a '*tabulette*'), but do not correspond to those given away at Ardres.

53. Discussed, with references to the extensive literature, by Dillian Gordon in *Making and Meaning*, pp. 49–50.

54. For the hart as associated with Charles V and Charles VI of France (shown on gold ingots and in the form of a gold statue in the Palais de Justice in Paris), see A. Blanchet, 'Cerunnos et le cerf de Justice', *Académie Royale de Belgique: Bulletin de la classe des lettres et des sciences morales et politiques*, 5th Series, XXXV, 1949, pp. 322–6; also *Making and Meaning*, p. 63 n. 21. The *Queste de Saint Graal* has been cited as inspiring Charles VI by its tale of the white stag with golden collar, see C. Beaune, 'Costume et pouvoir en France à la fin du moyen âge: les devises royales vers 1400', *Revue des sciences humaines*, CLXXXIII, 1981–83, pp. 136–7. It is interesting that this book is one of the few known to have been inherited from Edward III by Richard and in his possession in 1384–85, see V. J. Scattergood, 'Literary Culture at the Court of Richard II' in *English Court Culture*, p. 32.

55. *Making and Meaning*, p. 50, fig. 10 and see note 7 above.

56. See note 7 above.

57. *Making and Meaning*, pp. 26–7, and pls. 2 and 3.

58. PRO, E 403/556, 1 December 1397: each of the more costly *cervi* was accompanied by a piece of red velvet '*de Crymezin*'.

59. PRO, E 403/556, 4 December 1397. These may have been made by Christopher Tildesley, paid that year for gold and silver harts, for '*milites*' and '*scutiferi*' respectively, see Enrolled Accounts, PRO, E 361/5, roll 10.

60. PRO, E 403/561, m. 14. Funds collected for the crusade were to be kept in a chest in St Paul's Cathedral, see *CPR 1396–99*, p. 597, for 22 June 1399.

61. C. A. Dehaisnes, *Documents et extraits divers concernant l'histoire de l'art dans la Flandre avant*

le XV siècle*, 2 vols., Lille, 1886, pp. 865–6, and *Age of Chivalry*, cat. no. 725.

62. Clearly of *ronde bosse* enamel, this was given to the Countess of Derby, see Wylie (cited in note 8 above), Vol. IV, p. 161. Herman was almost certainly Herman van Cleve, recorded as maker of the extant Dublin civic sword *c*. 1390–99 (see *Age of Chivalry*, cat. no. 730), probably one of John of Gaunt's goldsmiths too, and one of the influx of 'Dutch' goldsmiths to England at this time, see T. F. Reddaway and L. E. M. Walker, *The Early History of the Goldsmiths' Company 1327–1509*, London, 1975, pp. 120ff.; M. L. Campbell, 'English Goldsmiths in the 15th Century' in *England in the Fifteenth century*, ed. D. Williams, Woodbridge, 1987, pp. 50-51.

63. Wylie (cited in note 8 above), Vol. IV, p. 169.

64. The payment by the Earl of March is for 1393–94 in an account wrongly attributed to Richard, see W. Paley Baildon, 'A Wardrobe Account of Richard II', *Archaeologia*, LXII/II, 1911, pp. 499, 504 and 511.

65. Skirlaw's cup weighed 18 marks, and had '*uno chapletto in fundo de rosis albis blancis et rubeis*'; also from Richard may have been a silver cover with the arms of the Prince of Wales, and a mazer cup with an image of St John the Baptist inside, and a lid bordered with silver eagles and enamelled with a chaplet of green and white roses. See *Testamenta Eboracensia*, Vol. I, ed. J. Raine, Surtees Society, IV, 1836, pp. 317–18.

66. Golafre died 18 November 1396. His will is dated 19 January 1396 (London, Lambeth Palace Library, Register Arundel I, ff. 155–6). He also left to the King a diamond ring inscribed on the inside '*saunz departier*', a motto not uncommon on rings and brooches of the period, see J. Evans, *English Posies and Posy Rings*, London, 1931, p. 13. The pounced cup is left to Baldwyn Beresford, and another, pounced with vine leaves, to Richard Abberbury (Register Arundel I, f. 155). For Golafre's tomb, see N. Saul, 'The Fragments of the Golafre Brass in Westminster Abbey', *Transactions of the Monumental Brass Society*, XV/I, 1992, p. 19ff.

67. Christmas 1377, all goldsmiths' work supplied by Nicholas Twyford, is documented in PRO, E 403/468 (1 Richard II: 1378), where 79 gold rings, 24 silver-gilt cups, and various lesser items cost £145 3s. 6d. By the following Christmas, expenditure exceeded £200, see

note 68 below. In 1398 Isabelle spent over £500, PRO, E 101/403/15 (see note 71 below).

68. PRO, E 101/400/7, for 26 February, 2 Richard II (1379), for Christmas 1378. Altogether there are about 75 drinking vessels, with an average value of £5 each.

69. London, Victoria and Albert Museum, no. M 239–1962 (from the Philip Nelson and Joan Evans collections). This is unusual in having an English inscription; most examples read '*en bon an*', see T. Murdoch, ed., *Treasures and Trinkets– Jewellery in London from Pre-Roman Times to the 1930s*, exh. cat., Museum of London, 1991, cat. nos. 74, 118.

70. A *hanap*, a goblet and a '*godet*', each valued at 8 marks. Another presumably Parisian piece was the gold *hanap* called 'lowys' which had belonged to the King of France, valued at £83 2s. 6d. on 9 March, 7 Richard II (1384), PRO, E 101/400/29; its weight was 117s. 9d. By this date, Paris had for long had the largest concentration of goldsmiths in Northern Europe. Not only did Edward I send his goldsmith, Adam, to Paris to buy jewels in 1285, but in 1290 his wife, Eleanor, was buying jewels from Parisian merchants visiting London, see Lightbown (cited in note 4 above), pp. 41, 59.

71. PRO, E 101/403/15, dated 3 January, 21 Richard II (1399).

72. For Christmas 1396, Bouer, 'citizen and jeweller of London', and William Fitzhugh, goldsmith and citizen of London (see note 105 below), receive payment in May 1397 (PRO, E 403/555). On 16 May Bouer is paid £9 6s. 8d. for paternosters and a gold tablet with pearls and saints. On 24 May, Fitzhugh is paid a total of £80 largely for the gold cup (£46 10s.) and ewer (£25 10s.) given by Isabelle to the King. John Pallyng, '*mercator*', is paid £106 6s. 8d. on 19 October 1397 (PRO, E 403/556), for gold rings, brooches and '*tabulettes*' for Isabelle's '*novis donis ad festum Natalis ult.*' and Roland Bussch, goldsmith, is paid £140 16s. 8d. only on 26 December (ibid.), probably also for Christmas presents of 1396.

73. Barantyn and '*certeines autres persones de nostre citee de londres*' were paid for Christmas 1384 on 15 June, 8 Richard II (1385), PRO, E 404/22/541.

74. PRO, E 403/562, for 20 June, 22 Richard II (1399). The cross, ornamented with balases, sapphires and and pearls, was bought '*ad opus*

ipsius domini Regis…ad festum Natal. ult'. Beryl was clearly valuable and seems to have been a sort of crystal; see *beril* in H. Kurath and S. Kuhn, eds., *Middle English Dictionary*, Michigan and Oxford, 1956 and later.

75. PRO, E 403/562, for 30 June 1399. The London goldsmith Thomas Lamport was paid £8 13s. 4d. for metal and the work of mending and gilding a silver *'nef'*, and for making the six silver escutcheons for a pair of candlesticks given at the previous Christmas.

76. When crowns are described, notable care is taken over the number and type of gems—by far the most valuable component—as with the crown worth £1,719 13s. 4d., where the gold accounts for just £42, and a single balas (spinel ruby) of 180 carats (at £3 6s. 8d. per carat) for £800 6s. 8d. See *Kalendars*, ed. Palgrave, Vol. III, pp. 309–10 and note 12 above. For seals, see note 79 below.

77. Balthazar Lumbard is paid 18 December 1385 (PRO, E 403/510); Bartholomaeus Lumbard, merchant of Lucca—perhaps the same man—offers precious stones and jewels as well as crowns to the King, with a companion, Louis Daport, who offers cloths of silk and gold, 24 May 1391 in *Foedera*, ed. Rymer, Vol. III, Part 4, p. 68. The Lucchese were also notable lenders of money to the Crown from the time of Edward III to Henry IV, see H. Bradley, *Italian Merchants in London, 1350-1450*, Ph.D. thesis, University of London, 1992, 457ff., Appendix 21.

78. *Eulogium Historiarum sive temporis…*, ed. F. S. Haydon, Rolls Series, IX, 3 vols., London, 1858–63, III, p. 378.

79. All are most usefully discussed by H. C. Maxwell Lyte, *Historical Notes on the Use of the Great Seal of England*, London, 1926, pp. 112–17; Tout (cited in note 1 above), Vol. V, pp. 133, 142, 200–6 and pls. III and IV; A. and A. B. Wyon, *The Great Seals of England*, London, 1887, nos. 67–9 and pl. XI. William Geyton, 'the King's engraver', was paid for alterations to the Great Seal and other seals early in the reign (Wyon, Appendix F). Peter de Hiltoft, another engraver, was paid for other seals in 1391, Devon, *Issues*, p. 246. The engraver of the handsomest seal, the Privy (Tout, Vol. V, pl. III), is not known at present.

80. See note 40 above. This may have been a finger ring. When Richard formally resigned the throne, he took from his finger *'anulum auri de signeto suo patentium'* and placed it on Henry's finger. There is no way of knowing what this ring was.

81. Doubler and Barantyn were paid on 3 December 1393 *'super fabricacionem'*, the King probably providing the metal and gems (PRO, E 403/546). By contrast, the £550 owed to Barantyn by the King in 1385 for a gold and gem collar probably represented both materials and workmanship (PRO, E 404/22/540). The 1398 payments to Barantyn are dated 11 June (PRO, E 403/559); the £40 seem to have been for setting gems into a collar (*'fousura unius collar operati de diversibus perr.'*) given to the King of France by Richard.

82. PRO, E 403/556, for 4 December 1397.

83. First mentioned in the Issue Roll for 22 January 1397/8 (PRO, E 403/556). Bellon was paid via Francis Almeyn *'lumbarde'* for the *'fabricacionem et operacionem'* of the gold 'plates' with balases, sapphires and pearls, *'apud civitatem Paris in Francia'*. In November 1399 they are listed as no. 265 of a long inventory, see *Kalendars*, ed. Palgrave, Vol. III, p. 350.

84. The Belons, also known as Belnati, were Lombard merchants who had supplied the French monarchy since the 1320s, see D. Gaborit-Chopin, *Inventaire du Dauphin 1363*, Paris, 1995, n. 26, also L. Mirot, 'La Colonie Lucquoise à Paris du XIII^e au XV^e siècle', *Bibliothèque de l'École des Chartes*, LXXXVIII, 1927, pp. 50–86, and A. Capitanio, 'Maestri e statuti dell'arte orafa a Lucca tra XIV e XVI secolo', *Annali dell scuola normale superiore di Pisa*, 3rd Series, XIII, 1993, pp. 485–505. No 'Assine' occurs in these, and it is conceivable that this is instead a distortion of Hans Bellyne, a goldsmith who was working for the Duke of Burgundy in 1417, see A. de Laborde, *Les Ducs de Bourgogne*, 3 vols., Paris, 1849–52, III, no. 6258.

85. *Foedera*, ed. Rymer, Vol. III, Part 4, p. 66, for 27 December 1390, in which Spynola seeks a licence to exempt him from customs payment if the piece was unsold.

86. *Inventories of St George's Chapel Windsor*, ed. M. Bond, Windsor, 1947, listed in the 1384 inventory as no. 64 at pp. 78–9.

87. See note 81 above.

88. See note 81 above. The *'tabulette'* was for the Duke of Burgundy, perhaps also an Ardres gift.

89. *Historia Anglicana* (cited in note 6 above), Vol. II, p. 222. Walsingham was writing with prejudice (see A. Gransden, *Historical Writing in England*, 2 vols., London, 1974–82, II, Chapter 5), and cites expenditure as exceeding 50,000 marks.

90. See note 52 above.

91. Meyer (cited in note 52 above), pp. 217, 213. Richard gave a lavish number of presents. He also gave to Charles VI, a gold *hanap* and a ewer (ibid., p. 218), and costly '*nouches*' to the French dukes (ibid., pp. 215, 217).

92. Ibid., pp. 214, 217. The tiger was one of Charles VI's badges. The Bestiary tale of the tiger and the mirror was adopted in heraldry, see G. C. Druce, 'Sybill Arms at Little Mole, Eynsford', *Archaeologia Cantiana*, XXVIII, 1909, pp. 363–72, esp. p. 364. The tiger *nef* is surely '*la Tigre…une almesdisshe dor esteant sur une urse dor*', weight 12lb. 1½oz., still in Henry VI's possession in 1433 (*Kalendars*, ed. Palgrave, Vol. III, p. 370), but soon after given to the Duke of Bedford (ibid., Vol. II, p. 145).

93. Londoners' gifts for Christmas 1392, see *Polychronicon Ranulphi Higden Monachi Cestrensis*, eds. C. Babington and J. R. Lumby, Rolls Series, XXXXI, 9 vols., London, 1865–86, IX, p. 278. Earlier that year, London had fêted Richard and Anne, presenting them with two golden crowns, two gold cups or basins, golden images of St Anne and the Trinity, and other exotica, see C. M. Barron, 'The Quarrel of Richard II with London, 1392–97' in *Reign of Richard II*, pp. 189–91.

94. David (cited in note 4 above), p. 62. This, at 1,800 francs, was the most costly of the gold images presented, second in value only to the gold collar (2,600 francs) given to his wife. The Diptych, too, gives prominence to St Edward, shown holding a ruby(?)-set ring.

95. Dehaisnes (cited in note 61 above), Vol. II, p. 737.

96. *Inventaires de Jean, Duc de Berry*, ed. J.-J. Guiffrey, 2 vols., Paris, 1894–96, II, p. 19, no. 65; the Ashanti jug is cat. no. 726 in *Age of Chivalry*.

97. A full translation of Courtenay's will is in J. H. Dahmus, *William Courtenay, Archbishop of Canterbury 1381–96*, Pennsylvania State University Press, University Park and London, 1966; for the feather cup, see p. 269, and for other gifts from Richard, see pp. 272–3. The undated inventory mentions both a gold ewer and a cup with ostrich feathers (PRO, E 101/403/24).

98. For foreign goldsmiths in London, see Reddaway and Walker (cited in note 62 above), pp. 120ff. and note 62 above, also M. L. Campbell, 'Gold, Silver and Precious Stones' in *English Medieval Industries*, eds. J. Blair and N. Ramsay, London, 1991, pp. 164-5. Records about foreigners are scattered, since they often were not freemen of the Company, and worked directly for their customers without the need for a retail outlet. Standelf was the Company's Warden in 1388 (ibid., p. 327) but does not appear otherwise, although he worked regularly for the King from at least 1392; see, for example, PRO, E 101/402/10, ff. 3, 13 (16-17 Richard II). Hans alias John Doubler was a citizen of London, a goldsmith but not a member of the Goldsmiths' Company; see Reddaway and Walker (p. 279). Items supplied to Richard are detailed in PRO, E 403/546, 547, 549, 561, for the period 1393–98, and there are probably many more.

99. Paid modest sums for repairs: London, British Library, MS Add. 35115 (Wardrobe Book for 16-17 Richard II, i.e. 1392–94), f. 38v, 3s. 4d. paid for mending silver *ollae*; PRO, E 403/556, 4 December 1397, for the work and gold used in repairing the King's chalice, £8 6s. 8d.

100. Cost of engraving, paid to William Fitzhugh: PRO, E 101/402/5 (Wardrobe Book for 13–14 Richard II, i.e. 1389–91), f. 28. Fitzhugh was again responsible for engraving the new arms on plate: PRO, E 101/403/10 (Wardrobe Book for 19–20 Richard II, i.e. 1395–97), f. 38 (1395–96), discussed further by Harvey, 'Wilton Diptych', p. 6, but see note 105 below.

101. One or other—if not both—are named in the Wardrobe Books throughout the reign, the earliest is PRO, E 101/401/9, for 4–9 Richard II (1380–86).

102. PRO, E 403/489, 14 December 1381, when he is paid for mending the King's gold cross for his chapel and for the price of some silver cups (£59 8d.). '*Aurifaber regis*' occurs elsewhere for Twyford, but was probably more a term of convenience than an official designation such as Tildesley enjoyed (see note 107 below).

103. See notes 46, 67 and 68 above.

104. For Twyford's biography, see Reddaway and Walker (cited in note 62 above), pp. 311–12.

Twyford died in 1390 (yet continues to be mentioned in royal Wardrobe Books after then). For his work for John of Gaunt, Duke of Lancaster, see *John of Gaunt's Register 1372–76*, ed. S. Armitage-Smith, Camden Society, 3rd Series, XX–XXI, London, 1911, nos. 1124, 1342, 1659, 1661 and *John of Gaunt's Register 1379–83*, eds. E. C. Lodge and R. Somerville, Camden Society, 3rd Series, LVI–LVII, London, 1937, nos. 256, 463.

105. For example, imprisoned in Newgate in 1372; see Reddaway and Walker (cited in note 62 above), p. 40. He died in 1389 (ibid., p. 44); a goldsmith of the same name was four times Company Warden between 1398 and 1417, perhaps his son (ibid., p. 368). For other references, see ibid., pp. 43, 48, 58, 291. It therefore cannot be certain at what date Fitzhugh engraved Richard's new arms—including those of St Edward—onto silver (see note 100 above).

106. Polle died in 1413, and was three times Company Warden between 1378 and 1395, Reddaway and Walker (cited in note 62 above), p. 302, also S. Thrupp, *The Merchant Class of Medieval London*, Ann Arbor, Mich., 1948, p. 361. To date, 31 individuals are known to have supplied Richard—goldsmiths, merchants, jewellers, and engravers. Of these, 24 were active goldsmiths, most but not all being members of the Goldsmiths' Company. It is noticeable that some goldsmiths appear in certain records and not others; Christopher Tildesley, 'King's goldsmith', does not figure in the Wardrobe Books.

107. Tildesley is cited by Reddaway and Walker (cited in note 62 above), only for being Company Warden in 1402. Active until at least 1411 (see note 110 below). He was named King's goldsmith by patent in March 1398, in succession to John (*sic*) Harsey, deceased, *CPR 1396–99*, pp. 319, 33. His predecessor, actually Thomas Hessey, was dead by 1376 at the latest. Tildesley received an annual payment for this office from both Richard and Henry IV, and was paid by Richard for going with him to Ireland in 1399 (PRO, E 361/5, roll 26). Barantyn (d. 1415) was one of the richest goldsmiths of his day; see biography in Reddaway and Walker (pp. 279–82), also Thrupp (cited in note 106 above), p. 323.

108. See note 79 above.

109. See note 107 above.

110. For Richard, see note 59 above, also PRO, E 361/5, roll 9: payment of £315 12s. 1½d. for gilding and enamelling the King's chapel ornaments at Christmas 1397. Rich commissions from Henry included £509 16s. 3d. for making collars and other jewels, paid on 8 January 1411 (PRO, E 404/25/179).

111. For Barantyn's marriage, see Reddaway and Walker (cited in note 62 above), p. 280, and note 107 above.

112. Discussed most recently by Bradley (cited in note 77 above), with full bibliography; also see M. L. Campbell, 'L'oreficeria Italiana nell' Inghilterra medievale' in *Oreficerie e smalti traslucidi nei secoli XIV e XV*, supplement to *Bollettino d'Arte*, XXXXIII, 1987, pp. 2–3.

113. See notes 50, 52, 70 above. Isabelle's trousseau included silver bird-cages, and dolls equipped with silver-gilt vessels; one of the goldsmiths who helped make the trousseau was Jehan Clerbouc, goldsmith also to Isabel of Bavaria, see P. Henwood, 'Les Orfèvres parisiens pendant le règne de Charles VI (1380–1422)', *Bulletin Archéologique*, New Series, XV, 1979, pp. 122–4.

114. Davy was paid 1s. a day to stay in the Tower workshops teaching and making armour, see Tout (cited in note 1 above), Vol. IV, p. 476.

115. Lodevico de Turry, otherwise Louis 'the goldsmith', made, repaired, and enamelled jewellery in 1391–92 for Henry Bolingbroke, Earl of Derby, see Campbell (cited in note 112 above), p. 3; PRO, DL 28/1/3, f. 15v; and Wylie (cited in note 8 above), Vol. IV, p. 161.

116. *Kalendars*, ed. Palgrave, Vol. III, p. 313ff., nos. 53, 55, 56, 71, 74. For extant Bohemian work, see note 49 above and J. M. Fritz, *Goldschmiedekunst der Gotik*, Munich, 1982, pp. 222–5, pls. 259–68.

117. '*Der Rat der Reichsstadt Nürnberg schenkt der Königin Anna...Schwester König Wenzels, zwei vergoldete "koppf" pokale, die ihn 52 fl. kosten*' (Nuremberg Staatsarchiv, rep. 54, Stadtsrechnungen, grosse Register I, f. 48v), information for which I am indebted to Professor Wolfgang von Stromer of Erlangen/Nuremberg University. For these distinctively Germanic cups, see Fritz (cited in note 116 above), pp. 355–6, pls. 369–70.

118. Paid £10 for armour ('*galea* and plates') on 6 May 1383 (PRO, E 403/496).

119. 6 July 1382 (*CPR 1381–85*, p. 149). The Spanish gold saddle was valued at £682 13s. 4d. and the palet of gold with gems at £1,708. These and the rest are discussed in W. Childs, *Anglo-Castilian Trade in the Later Middle Ages*, Manchester, 1978, p. 141 nn. 221-4.

120. PRO, E 101/400/29, 9 March 1384.

121. See note 53 above.

122. See note 57 above.

123. *Age of Chivalry*, cat. no. 724. By 1384 Richard owned two gold astrolabes (PRO, E 101/400/29) and in 1399 he left a gold quadrant (*Kalendars*, ed. Palgrave, Vol. III, p. 316, no. 16) set with pearls and enamelled.

124. See note 96 above, and also M. McLeod, 'Richard II, Part 3, at Kumase' in *West African Economic and Social History: Studies in Memory of Marion Johnson*, eds. D. Henige and T. C. McCaskie, Madison, Wis., 1990, pp. 171–4 and M. Bailey, 'Two Kings, their Armies and some Jugs', *Apollo*, CXXXVIII, 1993, pp. 387–90.

125. See note 79 above (Tout).

126. See note 100 above and W. de G. Birch, *Catalogue of Seals in the Department of Manuscripts, British Museum*, 6 vols., London, 1887, I, pp. 28–30, 83–4.

127. *Age of Chivalry*, cat. no. 13.

128. It has most recently been studied in detail by Renate Eikelmann, *Mittelalterliche Kronen in der Schatzkammer der Residenz München*, MA thesis, Ludwig-Maximilian University, Munich, 1980, pp. 167–202. She considers it to be Parisian work, possibly the gift of Charles V to the Emperor Charles on his visit to Paris in 1378 (ibid., pp. 201–2). The weight is 1.5kg.

129. *Kalendars*, ed. Palgrave, Vol. III, pp. 175, 339; see also J. Cherry, 'Late Fourteenth-Century Jewellery–the Inventory of 1399', *Burlington Magazine*, CXXX, 1988, pp. 137–40. It is worth noting that several coronals are described in Isabelle's trousseau (see note 113 above) and some have a superficial resemblance to the Munich Crown, especially in the types of gems used, but these were very commonly used in crowns. But the Munich Crown—even with eleven links—would have been far too big for Isabelle, a child of nearly eight at the time of her marriage.

130. References in notes 127 and 128 above.

131. The effigies of Anne and Richard in gilt copper were designed and made between 1395 and 1399 by Nicholas Broker and Godfrey Prest, coppersmiths of London, see *Age of Chivalry*, cat. no. 446 (the tomb contract), and Colvin, *King's Works*, Vol. I, pp. 487-8. Costing in all nearly £1,000 it was the most expensive 14th-century royal tomb. See also J. G. Nichols, 'Observations on the Heraldic Devices Discovered on the Effigies of Richard II and his Queen', *Archaeologia*, XXIX, 1842, pp. 32–49.

132. Although damage and their size make interpretation of the gems on the Diptych crown uncertain, there is a suggestion of angularity about the settings, which in turn suggests that the stones were facetted or '*quarre*', at this date a fairly recent fashion, see Lightbown (cited in note 20 above), pp. 12–17.

133. See note 52 above; Isabelle brought two broom cod collars with her too; see *Making and Meaning*, pp. 51–3, and nn. 53–9 and 71–8.

134. Museum of London, no. 8878 (6.2cm. by 1.3cm.), found in the Steelyard, City of London. Another example was found in the City at Swan Lane in a post-1422 context, now with the Museum of London Archaeology Service, no. SWA 81 (2103). Others are in private collections. See also *Making and Meaning*, pp. 52–3, and Spencer (cited in note 7 above), p. 98 and fig. 203, where these base metal broom cods are considered to be tokens of allegiance worn by Richard's supporters.

135. See notes 36, 39 above.

136. *Age of Chivalry*, cat. no. 659; J. Cherry, 'The Dunstable Swan Jewel', *Journal of the British Archaeological Association*, 3rd Series, XXXII, 1969, pp. 38–53.

137. Illustrated as fig. 9 (p. 421) in L. Monnas, 'Artists and Weavers–the Design of Woven Silks in Italy 1350–1550', *Apollo*, CXXV, 1987, pp. 416–24. The cheetah motif, here intended as a textile design, clearly derives from goldsmiths' work of the late 14th century. For the Grassi Sketch Book, see R. W. Scheller, *A Survey of Medieval Model Books*, Haarlem, 1963, cat. no. 21, pp. 142–54.

138. Müller and Steingräber (cited in note 36 above), cat. no. 11. This seems to be one of the earliest surviving examples of *pointillé* on goldsmiths' work, although it occurs juxtaposed

with Limoges enamel from the 12th century onwards. French inventories mention the technique from the 1360s (ex inf. Danielle Gaborit) and *'opus punctile'* was known to Theophilus, writing in *c.* 1123; see *Theophilus: De Diversis Artibus*, ed. C. R. Dodwell, London, 1961, pp. 129–31. Although instances of *pointillé* on early 14th-century Italian panel painting predate the surviving examples in goldsmiths' work, it seems likely that the technique was one borrowed by painters from metalworkers. That such reciprocity occurred at this date is demonstrated by the careers and work of two of the Limbourg brothers, at first (*c.* 1400) apprenticed to the Parisian goldsmith Alcbret de Bolure, see M. Meiss, *French Painting in the Time of Jean de Berry: The Limbourgs and their Contemporaries*, London, 1974, Vol. I, pp. 71–2.

139. Golafre's will, see note 65 above.

140. A. Way, 'A Gold Pectoral Cross found at Clare Castle, Suffolk', *Archaeological Journal*, XXV, 1868, pp. 59–71, with illustrations; for the pouncing on Richard and Anne's effigies, see Nichols (cited in note 131 above), pp. 54–8. By contrast, the slightly earlier Campion Hall Triptych of *c.* 1370 shows no pouncing but treats the halo of the Virgin with incised rays in a manner closely comparable with that of the Diptych, *Age of Chivalry*, cat. no. 585 and *Making and Meaning*, p. 78.

141. See notes 36, 131, 157–8. The Altötting Madonna, with Charles VI and saints, is the goldsmith's equivalent of the Diptych.

142. Most notably by Given-Wilson, *Royal Household*, and Barron (cited in note 93 above). See also note 143 below.

143. Expenses and receipts of the King's and the Great Wardrobe tabulated in Tout (cited in note 1 above), Vol. VI, pp. 94–101, 108. Loans forced by Richard, C. M. Barron, 'The Tyranny of Richard II', *Bulletin of the Institute of Historical Research*, XXXXI, 1968, pp. 12–13; loans and exceptional spending on mercery evidenced by 1393–94 Account Roll, Barron (cited in note 93 above), pp. 178, 195–7; improved finances after death of mother (1385), Given-Wilson, *Royal Household*, p. 132; rise in expenditure from 1395 (ibid., pp. 134–8); wealth of chamber from late 1390s (ibid., pp. 89–92). From 1396 Richard benefited from Isabelle's dowry—the first instalment, over £83,000, was paid between 1396 and 1399 (ibid., p. 90).

144. Given-Wilson, *Royal Household*, pp. 40–1, 134–41. Tuck argues that Richard's household was 20% larger than that of Edward III, J. A. Tuck, 'Richard II's System of Patronage' in *Reign of Richard II*, pp. 1–20; Steel describes heavy borrowing by Henry IV too, A. Steel, 'English Government Finance 1377–1413', *English Historical Review*, LI, 1936, pp. 34–5. For comparison with the Burgundian and royal French households, see Given-Wilson, *Royal Household*, pp. 258–9.

145. Apart from Richard's Irish losses (see note 152 below) objects were continually being recycled—old melted for new—given away or sold, as for instance the distinctive dish inherited in 1378 from Edward III inscribed 'al is for the best' (Oxford, Bodleian Library, MS Eng. hist. c. 775, p. 1), and sold in 1399 by Nicholas Inglefeld with much else (see PRO, E 361/5, Enrolled Accounts of the Clerk of the Wardrobe of the King's Household, roll 27 d).

146. Items specified as to be melted down in 1402–03 for *'nouvelles dons'* include the *'palet desspaigne'*, from which a gold *'cercle'* was to be made, and *'nouches'* showing falcons and griffons, given to Tildesley as a supplement to a collar of broom cods, all to go towards the making of *'un nouvel colier du Roy'*; see PRO, E 101/404/22, m. 1 (and see notes 152–6 below). Barantyn and Louth supply Henry with Christmas presents too (ibid., m. 3). These, with Palyng and Doubler, appear as suppliers of Christmas gifts in 1401–02 (PRO E 101/404/18, mm. 3 and 4). Tildesley continues as 'King's goldsmith for the works at the Great Wardrobe', confirmed on 15 January 1402 (*CPR 1401–05*, p. 110), and receives extravagant commissions from Henry, as for an SSS collar of gold and gems and the motto *'souveignez'* costing £385 6s. 8d. in 1406, Devon, *Issues*, p. 305.

147. *Kalendars*, ed. Palgrave, Vol. III, pp. 313–58, and Cherry (cited in note 129 above). Palgrave copies PRO, E 101/335/5, an indenture of 6 membranes. Each item is given a weight but no value.

148. PRO, E 101/334/12, for 11 January 1377: *'un ewer en guise dun dragon endorre'*, or *'une eawere dargent endorre ove un Roigne seant sur un Dragon esteant sur un pee darg. endorre et enaymelle'*. This document from the reign of Edward III specifies that objects are from both the Tower and Westminster treasuries; items not again encountered include a ewer enamelled

with knights of the round table and a *'terage'* with Tristram. For the gold chalice inherited in 1378, see Oxford, Bodleian Library, MS Eng. hist. c. 775, p. 5. See note 24 above.

149. See Meyer (cited in note 52 above), p. 219, and note 52 above. *Making and Meaning*, p. 51 and nn. 57–9.

150. See note 83 above.

151. Isabelle's commissions (PRO, E 101/403/15; see note 72 above) included eleven gold *'tabulae'*, either gem-set or enamelled with St George, the Virgin Mary, the Annunciation and the Passion, all perhaps comparable with the extant Campion Hall Triptych (see note 140 above), itself likely to have been a New Year commission. The Ardres Trinity (see Meyer, cited in note 52 above, p. 217) was *'une table ovec une trinite d'or et perles'*.

152. PRO, E 361/5, rot. 26 d., for 23 Richard II. Nine officials from the royal kitchen, buttery, ewery, saucery, scullery and *'hospitium'* are listed; their losses amounted to nearly 300lb. of gilt silver vessels, over 1200lb. of plain silver, valued at over £2,500. See also PRO, E 368/176, 7 April 1402, where one of these, John Halton, is excused his loss, which happened on his return from Ireland to Wales where he was *'robbez et despoillez'*. All, including a large silver kitchen ladle, is domestic plate. Only a little chapel plate is documented (see note 43 above) but that collection may have been stored and recorded separately. Clearly the records are not complete if we believe Walsingham's complaint that Richard took to Ireland *'thesaurum preterea et reliquias aliaque iocalia regnique divitias'*, see Thomas Walsingham's *Historia Anglicana* (cited in note 6 above), Vol. II, p. 232. No crowns or jewellery are documented in detail in association with Richard's Irish expedition, see G. Stow, 'Richard II in Thomas Walsingham's Chronicles', *Speculum*, LX, 1984, p. 96. Some of Richard's *'iocalia'* were left behind in Ireland and Wales, see G. O. Sayles, 'Richard II in 1381 and 1399', *English Historical Review*, XCIV, 1979, pp. 822–9. D. Johnston, 'Richard II's Departure from Ireland', *English Historical Review*, XCVIII, 1983, pp. 794–803, discusses the substantial quantity of luxuries left in Ireland, including £14,148 16s. of the King's gold (p. 803).

153. Much detail appears in the early inventories of Henry IV (see note 146); some pieces were not melted but given away, like the gold *hanap* pounced with broom given by Henry as a christening present to the son of the Earl of Somerset on 28 November 1401 (PRO, E 101/404/18).

154. Ibid., *'grosse cerf dor a guise dune nouche de don levesque de Sarum…pour un ouvrage de nouvell fait a une couronne de XI ouvrages pour ma dame Blanche'*, 17 April 1402. Another *cerf* went towards mending *'une couronne du Roy pour ma dame'*, ibid., 28 April 1402.

155. When listed in Germany in 1402, the crown is clearly described as of twelve sections, see Eikelmann (cited in note 128 above), p. 168, who further suggests that section IV of the crown (most of its components bear assembly numbers) is the addition. One of the small green and white enamel plaques set inside the crown—acting as a link—certainly looks most obviously different from the others.

156. PRO, E 101/404/22, 4–5 Henry IV (1402–4), 25 February, at Westminster.

157. Ibid., given to Syglym on 9 December *'pur portier a dame Blanche…en Alemaigne'*. The lost Munich piece also included Charles VI of France and his wife, see Müller and Steingräber (cited in note 36 above), cat. no. 7, p. 71ff.

158. London, Society of Antiquaries, MS 129, f. 10, an inventory of 'Juelles of the late King Henry VIII'. This version was probably made after 1551 (ex inf. John Goodall); another version is London, British Library, MS Add. 46348. This is one of the richest known inventories of royal jewels and plate, with over 30 folios devoted to gold items, many bejewelled. An edition is planned by David Starkey *et al.*, forthcoming (1998). For another rich cross owned by Richard, see note 85 above and PRO, E 101/400/29 (7 Richard II), where items pawned to Matthew Janyn include a cross on a green mountain worth £80.

159. See notes 4 and 104 above, and S. Armitage-Smith, *John of Gaunt*, London, 1904, and R. Barber, *Edward, Prince of Wales…the Black Prince*, London, 1978.

160. See note 98 above and, for Gaunt, see note 104 above. Among his goldsmiths were Herman, Rauland, Hans Doubler and Robert Laune (see index of Lodge and Somerville, cited in note 104 above) also Jacobes *'jueler de Parys'* (no. 1758 in Armitage-Smith, cited in note 104 above). Gaunt's will includes a gold chalice made in Bordeaux and a gold chapel

'table' called 'Domesday' bought in Amiens, see Armitage-Smith (cited in note 159 above), p. 424. Gaunt's New Year spending in 1375, on gifts of jewellery and plate amounted to £396 17s., see Armitage-Smith (cited in note 104), no. 1661, p. 299. The Black Prince also spent freely at New Year: for 1352, see *Register of Edward the Black Prince*, ed. M. C. B. Dawes, 4 vols., London, 1933, IV, p. 69. His main suppliers of jewellery and plate were two Italian brothers, Martin and John Parde of Pistoia, and Hankelyn van Lisle (ibid., Index).

161. See *Foedera*, ed. Rymer, Vol. III, Part 4, 158–9, translated in J. H. Harvey, *The Plantagenets*, London, 1967, pp. 219–23.

162. It was not unusual for a monarch to be buried with regalia of a semi-precious sort, as was Edward I, see J. Ayloffe, 'An Account of the Body of Edward I as it Appeared on Opening his Tomb', *Archaeologia*, III, 1786, pp. 376–413.

163. PRO, E 101/411/9 (catalogued as temp. Henry VI), and Ilg, 'Goldschmiedearbeiten Richards II', pp. 10–16.

164. The roll as such is evidently a later creation; originally the membranes were separate, and individually filled in (not all are full). The date is unclear; nowhere is Richard mentioned by name, although the date 5 January year 21 (1398) occurs on membrane 5, and there is a sense from the names of donors that the compilation was made after 1396, but a proper analysis needs to be carried out, both of donors and of their gifts, some of which were disposed of by Henry, like the *cerf* given by the Bishop of Salisbury, weighing 2 marks 2oz. and valued at £104 (m. 15), but melted for the Crown of Blanche in 1402 (see note 154 above). The roll is written in French, numbers over 1,200 entries—rather more than 1,500 items—of which half are of gold, many pieces being enamelled and/or gem-set.

165. Hitherto considered *'le plus important des inventaires royaux anglais'* (see F. de Mély and E. Bishop, *Bibliographie générale des inventaires imprimés*, 1892, Vol. I, no. 1576, p. 171) and published in *Rotuli Parliamentorum*, Vol. IV, pp. 214–41. Valued overall at £18,404 4s. 10d. It includes textiles and brass as well as goldsmiths' work, which predominates. The majority consists of jewellery rather than plate, and of silver gilt rather than gold.

166. From the Duc de Berry comes a gold tablet set with a cameo ('*teste dun pere d'Israel*') valued at £213 6s. 8d. (m. 29), and gold images of St Martin, at £459 6s. 10d. (m. 29), and St Katherine enamelled white, at £320 13s. 4d. (m. 29); from the Duke of Burgundy, the gold image of St Edward, at £116 6s. 8d. (m. 32 and see note 94); from the King of France, the gold '*nef*' with tigers, at £544 6s. 8d. (m. 2 and note 92 above), a pair of gold bottles with tigers and mirrors and the motto '*Jamais*', at £753 6s. 8d. (m. 2 notably heavy at 70 marks), St Edmund at £220 (m. 32), St George at £28 4s. 7d. (m. 29), and, most valuable, St Michael at £1,064 (m. 29), comparable with the lost Altötting piece, Müller and Steingräber (cited in note 36 above), cat. no. 8, pl. 22. The gold '*grande couronne*' weighing 23 marks (m. 1 and see notes 12 and 29 above) is at £33,584, more than three times the value given it in 1384 of £10,000 '*prisee en temps du roy Edward*'. Are the crowns the same? Despite the presence of balas '*quarres*' in both, a huge difference in weight (1384: 6li. 13s. 4d., and 1399: 23 marks or 15li. 6s. 8d.) indicates otherwise, and underlines the ambiguity of the term. By comparison, the Crown of Blanche (m. 1), at 3li. 6s. 8d. (1.6kg), is valued at only £246 3s. 4d., see *ill. 64* and note 128 above.

167. See note 158 above and *Inventaire du mobilier du Charles V*, ed. J. Labarte, Paris 1879, and Guiffrey (cited in note 96 above). Rich though the newly published Ricardian inventory is, it still falls short of these.

168. Printed by Palgrave (see note 147 above). Close comparison of the two would be revealing, for sections of each are identical, the same objects being listed in the same order; but Palgrave lacks the valuations, the huge quantities of gold and most of the chapel plate and reliquaries. This may suggest that the newly published inventory postdates Palgrave, and possibly includes items from various different stores. Or could it represent Richard's wealth before his fateful Irish expedition, on which so much was lost?

169. The cup inscribed 'god Grant hym gode ende yat drynketh of me to ye end', of gold, with a cover, valued at £67 7s. 6d. (m. 13) is very close to one with part of this motto, amongst the jewels forfeited to Richard by Thomas, Duke of Surrey, 22 March 1399 (PRO, E 101/334/30), which the latter had acquired from Bishop Arundel (PRO, E 403/556, 4 December 1397). Golafre (note 65) had a ring in-

scribed '*sauns departier*' but this was not an un-common motto, although the presence in the inventory of a *cerf* so inscribed (m. 32) certainly hints at a specific association.

VI. RICHARD II: KINGSHIP AND THE CULT OF SAINTS

I would like to express my gratitude to Nigel Saul who first suggested that I write about Richard II and the saints; to Caroline Barron, Michael Clanchy and Dillian Gordon for all their help and encouragement; to David Starkey and members of his post-graduate seminar at the London School of Economics; to Richard Mortimer and the staff of the Muniments Room, Westminster Abbey; to William Ryan of the Warburg Institute; Lisa Monnas; Katie Billington; Diana Dennis; and Philip, Guy and Alexander Mitchell. This paper is dedicated to the memory of the Revd Dr John Bishop, sometime lecturer at Chichester Theological College, Vicar of St Mary, Rattery, and Rector of St Mary, Dartington.

1. PRO, C 66/322, m. 44; *CPR 1385–89*, p. 188 for the Confessor; PRO, C 66/342, mm. 19 and 16; *CPR 1391–96*, p. 612 for St Edmund Rich; PRO, E 403/548, m. 4 for St Richard of Chichester; PRO, E 101/411/9, m. 29 for a relic of St Richard with one ruby and 58 pearls.

2. H. R. Luard, ed., *Lives of Edward the Confessor*, Rolls Series, London, 1858, pp. 122–3, 276–77; D. H. Farmer, *Oxford Dictionary of Saints*, Oxford, 1982, pp. 124–5 and footnotes.

3. WAM 9474, 10 August, year not given. The ring is referred to as '*...le noble relik lanel seint Edward qi fuist en la garde seint John lewangeliste en ciel*'.

4. These garments were made with 'pured' minever and ermine. See PRO, E 101/401/6, m. 7.

5. *Westminster Chronicle*, p. 373; *CChR* V, p. 312. Is this the same ring Richard had requested in 1386?

6. PRO, C 81/510, 5714; PRO, C 66/329, m. 23; *CPR 1388–92*, p. 168. Perhaps a further significance can be suggested in that this grant was made on the Vigil of the Feast of St Edmund, 19 November.

7. See note 1 above.

8. The two early books, PRO, E 101/401/9 and PRO, E 101/400/26, are incomplete. Yet the latter contains a damaged folio of Alms and Oblations which allows us to see that the Feast of the Confessor was not specially noted in this source for October 1382.

9. PRO, E 101/402/5, f. 26 which covers the period 1 October year 13 (1389) till 26 July following. The earlier existing Wardrobe Books for years 6/7 and 7/8 do not record this feast.

10. *Westminster Chronicle*, p. 451; WAM 19648. Although the editors of the Chronicle state that this last document refers to a visit in 1391 (see *Westminster Chronicle*, p. lv n. 7) both these references must be for the same occasion since WAM 19648 is for Michaelmas (29 September) of year 14 (1390) to Michaelmas of year 15 (1391); the Confessor's Feast is 13 October and so it has to be dated to 1390. The Sacrist's account of the expenses thus refers to the visit of 1390 recorded in the Chronicle. It is also note-worthy that in March of that same year Richard gave the Abbey a pair of slippers to replace the lost slipper of St Edward. See *Westminster Chronicle*, p. 415 and note 28 below. See also *Making and Meaning*, p. 55.

11. 11 October. The Tothill Gate was on the west side of the Abbey. See *Westminster Chronicle*, p. 509. WAM 19651 records expenses for three days and this entry must also refer to the visit of 1392 since the accounting period of this document is September of year 16 (1392) to September of year 17 (1393); October would thus fall in 1392. See note 9 above.

12. PRO, E 101/402/10, f. 33; London, British Library, MS Add. 35115, f. 73. Both these books are for the period 1 October year 16 to 30 September year 17. The Confessor's Day therefore falls in year 16 (1392).

13. PRO, E 101/403/10, f. 35.

14. PRO, E 101/402/10, f. 13 for 1392 (London, British Library, MS Add. 35115 which covers the same accounting year, records no saints' days in the margins of the daily expenses section); PRO, E 101/403/10, f. 8 for 1395.

15. PRO, E 101/402/10, f. 33 and London, British Library, MS Add. 35115, f. 73 for both feasts.

16. PRO, E 101/403/10, f. 35. Compare this to the previous occasion, in 1393, when the connections between this feast and the Vigil of the Epiphany were noted. See note 13 above.

17. PRO, E 36/203; PRO, E 36/204 and PRO, E 101/396/11 for example. The Confessor was mentioned in a general list of saints' days when provision was made for paupers as in PRO, E 101/392/12, ff. 34–35v; PRO, E 36/203, f. 89; and PRO, E 36/204, f. 73v.

18. PRO, E 36/204, f. 72 for example.

19. It is only Froissart who tells us of Richard's devotions at the Shrine of Our Lady at the Abbey; the Westminster Chronicler simply says he visited the Shrine of St Edward. Compare *Oeuvres de [Jean] Froissart...Chroniques*, ed. K. de Lettenhove, 25 vols., Brussels, 1870–77, IX, p. 409; *Westminster Chronicle*, pp. 8–10.

20. 10 November 1387. *Westminster Chronicle*, pp. 206–9; and esp. p. lv.

21. *Westminster Chronicle*, p. 506 n. 1 and p. 507. For further details of the reconciliation ceremony, see C. M. Barron, 'The Quarrel of Richard II with London 1392–97' in *Reign of Richard II*, pp. 173–201, esp. 190.

22. Barron (cited in note 21 above), p. 196.

23. *Annales Ricardi Secundi*, ed. H. T. Riley, Rolls Series, London, 1866, p. 223; Clarke, 'Wilton Diptych' in *Fourteenth Century Studies*, p. 275.

24. Clarke (cited in note 23 above), p. 275 n. 4; *Rotuli Parliamentorum*, Vol. III, p. 355.

25. PRO, E 101/403/10, ff. 58v, 59. See also ff. 38–39. This is for year 19 (1395/96). London, British Library, MS Add. 35115, f. 37d, for year 16/17 (1392/93), also shows silverware but with the arms of England and France.

26. T. F. Tout, *Chapters in the Administrative History of England*, 6 vols., Manchester, 1930, V, pp. 204, 488, pl. iv fig. 6. It is Tout who dates this signet to 1395, but see also Clarke, 'Wilton Diptych' in *Fourteenth Century Studies*, p. 276.

27. Froissart says that Richard abandoned the arms of England in favour of the Confessor's cross and martlets for his first Irish expedition. See Clarke, 'Wilton Diptych' in *Fourteenth Century Studies*, p. 274; on p. 276 (ibid.) are examples of earlier uses Richard had made of the Confessor's arms.

28. PRO, E 361/5, m. 9v, the Great Wardrobe Account of John Macclesfield.

29. There are contradictions in the sources concerning part of the regalia, the coronation slippers. The Westminster Chronicle states that they were the Confessor's; the Anonimalle Chronicle states that they were St Edmund's. In 1377 William of Sudbury wrote a treatise on the regalia for Richard. This confronts the contemporary argument about the provenance of the regalia: was it originally Alfred's or originally Edward the Confessor's? That any part of the regalia could have been St Edmund's is never considered. Indeed, it is difficult to see how the slippers could have got from Edmund to future kings of a unified England since Edmund died in 869, and his kingdom became part of the Danelaw and not part of the Wessex Alfred ruled from 871. See Richard of Cirencester's *Speculum Historiae*, ed. E. B. Mayor, Rolls Series, London, 1869, Vol. II, p. 26ff; *Westminster Chronicle*, p. 415 and esp. see p. 416 n. 1; *Polychronicon Ranulphi Higden Monachi Cestrensis*, ed. J. R. Lumby, Rolls Series, London, 1865–86, Vol. IX, p. 222. For the statement that the slippers are Edmund's, see V. H. Galbraith, ed., *The Anonimalle Chronicle 1388 to 1381*, Manchester, 1927, pp. 111, 114, 187.

30. PRO, C 66/321, m. 21; *CPR 1385–89*, p. 110.

31. PRO, C 66/319, m. 24; *CPR 1381–85*, p. 542.

32. G. E. Cockayne, *The Complete Peerage*, eds. H. A. Doubleday *et al.*, London, 1945, Vol. X, pp. 228–9; Thomas Walsingham, *Historia Anglicana*, ed. H. T. Riley, Rolls Series, XXVIII, 2 vols., London, 1863–64, Vol. II, p. 140; *Westminster Chronicle*, p. 144–5.

33. PRO, C 66/320, m. 1; *CPR 1385–89*, p. 78. Cockayne (cited in note 32 above), Vol. X, p. 229 n. b, identifies the three golden crowns as the arms of St Edmund.

34. Three golden crowns was used by the 12th-century English expedition to Ireland; three golden crowns also refers to the legendary King Arthur. See C. W. Scott-Giles, *Romance of Heraldry*, London and Toronto, 1929, pp. 107, 120, 157, C. W. Scott-Giles, ed., *Boutelle's Heraldry Revised*, London and New York, 1950, pp. 124–5; and V. Wheeler-Holonhan, *Boutelle's Manual of Heraldry*, London, 1931, p. 170.

35. *Westminster Chronicle*, pp. 42–3. It should be noted that this reference also gives evidence of Richard's devotion to St Etheldreda.

36. *Westminster Chronicle*, pp. 454–5. Richard gave the Convent of Westminster Abbey 10 marks on this occasion.

37. *CChR* V, p. 326. Richard did of course have a devotion to other saints, Thomas of Canterbury and Etheldreda for example. However, this aspect cannot be dealt with here.

38. Legg, 'Inventory', pp. 199, 223. This reference also makes mention of banners of St Edward and a banner of the Holy Roman Emperor.

39. Mrs Bury Palliser, *Historic Devices, Badges and Warcries*, London, 1870, pp. 363–4; John E. Cussans, *Handbook of Heraldry*, London, 1893, pp. 222, 239; London, British Library, MS Harley 1319. Also, in the initial letter of Roger Dymock's *Liber contra duodecim errores et hereses Lollardorum* Richard is seen with something very like the sun in splendour around his neck; for ease of reference, see *Making and Meaning*, pl. 11.

40. See PRO, E 101/411/9, m. 32 for the golden image of St Edmund with four arrows, a gift from the King of France, and for the golden image of St Edward, a gift from the Duke of Burgundy.

41. Farmer (cited in note 2 above), pp. 120–21.

42. M. F. Bukofzer, *Studies in Medieval and Renaissance Music*, New York, 1950, p. 18.

43. *Historia Anglicana* (cited in note 32 above), Vol. II, p. 164 alleges the surrender of Calais and Guysnes; p. 170 tells of the compact to surrender English possessions (1387). It is also relevant to note that in 1380 Richard and his mother sought to have Thomas of Hales canonized. Thomas was a monk of Dover who had met his death as a result of a French attack against his priory in 1295. Here we see Richard seeking the canonization of someone killed resisting the French. See P. Grosjean *et al.*, eds., 'Thomas de la Hale Moine et Martyr a Douvres en 1295', *Analecta Bollandiana*, LXXII, 1954, pp. 167–91, 368, esp. 184–5 and Farmer (cited in note 2 above) p. 378.

44. *Chronicon Henrici Knighton*, ed. J. R. Lumby, Rolls Series, XCII, 2 vols., London, 1889–95, II, p. 215ff. esp. p. 219. For the idea that Richard might actually have been deposed after the battle of Radcot Bridge, see L. S. Sutherland and M. McKisack, eds., *Fourteenth Century Studies*, Oxford, 1937, repr. 1968, p. 91.

45. *Westminster Chronicle*, pp. 436–7; pp. 158–9 say that Richard had started the process in 1385; E. Perroy, *L'Angleterre et la Grande Schisme*

d'Occident, Paris, 1933, pp. 301, 341; PRO, E 403/538, m. 11; PRO, E 403/539, m. 12; and PRO, E 403/540, m. 13.

46. PRO, E 101/44/26. The 'berill' weighed 1lb. 3½ oz.

47. Cockayne (cited in note 32 above), Vol. III, p. 173.

48. PRO, E 101/402/10, f. 33. Although the feasts are not individually dated, they are in chronological order following the accounting year 1 October–30 September. This particular entry is immediately prior to the Feast of the Annunciation and so must refer to Edward, King and Martyr, whose Feast-Day is on 18 March. It is similarly shown in London, British Library, MS Add. 35115, f. 33d.

49. PRO, E 101/403/10, f. 19.

50. PRO, C 66/342, m. 23. See also *CCR 1392–96*, p. 473, dated 7 July 1395.

51. *CChR* V, p. 349.

52. The idea that Richard was using the cult of murdered, sanctified kings to try and get rid of the stain on Edward II's reputation cannot be expanded here. Suffice it to say that from as early as October 1378 a connection between Richard and his great-grandfather can be made: Richard received the Great Seal for the ruling of England in a chamber within the Abbey of St Peter's Gloucester, where Edward II was buried. This connection is made explicit in the depictions of Richard's device of the White Hart on Edward's tomb. Also in 1383 Richard requested that the anniversary of Edward II be celebrated at St Peter's, Gloucester. See PRO, C 54/218, m. 25d; *CCR 1377–81*, p. 216 for the seal; PRO, C 66/315, m. 9; *CPR 1381–85*, p. 273 for the prayers.

53. Colvin, *King's Works*, Vol. II, pp. 637 and 714 for the Confessor, St Edmund and John the Evangelist with St Adrian; ibid., Vol. I, p. 142 for the Confessor, John the Evangelist and the Virgin, all in the time of Henry III; ibid., Vol. I, p. 150 for the Confessor and St Edmund in the time of Edward II; ibid., Vol. I, p. 481 for the Confessor, John the Evangelist and St George in the time of Edward III.

54. *CChR* V, p. 311.

55. PRO, C 66/345, m. 26; *CPR 1396–99*, p. 329 for the Baptist's tooth, dated 23 April 1398; PRO, C 66/322, m. 40; *CPR 1385–89*, p. 194 for

the platter which bore the Baptist's head, dated 1 July 1386; see also *Making and Meaning*, p. 56.

56. PRO, C 66/333, m. 29; *CPR 1388–92*, p. 470; WAM 4498. *Making and Meaning*, p. 56.

57. Royal Commission on the Historical Monuments of England, *An Inventory of the Historical Monuments in London. Vol. I, Westminster Abbey*, London, 1924, p. 31.

58. Barron (cited in note 21 above), p. 190.

59. PRO, E 404/12, f. 77 dated 24 July, 4 Richard II (1380).

60. See all the Wardrobe Books which contain Alms and Oblations: PRO, E 101/393/9, ff. 23–24; PRO, E 101/400/26 (incomplete); PRO, E 101/401/2, ff. 37–38d; PRO, E 101/402/5, ff. 26–27 and PRO, E 101/401/10, ff. 33–34; London, British Library, MS Add. 35115, ff. 33, 33d; and PRO, E 101/403/10, ff. 35–37d.

61. PRO, E 101/401/16, m. 10. Many thanks to Lisa Monnas for verifying this and for referring me to PRO, E 101/401/16, m. 16 which shows that John de Strawesburgh, Richard's embroiderer, did the embroidery of the raven in black velvet and black silk. It should also be noted that four long gowns and hoods were made for the Feast of St John the Baptist 1383 (year 7). These garments were of black long cloth, furred with pured minever and ermine and there is also mention of embroidered letters which unfortunately are unspecified. See PRO, E 101/401/6, m. 3.

62. *A Catholic Dictionary of Theology*, London and Edinburgh, 1967, Vol. II, pp. 212–13; Matthew 17:12; Mark 9:13 for the claim made by Christ himself that Elijah was the prototype of the Baptist; Matthew 3:4 and Mark 1:6 for a specific parallel between the Baptist and Elijah. St Augustine was the great proponent of the biblical typology that linked Elijah and the Baptist. See I Kings 17:4, 6 for Elijah and the ravens.

63. The chronology of this period is important. The Parliament of October 1386 imposed a commission upon Richard; in December 1386 Richard wore the gown with the symbols of the Baptist; the sequence of these events gives the iconography of the gown a political significance. See also note 3 above for Richard's request for the ring of Edward the Confessor in this same year: the exact date of Richard's request is unknown but the abbot's letter is dated

10 August, year unknown. Since old age and weakness are mentioned in the letter and the abbot died in November 1386, it can be assumed that the letter was written in 1386, the same year as the October Parliament and the commissions.

64. It is interesting to note that details of *two* embroidered gowns are given for Christmas 1386, year 10: the raven and the pyx already mentioned and another with a golden sun, a vine and grapes made of pearls. The sun was one of Richard's personal symbols, see note 39 above, and it may perhaps also be suggested that for this festival Richard's attire manifested the pyx which contained the bread, and the vine which signified the wine; both Eucharistic elements. See PRO, E 101/401/16, m. 10. See D. S. Guth and J. W. McKenna, eds., *Tudor Rule and Revolution. Essays for G. R. Elton and his American Friends*, Cambridge, 1982, p. 31. See also note 81 below.

65. The regnal year was from 22 June to the following 21 June. Year 10 therefore ran from 22 June 1386 to 21 June 1387.

66. PRO, E 101/401/16, m. 3. There is no firm evidence that he was a member. Henry IV also had a gown and hood of this same fraternity. See PRO, E 101/405/22, ff. 22, 25d. This strengthens the supposition that Richard belonged to the fraternity since Henry took over many of Richard's symbols. However, more work needs to be done on this.

67. PRO, E 101/402/5, f. 26v.

68. PRO, E 101/402/10, f. 49

69. PRO, E 101/403/10, ff. 26, 35v.

70. W. W. Skeat, ed., *Piers the Plowman and Richard the Redeless*, Oxford, 1886, Vol. II, p. 95 for the summer games at the festival of St John the Baptist. The Baptist's Day was also the start of a new law term, a quarter day, and in the 14th century it signalled the start of the Cotswold wool fair. I am grateful to Helen Bradley for the information about the wool fair. If it can be said that this day did indeed have special meaning for Richard, then his command that the Mayor and Sheriffs meet him at Nottingham the eve of the Baptist's Day, 1392, takes on an added significance, as do other events dated around this feast.

71. Except in general lists where Edward III seems to be trying comprehensively to cover all

saints. See for example, PRO, E 36/203, f. 89; PRO, E 36/204, ff. 73, 73d; PRO, E 101/392/12, f. 35; and PRO, E 101/393/11, f. 61v.

72. Furthermore there is the curious story that, in peril of death, the newborn Richard was first baptized as John. See *Annales Ricardi Secundi* (cited in note 23 above), pp. 237–238.

73. Unfortunately, there is no contemporary description of this particular livery so we do not know the colours, cloth, or symbols used; nor is there an earlier mention of this livery. It can however be stated with certainty that, by 1398, a special livery was used for the Feast of John the Baptist. PRO, E 101/403/19, no. 55, dated 6 November 1398 (year 22) authorizes one of Richard's clerks to receive the King's livery of *Internatos*: '...*drap pur la vesture de nostre liveree de Internatos pur la feste de Seinte Johan le Baptistre*...' A document of 1385, PRO, E 101/401/6, m. 24, makes it clear that *Internatos* was the antiphon particular to the Feast of John the Baptist: '...*una antiphona de Sancto Johane Baptista vocat Internatos*'. That Richard took the name of this particular antiphon as the name of a special livery for his clerks is another demonstration of his high regard for John the Baptist. *Internatos* echoes the Gospel of St Luke (Chapter 7, verse 28). Many thanks to Philip Mitchell for this reference.

74. That Richard had a special affiliation with John the Baptist can be seen from the many representations of the Baptist to be found in the list of jewels and chapel goods recorded in PRO, E 101/411/9; see, for example, membrane 32 for an image of the Baptist with two harts and two camels and one tablet of the Baptist and the Evangelist and membrane 31 for a tablet of the Baptist; that many of these items were gifts indicates that contemporaries were well aware of Richard's devotion to the Baptist. See for example, membrane 15, a mirror with the Virgin, the Baptist and the Evangelist from the Archbishop of York; membrane 40, a Missal with the image of St Edward, the Baptist and the Four Evangelists, from Henry Percy; membrane 31, two images of Our Lord and John the Baptist from Roger Walden; see membrane 31 as well for a tablet of the Baptist from the Bishop of Chichester and two images of the Baptist and St Edward from the Secretary. Whilst this document is invaluable for listing these possessions it is of little use in charting the chronological growth of Richard's particular cult of saints because of the lack of pre-

cise dating as to when specific items came into Richard's possession.

75. Sir Roger Twysden, ed., *Chronica William Thorn, Mon. S. Augustini Canturiae*, in *Historia Anglicanae Scriptores*, London, 1652, Vol. X, col. 2142. This author actually calls the kings '*magi*'. See *Making and Meaning*, p. 57.

76. J. H. Harvey, 'Richard II and York' in *Reign of Richard II*, p. 209 and esp. n. 30.

77. Ibid., pp. 211, 212.

78. W. M. Ormrod, 'The Personal Religion of Edward III', *Speculum*, LXIV, 1989, pp. 849–77. The Archbishop of Cologne was one of four electors in receipt of a pension from Richard in 1397. See *Annales Ricardi Secundi* (cited in note 23 above), p. 199 for the report that Richard had indeed been elected emperor.

79. See note 60 above for the Wardrobe Books which have surviving Alms and Oblations accounts.

80. PRO, E 36/204, ff. 72d, 73v; PRO, E 101/392/12; and PRO, E 101/398/9, f. 27 for Edward's offering of gold, frankincense and myrrh. PRO, E 36/203, f. 88; PRO, E 36/204, f. 72; and PRO, E 101/393/11, f. 11 for occasions when Edward only offered gold.

81. Their gifts were of course gold, frankincense and myrrh. See *Rotuli Parliamentorum*, Vol. II, p. 362.

82. PRO, E 101/402/10, f. 33 and PRO, E 101/403/10, f. 35; see notes 15 and 16 above.

83. F. Wormald, 'The Wilton Diptych', *JWCI*, XVII, 1954, p. 200 (reprinted in id., *Collected Writings. II: Studies in English and Continental Art of the Later Middle Ages*, eds. J. J. G. Alexander, T.J. Brown and J. Gibbs, London, 1988, pp. 103–16). He suggests that the positioning of the saints on the Diptych represents the position of the chapels in the Abbey.

84. See note 59 above.

85. PRO, E 101/393/11, ff. 11, 61 and PRO, E 36/204, ff. 72d, 73d.

86. PRO, E 36/203, f. 88(bis); PRO, E 36/204, ff. 72 (bis), 72d(bis); PRO, E 101/392/12, f. 35; and PRO, E 101/396/11, f. 13v for example.

87. PRO, E 101/401/2, f. 37 and PRO, E 101/403/10, f. 35.

88. PRO, E 101/402/5, f. 26.

89. PRO, E 101/402/10, f. 56 in the daily expenses section.

90. PRO, E 101/403/10, f. 12 for the Conception.

91. Under daily expenses as well as Alms and Oblations. PRO, E 101/402/10, ff. 29, 33 and PRO, E 101/403/10, ff. 16, 32.

92. See note 60 above.

93. *Age of Chivalry*, p. 449.

94. For Rushook see, for example, PRO, E 101/401/16, m. 26. For Bache, see PRO, C 81/515, 6230, for Burghill, C 66/343, m. 37; C 54/236, m. 22d. For Dominican preachers: see PRO, E 101/402/2, f. 26 for John Depyng; PRO, E 101/402/5, f. 26d for Thomas Palmer, William Laneham, John Dymok, Andrew Yakesle; PRO, E 101/402/10, f. 33ff. for John Syward, Matthew Shrouysbury, John Tylle, Thomas Ellemer, John Richard, Thomas Wytheley; PRO,

E 101/403/10, f. 36v for William Syward. Several preached more than once.

95. *CPL*, Vol. V, 1396–1404, p. 67.

96. PRO, C 54/227, m. 50d. It might be of some relevance at this point to note that Froissart says Richard dedicated himself to a statue of the Virgin before he met the rebels in 1381. Edward the Confessor also had the Virgin as one of his patrons. See Luard (cited in note 2 above), p. 219, lines 1430 following. The Virgin is here described as God's Mother, The Chancery Enrolment PRO, C 54/227, m. 50d also speaks of God and His Mother.

97. See p. 115 of this paper and note 63 above.

98. Bukofzer (cited in note 42 above), p. 18.

99. Ibid., p. 19.

VII. THE TECHNIQUE OF THE WILTON DIPTYCH

1. Consolidation, cleaning and restoration of the Wilton Diptych were undertaken in the National Gallery Conservation Department, London, in 1992–93. Photographic and analytical studies were carried out at the same time. Analysis of the wood, ground, pigments, and layer structure was carried out by the author using a range of microscopical and microchemical techniques. Paint cross-sections embedded in cold-setting polyester resin were prepared for reflected light study by grinding and fine polishing. The analysis of paint layers was carried out on carbon-coated samples using energy-dispersive X-ray microanalysis (EDX) in the scanning electron microscope (Cambridge Instruments S200 and Link Systems AN10,000). All spectra were acquired at 25kV. Certain samples were gold-coated for imaging in the SEM. X-ray diffraction was by the Debye-Scherrer powder method (Philips PW1720, equipped with 114 mm. cameras). Medium analysis was by Raymond White of the National Gallery Scientific Department, using gas-chromatography mass-spectrometry (GC-MS) and Fourier transform infra-red microspectrophotometry (FTIR). Some results were supplemented by staining and heating tests under the microscope by the author.

2. Recorded in M. Davies, *National Gallery Catalogues. French School*, 2nd edn, London, 1957, p.

92. The typographical style of the engraved script seems to be 18th-century. The plaques have now been removed and are preserved in the National Gallery, London.

3. J. Britton, *The Beauties of Wiltshire, Displayed in Statistical, Historical and Descriptive Sketches: Interspersed with Anecdotes of the Arts*, 3 vols., London, 1801–25, I, p. 194.

4. See R. K. R. Thornton and T. G. S. Cain, eds., *A Treatise Concerning the Arte of Limning by Nicholas Hilliard*, Edinburgh, 1981, p. 39.

5. Britton (cited in note 3 above), p. 195.

6. A brief description of the conservation work undertaken is given by M. Wyld, 'The Recent Treatment of the Wilton Diptych' in *Making and Meaning*, pp. 86–87.

7. Infra-red reflectography was carried out by Rachel Billinge, Leverhulme Research Fellow at the National Gallery. Composite image mosaics were assembled using a technique described in R. Billinge, J. Cupitt, N. Dessipris, and D. Saunders, 'A Note on an Improved Procedure for the Rapid Assembly of Infra-red Reflectogram Mosaics', *Studies in Conservation*, XXXVIII/II, 1993, pp. 92–98.

8. X-ray photographs were first recorded in 1956. A new set were taken in the National Gallery Photographic Department in 1992. Be-

cause the Wilton Diptych is double-sided, the image of the paint layers is quite difficult to read. However, it is clear that the frames are integral; also clearly registered are the extent of paint loss, particularly the damage in the heraldic panel, the extent of loss in the original gilding, and the high X-ray density of the paint in the ermine capes worn by Saints Edmund and Edward, the white pearls in the crowns and in the antlers of Richard's badge of the White Hart, the body of the hart, the angels' wings, the banner and the cap of maintenance. Other than the vermilion-containing paint of the cross on the banner and cap of maintenance, all the areas that register strongly in the X-ray image are painted with a high proportion of lead white. A faint dark image of the parchment fibres below the ground layers is also discernible. A full X-ray photograph is published in *Making and Meaning*, p. 75.

9. The wood of the panels was identified as oak (*Quercus* sp.) from microscopical examination of transverse thin sections cut from the end grain of the lower edges of the panels.

10. The X-ray images suggest that the iron hinges are original. Traces of gilding were detected by EDX analysis. The X-ray photographs also show unused metal inserts in the frames opposite the hinges which probably represent the intention—not carried out—of attaching clasps to the outer edges of the Diptych.

11. Calcium carbonate was identified in the ground by EDX analysis and confirmed by XRD (calcite: JCPDS file No. 5–586). Fossil coccoliths were found by SEM in several samples indicating that the ground is natural chalk.

12. Glue (gelatin) was indicated in the ground by staining tests using aqueous acid fuchsin and amido black.

13. R. White and J. Pilc, 'Analyses of Paint Media', *National Gallery Technical Bulletin*, XVI, 1995, pp. 90–91.

14. The fibres beneath the chalk ground are composed of collagen and closest to reference standards of parchment. Identified by Josephine Darrah, Senior Scientific Officer at the Victoria and Albert Museum, London.

15. D. Bomford, D. Gordon, J. Dunkerton, and A. Roy, *Art in the Making: Italian Painting Before 1400*, London, 1989, p. 17.

16. Lines incised into the ground are most clearly visible around the shoulders of the saints and the junction of Richard's *sgraffito* cloak with the paint of St Edward's robe. Incised lines are also present on the other compositions, particularly in the heraldry.

17. Examination of a minute sample of underdrawing from a line visible through the paint of St Edward's cloak showed very fine (submicron) particles clinging to the underside of the paint film. These appear to be composed of carbon, but positive identification of the material is difficult on samples of such small scale. Certain lines revealed in infra-red suggest the use of a fluid drawing medium applied with pen or fine brush; other very fine hard-edged lines could be interpreted as metalpoint.

18. The presence of silver as the only metallic component was confirmed in a darkened sample by EDX analysis. The silver leaf of the helm on the heraldic panel was clearly applied after the gold, since it overlaps gold leaf at several points at its periphery.

19. The tiny crescent of silver leaf for the sea within the orb was applied over a continuous layer of gold leaf beneath, which had already been stippled with a cross with the foliate background pattern. There is no bole between the two thin layers of metal and it is not clear how the silver leaf was applied. The silver content was confirmed by analysis (EDX).

20. Under magnification, paint can be seen to pass over the incised grid on the gold leaf. It is particularly clear where the white paint of the banner overlaps gilding and at the edges of some of the angels' wings.

21. The clearest changes between drawing and painting, as revealed in infra-red reflectograms, are in the pointing finger of the angel standing to the right (the finger was shortened, its angle changed, and the hand lowered), and in the position of the hand of the angel kneeling in the foreground (the hand was reduced in scale). See *Making and Meaning*, figs. 28–30, pp. 76–77.

22. The nature of the mordant and filler in the very small-scale mordant-gilded details is not known, only that it is light brown in colour and fairly dense in texture, clearly containing some pigment as well as the adhesive. Mordant gilding on a larger scale forms the gold fleurs-de-lis on the heraldic shield. The brownish mordant

was applied directly to the ultramarine background paint and was found to contain lead white and some earth pigment bound in egg. See *Making and Meaning*, pl. 4 (detail), p. 29 and pl. 45 (cross-section), p. 48.

23. This severe damage was very likely caused by water since a film of the white chalk ground was found to have been re-deposited around the area over paint and gilding.

24. The evidence for fading rests on the detection of a stronger pink colour in the paint layer beneath the surface. Characteristically, paint films mixed from red lake and white pigment are more vulnerable to fading through the action of light than darker, shadow values, comprising only lake pigment glazes. See D. Saunders and J. Kirby, 'Light-induced Colour Changes in Red and Yellow Lake Pigments', *National Gallery Technical Bulletin*, XV, 1994, pl. 2, pp. 81, 90–91.

25. Vermilion tends to be more vulnerable to discoloration in egg tempera medium than in oil, but the effect is usually only at the thinnest layer at the surface. However, the product of colour change, the black form of mercuric sulphide known as metacinnabar, is of such dark colour and density that the colour of a layer of red vermilion is strongly affected by even superficial change. The vermilion of Richard's cloak is ground finely and evenly; the discoloration is also unusually even in distribution on the paint surface. The vermilion of St Edmund's buskins seems unaffected by colour change. Where discoloration occurs, light and/or pressure applied to the paint surface are implicated. See R. Gettens, R. L. Feller, and W. T. Chase, 'Vermilion and Cinnabar' in *Artists' Pigments: A Handbook of their History and Characteristics*, ed. A. Roy, Washington and Oxford, 1994, Vol. II, pp. 166–67.

26. The vestiges of these glazes can now only be seen by illuminating the picture at an oblique angle and viewing the drapery, opposite the source of illumination, also at an acute angle. Fading is probably principally responsible for their loss.

27. These glazes were shown by analysis to have been prepared from a copper-containing pigment. They may be of the 'copper resinate' type since they show the characteristic behaviour of stronger or more complete discoloration where the glaze is thinner.

28. The small touches of grey-green foliage in the foregrounds of the Virgin and Child and hart panels must once have been a strong mid-green. Most of the loss of colour appears to be in fading of the orpiment (yellow arsenic trisulphide) component, although there may well be fading of the indigo dyestuff as well. In a cross-section, the upper part of the surface paint layer, once green, is totally devoid of colour, although unchanged orpiment is present beneath the surface. A green of this constitution registers strongly as light (reflective) areas in infra-red reflectograms.

29. There is both fading and loss by abrasion of the yellow glazes representing the iris flowers over gold. These may have been greenish yellow (with the gold leaf reflecting through the paint) since copper was detected in a small sample of remaining glaze.

30. There is microscopical evidence for fading of yellow lake from the paint layer here.

31. D. V. Thompson, Jr., '*Liber de coloribus illuminatorum siue pictorum* from Sloane MS. No. 1754', *Speculum*, I/III, 1926, p. 291.

32. Ibid.

33. D. V. Thomson, Jr., *The Craftsman's Handbook*, New York, 1933, pp. 93–4.

34. The occurrence of the cubic (pyrochlore) form of lead-tin yellow (*giallorino*), known as 'type II', in the Wilton Diptych is interesting. It was detected in samples of foliage green, including underlayers, by EDX analysis and X-ray mapping, showing the essential constituent of silicon associated with lead and tin in individual pigment particles. The pigment appears to be of 14th-century origin as a by-product of glass-making technology and is associated, particularly, with Italian trecento painting. See Bomford *et al.* (cited in note 15 above), pp. 37–38. It has also been found on Bohemian panels of the late 14th century (see H. Kühn, 'Lead-Tin Yellow' in *Artists' Pigments*, cited in note 25 above, Vol. II, p. 99) and on the painted wings of the Dijon Altarpiece (1390s) by Melchior Broederlam (see M. Comblen-Sonkes and N. Veronée-Verhaegen, *Les Primitifs Flamands: Le Musée des Beaux-Arts de Dijon*, Brussels, 1986, Vol. I, p. 74).

35. This combination for a mixed green is common in Italian trecento painting. See, for example, Bomford *et al.* (cited in note 15 above), pls. 110 and 111, p. 123; pls. 158 and 159, p. 181.

36. The results of medium analysis for the Tingelstad altar frontals and the Westminster Retable are reported in R. White, 'Analyses of Norwegian Medieval Paint Media: A Preliminary Report' in *Norwegian Medieval Altar Frontals and Related Material* (Papers from the Conference in Oslo 16–19 December 1989), *Institutum Romanum Norvegiae Acta*, Rome, 1995, pp. 127–36.

37. See, for example, L. Campbell, D. Bomford, A. Roy, and R. White, '"The Virgin before a Firescreen": History, Examination and Treatment', *National Gallery Technical Bulletin*, XV, 1994, p. 31.

38. L. Kockaert, 'Note sur les émulsions des primitifs flamands', *Bulletin de l'Institut Royal du Patrimoine Artistique*, XIV, 1973/74, pp. 133–39.

39. The technical investigation of the Antwerp panels was by Leopold Kockaert and published in H. M. J. Nieuwdorp, R. Guislain-Wittermann, and L. Kockaert, 'Het pre-Eyckiaanse Vierluik Antwerpen-Baltimore', *Bulletin de l'Institut Royal du Patrimoine Artistique*, XX, 1984/85, pp. 86–97. The Baltimore panels were studied by Melanie Gifford and published in M. Gifford, 'A Pre-Eyckian Altarpiece in the Context of European Materials and Techniques around 1400' in *Flanders in a European Perspective: Manuscript Illumination around 1400 in Flanders and Abroad* (Proceedings of the International Colloquium, Louvain, 7–10 September 1993), eds. M. Smeyers and B. Cardon, Louvain, 1995, pp. 357–70.

40. Gifford (cited in note 39 above).

41. L. Kockaert, 'Note on the Painting Technique of Melchior Broederlam' in *Preprint of ICOM Committee for Conservation*, 7th Triennial Meeeting, Copenhagen, 1984, Section 19, pp. 7–9.

42. Kockaert (cited in note 41 above).

43. I would like to thank Dominique Thiébaut, Conservateur, Département des Peintures, Musée du Louvre, for the opportunity of examining the Malouel Tondo under the microscope.

44. See G. Scharf, *Description of the Wilton House Diptych*, Arundel Society, London, 1882, pp. 72–73.

45. *Making and Meaning*, p. 71.

46. See particularly sections on 'Painting on Wood' in *Technologia Artis*, Archives of Art Technology, Prague, I, 1990; II, 1992; III, 1993.

47. Master of the Trebon Altarpiece. See M. Hamsik, 'On the Technique of Czech Panel Painting of the 14th Century', *Technologia Artis*, I, 1990, pp. 40–43.

48. See, for example, H. Hlaváčková, *Prag um 1400, der Schöne Stil. Böhmische Malerei und Plastik in der Gotik*, Vienna, 1990, cat. nos. 51 and 53.

49. See M. Hamsik *et al.*, 'Master Theodoric's Painting Technique and its Origin', *Technologia Artis*, II, 1992, pp. 50–75.

VIII. IMAGES OF DEVOTION

1. For recent studies of devotional images, see H. Belting, *Das Bild und sein Publikum im Mittelalter: Form und Funktion früher Bildtafeln der Passion*, Berlin, 1981; on devotional images in 15th-century manuscripts, see K. Scott, '*Caveat Lector*: Ownership and Standardization in the Illustrations of Fifteenth Century English Manuscripts', *English Manuscript Studies*, I, 1989, pp. 19–63; L. F. Sandler, 'The Image of the Book-Owner in the Fourteenth Century: Three Cases of Self-Definition', *Harlaxton Medieval Studies*, III, 1993, pp. 58–80.

2. Oxford, Bodleian Library, MS Rawl. G. 185, f. 20; see Sandler, *Gothic Manuscripts*, Vol. II, no. 128, p. 142.

3. Copenhagen, Kongelige Bibliotek, MS Thott. 547.4⁰, f. 1; Sandler, *Gothic Manuscripts*, Vol. II, no. 140, pp. 161–2.

4. Paris, Bibliothèque Nationale, MS lat. 919, f. 96; see M. Thomas, *Les Grandes Heures de Jean Duc de Berry*, London, 1971.

5. London, British Library, MS Yates Thompson 13, f. 118v; Sandler, *Gothic Manuscripts*, Vol. II, no. 98, pp. 107–9.

6. London, British Library, MS Royal 2 A XVIII, f. 23v; M. Rickert, 'The So-Called Beaufort Hours and York Psalter', *Burlington Magazine*, CIV, 1962, 238–46; K. Scott, *Later Gothic Manuscripts 1390–1490* (A Survey of Manuscripts Il-

luminated in the British Isles, VI), 2 vols., London, 1996, Vol. II, no. 37.

7. Oxford, Bodleian Library, MS Lat. liturg. f. 2 (f. 2v), datable 1405–13; O. Pächt and J. J. G. Alexander, *Illluminated Manuscripts in the Bodleian Library, III: British School*, Oxford, 1973, no. 795, pp. 70–1; Scott (cited in note 6 above), Vol. II, no. 22.

8. Scroll of Christ: '*Qui vidit ihc vidit et patrem que ego patre et pater in me est et spiritus sanctus ab utroque procedens*'. Scroll of male and female worshippers: '*Benedicta sit sancta undividual trinitas atque*' and '*misericordiam suam*'. The miniature faces a prayer to the Trinity which includes the words '*Te adoro deum et filium et spiritum sanctum unam divinitatem equalem gloriam, coeterna maiestatem*'; see V. Leroquais, *Les Livres d'heures manuscrits de la Bibliothèque Nationale*, Paris, 1927, Vol. II, p. 340.

9. Oxford, Keble College, MS 47, f. 9; Sandler, *Gothic Manuscripts*, Vol. II, no. 146, pp. 169–70; M. B. Parkes, *The Medieval Manuscripts of Keble College Oxford*, London, 1979, no. 47, pp. 215–24.

10. '*Mater dei memento me*' on each figure's scroll; historiated initial at the beginning of a prayer on the seven last words of Christ on the Cross, with a rubric attributing it to Bede, '*...quam orationem quicumque cotidie dixerit devote flexis genibus diabolus nec malus homo ei nocere poterit nec sine confessione morietur sed per triginta dies ante obitum suum videbit gloriosam virginem mariam sibi auxilium venientem*' ('which prayer, if anyone says daily on bended knee neither the devil nor evil man will be able to harm him, nor will he die without the sacrament of Confession but for thirty days before his death he will see the glorious Virgin Mary coming to his aid'). The prayer includes the words '*Domine ihu xpe qui septem verba in ultimo vite tue in cruce pendens dixisti*'; see *Horae Eboracenses*, ed. C. Wordsworth, Surtees Society, CXXXII, Durham and London, 1920, p. 140.

11. Oxford, Bodleian Library, MS Laud Misc. 188, f. 1, Matins of Hours of the Virgin; Sandler, *Gothic Manuscripts*, Vol. II, no. 149, pp. 171–2.

12. Cambridge, Fitzwilliam Museum, MS 48, f. 86; Sandler, *Gothic Manuscripts*, Vol. II, no. 130, pp. 143–5.

13. Oxford, Bodleian Library, MS Auct. D. 4. 4, f. 181v; Sandler, *Gothic Manuscripts*, Vol. II, no. 138, pp. 157–9. Mary Magdalene's uncharacter-

istic crown occurs in every representation of this saint in the Bohun manuscripts, see Sandler, Vol. II, nos. 134, 135, 137, 138.

14. Gloucestershire, Berkeley Castle, f. 7v, facing Matins; G. M. Spriggs, 'The Nevill Hours and the School of Herman Scheerre', *JWCI*, XXVII, 1974, pp. 104–30; Scott (cited in note 6 above), Vol. II, no. 23. The Nevill arms are later; the original owner is unidentified.

15. Naples, Galleria Nazionale Capodimonte; J. Gardner, 'Saint Louis of Toulouse, Robert of Anjou and Simone Martini', *Zeitschrift für Kunstgeschichte*, XCIII, 1976, pp. 12–33; A. Martindale, *Simone Martini: Complete Edition*, Oxford, 1988, p. 18, pl. 9 and cat. no. 16, pp. 192–4.

16. Paris, Bibliothèque Nationale, MS lat. 1052, f. 261; V. Leroquais, *Les Psautiers manuscrits des bibliothèques publiques de France*, Paris, 1934, Vol. V, pp. 49–56.

17. See C. R. Sherman, *The Portraits of Charles V of France, 1338–1380* (College Art Association Monographs, XX), New York, 1969.

18. Paris, Bibliothèque Nationale, MS lat. 18014, ff. 97v, 100v, 103v, 106, 115v, 117v, 119, 120, 121v, 122, etc.; M. Meiss, *French Painting in the Time of Jean de Berry: The Late Fourteenth Century and the Patronage of the Duke*, London, 1967, text volume, pp. 155–9, 334–7; F. Avril *et al.*, *Les Petites Heures de Jean Duc de Berry*, Luzern (Faksimile Verlag), 1989.

19. Brussels, Bibliothèque Royale, MS 11060–61, pp. 10–11; Meiss (cited in note 18 above), text volume, pp. 10–11, 199–205. On the parallel to the Wilton Diptych see, most recently, *Making and Meaning*, p. 70.

20. The motif of the worshipper in the private chapel, or at a prie-dieu screened by curtains, occurs frequently in the *Petites Heures* (see note 18 above), esp. ff. 97v, 105v, 106, 115v, 119, 121v, 122.

21. For example *Making and Meaning*, p. 21.

22. For a vivid evocation of the desert setting of the Resurrection of the Dead on Judgement Day, see the *Très Riches Heures*, Chantilly, Musée Condé, MS 65, f. 34v, illustrating Psalm 76 in Matins of the Hours of the Virgin; J. Longnon *et al.*, *Les Très Riches Heures du Duc de Berry*, London, 1969, pl. 30.

23. As depicted for instance by Domenico Veneziano in the small panel in Washington (Na-

tional Gallery, 1445–7), H. Wohl, *The Paintings of Domenico Veneziano*, Oxford, 1980, pp. 128–30, pl. 88.

24. The Virgin in a garden is depicted in French manuscripts in the early 15th century, for example in a fine Book of Hours at the Brooklyn Museum (MS 19.78, f. 162) called by Meiss (*French Painting in the Time of Jean de Berry: The Limbourgs and their Contemporaries*, London, 1974, text volume, p. 366), 'Bedford trend' and dated by him *c.* 1418. Verbal floral and garden imagery equating the Virgin with the *hortus conclusus* of the Song of Songs (Cant. 4:12) is traditional.

25. Paris, Bibliothèque Nationale, MS lat. 757, f. 109v, facing the opening of the text of the Joys of the Virgin; see K. Sutton, 'The Original Patron of the Lombard Manuscript Latin 757 in the Bibliothèque Nationale, Paris', *Burlington Magazine*, CXXIV, 1982, pp. 88–94 identifying the original owner as Bertrando de' Rossi, an important member of the Visconti court after 1385; more recently, see E. Kirsch, *Five Illuminated Manuscripts of Giangaleazzo Visconti* (College Art Association Monographs, XLVI), University Park, Penn., 1991, pp. 13–27, 94–8, attributing ownership to Giangaleazzo Visconti himself, and dating the work to *c.* 1380 on the occasion of his marriage to his cousin, Caterina Visconti.

26. New York, The Metropolitan Museum of Art, The Cloisters, Inv. no. 69.88; F. Deuchler, 'Looking at Bonne de Luxembourg's Prayer-Book', *Bulletin of the Metropolitan Museum of Art*, February 1971, pp. 267–78. Christ speaks to Jean le Bon and Bonne of Luxembourg from the Cross: '*Ha homme e fame/Voy que sueffre pour toy/Voy ma douleur, mon angoisseus conroy*' ('O man and woman, see me suffer for you, see my sorrow, my tormented state').

27. Paris, Bibliothèque Nationale, MS lat. 3093, Paris, Musée du Louvre, Cabinet des Dessins RF 2022–2024, Turin, Museo Civico (formerly Milan, Biblioteca Trivulziano), and formerly, Turin, Biblioteca Nazionale (destroyed); P. Durrieu, *Heures de Turin*, Paris, 1902, dated 1404–13; G. Hulin de Loo, *Heures de Milan*, Brussels, 1911, dated 1380–90; Meiss (cited in note 17 above), text volume, pp. 107–33, 337–40, dated 1380–90; E. Koenig, *Die Très Belles Heures de Notre-Dame des Herzogs von Berry*, Luzern (Faksimile Verlag), 1992, commentary volume, pp. 27–8, 62–75, 167–8, 203–17, dated 1404–07.

28. Paris, Musée du Louvre RF 2024 (f. 4).

29. Paris, Bibliothèque Nationale, MS lat. 18014, f. 199v; for an illustration see Meiss (cited in note 24 above), plate volume, fig. 163. The prayer to an individual's guardian angel asks for protection from harm on earth and for a safe passage to Heaven at the end of life.

30. Paris, Bibliothèque Nationale, MS lat. 5088, f. 1; Kirsch (cited in note 25 above), pp. 74–86, 98–9.

31. Paris, Musée Jacquemart André, MS 2, f. 26v; M. Meiss, *French Painting in the Time of Jean de Berry: The Boucicaut Master*, London and New York, 1968, pp. 7–22.

32. Ibid., p. 9.

33. See esp. Harvey, 'Wilton Diptych', p. 21.

34. On the concept of England as the Virgin's dowry, see the summary of Gordon, 'A New Discovery', pp. 665–7.

35. Oxford, Bodleian Library, MS Douce 131, f. 110. J. J. G. Alexander, 'Painting and Manuscript Illumination for Royal Patrons in the Later Middle Ages' in *English Court Culture*, pp. 142–3.

36. Paris, Bibliothèque Nationale, MS n. a. lat. 3145, f. 3v, an added single leaf to the Pucellian manuscript of *c.* 1335–45; F. Avril and P. Stirnemann, *Manuscrits enluminés d'origine Insulaire, VII^e–XX^e siècle*, Paris, 1987, no. 219, pp. 177–8. The queen holds a scroll with the English text 'Mercy and grace'. Avril and Stirnemann comment that the manuscript may have come to England with one of three French wives of English monarchs: Isabelle, second wife of Richard II (married 1396), who returned to France in 1401, married Charles of Orléans in 1406 and died in 1409; Jeanne de Navarre, who married Henry IV in 1403 and died in England in 1437; or her younger sister, Catherine de Valois, who married Henry V in 1420 and remained in England after his death. The style of the miniature points to a date between 1415 and 1425, and thus it could have been inserted for either Jeanne or Catherine, but probably not Isabelle.

37. *Making and Meaning*, p. 62.

IX. PLANTS AND FLOWERS

1. C. Fisher, *Gardens and Flowers in Fifteenth Century Netherlandish Paintings*, MA report, Courtauld Institute of Art, University of London, 1991.

2. B. E. Daley, 'Latin Medieval Iconography of Mary' in *Medieval Gardens*, ed. E. MacDougall, Dumbarton Oaks, 1986, p. 255 also C. Purtle, *The Marian Paintings of Jan van Eyck*, Princeton, 1982, p. 106.

3. Lambert of St Omer, *Liber Floridus* (*c.* 1120); Alexander Neckam, *De Naturis Rerum* (*c.* 1180) and *De Laudibus Divinae Sapientiae* (*c.* 1200), ed. T. Wright, Rolls Series, London, 1863; Bartholomew of Glanville, *De Proprietatibus Rerum* (*c.* 1260) in *Medieval Lore*, ed. R. Steele, London, 1907. Others, including Lambert of St Omer's *Liber Floridus* and Albertus Magnus, *De Vegetabilibus et Plantis* (*c.* 1260), are quoted in secondary sources: MacDougall (cited in note 2 above); E. Kosmer, 'Gardens of Virtue in the Middle Ages', *JWCI*, XXXXI, 1978, p. 302, and J. Harvey, *Medieval Gardens*, London, 1981.

4. A. Arbor, *Herbals their Origin and Evolution*, Cambridge, 1912. There are, however, the notable exceptions of the realistic illustrations in the Carrara Herbal (London, British Library, MS Egerton 2020) produced in Padua *c.* 1400, and related northern Italian manuscripts including Rinio's *Liber de Simplicibus* (Venice, Biblioteca Nazionale Cod. Lat. VI 59) made in Venice *c.* 1419.

5. W. Calkins, 'The Brussels Hours Re-evaluated', *Scriptorium*, XXIV, 1970, pp. 3–26.

6. C. Eisler, *The Prayer Book of Michelino da Besozzo, Morgan 944*, New York, 1981.

7. The Ghent-Bruges manuscripts of the 1480s onwards also show numerous examples of violets depicted from various angles, for instance the Huth Hours (London, British Library, MS Add. 38126) and the Hastings Hours (London, British Library, MS Add. 54782).

8. Harvey, 'Wilton Diptych', pp. 1–24.

9. For the symbolic meanings of flowers associated with the Virgin, see R. A. Koch, 'Flower Symbolism in the Portinari Altar', *Art Bulletin*, XXXXVI, 1964, pp. 70–77; M. Levi d'Ancona, *The Garden of the Renaissance. Botanical Symbolism in Renaissance Painting*, Florence, 1977; and

L. Behling, *Die Pflänze in der Mittelalterlichen Tafelmalerei*, Cologne, 1967.

10. See Roy, p. 127 above, at nn. 24 and 28.

11. R. Hakluyt, in *Voyages and Discoveries, 1598–1600*, London, 1972, described both the musk rose and the damask rose as newly introduced, quoted by A. Coates, *Garden Shrubs and their Histories*, London, 1963, p. 295.

12. The creamy colour of the roses in the Wilton Diptych is due to the ageing of the ground and later varnish. Only the central stamens appear to contain yellow pigment (see Roy, p. 127 above). In his *Herbal*, John Gerard treats the yellow rose as very new, and mocks those who suggested the colour was obtained by grafting it on a broom plant (John Gerard, *Herbal* or *General Historie of Plantes*, 1597; enlarged and amended by Thomas Johnson, 1633; repr. 1636). The single yellow *Rosa foetida* was known in the ancient Mediterranean (in Knossos for example) and grew in the Moorish gardens of Spain. The double yellow rose, *Rosa haemispherica*, arrived in Europe from Constantinople in the 1580s, but its buds fail to open if it rains, and it was still a rare plant when Jan van Huysum painted it in the 1720s.

13. Palgrave, ed., *Kalendars*, Vol. III, p. 356, item 326.

14. E. Wilkins, *The Rose Garden Game*, London 1969, pp. 157ff.

15. F. N. Robinson, *The Complete Works of Geoffrey Chaucer*, Oxford, 1957, p. 578.

16. C. Joret, *La Rose dans l'antiquité et au moyen âge*, Paris, 1892, pp. 393–8, details ceremonies where roses were scattered. Wilkins (cited in note 14 above), p. 157ff., also describes the scattering of rose petals as part of certain Whitsun ceremonies. In the Hours of Margaret of Orléans (Paris, Bibliothèque Nationale, MS lat. 1156B) made *c.* 1430, the miniature for Pentecost (f. 146) is surrounded by a border of flowers scattered by angels. In the introduction to the facsimile, E. König, *Les Heures de Marguérite d'Orléans*, Paris, 1992, p. 21, reference is made to documentation for the scattering of flowers during Pentecost in the Cathedrals of Vienne, Amiens and Beauvais.

17. Wilkins (cited in note 14 above), pp. 157ff.

18. Wilkins (cited in note 14 above), pp. 157ff.

19. G. Grigson, *The Englishman's Flora*, London, 1958, p. 407.

20. Robinson (cited in note 15 above), p. 483.

21. For the association of daisies with the Virgin, see Levi d'Ancona (cited in note 9 above).

22. Grigson (cited in note 19 above), pp. 295–6.

23. Ilg, 'Goldschmiedearbeiten Richards II', p. 13.

24. My thanks are due to the Mycological Department of the Royal Botanic Gardens, Kew, for this identification and information.

25. Palgrave, ed., *Kalendars*, Vol. III, p. 357, item 334.

26. *Romeo and Juliet*, IV, v.

27. J. Harvey, 'Rosemary', *Garden History Society Newsletter,* XXIII, Summer 1988.

28. M. Grieve, *A Modern Herbal*, London, 1976, p. 438.

29. Grigson (cited in note 19 above), p. 306.

30. Harvey, 'Wilton Diptych', pp. 1–24.

31. Henry Lyte, *A Niewe Herbal or Historie of Plantes,* London, 1578; repr. 1619.

32. J. Weston, *Ritual to Romance*, Cambridge, 1920. For the fertility rites associated with Adonis, from whom the flower is named, see esp. pp. 42–51.

33. Ilg, 'Goldschmiedearbeiten Richards II', p. 13. The inventory does suggest more than one type of fern was used as Anne of Bohemia's device in the collar designs.

34. For instance Memling's St Christopher in Cincinnati (Museum of Fine Arts); Geertgen tot Sint Jans's St John the Baptist in Berlin-Dahlem (Gemäldegalerie); and the Master of the Embroidered Foliage, St Peter in the triptych of the Miracles of Christ (Melbourne, National Gallery).

35. See Roy, p. 127 above.

X. FIGURED SILKS

I should like to thank Dillian Gordon and her colleagues at the National Gallery, Helen Bradley, John Harvey, Claude Blair, Jenny Stratford, Shelagh Mitchell, Kay Lacey, Kay Staniland and Karen Watts for their kind help in the preparation of this article.

1. W. W. Skeat, ed., *Piers the Plowman and Richard the Redeless*, Oxford, 1886, Vol. I, p. 619, Passus III.

2. In Richard II's Wardrobe Accounts, *'robe'* signified a set of several garments, see Livery Roll PRO, E 101/400/4, m. 1.

3. Harvey, 'Wilton Diptych', pp. 1–28; *Making and Meaning*, p. 51. See also Gordon in this volume (p. 20).

4. For the painting technique, see *Making and Meaning*, pp. 78–9; 'gown' is used in this article to denote the long-sleeved garment often termed *'houppelande'* during the 14th century. *'Houppelande'* does not occur in Richard II's Great Wardrobe Accounts, whereas 'goun' features regularly. Stella Mary Newton opines that 'goun and *houppelande* may have been two names for an identical or almost identical garment' in *Fashion in the Age of the Black Prince: A Study of the Years 1340–1365*, Woodbridge, 1980, p. 58.

5. B. Klesse, *Seidenstoffe in der italienischen Malerei des vierzehnten Jahrhunderts*, Bern, 1967; L. Monnas, 'Contemplate What Has Been Done: Silk Fabrics in Paintings by Jan van Eyck', *Hali*, LX, 1991, pp. 103–13.

6. All of the original documents cited in this paper are in the Public Record Office, London. Detailed accounts of Richard's clothing can be found in the seven Livery Rolls (of which three are fragmentary) from the reign of Richard II preserved there: PRO, E 101/397/20 (48 Edward III to 1 Richard II, 24 November 1374 to 6 July 1377, 33 mm.); PRO, E 101/400/4 (1–3 Richard II, 1377–80, 25 mm.); PRO, E 101/400/18 (5 Richard II, 1381–82, fragment); PRO, E 101/400/21 (5–7 Richard II, 1381–83, 2 mm.); PRO, E 101/401/6 (7–9 Richard II, 1383–85, 27 mm.); PRO, E 101/401/16 (9–11 Richard II, 1385–87, 34 mm.); PRO, E 101/403/6 (18–21 Richard II, 1394–98, fragmentary). Additional information is supplied by the Rolls of Purchase and of Expenses, and by indentures of the successive Keepers of the Great Wardrobe, by inventories and by the Issue Rolls.

7. L. Monnas, 'Silk Cloths Purchased for the Great Wardrobe of the Kings of England 1325–1462', *Ancient and Medieval Textiles, Studies in Honour of Donald King*, eds. L. Monnas and H.

Granger-Taylor, *Textile History*, XX/II, 1989, p. 284.

8. Account Roll of Richard Clifford, Keeper of the Great Wardrobe, PRO, E 101/405/21 (9–10 Henry IV), 'Expenses' included '*...cariag' div'so[rum] roba[rum] & alio[rum] garniament' d[omi]ni Regis de London usq' castrum Regis de Wyndesore mense maii anno ix* [1408] *de carriag' & portag' div[ersi]s pec' de veluet adaur' pann' adaur' de cipre & de s[er]ico de London usq[e] Langley mense Decembr' anno x* [1408] *ib[ide]m monstrand' d[omi]no Regi una cum custib[us] du[orum] homin[orum] cunc' cum eisdem reb[us] sup[er] salva custod' ea'dem p[er] viam...*'; see also Account Roll of Richard Clifford, PRO, E 101/405/22, 1 May 1408 to 29 September 1409, ff. 18v and 19 and PRO, E 101/405/25, 29 September 1409 to 1 April 1410.

9. Dr Helen Bradley points out that much of the cloth supplied to the Great Wardrobe by English mercers was imported into England by Italian merchants, see H. Bradley, *Italian Merchants in London, c. 1350–1450*, Ph.D. thesis, University of London, 1992, p. 262: for Lodewyco Anguill' ('Lowys Anguill'), ibid., p. 245; for John Foulcher and Lodewyco Anguill' see PRO, E 101/402/13; for Richard Whittington, see C. M. Barron, 'Richard Whittington: The Man Behind the Myth' in *Studies in London History*, eds. A. E. J. Hollaender and W. Kellaway, London, 1969, pp. 197–251.

10. Enrolled Account of the Great Wardrobe, PRO, E 361/5, mm. 2, 3, 4v, 7 recto and verso. When the expression '*pann' adaur' de cipr'/ damasc'/luk'* ' is employed, the silk may not have been woven in the specified place, as gold thread was traded internationally, see L. Monnas, 'The Cloth of Gold of the Pourpoint of the Blessed Charles de Blois: a pannus tartaricus?', *Bulletin de Liaison du Centre Internationale d'Étude de Textiles Anciens*, LXX, 1992 p. 122; for cloth of Cyprus gold made in England, see p. 172 of this paper.

11. Indenture between John de Sleford, Keeper of the Great Wardrobe under Edward III, and Alan de Stokes, Keeper under Richard II, of goods held in the Great Wardrobe, PRO, E 101/400/1 (1377). '*Baldekyn s[er]ic' dupl' op[er]at' cum auro de cipre...vj pec' pann' s[er]ic' op[er]at' cu[m] castell' de aur' de cipr'...*'; see also PRO, E 101/403/24, undated inventory, reign of Richard II, '*j doublet d'or le champ roug' poudr' avec alantz & arbr'* '; see G. Wingfield Digby and

W. Hefford, *The Devonshire Hunting Tapestries*, London, 1971, p. 45, where 'alaunts' are described as 'wolfhounds (or great dogs of indeterminate breed)'.

12. For a discussion of the rapid execution of stamping, see K. Staniland, 'Court Style—Painters and the Great Wardrobe in England in the Fourteenth Century' in *England in the Fourteenth Century* (Proceedings of the 1985 Harlaxton Symposium), ed. W. M. Ormrod, Woodbridge, 1986, pp. 236–46, esp. p. 242; a fragment of red silk with stamped gold decoration exists in the Victoria and Albert Museum in London (1539–1899), ibid., p. 241.

13. Livery Roll PRO, E 101/400/4, mm. 3 and 4. In addition to a '*...h[ar]nes integr' fac' p[ro] Rege de pann' adaur' racamatz rub' op[er]lat' cu[m] solis de auro...*' (requiring 1½ 'cloths'), the Livery Roll provides for '*...unum col' long & duo par' calig' de eodem pann' adaur' fac' pro vestur' Regis su[pr]a plat' & linand' cu[m] bokeram rub'...*' (requiring a further 'cloth'). The *calig'* would normally be translated as 'hose'. I am indebted to Karen Watts for pointing out that it was unusual to cover the leg armour with cloth. The way in which this cloth of gold *calig'* were worn 'over plate' is uncertain: a tentative hypothesis is that protective plates of metal or stiffened leather could have been inserted between the outer cloth of gold and the buckram lining of the hose (see Wilson, p. 36 and note 19; and Staniland, p. 90 and note 16).

14. Lampas denotes a figured weave in which the ground is created by a main warp and ground weft, and the pattern is created by one or more pattern and (optional) brocading wefts held in place by a binding warp.

15. For a comparison of *racamas* and *bawdekyn*, see D. and M. King, 'Silk Weaves of Lucca in 1376' in *Opera Textilia Variorum Temporum*, eds. I. Estham and M. Nockert, Stockholm, 1988, pp. 67–8; L. Monnas, 'The Price of Camacas Purchased at the English Court during the Fourteenth Century' in *La Seta in Europa Secolo XIII–XX* (Atti della Ventriquattresima Settimana di Studi, Istituto Internazionale di Storia Economica F. Datini), ed. S. Cavaciocchi, Prato, 1993, pp. 743–4.

16. For making a bed of *racamas*, '*cont[r]a adventu Anne Regine in Angl'* ' and other furnishings for the marriage celebrations and the coronation of Anne, 46 '*pann' adaur' racamacz'* ' were issued, of which five cloths were used for

the first bed alone; for canopies of *racamas* made to hang over the King and Queen in the palace of Westminster at Christmas 1383 and 1384, see Livery Roll PRO, E 101/401/6, mm. 18 and 21; for oblations of *racamas* offered by the King to the tombs of Edward III and the Black Prince on the anniversaries of their death, see Livery Roll PRO, E 101/397/20, m. 29 and PRO, E 101/401/6, mm. 20 and 24.

17. Alan de Stokes (Keeper of the Great Wardrobe) Roll of Expenses, PRO, E /101/401/15, Gilbert Prince was paid '...*p*[*ro*] *uno h*[*ar*]*nes integr' de tartar' rub' p*[*er*] *ip'm vapulat' cu*[*m*] *sol' de auro & nebul' de argento et asur' cum una bordur de coronis de auro et p*[*ro*] *uno magno sol' de auro p*[*ro*] *j crest & nebul' de argent' & asur et p*[*ro*] *una coron' & j lapkyn de ead*[*em*] *sect' p*[*re*]*c' xxv li' et p*[*ro*] *vj lanc' vj vantplat' j brestplat' ij vantbrac' & ij rerebrac' j mayndoser j cothec de plat' vj ga'tes vj coronalx p*[*er*] *ip'm colorat' in rub' cont*[*r*]*a hastilud' in Smythefeld mense marcii anno ix p*[*re*]*c' xls...*'. In this case the stamped red silk was worn with armour painted red; Livery Roll, PRO, E/101/401/16, m. 2, 6 ells of red satin and 18 ells of red taffeta were delivered to Walter Rauf for him to make '...*j goun curt' de satyn rub' fac' ad op*[*er*]*and' in broudar cum sol' & nebul' de auro & argento de plate & lin' tam p*[*ro*] *broudatur supportand' q*[*u*]*am post broudatur cu*[*m*] *taffat' rub' colar s'is manic' & fimbr' eiusdem goun lig' cum rubant aur' de venis p*[*ro*] *Rege cont*[*r*]*a hastilud' ten't' in Smithefeld...*'; PRO, E/101/401/15, m. 15, John de Strawesburgh received the materials to embroider the short gown with suns and clouds, together with a pair of *calig* (hose?) of scarlet cloth to be embroidered in gold thread for use at the same games.

18. J. G. Nichols, 'Observations on the Heraldic Devices Discovered on the Effigies of Richard II and his Queen in Westminster Abbey', *Archaeologia*, XXIX, 1842, pp. 47–8.

19. Ibid., pp. 47–8.

20. Ibid., pp. 47–8.

21. For the derivation of the ostrich feather badge, see N. H. Nicolas, 'Observations on the Origin and History of the Badge and Mottoes of Edward Prince of Wales', *Archaeologia*, XXXI, 1846, p. 350ff.; the earliest mention of the ostrich feather worn as Richard II's badge in the Great Wardrobe Accounts occurs on a set of jacks and a large pennon, Livery Roll PRO, E 101/401/6, m. 2.

22. These jacks were made entirely of woven cloth as distinct from the so-called jack of plate, see I. Eaves, 'The Remains of the Jack of Plate from Beeston', *Journal of the Arms and Armour Society*, September 1989, pp. 81–154.

23. For the surviving Livery Rolls, see above note 6; jacks are mentioned in the following Livery Rolls: PRO, E 101/401/4, m. 3; PRO, E 101/401/18; PRO, E 101/401/6, mm. 9, 13 and 14; PRO, E 101/401/16, mm. 4 and 15. In *ill. 100* the ostrich feather on the pennon is displayed on a blue field: the colour may not be accurately shown because the Great Wardrobe accounts of Richard II consistently refer to this badge as on a black field, esp. PRO, E 101/401/6, m. 2.

24. Livery Roll PRO, E 101/401/16, m. 15, black taffeta, thread of Cyprus gold and silver and coloured silk were issued to John de Strawesburgh, '*ad broudatur unius vagine et unius zone p*[*ro*] *uno gladio coop't' cum velvett nigr' op*[*er*]*at' in broudar' cum sol' de auro de cipr' & plum' dostrich' de argent' de cipr' & s*[*er*]*ico ordinat' ad portand' ante Regem cont*[*r*]*a f*[*este*]*m Nat' d*[*omi*]*ni anno ix*'.

25. Shelagh Mitchell observed some years earlier that these birds were cranes (verbal communication, July 1994); see Mitchell in this volume (p. 118); John Harvey identified them as demoiselle cranes in a letter to Dillian Gordon, 16 November 1993.

26. Nichols (cited in note 18 above), p. 37ff.

27. See Nigel Morgan's discussion of the use of related emblems by Richard II and Charles VI in this volume (p. 185).

28. Indenture between John de Sleford (Keeper of the Great Wardrobe under Edward III) and his successor under Richard II, Alan de Stokes, of goods held in the Great Wardrobe at the death of Edward III, PRO, E 101/400/1, '*Lect' de pann' s*[*er*]*ic' baldek*[*yn*]*...j coop'tor, linat' cu*[*m*] *sindon' de trip' cu*[*m*] *uno dorsor non linat' de pann' s*[*er*]*ic' baldek' dupl' op*[*er*]*at' cu*[*m*] *capit' c*[*er*]*vo*[*rum*] *de aur*[*o*] *de cipr' & una cellur' de tartaryn p*[*ro*] *eodem l*[*e*]*c*[*t*]*o...*'; Livery Roll PRO, E 101/397/20, 48 Edward III—1 Richard II, m. 15, among the items pertaining to Richard II was a bed of sarsenet which included '*coop'tor', 'iij tapet' pendent'* and sparver(?) of red worsted embroidered with circles of yellow chains containing harts lodged.

29. For the red velvet gown and hood, see *Making and Meaning*, p. 64 n. 36: Livery Roll PRO, E 101/401/16, m. 1 (Walter Rauf); ibid., m. 2 (John de Strawesburgh).

30. For the two blue velvet gowns and hoods: Livery Roll PRO, E 101/401/16, m. 2, *Eidem* [Walter Rauf] *ad j goun long' & j capuc' de velvett blu fac' ad op*[er]*and' in broudar' cu*[m] *c*[er]*vis alb' iacent' sub arborib*[us] *de auro de cipr' & s*[er]*ico div's' color' & rotul' de div's' dictamin' circumquaq*[ue] *arbores & furrurat' cu*[m] *m*[en]*u*[vair] *pur' & purfil' cum erm' p*[ro] *Rege cont*[ra] *f*[este]*m pasch' anno ix...'*; ibid., m. l5, John de Strawesburgh received materials to embroider a long blue velvet gown for the King *'...cu*[m] *c*[er]*vis alb' & arboribus de auro de cipr' aur' soldat' & s*[er]*ico div's color...cont*[r]*a seisonam estival anno ix'*; Roll of Expenses PRO, E 101/401/15, *'Eidem* [John de Strawesburgh] *ad f*[a]*c*[t]*uram unius goun long' de velvett blu ac ad broudatur eiusdem cu*[m] *c*[er]*vis & arboribus de sect' p*[re]*dict' goun' Reg' ordinat' p*[ro] *d*[omi]*na Regina de d*[omi]*ni Regis contra eandem seisonam'*. The embroiderer, who was issued with 'a piece and 5 ells' of blue velvet, seems to have made the queen's gown, as well as embroidered it.

31. Harvey, 'Wilton Diptych', p. 7.

32. PRO, E 101/403/6.

33. Inventory of Jewels and Plate Temp. Richard II, PRO, E 101/403/24, *'j slop de drap dor de cipr' la champ roug' poudr' ave*[c] *cerfs dor'*.

34. Livery Roll, PRO, E 101/403/6, *'...unu' slop' de satyn nigr' & op*[er]*and' in broudar cum bag d*[omi]*ni Reg*[is] *& lin' cum tel de reyns & postea lin' cu' tartar nigr & ad unu' coop'tor fac' de tel de custans custod' d*[i]*c*[t]*i slop' cont*[r]*a viag*[e]*m d*[omi]*ni Reg*[is] *usus hib*[er]*n'...'*

35. Compare the embroidered robes executed by John de Strawesburgh (see notes 29 and 30 above) and the garments embroidered in silver, gold and coloured silks by Robert de Varennes, embroiderer to King Charles VI of France, see L. Douët d'Arcq, *Nouveau Receuil de Comptes de l'Argenterie des Rois de France*, Paris, 1874, pp. 102 and 193.

36. See L. Monnas, 'Developments in Figured Velvet Weaving in Italy During the 14th Century', *Bulletin de Liaison du Centre Internationale d'Etude de Textiles Anciens*, LXIII–LXIV, I & II, 1986, pp. 70–71.

37. Ibid., pp. 72–3; G. Vial, 'Une Chasuble médiévale avec emblêmes héraldiques français. Dossier de recensement', *Bulletin de Liaison du Centre Internationale d'Etude de Textiles Anciens*, LXIII–LXIV, I & II, 1986, pp. 101–111.

38. The seal bag (WAM 1569) encloses a royal confirmation made to Abbot William de Colchester and the Convent of Westminster of all privileges and possessions granted from the time of King Edgar, dated to 20 February 1403; Frances Pritchard dates the half-silk fabric to the mid to late 13th century, see F. Pritchard, 'Two Royal Seal Bags from Westminster Abbey' in *Ancient and Medieval Textiles* (cited in note 7 above), pp. 228–32, ill. fig. 3 and pl. Vb.

39. I am indebted to Dr Helen Bradley for drawing my attention to the existence of Bendenell de Beek; payments to Bendenell de Beek are recorded in the Issue Rolls from 1386–93, Bradley (cited in note 9 above), pp. 244–5.

40. Issue Roll, PRO, E 403/510, m. 24; Bradley (cited in note 9 above), p. 244.

41. Another less extreme example of inconsistency is provided by the King's embroiderer, John de Strawesburgh, who is sometimes referred to as Hans de Strowesburgh, see PRO, E 403/510, m. 4 and Enrolled Account, PRO, E 361/5, m. 3v.

42. Livery Roll, PRO, E 101/401/16, m. 18. *'Baldewyno de Luk' Textori pann' adaur' ad unu*[m] *goun long' j capuc' & j par calig fac' & ad j par rob' de lin' de dono d*[omi]*ni Reg*[is] *cont*[r]*a f*[este]*m pur' b*[eat]*e marie anno ix p*[er] *eandem l*[itte]*ram de p*[ri]*vato sigillo'*. This required 2¾ ells *'pann' mixt' curt' '*, 3 ells *'pann' radiat' '*, and *'j par rob' lin' l'*.

43. Livery Roll, PRO, E 101/401/16, m. 3, *'Eidem* [Walter Rauf] *ad j goun' long' & j capuc' de panno adaur' de cipr' camp' alb' de op*[er]*e angl' fac' & furrurand' cu*[m] *m*[en]*u*[vair] *pur' & p'fil' cu*[m] *erm' p*[ro] *Rege cont*[r]*a idem f*[este]*m'* (Easter, year 9). This required 1½ cloths described as *'bald*[ekyn] *adaur' de cipr'*; it is likely that the *'2 jaks volants de pann' adaur' de cipr' bald*[ekyn] *camp' blu & rub' '* were of cloth woven by Bendenell as they would have displayed Richard II's arms. Only one piece of cloth is recorded for these jacks, which apparently were neither paned nor embroidered, see PRO, E 101/401/16, m. 4.

44. Alan de Stokes (Keeper of the Great Wardrobe), Roll of Expenses, PRO, E 101/401/15,

'...et p[ro] trib[us] patron' p[er] ips[u]m [Gilbert Prince] fact' p[ro] iij compas' de plum' dostrich' & coron' unde ij cu[m] scut' de armis d[omi]ni Regis & cu[m] galea Regis in medio ad lib[er]and' tapicer p[ro] exempl' suis ad op[er]and' tapet' lana vjs...; PRO, E 101/402/13, m. 2, Roll of Purchase of Richard Clifford, Keeper of the Great Wardrobe in 1392–94, a large set of woollen hangings and covers for *'banquers'* with comparable patterns woven to special order were purchased from John Dykes, *'tapicer London' '*, comprising fifteen *'tapet' lane op[er]at' in tapic'ia qualibet cum quatuor scutis de div'sis arm' & unu' magnu' compas' in medio cum arm' & galea d[omi]ni regis'* of which eight *tapet'* (each L. 8 × W. 4 ells), seven *tapet'* (each L. 6 × W. 4 ells) and three matching *'banquers'* (each L. 8 × W. 2½ ells) were to have a large circle (equal to 4 square ells, separately priced at 13s. 4d. each) in the middle, containing the arms of Richard II, and in each corner a shield bearing his arms (each 1 ell square and priced at 6s. 8d.). The total amount of cloth was 360 ells 'plain' at 20d. the ell, totalling £64 6s. 8d. This was rather less than the cost of the next entry but one, a *dorsor* of arras, woven with some Cyprus gold (L. 25 ells, W. 4½ ells), price £85. The enormous set of woollen hangings, (*tapet'*) measuring 106 ells end to end, was destined *'p[ro] camera Regis'* (location unspecified). See Wilson in this volume (p. 45 and note 56).

45. PRO, E 101/401/15, *'...et p[ro] ij al' patron' p[er] ip[su]m [Gilbert Prince] fact' cu[m] l[itte]ris de auro ad lib[er]and' textori pann' adaur' p'c' iiijs...'*

46. Examples of cloths embroidered with letters: PRO, E 101/401/6, m. 13, items 6, 8, 9 and 13; PRO, E 101/401/16/, m. 1, item 8, m. 3, item 7, m. 10, item 3, m. 11, item 1, m. 13, item 4.

47. Bradley (cited in note 9 above), p. 245.

48. O. von Falke, *Kunstgeschichte der Seidenweberei*, Berlin 1913, Vol. I, p. 77ff.

49. Legg, 'Inventory', pp. 252, 253, 258.

50. E. Crowfoot, F. Pritchard and K. Staniland, *Textiles and Clothing, Medieval Finds from Excavations in London*, London, 1992, pp. 113–20, esp. p. 118, figs. 88 and 89.

51. Illustrated in R. W. Valentiner, *Tino di Camaino*, Paris, 1935, pl. 15: when the tomb was opened in 1727, the body was found wrapped in silks woven with eagles (ibid., p. 41).

52. Professor Tristram saw these eagles as an allusion to the eagles traditionally woven on the coronation pallium of the kings of England, see Harvey, 'Wilton Diptych', p. 23 n. 1; Legg, 'Inventory', p. 257 n. c.; see also Morgan in this volume (p. 186); Richard II wore a gown embroidered with eagles to the marriage of the Countess of Nottingham in July 1384, Livery Roll PRO, E/101/401/6, m. 13.

53. For the 15th-century dating, see A. Wardwell, 'The Stylistic Development of 14th and 15th Century Italian Silk Design', *Aachener Kunstblätter*, XXXXVII, 1976/1977, p. 225; see also B. Tietzel, *Deutsches Textilmuseum Krefeld, Italienischen Seidengewebe des 13., 14., und 15. Jahrhunderts*, Cologne, 1964, cat. no. 151, pp. 438–40.

XI. THE SIGNIFICATION OF THE BANNER

1. I would single out as still fundamental reading for any understanding of the Diptych the articles of Maude Clarke and John Harvey: Clarke, 'Wilton Diptych' in *Fourteenth Century Studies*, pp. 272–92 and Harvey, 'Wilton Diptych', pp. 1–28. To these must be added the admirable catalogue raisonné entry of M. Davies, *National Gallery Catalogues. French School*, 2nd edn, London, 1957, pp. 92–101. In the more recent literature I have found the work of Michael Bath and Sumner Ferris particularly important: M. Bath, 'The White Hart, the *Cerf Volant* and the Wilton Diptych' in *The Third International Beast Epic, Fable and Fabliau Colloquium Proceedings*, eds. J. Goossens and T. Sodmann, Cologne, 1981, pp. 25–42 and S. J. Ferris, 'The Wilton Diptych and the Absolutism of Richard II', *Journal of the Rocky Mountain Medieval and Renaissance Association*, VIII, 1987, pp. 33–66. One contribution to the discussion, albeit by a scholar of great perception and knowledge, which I find totally unconvincing in suggesting that the Diptych was painted for one of his supporters after Richard's death is that presented by Francis Wormald, 'The Wilton Diptych', *JWCI*, XVII, 1954, pp. 191–203 (reprinted in id., *Collected Writings. II: Studies in English and Continental Art of the Later Middle Ages*, eds. J. J. G. Alexander, T.J. Brown and J. Gibbs, London, 1988, pp. 103–16). The argu-

ments for a date after 1414 proposed by Sylvia Wright I also find unconvincing: S. Wright, 'The Author Portraits in the Bedford Psalter-Hours; Gower, Chaucer and Hoccleve', *British Library Journal*, XVIII, 1992, p. 196. In what follows it is assumed that the painting was painted before the King's death in 1400.

2. On this interpretation, see Palmer, *England, France and Christendom*, pp. 242–4 and the article by Maurice Keen in this volume (pp. 189–96). As I argue for a date for the painting of 1397–98, that is, after the disastrous defeat of the western crusade at Nicopolis in 1396, any crusading imagery in those years would be extremely unlikely.

3. In the discussion of my paper at the symposium, Claude Blair pointed out that hands held open could equally be interpreted as a gesture of response to a visionary experience. He cited the tomb of Richard Beauchamp in St Mary's, Warwick, where with this hand gesture the Earl looks up to the Assumption on the roof boss directly above his tomb. Kneeling donors with their hands open before sacred figures can also be seen as responding to a vision; a good example would be the *c.* 1410 miniature of the man and woman kneeling before the Christ of the Transfiguration in Oxford, Bodleian Library, MS Lat. liturg. f. 2 (f. 2v). In the case of the Wilton Diptych, Richard's hand gesture seems to me primarily the functional one for receiving back the banner, but could equally as well signify response to a visionary event rather than an actual one.

4. On this Pontifical, see W. H. Frere, *Pontifical Services*, Alcuin Club Collections, III, London, 1901, pp. 87–9 and W. Maskell, *Monumenta Ritualia Ecclesiae Anglicanae*, London, 1847, Vol. III, pp. 320–22 (or pp. 326–8 in the reprint edn) for a full text of the prayer. The same prayer and rubric is found in two other early 15th-century English Pontificals: Cambridge, University Library, MS Mm. 3. 21, f. 269 and London, British Library, MS Lansdowne 451, f. 188v. On these, see Frere (pp. 90–1, 103–4) and J. Brückmann, 'Latin Manuscript Pontificals and Benedictionals in England and Wales', *Traditio*, XXIX, 1973, pp. 404–5, 414–6, 442.

5. In the manuscript, the silver used for the argent tincture has tarnished to black. No contemporary English Pontifical shows the scene of the bishop performing the blessing but this is illustrated in a *c.* 1375 French Pontifical:

Paris, Bibliothèque Sainte Geneviève, MS 143, f. 181v (*ill. 109*). On this, see V. Leroquais, *Les Pontificaux manuscrits des bibliothèques publiques de France*, Paris, 1937, p. 244.

6. See A. Franz, *Die kirchlichen Benediktionen im Mittelalter*, Freiburg im Breisgau, 1909, Vol. II, pp. 289–98. For a pre-Conquest English Pontifical with the blessing of a banner, see Cambridge, Corpus Christi College, MS 44, f. 67, Brückmann (cited in note 4 above), pp. 403–4.

7. M. Keen, *Chivalry*, New Haven, 1984, p. 47.

8. P. Contamine, *L'Oriflamme de Saint-Denis aux XIVe et XVe siècles*, Nancy, 1975, pp. 32–4 and W. M. Hinkle, *The Fleurs de Lis of the Kings of France*, Carbondale, 1991, pp. 91–3 and 163–5.

9. E. S. Dewick, ed., *The Coronation Book of Charles V of France*, Henry Bradshaw Society, XVI, London, 1899, p. 50, pl. 38 for an illustration of the blessing. Another blessing by the Archbishop of Reims of the oriflamme is for an expedition of war when it is held by Charles V standing in armour and presented to a kneeling knight in the *c.* 1372–74 Chronicle (Paris, Bibliothèque Nationale, MS fr. 437, f. 51v), Contamine (cited in note 8 above), fig. 5.

10. Regrettably there is no equivalent full study of English national standards to the excellent account of the oriflamme by Philippe Contamine. Useful accounts of the dragon standard are J. S. P. Tatlock, 'The Dragons of Wessex and Wales', *Speculum*, VIII, 1933, pp. 223–35 and P. E. Schramm, 'Beiträge zur Geschichte der Fahnen und ihr Verwandten' in id., *Herrschaftszeichen und Staatssymbolik*, Schriften der Monumenta Germaniae Historica, XIII/II, Stuttgart, 1955, pp. 661–4.

11. *CPR 1350–54*, p. 127.

12. The banner with the ensign *argent a cross gules* is borne by other saints than St George in 14th-century art, above all St Ursula, as in the Visconti Hours Missal (Paris, Bibliothèque Nationale, MS lat. 757, f. 380), see L. Castelfranchi-Vegas, *International Gothic Art in Italy*, London, 1968, pl. 19; K. Sutton, 'The Original Patron of the Lombard Manuscript Latin 757 in the Bibliothèque Nationale, Paris', *Burlington Magazine*, CXXIV, 1982, pp. 88–94 for an alternative view of the patron of the book and E. Kirsch, *Five Illuminated Manuscripts for Giangaleazzo Visconti*, University Park, Penn. and London, 1991, pp. 13–17, fig. 11. Also its use as a national military standard was not confined to

England. For a contemporary English representation of St George with the banner, see the *c.* 1390 Hours (now dismembered as dispersed leaves) sold at Bernard Quaritch, *A Catalogue of Illuminated and Other Manuscripts*, London, 1931, no. 56 with plate of the St George, but with a much too late dating of *c.* 1420 (*ill. 110*). Another use of the red cross on a white ground was for some of the Italian confraternities as in the painting of St Peter Martyr presenting a banner to the Captains of the Bigallo in a painting by Andrea Bonaiuti, see J. Henderson, *Piety and Charity in Late Medieval Florence*, Oxford, 1994, p. 26, pl. 1.1, and that used in Rome and well-discussed by W. F. Volbach, 'La Bandiera di San Giorgio', *Archivio della Reale Deputazione Romana di Storia Patria*, LVIII, 1935, pp. 153–70.

13. Harvey, 'Wilton Diptych', p. 21 points out that the banner of the Resurrection is usually surmounted by a cross, and that the prominence given to the orb surmounting the banner of the Wilton Diptych suggests strongly that it is not representing the Resurrection. For the view of the Wilton Diptych banner as representing both the banner of the Resurrection and that of St George, see Gordon, 'A New Discovery', p. 667. The overpainting of the original cross-headed banner with the orb suggests the correction of a mistake by the artist in placing a cross at the top.

14. I am aware that further research on contemporary inventories is needed to find references to the location of diptychs in England. For French, German and Italian diptychs, see K.-A. Wirth, 'Diptychon', *Reallexikon zur deutschen Kunstgeschichte*, IV, Stuttgart, 1958, cols. 62–74; W. Kermer, *Studien zum Diptychon in der sakralen Malerei*, Neunkirche-Saar, 1967; and G. Troescher, *Burgundische Malerei*, Berlin, 1966.

15. For biographies of the knights appointed by Richard, see G. F. Beltz, *Memorials of the Order of the Garter with Biographical Notices of the Knights in the Reigns of Edward III and Richard II*, London, 1841, pp. 243–376. On the courtiers close to Richard, but without comment specifically on the Garter Knights, see Given-Wilson, *Royal Household*, pp. 160–88.

16. See W. G. Constable, 'On the Date and Nationality of the Wilton Diptych', *Burlington Magazine*, LV, 1929, p. 41 on this connection. On this chapel and its confusion with a chapel of the same name within Westminster Abbey, see C. L. Kingsford, 'Our Lady of the Pew. The King's Oratory or Closet in the Palace of Westminster', *Archaeologia*, LXVIII, 1916, pp. 1–20 and J. M. Hastings, 'Our Lady of the Pew', *Architectural Review*, August 1945, pp. 57–8. In view of the personal nature of the Diptych, the Chapel of the Pew at St Stephen's would seem a more likely location for it than the chapel of the same name in the Abbey as suggested in *Making and Meaning*, p. 62.

17. M. Senior, *The Life and Times of Richard II*, London, 1981, pl. on p. 79. The chronicles record that the rebels bore only the banner of St George, on which see note 29 below.

18. For fundamental discussions of the golden dragon, see Tatlock and Schramm (both cited in note 10 above), pp. 661–4.

19. Tatlock (cited in note 10 above), p. 226 and S. Bentley, *Excerpta Historica or Illustrations of English History*, London, 1833, p. 404.

20. Contamine (cited in note 8 above), pp. 10–21.

21. I am grateful to Kay Staniland for informing me that there are documents which provide such information, and regret that the short time available for additional research for this paper has not enabled me to investigate them. For discussions of English medieval flags, see W. G. Perrin, *British Flags*, Cambridge, 1922, pp. 33–44 and C. Campbell, *Medieval Flags*, Edinburgh, n.d [*c.* 1980], pp. 2–15. For French military use of flags other than the oriflamme, see P. Contamine, *Guerre, état et société à la fin du moyen âge. Études sur les armées des rois de France 1337–1494*, Paris, 1972, pp. 670–76. For any study of the use of flags, the exhaustively documented article of O. Neubecker, 'Fahne', *Reallexikon zur deutschen Kunstgeschichte*, VI, Munich, 1973, cols. 1060–1168 is fundamental.

22. Perrin (cited in note 21 above), p. 37.

23. Perrin (cited in note 21 above), pp. 38–9; G. J. Brault, *Eight Thirteenth-Century Rolls of Arms in French and Anglo-Norman Blazon*, London, 1973, p. 122.

24. T. Twiss, *The Black Book of the Admiralty*, Rolls Series, London, 1871, p. 456. The same form for the Ordinances was incidentally used by Henry V at Le Mans in 1419, Twiss, p. 464.

25. Harvey, 'Wilton Diptych', p. 21.

26. Twiss (cited in note 24 above), p. 456.

27. H. A. Koch, *Medieval Warfare*, London, 1978, pl. on p. 133.

28. The direct link of the banner of St George with the King is evidenced by two banners of St George and two banners of Edward the Confessor set around his coffin at his funeral in St Paul's on 12 March 1400, B. Williams, *Chronicque de la traison et mort de Richard deux roy d'Engleterre*, London, 1846, p. 261.

29. In this respect it is very significant that two banners of St George were carried by the insurgents of the Peasant's Revolt in 1381 when they met the King and Archbishop Sudbury at Blackheath as the Anonimalle Chronicle of St Mary's York records, V. H. Galbraith, ed., *The Anonimalle Chronicle 1333 to 1381*, Manchester, 1927, p. 139.

30. See Campbell (cited in note 21 above), pp. 4, 12–13 for the terminology. An unusual case of the cross of St George being borne on a baronial shield is by Henry Bolingbroke at the combat with Thomas Mowbray on 16 September 1398 to which Richard put a stop, Williams (cited in note 28 above), pp. 152–3.

31. T. Willement, 'Banners, Standards and Badges Temp. Hen. VIII', *Collectanea Topographica et Genealogica*, III, 1836, pp. 55–6 and T. E. E. Howard de Walden, *Standards and Badges from a Tudor Manuscript in the College of Arms*, London, 1904, pp. 5, 71. I cannot find any contemporary evidence for the form of Richard's standard.

32. It is to Sumner Ferris's article (cited in note 1 above, pp. 42–4) that I am indebted for this reference and the interpretation that follows of the Radcot Bridge raising of the banner. Although he rightly emphasizes the importance of the banner in his subsequent overall interpretation of the Diptych, I find some aspects of his argument, to which I will refer later, not acceptable.

33. *Westminster Chronicle*, pp. 220–22.

34. *Chronicon Henrici Knighton*, ed. J. R. Lumby, Rolls Series, XCII, 2 vols., London, 1889–95, II, p. 290 and *Westminster Chronicle*, pp. 268–9.

35. C. Given-Wilson, ed., *Chronicles of the Revolution, 1397–1400*, Manchester, 1993, p. 173. I take Given-Wilson's translation with one emendation as noted in note 36 below. For the Parliament articles, see *Rotuli Parliamentorum*, Vol. III, p. 418.

36. In the Latin the text has *'vexillum eius…erigendo'*, which literally means 'setting up his standard' and not just 'challenging the peace' as Given-Wilson has paraphrased the passage (cited in note 35 above, p. 173). Undoubtedly 'challenging the peace' of course conveys exactly what was implied by setting up the standard. For the Latin text, see *Johannes de Trokelowe et Henrici de Blaneforde monachorum S. Albani necnon quorundam anonymorum Chronica et Annales*, ed. H. T. Riley, Rolls Series, London, 1866, pp. 260–1. See also the same passage in A. H. Thomas and I. D. Thornley, *The Great Chronicle of London*, London, 1938, p. 56.

37. Gordon, 'A New Discovery', pp. 662–7. J. Evans, 'The Wilton Diptych Reconsidered', *Archaeological Journal*, CV, 1950, p. 5 seems the first to emphasize the banner as denoting the sovereignty of England. See also with the same emphasis C. T. Wood, 'Richard II and the Wilton Diptych' in *Joan of Arc and Richard III. Sex, Saints, and Government in the Middle Ages*, ed. C. T. Wood, Oxford, 1988, p. 82.

38. C. Coupe, 'An Old Picture', *The Month*, LXXXIV, 1895, pp. 229–42; H. Thurston, 'The Wilton Diptych', *The Month*, CLIV, 1929, pp. 27–37; J. Allen, 'A Royal Reredos', *The Venerabile*, XX, 1961, pp. 127–39, Harvey, 'Wilton Diptych', pp. 20–21 and Gordon, 'A New Discovery', p. 667. In the 19th century, works such as T. E. Bridgett, *Our Lady's Dowry*, London, 1875 re-popularized the imagery. See M. Elvins, 'Mary's Dowry', *The Ransomer*, XXXII, no. V, 1993, pp. 8–15. References to the dowry of Mary in medieval texts and in recusant prayer books still need further research.

39. Allen (cited in note 38 above); Harvey, 'Wilton Diptych', pp. 20–21; and Whittingham, 'Chronology', pp. 12–15 provide the best recent discussions of the Rome painting.

40. It is tempting to see the figure as a reference to the figure of the Virgin donated by Henry III which was kept in the Chapel of Our Lady of the Pew. Edward III in 1369 grants an annuity to a chaplain, John Bulwyk, to celebrate Divine service daily for the departed souls of members of the royal family 'before the image of Blessed Mary in La Piewe by the King's Chapel of St Stephen in the Palace of Westminster', *CPR 1367–70*, p. 325. Froissart, confusing its location in Westminster Abbey, tells us the English kings had particular devotion to this image, and before it Richard may have sworn allegi-

ance to Charles VI when he meets Pierre Salmon on the embassy from the King of France in 1397 in this chapel; on these sources, see Kingsford (cited in note 16 above), pp. 6–9, Hastings (also cited in note 16 above), pp. 57–8 and *Making and Meaning*, p. 60 n. 128. Although many of Froissart's statements are fictional and confused, there seems no reason to doubt his veracity in claiming this image's special significance for the English kings. On Froissart's accounts of Richard II, see G. B. Stow, 'Richard II in Jean Froissart's *Chroniques*', *Journal of Medieval History*, XI, 1985, pp. 333–45. Everard Green's attempt at an explanation of the choice of eleven angels in relation to Richard's donation of eleven 'angels' at the time of his Coronation to this statue of the Virgin was not supported by any reference to a source for his information; see Constable (cited in note 16 above), p. 41 and M. Conway, 'The Wilton Diptych', *Burlington Magazine*, LXV, 1929, pp. 209–10. As Constable points out, the 'angels' may not refer to a gift of money, as the angel coin was not current in Richard's time, but of course a later chronicler may have translated whatever sum the King may have given into current coin terminology.

41. In the mid 14th century, Heinrich Suso described how he liked to adorn the image of the Virgin with roses; Heinrich Suso, *The Life of the Servant*, transl. J. M. Clark, London, 1952, p. 110. See also H. Thurston, 'The Dedication of the Month of May to Our Lady', *The Month*, XCVII, 1901, p. 475–7. Chaucer writes in the *Romaunt of the Rose* 'Have hat of floures as fresh as May, Chapelett of Roses of Whitsonday', *The Riverside Chaucer*, ed. L. G. Benson, Boston, 1987, p. 711, lines 2277–78.

42. Gordon, 'A New Discovery', p. 667.

43. Harvey, 'Wilton Diptych', p. 21. See also Pujmanová in this volume (note 57).

44. Harvey, 'Wilton Diptych', pp. 6–7. The Smithfield Tournament is discussed by S. Lindenbaum, 'The Smithfield Tournament of 1390', *Journal of Medieval and Renaissance Studies*, XX, 1990, pp. 1–20.

45. The use of the broom cod on Sir John Golafre's brass suggests that it had become part of Richard's emblems and had no specific French association as discussed by N. Saul, 'The Fragments of the Golafre Brass in Westminster Abbey', *Transactions of the Monumental Brass Society*, XV, 1992, pp. 19–32 and Ferris

(cited in note 1 above), p. 41. R. W. Lightbown, *Mediaeval European Jewellery*, London, 1992, pp. 162–7, 268–70 demonstrates how many of the emblems in this period on jewellery were widespread and used by more than one person.

46. J. G. Nichols, 'Observations on the Heraldic Devices Discovered on the Effigies of Richard II and his Queen in Westminster Abbey', *Archaeologia*, XXIX, 1842, pp. 36, 47–8.

47. Nichols (cited in note 46 above), p. 48 n. x and J. B. de Vaivre, 'Les Cerfs ailés de la tapisserie de Rouen', *Gazette des Beaux Arts*, C, 1982, p. 100.

48. Bath (cited in note 1 above) and M. Bath, 'The Legend of Caesar's Deer', *Medievalia et Humanistica*, IX, 1979, pp. 53–66. See also S. Hindman, *Christine de Pizan's "Epistre d'Othéa". Painting and Politics at the Court of Charles VI*, Toronto, 1986, pp. 148–52, fig. 52; de Vaivre (cited in note 47 above), pp. 94–8, 100; C. Beaune, 'Costume et pouvoir en France à la fin du moyen âge: les devises royales vers 1400', *Revue des sciences humaines*, LV, 1981, pp. 128–40.

49. For Bourges, see M. Meiss, *French Painting in the Time of Jean de Berry: The Late Fourteenth Century and the Patronage of the Duke*, London, 1967, pp. 38–9, fig. 431 and Bath (cited in note 1 above), p. 28. For Paris, see J. Guerout, 'Le Palais de la Cité à Paris des origines à 1417', *Mémoires de la fédération des sociétés historiques et archéologiques de Paris et de l'Île De France*, II, 1950, pp. 133–6.

50. Bath (cited in note 1 above), p. 30; A. H. E. de Queux de Saint-Hilaire, *Oeuvres complètes de Eustache Deschamps*, I, Paris, 1878, p. 164; II, Paris, 1880, pp. 9, 57.

51. R. F. Green, *Poets and Princepleasers: Literature and the English Court in the Late Middle Ages*, Toronto, 1980, pp. 64, 77.

52. Unfortunately, the published lists have no mention of Eustache Deschamps: E. Rickert, 'King Richard II's Books', *The Library*, 4th Series, XIII, 1933, pp. 144–7; R. S. Loomis, 'The Library of Richard II' in id., *Studies in Language, Literature and Culture of the Middle Ages and Later*, Austin, 1968, pp. 173–8; and R. F. Green, 'King Richard's Books Revisited', *The Library*, XXXI, 1976, pp. 235–9.

53. Ferris (cited in note 1 above), pp. 45–53 argues at length that Richard was concerned over

his legitimacy and thus wanted to be seen as approved by the two royal saints, but the sources for slurs on his legitimacy seem all to postdate Richard's reign as an aspect of Lancastrian propaganda. I am grateful to Nigel Saul for his opinion on this matter.

54. Evans (cited in note 37 above), p. 3 and Ferris (cited in note 1 above), p. 45.

55. E. Bysshe, *Nicolai Uptoni de Studio Militari, Iohan. de Bado Aureo Tractatus de Armis, Henrici Spelmanni Aspilogia,* London, 1654, p. 14. On the authorship, see E. J. Jones, *Medieval Heraldry. Tractatus de Armis of Johannes de Bado Aureo,* Cardiff, 1932, pp. 12–13.

56. E. W. Tristram, 'The Wilton Diptych', *The Month,* New Series, I, 1949, pp. 384–7; Harvey, 'Wilton Diptych', p. 23.

57. The best account of the medieval coronation vestments is W. H. St John Hope, 'The King's Coronation Ornaments', *The Ancestor,* I, 1902, pp. 127–59. See also J. W. Legg, *Three Coronation Orders,* Henry Bradshaw Society, XIX, 1900, pp. xxxii–xxxiii. For the rite of Richard's Coronation, see Legg, *Coronation Records,* pp. 112–30.

58. The buskins may have had a special place in Richard's memory in view of the famous incident when, at the conclusion of the rite, his beloved tutor, later to be executed by the Appellants, Simon Burley, while carrying the exhausted young boy to the Palace, allowed one of the probably too large buskins to fall off, and it was not recovered. The King later was asked to provide funds to Westminster Abbey to replace it. On this incident, see J. Armitage Robinson, 'An Unrecognised Westminster Chronicler 1381–94', *Proceedings of the British Academy,* III, 1907–08, pp. 71–2.

59. I am grateful to Lisa Monnas and Kay Staniland for their cautionary comments and information on interpreting the form of Richard's vesture. They pointed out to me that the mantle is worn over a *houppelande* whose sleeves are visible.

60. On these issues, see M. McKisack, *The Fourteenth Century 1307–99,* Oxford, 1959, pp. 475–77; J. J. N. Palmer, 'The Background to Richard II's Marriage to Isabelle of France (1396)', *Bulletin of the Institute of Historical Research,* XXXXIV, 1971, pp. 1–17; and id., 'English Foreign Policy 1388–99' in *Reign of Richard II,* pp. 75–107.

61. St John Hope (cited in note 57 above), pp. 150–2 for the regalia.

62. On the form of the English medieval coronation crowns see St John Hope (cited in note 57 above), pp. 150–2 and Lord Twining, *A History of the Crown Jewels of Europe,* London, 1960, pp. 122–5.

63. Similar views are held by Conway (cited in note 40 above), pp. 210–11; G. Henderson, *Gothic,* Harmondsworth, 1967, p. 202; Wood (cited in note 37 above), pp. 82, 84–5; and Ferris (cited in note 1 above), p. 43.

64. See Harvey, 'Wilton Diptych', pp. 11–13 and Whittingham, 'Chronology', pp. 12–21 on the problem of the moustache and beard. C. R. Beard, 'The Wilton Diptych–English!', *Connoisseur,* LXXXVII, 1931, p. 375 makes the quite sensible suggestion that from the time of Richard's second marriage to the young girl Isabelle in 1396 he may have decided to abandon his beard and moustache. As many contemporary French works of art show, it was also becoming fashionable in the 1390s for young men, and Richard was still only 30 at the time, to be clean shaven.

65. The prayer to the guardian angel, commonly found in the 15th century, was in use in the late 14th century in England. It is in the Bohun Psalter-Hours (London, British Library, MS Egerton 3277, f. 165). Angels wearing emblems and livery colours of a patron are found in contemporary work for the Maréchal de Boucicaut, M. Meiss, *French Painting in the Time of Jean de Berry. The Boucicaut Master,* London, 1968, pp. 7–9, pl. 39. The choice of blue garments for the Wilton Diptych angels might be linked to the similar blue robes of the Garter Knights, his intimate supporters, as Wood (cited in note 37 above), p. 89, has suggested. For their robes and the reasons for the choice of blue, see J. L. Nevinson, 'The Earliest Dress and Insignia of the Knights of the Garter', *Apollo,* XXXXVII, 1948, pp. 80–3 and particularly S. M. Newton, *Fashion in the Age of the Black Prince: A study of the years 1340–1365,* Woodbridge, 1980, pp. 43–6. If any allusion to Garter robes is intended, then it is significant to note that at the Smithfield Tournament in 1391, when the badge of the White Hart was first distributed by the King, the first to receive it were the Garter Knights, Beltz (cited in note 15 above), p. 252–3.

66. The literature on Richard's views of his role as King in this period is extensive. See R. H. Jones, *The Royal Policy of Richard II: Absolutism in the Later Middle Ages*, Oxford, 1968, pp. 165–85; J. Taylor, 'Richard II's Views on Kingship', *Proceedings of the Leeds Philosophical and Literary Society*, XIV, 1971, pp. 189–205; and Ferris (cited in note 1 above), pp. 59–60 with whose interpretation of the triumphal nature of the painting as a confirmation of Divine approval of royal authority I am in full agreement.

67. The prayer has identical wording in the three near contemporary English Pontificals: Cambridge, Corpus Christi College, MS 79; Cambridge, University Library, MS Mm. 3. 21; and London, British Library, MS Lansdowne 451. I have not yet examined all the extant English Pontificals to ascertain any possible variants.

XII. THE CASE FOR A CRUSADING CONTEXT

1. Clarke, 'Wilton Diptych' in *Fourteenth Century Studies*, pp. 272–92; Palmer, *England, France and Christendom*, pp. 205, 242–4; and M. H. Keen, 'Chivalrous Culture in Fourteenth Century England', *Historical Studies*, X, 1976 pp. 4–8.

2. See *Making and Meaning*, p. 59.

3. Harvey, 'Wilton Diptych', pp. 1–28; for the dating issues, see esp. pp. 4–14.

4. Ibid., p. 9 n. 1.

5. *Making and Meaning*, pp. 51–3 and fig. 12, which shows the details of the broom cods pounced on Richard's tomb effigy in Westminster Abbey; Palgrave, ed., *Kalendars*, Vol. III, pp. 354, 357—nos. 307 and 342 of the inventory refer to collars of broom.

6. Harvey, 'Wilton Diptych', p. 7 and n. 3.

7. Ibid., p. 10 n. 5; Clarke, 'Wilton Diptych' in *Fourteenth Century Studies*, p. 281. As Clarke notes, Charles on this occasion presented broom cod collars to the Duchesses of Lancaster and Gloucester, to the Countess of Huntingdon, and to Joan, daughter of John of Gaunt, Duke of Lancaster.

8. Harvey, 'Wilton Diptych', p. 9; *Making and Meaning*, p. 51.

9. Palgrave, ed., *Kalendars*, Vol. III, pp. 354, 357. After Richard's fall, Henry IV assumed the collar, and Froissart describes it as the collar of the King of France, *Oeuvres de [Jean] Froissart…Chroniques*, ed. K. de Lettenhove, 25 vols., Brussels, 1870–77, XVI, p. 205; Nicholas Upton, writing in the 1440s, described the broom cod collar as being that of the King of France, *De Studio Militari*, ed. E. Bysshe, London, 1654, p. 33.

10. A very full account of all the negotiations involved is given by Palmer, *England, France and Christendom*.

11. Ibid., pp. 198–9.

12. Ibid., p. 200.

13. Ibid.; for the text of the letter, see O. Cartellieri, *Philipp der Kühne*, Leipzig, 1910, Appendix 10.

14. J. J. N. Palmer, 'The Background to Richard II's Marriage to Isabelle of France, 1396', *Bulletin of the Institute of Historical Research*, XLIV, 1971, pp. 9–13. On Robert the Hermit, see Philippe de Mézières, *Letter to King Richard II*, ed. G. W. Coopland, Liverpool, 1975, pp. xxii–iv.

15. Palmer, *England, France and Christendom*, p. 180; for the full text, see M. D. Legge, ed., *Anglo-Norman Letters and Petitions*, Anglo-Norman Text Society, III, 1941, no. 172.

16. Coopland (cited in note 14 above), n. 14, prints and translates the full text. Palmer (cited in note 14 above) has shown that the letter was expressly commissioned by Charles VI (p. 11).

17. *Foedera*, ed. Rymer, Vol. VII, pp. 813–20 (marriage agreement), pp. 820–32 (28-year truce).

18. Palmer, *England, France and Christendom*, pp. 201, 239–40.

19. London, British Library, MS Royal 20 B VI, f. 2.

20. Ibid., f. 1v

21. Ibid., f. 35. Clarke here also reproduces the illustration of the Order's banner from *La Substance abrégée de la chevalerie de la passion*, the shortened version of its Rule presented by de Mézières to John Holland, Earl of Huntingdon;

it shows the same medallion with the Resurrection banner of the Lamb.

22. Gordon, 'A New Discovery', p. 664.

23. The fullest account of de Mézières' life remains N. Jorga, *Philippe de Mézières, 1327–1405, et la croisade au XIVᵉ siècle*, Paris, 1896, variorum reprint, 1973.

24. Ibid., pp. 74, 347–52, 453–59. By de Mézières' own account, the first inspiration to found the Order came to him in 1347, the first detailed plans were outlined in 1367–68, and the full text of the Rule of the Order appears to have been written *c.* 1384 (Paris, Bibliothèque de l'Arsenal, MS 2251). De Mézières was Chancellor to King Peter of Cyprus, and it is hard to believe that Peter's Order of the Sword was not an influence, on which see D'A. J. D. Boulton, *The Knights of the Crown. The Monarchical Orders of Knighthood in Later Medieval Europe 1325–1520*, Woodbridge, 1987, pp. 241–49.

25. Palmer, *England, France and Christendom*, p. 188; on Robert the Hermit, see Coopland (cited in note 14 above), n. 14, and on Otto de Granson, see L. Toulmin Smith, ed., *Expeditions to Prussia and the Holy Land made by Henry Earl of Derby*, Camden Society, New Series, LII, London, 1884, p. 309.

26. Palmer, *England, France and Christendom*, p. 180.

27. *Making and Meaning*, p. 60, and see pl. 18 for an illustration of the robes of a Prince of the Order; see also Clarke, 'Wilton Diptych' in *Fourteenth Century Studies*, p. 290.

28. The traditional arms of the Confessor were *azur*, between a cross fleury *or*, with five martlets *or*, they are, of course, fictitious.

29. Legg, 'Inventory', p. 280.

30. Froissart, *Oeuvres* (cited in note 9 above), Vol. XV, p. 180.

31. Harvey, 'Wilton Diptych', pp. 5–6.

32. R. Griffin, 'The Arms of Richard II as Shown in Windows at Westwell and Wateringbury', *Archaeologia Cantiana*, XLVII, 1935, pp. 170–76; the lights at Westwell show not only the arms of the Confessor impaling France and England, but also the Confessor's arms impaling those of St Edmund, who is also portrayed in the Diptych. For Richard's tomb canopy, see *Mak-*

ing and Meaning, fig. 16, p. 55; on Felbrigg, see further J. D. Milner, 'Sir Simon Felbrigg, K.G.: the Lancastrian Revolution and Personal Fortune', *Norfolk Archaeology*, XXXVII/I, 1978, pp. 84–91.

33. Clarke, 'Wilton Diptych' in *Fourteenth Century Studies*, p. 275 n. 4 and references there cited.

34. L. Douët d'Arcq, *Inventaires et documents: collection des Sceaux*, 3 vols., Paris, 1863, III, p. 299, cited by Clarke, 'Wilton Diptych' in *Fourteenth Century Studies*, p. 278.

35. A. Molinier, 'Description de deux manuscrits contenant la règle de la *Milicia Jhesus Christi* de Philippe de Mézières', *Archives de l'Orient Latin*, I, 1886, pp. 363–4; Clarke, 'Wilton Diptych' in *Fourteenth Century Studies*, p. 288.

36. *Making and Meaning*, p. 52; Palmer, *England, France and Christendom*, p. 200. Golafre was Richard II's envoy in the matter of the crusade to the Polish court in 1394.

37. Given-Wilson, *Royal Household*, p. 174. Janico Dartasso is presumably the Janicot D'Ortenye mentioned among the English leaders on Bourbon's Tunisian crusade of 1390, see A. M. Chazaud, ed., *Chronique de Bon Duc Loys de Bourbon*, Paris, 1876, p. 222. I owe this reference to Anthony Luttrell.

38. K. B. McFarlane, *Lancastrian Kings and Lollard Knights*, Oxford, 1972, pp. 178, 179.

39. Ibid., pp. 178, 197–206. As has been noted by Dr Sigrid Düll, on their tomb slab in Constantinople the arms of Neville and Clanvowe are shown impaled, see S. Düll, A. Luttrell and M. Keen, 'Faithful unto Death: the Tomb Slab of Sir William Neville and Sir John Clanvowe, Constantinople 1391', *Antiquaries Journal*, LXXI, 1994, pp. 174–90. With the other instances cited in notes 32 and 35 above, this suggests that the use of impaled arms in Richard II's time deserves further exploration.

40. On the orb, and on England as the dower of the Virgin, see Gordon, 'A New Discovery', pp. 662–7 n. 22.

41. C. T. Allmand, *Henry V*, London, 1992, p. 174.

XIII. THE PORTRAIT OF RICHARD II IN WESTMINSTER ABBEY

1. The cleaning in 1866 is described in detail by G. Scharf, *Observations on the Westminster Abbey Portrait and other Representations of Richard II* [reprinted with corrections for private distribution from *Fine Arts Quarterly*, copy in the Library of the Society of Antiquaries, London], Bungay, 1867; id., 'The Westminster Whole Length Portrait of Richard the Second', *Athenaeum*, 17 November 1866, p. 645. The most thorough discussion of the Westminster portrait to date is that of F. Hepburn, *Portraits of the Later Plantagenets*, Woodbridge, 1986, pp. 13–26. Dr Paul Binski (*Westminster Abbey and the Plantagenets. Kingship and the Representation of Power 1200–1400*, New Haven and London, 1995, pp. 203–5) also discusses the portrait. I am grateful to him for allowing me to see his text in typescript.

2. *Age of Chivalry*, cat. no. 713.

3. I want to thank Mr Ian McClure for arranging this, and also the Kress Foundation which provided the funds for the work through the good graces of Dr Caroline Elam. The photographs published here for the first time were taken by Christopher Hurst, Cambridge.

4. J. Speed, *The History of Great Britaine...*, London, 1611, p. 615; J. Weever, *Ancient Funeral Monuments within the United Monarchie of Great Britaine...*, London, 1631, p. 473; Hepburn (cited in note 1 above), pp. 20–1.

5. F. Sandford, *The History of the Coronation...of James II...*, London, 1687, ills. between pp. 102 and 103.

6. J. Dart, *Westmonasterium or the History and Antiquities of the Abbey Church of St Peter's Westminster*, 2 vols., London, 1723, I, p. 62, ill.; W. R. Lethaby (ed. J. G. Noppen), 'The Westminster Portrait of Richard II', *Burlington Magazine*, LXV, 1934, pp. 220–22; Hepburn (cited in note 1 above), pp. 13, 20–21.

7. 'Pannus de diversis coloribus stragulatus, vocatus Canope, ad coperiendum Cawagium Regis juxta magnum altare'. See F. Bond, *Westminster Abbey*, Oxford, 1909, pp. 71 nn. 172, 174.

8. Hepburn (cited in note 1 above), p. 23.

9. Scharf, *Observations* (cited in note 1 above), p. 37.

10. C. Tracy, *English Gothic Choir-Stalls 1200–1400*, Woodbridge, 1987, pp. 1–4, 7–8, pls. 9, 26.

The portrait is too wide to have been the back of one of these stalls.

11. I am very grateful to Dr Rowan Watson for tracing the negative for me and supplying a print.

12. E. W. Tristram, *English Wall-Painting of the Fourteenth Century*, London, 1955, pp. 42–4, suggests that the portrait was refurbished already *c.* 1395, which seems unnecessarily complicated.

13. Lethaby (cited in note 6 above), p. 220.

14. M. Rickert, *Painting in Britain: the Middle Ages* (Pelican History of Art), 2nd edn, Harmondsworth, 1965, p. 160–1, 246 n. 48, refers to 'tooled pattern, glimpses of which can still be seen through the openings in the tracery of the throne'. I have been able to examine the painting under ideal conditions without its modern frame in the Conservation Department of the National Gallery in London, thanks to the kindness of the Chief Restorer, Mr Martin Wyld, and was unable to find any sign of earlier tooling or pattern. The matter is also discussed by Tristram (cited in note 12 above), pp. 42–3, and Hepburn (cited in note 1 above), p. 14.

15. 'Pro pictura unius ymaginis ad similitudinem unius regis contrafacte in choro ecclesie predicte...' C. Eastlake, *Materials for the History of Oil Painting*, London, 1847, p. 178, first connected the payment, published by Devon (*Issues*), with the portrait. He was followed by W. Burges in G. G. Scott *et al.*, *Gleanings from Westminster Abbey*, 2nd edn, Oxford, 1863, p. 176. For the text, see Harvey, 'Wilton Diptych', p. 12 n. 2.

16. I must therefore retract what I said in 1983 which was based on Devon's translation of 'contrafacte' as 'made on the opposite side', J. J. G. Alexander, 'Painting and Manuscript Illumination for Royal Patrons in the Later Middle Ages' in *English Court Culture*, p. 155. Whittingham, 'Chronology', p. 20 n. 52 and Hepburn (cited in note 1 above), p. 20 n. 20, both consider the document more likely to refer to a statue. For other uses of the word *contrafactae* or *conterfait*, see Lindley in this volume (p. 64).

17. Though Scharf ruled out any connection of payment and portrait, it has been accepted by many authorities since, including Lethaby and Tristram, and more recently by John Harvey,

'Wilton Diptych', p. 12 ('probably to be associated') and Pamela Tudor-Craig (*Age of Chivalry*, cat. no. 713).

18. Queen Elizabeth also told Lambarde that Lumley had found the portrait nailed to a door. Lethaby considered the portrait referred to probably to be identifiable with a portrait of Richard II recorded in the Hampton Court catalogue of 1689. It must be the latter which is described by H. Keepe, *Monumenta Westmonasteriensia*, London, 1682, p. 31. He says it 'differs very little' from the Westminster picture.

Mrs R. L. Pool, 'Notes on the History in the Seventeenth Century of the Portraits of Richard II', *Antiquaries Journal*, XI, 1931, pp. 145–59, however, argued that the Lumley gift to Queen Elizabeth was a half-length portrait, probably painted in the early 16th century and recorded in Elstrack's print for Henry Holland's *Baziliologia* of 1618. For the full-length portrait of *c.* 1590–1600—still at Lumley Castle—which adapts the Westminster portrait with the addition of a kneeling figure of Ralph, Lord Lumley (d. 1400), see D. Piper, 'The 1590 Lumley Inventory', *Burlington Magazine*, XCIX, 1957, pp. 224–30, esp. p. 226 and fig. 10.

Pool also confidently asserted, though without any convincing evidence, that the Westminster portrait was removed from the Abbey during the Civil War in 1643, and then returned to King Charles II on the Restoration. No doubt this was occasioned by her belief, untenable as we have seen, that the painting of the Hampton Court catalogue of 1689 was identical with the Westminster portrait. She then hypothesized that the Westminster portrait was 'in course of time brought back to the Abbey'.

19. The Litlyngton Missal is still in the Library of Westminster Abbey (MS 37). See *Age of Chivalry*, cat. nos. 714–5.

20. Addition to Higden's *Polychronicon* by the Monk of Westminster, quoted by Hepburn (cited in note 1 above), pp. 23–4. *Westminster Chronicle*, pp. 450–1. See also Dart (cited in note 6 above), Vol. I, p. 55; J. P. Neale and E. W. Brayley, *The History and Antiquities of the Abbey Church of St Peter, Westminster*, London, 1818, Vol. II, pp. 46, 67.

21. See especially Whittingham, 'Chronology', for the King as bearded or unbearded in the various representations of him. Hepburn (cited in note 1 above, pp. 19–20) also discusses the question as whether or not there are traces of a

moustache in the Westminster portrait. A moustache is present in some of the later copies of the portrait, but the underdrawing does not appear to indicate one.

22. Quoted by Scharf, *Observations* (cited in note 1 above), p. 24.

23. Ibid., p. 28.

24. New York, Pierpont Morgan Library M. 346. S. C. Cockerell, 'André Beauneveu and the Portrait of Richard II at Westminster Abbey', *Burlington Magazine*, X, 1906–07, p. 126. The pattern book is discussed by R. W. Scheller, *A Survey of Medieval Model Books*, Haarlem, 1963, pp. 104–8 (cat. no. 14).

25. Paris, Bibliothèque Nationale fr. 13091. R. Fry, 'On a Fourteenth-Century Sketch Book', *Burlington Magazine*, X, 1906–07, pp. 31–8; for the Psalter, see M. Meiss, *French Painting in the Time of Jean de Berry: The Late Fourteenth Century and the Patronage of the Duke*, London, 1967, pp. 135–51, pls. 51–74.

26. Meiss (cited in note 25 above), pp. 206–8, 267, 278–80, figs. 279, 281–6.

27. W. R. Lethaby, *Westminster Abbey and the King's Craftsmen*, London, 1906, pp. 278–83. J. Harvey and D. G. King, 'Winchester College Stained Glass', *Archaeologia*, CIII, 1971, pp. 150–51.

28. W. A. Shaw, 'The Early English School of Portraiture', *Burlington Magazine*, LXV, 1934, pp. 171–84.

29. For the King's painters, see Colvin, *King's Works*, Vol. I, p. 227, Vol. II, pp. 1008, 1052.

30. W. Hayter, *William of Wykeham, Patron of the Arts*, London, 1970, pls. 26 a,b.

31. *Age of Chivalry*, cat. nos. 612–3. *Making and Meaning*, pl. 16.

32. Cambridge, Magdalene College, MS 1916. Scheller (cited in note 24 above), pp. 112–9 (cat. no. 16). *Age of Chivalry*, cat. no. 466.

33. Brunswick, Herzog Anton-Ulrich Museum, Kupferstichkabinett, Inv. no. 63. Scheller (cited in note 24 above), pp. 120–24 (cat. no. 17). U. Jenni, 'Vom Musterbuch zum Skizzenbuch', *Die Parler*, Vol. III, p. 142, ills.

34. In this I agree with Amanda Simpson, *The Connections between English and Bohemian Painting during the Second Half of the Fourteenth Century*, Ph.D., Courtauld Institute of Art, London

University, 1978, publ. Garland (New York and London), 1984, and id., 'English Art during the Second Half of the Fourteenth Century', *Die Parler*, Vol. V, pp. 137–59. But see Binski in this volume (pp. 233 ff.).

35. See Jenni in *Die Parler* (cited in note 33 above).

36. For the tradition of English court painters, see J. Harvey, 'Some London Painters of the 14th and 15th Centuries', *Burlington Magazine*, LXXXIX, 1947, pp. 303–5.

37. For St Stephen's Chapel, see *Age of Chivalry*, cat. nos. 680–1.

38. L. M. J. Delaissé, *A Century of Dutch Manuscript Illumination*, Berkeley, 1968.

39. For these, see A. Legner, 'Ikon und Porträt', *Die Parler*, Vol. III, pp. 232–3, and J. Luckhardt, 'Das Porträt Erzherzog Rudolfs IV. von Österreich bei seinem Grabmal', *Die Parler*, Vol. V, pp. 75–86. For portraiture more generally, see L. Campbell, *Renaissance Portraits: European Portrait Painting in the 14th, 15th and 16th Centuries*, New Haven, 1990.

40. See Sandler in this volume (pp. 137–54).

41. J. Neuwirth, *Der Bilderzyklus des Luxemburger Stammbaumes aus Karlstein*, Prague, 1897. K. M. Swoboda, ed., *Gotik in Böhmen*, Munich, 1969, pp. 184, 429 n. 119. Some of the figures are standing, some seated. For the Westminster kings, which are standing figures, see *Age of Chivalry*, cat. nos. 708–9.

42. For the enthroned images of the Emperor Charles IV and Wenceslas IV on the Bridge Tower in the Old Town of Prague, *c.* 1373–74, see J. Homolka, 'Zu den Iconographischen Programmen Karls IV', *Die Parler*, Vol. II, pp. 616–17, pls. pp. 606 and 617.

43. L. Patterson, *Chaucer and the Subject of History*, London, 1991.

44. For Richard II's Great Seal, see Hepburn (cited in note 1 above), p. 15, pl. 14. Dr Elizabeth Danbury has pointed out to me that Richard in the portrait holds the orb in his left hand and the sceptre in his right hand, whereas on the royal seals it is always the reverse. I have no explanation for this.

45. Hepburn (cited in note 1 above), pl. 18. For the documents on the tomb, see *Age of Chivalry*, cat. no. 446.

46. R. Klein, 'The Theory of Figurative Expression in Italian Treatises on the *impresa*' in id., *Form and Meaning. Essays on the Renaissance and Modern Art*, Princeton, 1979, pp. 3–24.

47. Meiss (cited in note 25 above), pp. 99–107, pls. 2–3.

48. P. Skubiszewski, 'Die Kunst in den Ländern der Polnischen Krone während der zweiten Hälfte des 14. Jahrhunderts', *Die Parler*, Vol. V, p. 115, fig. 53.

XIV. CONTEMPORARY ENGLISH PANEL AND WALL PAINTING

1. For the monument at Cartmel Priory, probably of John, first Lord Harrington, who died in 1347, and his wife Joan, see H. F. Rigge, 'The Harrington Tomb in Cartmel Priory Church', *Transactions of the Cumberland and Westmorland Antiquarian and Archaeological Society*, V, 1880–81, pp. 109–20 and J. Ward-Perkins, 'The Harrington Tomb in Cartmel Priory', *Antiquaries Journal*, XXIII, 1943, pp. 26–8.

2. For the funerary badges of the Black Prince, see *Age of Chivalry*, cat. nos. 68–69.

3. The contract for the tomb was drawn up on 1 April 1395 (PRO, E 101/473/7). The specific reference for paintings of the tester and of 'a king' (PRO, E 403/554, m. 12) is quoted by Harvey, 'Wilton Diptych', pp. 1–28, esp. p. 12

n. 2. See also Colvin, *King's Works*, Vol. I, p. 487. See also *Foedera*, ed. Rymer, Vol. VII, pp. 795–98.

4. See J. Cherry and N. Stratford, *Westminster Kings and the Medieval Palace of Westminster*, London, 1995, p. 66, reproducing the cast made for Sir John Soane before 1830 (London, Sir John Soane Museum M94). The shield bears the English royal arms, impaled, as they are on the Diptych, but with the impalement on the other side. This impalement is blank, and looks as if it was always unfinished, though it may have been so weathered that it did not register in the casting.

5. Colvin, *King's Works*, Vol. I, pp. 527–33.

6. For the Lumley version which appears in his inventory of 1590, see R. Strong, *The English Icon*, London and New York, 1969, p. 45 and illustrated in fig. 40.

7. Published in P. Lasko and N. Morgan, eds., *Medieval Art in East Anglia 1300–1520*, Norwich, 1973, cat. nos. 51–56. These panels all have a Norwich or Ipswich provenance. There is no comparable body of panel painting surviving from other parts of Britain.

8. The cleaning and conservation of the Clifton rood-screen, which had been reassembled under the tower arch, and the realization of its late 14th-century date, are the responsibility of Anna Hulbert. She worked on the screen from 1988 to 1992. The paintings had been covered with red lead, perhaps in the mid 16th century, and then with a further coat of lime wash. In consequence, the faces have not been scratched, or the eyes gouged out, the usual fate of screen painting.

9. The *locus classicus* for this fashion is the *Liber Regalis* in the Library of Westminster Abbey (MS 38).

10. *Age of Chivalry*, cat. no. 712, illustrated on p. 517.

11. See D. Park, 'A Lost Fourteenth-Century Altarpiece from Ingham, Norfolk', *Burlington Magazine*, CXXX, 1988, pp. 132-5, ill. I.

12. *Making and Meaning*, p. 22, fig. 4.

13. Lasko and Morgan (cited in note 7 above), ill. p. 37.

14. See T. Borenius, 'An English Painted Ceiling of the Late Fourteenth Century', *Burlington Magazine*, LXVIII, 1936, pp. 276ff.

15. I am grateful to the late Somerset de Chair and Lady Juliet de Chair for giving me access to the doorway and adjacent panelling, now placed in the private apartments in the Gateway of St Osyth's Priory, and for sending me a photograph.

16. Vestiges of at least two more figures appear in old photographs taken by Somerset de Chair at Park Farm when the room was in part dismantled.

17. *Age of Chivalry*, p. 134.

18. The house has been examined for me by John Burton and Peter Cleverly, architects, and by David Stenning, specialist in timber framing. I am greatly indebted to them.

19. Thanks to the then Curator, David Clarke, who was most active in acquiring this panel and ultimately the plaster-painted lady from the same room. I am grateful to him for much help in this enquiry.

20. Oxford, Bodleian Library, MS Ashmole 1381, illustrated in F. Wormald, 'The Wilton Diptych', *JWCI*, XVII, 1954, pp. 191–203 (reprinted in id., *Collected Writings. II: Studies in English and Continental Art of the Later Middle Ages*, eds. J. J. G. Alexander, T.J. Brown and J. Gibbs, London, 1988, pp. 103–16).

21. A. Wyon, *Great Seals of England*, London, 1887, no. 55, p. 30 and pl. IX. The format of the throne goes back to the Second Seal of Henry III in use 1259–72 (ibid., no. 43, p. 22 and pl. XII). In these seals the seated monarch has his feet on a pair of lions. In the rest of Edward III's seals the tamed lions sit beside him, the formula adopted in both Richard II's seals (ibid., nos. 67–9, pp. 41–2, pl. XI).

22. *Victoria County History for Essex*, London, 1907, Vol. II, p. 159 quoting *CPL*, Vol. V, 1396–1404, pp. 16, 21, for 29 March 1397. The Pontificals were revoked on 6 February 1403 at the petition of the Bishop of London. They were restored once more in 1412. Abbot John's complicity in the conspiracy of the autumn of 1403 led to a warrant for his arrest in 1404, but he was pardoned on the 6 November of that year. For the exceptional wealth of St Osyth's Abbey at the Reformation, see *Victoria County History*, p. 161.

23. Wormald (cited in note 20 above).

24. London, British Library, MS Royal 2 A XVIII, illustrated in *Making and Meaning*, pl. 30.

25. London, British Library, MS Add. 42131, see *Making and Meaning*, pl. 27.

26. I am greatly indebted to Martin Wyld for the privilege of seeing the Diptych under high magnification.

27. PRO, DL 23/3. I am grateful to the staff of the Public Record Office for allowing me to study this little published manuscript.

28. Lasko and Morgan (cited in note 7 above), cat. no. 56, p. 39 and detailed illustration on p. 40.

29. When Henry VII tore down the original Lady Chapel at Westminster Abbey to make way for his new chapel, of which the foundation stone was laid on 21 April 1503 (see C. Wilson *et al.*, *Westminster Abbey*, London, 1986, p. 70) a new home was found over the entrance to the Chapel of Our Lady of the Pew for the carving of the Martyrdom of St Erasmus which had been given to the Lady Chapel by Queen Elizabeth Woodville. Other altarpieces, including the main altarpiece of the original Lady Chapel, would also have been displaced. Henry VII was in close touch with the Pope over the canonization of Henry VI. Would this not have been a good moment to make friends in the Vatican by a conspicuous donation to the English College in Rome—a donation displaying the well-established devotion of English monarchs to Our Lady?

30. Detail illustration in Wilson (cited in note 29 above), p. 103. The intervening stage of an orb showing the sun, the moon and the stars with a mountainous earth and a foreground of sea is in the hand of Christ in Simone Martini's *sinopie* for the gable painting at Notre Dame des Doms, Avignon, of *c.* 1340. See A. Martindale, *Simone Martini: Complete Edition*, Oxford, 1988, pp. 98–100, cat. no. 5.1 and Chapter 7. See also id., 'The Ashwellthorpe Triptych' in *Early Tudor England* (Proceedings of the Harlaxton Symposium), ed. D. Williams, 1989, p. 117. The Avignon globe does not show the buildings which gave the Wilton Diptych globe a local habitation and name.

31. PRO, E 101/473/7.

32. A. P. Stanley, 'On Examination of the Tombs of Richard II and Henry III in Westminster Abbey', *Archaeologia*, XLV, 1880, pp. 314–27 esp. pp. 326–7. The original drawings are in the Society of Antiquaries, London.

33. '*Regnum…anglorum est dei; post te prouidit sibi regem ad placitum sui*', F. Barlow, ed. and trans., *The Life of King Edward who Rests at Westminster*, Oxford, 1992, pp. 14–15. The phrase echoes Daniel 4:25: 'The Most High ruleth in the kingdom of men, and giveth it to whomsoever He will…'.

34. '*Hi sic angelici iunctis duo viri*[bus] *Angli seruant Angligenos sub eodem federe fines*' (Barlow, cited in note 33 above, pp. 58–9).

35. John Harding, *Chronicle*, ed. H. Ellis, 1812, p. 352, reporting the incident of 17 November

1387. For the Parliament of January 1394, see S. Armitage-Smith, *John of Gaunt*, London, 1904.

36. Harvey, 'Wilton Diptych', pp. 27–8.

37. '*Vir felix ille, cui preueniet fauor abs te Hic bene dispositis gradibus de ualle doloris tendit ad alta Sion regemque uidere supremum*' (Barlow, cited in note 33 above, pp. 72–5).

38. '*Sed iungere tuo per federa casta marito, eterno sociata deo complexibus almis; Cuius fusa tua sata celica germen in aluo…Non quorum fletu tribulentur uiscera matris sed quibus angelicas clare modulantibus odas vel pulsu cithare toto resonabis in orbe…*' (Barlow, cited in note 33 above, pp. 72–5). The manuscript of this early Life of King Edward attributed to a monk of Saint-Bertin was probably written in 1067 (ibid., Chapter 3, pp. XXIX–XXXIII). The surviving text (London, British Library, MS Harley 526, ff. 38–57) was owned by 'Dr Bancroft', presumably Richard Bancroft who became a Canon of Westminster in 1587, Prebendary of St Paul's in 1590, Bishop of London in 1597 and Archbishop of Canterbury in 1604 (ibid., pp. LXXVII–LXXIX). All other things being equal, Bancroft ought to have picked up the Life of King Edward at Westminster. It is reasonable to deduce that in Richard's time the manuscript would have been in the library in Westminster Abbey. Richard II was always on close terms with the Westminster community, especially with Abbot Nicholas Litlyngton.

39. PRO, E 101/411/9. Ilg, 'Goldschmiedearbeiten Richards II', pp. 10–16.

40. Cambridge, University Library, MS Ee. 3. 59, see M. R. James, *La Estoire de Seint Aedward le Rei*, Roxburghe Club, Oxford, 1920. James discusses (p. 10 of his Introduction) the provenance of this version, of all the surviving manuscripts containing the Life of the Confessor, the one which would have appealed most immediately to Richard II. The text is largely an adaptation into rhymed couplets of Ailred of Rievaulx's definitive Life of St Edward of *c.* 1163, for which see the English translation by Jerome Bertram (*The Life of Saint Edward, King and Confessor by Blessed Ailred, Abbot of Rievaulx*, Guildford, 1990). The manuscript of the 13th-century *Estoire* belonged in 1563 to Laurence Newell, at that time at Brasenose College. He did work in London and shared chambers with William Lambarde, who wrote in the manuscript and probably owned it at some stage. It then passed to 'Cope', a friend of Lambarde,

and thence to Bishop Moore of Ely. It must have entered the Royal Collection before 1715, when it was presented to the British Museum. James thought that since it had been dedicated to Eleanor of Provence, it had remained throughout the Middle Ages among the royal books. However, since it was available for purchase in London in 1563, I would suggest that the *Estoire* had been given to Westminster Abbey—perhaps by Eleanor—when she took the veil after Henry III's death in 1272. In that event it would have been accessible to Richard II.

41. See *Making and Meaning*, p. 62 and n. 148, quoting the Great Wardrobe Accounts, PRO, E 101/401/5.

42. I am grateful to Martin Wyld for this observation.

43. Harvey, 'Wilton Diptych', pp. 2–4 and 24–26.

44. See J. Catto, 'The King's Government and the Fall of Pecock, 1457–58' in *Rulers and Ruled in Late Medieval England. Essays Presented to Gerald Harriss*, eds. R. E. Archer and S. Walker, London, 1995, pp. 206–7.

45. See J. Gairdner and R. H. Brodie, eds., *Letters and Papers Foreign and Domestic of the Reign of Henry VIII…*, Vol. XIV, Part I, London, 1894.

46. These three Syon manuscripts which belonged to Thomas, Earl of Arundel (1592–1646), have now found their way to the British Library: MSS Arundel 11, 146 and 259. MSS 11 and 146 (the Orders and Constitutions of the House) had previously belonged to William Howard. MS 259 includes a defective copy of the *Triplex via Syon*. All three have escaped the revised edition of N. Kerr's *Medieval Libraries of Great Britain*, London, 1987, pp. 64–5. They appear in the British Library catalogue of the Arundel manuscripts.

47. The letters of the Duchess of Norfolk are in the British Library (Cotton Tiberius B. I).

48. Gairdner and Brodie (cited in note 45 above), Vol. XIV, Part II (London, 1895), no. 424.

49. M. St Clare Bryne, ed., *The Lisle Letters*, Chicago and London, 1981.

50. See Colvin, *King's Works*, Vol. IV, Part II, pp. 272–73.

51. Sir John Froissart's *Chronicles of England, France, Spain…*, trans. Thomas Johnes, London, 1839, Book IV, Chapter CXII, p. 692: 'The Earl of Derby now issued a proclamation that no one should dare to touch anything in the castle or lay hands on any servant or officer of the King under pain of being instantly hanged, for that every person and thing were under his especial protection and guard'.

52. Legg, 'Inventory', pp. 195–286, esp. p. 282.

53. For the importance of his Syon foundation to Henry V, see his will of 1415 published in *Foedera*, ed. Rymer, Vol. IV, Part II, p. 138 onwards. Syon received his first bequest after the dispositions for his tomb, for masses for his soul and gifts to executors. For Syon, see also R. W. Dunning, 'The Building of Syon Abbey', *Transactions of the Ancient Monuments Society*, New Series, XXV, London, 1981, pp. 16–26 and Dom D. Knowles, *The Religious Orders in England*, Cambridge, 1955, pp. 175–81. The inventory of Syon, drawn up in November 1539 (PRO, LR 2/112, ff. 2–8) lists the plate, vestments and *some* furnishings. Thomas Walsingham, *Historia Anglicana*, ed. H. T. Riley, Rolls Series, XXVIII, 2 vols., London, 1863–64, II, quotation on p. 297, Henry V's moving of the body of Richard II from the Dominican house at King's Langley to Westminster Abbey in 1413. This must have been one of Henry V's first acts as King of England. Walsingham (p. 297) also says that Henry V 'now confessed that he owed to him the same veneration as his own father'.

XV. THE BIBLE OF WENCESLAS IV

1. J. W. Bradley, *Historical Introduction to the Collection of Illuminated Letters and Borders in the National Art Library, Victoria and Albert Museum*, London, 1901, pp. 127f., 156f.; M. Rickert, *Painting in Britain*, London, 1954, pp. 173–4.

2. A. Simpson, *The Connections between English and Bohemian Painting during the Second Half of* the Fourteenth Century, Ph.D., Courtauld Institute of Art, London University, 1978, publ. Garland (New York and London), 1984, pp. 147–60.

3. Sandler, *Gothic Manuscripts*, Vol. I, pp. 51–2; Vol. II, p. 178.

4. Both these manuscripts are now in Vienna, Österr. Nationalbibliothek Cod. s.n. 2643 (*Willehalm*) and Cod. 2759–2764 (Bible of Wenceslas IV).

5. The translation was commissioned by a citizen of Prague, Martin Rotlev, a short time after the first complete translation of the Bible into Czech. The most important literature is as follows: J. von Schlosser, 'Die Bibelhandschriften Königs Wenzel IV', *Jahrbuch der Kunsthistorischen Sammlungen des Allerhöchsten Kaiserhauses*, XIV, Wien, 1893, pp. 214–51, 266–9; G. Schmidt, 'Die Illuminatoren König Wenzels und ihre Werke' in *Gotik in Böhmen,* ed. K. Swoboda, Vienna, 1969, pp. 230–40; J. Krása, *Die Handschriften König Wenzel IV*, Prague, 1971; O. Mazal, 'Bibel (Wenzelsbibel)' in *Die Parler*, Vol. II, pp. 746–47; F. Unterkircher, *König Wenzels Bilderbibel. Die Miniaturen zur Genesis aus der Wenzelbibel*, Graz, 1983; and M. Thomas and G. Schmidt, *Die Bibel des König Wenzel*, Graz, 1989.

6. Von Schlosser (cited in note 5 above).

7. In his excellent book, Krása (cited in note 5 above) pointed to many controversies in von Schlosser's interpretation; nevertheless he left these questions open.

8. This coat of arms was considered to be that of Johanna by Unterkircher (cited in note 5 above) and also mentioned with this supposition by M. Thomas, *Grandes Heures de Jean de Berry*, Munich, 1979, p. 59 n. 10: *'Hälfte gelöschte Schild enhielt Zweifellos das bayerische Wappen zum Gedenken und die erste Gemählin des Königs, Johanna von Bayern'*. The idea of the 'memory of the first wife' in the book, which was, in the opinion of all these authors, dedicated to the second wife, seems to be very improbable.

9. For the history, see J. Spevácek, *Václav IV*, Prague, 1986, pp. 31–2.

10. J. V. Polc, *Svaty Jan Nepomucky*, Prague, 1993, p. 299.

11. Unterkircher (cited in note 5 above) was already of this opinion.

12. We know that, before Sophia, Wenceslas intended to marry Jane of Aragón, see Spevácek (cited in note 9 above), pp. 196, 715.

13. From 1384 Wenceslas was in conflict with the Archbishop of Prague, Jan of Jenstejn; he had an ongoing quarrel with members of the Luxembourg dynasty, especially with the Margrave of Moravia, Jodocus (Jost), and the King's younger brother, Sigismund (King of Hungary, King of Bohemia after 1420, and Holy Roman Emperor from 1433). The high Bohemian noble families were in opposition to the King who was imprisoned by them in 1394. Since the 1380s relations between the monarch and the *Kurfirsten* and towns in the Roman kingdom were strained. He was dethroned in 1400. At the beginning of the 15th century a growing reform movement was taking place in the Church, working up to a revolution shortly after the death of Wenceslas in 1419. This was the Hussite Rebellion; it corresponded with similar movements in England instigated by John Wycliffe and the Lollards who followed him. It is certain that Jan Huss was influenced by the writings of Wycliffe, and they certainly knew of each other's work.

14. The last bust—that of Václav of Radec—was finished probably *c.* 1385; the inscriptions above all the busts date from 1389–92. See J. Homolka, 'Praha-Veitsdom, Büstenzyklus im unteren Triforium' in *Die Parler*, Vol. II, pp. 655–7. Recently, I. Hlobil, 'Gotické socharství' ('Gothic Sculpture') in *Katedrála sv. Víta v Praze (St Vitus Cathedral in Prague)*, Prague, 1994, pp. 81–2.

15. The iconography of the seven medallions of the Creation is interesting: for example, in the second medallion, the Lord is depicted with a sphere and the four elements; above, there are two figures which evidently represent the personification of the second day of Creation, a very ancient motif also found in the Cotton Genesis (London, British Library, MS Cotton Otho B. VI) and mosaics in San Marco, Venice. Because this personification appears only in the second medallion, it is clear that the painter used, in addition, other models.

16. Alan of Lille, in J.-P. Migne, *Patrologiae cursus completus, Series latina*, 221 vols., Paris, 1844–64, Vol. 194, col. 1090 cited in G. R. Evans, *The Language and Logic of the Bible*, Cambridge, 1991, p. 120.

17. *Sanctii Ambrosii Hexaemeron Libri sex* (L. V, Cap. XIII) in Migne (cited in note 16 above), Vol. 14, col. 238–39. Manuscripts of the *Hexaemeron* were very common in the Middle Ages, also in Prague (for example Prague, Chapter Library Cod. A 131). Isidore of Seville (Migne, Vol. 82, col. 462); Rabanus Maurus (Migne, Vol. 111, col. 246).

18. Johannes Amos Comenius, *Orbis Sensualium pictus quadrilinguis. Leutschoviae. Typis Samuelis Brewer, Anno 1685*, reprint Prague/Bratislava, 1958, p. 39.

19. More about fertility symbols and their personal meaning for the childless Wenceslas can be found in H. Hlaváčková, 'Courtly Body in the Bible of Wenceslas IV' in *Künstlerischer Austausch–Artistic Exchange* (Akten des XXVIII Internationalen Kongresses für Kunstgeschichte, Berlin 15–20 July 1992), ed. T. W. Gaehtgens, Berlin, 1993, Vol. 2, pp. 371–82.

20. Its liturgical name is the 'Holy Aer' (*aer*, *Luft*, *vozduch*). See K. Onasch, *Liturgie und Kunst der Ostkirche in Stichworten*, Leipzig, 1981, pp. 81–2.

21. J. F. Hamburger, *Rothschild Canticles*, New Haven and London, 1990, p. 27, figs. 48, 51, 53, 55, 57.

22. Simpson (cited in note 2 above), p. 48 and n. 5. In 1396 Ofka married Robert Morton.

23. The seal, used since 1355, is on a letter of 1373 (Prague, Archive of the Czech Crown n. 1087). The same seal is found in a letter of 1376 now in the Treasury of Brandenburg Cathedral.

24. See R. Suckale, *Die Hofkunst Kaiser Ludwigs des Bayern*, Munich, 1993, p. 38, fig. 26.

25. E. W. Kirsch, *Five Illuminated Manuscripts of Giangaleazzo Visconti*, University Park, Penn. and London, 1991, pp. 19–27. See also Sandler in this volume (p. 149 and note 25).

26. Kirsch (cited in note 25 above), p. 19 n. 14.

27. Von Schlosser (cited in note 5 above), p. 300; Krása (cited in note 5), pp. 71–76. More recently and covering the subject in more detail, M. Studnicková, 'Hoforden der Luxemburger', *Umení*, XXXX, 1992, pp. 320–28.

XVI. THE 'LIBER REGALIS'

1. Earl Beauchamp, *Liber Regalis*, ed. W. H. Bliss, Roxburghe Club, London, 1870; Legg, *Coronation Records*; P. Schramm, *A History of the English Coronation*, Oxford, 1937; A. Simpson, *The Connections between English and Bohemian Painting during the Second Half of the Fourteenth Century*, Ph.D., Courtauld Institute of Art, London University, 1978, publ. Garland (New York and London), 1984, pp. 147–60; Sandler, *Gothic Manuscripts*, Vol. II, no. 155.

2. Sandler, *Gothic Manuscripts*, Vol. I, pp. 36–7, Vol. II, no. 150; *Missale ad usum ecclesie Westmonasteriensis*, ed. J. W. Legg, Henry Bradshaw Society, I, V, XXII (3 vols.), London, 1891–97.

3. Collated: 1–4^8, 5 two only.

4. F. Idoate, 'Un Ceremonial de Coronación de los Reyes de Inglaterra', *Hispania Sacra*, VI, 1953, pp. 151–80; Sandler, *Gothic Manuscripts*, Vol. II, no. 158; Simpson (cited in note 1 above), fig. 271 and Sandler, *Gothic Manuscripts*, Vol. I, figs. 416–7.

5. J. Le Goff, 'A Coronation Program for the Age of St Louis: the Ordo of 1250' and J.-C. Bonne, 'The Manuscript of the Ordo of 1250 and its Illuminations' in *Coronations: Medieval and Early Modern Monarchic Ritual*, ed. J. M. Bak, Berkeley, 1990, pp. 46–57, 58–71.

6. Bonne (cited in note 5 above), figs. 4.1–4.3.

7. E. S. Dewick, ed., *The Coronation Book of Charles V of France*, Henry Bradshaw Society, XVI, London, 1899.

8. C. R. Sherman, 'The Queen in Charles V's "Coronation Book": Jeanne de Bourbon and the "Ordo ad reginam benedicendam"', *Viator*, VIII, 1977, pp. 255–97; A. D. Hedeman, *The Royal Image: Illustrations of the Grandes Chroniques de France 1274–1422*, Berkeley, 1991, pp. 112–13.

9. Idoate (cited in note 4 above); Sandler, *Gothic Manuscripts*, Vol. I, figs. 416–8; for the *Flores Historiarum*, see N. J. Morgan, *Early Gothic Manuscripts 1250–1285* (A Survey of Manuscripts Illuminated in the British Isles, IV), London, 1988, Vol. I, fig. 8, Vol. II, no. 96.

10. J. W. Legg, ed., *Three Coronation Orders*, Henry Bradshaw Society, XIX, London, 1900, pp. xxxii–vii; Sandler, *Gothic Manuscripts*, Vol. I, fig. 263, Vol. II, no. 103.

11. Legg (cited in note 2 above), Vol. II, cols. 673–735 (ff. 206–23v, 224); see also Legg, *Coronation Records*, pp. xxxii–vii, 81–130.

12. Legg, *Coronation Records*, p. 81.

13. Simpson (cited in note 1 above), p. 33: The *Liber Regalis* is 'universally assumed to have been made *c.* 1382, when Anne of Bohemia was crowned Queen of England'; also p. 148, citing

Legg, *Coronation Records*, p. 81; R. Marks and N. J. Morgan, *The Golden Age of English Manuscripts Painting 1200–1500*, London, 1981, p. 86; N. Rogers, 'The Old Proctor's Book: A Cambridge Manuscript of *c.* 1390' in *England in the Fourteenth Century* (Proceedings of the 1985 Harlaxton Symposium), ed. W. M. Ormrod, Woodbridge, 1986, pp. 213–223, 219–20.

14. For example ff. 10, 12, 13, 17v, 20v, 28v, and see Legg (cited in note 2 above), Vol. I, p. xi; Legg, *Coronation Records*, p. 81; N. R. Kerr, *Medieval Manuscripts in British Libraries, I: London*, Oxford, 1969, p. 411, no. 38; for Sancroft's hand, see Oxford, Bodleian Library, MS Tanner 414.

15. See the marginal notes and rubrics in Cambridge, University Library, MS Mm. 3. 21, a fine 15th-century Lincoln diocese Pontifical (f. 195v), J. Brückmann, 'Latin Manuscript Pontificals and Benedictionals in England and Wales', *Traditio*, XXIX, 1973, pp. 391–458, 414.

16. Legg, 'Inventory', pp. 195–286, 233, 234; see M. E. C. Walcott, 'The Inventories of Westminster Abbey at the Dissolution', *Transactions of the London and Middlesex Archaeological Society*, IV, 1873, pp. 313–76, 344.

17. Legg (cited in note 2 above), Vol. III, p. vii; J. A. Robinson and M. R. James, *The Manuscripts of Westminster Abbey*, Notes and Documents Relating to Westminster Abbey, Cambridge, 1909, Vol. I, p. 24; N. R. Kerr, ed., *Medieval Libraries of Great Britain: A List of Surviving Books*, Royal Historical Society, London, 1964, p. 196; Brückmann (cited in note 15 above), p. 454.

18. The marginal note on f. 13, '*Haec oratio [Deus qui es iustorum gloria et misericordia] non est in veteri libro pontificale*', rules out both the Litlyngton Missal and Oxford, Bodleian Library, MS Rawl. C. 425 which contain this prayer.

19. M. Rickert, *The Reconstructed Carmelite Missal: An English Manuscript of the Late XIVth Century in the British Museum*, Chicago, 1952, pp. 76–80; Simpson (cited in note 1 above), pp. 150–4.

20. M. R. James, *A Descriptive Catalogue of the Manuscripts in the Library of St John's College Cambridge*, Cambridge, 1913, pp. 8–9; Whittingham, 'Chronology', pp. 12–21, esp. p. 15; Sandler, *Gothic Manuscripts*, Vol. II, no. 156.

21. Rickert (cited in note 19 above), p. 79–80 and pl. XLVb; Simpson (cited in note 1 above), p. 153.

22. Sandler, *Gothic Manuscripts*, Vol. II, no. 144; R. Gameson and A. Coates, eds., *The Old Library, Trinity College, Oxford*, Oxford, 1988, pp. 44–6, no. 9.

23. Rickert (cited in note 19 above), p. 79; Simpson (cited in note 1 above), pp. 150–1; Sandler, *Gothic Manuscripts*, Vol. II, no. 144 does not relate this work to the *Liber Regalis*, however.

24. Legg (cited in note 2 above), Vol. II, cols. 734–5; Sandler, *Gothic Manuscripts*, Vol. I, fig. 418.

25. Legg (cited in note 2 above), Vol. II, pl. 8, f. 224; Sandler, *Gothic Manuscripts*, Vol. I, fig. 415.

26. Colvin, *King's Works*, Vol. I, p. 487.

27. For Walter of Sudbury's text, see Richard of Cirencester, *Speculum historiale*, ed. J. E. B. Mayor, Rolls Series, XXX, London, 1869, Vol. II, pp. 26–39; also *Westminster Chronicle*, pp. 154–7.

28. Legg, *Coronation Records*, pp. 83, 113.

29. The only evidence for the provenance of the *Liber Regalis* is supplied by WAM 51191, verso: 'Extract from yᵉ Liber Regalis which was in the chapter clerk's custody June 21 1762, and was placed in yᵉ Record-Room under the care of the librarian [Mr Brooker] in 1764'; the text was bound by Bohn in 1806.

30. Legg (cited in note 10 above), pp. xxi–ii; Sandler, *Gothic Manuscripts*, Vol. II, no. 103.

31. Sandler, *Gothic Manuscripts*, Vol. II, no. 134; Gameson and Coates (cited in note 22 above), pp. 44–6.

32. Legg, *Coronation Records*, pp. lxxi–ii, 132–3, 151.

33. P. Schramm, *Der König von Frankreich: Das Wesen der Monarchie vom. 9. zum 16. Jahrhundert, ein Kapitel aus der Geschichte des abendländischen Staates*, 2 vols., Weimar, 1960, I, p. 237; Idoate (cited in note 4 above); *Liber regie capelle. A manuscript in the Biblioteca Publica, Evora*, ed. W. Ullmann, Henry Bradshaw Society, XCII, London, 1961.

34. See Simpson (cited in note 1 above), pp. 30–5, also Sandler, *Gothic Manuscripts*, Vol. II, pp. 19–20.

35. J. W. Bradley, *Historical Introduction to the Collection of Illuminated Letters and Borders in the National Art Library*, Victoria and Albert Museum, London, 1901, pp. 127–8, 156; id., *Illuminated Manuscripts*, London, 1905, pp. 161–6; for a more sceptical position, see E. Millar, *English Illuminated Manuscripts of the XIVth and XVth Centuries*, Paris and Brussels, 1928, pp. 29–31; O. E. Saunders, *English Illumination*, Florence, 1928, p. 114; E. Dostál, *Príspevky k dejinám ceského iluminátorského umení na sklonku XIV. století* [*Contributions to the History of the Czech Art of Illumination about the Year 1400*], Brno, 1928, pp. 148–71; Rickert (cited note 19 above), pp. 77–8.

36. Simpson (cited in note 1 above); see also her essay 'English Art during the Second Half of the Fourteenth Century' in *Die Parler*, Vol. V, pp. 144–5.

37. Rickert (cited in note 19 above), p. 78.

38. Ibid.; see also M. Rickert, *Painting in Britain, The Middle Ages*, Harmondsworth, 1954, pp. 173 and 191 n. 32; M. Dvorák, 'Die illuminatoren des Johann von Neumarkt', *Jahrbuch der Kunsthistorischen Sammlungen des allerhöchsten Kaiserhauses*, XXII/II, 1901, pp. 35–126, and J. von Schlosser, 'Die Bilderhandschriften Königs Wenzel I', *Jahrbuch der Kunsthistorischen Sammlungen des allerhöchsten Kaiserhauses*, XIV, 1893, pp. 214–317.

39. Rickert (cited in note 19 above), pp. 77–8.

40. See, for example, V. Dvoráková and J. Krása et al., *Gothic Mural Painting in Bohemia and Moravia 1300–1378*, London, 1964, p. 134, pl. 67.

41. Ibid., pl. 151; see also R. Gibbs in *Burlington Magazine*, CXXVII, 1985, pp. 232–3 (review of Simpson, cited in note 1 above).

42. Simpson (cited in note 1 above), p. 150; see, however, Rogers (cited note 13 above), p. 220.

43. Von Schlosser (cited in note 38 above); J. Krása, *Die Handschriften König Wenzels IV*, Prague, 1971; for the most recent overview, see H. Hlaváčková, 'Courtly Body in the Bible of Wenceslaus IV' in *Künstlerischer Austausch–Artistic Exchange* (Akten des XXVIII Internationalen Kongresses für Kunstgeschichte, Berlin 15–20 July 1992), ed. T. W. Gaehtgens, Berlin, 1992, pp. 371–82.

44. Hlaváčková (cited in note 43 above).

45. B. Brauer, 'The Prague Hours and Bohemian Manuscript Painting of the Late 14th Century', *Zeitschrift für Kunstgeschichte*, LII/IV, 1989, pp. 499–521 (suggesting a connection with Anne of Bohemia); *Prag um 1400: Der Schöne Stil, Böhmische Malerei und Plastik in der Gotik*, exh. cat., Vienna, 1990, cat. no. 51.

46. L. Kesner, *Kunst der Gotik aus Böhmen*, exh. cat., Cologne, 1985, cat. no. 10, p. 90; Z. Drobná, *Gothic Drawing*, Prague, n.d., pls. 69–80; *Prag um 1400* (cited in note 45 above), cat. no. 9.

47. Devon, *Issues*, p. 262; Simpson (cited in note 1 above), pp. 175–6; id., 'English Art' (cited in note 36 above), pp. 146–8; *Prag um 1400* (cited in note 45 above), cat. no. 7A.

48. Millar (cited in note 35 above), pp. 30–31; Rogers (cited in note 13 above), pp. 219–23; B. Turner, 'The Patronage of John of Northampton', *Journal of the British Archaeological Association*, CXXXVIII, 1985, pp. 89–100.

49. See, for example, J. Vale, *Edward III and Chivalry: Chivalric Society and its Context 1270–1350*, Woodbridge, 1982, pp. 42–56, 52.

50. Sandler, *Gothic Manuscripts*, Vol. II, no. 153; P. Binski, 'Abbot Berkyng's Tapestries and Matthew Paris's Life of St Edward the Confessor', *Archaeologia*, CIX, 1991, pp. 85–100.

51. Rickert (cited in note 19 above). See also Shrewsbury Guildhall (Muniments 1.24): Whittingham, 'Chronology', pp. 15–16; *Age of Chivalry*, cat. no. 716; E. Danbury, 'The Decoration and Illumination of English Royal Charters in England, 1250–1509: An Introduction' in *England and her Neighbours 1066–1453: Essays in Honour of Pierre Chaplais*, eds. M. Jones and M. Vale, London, 1989, pp. 157–9, 165; J. Hamburger, 'The Casanatense and the Carmelite Missals: Continental Sources for English Manuscript Illumination of the Early 15th Century' in *Masters and Miniatures, Proceedings of the Congress on Medieval Manuscript Illumination in the Northern Netherlands*, eds. K. van der Horst and J. C. Klamt, (Utrecht, 1989), Doornspijk, 1990, pp. 161–73.

52. For example the Charter of the Burgesses of Ipswich (1378), Ipswich and East Suffolk Record Office: P. Lasko and N. J. Morgan, eds., *Medieval Art in East Anglia 1300–1520*, Norwich, 1973, no. 38, see also no. 39, the Charter of Croyland Abbey (Oxford, Bodleian Library, MS Ashmole 1381); Danbury (cited in note 51 above), pp. 168, 169.

XVII. KINGS DEPICTED AS MAGI

1. Christie's, Old Master Pictures, London. The picture was sold on 6 July 1990. A photograph of the painting was kindly given to me by Dr David Ekserdjian and Dr Michael Michael.

2. The picture is now in Switzerland. I am indebted to its new owner, Mr E. Bucher, for detailed information and a colour slide of the work.

3. O. Pujmanová, 'Nová gotická deska ceského puvodu', *Umení, XXXI*, 1983, pp. 139–49; id., 'Neu entdectes Bohemicum', *Akt Kunst*, Tijdschrift 1, University of Groningen, Groningen, 1984, pp. 6–27.

4. J. Krása, *Rukopisy Václava IV*, Prague, 1974.

5. H. Kehrer, *Die heiligen drei Könige in Literatur und Kunst*, 2 vols., Leipzig, 1901, I, p. 39.

6. H. Hofmann, *Die heiligen drei Könige*, Bonn, 1975, p. 302.

7. H. G. Zender, 'Bilderchronik des Balduineurus: Adorant tres magos colonie' in *Die heiligen drei Könige – Darstellung und Verehrung*, exh. cat., Wallraf-Richartz-Museum, Cologne, 1982, pp. 150–1.

8. A. Wolf, 'Dreikönigenschrein' in *Ornamenta Ecclesiae, Kunst und Künstler der Romanik in Köln*, exh. cat., Schnütgen Museum, Cologne, 1985, p. 216.

9. The graphic identification of the ruler with one of the Three Kings was clearly contributed to by sepulchral sculpture. Kehrer (cited in note 5 above, pp. 221–2) mentions several German tombs where the deceased is depicted bearing a gift to Christ, thus imitating one of the Three Kings (for instance, the epitaph of Ulrich Burggraf [d. 1348] in Augsburg Cathedral). In northern Italy as early as the 13th century a donor had himself portrayed alongside the Three Kings; see the fresco in the Abbey of Vezzolano dating from 1354 and the one in the Bovi Chapel in San Michele di Pavia by Jacopo da Verona dating from 1397, A. de Marchi, *Gentile da Fabriano*, Milan, 1992, p. 188 n. 50.

10. Charles IV was a passionate collector of relics and certainly knew the *Dreikönigenschrein*. Cologne played an important part in his policy. He accorded it many new privileges and confirmed old ones as well, thus referring to his predecessors, beginning with Otto IV of Brunswick. The depiction of this German monarch on the case containing the holy relics can hardly have escaped his attention. It was clearly the inspiration—or one of them—for the appearance of his portrait on pictures of the Three Kings. One cannot rule out, however, that the motif of the crypto-portrait on pictures of the Adoration could have been derived by Charles directly from some unknown model. Kurt Weitzmann ('Icon Painting in the Crusader Kingdom', *Dumbarton Oaks Papers, XX*, 1966, 49–83, esp. p. 63, fig. 23) sees as the third of the Magi on a 13th-century Venetian icon now in the Monastery of St Catherine (Sinai) the Mongolian General Kitbuq who proclaimed himself the descendant of one of the Magi. The identification of an actual person with one of the Three Kings therefore may have existed before the time of Charles IV, but I was unable to find any other examples.

11. For the most recent study of the Karlstein paintings, see V. Dvoráková, 'Karlstejn a dvorské malírství doby Karla IV' in *Dejiny Ceského vytvarného umení*, I/I, Prague, 1984, pp. 310–27, where previous literature is listed.

12. The suggestions are the following: Louis of Hungary (Anjou), A. Friedl, *Mikulás Wurmser, mistr královskych portrétà na Karlstejne*, Prague, 1956, pp. 32–3, 67; St Aloysius Gonzaga, Z. Bouse and J. Myslivec, 'Sakrální prostory na Karlstejne', *Umení, XIX*, Prague, 1971, pp. 280–93; and Peter Lusignan of Cyprus, V. Dvoráková, and Dr Menclová, *Karlstein*, Prague, 1972, p. 42. Objections may be raised with regard to all three. I therefore considered the possibility of the second monarch depicted in a green cloak being Amadeo VI of Savoy, known for his love of green clothes. The '*Conte verde*' was Charles's Imperial Vicar in Arelat and could therefore perhaps have been depicted with a crown symbolizing the emperor's claim to rule in the kingdom of Arelat, O. Pujmanová, 'Nekolik poznámek k interpretaci Ostatkovych scén v kapli P. Marie na Karlstejne', unpublished lecture delivered at a seminar in Charles University (Prague) in January 1981.

13. Attention was drawn to this connection by J. Pesina, 'Podoba a podobizny Karla IV, príspevek k poznání Ceského portrétního realismu ve 14. století', *Acta Universitatis Carolinae, Philosòphica et Historia Monographia*, I, 1955, No. 1, pp. 1–60, esp. p. 2. Today the portraits of

Charles IV are already the subject of quite an extensive literature. The work of Helga Wammetsberger, 'Individuum und Typ in den Porträts Kaiser Karls IV', *Wissenschaftliche Zeitschrifts- und Sprachwissenschaftliche Reihe*, XVI, 1967, Vol. I, pp. 79–93, contains valuable information on the depictions of Charles IV outside Bohemia.

14. T. Kubátová, 'Zpodobnení Karla IV. Mistrem Theodorikem na Karlstejne', *Umení*, I, 1953, pp. 210–14.

15. Hana Hlaváčková, opinion as yet unpublished.

16. The solemn ceremonies were conducted according to the newly introduced coronation protocol, whose author was Charles IV himself with the help of other collaborators. The protocol laid particular emphasis on the royal insignia, clearly depicted in the Vyssí Brod Altarpiece. The Virgin of the Annunciation wears a crown, while Gabriel holds the Imperial orb surmounted by a cross and on his robe features the French fleur-de-lis which recurs in the scenes of the Ascension and the Descent of the Holy Ghost. The Angel in the Resurrection carries the sceptre; J. Pesina, *Mistr vysebrodského cyklu*, Prague, 1982, pp. 13–40.

17. In terms of style, the Pierpont Morgan panels exemplify the initial stage of the soft style of courtly painting which prevailed *c.* 1360. They were probably produced, as one of this style's earliest manifestations, shortly after Charles's Coronation as Holy Roman Emperor, which they promptly echoed, J. Pesina, 'Imperium et Sacerdotium, Zur Inhaltsdeutung der sgn. Morgan – Täfelchen', *Umení*, XXVI, 1978, No. 1, pp. 521–8, esp. p. 522.

18. E. W. Kirsch, *Five Illuminated Manuscripts of Giangaleazzo Visconti*, University Park, Penn. and London, 1991, p. 9. See also Sandler in this volume (p. 149 and note 25).

19. Hofmann (cited in note 6 above), pp. 141–2.

20. Accordingly, he figures as emperor in almost all of his Karlstein portraits. The sole exception is the Adoration of the Magi in the Chapel of the Holy Rood, where he is depicted wearing only his royal crown, with which he is also portrayed in the Pierpont Morgan Adoration in New York.

21. J. Homolka, *Arcibiskup Jenstejn a vytvarné umení* (*Notes on the Artistic Promotion of Pre-*

Hussite Bohemia), lecture delivered at a seminar of historians of ancient history from museums of the Czech Socialist Republic, Jenstejn, 22 June 1977.

22. The portraits of Wenceslas IV have not yet been studied as a group. However, many notes on them are included in the studies of Jaromir Homolka ('Studie k pocátkum umení krásného slohu v Cechách', *Acta Universitatis Carolinae, Philosophica et Historia Monographia*, LV, 1974); Krása (cited in note 4 above); and K. Stejskal (*Umení na dvore Karla IV*, Prague, 1978).

23. Krása (cited in note 4 above), p. 96, fig. 7.

24. Wenceslas was crowned King of the Romans in Frankfurt on 10 June 1376, strongly endorsed by Duke Wenceslas of Saxony (d. 1388), a stalwart ally of the Luxembourgs. It was probably to mark that occasion that the Electors of Saxony commissioned the wall-painting of the Adoration for the chapel in the Cathedral of St Vitus of which they were patrons, Z. Vsetecková (*Monumentální malba, katedrála sv. Víta na Prazském hrade*, Prague, 1990, submitted for editing) kindly permitted me to quote her yet unpublished manuscript.

25. The scene of the Adoration of the Magi follows the text of Matthew 2:1–11 which makes references to Psalm 72:10, Isaiah 60:6, and Luke 2:16. Zuzana Vsetecková has drawn attention to the unusual iconography, 'Nástenné malby v kostele sv. Jakuba v Libisi', *Acta Universitatis Carolinae, Philosophica et Historia Monographia*, I, 1980, No. 4, pp. 137–81.

26. 'Give the king Thy justice, O God, and Thy righteousness to the royal son! May He judge Thy people with righteousness and Thy poor with justice! Let the mountains bear prosperity for the people, and the hills, in righteousness! May He defend the cause of the poor of the people, give deliverance to the needy, and crush the oppressor!'

27. Vsetecková (cited in note 25 above), pp. 155–7. While the Adoration of Libis links up with that of St Vitus's Cathedral, it betrays a much greater emphasis on drawing and prefigures the early phase of the *beau style*.

28. An interesting analogy is Wenceslas' crypto-portrait on the frame of the Madonna Aracoeli already discussed. It shows King Wenceslas as the Prophet Jeremiah, his head wreathed in a mantling. His head is bent backwards, making his brow all but invisible. No-

twithstanding, typological closeness to the second king in the Bucher Adoration is noticeable, O. Pujmanová, 'Studi sul culto della Madonna di Aracoeli e della Veronica vella Boemia tardomedievale', *Arte Cristiana*, LXXX, No. 751, 1992, pp. 255–6.

29. B. Kéry, *Kaiser Sigismund, Ikonographie*, Vienna and Munich, 1972, pp. 28–32, 141–3; M. Studnicková, 'Príspevek k ikonografii císare Karla IV a Zigmunda Lucemburského', *Umení*, XXXVII, 1989, No. 3, pp. 221–6; and A. Braham, 'The Emperor Sigismund and the S. Maria Maggiore Altarpiece', *Burlington Magazine*, CXXII, 1980, pp. 106–112.

30. F. Seibt *et al.*, eds., *Kaiser Karl IV, Staatsmann und Mäzen*, Munich, 1978, p. 161, cat. no. 186.

31. Among the six Epiphanies figures the Adoration of the Magi by Gentile da Fabriano in Florence (Uffizi) and the triptych of Stephan Lochner in Cologne Cathedral, upon which doubts are cast by Gerhard Schmid in his review of Kéry's monograph (cited in note 29 above), G. Schmid, *Zeitschrift für Kunstgeschichte*, Munich and Berlin, pp. 78–82.

32. The fur hat identifies Sigismund as the third king in a Dutch drawing in Berlin-Dahlem (Staatliche Museen) and as the second king on the Altarpiece of Bishop Johann von Bayern (Vierhouten, Van Beuningen Collection). These are clearly connected with Sigismund's stays in Holland and date from 1415–20 (Kéry, cited in note 29 above, pp. 162–7, 198–202, figs. 118–120). At this time, the depiction of a real person as one of the Three Kings was clearly no longer unusual. In the Hours of Maréchal de Boucicaut of *c.* 1405–08 (Paris, Musée Jacquemart André, MS 2), Louis d'Orléans is depicted in the role of the second king (f. 83v). In a Lombard miniature of *c.* 1380 (Paris, Bibliothèque Nationale, MS lat. 757), the king in the centre is identified as Giangaleazzo Visconti by his emblem (f. 293v), Kirsch (cited in note 18 above), p. 36. See also Sandler in this volume, note 25.

33. G. Bott and W. Beck, *Der Ortenberger Altar*, Hessisches Landesmuseum, Darmstadt, 1981.

34. The picture with a carved frame was ordered for St Vitus Cathedral most probably by the Archbishop of Prague, Jan Jenstejn, in the years 1392–96, J. Homolka, 'Madona ze Svojsína', *Umení*, X, 1962, pp. 444.

35. Reliquary bust of *c.* 1390 from Parler's workshop. The crown which originally adorned the head of the saint has not been preserved. Unfortunately, the two coats of arms and the inscription on the base, which might have identified the saint, have been worn away. Attention was drawn to the close kinship of the bust and the carving of St Sigismund on the frame of the St Vitus Madonna by Hans Peter Hilger, 'Reliquienbüste eines jugendlichen Heiligen' in *Die Parler*, Vol. I, pp. 184–5. The parallel with the Wilton Diptych is also interesting, as was proposed by Alfred Schädler in *Kaiser Karl IV*, exh. cat., Nuremberg (Kaiserburg), Munich, 1978, cat. no. 107.

36. E. R. Knauer, 'Kaiser Sigismund. Eine Ikonographische Nachlese' in *Festschrift für Otto von Simson zum 65. Geburtstag*, eds. L. Grisebach and K. Renger, Frankfurt on Main-Berlin-Vienna, 1977, pp. 183–4, 192; M. Studnicková, 'Hoforden der Luxemburger', *Umení*, XXXX, 1992, pp. 320–28, esp. p. 327.

37. On 12 December 1408 Sigismund founded, together with his second wife, Barbara Cilli, and Hungarian magnates, the knightly Order of the Dragon. Its members wore, as a symbol of their fight against the infidel, the sign of a dragon beneath a cross, one example of which is preserved in Munich (Bayerisches Nationalmuseum, No. T 3792), Seibt *et al.* (cited in note 30 above), pp. 161–2. The raised embroidery with a pearl for the dragon's eye recalls the sword depicted in the Ortenberg Adoration. Because the dragon appeared very frequently in various connections, this analogy must be treated with reserve. Similarly, the significance of the cloak with the oak leaves should not be overestimated. What was originally a French fancy-dress costume known as *livrée de May* became a popular fashion in various European courts in the first quarter of the 15th century.

38. Hofmann (cited in note 6 above), p. 163 feels that the sketch for this fresco might be the lost pen-drawing of the Adoration where the middle king is marked with a contemporary inscription: '*Sigismund Rex Romanorum 1424*'.

39. E. Windecke, *Denkwürdigkeiten zur Geschichte des Zeitalters Kaiser Sigismunds*, ed. W. Altmann, Berlin, 1893 and Kéry (cited in note 29 above), p. 157.

40. Sigismund's stays in Mainz in 1414 were the following: 2–4 August, 25–29 October, and 14–

22 December, Kéry (cited in note 29 above), p. 198.

41. After the Coronation he is alleged to have read aloud the Gospel of St Matthew himself, amazing those present not only for his appearance, but for his education as well, Hofmann (cited in note 6 above), p. 142.

42. From the Ortenberg Altarpiece only its right wing, with the Adoration, was copied. Two reasons for this may have been the staging of the play of the Three Kings documented in Ortenberg in 1466 (but possibly connected with an older tradition) and the identity of the donor depicted in the role of the standing king. Wolfgang Beeh considers the possibility that the donor was a member of an important noble family, Adolf von Eppensteins (d. 1434), Canon of Mainz and Provost of Frankfurt (W. Beeh, 'Mittelalterliche Abbilder als Legitimationsnachweis. Die Tafel mit Anbetung der Könige in Lenzburg und der Ortenberger Altar', *Kritische Berichte, Mitteilungen des Ulmervereins*, 4th Year, IV, 1976, pp. 3–19).

43. First published by E. Eich, 'Fürstenbildnisse einer religiösen Darstellung aus dem Mittelalter der Lenzburger Sammlung', *Lenzburger Neujahrs Blätter*, 1939, pp. 15–29.

44. Cologne, Kunsthaus am Museum, Auction 38, 12–15 March 1969, No. 1225, fig. 49.

45. Bayerische Staatsgemäldesammlungen, Galerie Aschaffenburg, *Katalog* (Contributions by E. Brochhagen, G. Goldberg, R. Oertel, Ch. A. zu Salm), Munich, 1964, p. 105.

46. A. Benedetti, *Eduardo II d'Inghilterra all'Abbazia di S. Alberto di Butrio*, Palermo, 1924, p. 10 n. 4 and Hofmann (cited in note 6 above), pp. 134, 163.

47. *Age of Chivalry*, cat. no. 681.

48. *Making and Meaning*, p. 57.

49. This would be in keeping with contemporary practice. In the years 1360–1425 the composition of the Adoration begins to change and the pictures acquire more levels of significance. D. D. Davidson, *The Advent of the Magi in Religious Images in Italian Art 1260–1425*, Baltimore, 1971, p. 175.

50. *Making and Meaning*, p. 57.

51. For Richard's attempt to have Edward II canonized, see C. M. Barron, 'Richard II: Image and Reality' in *Making and Meaning*, pp. 13–18.

52. Queen Anne was in favour of the translation of the Bible into the vulgate. This was not lost on Wycliffe, who writes with satisfaction that 'to pillory for this the noble Queen of England, sister to the emperor, would be devilish foolishness'. For Wycliffe's polemic writings, see R. Buddensieg, ed., *Polemical works in Latin*, 2 vols., London, 1883, I, p. 168.

53. *Making and Meaning*, pp. 71–72.

54. For an illustration of this painting, see *Staatsgalerie Augsburg, Städtische Kunstsammlungen, I: Altdeutsche Gemälde*, Munich, 1988, fig. 1.

55. We find this motif not only in many panel paintings from the circle of the Master of Vyssí Brod, but also in contemporary frescoes and manuscript illuminations. The originally Byzantine motif is not intended to humanize a hieratic picture, as Professor Pesina thinks, but is based on specific texts and has a particular significance; J. Pesina, 'Un motivo bizantino-italiano nella pittura boema verso la metà del XIV secolo', *Acta Historiae Artium, Academiae scientiarum Hungaricae*, XXIV, Fasc. 1–4, pp. 91–9. The motif of the Christ Child's proffered sole occurs also in French painting, for example in the illumination of a Book of Hours in Brussels (Bibliothèque Royale, MSS 11060–1, ff. 10 and 11).

56. The Czech Madonna in the Louvre described by Charles Sterling ('Une Madonne tchèque au Musée du Louvre', *La Revue des arts*, X, 1960, p. 83) has unnaturally extended fingers on the right hand which are evidently based on the way in which the Virgin of the Wilton Diptych is holding the proffered sole of the Child. Another, again misunderstood version of this motif can be seen on the painting of the Madonna from Augsburg already mentioned. It therefore seems probable that the Virgin's gesture on the Wilton Diptych was inspired by a Czech model. If the Virgin of the Wilton Diptych was painted following the composition of a statue belonging to Queen Anne, as is proposed, then this statue may have been endowed with some magical power, either healing or the granting of wishes. From the 1380s onwards, the Archbishop of Prague, Jan Jenstejn, granted indulgences not only to various miraculous paintings, but also to statues of the Virgin which soon became the target of reformers. On the attitude of reformers to paintings in Bohemia, see J. Krása, 'Study on Manuscripts of the Hussite Period',

Umení, XXII, 1974, p. 17 and I. Korán, 'The Life of Our Madonnas', *Umení,* XXXVII, 1974, pp. 200–202.

57. In scenes of the Epiphany very often one of the Magi, usually the first one, kisses the Child's foot (especially in Italian art) following the description in the *Meditationes Vitae Christi.* It is possible, therefore, that in displaying the sole of the Child's foot, the Virgin is offering it for a kiss or expecting it to be kissed.

58. See Shelagh Mitchell's paper in this volume (pp. 115–124). Mitchell kindly provided me with many references to such donations by Edward III and Richard II between 1343 and 1392.

59. According to his legend, Edward gave his ring to a pilgrim who was in fact St John the Evangelist. After some time, two English pilgrims in Palestine met a handsome old man, again St John. He returned them the ring with the request that they give it to their teacher and inform him that he is awaited among the chosen.

60. It was believed that it had originally belonged to St John the Evangelist and that it was in Paradise for seven years. This increased the respect of pilgrims for Westminster Abbey, where homage was paid not only to the saint's Shrine, but also to the ring of St Edward the Confessor. From around the year 1400 there is testimony to this from the preacher John Mirk: 'Then whoso lust to have this preuet sothe, go he to Westminstyr; and there may se the same ryng that was seuen yere yn paradys', *Mirk's Festival,* ed. T. Erbe, Early English Text Society, Extra Series, XCVI, London, 1905, p. 149.

61. This ceremony should not be confused with another, far better known ceremony of miraculous healing, for which the usual designation is *'Le toucher des écrouelles'* (the word *écrouelle* is the popular word for the Latin *scrofula*). This ceremony was carried out from roughly the middle of the 13th century until 1825 in France and in England, where it was known as the 'King's Evil', up to 1714. The initiator of this ceremony is considered to have been St Edward the Confessor who was invoked not only as the first miraculous healer of scrofulous ulcers, but also of epilepsy, A. Cardinalli, *Biblioteca Sanctorum,* Vol. IV, Rome, 1964, p. 926. M. Bloch, *Les Rois Thaumaturges,* Paris, 1924, new edn (Gallimard), 1983, esp. pp. 159–183 and F. Barlow, 'The King's Evil', *English Historical Review,* 1980, pp. 3–27.

62. In the Household Ordinance of Edward II in York for June 1323 the following is written: *'Item le roi doit offrer de certein le jour de graunde venderdy a crouce V s., queux il est acustumez recivre divers lui a le mene le chapeleyn, a faire ent anulx a doner pur medicine as divers gentz, et a rementre autre v s',* T. F. Tout, *The Place of the Reign of Edward II in English History,* Manchester, 1914, p. 317. In the same work (p. 445), there is mention of accounts where the rite is more precisely described.

63. From Antiquity rings have been popular objects of magic. In the Middle Ages they were often connected with witchcraft. Joan of Arc (burned in 1431) tried in vain to convince her judges that she had never tried to heal with her rings. When St Bernard of Siena preached against superstition in Italy at the beginning of the 15th century, he scolded those who wore rings against cramps cast during readings of Christ's Agony, Bloch (cited in note 61 above), p. 167. An English medical treatise from this period (London, British Library, MS Arundel 276, f. 23v) contains instructions on how to make healing rings on Good Friday. Their outer side was to be marked with the name of Christ, the inner side with the names of the Three Kings who were often evoked against epilepsy. The reference to the treatise is in Bloch (p. 168 n. 1). The rite of the English kings, the 'cramp rings', was therefore connected to ancient folk tradition: the consecration of metal from which a talisman was to be made.

64. Bloch (cited in note 61 above), p. 173.

65. In the course of time the ceremony was gradually simplified until in the end it was completely transformed. Originally the rings were made from gold and silver placed on the altar during the Adoration of the Cross. It was easier, however, to bring ready-made rings to the altar on Good Friday. This change appears to have been made in the first years of the reign of Henry VI (1413–42). Bloch (cited in note 61 above), pp. 173 and 179.

66. London, British Library, MS Add. 35115, f. 33v (4 April 1393); R. Crawford, 'The Blessing of Cramp-Rings. A Chapter in the History of the Treatment of Epilepsy', *Studies in the History and Method of Science,* ed. C. Singer, Oxford, 1917, Vol. I, p. 170. Quoted in Bloch (cited in note 61 above), p. 446.

67. *'In consimilibus oblacionibus domine regine factis adorando crucem in precio quinque solidorum*

argenti in capella sua ibidem eodem die V s. In denariis solutis pro eisdem oblacionibus reassumptis pro anulis medicinalibus inde faciendis V s'. Account book of John of Ipre, Controller of the Household, 13 February–27 June, 43 Edward III (1369), PRO, E 101/396/11, f. 122. Quoted in Bloch (cited in note 61 above), p. 176 n. 2.

68. Bloch (cited in note 61 above), p. 176.

69. *Making and Meaning,* pp. 15, 55.

70. It is perhaps not without significance to recall in connection with this the ruby ring which Richard II dedicated for use in future coronations. While he was in England Richard kept the ring himself, as opposed to other regalia which were kept permanently in Westminster Abbey; *Making and Meaning,* p. 55.

71. Ibid., p. 67 n. 130.

72. Ibid., p. 60.

73. Bloch (cited in note 61 above), p. 161.

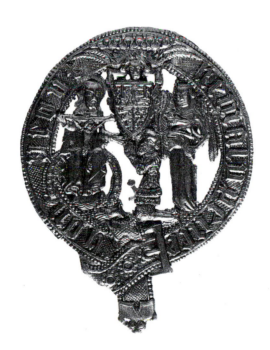

Lead Badge showing the Black Prince
kneeling before the Trinity. London, British Museum

Chronological Table

1367	6 January	Birth of Richard at Bordeaux
1377	21 June	Death of Edward III. Accession of Richard II
	16 July	Richard's Coronation
1380	January	Ending of the system of minority councils
	November	Granting of the third poll tax
1381	13 June	Entry of the Kent and Essex rebels into London
	14 June	Richard's meeting with the rebels at Mile End
	15 June	Confrontation with Wat Tyler at Smithfield
1382	20 January	Richard's marriage to Anne of Bohemia
1383	May-Sep.	Bishop Despenser's crusade in Flanders
1385	August	Richard leads Scottish expedition
1386	8 July	John of Gaunt (Duke of Lancaster) departs for Spain
	Aug.-Sep.	French invasion threat
	23 October	Michael de la Pole dismissed as Chancellor
	20 November	Commission of government takes office
1387	9 February	Richard leaves Westminster for a tour of the realm
	August	Questions put to the judges about the nature of royal authority
	10 November	Richard returns to London
	14 November	Submission of the 'appeal of treason' against the King's favourites
	20 December	De Vere defeated at the battle of Radcot Bridge
1388	Feb.-May	Merciless Parliament at which Richard's friends are tried
	5 May	Execution of Richard's tutor, Sir Simon Burley
	October	Richard recovers the initiative at the Cambridge Parliament
1389	3 May	Richard assumes full responsibility for government
	18 June	Truce brings war with the French to an end
	19 November	Gaunt returns to England
1392	25 June	Richard confiscates liberties of the City of London
	21 August	Settlement with the Londoners
1394	7 June	Death of Anne of Bohemia
	1 October	Richard departs for Ireland
1395	1 April	Contracts placed for the tomb of Richard and Anne of Bohemia
	May	Richard returns to England

1396	28–30 October	Conference with Charles VI at Ardres
	4 November	Marriage to Isabelle of France at Calais
1397	10–11 July	Arrest of Gloucester, Arundel and Warwick
	17–30 September	'Revenge' Parliament at Westminster at which some of the former Appellants are tried
	?8–9 September	Murder of Gloucester at Calais
1398	28–31 January	Continuation of Parliament at Shrewsbury
	30 January	Bolingbroke (Earl of Derby) accuses Mowbray of treason
	16 September	Exile of Bolingbroke and Mowbray at Coventry
1399	3 February	Death of John of Gaunt
	18 March	Richard seizes Lancastrian inheritance
	1 June	Richard lands in Ireland
	late June	Bolingbroke lands at Ravenspur
	?17 July	Salisbury sent from Ireland to North Wales
	?24 July	Richard lands at Milford Haven
	?31 July	Richard leaves South Wales for Conway
	8 August	Bolingbroke enters Chester
	?15 August	Meeting of Richard and Northumberland at Conway
	?16 August	Meeting of Richard and Bolingbroke at Flint
	2 September	Richard imprisoned in Tower of London
	30 September	Deposition of Richard
	13 October	Coronation of Henry IV
1400	13 January	'Epiphany Rising' in Richard's favour
	?14 February	Death of Richard at Pontefract Castle
	17 February	Council orders Richard's body to be brought to London

Compiled by Nigel Saul

Glossary

Advowson
The right of a patron to appoint to a benefice.

Annual obit
A mass said or sung on the anniversary of a death.

Antiphon
Usually these were verses sung alternately by two choirs as part of the Divine Office. On saints' days, the antiphon would refer to the particular saint whose feast it was.

Appellants
The group of five lords critical of Richard II's courtiers and patronage who submitted the 'appeal of treason' in November 1387. They were Thomas of Woodstock, Duke of Gloucester; Richard FitzAlan, Earl of Arundel; Thomas Beauchamp, Earl of Warwick; Henry Bolingbroke, Earl of Derby and Thomas Mowbray, Earl of Nottingham.

Arched-brace and collar roof
A roof incorporating arched braces (pairs of curved timbers forming an arch) springing from below the wall-head and connected to collars (horizontal timbers linking the rafters at a level between wall-head and apex).

Badge
A device or emblem usually worn as a mark of identification, ownership, or allegiance.

Balas ruby
A spinel ruby.

Book of Hours
A devotional text whose core is the daily liturgical Office of the Virgin, or Hours of the Virgin, adapted for private use primarily by the laity. In addition to the Hours of the Virgin, Books of Hours customarily include a Calendar, the Office of the Dead, the Litany, the Penitential Psalms, the Gradual Psalms, and often other offices such as the Short Office of the Cross, the Hours of the Holy Spirit, the Hours of the Trinity, and the Hours of the Passion. The Hours of the Virgin (as well as the other offices) are recited at the eight Canonical Hours (Matins, Lauds, Prime, Terce, Sext, None, Vespers and Compline) into which the devotional day is divided. The texts consist of Psalms, readings ('lessons') and prayers, together with antiphons, versicles and responses.

Burden
Chorus, refrain.

Cap of maintenance
In heraldic terms, a cap of dignity borne by a person of noble rank.

capp.
Form not exactly known - possibly early form of cap of estate.

Corrody
A form of pension provided by monasteries whereby the holder, or corrodian, was entitled to live in the monastery and receive a specified amount of food daily or, alternately, just to receive the food.

Cross *patonce* or fleury
In heraldic terms, a cross with three splayed points at the end of each arm.

Curtana
A sword without a point, carried before kings of England at their coronation, as an emblem of mercy.

Dais
Platform at high table end of a hall.

Diaper
A small geometrical design.

Dorsorium
Curtain, usually hung vertically behind a chair, bed, etc.

England and France ancient
The royal arms as used from 1340 to *c.* 1406 consisting of the arms of the kingdom of France (azure semé or scattered with with fleurs-de-lis) quartered with those of the kingdom of England (gules three lions *passant guardant*).

Enrolment
The record kept on the Chancery Rolls.

Fan vault
A vault consisting of concave-profiled inverted cones (or half or quarter cones) built entirely of jointed ashlar and decorated with blind tracery. Specific to the English Perpendicular Gothic style.

Fly
In a triangular flag, the fly is the triangular tail of the flag, the section after the **hoist** which is the part nearest the staff.

Guardant
In heraldic terms, descriptive of a beast with its head turned towards the observer.

Gilt-latten
An alloy of copper, zinc, tin and lead often referred to as bronze or brass. The contract for Richard and Anne's double tomb calls it *'laton'*.

Gouna
Exact form unknown, a tunic-like garment, possibly the English equivalent of the French *houppelande*.

Half a mark
This was 6s. 8d. A mark represented 13s. 4d. or two thirds of £1; it did not exist as an actual coin.

Hammer-beam roof
A roof incorporating brackets (hammer-beams) projecting from wall-head level and supporting on their inner extremities vertical posts (hammer-posts) which in turn support rafters connected to collars by means of curved braces.

Hanap
A drinking vessel, usually on a foot.

Hoist
In a triangular flag, the hoist, usually bearing a heraldic device, is the section nearest the staff.

Impaled
Two coats of arms combined side by side on a shield.

Imprimitura
The first layer in a painting covering the entirety of the ground, usually playing no part in the design of the image.

louver
An opening in the roof of a hall to enable the smoke of a heating fire to escape.

Magnate
Powerful noble.

Mantlett
Deep collar shoulder cape?

Mantel
Outer garment similar to a cloak.

Martlet
In heraldic terms, a martin or swallow without feet used as a bearing.

Matins
The first of the eight 'Hours' (Canonical Hours) into which the devotional day is divided (*see* **Book of Hours**).

Minever
Squirrel furs, made of bellies only, white with a little grey surrounding it.

Motet
An (unaccompanied) anthem usually used in church music. Motets could also convey secular themes.

Oriflamme
The French royal battle standard, donated by King Dagobert to the Abbey of Saint-Denis, and taken by the French king to war.

Orphrey
Derived from *aurifrisium* . Gold embroidery or an ornamental border or band especially on an ecclesiastical vestment sometimes richly embroidered.

Pontifical
The liturgical book containing the texts of the rituals and services of the church at which a bishop officiates.

Psalter
The Book of Psalms as recited in entirety in the course of a week at Matins and Vespers of the daily liturgical offices of the clergy. Also used as a private devotional text by the laity. In addition to the Psalms, subdivided in accordance with the daily readings (the normal divisions are at Psalms 1, 26, 38, 52, 68, 80, 97 and 109 in the Vulgate), Psalters generally contain a Calendar, Canticles, Creeds, and the Litany of the Saints.

Pulpitum
A screen of solid construction, normally stone, dividing the choir from the nave and forming a backing for the retro-choir stalls.

Pured minever
The white belly skins of squirrels with all the grey trimmed off. It was used extensively as a lining for royal clothing, only very rarely being replaced by ermine.

Scarletta
The most luxurious woollen cloth, finer and softer than any other contemporary fabric except silk. It was much associated with the expensive red dye, kermes, and eventually gave the meaning of a red colour to the term 'scarlet'.

Sedilia
A seat, or series of seats, crowned by canopies, often in the choir of a church for use of the officiating clergy.

Sext
The fifth of the eight 'Hours' (Canonical Hours) into which the devotional day is divided (*see* **Book of Hours**).

Sgraffito
Literally, scratched. A technique in which paint is applied over gold leaf and then scraped away from specific areas to reveal the gold beneath; particularly used to represent cloth of gold textiles.

Statant
In heraldic terms, descriptive of animals standing.

Tail male
Inheritance restricted to the male line.

Tenement
House, dwelling.

Tester
A canopy suspended over a tomb, bed, or chair.

Tie-beam roof
A roof incorporating transverse horizontal timbers (tie-beams) whose outer ends are joined to the lower ends of rafters.

List of Illustrations

Additional Illustrations in the Text

Colour Plates

Index

Numbers in italic refer to illustrations